Tyler Graphics
Catalogue Raisonné, 1974–1985

Walker Art Center
Minneapolis

Abbeville Press Publishers
New York

Tyler Graphics:
Catalogue Raisonné, 1974–1985

Foreword
Elizabeth Armstrong

Essay
Pat Gilmour

Catalogue Raisonné
Kenneth E. Tyler

Library of Congress Cataloging in
Publication Data

Tyler, Kenneth E.
 Tyler Graphics: catalogue raisonné,
1974–1985.

1. Tyler Graphics Ltd.—Catalogs.
2. Prints, American—Catalogs.
3. Prints—20th century—United States
—Catalogs.
4. Printmakers—United States—Biography.
I. Walker Art Center.
II. Title.
NE508.T95 1987
769.973'074'0176579 87-1299
ISBN 0-89659-757-1 (Abbeville Press)

First edition

Editor: Karen Jacobson
Designer: Laura Lovett
Production manager: Dana Cole

Throughout this publication the titles of
individual works and books are given in
italics, and titles for series and portfolios
are given in roman type.

(front cover)
Frank Stella
Pergusa Three 1983
relief, woodcut on TGL handmade paper
66 × 52 (167.6 × 132.1)
Collection Walker Art Center, Minneapolis
Tyler Graphics Archive

(back cover, top)
Frank Stella with Rodney Konopaki,
Kenneth Tyler, and Bob Cross working on
Pergusa Three and the Swan Engravings,
1981, Tyler Graphics Ltd.

(back cover, bottom)
Kenneth Tyler inking relief section of a
Swan Engraving plate through a plastic
stencil, with Rodney Konopaki and Frank
Stella assisting, 1981, Tyler Graphics Ltd.

(frontispiece)
Applying ink to the automatic ink rollers in
the flatbed offset press, Tyler Graphics Ltd.

Contents

Foreword

Elizabeth Armstrong

Tyler Graphics: Catalogue Raisonné, 1974–1985 and an accompanying volume of analytical essays, *Tyler Graphics: The Extended Image*, are the direct outgrowth of the establishment of the Tyler Graphics Archive at Walker Art Center, Minneapolis, in 1983. At the outset the Walker acquired some twelve hundred prints, proofs, working sketches, and unique images created at Tyler Graphics Ltd. in Bedford Village, New York. This remarkable print workshop was founded in 1974 by Kenneth E. Tyler, who, as its director and master printer, has overseen the total output to date of more than fourteen hundred print editions and unique images. Over the past two decades Tyler has been one of the most active printers in America, not only as the helmsman of Tyler Graphics but also as founder of Gemini Ltd. and cofounder of Gemini G.E.L. in Los Angeles.

By the time Tyler established his own shop in Bedford he had earned the confidence of a number of eminent artists with whom he had worked in Los Angeles, including Josef Albers, David Hockney, Ellsworth Kelly, Roy Lichtenstein, Robert Motherwell, and Frank Stella. In his new setting on the East Coast, Tyler provided a more relaxed working environment consistent with the introspective artistic mood of the 1970s. Tyler focused on helping artists to find ways of using printmaking as a significant art form in itself, a concern that led to artist-printer dialogues of unusual complexity and depth. Settling into the guest apartment above the Bedford workshop, artists have extended their stays from days to weeks and sometimes months to explore fully the resources of this advanced facility and its innovative and demanding master printer.

Throughout the 1970s, as Tyler continued to attract a diverse group of artists that included Helen Frankenthaler, Nancy Graves, Richard Hamilton, Michael Heizer, Kenneth Noland, and Alan Shields, he began to think seriously about how to house his rapidly expanding archive. Tyler sought a museum that displayed an active interest in the artists with whom he collaborated and that had the facilities to accommodate a large collection. Walker Art Center satisfied both criteria. As part of the acquisition arrangement, Tyler agreed to provide the museum with one impression

from every future print edition produced at Tyler Graphics, thus assuring the continuing development of the collection. Housed in the McKnight Print Study Room, the Tyler Graphics Archive is accessible to artists, scholars, and interested members of the public.

When the archive came to Walker Art Center in 1983, the museum initiated a series of exhibitions exploring the range of imagery and techniques represented in the collection. It also undertook the publication of this catalogue raisonné, in which Tyler's work in Bedford has been scrupulously documented. Relatively few catalogues raisonnés address the work of contemporary printmakers; even rarer are those that focus on the production of a single workshop. Tyler Graphics offers artists the full range of print processes—including intaglio, lithography, screen printing, relief printing, and monotype printing—as well as papermaking. Many prints are made in variant editions. Consequently the thorough documentation of this diverse collection posed a formidable challenge, as did finding a format to accommodate the degree of detail required by Tyler. In addition to the customary catalogue raisonné information, such as the number of colors in a print, its dimensions, the type of paper used, and the edition size, this publication elucidates the entire printmaking process. Paper-making, techniques used for making each printing element, inking, and the printing of each edition are specified, with credit given to those individuals involved with each process.

With the same fidelity to detail that characterizes his working method in the studio, Tyler oversaw the compilation of all documentary material for this book. During the lengthy process of assembling the catalogue, he developed unique ways to present its complex information. This publication is a tribute to Tyler's imaginative approach, his resourcefulness, and his boundless energy. At the time of this writing, he had just moved Tyler Graphics from its carriage house in Bedford Village to a new, larger facility in nearby Mount Kisco. There he is already planting the seeds of numerous collaborations that may someday become the subject of a sequel.

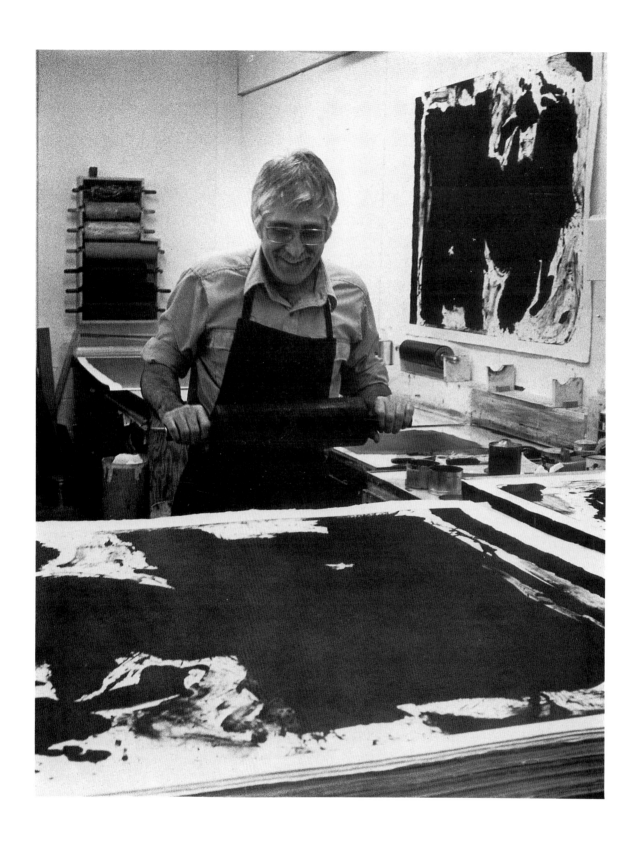

Kenneth Tyler viewing
an impression of
Robert Motherwell's
lithograph *Lament for
Lorca*, 1982.

Kenneth Tyler
A Collaborator in Context

Pat Gilmour

After two decades of outstanding work, Kenneth Tyler seems certain to go down in history as one of the most accomplished and dynamic printers to have assisted artists in the making of graphic art. His visionary grasp of the possibilities of his field has radically altered the look of prints in the United States, investing them with exceptional scale and ambition. As artist and historian of lithography Clinton Adams put it recently: "No other printer has so directly affected the work that has come from his studio; no other printer has so changed the character of the contemporary print."[1]

By mastering a remarkable repertoire of modern graphic processes and making them available to artists under one roof, Tyler has demonstrated that printmaking is a language distinct from painting and that ultimately its originality resides in the extent to which concept is united with technique. As masterpieces have come from his presses in which it is well-nigh impossible to distinguish his input from that of the artist, Tyler has caused us to reconsider the limitations that our romantic notion of the artist's role may hitherto have placed on the printer's activity. Indeed, as a direct result of Tyler's work—and not least of the honesty of his documentation—we may for the first time be on the threshold of a genuine aesthetic of collaborative printmaking.

During his career Tyler has witnessed one of those regular fluctuations of taste in printmaking in which the viewing public moves from acceptance of an essentially graphic mark to longing for a more painterly one. The allegedly cool and industrial aesthetic that Tyler helped to develop between 1966 and 1973 at his Los Angeles workshop Gemini G.E.L. gave way during the following decade to the personalized, manually individuated, even unique print that curators and collectors so gratefully welcomed back. Although there are rarely guarantees that such individuation does not stem from an amanuensis copying the artist's maquette,[2] this recurring demand for the "humanity" of marginal fingerprints,[3] for obvious handling, and for the related aesthetic of "bad printing"[4]—features that printers in the 1960s had worked hard to eliminate—reveals how indelible the craving for even an illusion of the artist's touch remains.

Although many lovely hybrids resulted from this swing in taste, it is not difficult to argue that this cyclical return to an aesthetic more appropriate to

painting may have hindered the formulation of a true aesthetic of the print. The best reason for making graphic art is to do something that cannot be done in any other way. And the truth is that the potential the print has for multiplication is acquired at the expense of direct touch. There is no print process that does not place at one remove from the sheet of paper the hand that seeks to mark it.[5] However spontaneously the artist splashes lithographic tusche on stone or sugar aquatint solution on metal, the image—usually reversed in direction and modified by the choice of ink and support—must be processed by a printer if it is to continue its existence. Once printed, the mark is not intrinsically better or worse than one drawn directly; it is simply different.

Our romantic conception of the artist as a lonely genius in a garret struggling to perfect an idiosyncratic autograph is so entrenched, however, that while we accept the actor as the intermediary for the dramatist, or the musician for the composer, we have been much slower to acknowledge the printer's contribution to what is essentially an interpretative activity. As the print has struggled to be almost anything but itself, schizophrenically going downmarket to be democratic or upmarket to appeal to an elite, the battleground has been strewn with a litter of false antitheses—of content versus technique, of mind versus hand, of artist versus artisan, and of "high art" versus craft. Our ambivalence may be explained by the fact that since the nineteenth century the kind of graphic art most valued in the West has been made by stars—usually painters with minimal graphic training—whose contribution as "original"[6] printmakers depended, even as the importance of the autograph was emphasized, upon the manual assistance of collaborators.

The fluctuations in taste that have occurred during Tyler's working life have echoed nineteenth-century developments after the establishment of "originality." By 1893 color lithography, initially popularized by Jules Chéret's posters, was being used for connoisseur prints such as Henri de Toulouse-Lautrec's *Loie Fuller*, each of which was dusted with metallic powder and individually iris-inked with different rainbow colors, probably by the printer, Henry Stern. A parallel situation can be traced in etching. In the early 1860s Alfred Cadart's inexpensive publication *Eaux-fortes modernes* was virtually mass-produced in an unlimited edition; by 1875, however, the critic Philippe Burty was advocating the connoisseurship of the "belle épreuve."[7] To serve this etching revival, the remarkable printer Auguste Delâtre changed the look of intaglio prints all over the world by introducing his "sauce hollandaise,"[8] a manipulative inking technique. The vogue that Delâtre originated produced what has been wittily described as "that wonderful contradiction so dear to the shackled imagination of an age of mechanical reproduction—the unique variant."[9] In fact, his method was so adaptable that it could range from an allover plate tone or the merest whiff of retroussage sustainable over an edition to the ink modeling developed by Edgar Degas in monotypes, which was indirectly inspired by Delâtre's example.[10] Delâtre's method could become a boring mannerism, but in the hands of its best exponents it displayed admirable flexibility. When commentators pointed out how dependent on the printer's hand artists had now become, however,[11] those who perceived collaboration as a threat to their integrity had to consider pulling their own impressions.

While Seymour Haden applauded the duchesslike palm of the famous English printer Frederick Goulding,[12] James McNeill Whistler, although content

to collaborate with a printer on his lithographs,[13] took an entirely different view of printing etchings. No artist reveals more clearly the shaky ground on which our prejudices about collaborative printmaking may be based. Whistler learned his métier in Delâtre's shop in 1858; watching the printer ink several of his etchings, including *Street at Saverne*, from The French Set, affected his aesthetic for the remainder of his life. Eventually he rejected the work of all professional intaglio printers and ran down Goulding's "ghastly glassy," "gummy and treacly" impressions.[14] But while few could improve on an impression pulled by Whistler on one of his good days, his failure rate was distressingly high.[15] It was a struggle for him to sustain an edition and fulfill his orders. Indeed, more than one of his contemporaries noted that through failing to damp the sheet or blanket the plate correctly, he cut into or cockled the impressions he made on the old paper he adored.[16] Being Whistler, he made an aesthetic virtue of necessity by trimming the telltale margins to conceal his lack of skill.

In the 1880s, when he was printing his Venice etchings, Whistler acquired an Australian disciple named Mortimer Menpes. Menpes recorded Whistler's belief that "the etcher should print his own plate. In that, as in most things, he was perfectly right. The work is not complete until it has been printed. . . . as that printing requires the handling of an artist just as much as would a water-colour drawing, it is obvious that when a professional printer prints a plate it becomes the work of two men instead of one, which on the face of it cannot be right. Collaboration was an abomination to the Master." One day, however, when Whistler's failure rate was even higher than usual, the pathetically grateful Menpes was told to "try and print a palace." The result was so convincing that Menpes was appointed permanently to the task. Whistler, "not looking at all like a printer," would turn up wearing his canary-colored kid gloves and suggest that Menpes labor over twenty proofs while he himself wafted off to a garden party.[17] A genius at presenting the case for the division of labor that William Morris found so reprehensible,[18] Whistler informed his apprentice that he was not really doing the printing at all: "Your hands, I know Menpes, are doing the work, and your palm wipes the plates; but it is my mind, the mind of the Master, that is in the work, making it possible for you to do it. I have educated and trained you, and have created an atmosphere which enables you to carry out my intentions exactly as I myself should. You are the medium translating the ideas of the Master."[19] And so, with Menpes a willing accomplice in his own exploitation, the idea of the printer doing the work without getting too much of the credit was sanctified.

The Tamarind Lithography Workshop, founded by June Wayne in Los Angeles in 1960, was where Tyler earned his right to the title "master printer." Tamarind not only prevented hand lithography from dying out in the United States but also presented printing as a worthwhile career. The workshop's conception of the printer's role was particularly interesting, encouraging the traditional reticence designed to protect "originality" and the artist's ego, yet offering high incentives for technical experimentation. The artist John McLaughlin, for example, said in 1968 that he had been impressed by the insistence that technique should be pushed "to even greater limits rather than adjusting to its already proven capabilities."[20] But as the printers translated individual requirements into ink densities, etch strengths, and rolling patterns,

doing their best to serve as the artist's hands, eyes, and thought processes, they were cautioned "never to cross the fine line that separated technical advice from aesthetic interference."[21]

Theoretically the notion that an idea springing from an artist's head can be partially realized by a printer's hands is somewhat at odds with the concept of an "original" art form dependent upon the creator's touch. If "originality" is taken to its logical conclusion, the purest form of graphic art would be a traditional single-color lithograph or drawn intaglio in which the author's hand, seismographically recording its trace, would go on to accomplish the infinite subtleties of the printing.

Indeed, the belief that the artist should also be the printer was firmly held by Stanley William Hayter, the British artist who extended the boundaries of intaglio color printing at his experimental workshop, Atelier 17. Hayter argued with cogency that content and means of expression in gravure were totally interdependent. In an influential article written at a time when he was educating a generation of Americans about graphic art, Hayter reasoned that separating idea from technique was akin to isolating the physical, emotional, intellectual, and spiritual aspects of "integral" man.[22] For Hayter, the artist's direct participation in every part of the process, including the printing, was axiomatic, because every aspect of process affected the aesthetic.

But if the conception of images takes a lifetime to perfect, so too does the skill of printing them. In the late nineteenth century the growing variety and sophistication of graphic techniques brought about a new phenomenon— the printer as genius—exemplified by the Parisian lithographer Auguste Clot. Opening his workshop for artists after 1888, Clot helped nearly every important painter of his day to participate in the blossoming "color revolution." His was a formidable example; for if Delâtre's invention had caused consternation even in essentially monochrome prints, the problems were greatly increased when color became the norm. Artists now had not only to imagine their images reversed but also to analyze them into layers separated onto sequential stones. As Robert Hughes noted: "For some painters, making a print is worse than learning to play Ping Pong backwards in a mirror with a time lapse . . ."[23]

In her catalogue of Ambroise Vollard's publications, Una Johnson describes Clot's virtuosity in lithography as "virtual wizardry,"[24] a term that, with its implication of almost magical or occult skill, has frequently been applied to Tyler.[25] Like Tyler, Clot was ahead of his time and was severely criticized because of the liberal assistance he gave the artists who worked with him. The critic André Mellerio complained that instead of expressing themselves directly in the language of print, painters were allowing Clot to produce mere facsimiles of their work in other media. In the case of Pierre-Auguste Renoir, Paul Cézanne, and Alfred Sisley, Mellerio maintained, Clot had made the artists lazy, substituting his intimidating skill and graphic fluency for their involvement.[26]

Very often the criteria used to distinguish "originals" from reproductions caused critics to react to what they thought they knew, rather than to what they actually saw. Renoir's *Child with a Biscuit*, for example, is a miracle of lightness and delicacy, a far cry from the traditional chromolithograph. With its mat finish and the subtle use of a white ink last in the printing sequence— one of Clot's hallmarks—the print displays the genius of both printer and artist. While Claude Roger-Marx could not deny its charm, he nevertheless

dismissed it as "no more than an interpretation."[27] Roger Passeron, however, found it one of the high-water marks of color lithography and, providing the perfect rationale for collaboration, commented: "Clot alone would never have been able to create such a lithograph. But for Clot, on the other hand, Renoir would never have undertaken it."[28]

Some artists, such as Pierre Bonnard, Maurice Denis, and Edouard Vuillard, became more deeply involved in printmaking and made substantial portfolios with Clot before the century was out.[29] Although they escaped Mellerio's criticism relatively unscathed, even these artists gave the printer considerable leeway, as their letters to him reveal.[30] In 1897, for example, Denis, writing about a whole list of tasks, including retouching, asked the printer to carry them out for him, and ended: "Look after this for me—as if I were there."[31] In an undated letter he told Clot to select "a sustained mauve" to satisfy his own fantasy. Maurice Eliot, one of the minor artists working for Vollard, revealingly wrote: "I would prefer to have a few blemishes; above all, give it the air of having been made *by me*."[32]

Although lithography fell out of fashion early in the twentieth century— maybe because of prejudice against color, maybe because of overproduction— Clot persevered with the technical researches typical of all great printers.[33] In his diversification into woodcut one recognizes the first stirrings of the modern multimedia workshop that Tyler now runs. The prints uniting lithography and woodcut on one sheet that Clot helped Henri Héran and others to make are absolutely exceptional for their time.[34]

Despite the opprobrium initially attached to it, Clot's practice of assisting artists in elaborating with color the drawings they themselves had made on the key matrices became common procedure in twentieth-century printmaking. The artists, of course, were always free to accept or reject whatever the printer helped them produce, and if the defenders of "originality" had pursued their ideal less aggressively, the deliberate verbal obfuscation of what actually occurred might have been less prevalent. Marc Chagall and Georges Rouault could hardly be accused of not immersing themselves in printmaking. Yet there is abundant evidence that when it came to embellishing his basic lithographic drawings with color, Chagall needed and received help.[35] Rouault, apparently also a devotee of Clot,[36] made many of his color intaglio prints in Paris, first with the help of Maurice Potin and later with Roger Lacourière. Comparing Potin's often muddy wish-wash with the brilliant purity afforded the artist by Lacourière illuminates once again how false is our separation of the technical from the aesthetic.

In lithography Clot's most significant successor was Fernand Mourlot, who built a dazzling reputation based on the work Pablo Picasso did in his shop after World War II. Largely confining himself to black and white, the brilliant and prolific artist drew all his matrices himself, using unheard-of materials. When given advice, said Mourlot, "he looked, he listened, he did the opposite of what he had learnt—and it worked!"[37] Drawing nonstop from dawn to dusk in a corner of the atelier, Picasso would use boot polish, watercolor, or gouache on stone, zinc, or transfer paper. Advised of the dangers of contaminating the stone with his saliva, the artist would deliberately create whites with his spit. Images were fingerprinted, textured by rubbings, cut up and collaged from inked transfer papers, Rorschach-blotted in tusche, fused with solvents, and scraped and scratched until his matrices squealed for mercy. Magically he fashioned some exquisite birds—Tyler's favorites

among his prints—using body color over an oily wash; the drawings were perfectly transferred and printed, defying all precedents.[38]

In the traditional European workshop, where printers are apprenticed and not trained as artists as in America, the jobs are highly stratified. A *chromiste* such as Henri Deschamps,[39] who was close to Picasso, would advise the artists about their drawings if asked but was not the man who processed and printed their stones. The unsung heroes of Picasso's print production were the pressmen Jean Célestin and Raymond Tutin.[40] To them fell the unenviable and often problematic task of restabilizing the artist's work on stone after each of his many forays into it to make corrections or alterations. Tutin did not like Picasso's work and "often cursed his lithographic oddities,"[41] but he was a particularly skillful and immaculate craftsman. Reading between the lines of Mourlot's catalogue of Picasso's lithographs, one appreciates just how daunting and fraught with danger was the task the pressmen had to accomplish.[42] For the image brought to life by the joint skills of artist and printer may die by the same token.

Even if, in the end, his work was in their hands, Picasso dominated the relationship with the Mourlot printers. As Garo Antreasian put it: "He compelled a brilliant but traditionally intransigent group of craftsmen to find solutions outside routine and customary practice."[43] But even with Picasso, influence did not flow only one way. Brigitte Baer, who has updated Bernhard Geiser's catalogue of Picasso's graphic work, has commented that whereas the stimulus of Mourlot's workshop helped the artist reinvent lithography, the lithographs of Picasso's novitiate, made with a number of different printers, lacked "any passion or originality, remaining very close to drawing."[44] Similarly, in the early intaglio prints Baer sees no sign of true collaboration between Picasso and Louis Fort, who "was merely an intaglio printer."[45] Fort did not have a workshop where Picasso could draw on his copper plates; nor was he an engraver. The work that Picasso produced with him was conventional and classic in technique. When Picasso went to work with Lacourière, however, the printer, who was also a draftsman, became a true collaborator and "would show him new techniques . . . could discuss or even suggest new ideas." Up to every trick of the trade, the printer was a master of sugar aquatint, which he taught Picasso in 1934. From that time onward Picasso discarded all conventions, stimulated "to leave behind the classical and traditional engraver he still was, to seek new inventive horizons." In this way, Baer suggests, Picasso eventually surpassed himself and became "the most important engraver of this century and one of the four greatest engravers of all time."[46]

Tyler recognized that Picasso had virtually reinvented the art of lithography. It was certainly the artist's practice of pushing the printer to find a solution, however tough the problem, that lay behind the Tamarind model. Likewise, Picasso's sheer effrontery in challenging and breaking technical and academic rules became an article of faith for Tyler. "Tear up the rule books," he told a group of Australian artists in 1985, some of whom had crossed a continent to see him. "Use your imagination and just keep going."[47]

It was Jean Adhémar who pointed out that the improved status and visibility of printers in the modern period was a direct result of technical advances.[48] As early as 1866 Maxime Lalanne had put forward a sophisticated image of collaboration, which, he said, "sometimes rises to the dignity of an art, in which the artist and the printer are merged into each other, the printer

losing himself in the artist, as he is compelled to enter into the latter's ideas; the artist giving way to the printer, to avail himself of his practical experience."[49] Delâtre, too, spoke of the need either for the artist to become a printer or for the printer to become an artist.[50] Henri Béraldi, gently suggesting, tongue in cheek, that the printer was getting above himself, described a workshop as "a tranquil place, where in a spirit of contemplation a workman, pardon! a skillful artist, pulls ten to twelve proofs a day."[51] This ideal was certainly established in America, for when Childe Hassam's printer died, he was described as "co-author" of the prints he had helped to produce, "his artistry as necessary to the realization of the etching as are the strokes of the genius who etched the picture into the copper."[52]

The fusion of artist with printer and printer with artist is the subject of a much more recent eulogy by the German artist Gerd Winner. It was written on the occasion of a 1980 London exhibition[53] surveying the output of the celebrated screen printer Christopher Prater of Kelpra Studio, said "almost singlehandedly" to have "metamorphosed screenprinting into a fine art."[54] Tyler felt that Prater, of all contemporary printers, had ideals closest to his own, and in the 1960s he had invited the Englishman to work with him in Los Angeles. "I felt we shared a common love of perfection and technological achievement," said Tyler. "I felt we would be a helluva team."[55]

A number of observers have recognized that the collaborations entered into by Tyler have often attained an unprecedented level of intensity. But traditions die hard. William S. Lieberman, a distinguished curator who impressed on Tyler that only great artists make great prints, has called him "a brillant practitioner." He nevertheless clings to the idea that the printer should take no part in decisions "which are the artist's prerogative." The printer's job is to "make the tusche heavier if the artist wants it heavier."[56]

At the other extreme, Robert Rauschenberg, for whom Tyler made some of the largest lithographs ever to be pulled by hand, said he was "a strong believer that two people having good ideas can produce more together than two people with good ideas can produce separately."[57] Recently the artist amplified his earlier remarks, insisting that to engage only a person's hands was "usury": "That's slavery. Just because they have a sophisticated skill, no matter how sophisticated, it's a physical waste, and to my way of thinking an artistic waste, not to use the entire body that those skilled hands come with."[58]

At times even those who helped launch collaborative printmaking in America have found Tyler's visibility and involvement intrusive. Garo Antreasian, who not only taught Tyler lithography but was the only American June Wayne could find who was skillful enough to man the presses when Tamarind first opened, has a special appreciation of the fact that once the work is done, the printer "steps back into the shadow of virtual anonymity and the artist steps forward to bask in the light of achievement."[59] Nevertheless, in a pioneering 1980 article Antreasian made it clear that he looked with some misgivings upon certain aspects of collaboration. In particular, he expressed doubt about "the complex and catalytic role . . . best epitomized by the master printer Ken Tyler whose cunning and calculated utilization of present day technological materials and processes, like the experimental outlook of Hayter in the 1950s, stimulated the methodology of printmaking beyond its characteristically nineteenth century confines." Considering other Tamarind-trained printers, Antreasian noted with approval the "altruistic selflessness"

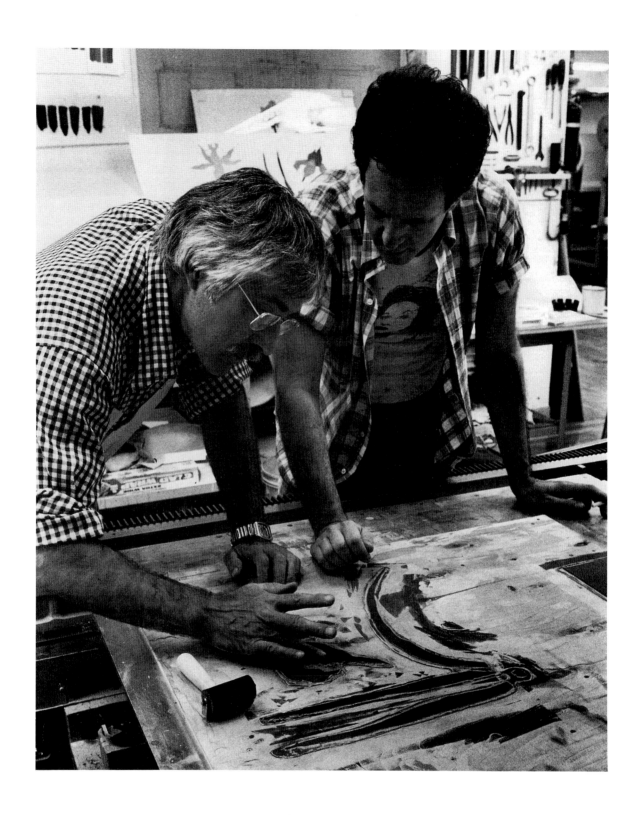

Ed Baynard observing
Kenneth Tyler blending
ink with his fingers on
a color woodblock for
The Dragonfly Vase,
1980.

of Irwin Hollander, who left Tamarind to found his own New York shop, and the example of Serge Lozingot, who, "with extremely low visibility," succeeded Tyler as Gemini's master printer.[60] Both men are marvelous printers, about whose skills and human qualities artists speak with great warmth; at the time Antreasian was writing, they exemplified for him a more acceptable printer profile. Betty Fiske, who worked at Tamarind and also served as printer at Tyler Graphics from July 1974 to October 1976, differentiated Lozingot from Tyler as one who "always envisioned himself as an expert on the technical aspect, but as someone who has to follow the artist's wishes, to follow his aesthetic objectives as much as possible. Whereas Ken is someone who takes more of an active role in directing or envisioning where the aesthetic can go."[61]

Tyler knows that the distinction between technical and aesthetic control "gets very gray at times."[62] However, the bottom line is that if the artist dislikes something, he can say no. Nevertheless, Tyler feels a symbiotic relationship has to develop between himself and every artist he chooses to work with: "You can't separate it after a while and you don't know whether the suggestion came from the printer on the press or was the artist's idea. But you know that something's going on there and if it works, it's magic."[63]

When Tyler departed from Tamarind in 1965 to found his first workshop, Gemini Ltd., Pop Art had been brought to its peak by artists later aptly described as "graphic artists of great genius, who also paint."[64] Many of them were interested in bringing into "high art" photomechanical processes hitherto outlawed by the prevailing definitions of originality. Tyler announced (somewhat woundingly from the point of view of Tamarind, whose many opportunities and rigorous programs of research had substantially benefited him) that he was leaving the evangelistic revival mounted by "hopeless craft romantics" to try to close the gap between technology and art.[65] Tyler felt that the craft traditions then being resuscitated were incompatible with the statements contemporary artists wanted to make. While in his view Tamarind favored the "romantic printer," Tyler wanted to expose artists to research-oriented collaborators equipped for technological advance. Another important ambition was to provide complete artistic freedom. "You cannot dictate to contemporary artists what is going to be art," he said. "And if you want to run a vital shop, you have to run it within contemporary times."[66]

One anecdote reveals Tyler's genuine openness to experimentation at this date, compared to some of those around him. The artist Bruce Conner, a rebel who, like Picasso, knew that rules were made to be broken, discovered that at Tamarind not only were fingerprints taboo but an edition could not be pulled once the artist had canceled his lithographic drawing. So on one of his prints he featured a single fingerprint, while he canceled another before he had so much as pulled a proof. "That's nice," said Tyler, looking at the canceled stone. "Let's print it." In the absence of June Wayne, the acting director, Cal Goodman, suggested that he and Conner sit down and discuss the matter "like gentlemen." "What is this crap you're trying to put over here?!" was allegedly Goodman's opening gambit.[67]

Tyler's work at Gemini is already amply documented,[68] but the sea change marking his move to Bedford Village can be evaluated only in light of the criticism of his earlier work, the validity of that criticism, and the extent to which his later production can be seen as a response to it. On the West Coast, Tyler had set out to encourage artists to go beyond the traditional

prints they could make in their own studios and to challenge the invention, ingenuity, and considerable technological resources of his shop. Although Gemini had certainly expanded beyond the traditional lithograph, a newspaper writer recognized that, even so, the place still stood for "delicate hand labor performed by college aesthetes."[69] The shift in taste from Gemini's so-called industrial aesthetic to a more obviously handcrafted one coincided with a wavering of technological optimism in the face of ecological concerns. In 1971, at the time of *Technics and Creativity*, an exhibition of Gemini prints at the Museum of Modern Art in New York, Tyler's productions inspired a chilly vocabulary that included among its kinder epithets such words as "cool," "crisp," "pristine," "immaculate," "polished," "hygienic," "meticulous," and "severe."

Continually described as a technocratic "wizard," Tyler was congratulated for "Americanizing print production with Detroit efficiency."[70] He maintains that he was never interested in technical virtuosity for its own sake but only in encouraging artists to make "more generous, more open-ended and more expansive" statements. Scale was of fundamental importance to him because he felt that major artists would be prepared to spend time on prints only if they were seen to be as important as paintings. He wanted what had hitherto been chamber music, at best, to grow into a symphony. Then, as now, he was willing to dedicate every hour of the day and every day of the week to an unremitting search for excellence.

It's easy to see that whereas Tyler's work at Gemini was unfamiliar to old-world connoisseurship, the work Tatyana Grosman produced at her West Islip, New York, workshop—Universal Limited Art Editions (ULAE)—was far more in line with tradition and curatorial expectations. As Richard S. Field has pointed out, although precision and control in the work of Jasper Johns were never better served than at Gemini, the prints he made there were criticized for seeming to lack "the warmth and slightly *malerisch* artistry of Tatyana Grosman's workshop. . . ."[71] Reflecting later on East Coast criticism of Gemini's achievement, Field regretted that the author of a book he was reviewing had not done more to deflect the uninformed charges that had been made.[72]

As Fields had himself observed, when Johns worked on his first lithographic series of numerals at ULAE, he did so on an intimate scale, with the nuances, textures, and surfaces of classical printmaking. At Gemini in Los Angeles those self-same numerals became monumental in scale, needing a specially designed inking device to realize their complex color changes. Creating a kind of treatise upon printmaking, Johns's ambitious conception carried graphic art, as Tyler had hoped, into a class commensurate with painting.

Tyler himself was full of admiration for much of the work that came from ULAE and responded very positively to images like Johns's *Coat Hanger*. Where work from his own press was concerned, however, Tyler wanted more technical innovation than he felt ULAE was achieving. His perception that ULAE lacked the technical experimentation necessary to match the advanced aesthetics of its artists has been confirmed by several of those who worked in West Islip. Jim Dine, for example, came to resent being told what to do and what was good: "[Robert Rauschenberg or Jasper Johns] would pick up a piece of string and say 'Oh, it's beautiful!' " he told an interviewer, "And Tanya [Grosman] . . . thought that was a general overall aesthetic for everyone." He added: "It was very difficult for me to make new things

there. . . . She'd say, 'No Dine, we don't do that here.' . . . I think it was one of the least experimental places I'd ever been in. Absolutely very rigid and a lot of relying on paper to carry the ball."[73] To the same interviewer, Larry Rivers confided that many of the marks he made on ULAE stones failed to emerge in the printing. "I didn't like to do work for her," he said, "because I never got what I wanted."[74] In the opinion of James Rosenquist, who was invited to make mural prints despite the fact that ULAE had only a tiny Mailander press, Grosman "simply didn't understand printing and its problems."[75]

It seems amazing, in retrospect, that Tyler's impeccable surface and the image stability that he was able to sustain over long editions only as a result of intensive research were adversely compared to the more primitive processing of early ULAE images. Of course, the most beautiful printing in the world is irrelevant if the image is second-rate to begin with. But the mythmaking in which the art world indulged and the simplistic way it decided that technique could be divorced from idea concealed an important fact: that, all other things being equal, a beautiful conception gains from being beautifully printed. As E. S. Lumsden wrote: "A really great work is always technically beautiful."[76] And the artist Bolton Brown, who had exquisite sensitivity when it came to his beloved "crayonstone," would have none of it when the curator William Ivins, having raved about a design printed "after it had become a wreck of itself," tried to tell Brown that it was mere affectation "to like a perfect impression better than any old rag."[77] Tyler must have found ignorance about such matters devastating; for whereas he could have produced fingerprinted and badly processed impressions without the slightest difficulty, most of his contemporaries in the mid-1960s would have been incapable of achieving the surface he had developed in response to the demands of a particular decade.

An article of 1975 cheerily in favor of "bad printing" announced that all a painter like Josef Albers needed was to rely on any competent printer, since there were "virtually no great technical complications to printing geometric abstraction."[78] If that was true, Tyler, who had cut his teeth printing Albers's work at Tamarind, must have wondered why he had bothered to design a hydraulic press to avoid push marks, why he mixed thirty-five blues to get the precise blue Albers wanted, why he had discarded more than one hundred proofs to arrive at the seventeen radiant White Line Squares, why he had devoted months of research to registering those squares without overlap, why he had sought the right substrate to prevent inks of different capillary action from bleeding into the fine white line, and, finally, why his printers were so daunted at the prospect of "feathering" with rollers that were narrower than the color flats to be inked. Yet that scenario was precisely what was necessary to achieve the exquisite surface and sublimated sensuality that Albers's lithographs required.

Gray Instrumentation I, in which Albers convinces us that a hard edge can magically disappear, was one of the first portfolios that Tyler undertook at his new facility in Bedford Village, and it is perhaps one of the loveliest suites that Albers ever made. Again, this time in screen printing, many problems had to be solved to arrive at a technical sophistication without which Albers's aesthetic would have been immeasurably impaired. The paradox was that although neither the prints nor their matrices had been touched by the artist's hand, their "originality" was such that in addition to being

irreproducible (a sure test of whether something is conceived in the medium of execution), they would also have been impossible to realize in paint. "He was the first note on the piano," said Tyler of Albers in 1973. "Whatever symphony there is today is because of him."[79]

Faced with misunderstanding of the true nature of his achievement, but also sensitive to the need for change and growth, Tyler searched for a foil to his smoothness of surface. The road on which he chose to move away from the Gemini technical mystique led to a radical development of handmade paper. Several individual artists had worked in pulp at the wet stage before Tyler took it up, but the project he launched in a French paper mill in 1973 became the catalyst for a worldwide acceptance of pulp as a new medium. What was so satisfying about it was that, like Delâtre's inking method, it had rich enough possibilities to attract every aesthetic.[80]

Collaborating first with local papermakers and later setting up his own mill, Tyler was able to do everything from running up substrates based on artists' specifications to encouraging painters and sculptors to manipulate, cast, and color pulp directly. Many delightful works resulted from the printer's initiative. Kenneth Noland's shapes in duck-egg colors were sprinkled with silk clippings and misted by the thinnest layers of Oriental pulp. Frank Stella painted and collaged onto editions of spunky reliefs. Ellsworth Kelly's austere geometries were softened by the migration of bleeding dyes. David Hockney, reveling in the excuse for sumptuous color on a grand scale, made "editions" of unique pieces. Working with a basic iconography derived from Tyler's swimming pool, he created many variants conveying both mood and temporal suggestion. "It's a pity Miró and Picasso never used this," said Tyler at an Australian workshop where he generously passed on what he had learned from these paper projects.[81] And the thought of what these great artists and Tyler might have achieved together was beguiling. But not everyone welcomed the unclassifiable paper-pulp creations with equal fervor. Provided only with essentially nineteenth-century storage facilities, one curator drily noted that these "eccentric interpretations" of what constituted a print were denying "its inherent two-dimensionality."[82] (Presumably this did not worry those who had found the Gemini prints too flat!)

Tyler found other ways of expanding his technical horizons and elaborating his surfaces. Enriching an already high-key palette, his tiny mill made huge sheets of handmade paper, lifting them wet from the vat with a specially designed crane and winch and, with the help of another ingenious device, embellishing them with myriad color patches. While these sheets were used for Stella's Circuits, uncolored ones were used for the same artist's monochrome engravings, sculpturally modeled by deep-etched magnesium plates. Although intaglio has traditionally been defined as printing from the incisions bitten by acid into a metal plate, even conventional nineteenth-century etchings utilized both the incisions and the relief for surface tone. Between the wars Stanley William Hayter and Rolf Nesch had inventively explored the three-dimensional implications of intaglio platemaking, but nothing they did quite prepared us for Stella's universally acclaimed magnesium etchings. How Auguste Delâtre might have stared, had he seen Rodney Konopaki working all day with up to a thousand cotton swabs to make one impression of a print embodying the Tyler Graphics update on manipulative inking! Only confidence born of a long-standing partnership has permitted Stella to progress

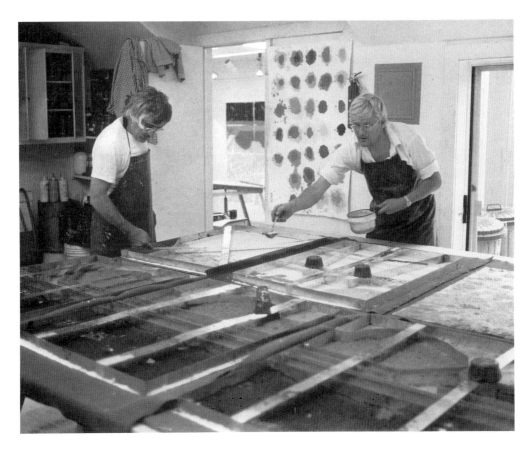

from the minimal Star of Persia chevrons through intervening periods of
Celtic interlace and scribbled glitz to the maximal Circuits and Swan Engravings,
which have established him as one of the century's major graphic artists. It
has been recognized that, like the French artists served by Clot, Stella could
not have created these complex works without the help of his inventive
printers. Maintaining the familiar distinction between a "painter-etcher"
and the more lowly "printmaker," Stella still pretends ignorance of graphic
process, but Robert Hughes has rightly told us to take this with a pinch of
salt. "If Stella's sardonic *blague* is to affect an indifference to technique, so
Tyler's is to come on as a technician pure and simple: a two-man routine.
But in printing as in other collaborative work—the mutuality of architect
and engineer for instance—there is no clear division of labor between *cose
mentale* and *cose manuale*."[83] In fact, Stella admits that three giant technical
advances won him the aesthetic freedom that helped to make prints as
important to him as paintings.[84] These advances were the surface and sculptural
possibilities of handmade paper, the scale and fidelity of etched magnesium,
and the ability to superimpose repeated veils of ink from the offset press,
almost as if he were using it to paint.

The offset press had long been banned as too "mechanical" a device for
the creation of original graphic art,[85] but Tyler's adoption of it when he
moved to Bedford Village liberated not only Stella but Hockney too. Tyler
Graphics is now well ahead of the field in the development of screenless
lithography, a process that enables an artist's drawing on a transparent
surface to be transferred to continuous-tone plates with minimum delay and
complete fidelity to the most sensitively nuanced washes. Tyler's specially
designed hydraulic press, with its refrigerated bed, has been central to this
expertise, just as his adaptation of drawing materials has allowed Hockney

to make color prints almost as spontaneously as paintings or drawings. Tyler provided this facility at precisely the moment the artist was exploring the profound limitations that the Renaissance system of one-point perspective had placed on the way we perceive the world. Of Tyler, Hockney has said: "I think real collaborators are quite rare, actually. They are. Because a collaborator is offering you something and then you offer him something back. That's how it must work, isn't it? And with somebody like Ken, what he's offering you, is something you couldn't do on your own, something you don't even know about."[86] In return for the spontaneity Tyler had made possible, the artist offered the printer an astonishing 350 plates for seventeen editions in a period of just twenty-eight months.

Tyler said eighteen years ago that the rapprochement between craft and technology necessary for printmaking in the twentieth century would develop "a new breed of sophisticated and dedicated printer."[87] His own staff epitomizes this development. Able to handle the ancient craft of papermaking and the most sophisticated techniques of magnesium etching and continuous-tone lithography, his printers embrace with equal facility woodblock and screen printing. The complete team, some of whom have been with him for nine years, comprises the "almost saintly"[88] etcher Rodney Konopaki and his assistant, Bob Cross; Lee Funderburg, who has developed the most advanced platemaking technology with the help of Roger Campbell; and Steve Reeves, an ingenious inventor whose right-hand man is Tom Strianese. Like the seventh member of the team, Mark Mahaffey, however, each is not so much a specialist in an individual medium as a professional collaborator, able to turn his hand to any task, as needed.

When the Stella prints of the early 1980s were first shown, Clifford Ackley of the Museum of Fine Arts, Boston, commented that the techniques used to realize them were so inextricably fused that even a trained observer could not unravel the puzzle without a crib sheet.[89] Indeed, because of the complexity of his multimedia production, the writing of the entries for this catalogue has required Tyler to become his own historian. American documentation, starting with Tamarind, became justly famous when it first attempted to clarify for the public the way prints were made. As time has gone on, however, the verbal barrage has sometimes been used to conceal rather than reveal. As Riva Castleman recently pointed out: "In this attention to documentation, very little information is given about the artist's involvement . . . except that his or her signature in pencil on the paper seems to assure the work's originality. Unlike the prints of earlier centuries (which bore the names of artist, engraver and printer) contemporary works are surrounded with a mass of data that reveals very little. All this mumbo jumbo has fogged our view of prints as objects of art, loading them with the burden of authenticity in order to protect the gullible."[90]

As long ago as 1971 the artist Jack Beal attempted to counteract the more blatant corruptions of the marketplace by devising a letter code to explain print production. The example Beal gave—OL6PHCHPP150—meant "an original lithograph of six colors mixed and printed by the artist's own hand on a power press to a total of 150 impressions."[91] Trying out Beal's system on Stella's *Pergusa Three Double* and Steven Sorman's *Still Standing Still*, Tyler not only found more than a dozen activities for which no codes had been provided but also found that media were mixed to such an extent that the rubrics he formulated—OLCEEnSW64PHPPOScPCHPHP49 and

ODLEWSIOPHPPcHPHPPPScO34—were impossibly unwieldy as well as incapable of encapsulating contemporary practice.

The question of who did what, with its attendant implications for "originality," still raises blood pressures in the United States. This was demonstrated in November 1985, when a group of seven people (including myself) sat down in New York at the invitation of *Print Collector's Newsletter* to discuss "Collaboration East and West."[92] The focus of the debate was the fascinating but contentious woodblock print project initiated by Crown Point Press, in which Western artists are invited to Japan to work within the centuries-old ukiyo-e tradition. Although the occasional artist insists on cutting a block or two,[93] the involvement of most consists in providing craftsmen with a watercolor or other maquette. Then the Japanese cutter Reizo Monjyu and the printer Tadashi Toda, with unimaginable skill, translate the model into print, much as Hokusai Katsushika and Utamaro Kitagawa were translated in the past.

Although Crown Point Press has always differentiated these prints from the "original" intaglio editions for which it is famous, the curator Robert Flynn Johnson, "representing many hundreds of artists in the state of California,"[94] campaigned for some visible device to identify the ukiyo-e works. Curiously, although it is the brilliant *cutter*, rather than the printer, who usurps the Western artist's expected function, Johnson felt honor was satisfied by having the *printer* sign each image. It was never clear to me how this solution could truly explain to the uninitiated a sliding scale of Japanese involvement ranging from partial to total fabrication.

The discussion unfortunately implied that the Eastern and Western traditions were completely antithetical. In fact, the distinction is rarely black and white but rather a succession of subtle and intriguing shades of gray. For example, just as we now know that Degas used photolithography in prints once thought to be completely hand-drawn and therefore "original,"[95] so Henri Matisse relied on his wife to help cut his woodblocks and the stenciler Edmond Vairel to follow (in a way very close to Japanese procedures) the maquette that was reproduced for *Jazz*.[96]

Significantly, both artists taking part in the discussion—Jennifer Bartlett and Alex Katz—felt that all methods used in making prints were equally legitimate, while their awareness of the aesthetic force exerted by the printer was particularly enlightening. Katz thought the Crown Point woodblock prints really "buzzed" and that this had to do "with the personality of the printer. What you have is alive out there." Bartlett suggested that one should choose a printer to suit the aesthetic of the image—for example, going to the Parisian intaglio printer Aldo Crommelynck not "for real juicy expressionistic things, but for a look as precise and clear and clean as he is."[97]

The Tyler catalogue raisonné makes a significant contribution to this prickly debate. It attempts, with professional economy and a degree of analytic clarity rarely encountered, to set new standards, not only by undertaking the difficult task of defining the nature of the techniques and even the presses used but also by naming all who have had a hand in each print and describing their exact roles. No one need feel threatened by this; the catalogue simply reveals what has always been true—that collaborative graphic art involves not only stars but supporting players as well. This knowledge is necessary if the activity is ever to be fully comprehended.

It is indicative of Tyler's genius that he has been able to make a distinctive

contribution even to the relatively traditional lithograph. Faced with the scale and complexity of the prints he has helped to create, the printer (whose sensitive antennae may be intuiting the developments of tomorrow) says that he is waiting for someone to come in, sit in a corner, and "draw on a teeny little stone." So far that hasn't happened, although the simple drawn print, which excites Tyler least because it leaves him a relatively small part to play, is one that his artist neighbor Robert Motherwell likes best.

Despite his fascination for Tyler's extroverted energy and the fact that this "Don Juan of printmaking" continually seduces him with the miracle of a thing well done, Motherwell says large or colorful prints involving many matrices, ready-made photomechanical collage elements, or solutions dependent upon other people make him feel like a foreign poet, the translation of whose work "betrays the original text because the translator necessarily has a totally different sensibility, background and sense of nuance." Despite the panache with which he brought off the authoritative *Bastos* and the sensitivity of the lyrical collage series America–La France Variations, Motherwell does not really feel at home in the collaborative situation. The problem is that the mark he makes records "a moment of passion," his inspiration for which is "being fully alive at a given moment." Face to face with the blank drawing surface, the artist seeks to convey "the real Motherwell" in a way that will be true to his quickening spirit.[98] Although he has acknowledged the help of printers more generously than any other artist,[99] Motherwell feels the need not so much for a collaborator as for an alter ego to serve him.

Tatyana Grosman, whose outlook and traditional view of lithography he substantially shared, electrified Motherwell once by insisting that he clean his own margins. It is interesting to conjecture what might have happened if, being more sensitive to the aesthetics of the actual processing and imposition, she had also advised him to etch and ink his own stones. The importance of this last stage in the realization of a work of graphic art—customarily left entirely to the printer—can be savored in one of Motherwell's masterpieces, *The Stoneness of the Stone,* 1974, printed at Tyler Graphics Ltd.

Garo Antreasian finds in this image "the grace, command and noble austerity of a Zen brushmaster." Since he himself is a printer, he also recognizes that Tyler's "sheer mastery of processing and printing the magnificent washes is unsurpassed; it rises to complement perfectly the touch of Motherwell's hand."[100] Tyler has given the artist's powerful conception its ultimate distinction by referring the two exquisite and dramatic strokes back to the moment when Motherwell made them, imposing them on a paper that in size, color, and texture exactly recaptures the surface of the stone.

Antreasian's appreciation of his former pupil is doubly flattering because there is no sterner critic than someone who, having covered similar ground, knows intimately what is involved. He had made his own large-scale lithographs and designed a hydraulic press before Tyler enrolled in his classes. As Tamarind's first master printer, he also brought into being some very remarkable prints. A lucid commentator on the graphic scene, he has had his moments of doubt, but his most recent tribute to Tyler's work is unequivocal. Tyler, he says, in extending the horizons of printmaking and the creative capacities of artists, has enriched all who make graphic art. He concludes: "Kenneth Tyler has fully invested his creative instincts, his energy and great skill—and, above all, his heart—into the art of printing art. In so doing, he has demonstrated for us the ultimate measurement of the title *Master Printer.*"[101]

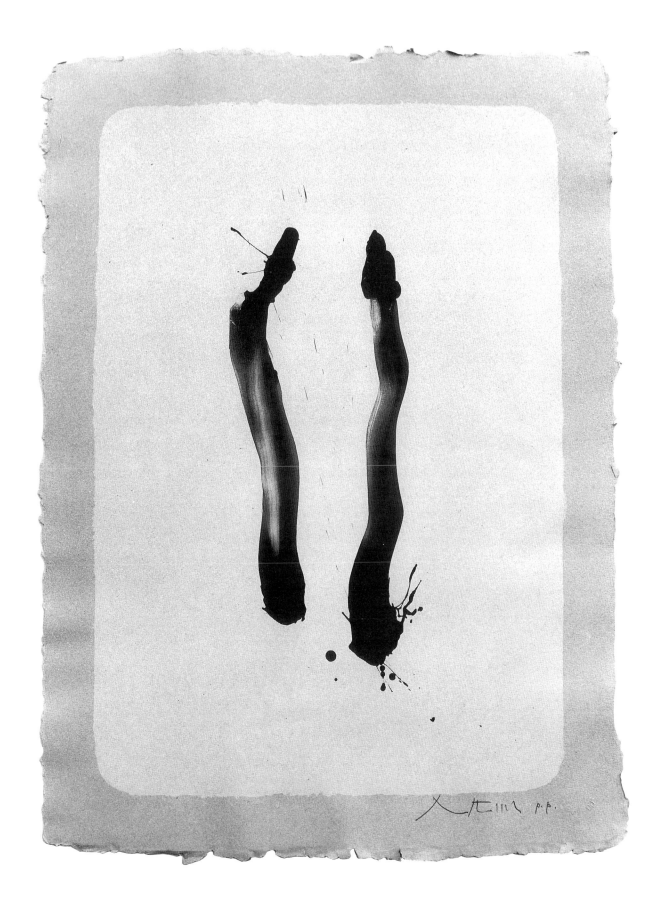

Robert Motherwell
*The Stoneness of the
Stone* 1974
Lithograph
41 × 30 (104.1 × 76.2)
See 382:RM1

Notes

1 Clinton Adams, review of *Ken Tyler, Master Printer, and the American Print Renaissance,* by Pat Gilmour, *Print Collector's Newsletter* 17 (July–August 1986): 108. Adams was director of the Tamarind Institute for a decade.

2 In "Collaboration East and West: A Discussion," Robert Flynn Johnson says: "There are artists out there, very famous artists, who, in fact, have a watercolor impression made up and then make, basically, an assembly line to hand-color these prints" (*Print Collector's Newsletter* 16 [January–February 1986]: 204).

3 Reviewing a recent exhibition of contemporary Japanese prints, Margaret Johnson wrote: "The technical achievement with printmaking processes and the refinement and perfection of detail, true to Japanese reputation, make an astoundingly flawless display. One New York artist wanted to see an inky fingerprint or some indication of human touch. Another, an American printmaker, remarked that it took him time to adjust to the perfection and deliberation exemplified in most of the prints. He missed the spontaneity and accidental markings that energize so much of contemporary Western printed and painted art" (*Printnews* 8 [Spring 1986]: 4).

4 See John Loring, "Bad Printing," *Print Collector's Newsletter* 6 (March–April 1975): 1–3.

5 The only exception is perhaps pochoir, where the hand-coloring through a stencil is usually done by someone other than the artist.

6 "Originality" traditionally required the artist personally to fabricate the matrix, although some definitions insisted on peripheral distinctions such as signature and limitation. Since photography entered the lists as a legitimate printmaking technique in the 1960s, it has been difficult to apply with any degree of consistency what was always a problematic concept.

7 Philippe Burty, in the preface to *L'Eau-forte en 1875,* explained that the elevated price for choice examples had nothing to do with rarity, but with "le sentiment de l'artiste qui l'a conçue, l'habileté de l'imprimeur qui l'a fait naître, le goût de l'amateur qui la distingue et la choie [the sentiment of the artist who conceived it, the skill of the printer who gave it birth, the taste of the art lover who singled it out and chose it]" ([Paris: A. Cadart, Imprimerie Seringe Frères, 1875], n.p.).

8 "Dutch sauce," so called because this method of inking was inspired by Rembrandt. No less than seven technical terms to describe ink application were listed by Henri Béraldi in volume 5 of *Les Graveurs du dix-neuvième siècle* under the entry for Auguste Delâtre ([Paris: L. Coquet, 1885–92; Nogent-le-Roi: Lame, 1981], pp. 172–73). Delâtre later boasted that his son Eugène, who followed in his footsteps, could ink the same plate in at least forty different ways.

9 Eugenia Parry Janis, "Setting the Tone," in *The Painterly Print,* exh. cat. (New York: Metropolitan Museum of Art, 1980), p. 9.

10 Ambroise Vollard wrote, "As a rule Degas executed these monotypes after dinner at Cadard [*sic*] the printer" (*Recollections of a Picture Dealer* [1936; reprint, New York: Dover, 1978], p. 258). The monotypes were made in the 1870s, when Delâtre was no longer Cadart's printer, but earlier prints by Degas already display the influence of Delâtre's techniques.

11 Philip G. Hamerton, *Etching and Etchers* (London: Macmillan, 1868), pp. 350–54.

12 Goulding was elected master printer to the Society of Painter-Etchers in February 1890. Martin Hardie, *Frederick Goulding, Master Printer of Copper Plates* (Stirling: Eneas Mackay, 1910), details his achievements.

13 Nicholas Smale quotes Whistler as writing in 1894, of his lithographic printer Thomas Way, "I owe all the encouragement I may have received in my work to his exquisite interpretation" ("Brown, Pennell, and Whistler: Eradicating Errors and Presenting a Non-Partisan View," *The Tamarind Papers* 8 [Spring 1985]: 70).

14 James McNeill Whistler, in Mortimer Menpes, *Whistler as I Knew Him* (London: Adam and Charles Black, 1904), pp. 96, 92.

15 Katharine Lochnan relates how Joseph Pennell and Whistler tried to print the Paris etchings together. Every plate was a disappointment, and it was six years before Whistler completed the task (*The Etchings of James McNeill Whistler,* exh. cat. [New Haven: Yale University Press in association with the Art Gallery of Ontario, 1984], p. 263).

16 E. S. Lumsden, *The Art of Etching* (1924; reprint, New York: Dover, 1962), pp. 303, 307; and Joseph Pennell, *Etchers and Etching* (New York: Macmillan, 1919), pp. 97, 98.

17 Menpes, *Whistler*, pp. 91, 99, 100.

18 Morris felt sympathy for the nineteenth-century artisan doing boring, repetitive work and wrote: "If there is to be any pretence of beauty in the work which is to pass through his hands, it will have been arranged for him by someone else's mind" (*The Unpublished Lectures of William Morris*, ed. Eugene D. LeMire [Detroit: Wayne State University Press, 1969], p. 86).

19 Menpes, *Whistler*, p. 100.

20 John McLaughlin, in Virginia Allen, *Tamarind: Homage to Lithography*, exh. cat. (New York: Museum of Modern Art, 1969; reprinted for New Zealand, 1973), p. 6.

21 Ibid.

22 Stanley William Hayter, "The Ides of Art—Eleven Graphic Artists Write: Interdependence of Idea and Technique in Gravure," *Tiger's Eye* 1 (June 1949): 41.

23 Robert Hughes, *Frank Stella: The Swan Engravings*, exh. cat. (Fort Worth, Tex.: Fort Worth Art Museum, 1984), p. 6.

24 Una E. Johnson, *Ambroise Vollard, Editeur* (New York: Museum of Modern Art, 1977), p. 29.

25 In Ruth E. Fine, *Gemini G.E.L.: Art and Collaboration*, exh. cat. (Washington, D.C.: National Gallery of Art; New York: Abbeville Press, 1984), p. 19, the printer Timothy Isham is quoted as saying of Tyler's contribution to Gemini, "Everything pretty well depended on his personal wizardry"; Clifford Ackley, discussing Frank Stella's Circuits in "Frank Stella's Big Football Weekend," *Print Collector's Newsletter* 13 (January–February 1983): 207–8, speaks of the "high-tech wizardry and inventiveness of the printer"; Judith Goldman, in "Printmaking: The Medium *Isn't* the Message Anymore," *Art News* 79 (March 1980): 82, calls Tyler Gemini's "gifted technical wizard and master printer"; Garo Z. Antreasian, in "Some Thoughts about Printmaking and Print Collaborations," *Art Journal* 39 (Spring 1980): 185, speaks of the development of the master printer, whose role "became that of a glamorous alchemist, one whose wizardry no-one could understand."

26 Several of Renoir's color prints, Cézanne's *Great Bathers*, and Sisley's *Geese* were among the so-called facsimiles discussed. Today the market does not differentiate these prints from "originals." In fact, in most cases the artists drew their own keystones, except for Sisley, who was dying. Mellerio's views appear in *La Lithographie originale en couleurs* (Paris, 1898), translated by Margaret Needham, in Phillip Dennis Cate and Sinclair Hitchings, *The Color Revolution: Color Lithography in France, 1890–1900* (Salt Lake City: Peregrine Smith, 1978).

27 Claude Roger-Marx, *Graphic Art in the Nineteenth Century* (London: Thames and Hudson, 1962), p. 199.

28 Roger Passeron, *Impressionist Prints* (London: Phaidon, 1974), pp. 126–27.

29 The portfolios, each containing twelve prints, were Quelques aspects de la ville de Paris, 1895; Amour, 1898–99; Paysages et intérieurs, 1899.

30 Photocopies of this correspondence were kindly made available by Dr. Guy Georges, a descendant of Auguste Clot, who perpetuates his grandfather's memory at Clot, Bramsen et Georges, the Paris lithographic workshop he now runs.

31 Dated July 22, 1897, and sent from Perros Guirec. It is not clear to which print the letter from Denis refers, but it could be a plate from Amour or *Le Reflet dans la fontaine*. Clot would always work through many proof stages, and the Australian National Gallery owns a proof of the latter print dedicated to Clot with the words "souvenir d'une opération laborieuse." The Denis letter reads in part: "Le planche de vert pour Vollard me plait ainsi. Vous pouvez tirez si cependant on peut remplacer la tête de la femme habillée en noir par celle que j'ai dessinée sur le calque, et que je vous envoie, ce serait mieux. . . . J'aurais voulu le noir moins gras, le grain moins rempli, en un mot, ce que l'autre épreuve a d'excessif dans le travail. J'ai marqué au crayon un endroit qui fait très bien, pour que vous compreniez ce que je veux dire. Il n'y a guère moyen de remédier à ce defaut. Vous tirerez c'est entendu, sur papier jaune, et moins gras si possible. . . . Soignez moi bien; comme si j'irais là. Votre Maurice Denis [I am happy with the green plate for Vollard as it is. You can pull it. If, however, we could replace the head of the woman dressed in black with the one I drew on the tracing, which I am sending you, that would be better. . . . I would have preferred that the black be less thick, the grain less full, in a word, what was excessive about the way the other proof had been worked. I have marked in pencil one place that is very good, so that you can understand what I mean. There's hardly any way to remedy this defect. Of course, you will do the edition on yellow paper—and less thickly if possible]."

32 Maurice Eliot's *Tête de fillette*, 1897 (Johnson 38), was the Vollard print. Eliot's letter said, "Je prefère quelques taches, mais surtout que ça ait l'air d'être fait *par moi*."

33 One of the processes Clot is said to have developed stemmed from an existing technique called "Fougeadoire," after its inventor. It was capable of enlarging or reducing transfers by the use of a rubber surface, but E. de Crauzat describes it as if, in Clot's hands, it was also magically able to preserve, completely intact, the artist's original drawing; this could be freely made on any kind of surface so long as greasy drawing materials were used. In *L'Art décoratif*, no. 139 (1910): 164–68, Crauzat obliquely implies that Fougeadoire was used for Rodin's *Jardin des supplices*, although Rodin's surviving drawings are actually in pencil and watercolor. More or less the same information is repeated by Françoise Woimant in her "Répertoire des imprimeurs lithographes en France," in *Nouvelles de l'estampe*, no. 24 (November–December 1975): 23. It may be irrelevant to the Rodin illustrations, which are often said to have been manually copied by Clot, but in an interview of October 17, 1984, Dr. Georges told me that Clot considered lithography to be finished and believed that the future belonged to photography. His grandfather "had recourse to photography rather often, and this is not said; it is not known well enough."

34 Clot printed a number of woodcuts, for Félix Vallotton, James Pitcairn Knowles, Edvard Munch, Henri Héran (a pseudonym of the German artist Paul Herrmann), and Henri Matisse. A letter to the printer from P. G. Jeanniot mentions ink for transferring woodcut to litho stone, and *Le Bain* by Knowles (Johnson 97) is so suave that it suggests a transfer of this kind. Héran is the eyewitness who described the famous incident in Clot's shop when Munch, on his way out for a glass of schnapps, left Clot proofing different color combinations for *The Sick Child*. Both Héran and Munch combined lithography and woodcut in one image. Although he had made a few prints previously, Munch served his graphic apprenticeship with Clot, which may go some way toward explaining the acute sensibility he developed for printmaking. The artists mentioned above are discussed in Jacqueline Baas and Richard S. Field, *The Artistic Revival of the Woodcut in France, 1850–1900* (Ann Arbor: University of Michigan, 1984).

35 A letter from Chagall to Gustave von Groschwitz concerning his collaboration with Carman is quoted by Clinton Adams in *American Lithographers, 1900–1960: Artists and Their Printers* (Albuquerque: University of New Mexico Press, 1983), p. 149. In 1962 the Print Council of America sent a questionnaire to Mourlot about Chagall's collaboration with *chromistes*, and Mourlot's reply makes clear the extent of the help the artist received (Print Council of America papers, Archives of American Art, Smithsonian Institution, Washington, D.C.). Charles Sorlier, one of Mourlot's *chromistes*, has also described the help he gave Chagall with his color prints in *Chagall Lithographs, 1974–1979* (New York: Crown, 1979).

36 According to François Chapon, Rouault greatly liked Clot, whose shop was next door to the place where the photogravures for his Miserere plates were probably made. "The artist apparently used Clot's studio for research and experiments that were not concerned solely with lithography, the firm's speciality" (*Oeuvre gravé Rouault* [Monte Carlo: André Sauret, 1978], p. 80, n. 193).

37 Hélène Parmelin, "Picasso's Iron Wall," in Fernand Mourlot, *Picasso Lithographs*, trans. Jean Didry (Monte Carlo: André Sauret, 1970), n.p.

38 Ibid., cat. nos. 64–66.

39 Jacques Mourlot, in an interview with the author, Paris, December 2, 1985, said: "Deschamps is a perfect craftsman. His work is unbelievable. Last month he copied a Mucha exactly as it was in the nineteenth century. . . . But Charles [Sorlier] is more intelligent and knows all about painting. He speaks about it beautifully and knows more than Deschamps. Sorlier is not such a good craftsman, but he is brighter."

40 "Picasso was very close to Deschamps, but not so close with Tutin. Tutin was a perfect craftsman and did for Picasso what he did for everybody, but he was a perfect printer, period. Nowadays we don't have the same kind of workman—we have workers who are sharper and more intelligent. They understand the feeling of the artist" (ibid.).

41 Mourlot, *Picasso Lithographs*, p. 93.

42 Ibid. A note beneath cat. no. 146 states: "Picasso who practically does not stop working, produces too much for a single pressman . . . it is necessary to call for a second printer, less skilful, who deteriorates the plate." In the introduction to the catalogue (n.p.), Hélène Parmelin states: "he would scrape and add ink and crayon and change everything! After this sort of treatment the design generally becomes indecipherable and is destroyed. But with him! Each time it would turn out very well. Why? That's a mystery. . . ."

43 Antreasian, "Some Thoughts about Printmaking," p. 184.

44 Brigitte Baer, *Picasso the Printmaker*, exh. cat. (Dallas: Dallas Museum of Art, 1983), p. 48.

45 Ibid., p. 55.

46 Ibid., p. 72.

47 Kenneth Tyler, at a workshop at Canberra School of Art, June 7, 1985, during a visit to Australia for the opening of the Australian National Gallery exhibition *Ken Tyler, Printer Extraordinary*.

48 "Le manque de travail et la rupture des traditions pendant près de trente ans, obligent les imprimeurs à accentuer leur rôle, et par conséquent à l'indiquer [the lack of work and the break with tradition for a period of almost thirty years obliged the printers to accentuate their role and, consequently, to draw attention to it]" (Jean Adhémar, "Hommage aux imprimeurs," *Nouvelles de l'estampe*, no. 16 [July–August 1974]: 9).

49 Maxime Lalanne, *The Technique of Etching* (1866; reprint, New York: Dover, 1981), pp. 56–57.

50 Delâtre, in M. Melot, *L'Estampe impressioniste* (Paris: Bibliothèque Nationale, 1974), p. 30.

51 Béraldi, *Graveurs*, vol. 5, pp. 172–73.

52 Dr. Leigh Hunt, *In Memoriam, Peter Platt* (Emma Platt, 1935), p. 11.

53 Gerd Winner, "The Artist as Printer—the Printer as Artist," in *Kelpra Studio: The Rose and Chris Prater Gift*, exh. cat. (London: Tate Gallery, 1980), pp. 60–61.

54 Richard S. Field, *The Prints of Richard Hamilton*, exh. cat. (Middletown, Conn.: Davison Art Center, Wesleyan University, 1973), p. 7.

55 Kenneth Tyler, in Pat Gilmour, *Ken Tyler, Master Printer, and the American Print Renaissance* (New York: Hudson Hills Press in association with the Australian National Gallery, 1986), p. 36. Tyler's invitation to Prater was never taken up.

56 William S. Lieberman, telephone conversation with author, New York, September 1984.

57 Robert Rauschenberg, interview by Joseph Young, *Print Collector's Newsletter* 5 (May–June 1974): 25.

58 Robert Rauschenberg, conversation with author, New York, June 19, 1985.

59 Garo Z. Antreasian, review of *Ken Tyler, Master Printer, and the American Print Renaissance*, by Pat Gilmour, *The Tamarind Papers* 9 (Spring 1986): 32–36.

60 Antreasian, "Some Thoughts about Printmaking," pp. 185, 186.

61 Betty Fiske, conversation with author, New York, June 21, 1985.

62 Robert Hughes, *Time*, January 18, 1971, p. 56.

63 Kenneth Tyler, in Gilmour, *Ken Tyler*, p. 32.

64 John Loring, in "Pricing Prints; or, The Poorman's Art," *Print Collector's Newsletter* 6 (March 1975): 5.

65 Kenneth Tyler, in Michael Knigin and Murray Zimiles, *The Contemporary Lithographic Workshop around the World* (New York: Van Nostrand Reinhold, 1974), p. 75.

66 Kenneth Tyler, conversation with author, winter 1984–85. Unless otherwise noted, all quotations from Tyler are from this conversation.

67 Bruce Conner, in Mary Fuller, "You're Looking for Bruce Conner, the Artist; or, What Is This Crap You're Trying to Put Over Here?" *Currant* 2 (May–July 1976): 9.

68 See Riva Castleman, *Technics and Creativity: Gemini G.E.L.*, exh. cat. (New York: Museum of Modern Art, 1971); and Fine, *Gemini G.E.L.*

69 Art Seidenbaum, *Los Angeles Times*, December 14, 1967.

70 Judith Goldman, *American Prints: Process and Proofs*, exh. cat. (New York: Whitney Museum of American Art and Harper and Row, 1981), p. 63.

71 Richard S. Field, *Jasper Johns: Prints 1970–1977*, exh. cat. (London: Petersburg Press; Middletown, Conn.: Davison Art Center, Wesleyan University, 1978), p. 14.

72 Richard S. Field, review of *Gemini G.E.L.: Art and Collaboration*, by Ruth E. Fine, *Print Quarterly* 2 (June 1985): 144–46.

73 Jim Dine, conversation with Esther Sparks, January 19, 1985, transcript (kindly shared by Esther Sparks, as were the next two references).

74 Larry Rivers, conversation with Esther Sparks, March 21, 1985, transcript.

75 James Rosenquist, conversation with Esther Sparks, April 3, 1985, transcript.

76 Lumsden, *Art of Etching*, p. 307.

77 Bolton Brown, with notes by Clinton Adams, "My Ten Years of Lithography, Part II," *The Tamarind Papers* 5 (Summer 1982): 41.

78 Loring, "Bad Printing," p. 3.

79 Kenneth Tyler, on the sound track of the film *Reaching Out*, Avery Tirce Productions, 1973.

80 All Tyler's paper projects are discussed in Pat Gilmour and Anne Willsford, *Paperwork*, exh. cat. (Canberra: Australian National Gallery, 1982) and in Ruth E. Fine, "Paperworks at Tyler Graphics," in the companion volume to this catalogue, *Tyler Graphics: The Extended Image* (Minneapolis: Walker Art Center; New York: Abbeville Press, 1987).

81 See note 47.

82 "During the past decade, printmaking has strenuously endeavoured to improve its position within the hierarchy of artistic expression. This has at times taken the form of a denial of the print's inherent two dimensionality, by imparting a sculptural quality to the work; technological advances have enabled the production of multiple lead reliefs and moulded paper objects among other eccentric interpretations of what constituted a print" (Frances Carey and Antony Griffiths, *American Prints 1879–1979* [London: British Museum, 1980], p. 19).

83 Hughes, *Frank Stella*, p. 6.

84 Frank Stella, interview with author, September 26, 1984.

85 Attitudes toward offset have been fully discussed in Richard S. Field and Louise Sperling, *Offset Lithography* (Middletown, Conn.: Wesleyan University Press, 1973); and Hanlyn Davies and Hiroshi Murata, *Art and Technology: Offset Prints*, exh. cat. (Bethlehem, Penn.: Ralph Wilson Gallery, Lehigh University, 1983).

86 David Hockney, interview with author, June 22, 1985.

87 Kenneth Tyler, in "A Heart of Stone," *Western Printer and Lithographer* (April 1968): 16–17.

88 Kenneth Tyler, conversation with author, winter 1984–85.

89 Ackley, "Frank Stella's Big Football Weekend," pp. 207–8.

90 Riva Castleman, *American Impressions: Prints since Pollock* (New York: Alfred A. Knopf, 1985), p. 181.

91 Letter from Jack Beal, *Print Collector's Newsletter* 2 (May–June 1971): 31.

92 See "Collaboration East and West."

93 In a letter published in *Print Collector's Newsletter* 16 (May–June 1985): 53, Helen Frankenthaler wrote of her Crown Point woodcut, *Cedar Hill:* "I did the wood-cutting *myself,* mixed the colors *myself,* passing (or not) on the proofs, registrations, etc., *myself* with the help of the first-rate willing Tadashi Toda and the master woodcarver Reizo Monjyu." Japanese skills are, however, visible in the print.

94 "Collaboration East and West," p. 198.

95 See *Edgar Degas: The Painter as Printmaker*, exh. cat. (Boston: Museum of Fine Arts, 1984), cat. no. 63.

96 *Matisse, l'oeuvre gravé*, exh. cat. (Paris: Bibliothèque Nationale, 1970), p. 25; and *Hommage à Tériade*, exh. cat. (London: Royal Academy, 1975), pp. 11–12.

97 "Collaboration East and West," p. 203.

98 Robert Motherwell, conversation with author, November 1985.

99 Stephanie Terenzio and Dorothy C. Belknap, *The Prints of Robert Motherwell: A Catalogue Raisonné, 1943–1984* (New York: Hudson Hills Press, 1984), includes interviews with all Motherwell's printers.

100 Antreasian, review of *Ken Tyler*, p. 36.

101 Ibid.

Key to the Catalogue Raisonné

This catalogue documents the production of Tyler Graphics Ltd. from its founding in 1974 through 1985. Each edition or unique work of art is documented in an entry that provides general information about the work, such as title, date of publication, media, and dimensions, as well as details about the people and processes involved in making the work.

Most entries follow a specific format, which is explained below. Prints made by conventional means lend themselves to this form of documentation because of the methodical, run-by-run manner in which they are created. Unique impressions, such as monoprints and monotypes; paper-pulp works; and sculptures do not follow a run-by-run procedure, so the entries for these works often deviate from the established format.

The catalogue includes a glossary of printmaking and paper-making terms in which processes and materials referred to in the entries are explained. The Glossary is intended as a supplement to the entries, and readers should keep in mind that the terms and definitions used in this text are based on workshop usage and do not necessarily apply universally in the print world. It should also be noted that some works included in this catalogue have not been published.

Edition entries are arranged alphabetically by artist's name. Each artist's work is catalogued in order of publication. For unpublished works the date of completion is used.

In some cases, due to space limitations, representative examples from series of unique works have been selected for inclusion in the catalogue. Information concerning omitted works can be obtained from Tyler Graphics Ltd., 250 Kisco Avenue, Mount Kisco, N.Y. 10549.

Sample entry:

453:RM72
Belknap 307

Robert Motherwell
Water's Edge 1984

Lithograph, relief, embossing, collage (4)
33 × 26½ (83.8 × 67.3)
Paper: white TGL, handmade; black German Etching, mould-made
Edition: 62
Proofs: 12AP, 3SP, RTP, PPI, PPII, A, C

Papermaking by Steve Reeves and Tom Strianese; prep work for transfer from artist's original paper collage material to print processes by Kenneth Tyler; preparation of film copy from collage elements for plate-making by Lee Funderburg; plate preparation and processing by Funderburg; proofing and edition printing by Roger Campbell and Funderburg; preparation and adhering of collage elements by Campbell, Funderburg, and Tyler

Signed *Motherwell* and numbered in pencil lower right; chop mark lower right; workshop number RM83-707 lower left verso

5 runs: 4 colors, including 1 colored paper; 4 runs from 2 aluminum plates, 1 relief magnesium plate, and 1 embossing die made from 1 shaped relief copper plate:
1. pale yellow; method 5a (LF); IIa
2. gray; methods 5a, 5c; IIa
3. light blue; method 21b (KT); V
4. inkless; methods 15a (embossing die, RC), 24; V
5. black paper torn; method 36a (RC, LF, KT); III

Entry explanation:

453:RM72
The number preceding the colon is the catalogue number assigned to the object or edition. The number following the artist's initials is the identification number assigned to the object or edition by the workshop. Because of the exclusion of some works from the catalogue and the inclusion of others in the Appendix, these numbers are not consecutive.

Belknap 307
If the work appears in another catalogue raisonné, a reference to that catalogue is given. Catalogues cited are:

Axsom, Richard H. *The Prints of Frank Stella: A Catalogue Raisonné, 1967–1982.* New York: Hudson Hills Press in association with the University of Michigan Museum of Art, Ann Arbor, 1983. Citations for works from 1982 to 1985 are from the forthcoming second edition.

Belknap, Dorothy C., and Stephanie Terenzio. *The Prints of Robert Motherwell: A Catalogue Raisonné, 1943–1984.* New York: Hudson Hills Press, 1984.

Blume, Dieter. *The Sculpture of Anthony Caro, 1981–1983: Catalogue Raisonné.* Translated by Tim Hilton. Cologne: Verlag Galerie Wentzel, 1983.

Krens, Thomas. *Helen Frankenthaler Prints: 1961–1979.* New York: Harper & Row, 1980.

Robert Motherwell
Artist's name.

Water's Edge 1984
Title and publication date.

If a print is part of a series or group of prints or was published in a portfolio or book, the title of the series, portfolio, or book is also stated. Differences between the publication date (date of release) and the date inscribed on the print are due to the artist's decision to sign the date that the image was drawn or printed, rather than the date it was published.

Lithograph, relief, embossing, collage (4)
Media and, in parentheses, the number of colors.

Media terms are general. Etching, for example, includes hard-ground, soft-ground, and lift-ground etching. Lithography includes offset lithography. Specific information about techniques appears in run lines.

The number of colors may include printed colors, hand-applied colors, and color from collage elements (for example, colored paper torn and adhered to a composition). The notation "(v)" indicates that the number and use of colors were not consistent in an edition, and the notation "(-)" indicates no color, as in an inkless embossing. The number of colors in a one-of-a-kind work such as a monoprint or monotype is not stated.

33 × 26½ (83.8 × 67.3)
Measurements in inches followed by measurements in centimeters.

Measurements for prints indicate sheet size; height precedes width. In measurements for three-dimensional works the depth follows the height and width.

For works combining several sheets of handmade paper, the overall dimension is listed first, followed by the dimensions of the mould used to make the individual sheets. Discrepancies between the overall and the sheet dimensions are due to the overlapping of sheets and to differences in the size of the finished sheet from that of the mould used to make it.

Paper: white TGL, handmade; black German Etching, mould-made
Paper is identified by color, name, and method of manufacture (hand-made, mould-made, machine-made).

When several papers are listed, the first is the base sheet on which the other papers are layered or adhered, except where otherwise noted.

If a newly made pulp sheet is colored with pulps or dyes or if an already manufactured paper is colored with pigments or dyes in the shop, that paper is described as *hand-colored*.

With a few exceptions, all mould-made papers that the shop uses are sized. Handmade papers usually are not. Examples of hand-made waterleaf (unsized) papers include TGL, HMP, Duchene, and some Oriental papers.

Edition: 62
Edition sizes are listed. When a work is uneditioned, this line is omitted.

Proofs: 12AP, 3SP, RTP, PPI . . .
Proofs are listed.

The workshop director and the artist determine which proofs will be signed as part of the edition. All others are destroyed.

Proof designations are defined in the Glossary. In entries they are abbreviated and listed in the following order:

AP: artist's proof
TP: trial proof
CTP: color trial proof
EP: experimental proof
PP: progressive proof
SP: special (presentation) proof
WP: work proof
RTP: right to print
PPI: printer's proof I
PPII: printer's proof II
PPIII: printer's proof III
HC: hors de commerce
A: archive copy
C: cancellation proof
RP: reference proof (unsigned)

Proof titles are generally abbreviated by the artist on the print, with the exception of archive, cancellation, and reference proofs.

The size and kind of papers used for proofs are not listed.

In lithography drawn plates and stones are normally proofed in black ink to aid in processing. In etching, screen printing, linocut, woodcut, and other media, proofing is rarely done in black ink.

Papermaking by Steve Reeves and Tom Strianese; prep work for transfer from artist's original . . .
Production credits.

When TGL paper is used in an edition, the artisans responsible for making that paper are named. This applies even when only one of the papers used in a work is TGL.

For prints the senior printer or printers and first assistant (when applicable) are mentioned. In object making, papermaking, and assemblies, all artisans involved are named in order of their involvement in the project.

All lithography stones, intaglio plates, relief plates, woodblocks, and screens are drawn or painted on by the artist unless otherwise noted. All aquatint grounds and hard and soft etching grounds are prepared by printers for the artist to work on.

Signed *Motherwell* and numbered in pencil lower right; chop mark lower right; workshop number RM83-707 lower left verso
Signature information (how the work is signed by the artist) is followed by a description of how the work is numbered, dated, titled (if the title or state is inscribed on the print), and chopped.

Signatures sometimes vary within an edition or in an edition and its proofs because an artist may sign portions of the edition or the edition and proofs at different times. Occasionally trial proofs are signed before an edition is completed to accommodate a scheduled exhibition.

The workshop number is inscribed on the verso of each print and identifies the artist, the year the project began, and the number assigned to the work as part of a series, progression, or group.

5 runs: 4 colors, including 1 colored paper; 4 runs from 2 aluminum plates, 1 relief magnesium plate . . .
Summary and order of runs. This section includes:

5 runs
The total number of runs. A run is any process employed in the making of a print; each run represents a step leading to the completed work. A run may involve the printing of an impression, the application of colored pulps or dyes, collage, or relief embossing.

4 colors, including 1 colored paper
The number of colors in the print after all the runs are completed but before hand-coloring. Unless otherwise specified, the number of colors refers to ink colors but may also include colored papers, pulps, or dyes. The total number of colors in the finished print, including colors applied after printing, is indicated in parentheses after the media.

4 runs from 2 aluminum plates, 1 relief magnesium plate . . .
The number of runs involving printing elements and a listing of the printing elements.

1 pale yellow; method 5a (LF); IIa
2 gray; methods 5a, 5c; IIa
3 light blue; method 21b (KT); V
4 inkless; methods 15a (embossing die, RC), 24; V
5 black paper torn; method 36a (RC, LF, KT); III

Each run begins with a listing of printed inks, hand-applied colored pulps and dyes, or collage elements. Colors are listed in the following order: yellow, orange, yellow ocher, red, magenta, pink, violet, purple, tan, brown, blue, green, white, gray, black, silver, and gold. Unless otherwise noted, all colors are ink colors.

When a color name appears more than once in an entry, it is not necessarily the same color. If it is the same color, this is noted in the entry. An ink color that is used repeatedly in an edition printing is counted as a separate, distinct color each time it is applied. Since color names are often ambiguous, an attempt has been made to describe colors as simply as possible; for example, *yellow-orange* is used instead of *peach*. A composite color name, such as *yellow-green*, indicates that one color has been added to another (in this case yellow is added to green, resulting in a color that is predominantly green, with a yellow tint).

A run that does not involve the application of coloring material or the adhering of a collage element is described as "inkless."

The listing of coloring materials is often followed by information in parentheses concerning the paper or the placement of the image; for example, when more than one paper is involved, "on same paper as run 1," "on left sheet," "on right sheet."

Printer's initials appear after ink colors when the printer applied inks from the artist's palette.

The listing of coloring materials is followed by a method number or numbers denoting the technical procedures employed. See List of Methods, page 403.

Printing elements are sometimes noted after the method to distinguish one printing element from others that are similar. A printer's initials are given in parentheses after the method number when the printer made the printing element following a pattern provided by the artist.

The press used for each run is identified by a Roman numeral following the method number. See List of Presses, page 402.

A note explaining any process that preceded or followed printing and is not included in the runs may follow the run section. In addition to providing information about how the work was made, notes may also include details about commissions, framing, signatures, or inscriptions.

Betty Fiske moving a partially printed proof
of Roy Lichtenstein's *Entablature IX* to the
vacuum screen press for printing by Kim
Halliday, 1976.

Catalogue Raisonné

Artists' Biographies
Barbara Delano
Kim Tyler

Catalogue Entries
Kenneth E. Tyler
Barbara Delano
Kim Tyler
Marabeth Cohen

Kim Halliday and Kenneth Tyler printing
Roy Lichtenstein's Entablature series and
Betty Fiske curating Stanley Boxer's Ring of
Dust in Bloom, 1976.

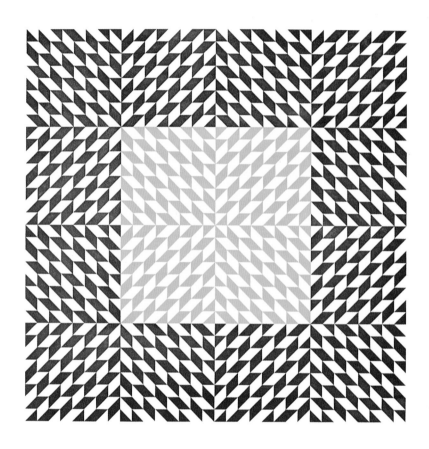

Second Movement II 1978
See 14:AA14

Anni Albers

1899 Born in Berlin

1916–20 Studies at Art School, Berlin, and School of Applied Art, Hamburg

1922–29 Studies at Bauhaus, Weimar; receives diploma

1933 Emigrates to United States; assistant professor of art, Black Mountain College, Black Mountain, North Carolina (through 1939)

1937 Becomes United States citizen

1949 Traveling exhibition *Anni Albers: Textiles*, originating at Museum of Modern Art, New York

1950 Moves to New Haven, Connecticut; lectures widely and gives seminars at Yale University; Carnegie Institute of Technology; San Francisco Museum of Art; Contemporary Arts Museum, Houston; and other institutions

1959 *Anni Albers: On Designing* published by Pellango Press; solo exhibition *Pictorial Weavings* at Massachusetts Institute of Technology

1961 Receives American Institute of Architects Gold Medal in the field of craftsmanship

1964 Receives fellowship to Tamarind Lithography Workshop, Los Angeles, and completes first portfolio of prints there

1965 *On Weaving* published by Wesleyan University Press

1970 Completes lithographs and screenprints at Gemini G.E.L., Los Angeles

1971 Included in exhibition *Technics and Creativity: Gemini G.E.L.* at Museum of Modern Art, New York

1972 Receives honorary doctorate in fine arts from Maryland Institute College of Art, Baltimore

1976 Completes Triangulated Intaglio series of etchings with aquatint at Tyler Graphics

1977 Retrospective exhibition *Anni Albers: Drawings and Prints* at Brooklyn Museum; included in exhibition *Art Off the Picture Press* at Emily Lowe Gallery, Hofstra University, New York

1978 Completes Mountainous series of embossings and Second Movement series of etchings with aquatint at Tyler Graphics

1981 Receives American Craft Council Gold Medal

1984 Included in exhibition *Prints from Tyler Graphics* at Walker Art Center, Minneapolis

1985 Retrospective exhibition *The Woven and Graphic Art of Anni Albers* at Smithsonian Institution, Washington, D.C.

Currently lives and works in New Haven, Connecticut

1:AA1	2:AA2	3:AA3

Anni Albers
Triangulated Intaglio I 1976

Anni Albers
Triangulated Intaglio II 1976

Anni Albers
Triangulated Intaglio III 1976

Etching (1)
24 × 20 (61 × 50.8)
Paper: white Arches Cover, mould-made
Edition: 20
Proofs: 9AP, RTP, PPI, A, C

Etching, aquatint (1)
24 × 20 (61 × 50.8)
Paper: white Arches Cover, mould-made
Edition: 20
Proofs: 9AP, RTP, PPI, A, C

Etching, aquatint (1)
24 × 20 (61 × 50.8)
Paper: white Arches Cover, mould-made
Edition: 20
Proofs: 9AP, RTP, PPI, A, C

Plate preparation, processing, proofing, and edition printing by Betty Fiske

Plate preparation, processing, proofing, and edition printing by Betty Fiske

Plate preparation, processing, proofing, and edition printing by Betty Fiske

Signed *Anni Albers* and dated in pencil lower right; numbered lower left; chop mark lower right; workshop number AA75-212 lower left verso

Signed *Anni Albers* and dated in pencil lower right; numbered lower left; chop mark lower right; workshop number AA75-216 lower left verso

Signed *Anni Albers* and dated in pencil lower right; numbered lower left; chop mark lower right; workshop number AA75-214 lower left verso

1 run: 1 color; 1 run from 1 copper plate:
 1 black; method 6; IV

1 run: 1 color; 1 run from 1 copper plate:
 1 black; methods 11b, 9 (BF); IV

1 run: 1 color; 1 run from 1 copper plate:
 1 black; methods 6, 9 (BF); IV

4:AA4

Anni Albers
Triangulated Intaglio IV 1976

Etching, aquatint (1)
24 × 20 (61 × 50.8)
Paper: white Arches Cover, mould-made
Edition: 20
Proofs: 9AP, RTP, PPI, A, C

Plate preparation, processing, proofing, and edition printing by Betty Fiske

Signed *Anni Albers* and dated in pencil lower right; numbered lower left; chop mark lower right; workshop number AA75-215 lower left verso

1 run: 1 color; 1 run from 1 copper plate:
 1 red; methods 11b, 9 (BF); IV

5:AA5

Anni Albers
Triangulated Intaglio V 1976

Etching, aquatint (2)
24 × 20 (61 × 50.8)
Paper: white Arches Cover, mould-made
Edition: 20
Proofs: 9AP, RTP, PPI, A, C

Plate preparation, processing, proofing, and edition printing by Betty Fiske

Signed *Anni Albers* and dated in pencil lower right; numbered lower left; chop mark lower right; workshop number AA75-217 lower left verso

2 runs: 2 colors; 2 runs from 2 copper plates:
 1 blue; methods 11b, 9 (BF); IV
 2 black; methods 11b, 9 (BF); IV

6:AA6

Anni Albers
Triangulated Intaglio VI 1976

Etching (1)
24 × 20 (61 × 50.8)
Paper: white Arches Cover, mould-made
Edition: 20
Proofs: 9AP, RTP, PPI, A, C

Plate preparation, processing, proofing, and edition printing by Betty Fiske

Signed *Anni Albers* and dated in pencil lower right; numbered lower left; chop mark lower right; workshop number AA75-213 lower left verso

1 run: 1 color; 1 run from 1 copper plate:
 1 black; method 6; IV

7:AA7

Anni Albers
Mountainous I 1978

Embossing (-)
22½ × 21 (57.2 × 53.3)
Paper: white TGL, handmade
Edition: 20
Proofs: 10AP, RTP, PPI, A, C

Plate preparation by Kenneth Tyler;
processing by Swan Engraving; proofing
and edition printing by Rodney Konopaki;
papermaking by Lindsay Green and Lee
Funderburg

Signed *Anni Albers* and dated in pencil
lower right; numbered lower left; chop
mark lower right; workshop number
AA78-406 lower left verso

1 run: no color; 1 run from 1 magnesium
plate:
 1 inkless; methods 21b (RK), 24; III

8:AA8

Anni Albers
Mountainous II 1978

Embossing (-)
22½ × 21 (57.2 × 53.3)
Paper: white TGL, handmade
Edition: 20
Proofs: 10AP, RTP, PPI, A, C

Plate preparation by Kenneth Tyler;
processing by Swan Engraving; proofing
and edition printing by Rodney Konopaki;
papermaking by Lindsay Green and Lee
Funderburg

Signed *Anni Albers* and dated in pencil
lower right; numbered lower left; chop
mark lower right; workshop number
AA78-407 lower left verso

1 run: no color; 1 run from 1 magnesium
plate:
 1 inkless; methods 21b (RK), 24; III

9:AA9

Anni Albers
Mountainous III 1978

Embossing (-)
22½ × 21 (57.2 × 53.3)
Paper: white TGL, handmade
Edition: 20
Proofs: 10AP, RTP, PPI, A, C

Plate preparation by Kenneth Tyler;
processing by Swan Engraving; proofing
and edition printing by Rodney Konopaki;
papermaking by Lindsay Green and Lee
Funderburg

Signed *Anni Albers* and dated in pencil
lower right; numbered lower left; chop
mark lower right; workshop number
AA78-408 lower left verso

1 run: no color; 1 run from 1 magnesium
plate:
 1 inkless; methods 21b (RK), 24; III

10:AA10

Anni Albers
Mountainous IV 1978

Embossing (-)
22½ × 21 (57.2 × 53.3)
Paper: white TGL, handmade
Edition: 20
Proofs: 10AP, RTP, PPI, A, C

Plate preparation by Kenneth Tyler;
processing by Swan Engraving; proofing
and edition printing by Rodney Konopaki;
papermaking by Lindsay Green and Lee
Funderburg

Signed *Anni Albers* and dated in pencil
lower right; numbered lower left; chop
mark lower right; workshop number
AA78-409 lower left verso

1 run: no color; 1 run from 1 magnesium
plate:
 1 inkless; methods 21b (RK), 24; III

11:AA11

Anni Albers
Mountainous V 1978

Embossing (-)
22½ × 21 (57.2 × 53.3)
Paper: white TGL, handmade
Edition: 20
Proofs: 10AP, RTP, PPI, A, C

Plate preparation by Kenneth Tyler;
processing by Swan Engraving; proofing
and edition printing by Rodney Konopaki;
papermaking by Lindsay Green and Lee
Funderburg

Signed *Anni Albers* and dated in pencil
lower right; numbered lower left; chop
mark lower right; workshop number
AA78-410 lower left verso

1 run: no color; 1 run from 1 magnesium
plate:
 1 inkless; methods 21b (RK), 24; III

12:AA12

Anni Albers
Mountainous VI 1978

Embossing (-)
22½ × 21 (57.2 × 53.3)
Paper: white TGL, handmade
Edition: 20
Proofs: 10AP, RTP, PPI, A, C

Plate preparation by Kenneth Tyler;
processing by Swan Engraving; proofing
and edition printing by Rodney Konopaki;
papermaking by Lindsay Green and Lee
Funderburg

Signed *Anni Albers* and dated in pencil
lower right; numbered lower left; chop
mark lower right; workshop number
AA78-411 lower left verso

1 run: no color; 1 run from 1 magnesium
plate:
 1 inkless; methods 21b (RK), 24; III

13:AA13	14:AA14	15:AA15
Anni Albers	**Anni Albers**	**Anni Albers**
Second Movement I 1978	*Second Movement II* 1978	*Second Movement III* 1978
Etching, aquatint (1)	Etching, aquatint (2)	Etching, aquatint (2)
28 × 28 (71.1 × 71.1)	30 × 30 (76.2 × 76.2)	30½ × 25½ (77.5 × 64.8)
Paper: white Arches Cover, mould-made	Paper: white Arches Cover, mould-made	Paper: white Arches Cover, mould-made
Edition: 20	Edition: 20	Edition: 20
Proofs: 8AP, 2TP, CTP, RTP, PPI, A	Proofs: 8AP, 3CTP, RTP, PPI, A, C	Proofs: 8AP, RTP, PPI, A, C

Plate preparation, processing, proofing, and edition printing by Rodney Konopaki

Plate preparation, processing, proofing, and edition printing by Rodney Konopaki

Plate preparation, processing, proofing, and edition printing by Rodney Konopaki

Signed *Anni Albers* and dated in pencil lower right; numbered lower left; chop mark lower right; workshop number AA78-400 lower left verso

Signed *Anni Albers* and dated in pencil lower right; numbered lower left; chop mark lower right; workshop number AA78-401 lower left verso

Signed *Anni Albers* and dated in pencil lower right; numbered lower left; chop mark lower right; workshop number AA78-402 lower left verso

1 run: 1 color; 1 run from 1 copper plate:
 1 black; methods 11b, 9 (RK); IV

1 run: 2 colors; 1 run from 1 copper plate:
 1 orange and transparent black; methods 11b, 9 (RK), 16a; IV

1 run: 2 colors; 1 run from 1 copper plate:
 1 blue and black; methods 11b, 9 (RK), 16a; IV

16:AA16

Anni Albers
Second Movement IV 1978

Etching, aquatint (2)
28 × 28 (71.1 × 71.1)
Paper: white Arches Cover, mould-made
Edition: 20
Proofs: 8AP, RTP, PPI, A, C

Plate preparation, processing, proofing, and
edition printing by Rodney Konopaki

Signed *Anni Albers* and dated in pencil
lower right; numbered lower left; chop
mark lower right; workshop number
AA78-403 lower left verso

1 run: 2 colors; 1 run from 1 copper plate:
 1 brown and black; methods 11b, 9
 (RK), 16a; IV

17:AA17

Anni Albers
Second Movement V 1978

Etching, aquatint (2)
28 × 28 (71.1 × 71.1)
Paper: white Arches Cover, mould-made
Edition: 20
Proofs: 8AP, RTP, PPI, A, C

Plate preparation, processing, proofing, and
edition printing by Rodney Konopaki

Signed *Anni Albers* and dated in pencil
lower right; numbered lower left; chop
mark lower right; workshop number
AA78-404 lower left verso

1 run: 2 colors; 1 run from 1 copper plate:
 1 transparent green and black; methods
 11b, 9 (RK), 16a; IV

18:AA18

Anni Albers
Second Movement VI 1978

Etching, aquatint (2)
28 × 28 (71.1 × 71.1)
Paper: white Arches Cover, mould-made
Edition: 20
Proofs: 8AP, RTP, PPI, A, C

Plate preparation, processing, proofing, and
edition printing by Rodney Konopaki

Signed *Anni Albers* and dated in pencil
lower right; numbered lower left; chop
mark lower right; workshop number
AA78-405 lower left verso

1 run: 2 colors; 1 run from 1 copper plate:
 1 gray and black; methods 11b, 9 (RK),
 16a; IV

Never Before e, from Never Before 1976
See 62:JA44

Josef Albers

1888 Born in Bottrop, Westphalia

1905–8 Attends teachers' seminary in Bueren

1908–13 Teaches elementary school in Bottrop, Weddern, and Stadtlohn

1913–15 Attends Royal Art School, Berlin

1916–19 Continues to teach elementary school in Bottrop and attends School of Applied Arts in Essen; completes first lithographs, woodcuts, and linocuts

1919–20 Studies with Franz von Stuck and Max Doerner at Art Academy, Munich

1920 Enrolls in Bauhaus; completes works assembled from bits of colored glass; is invited to set up glass workshop

1923 Teaches Bauhaus foundation course with László Moholy-Nagy

1933 Accepts teaching position at Black Mountain College, Black Mountain, North Carolina; emigrates to United States

1934 Delivers first lecture series at Lyceum Habana, Cuba

1936–40 Lectures at Graduate School of Design, Harvard University, Cambridge, Massachusetts

1949 Leaves Black Mountain College; begins Homage to the Square series

1950 Appointed director of the department of design, Yale University, New Haven, Connecticut; completes mural *America* for Harvard Graduate Center

1956 Retrospective exhibition at Yale University Art Gallery

1957 Receives Cross of Merit First Class of the Order of Merit of the Federal Republic of Germany

1959 Receives grant from Ford Foundation

1961 Retrospective exhibition at Stedelijk Museum, Amsterdam

1962 Receives fellowship and grant from Graham Foundation; receives honorary doctorate in fine arts from Yale University

1963 *Interaction of Color* published by Yale University Press; designs mural *The City* for Pan-American World Airways Building, New York; receives fellowship to Tamarind Lithography Workshop, Los Angeles, where he meets and works with Kenneth Tyler and completes Day and Night, a suite of lithographs

1964 Completes Midnight and Noon suite of eight monochromatic lithographs at Tamarind Lithography Workshop, Los Angeles; receives Medal of the Year 1964 from American Institute of Graphic Art, New York; retrospective exhibition *Josef Albers: Homage to the Square*, organized by International Council of the Museum of Modern Art, New York

1966 Completes White Line Squares lithograph series at Gemini G.E.L., Los Angeles

1968 Elected member of National Institute of Arts and Letters, New York

1969 Completes Embossed Linear Constructions series at Gemini G.E.L., Los Angeles

1971 Completes White Embossings on Gray series at Gemini G.E.L., Los Angeles; included in exhibition *Technics and Creativity: Gemini G.E.L.* at Museum of Modern Art, New York

1974 Completes Gray Instrumentation I and Gray Instrumentation II screenprint series at Tyler Graphics

1976 Completes Mitered Squares and Never Before screenprint series at Tyler Graphics

1977 Included in exhibition *Art Off the Picture Press* at Emily Lowe Gallery, Hofstra University, New York

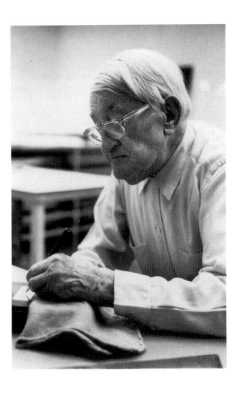

1984 Included in exhibition *Prints from Tyler Graphics* at Walker Art Center, Minneapolis; included in exhibition *Gemini G.E.L.: Art and Collaboration* at National Gallery of Art, Washington, D.C.

1985 Included in exhibition *Ken Tyler: Printer Extraordinary* at Australian National Gallery, Canberra

Josef Albers died on March 25, 1976

Four Portfolios

Gray Instrumentation I

Josef Albers's lifelong study of the interaction of colors and his love for precise printing techniques were the inspiration for the four portfolios Gray Instrumentation I, Gray Instrumentation II, Mitered Squares, and Never Before, each consisting of twelve screenprints. Three of the portfolios are followed by separate but related editions, *Gray Instrumentation I, Plus I* (31:JA13), *Gray Instrumentation II, Plus II* (44:JA26), and *Mitered Squares, Plus II* (57:JA39).

Josef Albers and Kenneth Tyler decided that the areas of color in each edition would be printed side by side, without overlapping, to maintain the purity of the mixed colors and to create a uniform printed surface. Every color screen for the fifty-one screenprint editions was made from a master set of Rubylith films that Tyler hand-cut using the artist's original graph-paper drawings as models. The Rubylith films for each edition were carefully registered using registration pins. The pins were essential for maintaining precise registration between the cut films, the screen stencil, and the punched paper attached to fixed pins on the press bed. The color screen had to register perfectly with

every sheet of paper during the print runs for each impression. If registration was not exact (due to expansion and contraction of the paper or stretching of screens caused by squeegee pressure during runs), Tyler, Charles Hanley, or Kim Halliday remade the stencils and screens.

Albers communicated his ideas about color to Tyler by using a variety of samples, such as partially painted images on blotting paper, leaves and flowers he picked to illustrate certain color effects, and fragments of colored paper from his studio. Tyler, assisted by Halliday and Hanley, mixed and proofed numerous inks. Color variations were screen-printed on Arches 88, the edition paper, and Albers cut and collaged the colored papers into trial combinations that were then made into prints and proofed for further study. Each print was revised repeatedly until Albers achieved the desired color interaction. The lengthy proofing sessions for each portfolio led to the creation of hundreds of color trial proofs. Nearly all of these proofs were destroyed because of poor registration or damage that took place during proofing.

Gray Instrumentation I, completed in 1974, is the first of a series of four screenprint portfolios by Josef Albers containing twelve prints and interleaving pages of verse written by the artist. The portfolio text (title page, verse, and colophon page) was designed by Hardy Hanson, set in Bodoni phototypositor typeface by Stamford Typesetting Corporation, and printed by A. Colish Inc. on Japanese Masa Dosa paper. The gray cloth-covered portfolio box and black cloth-covered slipcase were designed and fabricated by Cardoza-James Inc.

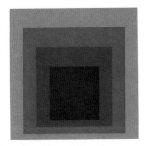

19:JA1

Josef Albers
Gray Instrumentation Ia, from Gray
Instrumentation I 1974

Screenprint (4)
19 × 19 (48.3 × 48.3)
Paper: white Arches 88, mould-made
Edition: 36
Proofs: 10AP, CTP, RTP, PPI, A

Screen preparation and processing by
Kenneth Tyler; proofing and edition
printing by Tyler assisted by Charles
Hanley

Signed *Albers* in pencil lower right;
numbered and titled lower left; chop marks
of workshop and artist lower right; artist's
copyright stamp and workshop number
JA74-107 lower left verso

4 runs: 4 colors; 4 runs from 4 screens:
 1 light blue-gray; method 29b (KT); VI
 2 blue-gray; method 29b (KT); VI
 3 medium violet-gray; method 29b (KT);
 VI
 4 dark violet-gray; method 29b (KT); VI

20:JA2

Josef Albers
Gray Instrumentation Ib, from Gray
Instrumentation I 1974

Screenprint (3)
19 × 19 (48.3 × 48.3)
Paper: white Arches 88, mould-made
Edition: 36
Proofs: 10AP, CTP, SP, RTP, PPI, A

Screen preparation and processing by
Kenneth Tyler; proofing and edition
printing by Charles Hanley and Betty Fiske

Signed *Albers* in pencil lower right;
numbered and titled lower left; chop marks
of workshop and artist lower right; artist's
copyright stamp and workshop number
JA74-111 lower left verso

3 runs: 3 colors; 3 runs from 3 screens:
 1 black; method 29b (KT); VI
 2 dark violet-gray; method 29b (KT); VI
 3 gray; method 29b (KT); VI

21:JA3

Josef Albers
Gray Instrumentation Ic, from Gray
Instrumentation I 1974

Screenprint (4)
19 × 19 (48.3 × 48.3)
Paper: white Arches 88, mould-made
Edition: 36
Proofs: 10AP, CTP, RTP, PPI, A

Screen preparation and processing by
Kenneth Tyler; proofing and edition
printing by Tyler and Charles Hanley
assisted by Betty Fiske

Signed *Albers* in pencil lower right;
numbered and titled lower left; chop marks
of workshop and artist lower right; artist's
copyright stamp and workshop number
JA74-103 lower left verso

4 runs: 4 colors; 4 runs from 4 screens:
 1 blue-gray; method 29b (KT); VI
 2 light violet-gray; method 29b (KT); VI
 3 medium brown-gray; method 29b
 (KT); VI
 4 dark brown-gray; method 29b (KT);
 VI

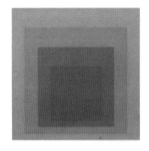

22:JA4

Josef Albers
Gray Instrumentation Id, from Gray
Instrumentation I 1974

Screenprint (3)
19 × 19 (48.3 × 48.3)
Paper: white Arches 88, mould-made
Edition: 36
Proofs: 10AP, 4TP, RTP, PPI, A

Screen preparation and processing by
Kenneth Tyler; proofing and edition
printing by Tyler assisted by Charles
Hanley

Signed *Albers* in pencil lower right;
numbered and titled lower left; chop marks
of workshop and artist lower right; artist's
copyright stamp and workshop number
JA74-115 lower left verso

3 runs: 3 colors; 3 runs from 3 screens:
 1 light green-gray; method 29b (KT); VI
 2 medium green-gray; method 29b (KT);
 VI
 3 dark green-gray; method 29b (KT); VI

23:JA5

Josef Albers
Gray Instrumentation Ie, from Gray
Instrumentation I 1974

Screenprint (3)
19 × 19 (48.3 × 48.3)
Paper: white Arches 88, mould-made
Edition: 36
Proofs: 10AP, 2TP, RTP, PPI, A

Screen preparation and processing by
Kenneth Tyler; proofing and edition
printing by Tyler assisted by Charles
Hanley

Signed *Albers* in pencil lower right;
numbered and titled lower left; chop marks
of workshop and artist lower right; artist's
copyright stamp and workshop number
JA74-112 lower left verso

3 runs: 3 colors; 3 runs from 3 screens:
 1 medium blue-gray; method 29b (KT);
 VI
 2 dark brown-gray; method 29b (KT);
 VI
 3 light blue-gray; method 29b (KT); VI

24:JA6

Josef Albers
Gray Instrumentation If, from Gray
Instrumentation I 1974

Screenprint (4)
19 × 19 (48.3 × 48.3)
Paper: white Arches 88, mould-made
Edition: 36
Proofs: 10AP, TP, RTP, PPI, A

Screen preparation and processing by
Kenneth Tyler; proofing and edition
printing by Tyler assisted by Charles
Hanley

Signed *Albers* in pencil lower right;
numbered and titled lower left; chop marks
of workshop and artist lower right; artist's
copyright stamp and workshop number
JA74-116 lower left verso

4 runs: 4 colors; 4 runs from 4 screens:
 1 light yellow-gray; method 29b (KT); VI
 2 medium yellow-gray; method 29b
 (KT); VI
 3 medium green-gray; method 29b (KT);
 VI
 4 dark green-gray; method 29b (KT); VI

25:JA7

Josef Albers
Gray Instrumentation Ig, from Gray
Instrumentation I 1974

Screenprint (3)
19 × 19 (48.3 × 48.3)
Paper: white Arches 88, mould-made
Edition: 36
Proofs: 10AP, CTP, RTP, PPI, A

Screen preparation and processing by
Kenneth Tyler; proofing and edition
printing by Tyler assisted by Charles
Hanley

Signed *Albers* in pencil lower right;
numbered and titled lower left; chop marks
of workshop and artist lower right; artist's
copyright stamp and workshop number
JA74-102 lower left verso

3 runs: 3 colors; 3 runs from 3 screens:
 1 light red-gray; method 29b (KT); VI
 2 medium brown-gray; method 29b
 (KT); VI
 3 red-black; method 29b (KT); VI

26:JA8

Josef Albers
Gray Instrumentation Ih, from Gray
Instrumentation I 1974

Screenprint (3)
19 × 19 (48.3 × 48.3)
Paper: white Arches 88, mould-made
Edition: 36
Proofs: 10AP, CTP, RTP, PPI, A

Screen preparation and processing by
Kenneth Tyler; proofing and edition
printing by Charles Hanley assisted by
Betty Fiske

Signed *Albers* in pencil lower right;
numbered and titled lower left; chop marks
of workshop and artist lower right; artist's
copyright stamp and workshop number
JA74-114 lower left verso

3 runs: 3 colors; 3 runs from 3 screens:
 1 light green-gray; method 29b (KT); VI
 2 medium red-gray; method 29b (KT);
 VI
 3 dark brown-gray; method 29b (KT);
 VI

27:JA9

Josef Albers
Gray Instrumentation Ii, from Gray
Instrumentation I 1974

Screenprint (3)
19 × 19 (48.3 × 48.3)
Paper: white Arches 88, mould-made
Edition: 36
Proofs: 10AP, 2CTP, RTP, PPI, A

Screen preparation and processing by
Kenneth Tyler; proofing and edition
printing by Tyler assisted by Charles
Hanley

Signed *Albers* in pencil lower right;
numbered and titled lower left; chop marks
of workshop and artist lower right; artist's
copyright stamp and workshop number
JA74-113 lower left verso

3 runs: 3 colors; 3 runs from 3 screens:
 1 dark violet-gray; method 29b (KT); VI
 2 medium green-gray; method 29b (KT);
 VI
 3 dark green-gray; method 29b (KT); VI

 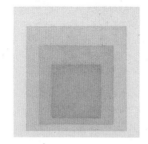

28:JA10

Josef Albers
Gray Instrumentation Ij, from Gray
Instrumentation I 1974

Screenprint (4)
19 × 19 (48.3 × 48.3)
Paper: white Arches 88, mould-made
Edition: 36
Proofs: 10AP, CTP, RTP, PPI, A

Screen preparation and processing by
Kenneth Tyler; proofing and edition
printing by Tyler assisted by Charles
Hanley

Signed *Albers* in pencil lower right;
numbered and titled lower left; chop marks
of workshop and artist lower right; artist's
copyright stamp and workshop number
JA74-105 lower left verso

4 runs: 4 colors; 4 runs from 4 screens:
 1 light blue-gray; method 29b (KT); VI
 2 medium blue-gray; method 29b (KT);
 VI
 3 medium violet-gray; method 29b (KT);
 VI
 4 dark violet-gray; method 29b (KT); VI

29:JA11

Josef Albers
Gray Instrumentation Ik, from Gray
Instrumentation I 1974

Screenprint (4)
19 × 19 (48.3 × 48.3)
Paper: white Arches 88, mould-made
Edition: 36
Proofs: 10AP, 2TP, RTP, PPI, A

Screen preparation and processing by
Kenneth Tyler; proofing and edition
printing by Charles Hanley assisted by
Betty Fiske

Signed *Albers* in pencil lower right;
numbered and titled lower left; chop marks
of workshop and artist lower right; artist's
copyright stamp and workshop number
JA74-110 lower left verso

4 runs: 4 colors; 4 runs from 4 screens:
 1 pale light gray; method 29b (KT); VI
 2 light blue-gray; method 29b (KT); VI
 3 medium blue-gray; method 29b (KT);
 VI
 4 dark blue-gray; method 29b (KT); VI

30:JA12

Josef Albers
Gray Instrumentation Il, from Gray
Instrumentation I 1974

Screenprint (3)
19 × 19 (48.3 × 48.3)
Paper: white Arches 88, mould-made
Edition: 36
Proofs: 10AP, CTP, RTP, PPI, A

Screen preparation and processing by
Kenneth Tyler; proofing and edition
printing by Tyler assisted by Charles
Hanley

Signed *Albers* in pencil lower right;
numbered and titled lower left; chop marks
of workshop and artist lower right; artist's
copyright stamp and workshop number
JA74-106 lower left verso

3 runs: 3 colors; 3 runs from 3 screens:
 1 dark blue-gray; method 29b (KT); VI
 2 medium blue-gray; method 29b (KT);
 VI
 3 light blue-gray; method 29b (KT); VI

GRAY INSTRUMENTATION II

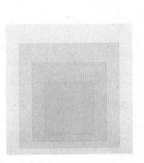

31:JA13

Josef Albers
Gray Instrumentation I, Plus I 1974

Screenprint (3)
19 × 19 (48.3 × 48.3)
Paper: white Arches 88, mould-made
Edition: 36
Proofs: 10AP, TP, RTP, PPI, A

Screen preparation and processing by Kenneth Tyler; proofing and edition printing by Charles Hanley assisted by Betty Fiske

Signed *Albers* in pencil lower right; numbered and titled lower left; chop marks of workshop and artist lower right; artist's copyright stamp and workshop number JA74-101 lower left verso

3 runs: 3 colors; 3 runs from 3 screens:
 1 blue-black; method 29b (KT); VI
 2 medium purple-gray; method 29b (KT); VI
 3 light blue-gray; method 29b (KT); VI

This edition was printed for the Albers Foundation and is separate from the portfolio of twelve prints entitled Gray Instrumentation I (19:JA1–30:JA12).

Gray Instrumentation II, completed in 1975, is the second of a series of four screenprint portfolios by Josef Albers containing twelve prints and interleaving pages of verse written by the artist. The portfolio text (title page, verse, and colophon page) was designed by Hardy Hanson, set in Bodoni phototypositor typeface by Stamford Typesetting Corporation, and printed by A. Colish Inc. on Japanese Masa Dosa paper. The gray cloth-covered portfolio box and black cloth-covered slipcase were designed and fabricated by Cardoza-James Inc.

32:JA14

Josef Albers
Gray Instrumentation IIa, from Gray Instrumentation II 1975

Screenprint (4)
19 × 19 (48.3 × 48.3)
Paper: white Arches 88, mould-made
Edition: 36
Proofs: 10AP, 2TP, RTP, PPI, A

Screen preparation and processing by Kenneth Tyler; proofing and edition printing by Charles Hanley assisted by Igor Zakowortny

Signed *Albers* in pencil lower right; numbered and titled lower left; chop marks of workshop and artist lower right; artist's copyright stamp and workshop number JA74-109 lower left verso

4 runs: 4 colors; 4 runs from 4 screens:
 1 turquoise blue–gray; method 28 (KT); VI
 2 medium blue-gray; method 28 (KT); VI
 3 light green-gray; method 28 (KT); VI
 4 pale green-gray; method 28 (KT); VI

33:JA15

Josef Albers
Gray Instrumentation IIb, from Gray
Instrumentation II 1975

Screenprint (3)
19 × 19 (48.3 × 48.3)
Paper: white Arches 88, mould-made
Edition: 36
Proofs: 10AP, 2TP, RTP, PPI, A

Screen preparation and processing by
Kenneth Tyler; proofing and edition
printing by Charles Hanley assisted by Igor
Zakowortny

Signed *Albers* in pencil lower right;
numbered and titled lower left; chop marks
of workshop and artist lower right; artist's
copyright stamp and workshop number
JA74-117 lower left verso

3 runs: 3 colors; 3 runs from 3 screens:
 1 pale green-gray; method 28 (KT); VI
 2 light violet-gray; method 28 (KT); VI
 3 medium blue-gray; method 28 (KT); VI

34:JA16

Josef Albers
Gray Instrumentation IIc, from Gray
Instrumentation II 1975

Screenprint (3)
19 × 19 (48.3 × 48.3)
Paper: white Arches 88, mould-made
Edition: 36
Proofs: 10AP, 2CTP, RTP, PPI, A

Screen preparation and processing by
Kenneth Tyler; proofing and edition
printing by Charles Hanley assisted by Igor
Zakowortny

Signed *Albers* in pencil lower right;
numbered and titled lower left; chop marks
of workshop and artist lower right; artist's
copyright stamp and workshop number
JA75-127 lower left verso

3 runs: 3 colors; 3 runs from 3 screens:
 1 pale green-gray; method 28 (KT); VI
 2 light green-gray; method 28 (KT); VI
 3 medium green-gray; method 28 (KT);
 VI

35:JA17

Josef Albers
Gray Instrumentation IId, from Gray
Instrumentation II 1975

Screenprint (3)
19 × 19 (48.3 × 48.3)
Paper: white Arches 88, mould-made
Edition: 36
Proofs: 10AP, 3TP, RTP, PPI, A

Screen preparation and processing by
Kenneth Tyler; proofing and edition
printing by Charles Hanley assisted by Igor
Zakowortny

Signed *Albers* in pencil lower right;
numbered and titled lower left; chop marks
of workshop and artist lower right; artist's
copyright stamp and workshop number
JA75-121 lower left verso

3 runs: 3 colors; 3 runs from 3 screens:
 1 pale yellow-gray; method 28 (KT); VI
 2 light gray-yellow; method 28 (KT); VI
 3 medium gray-yellow; method 28 (KT);
 VI

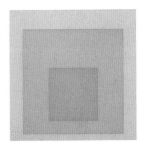 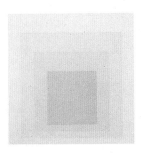

36:JA18

Josef Albers
Gray Instrumentation IIe, from Gray
Instrumentation II 1975

Screenprint (3)
19 × 19 (48.3 × 48.3)
Paper: white Arches 88, mould-made
Edition: 36
Proofs: 10AP, 2TP, RTP, PPI, A

Screen preparation and processing by
Kenneth Tyler; proofing and edition
printing by Charles Hanley assisted by Igor
Zakowortny

Signed *Albers* in pencil lower right;
numbered and titled lower left; chop marks
of workshop and artist lower right; artist's
copyright stamp and workshop number
JA74-118 lower left verso

3 runs: 3 colors; 3 runs from 3 screens:
 1 pale blue-gray; method 28 (KT); VI
 2 light violet-gray; method 28 (KT); VI
 3 medium violet-gray; method 28 (KT);
 VI

37:JA19

Josef Albers
Gray Instrumentation IIf, from Gray
Instrumentation II 1975

Screenprint (3)
19 × 19 (48.3 × 48.3)
Paper: white Arches 88, mould-made
Edition: 36
Proofs: 10AP, 2CTP, RTP, PPI, A

Screen preparation and processing by
Kenneth Tyler; proofing and edition
printing by Charles Hanley assisted by Don
Carli

Signed *Albers* in pencil lower right;
numbered and titled lower left; chop marks
of workshop and artist lower right; artist's
copyright stamp and workshop number
JA75-125 lower left verso

3 runs: 3 colors; 3 runs from 3 screens:
 1 pale blue-gray; method 28 (KT); VI
 2 light green-gray; method 28 (KT); VI
 3 light violet-gray; method 28 (KT); VI

38:JA20

Josef Albers
Gray Instrumentation IIg, from Gray
Instrumentation II 1975

Screenprint (4)
19 × 19 (48.3 × 48.3)
Paper: white Arches 88, mould-made
Edition: 36
Proofs: 10AP, 4TP, RTP, PPI, A

Screen preparation and processing by
Kenneth Tyler; proofing and edition
printing by Charles Hanley assisted by Igor
Zakowortny

Signed *Albers* in pencil lower right;
numbered and titled lower left; chop marks
of workshop and artist lower right; artist's
copyright stamp and workshop number
JA75-123 lower left verso

4 runs: 4 colors; 4 runs from 4 screens:
 1 green-gray; method 28 (KT); VI
 2 medium green-gray; method 28 (KT);
 VI
 3 light green-gray; method 28 (KT); VI
 4 pale green-gray; method 28 (KT); VI

 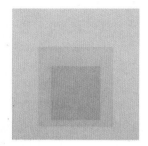

39:JA21

Josef Albers
Gray Instrumentation IIh, from Gray
Instrumentation II 1975

Screenprint (3)
19 × 19 (48.3 × 48.3)
Paper: white Arches 88, mould-made
Edition: 36
Proofs: 10AP, 2TP, RTP, PPI, A

Screen preparation and processing by
Kenneth Tyler; proofing and edition
printing by Charles Hanley assisted by Igor
Zakowortny

Signed *Albers* in pencil lower right;
numbered and titled lower left; chop marks
of workshop and artist lower right; artist's
copyright stamp and workshop number
JA75-122 lower left verso

3 runs: 3 colors; 3 runs from 3 screens:
 1 pale gray-yellow; method 28 (KT); VI
 2 pale gray-green; method 28 (KT); VI
 3 light gray-green; method 28 (KT); VI

40:JA22

Josef Albers
Gray Instrumentation IIi, from Gray
Instrumentation II 1975

Screenprint (3)
19 × 19 (48.3 × 48.3)
Paper: white Arches 88, mould-made
Edition: 36
Proofs: 10AP, 2TP, RTP, PPI, A

Screen preparation and processing by
Kenneth Tyler; proofing and edition
printing by Charles Hanley assisted by Igor
Zakowortny

Signed *Albers* in pencil lower right;
numbered and titled lower left; chop marks
of workshop and artist lower right; artist's
copyright stamp and workshop number
JA74-120 lower left verso

3 runs: 3 colors; 3 runs from 3 screens:
 1 blue-gray; method 28 (KT); VI
 2 medium blue-gray; method 28 (KT); VI
 3 light blue-gray; method 28 (KT); VI

41:JA23

Josef Albers
Gray Instrumentation IIj, from Gray
Instrumentation II 1975

Screenprint (4)
19 × 19 (48.3 × 48.3)
Paper: white Arches 88, mould-made
Edition: 36
Proofs: 10AP, 2TP, RTP, PPI, A

Screen preparation and processing by
Kenneth Tyler; proofing and edition
printing by Charles Hanley assisted by Igor
Zakowortny

Signed *Albers* in pencil lower right;
numbered and titled lower left; chop marks
of workshop and artist lower right; artist's
copyright stamp and workshop number
JA75-124 lower left verso

4 runs: 4 colors; 4 runs from 4 screens:
 1 medium purple-gray; method 28 (KT);
 VI
 2 light blue-gray; method 28 (KT); VI
 3 light green-gray; method 28 (KT); VI
 4 pale green-gray; method 28 (KT); VI

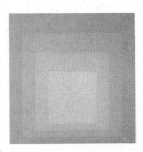

42:JA24

Josef Albers
Gray Instrumentation IIk, from Gray
Instrumentation II 1975

Screenprint (3)
19 × 19 (48.3 × 48.3)
Paper: white Arches 88, mould-made
Edition: 36
Proofs: 10AP, CTP, RTP, PPI, A

Screen preparation and processing by
Kenneth Tyler; proofing and edition
printing by Charles Hanley assisted by Igor
Zakowortny

Signed *Albers* in pencil lower right;
numbered and titled lower left; chop marks
of workshop and artist lower right; artist's
copyright stamp and workshop number
JA75-126 lower left verso

3 runs: 3 colors; 3 runs from 3 screens:
 1 pale gray-violet; method 28 (KT); VI
 2 light gray-green; method 28 (KT); VI
 3 light green-gray; method 28 (KT); VI

43:JA25

Josef Albers
Gray Instrumentation IIl, from Gray
Instrumentation II 1975

Screenprint (3)
19 × 19 (48.3 × 48.3)
Paper: white Arches 88, mould-made
Edition: 36
Proofs: 10AP, 2TP, RTP, PPI, A

Screen preparation and processing by
Kenneth Tyler; proofing and edition
printing by Charles Hanley assisted by Igor
Zakowortny

Signed *Albers* in pencil lower right;
numbered and titled lower left; chop marks
of workshop and artist lower right; artist's
copyright stamp and workshop number
JA74-119 lower left verso

3 runs: 3 colors; 3 runs from 3 screens:
 1 pale green-gray; method 28 (KT); VI
 2 light blue-gray; method 28 (KT); VI
 3 light gray-blue; method 28 (KT); VI

44:JA26

Josef Albers
Gray Instrumentation II, Plus II 1975

Screenprint (4)
19 × 19 (48.3 × 48.3)
Paper: white Arches 88, mould-made
Edition: 36
Proofs: 10AP, 2TP, RTP, PPI, A

Screen preparation and processing by
Kenneth Tyler; proofing and edition
printing by Charles Hanley assisted by Igor
Zakowortny

Signed *Albers* in pencil lower right;
numbered and titled lower left; chop marks
of workshop and artist lower right; artist's
copyright stamp and workshop number
JA74-128 lower left verso

4 runs: 4 colors; 4 runs from 4 screens:
 1 pale gray-green; method 28 (KT); VI
 2 light gray-green; method 28 (KT); VI
 3 medium gray-green; method 28 (KT);
 VI
 4 gray-green; method 28 (KT); VI

This edition was printed for the Albers
Foundation and is separate from the port-
folio of twelve prints entitled Gray Instru-
mentation II (32:JA14–43:JA25).

MITERED SQUARES

Mitered Squares, completed in 1976, is the third of a series of four screenprint portfolios by Josef Albers containing twelve prints and interleaving pages of verse written by the artist. The portfolio text (title page, verse, and colophon page) was designed by Kenneth Tyler, set in Bodoni phototypositor typeface by Stamford Typesetting Corporation, and printed by Lithocraft of New England Inc. on Japanese Masa Dosa paper. The gray cloth-covered portfolio box and black cloth-covered slipcase were designed and fabricated by Jordan Specialty Company.

45:JA27

Josef Albers
Mitered Squares a, from Mitered Squares 1976

Screenprint (3)
19 × 19 (48.3 × 48.3)
Paper: white Arches 88, mould-made
Edition: 36
Proofs: 10AP, 2CTP, RTP, PPI, A

Screen preparation and processing by Kenneth Tyler; proofing and edition printing by Charles Hanley and Tyler assisted by Betty Fiske

Signed *Albers* in pencil lower right; numbered and titled lower left; chop marks of workshop and artist lower right; artist's copyright stamp and workshop number JA75-104 lower left verso

3 runs: 3 colors; 3 runs from 3 screens:
 1 pale blue-gray; method 28 (KT); VI
 2 light gray-green; method 28 (KT); VI
 3 medium gray-green; method 28 (KT); VI

46:JA28

Josef Albers
Mitered Squares b, from Mitered Squares 1976

Screenprint (3)
19 × 19 (48.3 × 48.3)
Paper: white Arches 88, mould-made
Edition: 36
Proofs: 10AP, 2CTP, RTP, PPI, A

Screen preparation and processing by Kenneth Tyler; proofing and edition printing by Charles Hanley assisted by Betty Fiske

Signed *Albers* in pencil lower right; numbered and titled lower left; chop marks of workshop and artist lower right; artist's copyright stamp and workshop number JA75-108 lower left verso

3 runs: 3 colors; 3 runs from 3 screens:
 1 medium gray-orange; method 28 (KT); VI
 2 pale orange-gray; method 28 (KT); VI
 3 light gray-orange; method 28 (KT); VI

47:JA29

Josef Albers
Mitered Squares c, from Mitered
Squares 1976

Screenprint (3)
19 × 19 (48.3 × 48.3)
Paper: white Arches 88, mould-made
Edition: 36
Proofs: 10AP, 2CTP, RTP, PPI, A

Screen preparation and processing by
Kenneth Tyler; proofing and edition
printing by Charles Hanley assisted by
Betty Fiske

Signed *Albers* in pencil lower right;
numbered and titled lower left; chop marks
of workshop and artist lower right; artist's
copyright stamp and workshop number
JA75-129 lower left verso

3 runs: 3 colors; 3 runs from 3 screens:
 1 medium yellow-green; method 28 (KT);
 VI
 2 light gray–yellow-green; method 28
 (KT); VI
 3 pale yellow-gray; method 28 (KT); VI

48:JA30

Josef Albers
Mitered Squares d, from Mitered
Squares 1976

Screenprint (3)
19 × 19 (48.3 × 48.3)
Paper: white Arches 88, mould-made
Edition: 36
Proofs: 10AP, 2CTP, RTP, PPI, A

Screen preparation and processing by
Kenneth Tyler; proofing and edition
printing by Charles Hanley

Signed *Albers* in pencil lower right;
numbered and titled lower left; chop marks
of workshop and artist lower right; artist's
copyright stamp and workshop number
JA75-130 lower left verso

3 runs: 3 colors; 3 runs from 3 screens:
 1 medium gray-blue; method 28 (KT); VI
 2 light violet-gray; method 28 (KT); VI
 3 pale blue-gray; method 28 (KT); VI

49:JA31

Josef Albers
Mitered Squares e, from Mitered
Squares 1976

Screenprint (3)
19 × 19 (48.3 × 48.3)
Paper: white Arches 88, mould-made
Edition: 36
Proofs: 10AP, 2CTP, RTP, PPI, A

Screen preparation and processing by
Kenneth Tyler; proofing and edition
printing by Charles Hanley

Signed *Albers* in pencil lower right;
numbered and titled lower left; chop marks
of workshop and artist lower right; artist's
copyright stamp and workshop number
JA75-131 lower left verso

3 runs: 3 colors; 3 runs from 3 screens:
 1 medium yellow-brown; method 28
 (KT); VI
 2 light green-gray; method 28 (KT); VI
 3 pale pink-gray; method 28 (KT); VI

50:JA32	51:JA33	52:JA34

Josef Albers
Mitered Squares f, from Mitered
Squares 1976

Screenprint (3)
19 × 19 (48.3 × 48.3)
Paper: white Arches 88, mould-made
Edition: 36
Proofs: 10AP, 2CTP, RTP, PPI, A

Screen preparation and processing by
Kenneth Tyler; proofing and edition
printing by Charles Hanley assisted by Igor
Zakowortny

Signed *Albers* in pencil lower right;
numbered and titled lower left; chop marks
of workshop and artist lower right; artist's
copyright stamp and workshop number
JA75-132 lower left verso

3 runs: 3 colors; 3 runs from 3 screens:
 1 dark violet-red; method 28 (KT); VI
 2 light yellow-gray; method 28 (KT); VI
 3 medium red-gray; method 28 (KT); VI

Josef Albers
Mitered Squares g, from Mitered
Squares 1976

Screenprint (3)
19 × 19 (48.3 × 48.3)
Paper: white Arches 88, mould-made
Edition: 36
Proofs: 10AP, 2CTP, RTP, PPI, A

Screen preparation and processing by
Kenneth Tyler; proofing and edition
printing by Charles Hanley

Signed *Albers* in pencil lower right;
numbered and titled lower left; chop marks
of workshop and artist lower right; artist's
copyright stamp and workshop number
JA75-133 lower left verso

3 runs: 3 colors; 3 runs from 3 screens:
 1 dark blue-gray; method 28 (KT); VI
 2 light green-gray; method 28 (KT); VI
 3 medium blue-gray; method 28 (KT); VI

Josef Albers
Mitered Squares h, from Mitered
Squares 1976

Screenprint (3)
19 × 19 (48.3 × 48.3)
Paper: white Arches 88, mould-made
Edition: 36
Proofs: 10AP, 2CTP, RTP, PPI, A

Screen preparation and processing by
Kenneth Tyler; proofing and edition
printing by Charles Hanley

Signed *Albers* in pencil lower right;
numbered and titled lower left; chop marks
of workshop and artist lower right; artist's
copyright stamp and workshop number
JA75-158 lower left verso

3 runs: 3 colors; 3 runs from 3 screens:
 1 dark yellow-green; method 28 (KT); VI
 2 pale violet-gray; method 28 (KT); VI
 3 medium blue-green; method 28 (KT);
 VI

53:JA35

Josef Albers
Mitered Squares i, from Mitered
Squares 1976

Screenprint (3)
19 × 19 (48.3 × 48.3)
Paper: white Arches 88, mould-made
Edition: 36
Proofs: 10AP, 2CTP, RTP, PPI, A

Screen preparation and processing by
Kenneth Tyler; proofing and edition
printing by Charles Hanley assisted by
Betty Fiske

Signed *Albers* in pencil lower right;
numbered and titled lower left; chop marks
of workshop and artist lower right; artist's
copyright stamp and workshop number
JA75-135 lower left verso

3 runs: 3 colors; 3 runs from 3 screens:
 1 dark gray–blue-green; method 28
 (KT); VI
 2 medium gray–blue-green; method 28
 (KT); VI
 3 light gray–blue-green; method 28
 (KT); VI

54:JA36

Josef Albers
Mitered Squares j, from Mitered
Squares 1976

Screenprint (3)
19 × 19 (48.3 × 48.3)
Paper: white Arches 88, mould-made
Edition: 36
Proofs: 10AP, 2CTP, RTP, PPI, A

Screen preparation and processing by
Kenneth Tyler; proofing and edition
printing by Charles Hanley assisted by
Betty Fiske

Signed *Albers* in pencil lower right;
numbered and titled lower left; chop marks
of workshop and artist lower right; artist's
copyright stamp and workshop number
JA75-136 lower left verso

3 runs: 3 colors; 3 runs from 3 screens:
 1 dark gray–violet-red; method 28 (KT);
 VI
 2 medium gray-pink; method 28 (KT);
 VI
 3 light yellow-gray; method 28 (KT); VI

55:JA37

Josef Albers
Mitered Squares k, from Mitered
Squares 1976

Screenprint (3)
19 × 19 (48.3 × 48.3)
Paper: white Arches 88, mould-made
Edition: 36
Proofs: 10AP, CTP, RTP, PPI, A

Screen preparation and processing by
Kenneth Tyler; proofing and edition
printing by Charles Hanley assisted by
Betty Fiske

Signed *Albers* in pencil lower right;
numbered and titled lower left; chop marks
of workshop and artist lower right; artist's
copyright stamp and workshop number
JA75-137 lower left verso

3 runs: 3 colors; 3 runs from 3 screens:
 1 dark gray-green; method 28 (KT); VI
 2 light green-gray; method 28 (KT); VI
 3 medium gray–yellow-green; method 28
 (KT); VI

NEVER BEFORE

56:JA38

Josef Albers
Mitered Squares I, from Mitered
Squares 1976

Screenprint (3)

19 × 19 (48.3 × 48.3)	
Paper: white Arches 88, mould-made	
Edition: 36	
Proofs: 10AP, 2CTP, RTP, PPI, A	

Screen preparation and processing by
Kenneth Tyler; proofing and edition
printing by Charles Hanley assisted by
Betty Fiske

Signed *Albers* in pencil lower right;
numbered and titled lower left; chop marks
of workshop and artist lower right; artist's
copyright stamp and workshop number
JA75-134 lower left verso

3 runs: 3 colors; 3 runs from 3 screens:
 1 dark red–yellow-ocher; method 28
 (KT); VI
 2 medium red–yellow-ocher; method 28
 (KT); VI
 3 light gray–yellow-ocher; method 28
 (KT); VI

57:JA39

Josef Albers
Mitered Squares, Plus II 1976

Screenprint (3)

19 × 19 (48.3 × 48.3)	
Paper: white Arches 88, mould-made	
Edition: 36	
Proofs: 10AP, 2TP, RTP, PPI, A	

Screen preparation and processing by
Kenneth Tyler; proofing and edition
printing by Charles Hanley

Signed *Albers* in pencil lower right;
numbered and titled lower left; chop marks
of workshop and artist lower right; artist's
copyright stamp and workshop number
JA75-157A lower left verso

3 runs: 3 colors; 3 runs from 3 screens:
 1 pale pink-gray; method 28 (KT); VI
 2 light green-gray; method 28 (KT); VI
 3 medium blue-gray; method 28 (KT); VI

This edition was printed for the Albers
Foundation and is separate from the port-
folio of twelve prints entitled Mitered
Squares (45:JA27–56:JA38).

Never Before, completed in 1976, is the
fourth and final screenprint portfolio by
Josef Albers containing twelve prints and
interleaving pages of verse written by the
artist. In a statement reproduced on the
second page, Albers explains that the port-
folio began twenty-seven years before it was
printed, with the painting *Indicating Solids*
(1949), which he "raised . . . to a more
intense or more sculptural plasticity" with
his 1971 painting *Never Before* and its
"following variants," the twelve portfolio
prints.

Print editions *Never Before d*, *Never
Before h*, *Never Before i*, and *Never Before l*
bear the artist's chop mark but are
unsigned. At the time of his death, on
March 25, 1976, Albers had already
approved the twelve portfolio print editions
but had not finished signing them. With
Anni Albers's permission, the portfolio was
published complete.

The portfolio text (title page, artist's
statement, verse, and colophon page) was
designed by Kenneth Tyler and set in
Baskerville phototypositor typeface by
Stamford Typesetting Corporation. The
photo aluminum plate was prepared,
processed, and printed by John Hutcheson
on Japanese Masa Dosa paper. The blue
cloth-covered portfolio box and slipcase
were designed and fabricated by Jordan
Specialty Company.

58:JA40

Josef Albers
Never Before a, from Never Before 1976

Screenprint (5)
19 × 20 (48.3 × 50.8)
Paper: white Arches 88, mould-made
Edition: 46
Proofs: 10AP, 2CTP, RTP, PPI, A

Screen preparation, processing, proofing, and edition printing by Kim Halliday assisted by Don Carli

Signed *Albers* in pencil lower right; numbered and titled lower left; chop marks of workshop and artist lower right; artist's copyright stamp and workshop number JA75-129 lower left verso

5 runs: 5 colors; 5 runs from 5 screens:
1 pale gray; method 28 (KT); VI
2 medium light gray; method 28 (KT); VI
3 light gray; method 28 (KT); VI
4 medium gray; method 28 (KT); VI
5 dark gray; method 28 (KT); VI

59:JA41

Josef Albers
Never Before b, from Never Before 1976

Screenprint (5)
19 × 20 (48.3 × 50.8)
Paper: white Arches 88, mould-made
Edition: 46
Proofs: 10AP, RTP, PPI, A

Screen preparation and processing by Kenneth Tyler; proofing and edition printing by Kim Halliday

Signed *Albers* in pencil lower right; numbered and titled lower left; chop marks of workshop and artist lower right; artist's copyright stamp and workshop number JA75-132 lower left verso

5 runs: 5 colors; 5 runs from 5 screens:
1 dark gray-green; method 28 (KT); VI
2 light green; method 28 (KT); VI
3 medium yellow-green; method 28 (KT); VI
4 dark gray-blue; method 28 (KT); VI
5 dark violet-gray; method 28 (KT); VI

60:JA42

Josef Albers
Never Before c, from Never Before 1976

Screenprint (5)
19 × 20 (48.3 × 50.8)
Paper: white Arches 88, mould-made
Edition: 46
Proofs: 10AP, RTP, PPI, A

Screen preparation, processing, proofing, and edition printing by Kim Halliday

Signed *Albers* in pencil lower right; numbered and titled lower left; chop marks of workshop and artist lower right; artist's copyright stamp and workshop number JA75-134 lower left verso

5 runs: 5 colors; 5 runs from 5 screens:
1 light pink; method 28 (KT); VI
2 medium blue; method 28 (KT); VI
3 medium brown-gray; method 28 (KT); VI
4 dark green-gray; method 28 (KT); VI
5 medium yellow-green; method 28 (KT); VI

61:JA43

Josef Albers
Never Before d, from Never Before 1976

Screenprint (5)
19 × 20 (48.3 × 50.8)
Paper: white Arches 88, mould-made
Edition: 46
Proofs: 10AP, RTP, PPI, A

Screen preparation, processing, proofing, and edition printing by Kim Halliday

Unsigned; numbered and lettered in pencil by the workshop lower left; chop marks of workshop and artist lower right; workshop number JA75-157 lower left verso

5 runs: 5 colors; 5 runs from 5 screens:
 1 pale gray; method 30b (KT); VI
 2 dark blue-gray; method 30b (KT); VI
 3 medium violet-gray; method 30b (KT); VI
 4 medium gray-ocher; method 30b (KT); VI
 5 medium gray-orange; method 30b (KT); VI

62:JA44

Josef Albers
Never Before e, from Never Before 1976

Screenprint (5)
19 × 20 (48.3 × 50.8)
Paper: white Arches 88, mould-made
Edition: 46
Proofs: 10AP, RTP, PPI, A

Screen preparation, processing, proofing, and edition printing by Kim Halliday

Signed *Albers* in pencil lower right; numbered and titled lower left; chop marks of workshop and artist lower right; artist's copyright stamp and workshop number JA75-133 lower left verso

5 runs: 5 colors; 5 runs from 5 screens:
 1 pale gray-blue; method 28 (KT); VI
 2 dark gray-blue; method 28 (KT); VI
 3 medium gray-blue; method 28 (KT); VI
 4 dark gray-brown; method 28 (KT); VI
 5 dark gray-red; method 28 (KT); VI

63:JA45

Josef Albers
Never Before f, from Never Before 1976

Screenprint (5)
19 × 20 (48.3 × 50.8)
Paper: white Arches 88, mould-made
Edition: 46
Proofs: 10AP, 2CTP, RTP, PPI, A

Screen preparation, processing, proofing, and edition printing by Kim Halliday

Signed *Albers* in pencil lower right; numbered and titled lower left; chop marks of workshop and artist lower right; artist's copyright stamp and workshop number JA75-130 lower left verso

5 runs: 5 colors; 5 runs from 5 screens:
 1 light pink; method 28 (KT); VI
 2 medium gray-pink; method 28 (KT); VI
 3 medium blue-violet; method 28 (KT); VI
 4 medium gray-yellow; method 28 (KT); VI
 5 dark gray-orange; method 28 (KT); VI

64:JA46

Josef Albers
Never Before g, from Never Before 1976

Screenprint (5)
19 × 20 (48.3 × 50.8)
Paper: white Arches 88, mould-made
Edition: 46
Proofs: 10AP, RTP, PPI, A

Screen preparation, processing, proofing, and edition printing by Kim Halliday

Signed *Albers* in pencil lower right; numbered and titled lower left; chop marks of workshop and artist lower right; artist's copyright stamp and workshop number JA75-131 lower left verso

5 runs: 5 colors; 5 runs from 5 screens:
 1 pale gray-yellow; method 28 (KT); VI
 2 medium gray-brown; method 28 (KT); VI
 3 light gray-yellow; method 28 (KT); VI
 4 medium gray-orange; method 28 (KT); VI
 5 dark orange-brown; method 28 (KT); VI

65:JA47

Josef Albers
Never Before h, from Never Before 1976

Screenprint (5)
19 × 20 (48.3 × 50.8)
Paper: white Arches 88, mould-made
Edition: 46
Proofs: 10AP, RTP, PPI, A

Screen preparation and processing by Kenneth Tyler; proofing and edition printing by Kim Halliday and Tyler

Unsigned; numbered and lettered in pencil by the workshop lower left; chop marks of workshop and artist lower right; workshop number JA75-137 lower left verso

5 runs: 5 colors; 5 runs from 5 screens:
 1 pale gray; method 31b (KT); VI
 2 medium green-gray; method 31b (KT); VI
 3 light green-gray; method 31b (KT); VI
 4 dark blue-green; method 31b (KT); VI
 5 dark yellow-green; method 31b (KT); VI

66:JA48

Josef Albers
Never Before i, from Never Before 1976

Screenprint (5)
19 × 20 (48.3 × 50.8)
Paper: white Arches 88, mould-made
Edition: 46
Proofs: 10AP, RTP, PPI, A

Screen preparation and processing by Kenneth Tyler; proofing and edition printing by Kim Halliday

Unsigned; numbered and lettered in pencil by the workshop lower left; chop marks of workshop and artist lower right; workshop number JA75-158 lower left verso

5 runs: 5 colors; 5 runs from 5 screens:
 1 pale blue-gray; method 30b (KT); VI
 2 medium gray-blue; method 30b (KT); VI
 3 light gray-blue; method 30b (KT); VI
 4 dark gray-blue; method 30b (KT); VI
 5 dark blue; method 30b (KT); VI

67:JA49

Josef Albers
Never Before j, from Never Before 1976

Screenprint (5)

19 × 20 (48.3 × 50.8)
Paper: white Arches 88, mould-made
Edition: 46
Proofs: 10AP, 2CTP, RTP, PPI, A

Screen preparation, processing, proofing, and edition printing by Kim Halliday

Signed *Albers* in pencil lower right; numbered and titled lower left; chop marks of workshop and artist lower right; artist's copyright stamp and workshop number JA75-135 lower left verso

5 runs: 5 colors; 5 runs from 5 screens:
 1 light pink; method 28 (KT); VI
 2 medium pink; method 28 (KT); VI
 3 medium gray-tan; method 28 (KT); VI
 4 medium red; method 28 (KT); VI
 5 dark purple-red; method 28 (KT); VI

68:JA50

Josef Albers
Never Before k, from Never Before 1976

Screenprint (5)

19 × 20 (48.3 × 50.8)
Paper: white Arches 88, mould-made
Edition: 46
Proofs: 10AP, RTP, PPI, A

Screen preparation, processing, proofing, and edition printing by Kim Halliday

Signed *Albers* in pencil lower right; numbered and titled lower left; chop marks of workshop and artist lower right; artist's copyright stamp and workshop number JA75-136 lower left verso

5 runs: 5 colors; 5 runs from 5 screens:
 1 light gray-tan; method 28 (KT); VI
 2 medium gray-tan; method 28 (KT); VI
 3 medium gray; method 28 (KT); VI
 4 medium gray-ocher; method 28 (KT); VI
 5 dark gray–yellow-brown; method 28 (KT); VI

69:JA51

Josef Albers
Never Before l, from Never Before 1976

Screenprint (5)

19 × 20 (48.3 × 50.8)
Paper: white Arches 88, mould-made
Edition: 46
Proofs: 10AP, RTP, PPI, A

Screen preparation and processing by Kenneth Tyler; proofing and edition printing by Kim Halliday

Unsigned; numbered and lettered in pencil by the workshop lower left; chop marks of workshop and artist lower right; workshop number JA75-159 lower left verso

5 runs: 5 colors; 5 runs from 5 screens:
 1 pale violet-gray; method 30b (KT); VI
 2 medium green-gray; method 30b (KT); VI
 3 light green-gray; method 30b (KT); VI
 4 medium green-gray; method 30b (KT); VI
 5 dark green-gray; method 30b (KT); VI

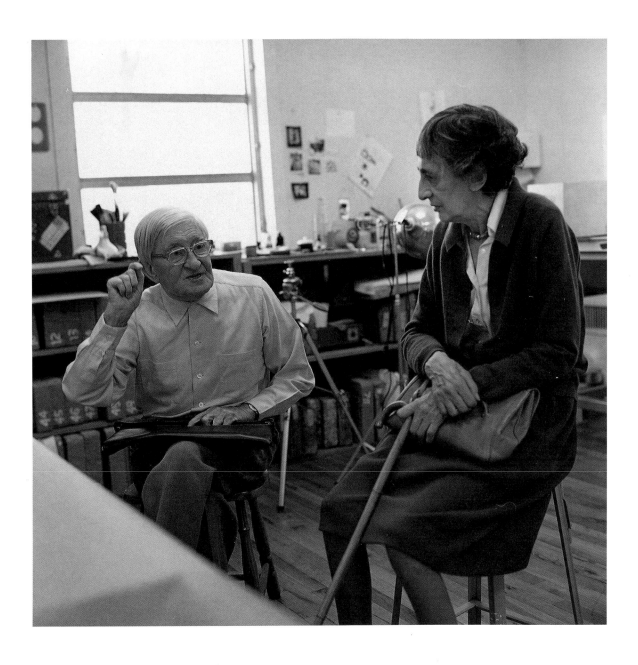

Josef and Anni Albers in the artist's studio
at Tyler Graphics, 1976.

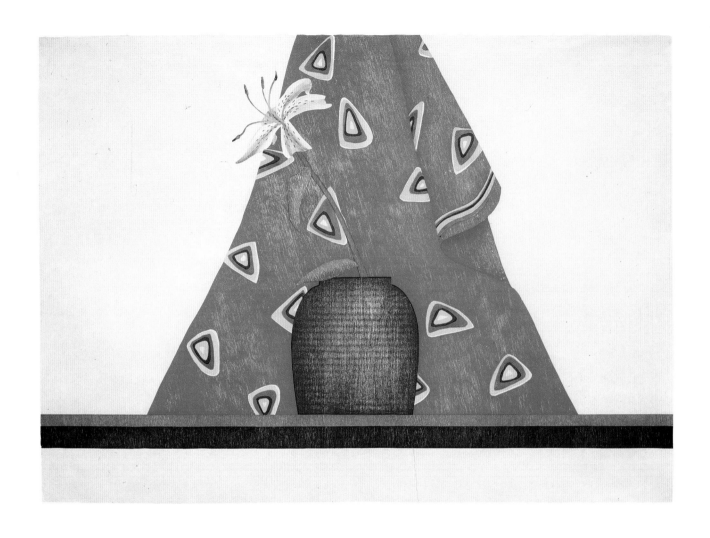

The Print Scarf 1980
See 75:EB6

Ed Baynard

1940 Born in Washington, D.C.

1960 Moves to Europe and lives mainly in Ibiza, Spain; Paris; and London

1962 Moves to New York and designs clothing for Van Heusen and other companies; also works as draft counselor and antiwar activist

1965 Moves to Ibiza, Spain

1967–68 Designs posters and graphics in London and works for the Beatles at Apple

1968–69 Teaches experimental art at Ecole des Beaux-Arts, Paris, and does sketches for Women's Wear Daily Paris office

1970 First solo exhibition at Ivan Spence Gallery, Ibiza, Spain; moves to New York

1971 First solo exhibition in United States at Willard Gallery, New York

1973 Included in exhibition *American Drawing, 1963–1973* at Whitney Museum of American Art, New York

1976 Completes Bowl stencil print series at Maurel Studios, New York, published by Multiples Inc., New York

1978 Begins flower watercolors; becomes spokesperson for International Rescue Committee

1979–80 Completes Orchid aquatint series, published by Barbara Gladstone Editions, New York

1980 Completes woodcuts and hand-colored lithographs at Tyler Graphics; explores still-life subject matter

1981 Completes Monotype Series at Tyler Graphics

1984 Moves to Shokan, New York; included in exhbition *Prints from Tyler Graphics* at Walker Art Center, Minneapolis; exhibition *The Etchings and Woodblock Prints of Ed Baynard* at Washington County Museum of Fine Arts, Hagerstown, Maryland

Currently lives and works in Shokan, New York

Eight Woodcuts

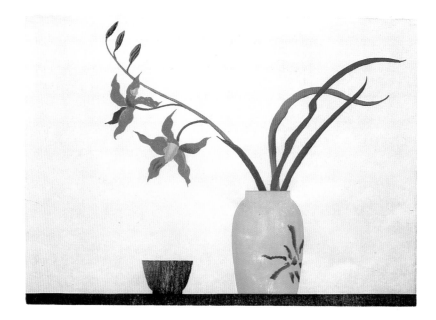

In 1980 Ed Baynard made eight woodcut prints based on watercolor studies he painted specifically for the project. He traced the watercolor images onto Mylar and transferred them to wood. Work for these editions was divided into five stages, beginning with the artist's selection of assorted woods—fir, pine, luan plywood, walnut, Russian plywood, and mahogany—for texture and grain, and with preliminary cutting and carving of each woodblock by the artist, Kenneth Tyler, Roger Campbell, and Lee Funderburg, assisted by Duane Mitch, Steve Reeves, and Tom Strianese. Numerous inks were mixed and experimentally applied to the blocks by Campbell, Funderburg, and Tyler. The color mixes and application techniques changed as the artist revised and developed his images during proofing. Baynard, Campbell, Funderburg, and Tyler used assorted inking methods, applying colors directly with their fingers and palms, employing small brayers, brushes, and compressed paper stumps for wiping on colors, and using rollers for blend inking. Each print was proofed many times before Baynard made his final ink and woodblock corrections. Once the edition standards were established, the woodblocks were inked and printed on handmade Okawara paper by Campbell and Funderburg on a flatbed offset press.

70:EB1

Ed Baynard
A Still Life with Orchid 1980

Woodcut (21)
30 × 42 (76.2 × 106.7)
Paper: natural Okawara, handmade
Edition: 70
Proofs: 16AP, 2TP, 6CTP, RTP, PPI, PPII, A

Proofing and edition printing by Kenneth Tyler, Roger Campbell, and Lee Funderburg

Signed *Ed Baynard*, numbered, and dated in pencil lower right; chop mark lower left; workshop number EB80-502 lower right verso

10 runs: 21 colors; 10 runs from 8 woodblocks:
 1 dark brown; method 19a (luan plywood); IIa
 2 blend of blue and black; methods 19a (luan plywood), 16g; IIa
 3 white acrylic gesso applied with sponge; method 19a (Russian plywood); IIa
 4 white acrylic gesso applied with sponge; method 19a (same block as run 3); IIa
 5 turquoise green; method 19a (same block as run 3); IIa
 6 blend of blue-green and turquoise green; methods 19a (same block as run 3), 16g; IIa
 7 blend of blue and gray and blend of medium brown and dark brown; methods 19a (Russian plywood), 16g; IIa
 8 yellow, orange, pink, and dark green; methods 19a (Russian plywood), 16a; IIa
 9 medium red, dark red, and pink; methods 19a (Russian plywood), 16a; IIa
 10 medium green and dark green; methods 19a (Russian plywood), 16a; IIa

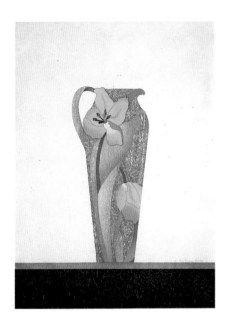

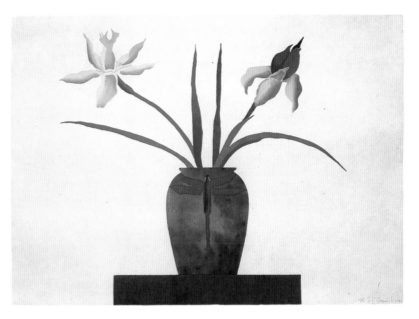

71:EB2

Ed Baynard
The Tulip Pitcher 1980

Woodcut (16)
42 × 30 (106.7 × 76.2)
Paper: natural Okawara, handmade
Edition: 70
Proofs: 18AP, 4CTP, RTP, PPI, PPII, A

Proofing by Kenneth Tyler, Roger Campbell,
and Lee Funderburg; edition printing by
Campbell and Funderburg

Signed *Ed Baynard*, numbered, and dated
in pencil lower right; chop mark lower left;
workshop number EB80-507 lower right
verso

8 runs: 16 colors; 8 runs from 8
woodblocks:
 1 tan; method 19a (Russian plywood);
 IIa
 2 dark brown; method 19a (luan
 plywood); IIa
 3 medium gray, dark gray, and black;
 methods 19a (luan plywood), 16a; IIa
 4 blend of green and dark green; methods
 19a (luan plywood), 16g; IIa
 5 medium red, medium green, and dark
 green; methods 19a (luan plywood),
 16a; IIa
 6 blend of light green and medium green;
 methods 19a (luan plywood), 16g; IIa
 7 blend of light orange, dark orange, and
 violet-red; methods 19a (Russian
 plywood), 16g; IIa
 8 dark red; method 19a (Russian
 plywood); IIa

72:EB3

Ed Baynard
The Dragonfly Vase 1980

Woodcut (21)
30 × 42 (76.2 × 106.7)
Paper: natural Okawara, handmade
Edition: 70
Proofs: 16AP, 8CTP, RTP, PPI, PPII, A

Proofing by Kenneth Tyler, Roger Campbell,
and Lee Funderburg; edition printing by
Campbell and Funderburg

Signed *Ed Baynard*, numbered, and dated
in pencil lower right; chop mark lower left;
workshop number EB80-503 lower right
verso

7 runs: 21 colors; 7 runs from 4
woodblocks:
 1 dark brown, light blue, dark green, and
 gray; methods 19a (Russian plywood),
 16a; IIa
 2 light purple, light blue, and green;
 methods 19a (same block as run 1),
 16a; IIa
 3 light blue; method 19a (Russian
 plywood); IIa
 4 dark blue; method 19a (same block as
 run 3); IIa
 5 medium blue; method 19a (same block
 as run 3); IIa

 6 pale purple, light purple, medium
 purple, dark purple, red-blue, light
 blue, medium blue, dark blue, medium
 green, and dark green; methods 19a
 (Russian plywood), 16a; IIa
 7 light gray-brown; method 19a (luan
 plywood); IIa

73:EB4

Ed Baynard
A Quarter Moon 1980

Woodcut (25)

42 × 30 (106.7 × 76.2)	

Paper: natural Okawara, handmade

Edition: 70

Proofs: 12AP, TP, 7CTP, RTP, PPI, PPII, A

Proofing by Kenneth Tyler, Roger Campbell, and Lee Funderburg; edition printing by Campbell and Funderburg

Signed *Ed Baynard*, numbered, and dated in pencil lower right; chop mark lower left; workshop number EB80-500 lower right verso

11 runs: 25 colors; 11 runs from 11 woodblocks:
1 light brown, dark brown, and blend of medium brown and dark brown; methods 19a (Russian plywood), 16g; IIa
2 light purple, medium green, and dark green; methods 19a (Russian plywood), 16a; IIa
3 blend of light gray and medium gray; methods 19a (Russian plywood), 16g; IIa
4 blend of medium blue and dark blue; methods 19a (Russian plywood), 16g; IIa
5 black; method 19a (maple wood); IIa
6 blend of medium green and dark green; methods 19a (Russian plywood), 16g; IIa
7 brown-green and blue-green; methods 19a (Russian plywood), 16a; IIa
8 purple; method 19a (Russian plywood); IIa
9 magenta, purple-blue, medium blue, and dark blue; methods 19a (Russian plywood), 16a; IIa
10 yellow, orange, and dark purple; methods 19a (pinewood), 16a; IIa
11 dark brown; method 19a (fir plywood); IIa

74:EB5

Ed Baynard
The China Pot 1980

Woodcut (27)

42 × 30 (106.7 × 76.2)	

Paper: natural Okawara, handmade

Edition: 70

Proofs: 18AP, 4CTP, RTP, PPI, PPII, A

Proofing by Kenneth Tyler, Roger Campbell, and Lee Funderburg; edition printing by Campbell and Funderburg

Signed *Ed Baynard*, numbered, and dated in pencil lower right; chop mark lower left: workshop number EB80-501 lower right verso

9 runs: 27 colors; 9 runs from 9 woodblocks:
1 light brown; method 19a (Russian plywood); IIa
2 blend of purple and red-brown; methods 19a (mahogany plywood), 16g; IIa
3 yellow and yellow-orange; methods 19a (mahogany plywood), 16a; IIa

4 light blue, medium blue, dark blue, white, and gray; methods 19a (Russian plywood), 16a; IIa

5 dark red, dark pink, and turquoise green; methods 19a (Russian plywood), 16a; IIa

6 dark yellow, medium orange, dark orange, and viridian; methods 19a (Russian plywood), 16a; IIa

7 light blue, light green, dark green, blue-gray, green-gray, and gray; methods 19a (Russian plywood), 16a; IIa

8 dark brown, green-brown, and gray-brown; methods 19a (Russian plywood), 16a; IIa

9 purple; method 19a (Russian plywood); IIa

75:EB6

Ed Baynard
The Print Scarf 1980

Woodcut (29)
30 × 42 (76.2 × 106.7)
Paper: natural Okawara, handmade
Edition: 70
Proofs: 18AP, 4CTP, RTP, PPI, PPII, A

Proofing by Kenneth Tyler, Roger Campbell, and Lee Funderburg; edition printing by Campbell and Funderburg

Signed *Ed Baynard*, numbered, and dated in pencil lower right; chop mark lower left; workshop number EB80-505 lower right verso

12 runs: 29 colors; 12 runs from 14 woodblocks:

1 medium brown; method 19a (walnut plywood); IIa

2 brown; method 19a (luan plywood); IIa

3 medium red; method 19a (fir plywood); IIa

4 dark blue and white; methods 19a, 15a (Russian plywood), 16a; IIa

5 medium gray and dark gray; methods 19a (Russian plywood), 16a; IIa

6 blend of dark red and violet-red; methods 19a (fir plywood), 16g; IIa

7 green-brown; method 19a (Russian plywood); IIa

8 dark blue; method 19a (Russian plywood); IIa

9 medium red and violet-red; methods 19a (fir plywood), 16a; IIa

10 medium yellow, light pink, medium pink, light purple, medium purple, light blue, and medium green; methods 19a (Russian plywood), 16a; IIa

11 yellow-green, light green, medium green, and dark green; methods 19a, 15a (Russian and luan plywoods), 16a; IIa

12 light gold, rubine red, brown, medium green, and dark green; methods 19a (pinewood), 16a; IIa

76:EB7

Ed Baynard
The Blue Tulips 1980

Woodcut (15)

30 × 42 (76.2 × 106.7)

Paper: natural Okawara, handmade

Edition: 70

Proofs: 18AP, 4CTP, 9PP, RTP, PPI, PPII, A

Proofing by Kenneth Tyler, Roger Campbell, and Lee Funderburg; edition printing by Campbell and Funderburg

Signed *Ed Baynard*, numbered, and dated in pencil lower right; chop mark lower left; workshop number EB80-506 lower right verso

9 runs: 15 colors; 9 runs from 11 woodblocks:
1. blend of medium brown and dark brown; methods 19a (luan plywood), 16g; IIa
2. medium blue and transparent gray; methods 19a, 15a (walnut and Russian plywoods), 16a; IIa
3. magenta, medium purple, and dark purple; methods 19a, 15a (Russian plywood), 16a; IIa
4. purple-black; method 19a (luan plywood); IIa
5. medium yellow-green; method 19a (Russian plywood); IIa
6. brown-green and dark green; methods 19a (luan plywood), 16a; IIa
7. medium green and dark green; methods 19a (luan plywood), 16a; IIa
8. light brown-green; method 19a (luan plywood); IIa
9. transparent green; method 19a (Russian plywood); IIa

77:EB8

Ed Baynard
A Dark Pot with Roses 1980

Woodcut (35)

42 × 30 (106.7 × 76.2)

Paper: natural Okawara, handmade

Edition: 70

Proofs: 18AP, 8PP, RTP, PPI, PPII, A

Proofing by Kenneth Tyler, Roger Campbell, and Lee Funderburg; edition printing by Campbell and Funderburg

Signed *Ed Baynard*, numbered, and dated in pencil lower right; chop mark lower left; workshop number EB80-504 lower right verso

8 runs: 35 colors; 8 runs from 10 woodblocks:
1. dark blue, medium green, dark green, and dark brown; methods 19a (fir plywood), 16a; IIa
2. blend of orange-yellow, orange, violet-red, medium blue, dark blue, and transparent black; methods 19a (fir plywood), 16g; IIa

3 medium green, dark green, and transparent black; methods 19a, 15a (luan plywood), 16a; IIa

4 orange-yellow, light orange, medium orange, dark orange, red-orange, medium red, and pink-red; methods 19a (Russian plywood), 16a; IIa

5 light gold-yellow, medium gold-yellow, light gold-orange, medium gold-orange, dark gold-orange, violet-red, and purple-red; methods 19a (Russian plywood), 16a; IIa

6 brown, light green, medium green, and dark green; methods 19a, 15a (luan and walnut plywoods), 16a; IIa

7 transparent yellow and blue-green; methods 19a (Russian plywood), 16a; IIa

8 medium green and dark green; methods 19a (Russian plywood), 16a; IIa

78:EB9

Ed Baynard
The Lilies 1980

Lithograph, hand-colored (v)
57½ × 40½ (146.1 × 102.9)
Paper: white Arches Watercolor, mould-made
Edition: 12
Proofs: 4AP, RTP, PPI, A

Plate preparation, processing, and proofing by Lee Funderburg on press I; edition printing by Funderburg and Roger Campbell on press IIa

Signed *Ed Baynard*, numbered, and dated in pencil lower right; chop mark lower left; workshop number EB80-508 lower right verso

1 run: 1 color; 1 run from 1 aluminum plate:
 1 black; method 1b; IIa

The artist painted each impression with watercolors.

79:EB10

Ed Baynard
The Sunflower 1980

Lithograph, hand-colored (v)
57½ × 40½ (146.1 × 102.9)
Paper: white Arches Watercolor, mould-made
Edition: 12
Proofs: 4AP, RTP, PPI, A

Plate preparation, processing, and proofing by Kenneth Tyler on press I; edition printing by Roger Campbell and Lee Funderburg on press IIa

Signed *Ed Baynard*, numbered, and dated in pencil lower right; chop mark lower left; workshop number EB80-509 lower right verso

1 run: 1 color; 1 run from 1 aluminum plate:
 1 black; method 1b; IIa

The artist painted each impression with watercolors.

80:EB11

Ed Baynard
The Roses 1980

Lithograph, hand-colored (v)	
40 × 40½ (101.6 × 102.9)	
Paper: white Arches Watercolor, mould-made	
Edition: 12	
Proofs: 4AP, RTP, PPI, A	

Plate preparation, processing, and proofing by Kenneth Tyler on press I; edition printing by Roger Campbell and Lee Funderburg on press IIa

Signed *Ed Baynard*, numbered, and dated in pencil lower right; chop mark lower left; workshop number EB80-514 lower right verso

1 run: 1 color; 1 run from 1 aluminum plate:
 1 black; method 1b; IIa

The artist painted each impression with watercolors.

MONOTYPE SERIES

In 1980 Ed Baynard created a series of eighty-one monotypes (published 1981), consisting of six diptychs and seventy-five single-sheet images, all printed on white TGL handmade paper. The artist worked on the flatbed offset press, painting directly on a polished magnesium plate with lithographic inks mixed with solvents and varnishes. Kenneth Tyler worked with Baynard, blend-rolling and inking each plate with brayers before the artist began to paint. During the printing sessions Tyler was assisted by Roger Campbell and Lee Funderburg. After each impression was pulled, the image was reworked with ink by the artist.

Each of the diptych monotypes is signed *Ed Baynard* and dated in white pencil with chop mark lower right and diptych number lower left verso. Each of the single-sheet monotypes is signed *Ed Baynard* and dated in pencil (some of the dark images are signed and dated in white pencil) lower right with chop mark lower left and series letter and number lower right verso.

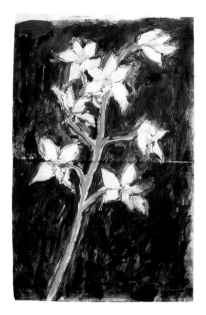

81:EB16

Ed Baynard
Diptych 5, from the Monotype Series 1981

Monotype	
Two sheets: 56 × 36 (142.2 × 91.4); each: 28 × 36 (71.1 × 91.4)	
Paper: white TGL, handmade	

Preliminary blend rolling and inking of plate by Kenneth Tyler; project assistance by Roger Campbell and Lee Funderburg

Signed *Ed Baynard* and dated in white pencil lower right; chop mark lower right diptych number lower left verso

1 run: ink colors; 1 run from 1 polished magnesium plate:
 1 ink colors painted on inked plate (2 sheets printed simultaneously); IIa

The artist drew on the previously inked plate using inks and a variety of tools.

82:EB47

Ed Baynard
E-6, from the Monotype Series 1981

Monotype
29 × 40 (73.7 × 101.6)
Paper: white TGL, handmade

Preliminary blend rolling and inking of
plate by Kenneth Tyler; project assistance
by Roger Campbell and Lee Funderburg

Signed *Ed Baynard* and dated in white
pencil lower right; chop mark lower left;
series identification lower right verso

1 run: ink colors; 1 run from 1 polished
magnesium plate:
 1 ink colors painted on inked plate; IIa

The artist drew on the previously inked
plate using inks and a variety of tools.

83:EB57

Ed Baynard
H-1, from the Monotype Series 1981

Monotype
41½ × 29 (105.4 × 73.7)
Paper: white TGL, handmade

Preliminary blend rolling and inking of
plate by Kenneth Tyler; project assistance
by Roger Campbell and Lee Funderburg

Signed *Ed Baynard* and dated in pencil
lower right; chop mark lower left; series
identification lower right verso

1 run: ink colors; 1 run from 1 polished
magnesium plate:
 1 ink colors painted on inked plate; IIa

The artist drew on the previously inked
plate using inks and a variety of tools.

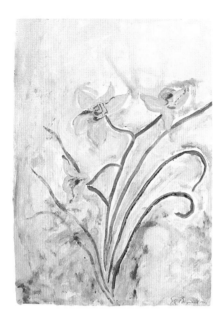

| 84:EB63 | 85:EB76 | 86:EB81 |

Ed Baynard
I-1, from the Monotype Series 1981

Monotype
42 × 29½ (106.7 × 74.9)
Paper: white TGL, handmade

Preliminary blend rolling and inking of
plate by Kenneth Tyler; project assistance
by Roger Campbell and Lee Funderburg

Signed *Ed Baynard* and dated in pencil
lower right; chop mark lower left; series
identification lower right verso

1 run: ink colors; 1 run from 1 polished
magnesium plate:
 1 ink colors painted on inked plate; IIa

The artist drew on the previously inked
plate using inks and a variety of tools.

Ed Baynard
J-7, from the Monotype Series 1981

Monotype
42 × 29½ (106.7 × 74.9)
Paper: white TGL, handmade

Preliminary blend rolling and inking of
plate by Kenneth Tyler; project assistance
by Roger Campbell and Lee Funderburg

Signed *Ed Baynard* and dated in pencil
lower right; chop mark lower left; series
identification lower right verso

1 run: ink colors; 1 run from 1 polished
magnesium plate:
 1 ink colors painted on inked plate; IIa

The artist drew on the previously inked
plate using inks and a variety of tools.

Ed Baynard
K-4, from the Monotype Series 1981

Monotype
41¼ × 29¼ (104.8 × 74.3)
Paper: white TGL, handmade

Preliminary blend rolling and inking of
plate by Kenneth Tyler; project assistance
by Roger Campbell and Lee Funderburg

Signed *Ed Baynard* and dated in pencil
lower right; chop mark lower left; series
identification lower right verso

1 run: ink colors; 1 run from 1 polished
magnesium plate:
 1 ink colors painted on inked plate; IIa

The artist drew on the previously inked
plate using inks and a variety of tools.

87:EB86

Ed Baynard
M-1, from the Monotype Series 1981

Monotype

29 × 40 (73.7 × 101.6)

Paper: white TGL, handmade

Preliminary blend rolling and inking of
plate by Kenneth Tyler; project assistance
by Roger Campbell and Lee Funderburg

Signed *Ed Baynard* and dated in pencil
lower right; chop mark lower left; series
identification lower right verso

1 run: ink colors; 1 run from 1 polished
magnesium plate:
 1 ink colors painted on inked plate; IIa

The artist drew on the previously inked
plate using inks and a variety of tools.

88:EB90

Ed Baynard
N-2, from the Monotype Series 1981

Monotype

29 × 37 (73.7 × 94)

Paper: white TGL, handmade

Preliminary blend rolling and inking of
plate by Kenneth Tyler; project assistance
by Roger Campbell and Lee Funderburg

Signed *Ed Baynard* and dated in pencil
lower right; chop mark lower left; series
identification lower right verso

1 run: ink colors; 1 run from 1 polished
magnesium plate:
 1 ink colors painted on inked plate; IIa

The artist drew on the previously inked
plate using inks and a variety of tools.

Jackass Free,
from Carnival of Animals 1979
See 108:SB20

Stanley Boxer

1926 Born in New York

1946–49 Studies with Morris Kantor at Art Students League, New York

1952 Establishes first studio and takes part-time job at a bookbinding and printing company

1953 First solo exhibition of paintings at Perdalma Gallery, New York

1965 Exhibition of paintings and sculptures at Grand Central Moderns Gallery, New York

1970 The titles of his works evolve; words are run together, creating long words that, although difficult to read, are meant to be evocative, not informational

1971–72 Solo exhibitions of paintings and sculptures at Tibor de Nagy Gallery, New York

1972 Designs and builds sculptural set for *Classic Kite Takes*, Eric Hawkins Dance Company

1975 Receives John Simon Guggenheim Memorial Foundation Fellowship; solo exhibition of paintings and drawings at André Emmerich Gallery, New York

1976 Completes first portfolio of intaglio prints, Ring of Dust in Bloom, at Tyler Graphics

1977 Included in exhibition *Art Off the Picture Press* at Emily Lowe Gallery, Hofstra University, New York

1978 Drawing retrospective at Mint Museum of Art, Charlotte, North Carolina

1979 Completes second portfolio of intaglio prints, Carnival of Animals, at Tyler Graphics

1980 Included in exhibition *L'Amérique aux indépendants: Quatre-vingt-*

onzième Exposition Société des Artistes at Grand Palais, Paris

1983 Completes suite of monotypes at Institute of Experimental Printmaking, San Francisco

1984–85 Completes hand-painted bronze sculpture multiples at Garner Tullis Workshop, Santa Barbara, California; completes monoprints at Echo Press, Bloomington, Indiana

Currently lives and works in New York

RING OF DUST IN BLOOM

RING OF DUST IN BLOOM

TWELVE ORIGINAL HAND PRINTED ETCHINGS
WITH AQUATINT AND WATERCOLORED

STANLEY BOXER

TYLER GRAPHICS LTD. NEW YORK 1976

From September 1975 to July 1976 Stanley Boxer collaborated with Kenneth Tyler and Betty Fiske in creating Ring of Dust in Bloom, a portfolio of twelve intaglio prints painted by the artist with watercolors. Using Boxer's outline drawings, Fiske cut copper plates into a variety of shapes, including circles, half circles, ovals, and triangles, on which the artist made his imagery. He combined the intaglio techniques of aquatint, drypoint, and hard- and soft-ground etching. After Fiske processed the plates, Boxer applied inks selected from a palette of fifteen colors with his fingers and palm. Fiske finish-wiped the plates and printed them. When the prints were dry, Boxer painted each one differently with watercolors.

The portfolio text (title page and colophon page) was designed by Tyler and set in Baskerville phototypositor typeface by Stamford Typesetting Corporation. Ten sets of prints from the editions of twenty-eight are encased in light yellow-ocher cloth-covered portfolio boxes and dark yellow-ocher cloth-covered slipcases fabricated by Len Hartnett Archival Products. Two of the twelve canceled etching plates are mounted on the inside bottom of the special presentation portfolio boxes. A copperplate etching made especially for the encased portfolio is printed on the title page.

89:SB1

Stanley Boxer
Title page from Ring of Dust in Bloom 1976

Etching, lithograph (2)	
24 × 20 (61 × 50.8)	
Paper: white Duchene, handmade	
Edition: 28	

Copper plate preparation, processing, proofing, and edition printing by Betty Fiske; aluminum plate preparation, processing, proofing, and edition printing by John Hutcheson

2 runs: 2 colors; 2 runs from 1 aluminum and 1 copper plate:
 1 dark brown; method 3c; IIa
 2 light brown; method 6; IV

90:SB2

Stanley Boxer
Obliquequestionofaturtle, from Ring of Dust in Bloom 1976

Etching, aquatint, hand-colored (v)	
24 × 20 (61 × 50.8)	
Paper: white HMP, handmade	
Edition: 28	
Proofs: 9AP, TP, 2PP, RTP, PPI, A, C	

Plate preparation, processing, proofing, and edition printing by Betty Fiske

Signed *S. Boxer* and dated in pencil lower right; numbered lower left; chop mark lower right; workshop number SB75-241 lower left verso

1 run: ink colors; 1 run from 1 diamond-shaped copper plate:
 1 variant inking from palette: medium yellow, orange, yellow-ocher, vermilion, dark red, violet, purple, brown, dark brown, Prussian blue, turquoise green, medium green, dark green, white, and black; methods 6, 9 (BF), 16a; IV

The artist painted each print with watercolors.

91:SB3

Stanley Boxer
Gatheringforsomereason, from Ring of
Dust in Bloom 1976

Etching, aquatint, hand-colored (v)
20 × 24 (50.8 × 61)
Paper: white HMP, handmade
Edition: 28
Proofs: 9AP, TP, 2PP, RTP, PPI, A, C

Plate preparation, processing, proofing, and
edition printing by Betty Fiske

Signed *S. Boxer* and dated in pencil lower
right; numbered lower left; chop mark
lower right; workshop number SB75-238
lower left verso

1 run: ink colors; 1 run from 1 rectangular
copper plate:
 1 variant inking from palette: medium
 yellow, orange, yellow-ocher, vermilion,
 dark red, violet, purple, brown, dark
 brown, Prussian blue, turquoise green,
 medium green, dark green, white, and
 black; methods 6, 9 (BF), 16a; IV

The artist painted each print with
watercolors.

92:SB4

Stanley Boxer
Feybowlofplay, from Ring of Dust in
Bloom 1976

Etching, aquatint, hand-colored (v)
20 × 24 (50.8 × 61)
Paper: white HMP, handmade
Edition: 28
Proofs: 9AP, TP, 2PP, RTP, PPI, A, C

Plate preparation, processing, proofing, and
edition printing by Betty Fiske

Signed *S. Boxer* and dated in pencil lower
right; numbered lower left; chop mark
lower right; workshop number SB75-234
lower left verso

1 run: ink colors; 1 run from 1 arch-
shaped copper plate:
 1 variant inking from palette: medium
 yellow, orange, yellow-ocher, vermilion,
 dark red, violet, purple, brown, dark
 brown, Prussian blue, turquoise green,
 medium green, dark green, white, and
 black; methods 6, 9 (BF), 16a; IV

The artist painted each print with
watercolors.

93:SB5

Stanley Boxer
Askanceglancelongingly, from Ring of Dust
in Bloom 1976

Etching, aquatint, hand-colored (v)
24 × 20 (61 × 50.8)
Paper: white HMP, handmade
Edition: 28
Proofs: 9AP, TP, 2PP, RTP, PPI, A, C

Plate preparation, processing, proofing, and
edition printing by Betty Fiske

Signed *S. Boxer* and dated in pencil lower
right; numbered lower left; chop mark
lower right; workshop number SB75-236
lower left verso

1 run: ink colors; 1 run from 1 rectangular
copper plate:
 1 variant inking from palette: medium
 yellow, orange, yellow-ocher, vermilion,
 dark red, violet, purple, brown, dark
 brown, Prussian blue, turquoise green,
 medium green, dark green, white, and
 black; methods 6, 9 (BF), 16a; IV

The artist painted each print with
watercolors.

94:SB6

Stanley Boxer
Curiousstalking, from Ring of Dust in
Bloom 1976

Etching, aquatint, hand-colored (v)
20 × 24 (50.8 × 61)
Paper: white HMP, handmade
Edition: 28
Proofs: 9AP, TP, 2PP, RTP, PPI, A, C

Plate preparation, processing, proofing, and
edition printing by Betty Fiske

Signed *S. Boxer* and dated in pencil lower
right; numbered lower left; chop mark
lower right; workshop number SB75-243
lower left verso

1 run: ink colors; 1 run from 1 rectangular
copper plate:
 1 variant inking from palette: medium
 yellow, orange, yellow-ocher, vermilion,
 dark red, violet, purple, brown, dark
 brown, Prussian blue, turquoise green,
 medium green, dark green, white, and
 black; methods 6, 9 (BF), 16a; IV

The artist painted each print with
watercolors.

95:SB7

Stanley Boxer
Pauseofnoconcern, from Ring of Dust in
Bloom 1976

Etching, aquatint, hand-colored (v)
20 × 24 (50.8 × 61)
Paper: white HMP, handmade
Edition: 28
Proofs: 9AP, TP, 2PP, RTP, PPI, A, C

Plate preparation, processing, proofing, and
edition printing by Betty Fiske

Signed *S. Boxer* and dated in pencil lower
right; numbered lower left; chop mark
lower right; workshop number SB75-219
lower left verso

1 run: ink colors; 1 run from 1 rectangular
copper plate:
 1 variant inking from palette: medium
 yellow, orange, yellow-ocher, vermilion,
 dark red, violet, purple, brown, dark
 brown, Prussian blue, turquoise green,
 medium green, dark green, white, and
 black; methods 6, 9 (BF), 16a; IV

The artist painted each print with
watercolors.

96:SB8

Stanley Boxer
Strangetalkwithfriend, from Ring of Dust
in Bloom 1976

Etching, aquatint, hand-colored (v)
24 × 20 (61 × 50.8)
Paper: white HMP, handmade
Edition: 28
Proofs: 9AP, TP, 2PP, RTP, PPI, A, C

Plate preparation, processing, proofing, and
edition printing by Betty Fiske

Signed *S. Boxer* and dated in pencil lower
right; numbered lower left; chop mark
lower right; workshop number SB75-235
lower left verso

1 run: ink colors; 1 run from 1 circular
copper plate:
 1 variant inking from palette: medium
 yellow, orange, yellow-ocher, vermilion,
 dark red, violet, purple, brown, dark
 brown, Prussian blue, turquoise green,
 medium green, dark green, white, and
 black; methods 6, 9 (BF), 16a; IV

The artist painted each print with
watercolors.

97:SB9

Stanley Boxer
Oddconversationatnoon, from Ring of
Dust in Bloom 1976

Etching, aquatint, hand-colored (v)
20 × 24 (50.8 × 61)
Paper: white HMP, handmade
Edition: 28
Proofs: 9AP, TP, 2PP, RTP, PPI, A, C

Plate preparation, processing, proofing, and
edition printing by Betty Fiske

Signed *S. Boxer* and dated in pencil lower
right; numbered lower left; chop mark
lower right; workshop number SB75-240
lower left verso

1 run: ink colors; 1 run from 1 rectangular
copper plate:
 1 variant inking from palette: medium
 yellow, orange, yellow-ocher, vermilion,
 dark red, violet, purple, brown, dark
 brown, Prussian blue, turquoise green,
 medium green, dark green, white, and
 black; methods 6, 9 (BF), 16a; IV

The artist painted each print with
watercolors.

98:SB10

Stanley Boxer
Amissinamist, from Ring of Dust in
Bloom 1976

Etching, aquatint, hand-colored (v)
20 × 24 (50.8 × 61)
Paper: white HMP, handmade
Edition: 28
Proofs: 9AP, TP, 2PP, RTP, PPI, A, C

Plate preparation, processing, proofing, and
edition printing by Betty Fiske

Signed *S. Boxer* and dated in pencil lower
right; numbered lower left; chop mark
lower right; workshop number SB75-242
lower left verso

1 run: ink colors; 1 run from 1 triangular
copper plate:
 1 variant inking from palette: medium
 yellow, orange, yellow-ocher, vermilion,
 dark red, violet, purple, brown, dark
 brown, Prussian blue, turquoise green,
 medium green, dark green, white, and
 black; methods 6, 9 (BF), 16a; IV

The artist painted each print with
watercolors.

99:SB11

Stanley Boxer
Argumentofnoavail, from Ring of Dust in
Bloom 1976

Etching, aquatint, hand-colored (v)
24 × 20 (61 × 50.8)
Paper: white HMP, handmade
Edition: 28
Proofs: 9AP, TP, 2PP, RTP, PPI, A, C

Plate preparation, processing, proofing, and
edition printing by Betty Fiske

Signed *S. Boxer* and dated in pencil lower
right; numbered lower left; chop mark
lower right; workshop number SB75-237
lower left verso

1 run: ink colors; 1 run from 1 rectangular
copper plate:
 1 variant inking from palette: medium
 yellow, orange, yellow-ocher, vermilion,
 dark red, violet, purple, brown, dark
 brown, Prussian blue, turquoise green,
 medium green, dark green, white, and
 black; methods 6, 9 (BF), 16a; IV

The artist painted each print with
watercolors.

100:SB12

Stanley Boxer
Buddingwithoutpast, from Ring of Dust in Bloom 1976

Etching, aquatint, hand-colored (v)	
20 × 24 (50.8 × 61)	
Paper: white HMP, handmade	
Edition: 28	
Proofs: 9AP, TP, 2PP, RTP, PPI, A, C	

Plate preparation, processing, proofing, and edition printing by Betty Fiske

Signed *S. Boxer* and dated in pencil lower right; numbered lower left; chop mark lower right; workshop number SB75-239 lower left verso

1 run: ink colors; 1 run from 1 oval copper plate:
1 variant inking from palette: medium yellow, orange, yellow-ocher, vermilion, dark red, violet, purple, brown, dark brown, Prussian blue, turquoise green, medium green, dark green, white, and black; methods 6, 9 (BF), 16a; IV

The artist painted each print with watercolors.

101:SB13

Stanley Boxer
Conventionofslydiscussants, from Ring of Dust in Bloom 1976

Etching, aquatint, hand-colored (v)	
24 × 20 (61 × 50.8)	
Paper: white HMP, handmade	
Edition: 28	
Proofs: 9AP, TP, 2PP, RTP, PPI, A, C	

Plate preparation, processing, proofing, and edition printing by Betty Fiske

Signed *S. Boxer* and dated in pencil lower right; numbered lower left; chop mark lower right; workshop number SB75-244 lower left verso

1 run: ink colors; 1 run from 1 arch-shaped copper plate:
1 variant inking from palette: medium yellow, orange, yellow-ocher, vermilion, dark red, violet, purple, brown, dark brown, Prussian blue, turquoise green, medium green, dark green, white, and black; methods 6, 9 (BF), 16a; IV

The artist painted each print with watercolors.

102:SB14

Stanley Boxer
Softwinterseekingwhiteness 1976

Lithograph (1)	
23 × 20 (58.4 × 50.8)	
Paper: gray Rives BFK, mould-made	
Edition: 6	
Proofs: 4AP, TP, PP, RTP, A, C	

Stone preparation, processing, proofing, and edition printing by John Hutcheson

Signed *S. Boxer* and dated in pencil lower right; titled center; numbered lower left; chop mark lower right; workshop number SB76-178 lower left verso

1 run: 1 color; 1 run from 1 stone:
1 black; method 1a; I

103:SB15

Stanley Boxer
Spawnofcloverwithcuriousoccupants
1977

Etching, aquatint (v)

23½ × 24 (59.7 × 61)

Paper: white Amgoumois à la Main,
handmade

Edition: 45

Proofs: 12AP, 2TP, RTP, PPI, A, C

Plate preparation, processing, proofing, and
edition printing by Paul Sanders

Signed *S. Boxer* and dated in pencil lower
right; numbered lower left; chop mark
lower right; workshop number SB77-319
lower left verso

1 run: ink colors; 1 run from 1 clover-
shaped copper plate:
 1 variant inking from palette: medium
 yellow, orange, yellow-ocher, vermilion,
 dark red, violet, purple, brown, dark
 brown, Prussian blue, turquoise green,
 medium green, dark green, white, and
 black; methods 6, 9 (PS), 16a; IV

104:SB16

Stanley Boxer
Cleavedsummerautumnalglance 1977

Etching, aquatint, engraving (v)

23 × 30½ (58.4 × 77.5)

Paper: white Hawthorne of Larroque,
handmade

Edition: 34

Proofs: 12AP, TP, PP, RTP, A

Plate preparation, processing, proofing, and
edition printing by Paul Sanders

Signed *S. Boxer* and dated in pencil lower
right; numbered lower left; chop mark
lower right; workshop number SB77-320
lower left verso

1 run: ink colors; 1 run from 1 assembled
plate made from 3 irregularly shaped
copper plates:
 1 variant inking from palette: medium
 yellow, orange, yellow-ocher, vermilion,
 dark red, violet, purple, brown, dark
 brown, Prussian blue, turquoise green,
 medium green, dark green, white, and
 black; methods 6, 9 (PS), 10, 12, 15b,
 16a; IV

Carnival of Animals

STANLEY BOXER

CARNIVAL OF ANIMALS

A suite of 14 intaglios on colored handmade paper

© Printed and Published by Tyler Graphics Ltd. ©

Stanley Boxer's Carnival of Animals is a portfolio of fourteen intaglio prints on handmade, hand-colored paper, completed in 1979. The artist and Kenneth Tyler worked out a system whereby newly made paper was colored with pulps and dyes, pressed, and printed on before it was dry. First Boxer mixed colored pulps and dyes, then he covered the borders of the newly made white pulp base sheet with a plastic stencil and hand-colored the sheet. After pressing, the sheets were colored with additional dyes and pressed once more. The moist colored paper was then printed on.

The artist created his imagery on copper plates, combining the intaglio techniques of etching, aquatint, engraving, drypoint, soft ground, and lift ground. Boxer also engraved images on Plexiglas plates designed for printing along the borders of the sheets. The artist inked the Plexiglas, choosing from his palette of fifteen colors. Rodney Konopaki finish-wiped the plates, joined them together in a jig on the press bed, and printed the Plexiglas and copper plates simultaneously on the moist colored paper.

The portfolio text was designed by Kenneth Tyler and set in Garamond (title page) and Jansen (colophon page) phototypositor typefaces by Stamford Typesetting Corporation. The letterpress was printed by A. Colish, Inc. Ten sets of prints from the editions of twenty are encased in maroon cloth-covered portfolio boxes and slipcases fabricated by Len Hartnett Archival Products. An etching made especially for the encased portfolio is printed on the title page.

105:SB17

Stanley Boxer
Title page from Carnival of Animals
1979

Etching, engraving, letterpress (2)
23 × 26 (58.4 × 66)
Paper: white TGL, handmade
Edition: 20

Papermaking by Lindsay Green and Lee Funderburg; copper plate preparation, processing, proofing, and edition printing by Rodney Konopaki; zinc letterpress plate printed at A. Colish, Inc.

2 runs: 2 colors; 2 runs from 1 copper and 1 zinc plate:
 1 blue; methods 6, 12; IV
 2 red-brown; commercial letterpress

106:SB18

Stanley Boxer
Introduction, Royal Prance of the Lion, from Carnival of Animals 1979

Etching, engraving (v)
23 × 26 (58.4 × 66)
Paper: white TGL, handmade, hand-colored
Edition: 20
Proofs: 9AP, TP, 5CTP, EP, RTP, PPI, A, C

Papermaking by Lindsay Green and Lee Funderburg; experimental trials and standard proof paper coloring by artist assisted by Kenneth Tyler and Green; paper coloring by artist; copper plate preparation and processing by Rodney Konopaki and Paul Sanders; proofing and edition printing by Konopaki; Plexiglas plate preparation, proofing, and edition printing by Konopaki

Signed *S. Boxer* and dated in pencil lower right; numbered lower left; chop marks of workshop and artist lower right; workshop number SB79-418 lower left verso

3 runs: 2 pulp colors, 2 dye colors, 2 paper pressings; ink colors, 1 run from 1 copper and 1 Plexiglas plate printed simultaneously:
 1 mauve and pale green pulps (on newly made white pulp base sheet); III

2 pale yellow and pale green dyes (on same sheet); III

3 dark brown; methods 6, 8, 12; variant inking from palette: medium yellow, orange, yellow-ocher, vermilion, dark red, violet, purple, brown, dark brown, Prussian blue, turquoise green, medium green, dark green, white, and black; methods 12 (Plexiglas plate), 16a, 15b; IV

Printing took place while the newly made, newly colored paper was still moist.

107:SB19

Stanley Boxer
Chicken and Cock, from Carnival of
Animals 1979

Etching, engraving, drypoint (v)	
23 × 26 (58.4 × 66)	
Paper: white TGL, handmade, hand-colored	
Edition: 20	
Proofs: 9AP, 2TP, CTP, SP, RTP, PPI, A, C	

Papermaking by Lindsay Green and Lee Funderburg; experimental trials and standard proof paper coloring by artist assisted by Kenneth Tyler and Green; paper coloring by artist; copper plate preparation and processing by Rodney Konopaki and Paul Sanders; proofing and edition printing by Konopaki; Plexiglas plate preparation, proofing, and edition printing by Konopaki

Signed *S. Boxer* and dated in pencil lower right; numbered lower left; chop marks of workshop and artist lower right; workshop number SB79-420 lower left verso

3 runs: 6 pulp colors, 2 dye colors, 2 paper pressings; ink colors, 1 run from 1 copper and 1 Plexiglas plate printed simultaneously:

1 light yellow-orange, red-ocher, light blue, light green, light gray, and medium gray pulps (on newly made white pulp base sheet); III

2 yellow and light blue dyes (on same sheet); III

3 red-brown; methods 6, 12, 13; variant inking from palette: medium yellow, orange, yellow-ocher, vermilion, dark red, violet, purple, brown, dark brown, Prussian blue, turquoise green, medium green, dark green, white, and black; methods 12 (Plexiglas plate), 16a, 15b; IV

Printing took place while the newly made, newly colored paper was still moist.

108:SB20

Stanley Boxer
Jackass Free, from Carnival of Animals
1979

Etching, engraving, drypoint (v)
23 × 26 (58.4 × 66)
Paper: white TGL, handmade,
hand-colored
Edition: 20
Proofs: 9AP, 3CTP, RTP, PPI, A, C

Papermaking by Lindsay Green and Lee
Funderburg; experimental trials and stan-
dard proof paper coloring by artist assisted
by Kenneth Tyler and Green; paper coloring
by artist; copper plate preparation and
processing by Rodney Konopaki and Paul
Sanders; proofing and edition printing by
Konopaki; Plexiglas plate preparation,
proofing, and edition printing by Konopaki

Signed *S. Boxer* and dated in pencil lower
right; numbered lower left; chop marks of
workshop and artist lower right; workshop
number SB79-422 lower left verso

3 runs: 3 pulp colors, 1 dye color, 2 paper
pressings; ink colors, 1 run from 1 copper
and 1 Plexiglas plate printed simultaneously:
1 brown, gray-brown, and blue-green
 pulps (on newly made white pulp base
 sheet); III
2 yellow dye (on same sheet); III
3 green-brown; methods 6, 8, 12, 13;
 variant inking from palette: medium
 yellow, orange, yellow-ocher, vermilion,
 dark red, violet, purple, brown, dark
 brown, Prussian blue, turquoise green,
 medium green, dark green, white, and
 black; methods 12 (Plexiglas plate),
 16a, 15b; IV

Printing took place while the newly made,
newly colored paper was still moist.

109:SB21

Stanley Boxer
Turtle, from Carnival of Animals 1979

Etching, aquatint, engraving, drypoint (v)
23 × 26 (58.4 × 66)
Paper: white TGL, handmade,
hand-colored
Edition: 20
Proofs: 9AP, 3CTP, RTP, PPI, A, C

Papermaking by Lindsay Green and Lee
Funderburg; experimental trials and stan-
dard proof paper coloring by artist assisted
by Kenneth Tyler and Green; paper coloring
by artist; copper plate preparation and
processing by Rodney Konopaki and Paul
Sanders; proofing and edition printing by
Konopaki; Plexiglas plate preparation,
proofing, and edition printing by Konopaki

Signed *S. Boxer* and dated in pencil lower
right; numbered lower left; chop marks of
workshop and artist lower right; workshop
number SB79-415 lower left verso

3 runs: 3 pulp colors, 1 dye color, 2 paper pressings; ink colors, 1 run from 1 copper and 1 Plexiglas plate printed simultaneously:

1 yellow, gray-violet, and blue pulps (on newly made white pulp base sheet); III
2 yellow dye (on same sheet); III
3 dark purple; methods 6, 7, 9 (RK), 10, 12, 13; variant inking from palette: medium yellow, orange, yellow-ocher, vermilion, dark red, violet, purple, brown, dark brown, Prussian blue, turquoise green, medium green, dark green, white, and black; methods 12 (Plexiglas plate), 16a, 15b; IV

Printing took place while the newly made, newly colored paper was still moist.

110:SB22

Stanley Boxer
Elephants, from Carnival of Animals
1979

Etching, aquatint, engraving (v)	
23 × 26 (58.4 × 66)	
Paper: white TGL, handmade, hand-colored	
Edition: 20	
Proofs: 9AP, TP, CTP, RTP, PPI, A, C	

Papermaking by Lindsay Green and Lee Funderburg; experimental trials and standard proof paper coloring by artist assisted by Kenneth Tyler and Green; paper coloring by artist; copper plate preparation and processing by Rodney Konopaki and Paul Sanders; proofing and edition printing by Konopaki; Plexiglas plate preparation, proofing, and edition printing by Konopaki

Signed *S. Boxer* and dated in pencil lower right; numbered lower left; chop marks of workshop and artist lower right; workshop number SB79-413 lower left verso

3 runs: 3 pulp colors, 2 dye colors, 2 paper pressings; ink colors, 1 run from 1 copper and 1 Plexiglas plate printed simultaneously:

1 yellow-orange, blue, and light gray pulps (on newly made white pulp base sheet); III
2 yellow and light gray dyes (on same sheet); III
3 black; methods 6, 9 (PS), 10; variant inking from palette: medium yellow, orange, yellow-ocher, vermilion, dark red, violet, purple, brown, dark brown, Prussian blue, turquoise green, medium green, dark green, white, and black; methods 12 (Plexiglas plate), 16a, 15b; IV

Printing took place while the newly made, newly colored paper was still moist.

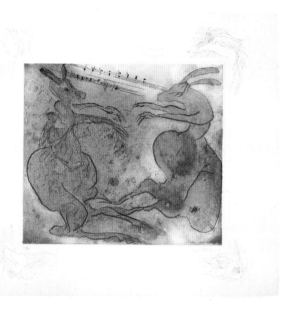

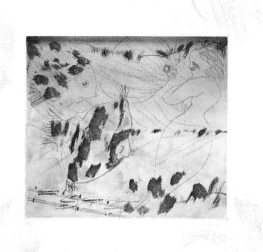

111:SB23

Stanley Boxer
Kangaroos, from Carnival of Animals
1979

Etching, aquatint, engraving (v)
23 × 26 (58.4 × 66)
Paper: white TGL, handmade,
hand-colored
Edition: 20
Proofs: 9AP, 4CTP, 2EP, RTP, PPI, A, C

Papermaking by Lindsay Green and Lee
Funderburg; experimental trials and stan-
dard proof paper coloring by artist assisted
by Kenneth Tyler and Green; paper coloring
by artist; copper plate preparation and
processing by Rodney Konopaki and Paul
Sanders; proofing and edition printing by
Konopaki; Plexiglas plate preparation,
proofing, and edition printing by Konopaki

Signed *S. Boxer* and dated in pencil lower
right; numbered lower left; chop marks of
workshop and artist lower right; workshop
number SB79-414 lower left verso

3 runs: 3 pulp colors, 1 dye color, 2 paper
pressings; ink colors, 1 run from 1 copper
and 1 Plexiglas plate printed simultaneously:
1 pale yellow, pink, and light green pulps
 (on newly made white pulp base sheet);
 III
2 yellow dye (on same sheet); III
3 brown-red; methods 6, 7, 8, 9 (RK),
 10, 12; variant inking from palette:
 medium yellow, orange, yellow-ocher,
 vermilion, dark red, violet, purple,
 brown, dark brown, Prussian blue,
 turquoise green, medium green, dark
 green, white, and black; methods 12
 (Plexiglas plate), 16a, 15b; IV

Printing took place while the newly made,
newly colored paper was still moist.

112:SB24

Stanley Boxer
Aquarium, from Carnival of Animals
1979

Etching, aquatint, engraving (v)
23 × 26 (58.4 × 66)
Paper: white TGL, handmade,
hand-colored
Edition: 20
Proofs: 9AP, TP, 3CTP, RTP, PPI, A, C

Papermaking by Lindsay Green and Lee
Funderburg; experimental trials and stan-
dard proof paper coloring by artist assisted
by Kenneth Tyler and Green; paper coloring
by artist; copper plate preparation and
processing by Rodney Konopaki and Paul
Sanders; proofing and edition printing by
Konopaki; Plexiglas plate preparation,
proofing, and edition printing by Konopaki

Signed *S. Boxer* and dated in pencil lower
right; numbered lower left; chop marks of
workshop and artist lower right; workshop
number SB79-417 lower left verso

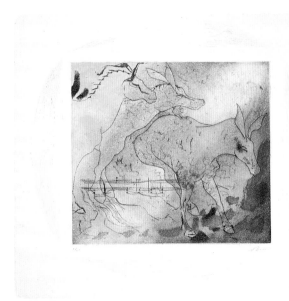

3 runs: 2 pulp colors, 2 dye colors, 2 paper pressings; ink colors, 1 run from 1 copper and 1 Plexiglas plate printed simultaneously:

1 violet and green pulps (on newly made white pulp base sheet); III

2 pink and gray dyes (on same sheet); III

3 medium green; methods 6, 7, 9 (PS), 10, 12; variant inking from palette: medium yellow, orange, yellow-ocher, vermilion, dark red, violet, purple, brown, dark brown, Prussian blue, turquoise green, medium green, dark green, white, and black; methods 12 (Plexiglas plate), 16a, 15b; IV

Printing took place while the newly made, newly colored paper was still moist.

113:SB25

Stanley Boxer
Personages with Long Ears, from Carnival of Animals 1979

Etching, aquatint, engraving (v)	
23 × 26 (58.4 × 66)	
Paper: white TGL, handmade, hand-colored	
Edition: 20	
Proofs: 9AP, CTP, RTP, PPI, A, C	

Papermaking by Lindsay Green and Lee Funderburg; experimental trials and standard proof paper coloring by artist assisted by Kenneth Tyler and Green; paper coloring by artist; copper plate preparation and processing by Rodney Konopaki and Paul Sanders; proofing and edition printing by Konopaki; Plexiglas plate preparation, proofing, and edition printing by Konopaki

Signed *S. Boxer* and dated in pencil lower right; numbered lower left; chop marks of workshop and artist lower right; workshop number SB79-412 lower left verso

3 runs: 4 pulp colors, 1 dye color, 2 paper pressings; ink colors, 1 run from 1 copper and 1 Plexiglas plate printed simultaneously:

1 light yellow-orange, light orange, violet, and yellow-green pulps (on newly made white pulp base sheet); III

2 yellow dye (on same sheet); III

3 dark gray; methods 6, 7, 8, 9 (RK), 12; variant inking from palette: medium yellow, orange, yellow-ocher, vermilion, dark red, violet, purple, brown, dark brown, Prussian blue, turquoise green, medium green, dark green, white, and black; methods 12 (Plexiglas plate), 16a, 15b; IV

Printing took place while the newly made, newly colored paper was still moist.

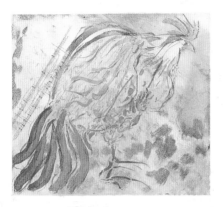

114:SB26

Stanley Boxer
Cockatoo in the Depth of the Woods, from
Carnival of Animals 1979

Etching, aquatint, engraving (v)
23 × 26 (58.4 × 66)
Paper: white TGL, handmade,
hand-colored
Edition: 20
Proofs: 9AP, TP, RTP, PPI, A, C

Papermaking by Lindsay Green and Lee
Funderburg; experimental trials and stan-
dard proof paper coloring by artist assisted
by Kenneth Tyler and Green; paper coloring
by artist; copper plate preparation and
processing by Rodney Konopaki and Paul
Sanders; proofing and edition printing by
Konopaki; Plexiglas plate preparation,
proofing, and edition printing by Konopaki

Signed *S. Boxer* and dated in pencil lower
right; numbered lower left; chop marks of
workshop and artist lower right; workshop
number SB79-416 lower left verso

3 runs: 3 pulp colors, 1 dye color, 2 paper
pressings; ink colors, 1 run from 1 copper
and 1 Plexiglas plate printed simultaneously:
 1 yellow, pink, and green pulps (on newly
 made white pulp base sheet); III
 2 yellow dye (on same sheet); III
 3 brown-red; methods 6, 7, 9 (RK), 12;
 variant inking from palette: medium
 yellow, orange, yellow-ocher, vermilion,
 dark red, violet, purple, brown, dark
 brown, Prussian blue, turquoise green,
 medium green, dark green, white, and
 black; methods 12 (Plexiglas plate),
 16a, 15b; IV

Printing took place while the newly made,
newly colored paper was still moist.

115:SB27

Stanley Boxer
Birds Soaring, from Carnival of Animals
1979

Etching, aquatint, engraving (v)
23 × 26 (58.4 × 66)
Paper: white TGL, handmade,
hand-colored
Edition: 20
Proofs: 9AP, 2CTP, RTP, PPI, A, C

Papermaking by Lindsay Green and Lee
Funderburg; experimental trials and stan-
dard proof paper coloring by artist assisted
by Kenneth Tyler and Green; paper coloring
by artist; copper plate preparation and
processing by Rodney Konopaki and Paul
Sanders; proofing and edition printing by
Konopaki; Plexiglas plate preparation,
proofing, and edition printing by Konopaki

Signed *S. Boxer* and dated in pencil lower
right; numbered lower left; chop marks of
workshop and artist lower right; workshop
number SB79-421 lower left verso

3 runs: 3 pulp colors, 2 dye colors, 2 paper pressings; ink colors, 1 run from 1 copper and 1 Plexiglas plate printed simultaneously:

1 light violet, light purple, and light blue pulps (on newly made white pulp base sheet); III

2 yellow and light blue dyes (on same sheet); III

3 cobalt blue; methods 6, 7, 9 (PS), 10, 12; variant inking from palette: medium yellow, orange, yellow-ocher, vermilion, dark red, violet, purple, brown, dark brown, Prussian blue, turquoise green, medium green, dark green, white, and black; methods 12 (Plexiglas plate), 16a, 15b; IV

Printing took place while the newly made, newly colored paper was still moist.

116:SB28

Stanley Boxer
Pianist, from Carnival of Animals 1979

Etching, aquatint, engraving, drypoint (v)

23 × 26 (58.4 × 66)

Paper: white TGL, handmade, hand-colored

Edition: 20

Proofs: 9AP, RTP, PPI, A, C

Papermaking by Lindsay Green and Lee Funderburg; experimental trials and standard proof paper coloring by artist assisted by Kenneth Tyler and Green; paper coloring by artist; copper plate preparation and processing by Rodney Konopaki and Paul Sanders; proofing and edition printing by Konopaki; Plexiglas plate preparation, proofing, and edition printing by Konopaki

Signed *S. Boxer* and dated in pencil lower right; numbered lower left; chop marks of workshop and artist lower right; workshop number SB79-419 lower left verso

3 runs: 2 pulp colors, 3 dye colors, 2 paper pressings; ink colors, 1 run from 1 copper and 1 Plexiglas plate printed simultaneously:

1 yellow-orange and blue-green pulps (on newly made white pulp base sheet); III

2 yellow, blue, and green dyes (on same sheet); III

3 black; methods 6, 7, 9 (PS), 10, 12, 13; variant inking from palette: medium yellow, orange, yellow-ocher, vermilion, dark red, violet, purple, brown, dark brown, Prussian blue, turquoise green, medium green, dark green, white, and black; methods 12 (Plexiglas plate), 16a, 15b; IV

Printing took place while the newly made, newly colored paper was still moist.

117:SB29

Stanley Boxer
Fossils, from Carnival of Animals 1979

Etching, aquatint, engraving, drypoint (v)
23 × 26 (58.4 × 66)
Paper: white TGL, handmade,
hand-colored
Edition: 20
Proofs: 9AP, 2TP, RTP, PPI, A, C

Papermaking by Lindsay Green and Lee
Funderburg; experimental trials and stan-
dard proof paper coloring by artist assisted
by Kenneth Tyler and Green; paper coloring
by artist; copper plate preparation and
processing by Rodney Konopaki and Paul
Sanders; proofing and edition printing by
Konopaki; Plexiglas plate preparation,
proofing, and edition printing by Konopaki

Signed *S. Boxer* and dated in pencil lower
right; numbered lower left; chop marks of
workshop and artist lower right; workshop
number SB79-423 lower left verso

3 runs: 3 pulp colors, 2 dye colors, 2 paper
pressings; ink colors, 1 run from 1 copper
and 1 Plexiglas plate printed simultaneously:
1 yellow-orange, pink, and blue-green
 pulps (on newly made white pulp base
 sheet); III
2 yellow and pink dyes (on same sheet);
 III
3 brown-green; methods 6, 7, 9 (PS), 10,
 12, 13; variant inking from palette:
 medium yellow, orange, yellow-ocher,
 vermilion, dark red, violet, purple,
 brown, dark brown, Prussian blue,
 turquoise green, medium green, dark
 green, white, and black; methods 12
 (Plexiglas plate), 16a, 15b; IV

Printing took place while the newly made,
newly colored paper was still moist.

118:SB30

Stanley Boxer
Swan, from Carnival of Animals 1979

Etching, aquatint, engraving (v)
23 × 26 (58.4 × 66)
Paper: white TGL, handmade,
hand-colored
Edition: 20
Proofs: 9AP, TP, RTP, PPI, A, C

Papermaking by Lindsay Green and Lee
Funderburg; experimental trials and stan-
dard proof paper coloring by artist assisted
by Kenneth Tyler and Green; paper coloring
by artist; copper plate preparation and
processing by Rodney Konopaki and Paul
Sanders; proofing and edition printing by
Konopaki; Plexiglas plate preparation,
proofing, and edition printing by Konopaki

Signed *S. Boxer* and dated in pencil lower
right; numbered lower left; chop marks of
workshop and artist lower right; workshop
number SB79-424 lower left verso

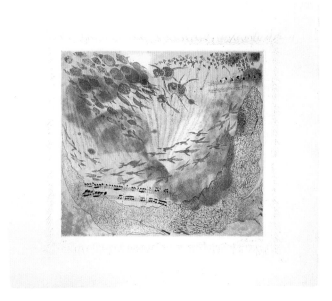

3 runs: 4 pulp colors, 2 dye colors, 2 paper pressings; ink colors, 1 run from 1 copper and 1 Plexiglas plate printed simultaneously:

1 yellow-orange, pink, light blue, and green pulps (on newly made white pulp base sheet); III

2 light blue and light green dyes (on same sheet); III

3 Prussian blue; methods 6, 7, 8, 9 (RK), 12; variant inking from palette: medium yellow, orange, yellow-ocher, vermilion, dark red, violet, purple, brown, dark brown, Prussian blue, turquoise green, medium green, dark green, white, and black; methods 12 (Plexiglas plate), 16a, 15b; IV

Printing took place while the newly made, newly colored paper was still moist.

119:SB31

Stanley Boxer
Finale, from Carnival of Animals 1979

Etching, aquatint, engraving, drypoint (v)	
23 × 26 (58.4 × 66)	
Paper: white TGL, handmade, hand-colored	
Edition: 20	
Proofs: 9AP, TP, RTP, PPI, A, C	

Papermaking by Lindsay Green and Lee Funderburg; experimental trials and standard proof paper coloring by artist assisted by Kenneth Tyler and Green; paper coloring by artist; copper plate preparation and processing by Rodney Konopaki and Paul Sanders; proofing and edition printing by Konopaki; Plexiglas plate preparation, proofing, and edition printing by Konopaki

Signed *S. Boxer* and dated in pencil lower right; numbered lower left; chop marks of workshop and artist lower right; workshop number SB79-425 lower left verso

3 runs: 2 pulp colors, 2 dye colors, 2 paper pressings; ink colors, 1 run from 1 copper and 1 Plexiglas plate printed simultaneously:

1 pink and blue pulps (on newly made white pulp base sheet); III

2 yellow and blue-green dyes (on same sheet); III

3 thalo green; methods 6, 7, 9 (RK), 10, 12, 13; variant inking from palette: medium yellow, orange, yellow-ocher, vermilion, dark red, violet, purple, brown, dark brown, Prussian blue, turquoise green, medium green, dark green, white, and black; methods 12 (Plexiglas plate), 16a, 15b; IV

Printing took place while the newly made, newly colored paper was still moist.

 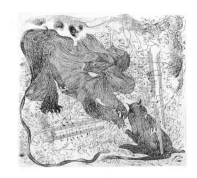 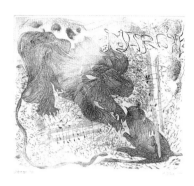

120:SB32

Stanley Boxer
Introduction, Royal Prance of the Lion,
State I, from Carnival of Animals 1979

Etching (1)
19½ × 21½ (49.5 × 54.6)
Paper: white Dutch Etching, mould-made
Edition: 1

Plate preparation and processing by Rodney
Konopaki and Paul Sanders; proofing and
edition printing by Konopaki

Signed *S. Boxer* and dated in pencil lower
right; numbered and titled (*State I*) lower
left; chop mark lower right; workshop
number SB79-418A lower left verso

1 run: 1 color; 1 run from 1 copper plate:
 1 black; method 6; IV

121:SB33

Stanley Boxer
Introduction, Royal Prance of the Lion,
State II, from Carnival of Animals 1979

Etching, engraving (v)
19½ × 21½ (49.5 × 54.6)
Paper: white Dutch Etching, mould-made
Edition: 2

Plate preparation and processing by Rodney
Konopaki and Paul Sanders; proofing and
edition printing by Konopaki

Signed *S. Boxer* and dated in pencil lower
right; numbered and titled (*State II*) lower
left; chop mark lower right; workshop
number SB79-418B lower left verso

1/2 impression: 1 run: 1 color; 1 run from
1 copper plate:
 1 black; methods 6, 12; IV

2/2 impression: 1 run: ink colors; 1 run
from 1 copper plate:
 1 variant inking from palette: medium
 yellow, orange, yellow-ocher, vermilion,
 dark red, violet, purple, brown, dark
 brown, Prussian blue, turquoise green,
 medium green, dark green, white, and
 black; methods 6, 12, 16a; IV

122:SB34

Stanley Boxer
Introduction, Royal Prance of the Lion,
State III, from Carnival of Animals 1979

Etching, engraving (v)
19½ × 21½ (49.5 × 54.6)
Paper: white Dutch Etching, mould-made
Edition: 6

Plate preparation and processing by Rodney
Konopaki and Paul Sanders; proofing and
edition printing by Konopaki

Signed *S. Boxer* and dated in pencil lower
right; numbered and titled (*State III*) lower
left; chop mark lower right; workshop
number SB79-418C lower left verso

1/6–5/6 impressions: 1 run: 1 color; 1 run
from 1 copper plate:
 1 black; methods 6, 8, 12; IV

6/6 impression: 1 run: ink colors; 1 run
from 1 copper plate:
 1 variant inking from palette: medium
 yellow, orange, yellow-ocher, vermilion,
 dark red, violet, purple, brown, dark
 brown, Prussian blue, turquoise green,
 medium green, dark green, white, and
 black; methods 6, 8, 12, 16a; IV

123:SB35

Stanley Boxer
Chicken and Cock, State I, from Carnival
of Animals 1979

Etching (1)
19½ × 21½ (49.5 × 54.6)
Paper: white Dutch Etching, mould-made
Edition: 5

Plate preparation and processing by Rodney
Konopaki and Paul Sanders; proofing and
edition printing by Konopaki

Signed *S. Boxer* and dated in pencil lower
right; numbered and titled (*State I*) lower
left; chop mark lower right; workshop
number SB79-420A lower left verso

1 run: 1 color; 1 run from 1 copper plate:
 1 black; method 6; IV

124:SB36

Stanley Boxer
Chicken and Cock, State II, from Carnival
of Animals 1979

Etching (1)
19½ × 21½ (49.5 × 54.6)
Paper: white Dutch Etching, mould-made
Edition: 5

Plate preparation and processing by Rodney
Konopaki and Paul Sanders; proofing and
edition printing by Konopaki

Signed *S. Boxer* and dated in pencil lower
right; numbered and titled (*State II*) lower
left; chop mark lower right; workshop
number SB79-420B lower left verso

1 run: 1 color; 1 run from 1 copper plate:
 1 black; method 6; IV

125:SB37

Stanley Boxer
Chicken and Cock, State III, from Carnival
of Animals 1979

Etching, engraving (1)
19½ × 21½ (49.5 × 54.6)
Paper: white Dutch Etching, mould-made
Edition: 6

Plate preparation and processing by Rodney
Konopaki and Paul Sanders; proofing and
edition printing by Konopaki

Signed *S. Boxer* and dated in pencil lower
right; numbered and titled (*State III*) lower
left; chop mark lower right; workshop
number SB79-420C lower left verso

1 run: 1 color; 1 run from 1 copper plate:
 1 black; methods 6, 12; IV

126:SB38

Stanley Boxer
Jackass Free, State I, from Carnival of
Animals 1979

Etching (1)
19½ × 21½ (49.5 × 54.6)
Paper: white Dutch Etching, mould-made
Edition: 6

Plate preparation and processing by Rodney
Konopaki and Paul Sanders; proofing and
edition printing by Konopaki

Signed *S. Boxer* and dated in pencil lower
right; numbered and titled (*State I*) lower
left; chop mark lower right; workshop
number SB79-422A lower left verso

1 run: 1 color; 1 run from 1 copper plate:
 1 black; method 6; IV

127:SB39

Stanley Boxer
Jackass Free, State II, from Carnival of
Animals 1979

Etching (1)
19½ × 21½ (49.5 × 54.6)
Paper: white Dutch Etching, mould-made
Edition: 5

Plate preparation and processing by Rodney
Konopaki and Paul Sanders; proofing and
edition printing by Konopaki

Signed *S. Boxer* and dated in pencil lower
right; numbered and titled (*State II*) lower
left; chop mark lower right; workshop
number SB79-422B lower left verso

1 run: 1 color; 1 run from 1 copper plate:
 1 black; method 6; IV

128:SB40

Stanley Boxer
Turtle, State I, from Carnival of Animals
1979

Etching (1)
19½ × 21½ (49.5 × 54.6)
Paper: white Dutch Etching, mould-made
Edition: 7

Plate preparation and processing by Rodney
Konopaki and Paul Sanders; proofing and
edition printing by Konopaki

Signed *S. Boxer* and dated in pencil lower
right; numbered and titled (*State I*) lower
left; chop mark lower right; workshop
number SB79-415A lower left verso

1 run: 1 color; 1 run from 1 copper plate:
 1 black; method 6; IV

129:SB41

Stanley Boxer
Turtle, State II, from Carnival of Animals
1979

Etching, aquatint (1)
19½ × 21½ (49.5 × 54.6)
Paper: white Dutch Etching, mould-made
Edition: 4

Plate preparation and processing by Rodney Konopaki and Paul Sanders; proofing and edition printing by Konopaki

Signed *S. Boxer* and dated in pencil lower right; numbered and titled (*State II*) lower left; chop mark lower right; workshop number SB79-415B lower left verso

1 run: 1 color; 1 run from 1 copper plate: 1 black; methods 6, 7, 9 (RK); IV

130:SB42

Stanley Boxer
Turtle, State III, from Carnival of Animals
1979

Etching, aquatint (1)
19½ × 21½ (49.5 × 54.6)
Paper: white Dutch Etching, mould-made
Edition: 2

Plate preparation and processing by Rodney Konopaki and Paul Sanders; proofing and edition printing by Konopaki

Signed *S. Boxer* and dated in pencil lower right; numbered and titled (*State III*) lower left; chop mark lower right; workshop number SB79-415C lower left verso

1 run: 1 color; 1 run from 1 copper plate: 1 black; methods 6, 7, 9 (RK), 10; IV

131:SB43

Stanley Boxer
Elephants, State I, from Carnival of Animals 1979

Etching (1)
19½ × 21½ (49.5 × 54.6)
Paper: white Dutch Etching, mould-made
Edition: 5

Plate preparation and processing by Rodney Konopaki and Paul Sanders; proofing and edition printing by Konopaki

Signed *S. Boxer* and dated in pencil lower right; numbered and titled (*State I*) lower left; chop mark lower right; workshop number SB79-413A lower left verso

1 run: 1 color; 1 run from 1 copper plate: 1 black; method 6; IV

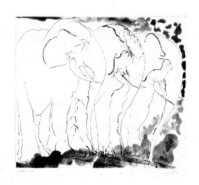

132:SB44

Stanley Boxer
Elephants, State II, from Carnival of
Animals 1979

Etching, aquatint (1)
19½ × 21½ (49.5 × 54.6)
Paper: white Dutch Etching, mould-made
Edition: 7

Plate preparation and processing by Rodney
Konopaki and Paul Sanders; proofing and
edition printing by Konopaki

Signed *S. Boxer* and dated in pencil lower
right; numbered and titled (*State II*) lower
left; chop mark lower right; workshop
number SB79-413B lower left verso

1 run: 1 color; 1 run from 1 copper plate:
 1 black; methods 6, 9 (PS), 10; IV

133:SB45

Stanley Boxer
Kangaroos, State I, from Carnival of
Animals 1979

Etching (1)
19½ × 21½ (49.5 × 54.6)
Paper: white Dutch Etching, mould-made
Edition: 1

Plate preparation and processing by Rodney
Konopaki and Paul Sanders; proofing and
edition printing by Konopaki

Signed *S. Boxer* and dated in pencil lower
right; numbered and titled (*State I*) lower
left; chop mark lower right; workshop
number SB79-414A lower left verso

1 run: 1 color; 1 run from 1 copper plate:
 1 black; method 6; IV

134:SB46

Stanley Boxer
Kangaroos, State II, from Carnival of
Animals 1979

Etching, aquatint (1)
19½ × 21½ (49.5 × 54.6)
Paper: white Dutch Etching, mould-made
Edition: 1

Plate preparation and processing by Rodney
Konopaki and Paul Sanders; proofing and
edition printing by Konopaki

Signed *S. Boxer* and dated in pencil lower
right; numbered and titled (*State II*) lower
left; chop mark lower right; workshop
number SB79-414B lower left verso

1 run: 1 color; 1 run from 1 copper plate:
 1 black; methods 6, 9 (RK); IV

135:SB47

Stanley Boxer
Kangaroos, State III, from Carnival of
Animals 1979

Etching, aquatint, engraving (1)
19½ × 21½ (49.5 × 54.6)
Paper: white Dutch Etching, mould-made
Edition: 5

Plate preparation and processing by Rodney
Konopaki and Paul Sanders; proofing and
edition printing by Konopaki

Signed *S. Boxer* and dated in pencil lower
right; numbered and titled (*State III*) lower
left; chop mark lower right; workshop
number SB79-414C lower left verso

1 run: 1 color; 1 run from 1 copper plate:
 1 black; methods 6, 8, 9 (RK), 10, 12; IV

136:SB48

Stanley Boxer
Aquarium, State I, from Carnival of
Animals 1979

Etching, aquatint (1)
19½ × 21½ (49.5 × 54.6)
Paper: white Dutch Etching, mould-made
Edition: 7

Plate preparation and processing by Rodney
Konopaki and Paul Sanders; proofing and
edition printing by Konopaki

Signed *S. Boxer* and dated in pencil lower
right; numbered and titled (*State I*) lower
left; chop mark lower right; workshop
number SB79-417A lower left verso

1 run: 1 color; 1 run from 1 copper plate:
 1 black; methods 6, 7, 9 (PS); IV

137:SB49

Stanley Boxer
Aquarium, State II, from Carnival of
Animals 1979

Etching, aquatint (1)
19½ × 21½ (49.5 × 54.6)
Paper: white Dutch Etching, mould-made
Edition: 5

Plate preparation and processing by Rodney
Konopaki and Paul Sanders; proofing and
edition printing by Konopaki

Signed *S. Boxer* and dated in pencil lower
right; numbered and titled (*State II*) lower
left; chop mark lower right; workshop
number SB79-417B lower left verso

1 run: 1 color; 1 run from 1 copper plate:
 1 black; methods 6, 7, 9 (PS), 10; IV

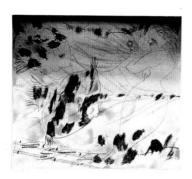

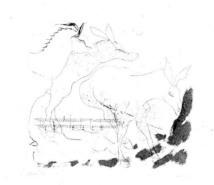

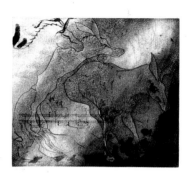

138:SB50

Stanley Boxer
Aquarium, State III, from Carnival of
Animals 1979

Etching, aquatint, engraving (1)
19½ × 21½ (49.5 × 54.6)
Paper: white Dutch Etching, mould-made
Edition: 1

Plate preparation and processing by Rodney
Konopaki and Paul Sanders; proofing and
edition printing by Konopaki

Signed *S. Boxer* and dated in pencil lower
right; numbered and titled (*State III*) lower
left; chop mark lower right; workshop
number SB79-417C lower left verso

1 run: 1 color; 1 run from 1 copper plate:
 1 black; methods 6, 9 (PS), 12; IV

139:SB51

Stanley Boxer
Personages with Long Ears, State I, from
Carnival of Animals 1979

Etching, aquatint (1)
19½ × 21½ (49.5 × 54.6)
Paper: white Dutch Etching, mould-made
Edition: 6

Plate preparation and processing by Rodney
Konopaki and Paul Sanders; proofing and
edition printing by Konopaki

Signed *S. Boxer* and dated in pencil lower
right; numbered and titled (*State I*) lower
left; chop mark lower right; workshop
number SB79-412A lower left verso

1 run: 1 color; 1 run from 1 copper plate:
 1 black; methods 6, 7, 9 (RK); IV

140:SB52

Stanley Boxer
Personages with Long Ears, State II, from
Carnival of Animals 1979

Etching, aquatint, engraving (1)
19½ × 21½ (49.5 × 54.6)
Paper: white Dutch Etching, mould-made
Edition: 6

Plate preparation and processing by Rodney
Konopaki and Paul Sanders; proofing and
edition printing by Konopaki

Signed *S. Boxer* and dated in pencil lower
right; numbered and titled (*State II*) lower
left; chop mark lower right; workshop
number SB79-412B lower left verso

1 run: 1 color; 1 run from 1 copper plate:
 1 green-black; methods 6, 7, 8, 9 (RK),
 12; IV

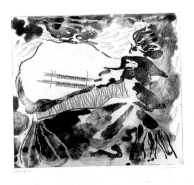

141:SB53

Stanley Boxer
Cockatoo in the Depth of the Woods, State I, from Carnival of Animals 1979

Etching, aquatint (1)
19½ × 21½ (49.5 × 54.6)
Paper: white Dutch Etching, mould-made
Edition: 6

Plate preparation and processing by Rodney Konopaki and Paul Sanders; proofing and edition printing by Konopaki

Signed *S. Boxer* and dated in pencil lower right; numbered and titled (*State I*) lower left; chop mark lower right; workshop number SB79-416A lower left verso

1 run: 1 color; 1 run from 1 copper plate: 1 black; methods 6, 7, 9 (RK); IV

142:SB54

Stanley Boxer
Birds Soaring, State I, from Carnival of Animals 1979

Etching, aquatint (1)
19½ × 21½ (49.5 × 54.6)
Paper: white Dutch Etching, mould-made
Edition: 6

Plate preparation and processing by Rodney Konopaki and Paul Sanders; proofing and edition printing by Konopaki

Signed *S. Boxer* and dated in pencil lower right; numbered and titled (*State I*) lower left; chop mark lower right; workshop number SB79-421A lower left verso

1 run: 1 color; 1 run from 1 copper plate: 1 black; methods 6, 7, 9 (PS); IV

143:SB55

Stanley Boxer
Pianist, State I, from Carnival of Animals 1979

Etching, aquatint, engraving (1)
19½ × 21½ (49.5 × 54.6)
Paper: white Dutch Etching, mould-made
Edition: 7

Plate preparation and processing by Rodney Konopaki and Paul Sanders; proofing and edition printing by Konopaki

Signed *S. Boxer* and dated in pencil lower right; numbered and titled (*State I*) lower left; chop mark lower right; workshop number SB79-419A lower left verso

1 run: 1 color; 1 run from 1 copper plate: 1 black; methods 6, 7, 9 (PS), 10, 12; IV

144:SB56

Stanley Boxer
Fossils, State I, from Carnival of Animals
1979

Etching, aquatint, engraving, drypoint (1)
19½ × 21½ (49.5 × 54.6)
Paper: white Dutch Etching, mould-made
Edition: 7

Plate preparation and processing by Rodney
Konopaki and Paul Sanders; proofing and
edition printing by Konopaki

Signed *S. Boxer* and dated in pencil lower
right; numbered and titled (*State I*) lower
left; chop mark lower right; workshop
number SB79-423A lower left verso

1 run: 1 color; 1 run from 1 copper plate:
 1 black; methods 6, 8, 7, 9 (PS), 10, 12,
 13; IV

145:SB57

Stanley Boxer
Swan, State I, from Carnival of Animals
1979

Etching (1)
19½ × 21½ (49.5 × 54.6)
Paper: white Dutch Etching, mould-made
Edition: 6

Plate preparation and processing by Rodney
Konopaki and Paul Sanders; proofing and
edition printing by Konopaki

Signed *S. Boxer* and dated in pencil lower
right; numbered and titled (*State I*) lower
left; chop mark lower right; workshop
number SB79-424A lower left verso

1 run: 1 color; 1 run from 1 copper plate:
 1 black; methods 6, 8; IV

146:SB58

Stanley Boxer
Swan, State II, from Carnival of Animals
1979

Etching, engraving (1)
19½ × 21½ (49.5 × 54.6)
Paper: white Dutch Etching, mould-made
Edition: 1

Plate preparation and processing by Rodney
Konopaki and Paul Sanders; proofing and
edition printing by Konopaki

Signed *S. Boxer* and dated in pencil lower
right; numbered and titled (*State II*) lower
left; chop mark lower right; workshop
number SB79-424B lower left verso

1 run: 1 color; 1 run from 1 copper plate:
 1 black; methods 6, 12; IV

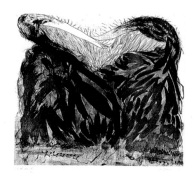

147:SB59

Stanley Boxer
Swan, State III, from Carnival of Animals
1979

Etching, aquatint, engraving (1)
19½ × 21½ (49.5 × 54.6)
Paper: white Dutch Etching, mould-made
Edition: 1

Plate preparation and processing by Rodney
Konopaki and Paul Sanders; proofing and
edition printing by Konopaki

Signed *S. Boxer* and dated in pencil lower
right; numbered and titled (*State III*) lower
left; chop mark lower right; workshop
number SB79-424C lower left verso

1 run: 1 color; 1 run from 1 copper plate:
 1 black; methods 6, 9 (RK), 12; IV

148:SB60

Stanley Boxer
Finale, State I, from Carnival of Animals
1979

Etching, aquatint, engraving (1)
19½ × 21½ (49.5 × 54.6)
Paper: white Dutch Etching, mould-made
Edition: 5

Plate preparation and processing by Rodney
Konopaki and Paul Sanders; proofing and
edition printing by Konopaki

Signed *S. Boxer* and dated in pencil lower
right; numbered and titled (*State I*) lower
left; chop mark lower right; workshop
number SB79-425A lower left verso

1 run: 1 color; 1 run from 1 copper plate:
 1 black; methods 6, 7, 9 (RK), 8, 12; IV

#61. *Auberge* 1982
See 152:AC56

Anthony Caro

1924 Born in New Malden, London

1937–42 Attends Charterhouse School, Goldaming in Surrey; apprentices with the sculptor Charles Wheeler during school vacations

1942–44 Attends Christ College in Cambridge; obtains M.S. in engineering; continues studies in sculpture; models portrait busts from life

1944–46 Serves with Fleet Air Arm of Royal Navy

1946 Attends Regent Street Polytechnic Institute, London

1947–52 Attends Royal Academy Schools, London

1952–53 Part-time assistant to Henry Moore

1953–67 Teaches sculpture at St. Martin's School of Art, London

1954 Receives prize for sculpture at first Biennale des Jeunes Artistes, Paris; breaks away from figuration and begins making sculptures out of pieces of scrap steel, girders, and sheet metal welded and bolted together

1956 First solo exhibition at Galleria del Naviglio, Milan

1958 Included in exhibition *Three Young English Artists*, Central Pavilion, twenty-ninth Venice Biennale

1959 Makes first trip to United States

1963–65 Teaches sculpture at Bennington College, Bennington, Vermont

1966 Included in exhibition *Five Young British Artists*, British Pavilion, thirty-third Venice Biennale; receives David Bright sculpture prize

1967 Included in traveling exhibition *Guggenheim International Exhibition, 1967: Sculpture from Twenty Nations*, originating at Solomon R. Guggenheim Museum, New York

1968 Included in exhibition *Ways of Contemporary Research*, Central Pavilion, thirty-fourth Venice Biennale; included in exhibition *Kenneth Noland, Morris Louis, Anthony Caro* at Metropolitan Museum of Art, New York

1969 Included in tenth São Paulo Bienal

1971 Awarded Commander of the British Empire

1972 Makes sculptures at Rigamonte factory in Veduggio, Italy

1974 Makes sculptures at York Steel Company, Toronto

1975 Retrospective exhibition of sculptures *Anthony Caro* at Museum of Modern Art, New York

1982 Completes series of hand-colored paper sculptures at Tyler Graphics

1984 Included in traveling exhibition *Artistic Collaboration in the Twentieth Century*, originating at Hirshhorn Museum and Sculpture Garden, Smithsonian Institution, Washington, D.C.

Currently lives and works in London

PAPER RELIEF SCULPTURES

Anthony Caro completed a series of 124 paper sculptures at Tyler Graphics in 1982. The artist collaborated with Kenneth Tyler, Steve Reeves, and Tom Strianese in the construction of shapes made from pressed wet pulp molded around plaster forms or clay pipes and freely shaped newly made sheets. Once the paper forms were dry, the artist modified them by cutting, folding, compressing, and joining them. During the collaboration Caro made a large inventory of paper designs. Most of these were used to make the 124 sculptures, but several were used as maquettes for constructions in metal and are in the artist's collection.

Caro's paper sculptures were built up from rigid backing planes constructed from flat sheets of paper, rag board, corrugated board (Archival Multi-Use Board), Tycore solid-support paper panels, or plywood covered with paper. These flat planes served as supports for paper forms, wood dowels, and slats. Caro colored the works at all stages of their construction, while wet, dry, and in their final assembled form, with pencils, graphite, acrylic paints, spray paints, and chalk. Many of the sculptures are contained in shallow wooden boxes.

Duane Mitch, Lee Funderburg, Roger Campbell, Rodney Konopaki, and Bob Cross assisted Tyler, Reeves, and Strianese in making the wood fabrications and assembling the sculptures. The sculptures

are numbered sequentially from 1 to 131 (numbers 2, 21, 31, 32, 43, 80, and 99 do not exist), and some also have titles. Each work is signed *Anthony Caro*, numbered, dated, and titled (where applicable) in pencil and has a label with series number, title, material content, and copyright information (© copyright Anthony Caro 1982. Fabricated by and published by Tyler Graphics Ltd.) on the verso.

Four of the works are documented in full here, and the remainder are documented in abbreviated form in the Appendix.

149:AC26
Blume 1400

Anthony Caro
#28. Untitled 1982

Sculpture, hand-colored
Materials: acrylic paints, handmade paper, wood on Tycore panel
24½ × 37 × 7½ (62.2 × 94 × 19.1)

Papermaking by Steve Reeves and Tom Strianese; paper shapes constructed by the artist assisted by Kenneth Tyler, Reeves, and Strianese; wood construction and assembly of sculpture by the artist assisted by Duane Mitch, Lee Funderburg, Roger Campbell, Rodney Konopaki, Tyler, Reeves, and Strianese

Signed *Anthony Caro*, numbered, and dated in pencil on verso; TGL label with series number, material content, and copyright information on verso

Handmade paper and wood on Tycore panel hand-colored with acrylic paints

150:AC41
Blume 1415

Anthony Caro
#46. Untitled 1982

Sculpture, hand-colored
Materials: acrylic paints, handmade paper, wood on Tycore panel
32½ × 26½ × 5 (82.6 × 67.3 × 12.7)

Papermaking by Steve Reeves and Tom Strianese; paper shapes constructed by the artist assisted by Kenneth Tyler, Reeves, and Strianese; wood construction and assembly of sculpture by the artist assisted by Duane Mitch, Lee Funderburg, Roger Campbell, Rodney Konopaki, Tyler, Reeves, and Strianese

Signed *Anthony Caro*, numbered, and dated in pencil on verso; TGL label with series number, material content, and copyright information on verso

Handmade paper and wood on Tycore panel hand-colored with acrylic paints

151:AC47
Blume 1421

Anthony Caro
#52. Remember This 1982

Sculpture, hand-colored
Materials: chalk, acrylic paints, Tycore panel, handmade paper, wood on Tycore panel
28½ × 38½ × 18 (72.4 × 97.8 × 45.7)

Papermaking by Steve Reeves and Tom Strianese; paper shapes constructed by the artist assisted by Kenneth Tyler, Reeves, and Strianese; wood construction and assembly of sculpture by the artist assisted by Duane Mitch, Lee Funderburg, Roger Campbell, Rodney Konopaki, Tyler, Reeves, and Strianese

Signed *Anthony Caro*, numbered, dated, and titled in pencil on verso; TGL label with series number, title, material content, and copyright information on verso

Handmade paper and wood on Tycore panel hand-colored with acrylic paints

152:AC56
Blume 1430

Anthony Caro
#61. Auberge 1982

Sculpture, hand-colored
Materials: pencil, chalk, acrylic paints, handmade paper, wood on Tycore panel
23¼ × 19 × 5 (59.1 × 48.3 × 12.7)

Papermaking by Steve Reeves and Tom Strianese; paper shapes constructed by the artist assisted by Kenneth Tyler, Reeves, and Strianese; wood construction and assembly of sculpture by the artist assisted by Duane Mitch, Lee Funderburg, Roger Campbell, Rodney Konopaki, Tyler, Reeves, and Strianese

Signed *Anthony Caro*, numbered, dated, and titled in pencil on verso; TGL label with series number, title, material content, and copyright information on verso

Handmade paper and wood on Tycore panel hand-colored with acrylic paints

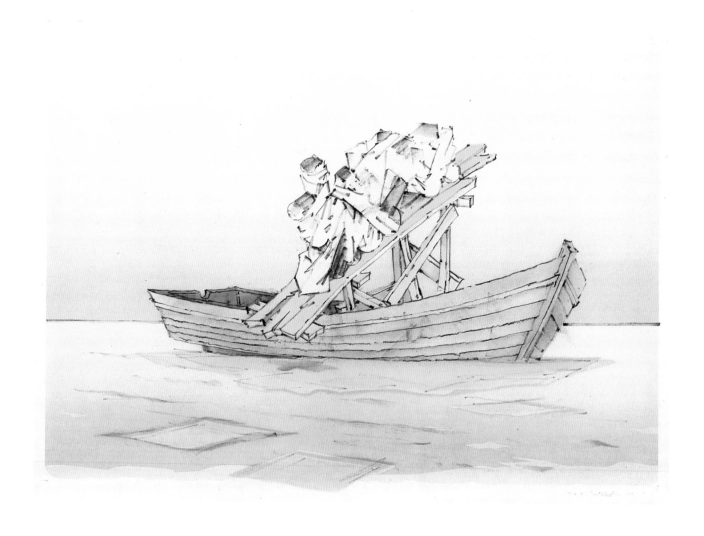

Burial at Sea 1978
See 159:WC7

William Crutchfield

1932 Born in Indianapolis

1956 Receives B.F.A. from Herron School of Art, Indianapolis; after graduation receives the Mary Milliken Award for travel in Europe

1960 Receives M.F.A. from Tulane University, New Orleans

1961 Receives Fulbright Scholarship for study at State Art Academy, Hamburg

1962 First solo exhibition at Gallery 20, Arnheim, Holland

1962–65 Teaches drawing, painting, and design at Herron School of Art; meets Kenneth Tyler in his drawing class

1963 Makes first lithographs of trains at his studio in Indianapolis

1965–67 Assistant professor and chairman of foundation studies at Minneapolis School of Art

1967 Moves to California; completes Vista hand-colored lithograph series and Americana Suite hand-colored lithograph series at Gemini G.E.L., Los Angeles

1970 Artist-in-residence, Hannover, West Germany; completes Owl Feathers screenprint portfolio at Domberger K.G., Stuttgart, West Germany; completes Air, Land, Sea lithograph series at Tamarind Lithography Workshop, Los Angeles

1971 Completes Six Rainbow Trains screenprint series at Bernard Jacobson Ltd., London; appointed guest lecturer at Atlanta School of Art (continues to travel around the United States as a guest lecturer through 1977); solo exhibition at Fort Lauderdale Museum of Art, Fort Lauderdale, Florida; included in exhibition *Technics and Creativity: Gemini G.E.L.* at Museum of Modern Art, New York

1973 Guest artist courtesy of NASA at the Skylab II launch at Cape Canaveral, Florida; "William Crutchfield, Sage of Machine Wit," half-hour special with Jonathan Winters and Vincent Price, KCET, Los Angeles

1974 Completes *Alphabet Spire VI*, thirty-two-foot reinforced, laminated-wood sculpture for Westfram Mall, Corbins Corner, Connecticut, commissioned by Taubman Company, Southfield, Michigan

1975 Completes *Friendly Eagle I*, original paint design on full-scale acrobatic biplane, commissioned by Anheuser-Busch for Busch Gardens, Van Nuys, California

1977 Completes bronze sculptures and lithograph at Tyler Graphics; included in exhibition *Art Off the Picture Press* at Emily Lowe Gallery, Hofstra University, New York; solo exhibition at Norton Gallery and School of Art, West Palm Beach, Florida

1978 Completes Train series of lithographs at Tyler Graphics

1979 Solo exhibition at ARCO Center for Visual Arts, Los Angeles

1980 Completes *Countdown*, thirty-foot reinforced, laminated-wood sculpture for Short Hills Mall, Short Hills, New Jersey, commissioned by Taubman Company, Southfield, Michigan

1981 Completes *Punctuation Spine*, twenty-eight-foot reinforced, laminated-wood sculpture for Beverly Center, Los Angeles, commissioned by Taubman Company, Southfield, Michigan

1982 Named Distinguished Artist of Los Angeles and receives Music Center Club 100 Award

1983 Completes brass sculpture *The Bravo Award* for Music Center of Los Angeles

1984 Included in exhibition *Gemini G.E.L.: Art and Collaboration* at National Gallery of Art, Washington, D.C.

1984–85 Completes lithographs at his studio in San Pedro, California

Currently lives and works in San Pedro, California

 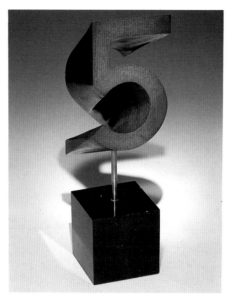 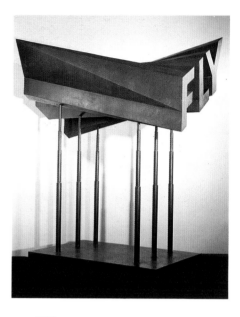

153:WC1

William Crutchfield
Double Three 1977

Cast bronze

6¼ × 3⅞ × 4¾ (15.9 × 8.5 × 12.1);
base: 3 × 3 × 3 (7.6 × 7.6 × 7.6)

Edition: 20

Ceramic mold for lost-wax casting made from wood maquette, which was constructed in California under artist's supervision; mold preparation, bronze casting, and patina by Tallix Foundry

Engraved *Crutchfield*, numbered, and dated with foundry mark of Tallix Foundry on bottom

154:WC2

William Crutchfield
Double Five 1977

Cast bronze

17½ × 11¼ × 13½ (44.5 × 28.6 × 34.3);
base: 10 × 10 × 24 (25.4 × 25.4 × 61)

Edition: 20

Ceramic mold for lost-wax casting made from wood maquette, which was constructed in California under artist's supervision; mold preparation, bronze casting, and patina by Tallix Foundry

Engraved *Crutchfield*, numbered, and dated with foundry mark of Tallix Foundry on bottom

155:WC3

William Crutchfield
Fly 1977

Cast bronze

72 × 30 × 60 (182.9 × 76.2 × 152.4);
base: 2½ × 48 × 30 (6.4 × 121.9 × 76.2)

Edition: 1

Ceramic mold for lost-wax casting made from wood maquette, which was constructed by Craig-Alisdair Corporation under the supervision of Kenneth Tyler and the artist; mold preparation, bronze casting, and patina by Tallix Foundry

Engraved *Crutchfield*, numbered, and dated with foundry mark of Tallix Foundry on base lower right

William Crutchfield using an airbrush to
prepare one of the color plates for *Trestle
Trains*, 1978.

156:WC4

William Crutchfield
Zeppelin Island 1977

Lithograph (10)
37½ × 56¼ (95.3 × 142.9)
Paper: white Arches Watercolor,
mould-made
Edition: 32
Proofs: 7AP, 9TP, 3WP, RTP, PPI, A, C

Plate and stone preparation, processing,
and proofing by Kenneth Tyler on press I;
proofing and edition printing by John
Hutcheson assisted by Rodney Konopaki
on press II

Signed *Crutchfield*, numbered, and dated in
pencil lower right; chop mark lower right;
workshop number WC77-345 lower left
verso

10 runs: 10 colors; 10 runs from 9
aluminum plates and 1 stone:
 1 light blue; method 1b; IIa
 2 gray-green; method 1b; IIa
 3 pale red-purple; method 1b; IIa
 4 ultramarine blue; method 1a; IIa
 5 transparent blue-gray; method 1b; IIa
 6 green; method 1b; IIa
 7 tan; method 1b; IIa
 8 violet; method 1b; IIa
 9 transparent blue; method 1b; IIa
10 pink; method 1b; IIa

157:WC5

William Crutchfield
Trestle Trains 1978

Lithograph (10)
39⁵⁄₁₆ × 55¼ (99.9 × 140.3)
Paper: white Arches 88, mould-made
Edition: 48
Proofs: 14AP, 3TP, 4CTP, RTP, PPI, A, C

Plate preparation, processing, and proofing
by Kenneth Tyler on press I; proofing and
edition printing by John Hutcheson on
press II

Signed *Crutchfield*, numbered, and dated in
pencil lower right; chop mark lower right;
workshop number WC77-347 lower left
verso

9 runs: 10 colors; 9 runs from 9 aluminum
plates:
 1 blue; method 1b; IIa
 2 blend of yellow and pink; methods 1b,
 16d; IIa
 3 yellow-ocher; method 1b; IIa
 4 blue-gray, method 1b; IIa
 5 red-brown; method 1b; IIa
 6 light gray; method 1b; IIa
 7 red-gray; method 1b; IIa
 8 orange; method 1b; IIa
 9 green; method 1b; IIa

158:WC6

William Crutchfield
Elevated Smoke 1978

Lithograph (8)
38⅞ × 53¼ (98.7 × 135.3)
Paper: white Arches 88, mould-made
Edition: 48
Proofs: 14AP, 3TP, 3CTP, RTP, PPI, A, C

Plate preparation, processing, and proofing
by Kenneth Tyler on press I; proofing and
edition printing by John Hutcheson on
press II

Signed *Crutchfield*, numbered, and dated in
pencil lower right; chop mark lower right;
workshop number WC77-346 lower left
verso

8 runs: 8 colors; 8 runs from 8 aluminum
plates:
 1 blue; method 1b; IIa
 2 pale red-purple; method 1b; IIa
 3 dark brown; method 1b; IIa
 4 orange-pink; method 1b; IIa
 5 transparent green; method 1b; IIa
 6 dark green; method 1b; IIa
 7 light blue; method 1b; IIa
 8 gray-blue; method 1b; IIa

159:WC7

William Crutchfield
Burial at Sea 1978

Lithograph (7)
39⅛ × 53⅛ (99.4 × 134.9)
Paper: white Arches 88, mould-made
Edition: 48
Proofs: 16AP, 3TP, CTP, RTP, PPI, A, C

Plate preparation, processing, and proofing
by Kenneth Tyler on press I; proofing and
edition printing by John Hutcheson assisted
by Rodney Konopaki on press II

Signed *Crutchfield*, numbered, and dated in
pencil lower right; chop mark lower right;
workshop number WC77-350 lower left
verso

7 runs: 7 colors; 7 runs from 7 aluminum
plates:
 1 black; method 1b; IIa
 2 light green; method 1b; IIa
 3 light blue; method 1b; IIa
 4 yellow-ocher; method 1b; IIa
 5 green; method 1b; IIa
 6 gray-green; method 1b; IIa
 7 gray; method 1b; IIa

160:WC8

William Crutchfield
Diamond Express 1978

Lithograph (10)
39⅞ × 51⅝ (101.3 × 131.1)
Paper: white Arches 88, mould-made
Edition: 48
Proofs: 16AP, 5TP, 5CTP, RTP, PPI, A, C

Plate preparation, processing, and proofing
by Kenneth Tyler on press I; proofing and
edition printing by John Hutcheson on
press II

Signed *Crutchfield*, numbered, and dated in
pencil lower right; chop mark lower right;
workshop number WC77-348 lower left
verso

10 runs: 10 colors; 10 runs from 10
aluminum plates:
 1 yellow-ocher; method 1b; IIa
 2 blue; method 1b; IIa
 3 transparent yellow-ocher; method 1b;
 IIa
 4 transparent pink; method 1b; IIa
 5 transparent green; method 1b; IIa
 6 gray-green; method 1b; IIa
 7 green; method 1b; IIa
 8 transparent blue-gray; method 1b; IIa
 9 blue-gray; method 1b; IIa
 10 magenta; method 1b; IIa

161:WC9

William Crutchfield
Cubie Smoke 1978

Lithograph (9)
39⁵⁄₁₆ × 55¼ (99.9 × 140.3)
Paper: white Arches 88, mould-made
Edition: 48
Proofs: 17AP, 3TP, CTP, RTP, PPI, A, C

Plate preparation, processing, and proofing
by Kenneth Tyler on press I; proofing and
edition printing by John Hutcheson on
press II

Signed *Crutchfield*, numbered, and dated in
pencil lower right; chop mark lower right;
workshop number WC77-347 lower left
verso

9 runs: 9 colors; 9 runs from 9 aluminum
plates:
 1 blue-black; method 1b; IIa
 2 pink; method 1b; IIa
 3 orange-pink; method 1b; IIa
 4 lavender; method 1b; IIa
 5 yellow; method 1b; IIa
 6 light green; method 1b; IIa
 7 gray; method 1b; IIa
 8 yellow-white; method 1b; IIa
 9 dark gray; method 1b; IIa

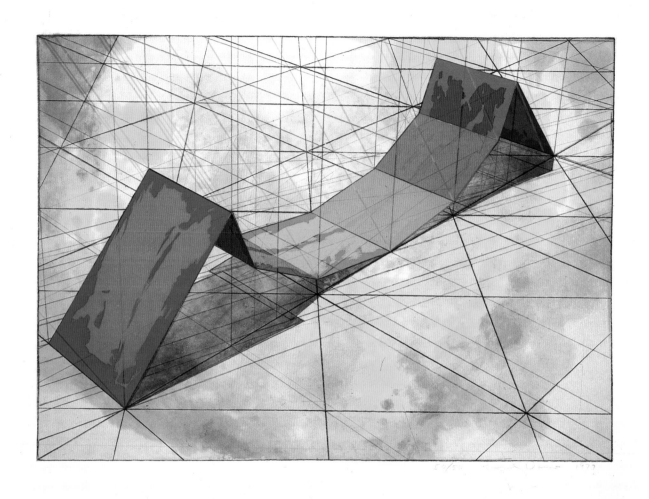

Invert Span 1979
See 167:RD6

Ronald Davis

1937 Born in Santa Monica, California

1955–56 Studies engineering at University of Wyoming, Laramie

1959 Is greatly impressed by an exhibition of contemporary painting at Denver Art Museum; starts painting

1960 Begins studies at San Francisco Art Institute

1963 Leaves San Francisco Art Institute just short of obtaining his B.A.

1964 Meets Nicholas Wilder and begins to exhibit at Wilder's new gallery in Los Angeles

1966 Solo exhibition at Tibor de Nagy Gallery, New York

1967–69 Begins experimenting with sound compositions using Buchla Series 100 Synthesizer

1968 Receives National Endowment for the Arts grant

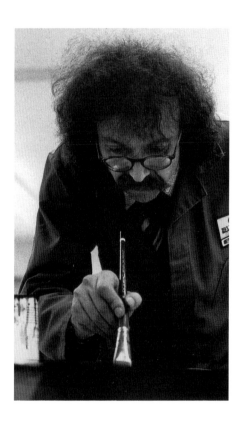

1971 Completes Cube Series, photo-offset prints with laminated Mylar overlay mounted on plastic, at Gemini G.E.L., Los Angeles; solo exhibition at Pasadena Art Museum, Pasadena, California; included in exhibition *Art and Technology* at Los Angeles County Museum of Art; included in exhibition *Technics and Creativity: Gemini G.E.L.* at Museum of Modern Art, New York

1972 Completes Rectangle Series of mixed-media prints at Gemini G.E.L., Los Angeles; included in thirty-sixth Venice Biennale

1975 Completes first intaglio prints on hand-colored handmade paper in collaboration with John Koller of HMP paper mill and Kenneth Tyler of Tyler Graphics

1976 Retrospective exhibition *Ronald Davis: Paintings, 1962–1976* at Oakland Museum

1977 Included in exhbition *Art Off the Picture Press* at Emily Lowe Gallery, Hofstra University, New York

1979 Completes a group of screenprint-lithographs on hand-colored, handmade paper at Tyler Graphics

1980 Completes group of intaglio prints at Gemini G.E.L., Los Angeles

1982 Completes group of lithographs at Gemini G.E.L., Los Angeles

1983 Completes group of aquatints at Gemini G.E.L., Los Angeles

1984 Included in exhibition *Prints from Tyler Graphics* at Walker Art Center, Minneapolis; included in exhibition *Gemini G.E.L.: Art and Collaboration* at National Gallery of Art, Washington, D.C.

Currently lives and works in Malibu, California

Intaglio
Print Series

Two craft disciplines, papermaking and intaglio printing, and two workshops were brought together to make the editions *Arch, Upright Slab, Big Open Box, Bent Beam,* and *Pinwheel, Diamond, and Stripe,* completed by Ronald Davis in 1975. Special handmade colored and pressed paper pulp was created by John and Kathleen Koller at HMP paper mill, and Betty Fiske printed the editions at Tyler Graphics. Collaboration between Davis, Kenneth Tyler, John and Kathleen Koller, and Fiske was divided into four stages. First the artist and Tyler designed an image mold, which Duane Mitch constructed from Plexiglas strips and string attached to a wood frame. The mold was placed on each newly made sheet of pulp, and Davis applied colored pulps and dyes with a spoon. After the water from the slurries and dye solutions drained, the mold was lifted, the string design from the mold was dipped in dye and transferred to the colored sheet, and the sheet was pressed between felts and then dried. The paper was moistened before printing. Davis created his intaglio images on copper plates, which Fiske prepared, processed, proofed, and printed.

162:RD1

Ronald Davis
Arch 1975

Aquatint, etching (15)
20 × 24 (50.8 × 61)
Paper: white HMP, handmade, hand-colored
Edition: 32
Proofs: 10AP, TP, 4CTP, RTP, PPI, A, C

Papermaking by John and Kathleen Koller at HMP; experimental trials and standard proof paper coloring by artist assisted by Kenneth Tyler and John Koller; paper coloring by John and Kathleen Koller; plate preparation, processing, proofing, and edition printing by Betty Fiske

Signed *Ronald Davis* and dated in pencil lower right; numbered lower left; chop mark lower right; workshop number RD75-181 lower left verso

4 runs: 10 pulp colors, 2 dye colors, 1 paper pressing; 3 ink colors, 3 runs from 3 copper plates:
1 dark yellow, light yellow-ocher, magenta, pink, violet, brown, light blue, dark blue, dark blue-green, and dark green pulps and yellow and pink dyes (applied on newly made white pulp base sheet through an image mold constructed from Plexiglas strips glued together); HMP hydraulic paper press
2 purple; method 6; IV
3 pink; method 9 (BF); IV
4 yellow-ocher; method 9 (BF); IV

163:RD2

Ronald Davis
Upright Slab 1975

Aquatint, etching, drypoint, engraving (14)
24 × 20 (61 × 50.8)
Paper: white HMP, handmade, hand-colored
Edition: 37
Proofs: 10AP, 2TP, 2CTP, RTP, PPI, A, C

Papermaking by John and Kathleen Koller at HMP; experimental trials and standard proof paper coloring by artist assisted by Kenneth Tyler and John Koller; paper coloring by John and Kathleen Koller; plate preparation, processing, proofing, and edition printing by Betty Fiske

Signed *Ronald Davis* and dated in pencil lower right; numbered lower left; chop mark lower right; workshop number RD75-180 lower left verso

4 runs: 5 pulp colors, 6 dye colors, 1 paper pressing; 3 ink colors, 3 runs from 3 copper plates:
1 yellow, orange, red, violet, and purple pulps and yellow, orange, red, violet, blue, and green dyes (applied on newly made white pulp base sheet through an image mold constructed from Plexiglas strips glued together); HMP hydraulic paper press
2 blue; methods 6, 9 (BF), 12, 13; IV
3 yellow; method 9 (BF); IV
4 red; method 9 (BF); IV

164:RD3

Ronald Davis
Big Open Box 1975

Aquatint, etching, drypoint (19)
20 × 24 (50.8 × 61)
Paper: white HMP, handmade,
hand-colored
Edition: 39
Proofs: 10AP, TP, 4CTP, RTP, PPI, A, C

Papermaking by John and Kathleen Koller
at HMP; experimental trials and standard
proof paper coloring by artist assisted by
Kenneth Tyler and John Koller; paper
coloring by John and Kathleen Koller; plate
preparation, processing, proofing, and
edition printing by Betty Fiske

Signed *Ronald Davis* and dated in pencil
lower right; numbered lower left; chop
mark lower right; workshop number
RD75-182 lower left verso

5 runs: 11 pulp colors, 3 dye colors, 1
paper pressing; 5 ink colors, 4 runs from 4
copper plates:
 1 yellow, orange, red, magenta, violet,
 light purple, purple, light blue, blue,
 yellow-green, and green pulps and
 yellow, magenta, and blue dyes (applied
 on newly made white pulp base sheet
 through an image mold constructed
 from Plexiglas strips glued together);
 HMP hydraulic paper press
 2 red and blue; methods 9 (BF), 16a; IV
 3 orange; method 9 (BF); IV
 4 dark violet; methods 6, 13; IV
 5 violet; method 9 (BF); IV

165:RD4

Ronald Davis
Bent Beam 1975

Aquatint, etching (17)
20 × 24 (50.8 × 61)
Paper: white HMP, handmade,
hand-colored
Edition: 44
Proofs: 11AP, 3CTP, PP, RTP, PPI, A, C

Papermaking by John and Kathleen Koller
at HMP; experimental trials and standard
proof paper coloring by artist assisted by
Kenneth Tyler and John Koller; paper
coloring by John and Kathleen Koller; plate
preparation, processing, proofing, and
edition printing by Betty Fiske

Signed *Ronald Davis* and dated in pencil
lower right; numbered lower left; chop
mark lower right; workshop number
RD75-183 lower left verso

3 runs: 13 pulp colors, 2 dye colors, 1
paper pressing; 2 ink colors, 2 runs from 2
copper plates:
 1 yellow, light orange, orange, violet,
 medium purple, purple, red-brown,
 brown, light blue, blue, yellow-green,
 pale green, and green pulps and yellow
 and blue dyes (applied on newly made
 white pulp base sheet through an image
 mold constructed from Plexiglas strips
 glued together); HMP hydraulic paper
 press
 2 yellow-ocher; methods 6, 9 (BF); IV
 3 orange; method 9 (BF); IV

166:RD5

Ronald Davis
Pinwheel, Diamond, and Stripe 1975

Aquatint, etching, drypoint (27)
20 × 24 (50.8 × 61)
Paper: white HMP, handmade,
hand-colored
Edition: 42
Proofs: 10AP, 5CTP, WP, RTP, PPI, A, C

Papermaking by John and Kathleen Koller
at HMP; experimental trials and standard
proof paper coloring by artist assisted by
Kenneth Tyler and John Koller; paper
coloring by John and Kathleen Koller; plate
preparation, processing, proofing, and
edition printing by Betty Fiske

Signed *Ronald Davis* and dated in pencil
lower right; numbered lower left; chop
mark lower right; workshop number
RD75-185 lower left verso

4 runs: 18 pulp colors, 6 dye colors, 1
paper pressing; 3 ink colors, 3 runs from 3
copper plates:
 1 yellow, orange, yellow-ocher, light red,
 medium red, dark red, light pink, dark
 pink, violet, purple, tan, brown, light
 blue, medium blue, yellow-green,
 blue-green, brown-green, and light
 green pulps and yellow, orange, red,
 magenta, blue, and green dyes (applied
 on newly made white pulp base sheet
 through an image mold constructed
 from Plexiglas strips glued together);
 HMP hydraulic paper press
 2 yellow; method 9 (BF); IV
 3 turquoise green; method 9 (BF); IV
 4 dark green; methods 9 (BF), 6, 13; IV

MIXED-MEDIA
PRINT SERIES

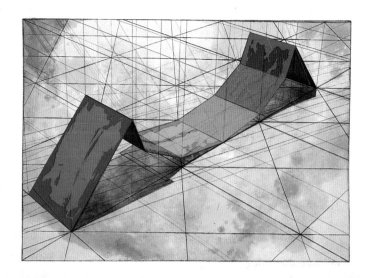

The print editions *Invert Span*, *Arc Arch*, *Wide Wave*, and *Twin Wave*, completed by Ronald Davis in 1979, are mixed-media works that combine colored, pressed paper pulp with screen printing and lithography. For each print the artist designed an image mold, which Duane Mitch constructed from Plexiglas strips. The mold was placed on newly made sheets of pulp, and colored pulps and dyes were applied by Lee Funderburg and Lindsay Green under the direction of the artist. After the water from the slurries and dye solutions drained, the mold was lifted, and the colored sheets were pressed between blotters and felts and dried. The paper was moistened before printing. Davis drew on stones and aluminum plates for lithographic printing and on clear Mylar sheets for transfer to photo screens for screen printing. All lithographed and screened colors were printed in registration with specific colored areas of the handmade paper.

167:RD6

Ronald Davis
Invert Span 1979

Screenprint, lithograph (34)

32 × 42 (81.3 × 106.7)

Paper: white TGL, handmade, hand-colored

Edition: 50

Proofs: 12AP, 2CTP, RTP, PPI, PPII, A, C

Papermaking by Lindsay Green and Lee Funderburg; experimental trials and standard proof paper coloring by artist assisted by Kenneth Tyler and Green; paper coloring by Green; stone preparation, processing, and proofing by Tyler on press I; plate preparation and processing by John Hutcheson; stone and plate proofing and edition printing by Hutcheson on press II; screen preparation, processing, proofing, and edition printing by Kim Halliday

Signed *Ronald Davis*, numbered, and dated in pencil lower right; chop mark lower right; workshop number RD78-400 lower left verso

23 runs: 6 pulp colors, 6 dye colors, 1 paper pressing; 22 ink colors, 22 runs from 2 screens, 5 aluminum plates, and 1 stone:

1. yellow, orange, violet, tan, light blue, and green pulps and yellow, orange, red, pink, purple, and blue dyes (applied on newly made white pulp base sheet through an image mold constructed from Plexiglas strips glued together); III
2. blue; method 1b; IIa
3. gray-green; method 1b; IIa
4. medium blue; methods 28 (KH), 27 (KH); VI
5. vermilion; methods 28 (same screen as run 4), 27 (KH); VI
6. dark blue-green; methods 28 (same screen as run 4), 27 (KH); VI
7. medium green; methods 28 (same screen as run 4), 27 (KH); VI
8. light green; methods 28 (same screen as run 4), 27 (KH); VI
9. yellow-orange; methods 28 (same screen as run 4), 27 (KH); VI
10. medium orange; methods 28 (same screen as run 4), 27 (KH); VI
11. red-brown; methods 28 (same screen as run 4), 27 (KH); VI
12. medium orange; methods 30a, 27 (KH); VI
13. dark blue-violet; methods 30a (same screen as run 12), 27 (KH); VI
14. dark pink; methods 30a (same screen as run 12), 27 (KH); VI

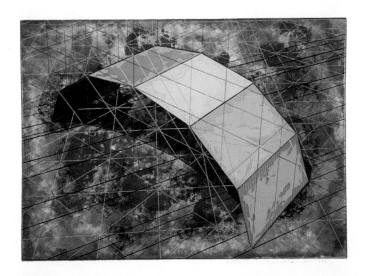

15 medium pink; methods 30a (same screen as run 12), 27 (KH); VI

16 violet; methods 30a (same screen as run 12), 27 (KH); VI

17 gray-brown; methods 30a (same screen as run 12), 27 (KH); VI

18 light gray-pink; methods 30a (same screen as run 12), 27 (KH); VI

19 blue-green; methods 30a (same screen as run 12), 27 (KH); VI

20 brown; method 1a; IIa

21 transparent brown; method 1b; IIa

22 red; method 1b; IIa

23 yellow; method 1b; IIa

168:RD7

Ronald Davis
Arc Arch 1979

Screenprint, lithograph (29)

32 × 42 (81.3 × 106.7)

Paper: white TGL, handmade, hand-colored

Edition: 50

Proofs: 12AP, CTP, RTP, PPI, PPII, A, C

Papermaking by Lindsay Green and Lee Funderburg; experimental trials and standard proof paper coloring by artist assisted by Kenneth Tyler and Green; paper coloring by Funderburg; stone preparation, processing, and proofing by Tyler on press I; plate preparation and processing by John Hutcheson; stone and plate proofing and edition printing by Hutcheson on press II; screen preparation, processing, proofing, and edition printing by Kim Halliday

Signed *Ronald Davis*, numbered, and dated in pencil lower right; chop mark lower right; workshop number RD79-401 lower left verso

22 runs: 5 pulp colors, 3 dye colors, 1 paper pressing; 21 ink colors, 21 runs from 2 screens, 8 aluminum plates, and 1 stone:

1 pale red, dark blue, light gray, medium gray, and dark gray pulps and yellow, magenta, and gray–blue-violet dyes (applied on newly made white pulp base sheet through an image mold constructed from Plexiglas strips glued together); III

2 blue; method 1b; IIa

3 transparent blue; method 1b; IIa

4 dark brown; method 1a; IIa

5 transparent brown; method 1b; IIa

6 medium gray; methods 28 (KH), 27 (KH); VI

7 green-gray; methods 28 (same screen as run 6), 27 (KH); VI

8 orange; methods 28 (same screen as run 6), 27 (KH); VI

9 blue-gray; methods 28 (same screen as run 6), 27 (KH); VI

10 yellow-gray; methods 28 (same screen as run 6), 27 (KH); VI

11 blue-gray; methods 28 (same screen as run 6), 27 (KH); VI

12 blue–green-gray; methods 30a, 27 (KH); VI

13 light gray; methods 30a (same screen as run 12), 27 (KH); VI

14 yellow-green; methods 30a (same screen as run 12), 27 (KH); VI

15 light blue-gray; methods 30a (same screen as run 12), 27 (KH); VI

16 orange-yellow; methods 30a (same screen as run 12), 27 (KH); VI

17 blue-gray; methods 30a (same screen as run 12), 27 (KH); VI

18 white; method 1b; IIa

19 magenta; method 1b; IIa

20 gray-green; method 1b; IIa

21 red-ocher; method 1b; IIa

22 yellow; method 1b; IIa

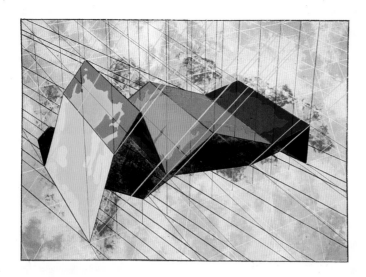

169:RD8

Ronald Davis
Wide Wave 1979

Screenprint, lithograph (30)
32 × 42 (81.3 × 106.7)
Paper: white TGL, handmade,
hand-colored
Edition: 50
Proofs: 12AP, 3CTP, RTP, PPI, PPII, A, C

Papermaking by Lindsay Green and Lee Funderburg; experimental trials and standard proof paper coloring by artist assisted by Kenneth Tyler and Green; paper coloring by Funderburg; stone preparation, processing, and proofing by Tyler on press I; plate preparation and processing by John Hutcheson; stone and plate proofing and edition printing by Hutcheson on press II; screen preparation, processing, proofing, and edition printing by Kim Halliday

Signed *Ronald Davis*, numbered, and dated in pencil lower right; chop mark lower right; workshop number RD79-402 lower left verso

23 runs: 5 pulp colors, 3 dye colors, 1 paper pressing; 22 ink colors, 22 runs from 2 screens, 7 aluminum plates, and 1 stone:

1 pink, violet, tan, dark brown, and blue-gray pulps and light yellow, gray-blue, and light green dyes (applied on newly made white pulp base sheet through an image mold constructed from Plexiglas strips glued together); III
2 pink; method 1b; IIa
3 blue; method 1b; IIa
4 vermilion; methods 28 (KH), 27 (KH); VI
5 green; methods 28 (same screen as run 4), 27 (KH); VI
6 blue-gray; methods 28 (same screen as run 4), 27 (KH); VI
7 turquoise green; methods 28 (same screen as run 4), 27 (KH); VI
8 violet; methods 28 (same screen as run 4), 27 (KH); VI
9 gray-green; methods 28 (same screen as run 4), 27 (KH); VI
10 blue-gray; methods 28 (same screen as run 4), 27 (KH); VI
11 gold-yellow; methods 30a, 27 (KH); VI
12 orange-yellow; methods 30a (same screen as run 11), 27 (KH); VI
13 gray; methods 30a (same screen as run 11), 27 (KH); VI
14 orange; methods 30a (same screen as run 11), 27 (KH); VI
15 red; methods 30a (same screen as run 11), 27 (KH); VI
16 magenta; methods 30a (same screen as run 11), 27 (KH); VI
17 red-gray; methods 30a (same screen as run 11), 27 (KH); VI
18 white; method 1b; IIa
19 dark brown; method 1a; IIa
20 transparent brown; method 1b; IIa
21 gray-green; method 1b; IIa
22 transparent magenta; method 1b; IIa
23 yellow; method 1b; IIa

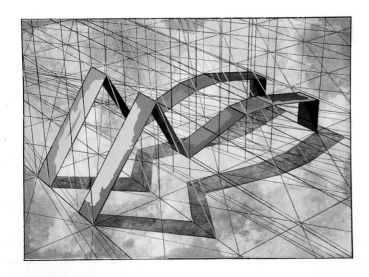

170:RD9

Ronald Davis
Twin Wave 1979

Screenprint, lithograph (34)	
32 × 42 (81.3 × 106.7)	
Paper: white TGL, handmade, hand-colored	
Edition: 50	
Proofs: 12AP, 8CTP, RTP, PPI, PPII, A, C	

Papermaking by Lindsay Green and Lee Funderburg; experimental trials and standard proof paper coloring by artist assisted by Kenneth Tyler and Green; paper coloring by Funderburg; stone preparation, processing, and proofing by Tyler on press I; plate preparation and processing by John Hutcheson; stone and plate proofing and edition printing by Hutcheson on press II; screen preparation, processing, proofing, and edition printing by Kim Halliday

Signed *Ronald Davis*, numbered, and dated in pencil lower right; chop mark lower right; workshop number RD78-403 lower left verso

27 runs: 5 pulp colors, 3 dye colors, 1 paper pressing; 26 ink colors, 26 runs from 2 screens, 7 aluminum plates, and 1 stone:

1 orange, yellow-ocher, dark red, violet, and medium purple pulps and yellow, purple, and green dyes (applied on newly made white pulp base sheet through an image mold constructed from Plexiglas strips glued together); III
2 pink; method 1b; IIa
3 purple; method 1b; IIa
4 pink; methods 28 (KH), 27 (KH); VI
5 light blue; methods 28 (same screen as run 4), 27 (KH); VI
6 light violet; methods 28 (same screen as run 4), 27 (KH); VI
7 light blue-green; methods 28 (same screen as run 4), 27 (KH); VI
8 yellow-green; methods 28 (same screen as run 4), 27 (KH); VI
9 medium blue; methods 28 (same screen as run 4), 27 (KH); VI
10 yellow-ocher; methods 28 (same screen as run 4), 27 (KH); VI
11 medium gray; methods 28 (same screen as run 4), 27 (KH); VI
12 medium brown; methods 28 (same screen as run 4), 27 (KH); VI
13 dark transparent brown; methods 28 (same screen as run 4), 27 (KH); VI

14 yellow; methods 30a, 27 (KH); VI
15 dark green; methods 30a (same screen as run 14), 27 (KH); VI
16 medium violet; methods 30a (same screen as run 14), 27 (KH); VI
17 medium orange; methods 30a (same screen as run 14), 27 (KH); VI
18 dark orange; methods 30a (same screen as run 14), 27 (KH); VI
19 violet; methods 30a (same screen as run 14), 27 (KH); VI
20 medium purple; methods 30a (same screen as run 14), 27 (KH); VI
21 dark purple; methods 30a (same screen as run 14), 27 (KH); VI
22 red-brown; method 1b; IIa
23 dark brown; method 1a; IIa
24 transparent brown; method 1b; IIa
25 dark brown; method 1b; IIa
26 dark blue; method 1b; IIa
27 yellow; method 1b; IIa

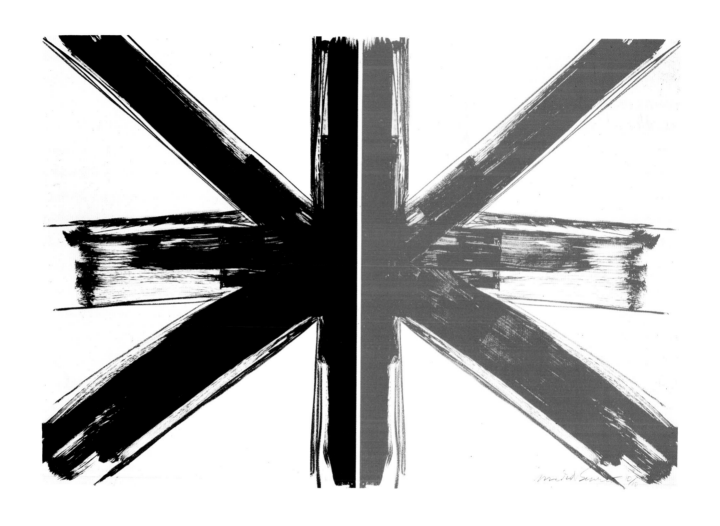

Centering, State I 1976
See 175:MdS5

Mark di Suvero

1933 Born in Shanghai, China

1941 His father, an official representative of the Italian government in China, is forced to leave due to political upheavals; family emigrates to San Francisco

1953–54 Studies at San Francisco City College

1954–55 Studies with sculptor Robert Thomas at University of California, Santa Barbara

1956 Receives B.A. in philosophy from University of California, Berkeley

1957 Arrives in New York and meets Richard Bellamy of the Green Gallery

1960 First solo exhibition at Green Gallery, New York

1966 Included in exhibitions *Contemporary American Sculpture Section I* and *Art of the United States, 1670–1966* at Whitney Museum of American Art, New York

1970 Included in sculpture annual, Whitney Museum of American Art, New York

1970–75 Lives in Europe; teaches architecture in Venice

1972 Completes *Untitled*, a movable steel sculpture multiple, at Gemini G.E.L., Los Angeles

1974 Included in thirty-seventh Venice Biennale

1975 Retrospective exhibition of sculpture *Mark di Suvero* at Whitney Museum of American Art, New York, and throughout New York City

1976 Completes first lithographs at Tyler Graphics; included in Sydney Biennial, North Sydney, Australia

1977 Included in exhibition *Art Off the Picture Press* at Emily Lowe Gallery, Hofstra University, New York

1981 Completes group of puzzle multiples at Gemini G.E.L., Los Angeles

1983 Solo exhibition at Oil and Steel Gallery, New York; included in exhibition *The First Show: Painting and Sculpture from Eight Collections, 1940–1981* at Museum of Contemporary Art, Los Angeles

1984 Included in exhibition *Prints from Tyler Graphics* at Walker Art Center, Minneapolis

1985 Solo exhibition *Twenty-five Years of Sculpture and Drawings* at Storm King Art Center, Mountainville, New York; solo exhibition at Oil and Steel Gallery, New York

Currently lives and works in Long Island City, New York, and Petaluma, California

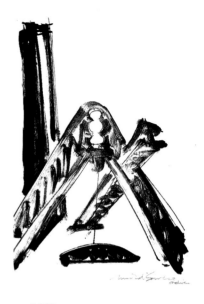

171:MdS1

Mark di Suvero
Jak 1976

Lithograph, screenprint (2)
41 × 29 (104.1 × 73.7)
Paper: white Arches Cover, mould-made
Edition: 100
Proofs: 20AP, 2TP, RTP, PPI, A, C

Stone and screen preparation, processing, and proofing by Kenneth Tyler; stone edition printing by Robert Bigelow; screen edition printing by Kim Halliday

Signed *Mark di Suvero* in pencil lower right; numbered lower left; chop mark lower right; workshop number MdS76-245 lower left verso

2 runs: 2 colors; 2 runs from 1 stone and 1 screen:
 1 black; method 1a; I
 2 yellow; method 28 (KT); VI

172:MdS2

Mark di Suvero
Afterstudy for Marianne Moore 1976

Lithograph (2)
39 × 51½ (99.1 × 130.8)
Paper: white Rives BFK, mould-made
Edition: 25
Proofs: 9AP, 7TP, 2CTP, SP, RTP, PPI, A, C

Stone and plate preparation, processing, and proofing by Kenneth Tyler on press I; proofing and edition printing by John Hutcheson assisted by Robert Bigelow on press II

Signed *Mark di Suvero* and numbered in pencil lower right; chop mark lower right; workshop number MdS76-246 lower left verso

2 runs: 2 colors; 2 runs from 1 stone and 1 aluminum plate:
 1 red; method 1a; IIa
 2 blue; method 3b (KT); IIa

173:MdS3

Mark di Suvero
For Rilke 1976

Lithograph (1)
48 × 32 (121.9 × 81.3)
Paper: white Arches Cover, mould-made
Edition: 26
Proofs: 10AP, RTP, PPI, A, C

Stone preparation, processing, and proofing by Kenneth Tyler; edition printing by Robert Bigelow

Signed *Mark di Suvero* and numbered in pencil lower right; chop mark lower right; workshop number MdS76-247 lower left verso

1 run: 1 color; 1 run from 1 stone:
 1 black; method 1a; I

174:MdS4

Mark di Suvero
Centering 1976

Lithograph (2)
42½ × 62¼ (108 × 158.1)
Paper: white Arches 88, mould-made
Edition: 10
Proofs: 5AP, TP, CTP, RTP, PPI, A, C

Stone preparation, processing, and proofing
by Kenneth Tyler on press I; proofing and
edition printing by John Hutcheson and
Tyler assisted by Robert Bigelow on press II

Signed *Mark di Suvero* and numbered in
pencil lower right; chop mark lower right;
workshop number MdS76-248 lower left
verso

2 runs: 2 colors; 2 runs from 1 stone:
 1 yellow; method 1a; IIb
 2 black; method 1a (same stone as run
 1); IIa

175:MdS5

Mark di Suvero
Centering, State I 1976

Lithograph (2)
42½ × 62¼ (108 × 158.1)
Paper: white Arches 88, mould-made
Edition: 10
Proofs: 5AP, TP, CTP, RTP, A

Stone preparation, processing, and proofing
by Kenneth Tyler on press I; proofing and
edition printing by John Hutcheson and
Tyler assisted by Robert Bigelow on press II

Signed *Mark di Suvero* and numbered in
pencil lower right; chop mark lower right;
workshop number MdS76-248A lower left
verso

2 runs: 2 colors; 2 runs from 1 stone:
 1 red; method 1a; IIb
 2 black; method 1a (same stone as run
 1); IIa

176:MdS6

Mark di Suvero
Tetra 1976

Lithograph (1)
51 × 39½ (129.5 × 100.3)
Paper: white Rives BFK, mould-made
Edition: 20
Proofs: 10AP, 2TP, 2CTP, RTP, PPI, A, C

Stone preparation, processing, and proofing
by Kenneth Tyler on press I; proofing and
edition printing by John Hutcheson on
press II

Signed *Mark di Suvero* and numbered in
pencil lower right; chop mark lower right;
workshop number MdS76-249 lower left
verso

1 run: 1 color; 1 run from 1 stone:
 1 yellow; method 1b; IIa

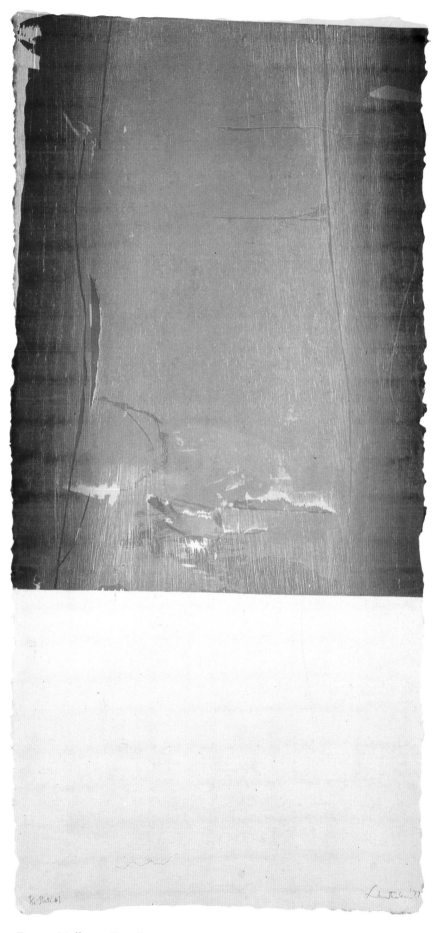

Essence Mulberry, State I 1977
See 181:HF5

Helen Frankenthaler

1928 Born in New York

1945 Graduates from the Dalton School, New York, where she studied with Rufino Tamayo

1946–49 Studies art with Paul Feely at Bennington College, Bennington, Vermont; spends nonresident term studying with Vaclav Vytlacil at Art Students League, New York

1949 Graduates from Bennington College; moves to New York; enters Graduate School of Fine Arts, Columbia University, New York

1950 Meets critic Clement Greenberg; studies with Hans Hofmann at his studio in Provincetown, Massachusetts; included in exhibition *Twelve Unknowns* at Kootz Gallery, New York

1951 First solo exhibition at Tibor de Nagy Gallery, New York

1952 Shares studio with Friedl Dzubas; paints influential stain painting *Mountains and Sea*

1959 Receives first prize at first biennial exhibition, Musée d'Art Moderne, Paris

1961 Completes first lithograph, *First Stone*, at Universal Limited Art Editions, West Islip, New York (continues to make prints there until 1978)

1967 Teaches at School of Art and Architecture, Yale University, New Haven, Connecticut, and School of Visual Arts, New York

1969 Traveling retrospective exhibition of paintings *Helen Frankenthaler*, originating at Whitney Museum of American Art, New York

1970 Completes stencil prints at Maurel Studios, New York, published by Abrams Original Editions, New York

1973 Receives honorary doctorate in fine arts from Smith College, Northampton, Massachusetts; completes three intaglio prints at 2RC Editrice, Rome

1974 Elected member of National Institute of Arts and Letters

1975 Retrospective exhibition of paintings at Corcoran Gallery of Art, Washington, D.C.

1977 Completes group of lithographs and woodcuts at Tyler Graphics; included in exhibition *Art Off the Picture Press* at Emily Lowe Gallery, Hofstra University, New York

1978–79 Completes intaglio prints, screenprint, and Experimental Impression series of intaglio monoprints at Tyler Graphics

1980 Completes woodcut *Cameo* at Tyler Graphics; traveling retrospective exhibition *Helen Frankenthaler Prints: 1961–1979*, originating at Phillips Collection, Washington, D.C.; receives honorary doctorate in art from Harvard University, Cambridge, Massachusetts

1981–83 Completes Monoprint, Monotype Series at Tyler Graphics

1983 Completes woodblock print, printed by ukiyo-e printer Tadashi Toda in Kyoto, Japan, published by Crown Point Press, Oakland

1984 Included in exhibition *Prints from Tyler Graphics* at Walker Art Center, Minneapolis

1985 Traveling exhibition *Frankenthaler: Works on Paper, 1949–1984*, originating at Solomon R. Guggenheim Museum, New York; included in exhibition *Ken Tyler: Printer Extraordinary* at Australian National Gallery, Canberra

Currently lives and works in New York

177:HF1
Krens 59

Helen Frankenthaler
Harvest 1977

Lithograph (6)
26 × 22 (66 × 55.9)
Paper: cream HMP, handmade
Edition: 43
Proofs: 10AP, 2TP, 3CTP, SP, 5WP, RTP,
PPI, A, C, 10RP

Stone and plate preparation, processing,
and proofing by Kenneth Tyler on press I;
photo plate preparation and processing by
John Hutcheson; edition printing by Tyler
and Hutcheson assisted by Rodney Kono-
paki on presses I and II

Signed *Frankenthaler* and dated in pencil
lower right; numbered lower left; chop
mark lower right; workshop number
HF76-284 lower left verso

6 runs: 6 colors; 6 runs from 3 stones and
3 aluminum plates:
 1 transparent yellow; method 3b (JH); IIa
 2 yellow; method 2a; IIa
 3 dark brown; method 1a; I
 4 magenta; method 1a; I
 5 transparent yellow-orange; method 3a;
 IIa
 6 red; method 1b; IIa

178:HF2
Krens 60

Helen Frankenthaler
Dream Walk 1977

Lithograph (7)
26 × 35 (66 × 88.9)
Paper: mauve HMP, handmade
Edition: 47
Proofs: 12AP, 2TP, 6CTP, WP, RTP, PPI,
A, C

Stone and plate preparation, processing,
and proofing by Kenneth Tyler on press I;
photo plate preparation and processing by
John Hutcheson; edition printing by Tyler
and Hutcheson assisted by Rodney Kono-
paki on presses I and II

Signed *Frankenthaler* and dated in pencil
lower right; numbered lower left; chop
mark lower right; workshop number
HF76-286 lower left verso

4 runs: 7 colors; 4 runs from 1 stone and 3
aluminum plates:
 1 blue and gray; methods 1a, 16b; I
 2 violet; method 3b (JH); IIa
 3 yellow-ocher and red; methods 1b,
 16b; I
 4 yellow and magenta; methods 1b,
 16b; I

179:HF3
Krens 61

Helen Frankenthaler
Barcelona 1977

Lithograph (9)
41 × 32 (104.1 × 81.3)
Paper: cream HMP, handmade
Edition: 30
Proofs: 10AP, 4TP, 2CTP, 2SP, WP, RTP,
PPI, A, C

Stone and plate preparation, processing,
and proofing by Kenneth Tyler on press I;
photo plate preparation and processing by
John Hutcheson; edition printing by Tyler
and Hutcheson assisted by Rodney Kono-
paki on presses I and II

Signed *Frankenthaler* and dated in pencil
lower right; numbered lower left; chop
mark lower left; workshop number
HF76-285 lower left verso

7 runs: 9 colors; 7 runs from 2 stones and
5 aluminum plates:
 1 dark green; method 1a; I
 2 yellow-green; method 1a; I
 3 transparent green; method 3b (JH); IIa
 4 transparent dark brown; method 1b;
 IIa
 5 yellow and transparent blue; methods
 1b, 16c; IIa
 6 blue and yellow; methods 1b, 16b; I
 7 yellow; method 1b; I

180:HF4
Krens 62

Helen Frankenthaler
Essence Mulberry 1977

Woodcut (8)
39½ × 18½ (100.3 × 47)
Paper: buff Maniai, handmade
Edition: 46
Proofs: 10AP, 13TP, 3WP, RTP, PPI, A, 8RP

Proofing and edition printing by John Hutcheson and Kenneth Tyler

Signed *Frankenthaler* and dated in pencil lower right; numbered lower left; chop mark lower right; workshop number HF77-287 lower left verso

4 runs: 8 colors; 4 runs from 4 woodblocks:
1 blend of yellow and brown; methods 19a, 19b (oak-veneer wood), 16d; IIa
2 blend of dark red and transparent base; methods 19a, 19b (birchwood), 16d; IIa
3 blend of blue and transparent base; methods 19a, 19b (walnut-veneer wood), 16d; IIa
4 pink and dark blue; methods 19a (luan plywood, KT), 16c; IIa

181:HF5
Krens 63

Helen Frankenthaler
Essence Mulberry, State I 1977

Woodcut (8)
39½ × 18½ (100.3 × 47)
Paper: gray Maniai, handmade
Edition: 10
Proofs: 2TP, C

Proofing and edition printing by John Hutcheson and Kenneth Tyler

Signed *Frankenthaler* and dated in pencil lower right; numbered and titled (*State I*) lower left; chop mark lower right; workshop number HF77-287A lower left verso

4 runs: 8 colors; 4 runs from 4 woodblocks:
1 blend of yellow and brown; methods 19a, 19b (oak-veneer wood), 16d; IIa
2 blend of dark red and transparent base; methods 19a, 19b (birchwood), 16d; IIa
3 blend of blue and transparent base; methods 19a, 19b (walnut-veneer wood), 16d; IIa
4 pink and dark blue; methods 19a (luan plywood, KT), 16c; IIa

The ink colors, woodblocks, and printing sequence were the same for *Essence Mulberry* and *Essence Mulberry, State I*.

182:HF6
Krens 64

Helen Frankenthaler
Earth Slice 1978

Etching, aquatint (4)
15½ × 26 (39.4 × 66)
Paper: mauve HMP, handmade
Edition: 46
Proofs: 12AP, 3WP, RTP, PPI, A, C

Plate preparation, processing, and proofing by Rodney Konopaki, Paul Sanders, and Kenneth Tyler; edition printing by Konopaki

Signed *Frankenthaler* and dated in pencil lower left; numbered lower right; chop mark lower right; workshop number HF76-288 lower left verso

4 runs: 4 colors; 4 runs from 4 copper plates:
1 yellow-ocher; method 9 (RK); IV
2 viridian; method 8; IV
3 brown; method 7; IV
4 brown-green; method 7; IV

EXPERIMENTAL IMPRESSIONS

The printing elements for the group of nine Experimental Impressions completed by Helen Frankenthaler in 1978 were the first, third, and fourth plates from the edition *Earth Slice* (182:HF6), the third plate from the edition *Ganymede* (192:HF16), and an etched line plate that was not used for any edition print. The artist, collaborating with Kenneth Tyler, Rodney Konopaki, and Paul Sanders, experimented with the printing order and the inking of the plates, using a palette consisting of eleven colors. The monoprints were printed on white Dutch Etching paper.

183:HF7
Krens 64.10

Helen Frankenthaler
Experimental Impression I 1978

Monoprint

12¾ × 24½ (32.4 × 66.2)

Paper: white Dutch Etching, mould-made

Plate preparation, processing, and printing by Rodney Konopaki, Paul Sanders, and Kenneth Tyler

Signed *Frankenthaler* and dated in pencil lower right; titled lower left; chop mark lower right

1 run: 1 color; 1 run from 1 copper plate:
 1 black; method 7; IV

184:HF8
Krens 64.11

Helen Frankenthaler
Experimental Impression II 1978

Monoprint

14 × 25 (35.6 × 63.5)

Paper: white Dutch Etching, mould-made

Plate preparation, processing, and printing by Rodney Konopaki, Paul Sanders, and Kenneth Tyler

Signed *Frankenthaler* and dated in pencil lower right; titled lower left; chop mark lower right

1 run: 1 color; 1 run from 1 copper plate:
 1 brown-green; method 7; IV

185:HF9

Krens 64.12

Helen Frankenthaler

Experimental Impression III 1978

Monoprint

18 × 29 (45.7 × 73.7)

Paper: white Dutch Etching, mould-made

Plate preparation, processing, and printing
by Rodney Konopaki, Paul Sanders, and
Kenneth Tyler

Signed *Frankenthaler* and dated in pencil
lower right; titled lower left; chop mark
lower right

4 runs: 5 colors; 4 runs from 4 copper
plates:
 1 brown; method 7; IV
 2 yellow-orange; method 7; IV
 3 black; method 7; IV
 4 orange and red; methods 6, 16a; IV

186:HF10

Krens 64.13

Helen Frankenthaler

Experimental Impression IV 1978

Monoprint

18 × 29 (45.7 × 73.7)

Paper: white Dutch Etching, mould-made

Plate preparation, processing, and printing
by Rodney Konopaki, Paul Sanders, and
Kenneth Tyler

Signed *Frankenthaler* and dated in pencil
lower right; titled lower left; chop mark
lower right

4 runs: 5 colors; 4 runs from 4 copper
plates:
 1 brown; method 7; IV
 2 yellow-orange; method 7; IV
 3 black; method 7; IV
 4 orange and red; methods 6, 16a; IV

187:HF11
Krens 64.14

Helen Frankenthaler
Experimental Impression V 1978

Monoprint

20 × 31 (50.8 × 78.7)
Paper: white Dutch Etching, mould-made

Plate preparation, processing, and printing
by Rodney Konopaki, Paul Sanders, and
Kenneth Tyler

Signed *Frankenthaler* and dated in pencil
lower right; titled lower left; chop mark
lower right

3 runs: 3 colors; 3 runs from 3 copper
plates:
 1 brown; method 7; IV
 2 brown-green; method 7; IV
 3 white; method 6; IV

188:HF12
Krens 64.15

Helen Frankenthaler
Experimental Impression VI 1978

Monoprint

20 × 31 (50.8 × 78.7)
Paper: white Dutch Etching, mould-made

Plate preparation, processing, and printing
by Rodney Konopaki, Paul Sanders, and
Kenneth Tyler

Signed *Frankenthaler* and dated in pencil
lower right; titled lower left; chop mark
lower right

3 runs: 4 colors; 3 runs from 3 copper
plates:
 1 transparent green; method 7; IV
 2 transparent brown; method 7; IV
 3 red and purple; methods 6, 16a; IV

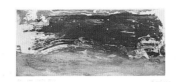

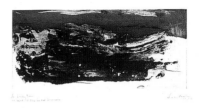

189:HF13
Krens 64.16

Helen Frankenthaler
Experimental Impression VII 1978

Monoprint

31 × 20 (78.7 × 50.8)

Paper: white Dutch Etching, mould-made

Plate preparation, processing, and printing by Rodney Konopaki, Paul Sanders, and Kenneth Tyler

Signed *Frankenthaler* and dated in pencil lower right; titled lower left; chop mark lower right

4 runs: 5 colors; 4 runs from 4 copper plates:
 1. transparent yellow-ocher; method 9 (RK); IV
 2. brown; method 7; IV
 3. brown-green; method 7; IV
 4. red and purple; methods 6, 16a; IV

190:HF14
Krens 64.17

Helen Frankenthaler
Experimental Impression VIII 1978

Monoprint

20 × 31 (50.8 × 78.7)

Paper: white Dutch Etching, mould-made

Plate preparation, processing, and printing by Rodney Konopaki, Paul Sanders, and Kenneth Tyler

Signed *Frankenthaler* and dated in pencil lower right; titled lower left; chop mark lower right

4 runs: 6 colors; 4 runs from 4 copper plates:
 1. transparent yellow-ocher; method 9 (RK); IV
 2. red-ocher; method 7; IV
 3. blend of brown-green and transparent brown-green; methods 7, 16a; IV
 4. red and purple; methods 6, 16a; IV

191:HF15
Krens 64.18

Helen Frankenthaler
Experimental Impression IX 1978

Monoprint

14 × 27⅞ (35.6 × 70.8)

Paper: white Dutch Etching, mould-made

Plate preparation, processing, and printing by Rodney Konopaki, Paul Sanders, and Kenneth Tyler

Signed *Frankenthaler* and dated in pencil lower right; titled lower left; chop mark lower right

1 run: 1 color; 1 run from 1 copper plate:
 1 brown-green; method 7; IV

192:HF16
Krens 65

Helen Frankenthaler
Ganymede 1978

Etching, aquatint (6)
22½ × 16½ (57.2 × 41.9)
Paper: white Arches Cover, mould-made
Edition: 49
Proofs: 12AP, 3SP, 2WP, RTP, PPI, A, C, 6RP

Plate preparation and processing by Rodney Konopaki and Paul Sanders; proofing and edition printing by Konopaki

Signed *Frankenthaler* and dated in pencil lower right; numbered lower left; chop mark lower right; workshop number HF76-289 lower left verso

4 runs: 6 colors; 4 runs from 4 copper plates:
1 blend of transparent yellow-ocher and dark yellow-ocher; methods 9 (RK), 16a; IV
2 red and blue; methods 8, 16a; IV
3 red; method 7; IV
4 yellow-orange; method 7; IV

193:HF17
Krens 68

Helen Frankenthaler
Untitled (Cleveland Orchestra Print) 1978

Screenprint (8)
22½ × 30 (57.2 × 76.2)
Paper: white Arches Cover, mould-made
Edition: 150
Proofs: 25AP, RTP, PPI, A, C

Screen preparation, processing, proofing, and edition printing by Kim Halliday

Signed *Frankenthaler*, numbered, and dated in pencil lower left; chop mark lower right; workshop number HF78-290 lower left verso

8 runs: 8 colors; 8 runs from 8 screens:
1 light yellow-orange; method 28 (KH); VI
2 dark brown; method 26; VI
3 red-orange; method 26; VI
4 yellow-ocher; method 26; VI
5 magenta; method 26; VI
6 dark brown-red; method 26; VI
7 red-orange; method 26; VI
8 brown-red; method 30c (KH); VI

194:HF18
Krens 70

Helen Frankenthaler
Sure Violet 1979

Etching, aquatint, drypoint (12)
31 × 43 (78.7 × 109.2)
Paper: white TGL, handmade
Edition: 50
Proofs: 9AP, 16CTP, SP, RTP, PPI, A

Papermaking by Steve Reeves and Lee Funderburg; plate preparation, processing, proofing, and edition printing by Rodney Konopaki

Signed *Frankenthaler* and dated in pencil lower right; numbered lower left; chop mark lower left; workshop number HF77-382 lower right verso

4 runs: 12 colors; 4 runs from 3 copper plates:
1 red, violet, mauve, and light tan; methods 7, 9 (RK), 16a; IV
2 red, transparent violet, transparent thalo blue, Prussian blue, turquoise blue, and blue-green; methods 7, 9 (RK), 6, 16a; IV
3 dark red; methods 7, 9 (RK), 6 (same plate as run 2; plate turned 180° and partially inked for printing); IV
4 red; method 13; IV

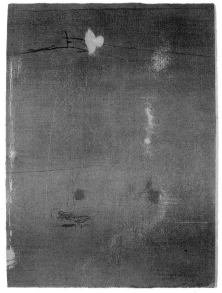

MONOPRINT, MONOTYPE SERIES

195:HF19

Helen Frankenthaler
Cameo 1980

Woodcut (8)
42 × 32 (106.7 × 81.3)
Paper: gray-pink TGL, handmade
Edition: 51
Proofs: 10AP, 8TP, SP, 5WP, RTP, PPI, PPII, A, C, 10RP

Papermaking by Steve Reeves and Tom Strianese; proofing by Kenneth Tyler, Roger Campbell, and Lee Funderburg; edition printing by Campbell and Funderburg

Signed *Frankenthaler* and numbered in pencil lower right; chop mark lower left; workshop number HF80-510 lower right verso

5 runs: 8 colors; 5 runs from 5 woodblocks:
1 blend of light blue and dark blue; methods 19a, 19b (Russian plywood), 16d; IIa
2 blend of light pink and dark pink; methods 19a, 19b (pinewood), 16d; IIa
3 brown-red and pink; methods 19a, 19b (Russian plywood), 16g; IIa
4 magenta; methods 19a, 19b (Russian plywood); IIa
5 pink; methods 19a, 19b (pinewood); IIa

Helen Frankenthaler made a group of twelve monoprints and monotypes in 1981, using partially printed proofs from the edition print *Cameo* (195:HF19) and assorted handmade papers. The monoprints numbered I through VIII combined the *Cameo* proofs with additional color printing from the woodblocks used for the edition and from one uncarved block. The monotypes numbered IX through XII were pulled from a polished magnesium plate that the artist painted on with lithographic inks mixed with solvents and varnishes. Frankenthaler hand-colored all of the works after printing, using lithographic inks, pastels, and Paintstiks. All of the impressions were printed on a flatbed offset press by Kenneth Tyler, Roger Campbell, and Lee Funderburg, on Suzuki, Mulberry, Gampi, Richard de Bas, Maniai, and TGL handmade papers.

 Each work is signed *Frankenthaler* and dated in pencil lower right, with the chop mark lower right. Some are also titled lower left.

196:HF20

Helen Frankenthaler
Monoprint I, from the Monoprint, Monotype Series 1981

Monoprint
25 × 32½ (63.5 × 82.6)
Paper: white Suzuki, handmade

Press assistance by Kenneth Tyler, Roger Campbell, and Lee Funderburg

Signed *Frankenthaler* and dated in pencil lower right; titled lower left; chop mark lower right

Ink colors on woodblocks used for the edition printing of *Cameo* and on 1 uncarved woodblock; IIa

The artist hand-colored the print using lithographic inks, pastels, and Paintstiks.

197:HF22

Helen Frankenthaler
Monoprint III, from the Monoprint,
Monotype Series 1981

Monoprint
42¾ × 33½ (108.6 × 85.1)
Paper: white Suzuki, handmade

Press assistance by Kenneth Tyler, Roger
Campbell, and Lee Funderburg

Signed *Frankenthaler* and dated in pencil
lower right; titled lower left; chop mark
lower right

Ink colors on woodblocks used for the
edition printing of *Cameo* and on 1
uncarved woodblock; IIa

The artist hand-colored the print using lith-
ographic inks, pastels, and Paintstiks.

198:HF26

Helen Frankenthaler
Monoprint VII, from the Monoprint,
Monotype Series 1981

Monoprint
42½ × 33½ (108 × 85.1)
Paper: white Suzuki, handmade

Press assistance by Kenneth Tyler, Roger
Campbell, and Lee Funderburg

Signed *Frankenthaler* and dated in pencil
lower right; chop mark lower right

Ink colors on woodblocks used for the
edition printing of *Cameo* and on 1
uncarved woodblock; IIa

The artist hand-colored the print using lith-
ographic inks, pastels, and Paintstiks.

199:HF28

Helen Frankenthaler
Monotype IX, from the Monoprint,
Monotype Series 1981

Monotype
19 × 39¼ (48.3 × 99.7)
Paper: buff Maniai, handmade

Press assistance by Kenneth Tyler, Roger
Campbell, and Lee Funderburg

Signed *Frankenthaler* and dated in pencil
lower right; chop mark lower right

Ink colors painted on a polished magne-
sium plate; IIa

The artist hand-colored the print using lith-
ographic inks, pastels, and Paintstiks.

200:HF32

Helen Frankenthaler
The Red Sea 1982

Lithograph (8)

24 × 28 (61 × 71.1)

Paper: pink HMP, handmade

Edition: 58

Proofs: 14AP, 8CTP, 7WP, RTP, PPI, PPII, A, C

Stone preparation, processing, and proofing by Kenneth Tyler on press I; plate preparation, processing, and proofing by Lee Funderburg and Tyler on press I; proofing by Funderburg, Tyler, and Roger Campbell on press II; edition printing by Campbell and Funderburg on press II

Signed *Frankenthaler* and dated in pencil lower right; numbered lower left; chop mark lower right; workshop number HF78-381 lower left verso

8 runs: 8 colors; 8 runs from 4 stones and 4 aluminum plates:
1 pink; method 5b (KT); IIa
2 red; method 1a; IIa
3 magenta; method 1a; IIa
4 light magenta; method 2a; IIa
5 yellow; method 1a; IIa
6 red; method 5a; IIa
7 dark magenta; method 5a; IIa
8 orange; method 5a; IIa

CTPs 7 and 8 are signed, and CTPs 1–6 are not.

201:HF33

Helen Frankenthaler
Deep Sun 1983

Etching, aquatint, drypoint, engraving, mezzotint (22)

30 × 40½ (76.2 × 102.9)

Paper: white St. Armand, handmade

Edition: 54

Proofs: 16AP, 5TP, 4PP, 8WP, RTP, PPI, PPII, A, C, 3RP

Plate preparation and processing by Rodney Konopaki and Kenneth Tyler; proofing by Konopaki, Bob Cross, and Tyler; edition printing by Konopaki and Cross

Signed *Frankenthaler* and dated lower right; numbered lower left; chop mark lower right; workshop number HF82-679 lower left verso

13 runs: 22 colors; 13 runs from 12 copper plates:
1 magenta; methods 9 (RK), 10, 6; IV
2 magenta; method 12; IV
3 orange-pink and dark red-brown; methods 9 (RK), 10, 14, 8, 16a; IV
4 black; methods 9 (RK), 14, 12, 10; IV
5 yellow, medium yellow, and dark yellow; methods 9 (RK), 10, 6, 16a; IV
6 yellow and dark yellow; methods 9 (RK), 10, 12, 16a; IV
7 repeat of run 6
8 dark orange; methods 9 (RK), 10; IV
9 blue-black; methods 11c, 6, 8, 12, 9 (RK), 10; IV
10 dark orange; methods 6, 12; IV
11 dark orange; method 8; IV
12 yellow, red, and pink; methods 8, 16a; IV
13 yellow, red, and pink; methods 6, 9 (RK), 12, 16a; IV

Calibrate 1981
See 210:NG9 (opposite)

Nancy Graves

210:NG9

Nancy Graves
Calibrate 1981

Etching, aquatint, engraving, lithograph
(16)

29¼ × 32½ (74.3 × 82.6)	

Paper: white Lana, mould-made

Edition: 30

Proofs: 12AP, 2TP, RTP, PPI, A, C

Stone preparation, processing, proofing, and edition printing by Kenneth Tyler; plate preparation, processing, proofing, and edition printing by Rodney Konopaki

Signed *N. S. Graves* and dated in pencil lower right; numbered lower left; chop mark lower right; workshop number NG77-551 lower left verso

7 runs: 16 colors; 7 runs from 1 stone, 1 zinc plate, and 5 copper plates:
1 violet; method 1a; I
2 red and violet-red; methods 6, 9 (RK), 16a; IV
3 medium blue, ultramarine blue, Prussian blue, and black; methods 8, 6, 9 (RK), 16a; IV
4 turquoise blue; methods 6, 9 (RK); IV
5 yellow; methods 6, 9 (RK), 12; IV
6 light blue, blue, dark blue, green, and gray-green; methods 6, 9 (RK), 12, 16a; IV
7 dark brown-green and white; methods 6 (zinc plate), 16a; IV

1940 Born in Pittsfield, Massachusetts

1959 Receives fellowship in painting to Yale-Norfolk Summer Art School

1961 Receives B.A. in English literature from Vassar College, Poughkeepsie, New York

1961–64 Studies at School of Art and Architecture, Yale University, New Haven, Connecticut; receives B.F.A. in 1962 and M.F.A. in 1964

1964 Receives Fulbright-Hayes Grant in painting to study in Paris for a year

1965 Lives and works in Florence; completes first camel sculpture

1966 Moves to New York; teaches for two years at Fairleigh Dickinson University, Madison, New Jersey

1968 First solo sculpture exhibition at Graham Gallery, New York

1969 Exhibition *Nancy Graves: Camels* at Whitney Museum of American Art, New York

1970 Completes first of five films, working with Linda Leeds as adviser and editor

1971 Receives Vassar College fellowship; teaches at San Francisco Art Institute; exhibition *Projects: Nancy Graves* at Museum of Modern Art, New York

1972 Completes screenprints based on geologic maps of the moon at Landfall Press, Chicago; receives National Endowment for the Arts grant

1976 Receives Skowhegan Medal for sculpture

1977 Completes hand-colored intaglio prints at Tyler Graphics; begins collaboration with Dick Polich at Tallix Foundry, Peekskill, New York; included in exhibition *Art Off the Picture Press* at Emily Lowe Gallery, Hofstra University, New York

1979 Artist-in-residence, American Academy of Arts and Letters, Rome; completes intaglio prints at 2RC Editrice, Rome

1980 Traveling exhibition *Nancy Graves: A Survey, 1969–1980*, originating at Albright-Knox Art Gallery, Buffalo

1981 Completes monoprint series and lithographs at Tyler Graphics

1983 Completes enameled sculptures at Tallix Foundry, Beacon, New York

1984 Included in exhibition *Prints from Tyler Graphics* at Walker Art Center, Minneapolis

1985 Included in exhibition *Ken Tyler: Printer Extraordinary* at Australian National Gallery, Canberra; designs sets for Trisha Brown's *Lateral Pass*, for which she receives a New York Dance and Performance Bessie Award (1986); receives Yale Arts Award for distinguished achievement

Currently lives and works in New York

202:NG1

Nancy Graves
Saille 1977

Etching, aquatint, hand-colored (14)
31½ × 35½ (80 × 90.2)
Paper: white Arches Cover, mould-made
Edition: 27
Proofs: 10AP, 3TP, RTP, PPI, A, C

Plate preparation, processing, proofing, and edition printing by Rodney Konopaki assisted by Paul Sanders

Signed *N. S. Graves* and dated in pencil lower right; numbered lower left; chop mark lower right; workshop number NG77-335 lower left verso

3 runs: 13 colors; 3 runs from 3 copper plates:
 1 pale yellow-ocher; method 6; IV
 2 pale yellow-green and light green; methods 6, 9 (RK), 16a; IV
 3 dark orange, yellow-ocher, red, violet-red, light violet, cobalt blue, light turquoise blue, turquoise blue, brown-green, and black; methods 6, 9 (RK), 16a; IV

The artist used a clear plastic stencil to register the purple pastel drawing she made on the edition prints.

203:NG2

Nancy Graves
Onon 1977

Etching, aquatint, drypoint, engraving, hand-colored (15)
31½ × 35½ (80 × 90.2)
Paper: white Arches Cover, mould-made
Edition: 29
Proofs: 10AP, 3TP, RTP, PPI, A, C

Plate preparation, processing, proofing, and edition printing by Rodney Konopaki assisted by Paul Sanders

Signed *N. S. Graves* and dated in pencil lower right; numbered lower left; chop mark lower right; workshop number NG77-336 lower left verso

4 runs: 13 colors; 4 runs from 4 copper plates:
 1 transparent red, transparent light violet, transparent violet, and transparent blue-purple; methods 6, 9 (RK), 16a; IV
 2 purple; methods 13, 12; IV
 3 pale yellow, medium yellow, pink, violet, cobalt blue, turquoise blue, and black; methods 6, 9 (RK), 16a; IV
 4 transparent yellow; method 9 (RK); IV

The artist used a clear plastic stencil to register the light yellow-green and blue-green pastel drawing she made on the edition prints.

204:NG3

Nancy Graves
Toch 1977

Etching, aquatint, drypoint, engraving, hand-colored (13)
31½ × 35½ (80 × 90.2)
Paper: white Arches Cover, mould-made
Edition: 28
Proofs: 11AP, 3TP, 2CTP, SP, RTP, PPI, A, C

Plate preparation and processing by Rodney Konopaki; proofing by Konopaki and Kenneth Tyler; edition printing by Konopaki

Signed *N. S. Graves* and dated in pencil lower right; numbered lower left; chop mark lower right; workshop number NG77-337 lower left verso

3 runs: 12 colors; 3 runs from 3 copper plates:
 1 transparent pink, transparent red-ocher, transparent orange-brown, transparent turquoise blue, transparent yellow-green, and transparent green; methods 9 (RK), 6, 16a; IV
 2 transparent yellow, transparent red, transparent violet, and transparent gray-blue; methods 9 (RK), 16a; IV
 3 transparent orange-red and transparent gray; methods 8, 6, 9 (RK), 13, 12, 16a; IV

The artist used a clear plastic stencil to register the cobalt blue pastel drawing she made on the edition prints.

205:NG4

Nancy Graves
Muin 1977

Etching, aquatint, drypoint, hand-colored
(18)
31½ × 35½ (80 × 90.2)
Paper: white Arches Cover, mould-made
Edition: 32
Proofs: 10AP, 4TP, SP, RTP, PPI, A, C

Plate preparation, processing, proofing, and
edition printing by Rodney Konopaki
assisted by Paul Sanders

Signed *N. S. Graves* and dated in pencil
lower right; numbered lower left; chop
mark lower right; workshop number
NG77-338 lower left verso

4 runs: 16 colors; 4 runs from 4 copper
plates:
 1 transparent blue–green-gray; method
 6; IV
 2 transparent yellow and transparent
 pink-orange; methods 9 (RK), 16a; IV
 3 pale yellow-orange, pink, medium
 purple, light gray-tan, turquoise blue,
 brown-green, and light blue-green;
 methods 6, 9 (RK), 13, 16a; IV
 4 transparent orange, medium red, light
 violet, light green, medium gray, and
 black; methods 6, 9 (RK), 13, 16a; IV

The artist used a clear plastic stencil to
register the yellow and white pastel drawing
she made on the edition prints.

206:NG5

Nancy Graves
Ngetal 1977

Etching, aquatint, engraving, drypoint,
hand-colored (20)
31½ × 35½ (80 × 90.2)
Paper: white Arches Cover, mould-made
Edition: 33
Proofs: 9AP, 3TP, 4CTP, SP, 2WP, RTP,
PPI, A, C

Plate preparation, processing, proofing, and
edition printing by Rodney Konopaki
assisted by Paul Sanders

Signed *N. S. Graves* and dated in pencil
lower right; numbered lower left; chop
mark lower right; workshop number
NG77-339 lower left verso

3 runs: 16 colors; 3 runs from 3 copper
plates:
 1 orange-red, light pink, blue-purple,
 yellow-green, and black; methods 6, 9
 (RK), 12, 16a; IV
 2 light yellow, red, cobalt blue, and black;
 methods 6, 13, 16a; IV
 3 medium yellow, medium orange, dark
 orange, turquoise blue, yellow-green,
 blue-green, and light blue-gray;
 methods 6, 16a; IV

The artist used a clear plastic stencil to
register the dark orange, yellow-green,
medium blue, and violet–blue-gray pastel
drawing she made on the edition prints.

207:NG6

Nancy Graves
Ruis 1977

Etching, aquatint, engraving, hand-colored
(9)
31½ × 35½ (80 × 90.2)
Paper: white Arches Cover, mould-made
Edition: 33
Proofs: 10AP, 2TP, SP, RTP, PPI, A, C

Plate preparation, processing, proofing, and
edition printing by Rodney Konopaki

Signed *N. S. Graves* and dated in pencil
lower right; numbered lower left; chop
mark lower right; workshop number
NG77-340 lower left verso

5 runs: 7 colors; 5 runs from 5 copper
plates:
 1 light transparent blue-gray and
 medium silver-gray; methods 9 (RK),
 16a; IV
 2 transparent blue-green; method 9
 (RK); IV
 3 medium purple; method 6; IV
 4 light blue-green; methods 6, 12; IV
 5 yellow and black; methods 6, 12, 16a;
 IV

The artist used a clear plastic stencil to
register the orange-red and black pastel
drawing she made on the edition prints.

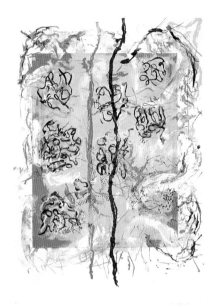

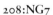

208:NG7

Nancy Graves
Approaches the Limit of I 1981

Lithograph (9)
46 × 31¾ (116.8 × 80.6)
Paper: white Arches Cover, mould-made
Edition: 30
Proofs: 14AP, RTP, PPI, PPII, A, C

Plate preparation, processing, and proofing
by Kenneth Tyler on press I; photo plate
preparation and processing by Lee Funder-
burg; proofing and edition printing by
Roger Campbell and Funderburg on press
II

Signed *N. S. Graves* and dated in pencil
lower right; numbered lower left; chop
mark lower right; workshop number
NG80-553A lower left verso

8 runs: 9 colors; 8 runs from 8 aluminum
plates:
 1 transparent pink; method 5a (LF); IIa
 2 orange-red; method 1b; IIa
 3 turquoise blue; method 1b; IIa
 4 dark blue; method 1b; IIa
 5 black; method 1b; IIa
 6 white; method 1b; IIa
 7 blend of medium yellow and medium
 orange-yellow; methods 1b, 16d; IIa
 8 white; method 1b; IIa

209:NG8

Nancy Graves
Approaches the Limit of II 1981

Lithograph, etching (17)
48 × 31⅝ (121.9 × 80.3)
Paper: white Arches Cover, mould-made
Edition: 30
Proofs: 14AP, RTP, PPI, PPII, A, C

Plate preparation, processing, and proofing
by Kenneth Tyler on press I; photo plate
preparation and processing by Lee Funder-
burg; proofing and edition printing by
Roger Campbell and Funderburg on press
II; magnesium plate preparation by Tyler,
with processing by Pete Duchess and
edition printing by Campbell and
Funderburg

Signed *N. S. Graves* and dated in pencil
lower right; numbered lower left; chop
mark lower right; workshop number
NG80-553 lower left verso

14 runs: 17 colors; 14 runs from 1 magne-
sium plate and 13 aluminum plates:
 1 transparent pink; method 1b; IIa
 2 transparent orange-red; method 5a
 (LF); IIa
 3 orange; method 5c (LF); IIa
 4 red; method 1b; IIa
 5 turquoise blue; method 1b; IIa
 6 blend of medium yellow and medium
 orange-yellow; methods 1b, 16d; IIa
 7 dark blue; method 1b; IIa
 8 violet; method 1b; IIa
 9 red-brown; method 1b; IIa

10 yellow-pink; method 1b; IIa
11 light orange; method 1b; IIa
12 gray-green; method 1b; IIa
13 white; method 1b; IIa
14 dark red, dark purple, and dark blue;
 methods 20, 16a; III

210:NG9

Nancy Graves
Calibrate 1981

See pp. 140–41

MONOPRINT SERIES

To make the series of thirty-one monoprints completed in 1981, Nancy Graves drew linear images on two magnesium plates, which were then etched deeply. Choosing from a palette of colors, she brushed ink into the etched lines. Rodney Konopaki, assisting, finish-wiped and printed the plates on an etching press on white and colored TGL papers. Graves also painted on a polished magnesium plate, which she used separately and in combination with the two etched plates. The polished magnesium plate was inked either with a flat color or with a color blend and printed on top of some of the monoprints on a flatbed offset press by Kenneth Tyler, Lee Funderburg, and Roger Campbell. Inking, printing sequence, and presses varied from impression to impression. Graves painted many of the impressions with printing inks thinned with varnishes and solvents.

Each work is signed *N. S. Graves* and dated in pencil, with the chop mark lower right.

211:NG12

Nancy Graves
Nomer 1981

Monoprint

32 × 38 (81.3 × 96.5)	
Paper: white TGL, handmade	

Papermaking by Steve Reeves and Tom Strianese; plate preparation and processing by Rodney Konopaki; printing by Konopaki on press IV and by Kenneth Tyler, Lee Funderburg, and Roger Campbell on press II

Signed *N. S. Graves* and dated in pencil lower left; chop mark lower right; workshop number lower left verso

2 runs: ink colors; 2 runs from 2 magnesium plates:
 1 ink colors; methods 20, 23c; IV
 2 ink colors painted on polished plate; IIa

Before printing, the artist painted on the paper with printing inks thinned with varnishes and solvents.

212:NG16

Nancy Graves
Ceive 1981

Monoprint

30 × 40 (76.2 × 101.6)	
Paper: yellow-tan TGL, handmade	

Papermaking by Steve Reeves and Tom Strianese; plate preparation and processing by Rodney Konopaki; printing by Konopaki on press IV and by Kenneth Tyler, Lee Funderburg, and Roger Campbell on press II

Signed *N. S. Graves* and dated in pencil lower left; chop mark lower right; workshop number lower left verso

2 runs: ink colors; 2 runs from 2 magnesium plates:
 1 ink colors; methods 20, 23c; IV
 2 ink colors painted on polished plate; IIa

Before and after printing, the artist painted on the paper with printing inks thinned with varnishes and solvents.

213:NG23

Nancy Graves
Owad 1981

Monoprint
31¾ × 43¾ (80.6 × 111.1)
Paper: blue TGL, handmade

Papermaking by Steve Reeves and Tom Strianese; plate preparation and processing by Rodney Konopaki; printing by Konopaki on press IV and by Kenneth Tyler, Lee Funderburg, and Roger Campbell on press II

Signed *N. S. Graves* and dated in pencil upper left; chop mark lower right; workshop number lower left verso

2 runs: ink colors; 2 runs from 2 magnesium plates:
 1 ink colors; methods 20, 23c; IV
 2 ink colors painted on polished plate; IIa

The artist painted on the print with printing inks thinned with varnishes and solvents.

214:NG26

Nancy Graves
Tate 1981

Monoprint
44 × 32 (111.8 × 81.3)
Paper: light pink TGL, handmade

Papermaking by Steve Reeves and Tom Strianese; plate preparation, processing, and printing by Rodney Konopaki

Signed *N. S. Graves* and dated in pencil lower right; chop mark lower right; workshop number lower left verso

2 runs: ink colors; 2 runs from 2 magnesium plates:
 1 ink colors; methods 20, 23c; IV
 2 ink colors; methods 20, 23c; IV

The artist painted on the print with printing inks thinned with varnishes and solvents.

215:NG30

Nancy Graves
Merab 1981

Monoprint
30¼ × 40¼ (76.8 × 102.2)
Paper: light orange TGL, handmade

Papermaking by Steve Reeves and Tom Strianese; plate preparation, processing, and printing by Rodney Konopaki

Signed *N. S. Graves* and dated in pencil lower left; chop mark lower right; workshop number lower left verso

2 runs: ink colors; 2 runs from 2 magnesium plates:
 1 ink colors; methods 20, 23c; IV
 2 ink colors; methods 20, 23c; IV

Before and after printing, the artist painted on the paper with printing inks thinned with varnishes and solvents.

216:NG31

Nancy Graves
Turnal 1981

Monoprint
42 × 29 (106.7 × 73.7)
Paper: light gray TGL, handmade

Papermaking by Steve Reeves and Tom Strianese; plate preparation and processing by Rodney Konopaki; printing by Kenneth Tyler, Lee Funderburg, and Roger Campbell

Signed *N. S. Graves* and dated in pencil lower left; chop mark lower right; workshop number lower left verso

1 run: ink colors; 1 run from 1 magnesium plate:
 1 ink colors and blend of gray and black; methods 20, 23c, 16d; IIa

The artist painted on the print with printing inks thinned with varnishes and solvents.

217:NG34

Nancy Graves
Gling 1981

Monoprint
Two sheets: 30 × 49 (76.2 × 124.5)
Paper: white TGL, handmade

Papermaking by Steve Reeves and Tom Strianese; plate preparation, processing, and printing by Rodney Konopaki

Signed *N. S. Graves* and dated in pencil upper left; chop mark lower right; workshop number lower left verso

1 run: 2 colors; 1 run from 2 magnesium plates printed simultaneously:
 1 light orange-tan and brown-green (2 sheets printed simultaneously); methods 20, 23a; IV

Before and after printing, the artist painted on the two sheets with printing inks thinned with varnishes and solvents.

218:NG36

Nancy Graves
Mosphe 1981

Monoprint
32¼ × 43½ (81.9 × 110.5)
Paper: light blue TGL, handmade

Papermaking by Steve Reeves and Tom Strianese; plate preparation and processing by Rodney Konopaki; printing by Konopaki on press IV and by Kenneth Tyler, Lee Funderburg, and Roger Campbell on press II

Signed *N. S. Graves* and dated in pencil lower left; chop mark lower right; workshop number lower left verso

2 runs: ink colors; 2 runs from 2 magnesium plates:
 1 ink colors painted on polished plate; IV
 2 blend of light transparent blue and light blue; methods 20, 23c, 16d; IIa

Before printing, the artist painted on the paper with printing inks thinned with varnishes and solvents.

Flower-Piece B 1976
See 219:RH1

Richard Hamilton

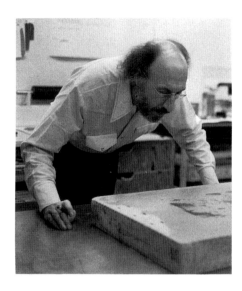

1922 Born in London

1936 Leaves elementary school; attends evening classes in art at Westminster Technical College and St. Martin's School of Art, London

1937 Engaged in display department of Reinmann Studios Art School, London

1938–40 Studies painting at Royal Academy Schools, London

1939 Completes first print, *Figure Composition*, drypoint on celluloid, at Central School of Arts and Crafts, London

1940 Studies engineering draftsmanship

1941–45 Works as jig and tool draftsman

1946 Resumes studies at Royal Academy but is expelled; begins eighteen months of military service

1948–51 Studies at Slade School of Fine Art, London

1951 Organizes exhibition *Growth and Form* at Institute of Contemporary Arts, London

1953 Teaches basic design and lectures at King's College, University of Durham, Durham, England

1955 Organizes exhibition *Man, Machine, and Motion* at Hatton Gallery, Newcastle-upon-Tyne, England

1956 Organizes exhibition *This Is Tomorrow* at Whitechapel Art Gallery, London; completes collage *Just What Is It That Makes Today's Homes So Different, So Appealing?*

1962 Completes first screenprint *Adonis in Y Fronts* at Kelpra Studio, London, published by the artist

1963 Visits United States; completes screenprint *Five Tyres Abandoned* at Kelpra Studio, London, published by Institute of Contemporary Arts, London

1965 Begins reconstruction of Marcel Duchamp's *Large Glass*; completes screenprints at Kelpra Studio, London, published by Editions Alecto, London

1966 Organizes exhibition *The Almost Complete Works of Marcel Duchamp* at Tate Gallery, London

1967 Exhibition of drawings and prints at Galerie Ricke, Kassel, West Germany; completes screenprints *I'm Dreaming of a White Christmas* at Editions Domberger, Stuttgart, West Germany

1969 Collaborates with James Scott on twenty-five-minute film about his work; completes Swingeing London 67 mixed-media print series at Petersburg Press Ltd., London; completes Cosmetic Studies at Studio Marconi, Milan

1970 Retrospective exhibition at Tate Gallery, London

1970–71 Completes screenprint over collotype *A Portrait of the Artist by Francis Bacon*, published by Petersburg Press Ltd., London

1972 Solo exhibition at Institute of Contemporary Arts, London

1973 Completes intaglio print *Picasso's Meninas* at Atelier Crommelynck, Paris, published by Propyläen Verlag, Berlin

1973–74 Completes Flower-Piece prints at Atelier Crommelynck, Paris

1974–75 Continues to work with Flower-Piece imagery and completes collotype and collotype-screenprints (collotype printing at E. Schrieber, Stuttgart, West Germany, and screen printing at Frank Kicherer, Stuttgart; prints published by the artist)

1976 Continues to work with Flower-Piece imagery and completes lithographs at Tyler Graphics

1977 Included in exhibition *Art Off the Picture Press* at Emily Lowe Gallery, Hofstra University, New York

1978 Retrospective exhibition of prints at Vancouver Art Museum

1980 Traveling solo exhibition *Interiors*, organized by Waddington Graphics, London

1982 *Collected Words, 1953–1982* published by Thames and Hudson; publishes first in a series of twelve proposed etchings based on James Joyce's *Ulysses*

1983 Traveling exhibition of prints *Richard Hamilton: Image and Process, 1952–1982*, organized by Tate Gallery, London

1984 Included in exhibition *Prints from Tyler Graphics* at Walker Art Center, Minneapolis; traveling retrospective exhibition of prints, organized by Waddington Graphics, London

Currently lives and works in London

219:RH1

Richard Hamilton
Flower-Piece B 1976

Lithograph (11)
25⅝ × 19¾ (65 × 50.2)
Paper: white Arches Cover, mould-made
Edition: 75
Proofs: 16AP, 8TP, 6CTP, 30PP (2 sets of 15), RTP, A, C

Stone and plate preparation, processing, and proofing by Kenneth Tyler on press I; edition printing by Tyler assisted by John Hutcheson on press I; edition printing by Hutcheson on press II

Signed *R. Hamilton* and numbered in pencil lower right; titled lower left; chop mark lower right; workshop number RH75-201 lower left verso

11 runs: 11 colors; 11 runs from 6 stones and 4 aluminum plates:
 1 transparent process yellow; method 1a; I
 2 transparent process yellow; method 1a; I
 3 transparent process yellow; method 3a; IIa
 4 process magenta; method 1a; I
 5 transparent process magenta; method 1a; I
 6 blue-magenta; method 3a; I
 7 process blue; method 1a; I
 8 transparent process blue; method 1a; I
 9 transparent process blue; method 3a; IIa
 10 white; method 3a; I
 11 white; method 3a (same plate as run 10); I

As an aid for color registration, each of the ten printing elements was screen-printed with a partial image using blue-dyed gum arabic. Two commercial screen stencils were prepared from a drawing made by Hamilton for this preparatory step.

220:RH2

Richard Hamilton
Flower-Piece B, Cyan Separation 1976

Lithograph (1)
25⅝ × 19¾ (65.2 × 50.2)
Paper: white Arches Cover, mould-made
Edition: 23
Proofs: 10AP, 4TP, RTP, PPI, A

Stone preparation, processing, and proofing by Kenneth Tyler; edition printing by Robert Bigelow assisted by Tyler

Signed *R. Hamilton* and numbered in pencil lower right; titled lower left; chop mark lower right; workshop number RH75-202 lower left verso

1 run: 1 color; 1 run from 1 stone:
 1 black; method 1a; I

The stone used to print this edition was also used to print the process blue color for *Flower-Piece B, Crayon Study*.

221:RH3

Richard Hamilton
Flower-Piece B, Crayon Study 1976

Lithograph (4)

25⅝ × 19¾ (65 × 50.2)

Paper: white Arches Cover, mould-made

Edition: 34

Proofs: 10AP, TP, 4CTP, RTP, PPI, A, C

Stone preparation, processing, and proofing
by Kenneth Tyler; edition printing by
Robert Bigelow

Signed *R. Hamilton* and numbered in
pencil lower right; titled lower left; chop
mark lower right; workshop number
RH75-203 lower left verso

4 runs: 4 colors; 4 runs from 4 stones:
 1 process yellow; method 1a; I
 2 process magenta; method 1a; I
 3 process blue; method 1a; I
 4 gray-black; method 1a; I

As an aid for color registration, each of the
four printing elements was screen-printed
with a partial image using blue-dyed
gum arabic. One commercial screen stencil
was prepared from a drawing made by
Hamilton for this preparatory step.

222:RH4

Richard Hamilton
Sunset 1976

Lithograph, chine appliqué (2)

16½ × 21⅛ (41.9 × 53.7)

Paper: white Arches Cover, mould-made;
white Gasenchi Echizen, handmade

Edition: 50

Proofs: 12AP, 2TP, RTP, PPI, A, C

Paper preparation and adhering by Kim
Halliday; stone preparation, processing,
proofing, and edition printing by Kenneth
Tyler

Signed *R. Hamilton*, numbered, and titled
in pencil lower right; chop mark lower
right; workshop number RH75-204 lower
left verso

2 runs: 2 colors, including 1 colored paper;
1 run from 1 stone:
 1 white Gasenchi Echizen paper;
 methods 27 (KH), 36b; III
 2 black; method 1a; I

45°, 90°, 180° 1983
See 233:MH82

Michael Heizer

1944 Born in Berkeley, California

1963–64 Attends San Francisco Art Institute

1966 Moves to New York

1968 Completes sculpture and ground paintings and drawings for earthwork *Nine Nevada Depressions;* photographs of project exhibited at Dwan Gallery, New York, and in sculpture annual, Whitney Museum of American Art, New York

1969 First solo exhibition at Heiner Friedrich Gallery, Munich

1969–70 Creates earthwork *Double Negative*, Nevada

1972–74 Creates earthwork *Complex One*, Nevada

1975 Completes Edition and State Edition series at Gemini G.E.L., Los Angeles

1976 Creates earthwork *Adjacent, Against, Upon*, Seattle

1977 Completes Circle series of intaglio prints and lithograph at Tyler Graphics; included in exhibition, *Art Off the Picture Press* at Emily Lowe Gallery, Hofstra University, New York; sculpture *Guennette* commissioned by Metropolitan Museum of Art, New York (originally exhibited at Seagram Plaza, New York, and currently on long-term loan to Massachusetts Institute of Technology, Cambridge)

1977–80 Completes *This Equals That*, Capitol Plaza, Lansing, Michigan

1979 Retrospective exhibition at Folkwang Museum, Essen, West Germany; completes Monotype, Collage Series at Tyler Graphics; completes Scrap Metal Drypoint series at Gemini G.E.L., Los Angeles

1980 Builds first 45°, 90°, 180° sculpture model relating to proposed site project in Montana

1980–83 Completes Swiss Survey lithograph-screenprint series, Montana Survey photoetching-drypoint series, and Platform etching series at Gemini G.E.L., Los Angeles

1982 *North, East, South, West* commissioned by Rockefeller Development Corporation for Wells Fargo Building, Los Angeles; *Levitated Mass* commissioned by IBM for its regional headquarters in New York

1983 Completes 45°, 90°, 180° Monoprint series and mixed-media prints at Tyler Graphics; solo sculpture exhibition *45°, 90°, 180°* at Xavier Fourcade Gallery, New York

1984 Included in exhibition *Prints from Tyler Graphics* at Walker Art Center, Minneapolis; included in exhibition *Gemini G.E.L.: Art and Collaboration* at National Gallery of Art, Washington, D.C.; builds large model *45°, 90°, 180°/Geometric Extraction* for exhibition *Michael Heizer: Sculpture in Reverse* at Museum of Contemporary Art, Los Angeles

1985 Solo exhibition of sculptures *45°, 90°, 180°* at Rice University, Houston; solo exhibition *Michael Heizer: Dragged Mass Geometric* at Whitney Museum of American Art, New York

Currently lives and works in New York and Hiko, Nevada

223:MH1

Michael Heizer
Circle I 1977

Etching, aquatint (1)

41 × 30½ (104.1 × 77.5)

Paper: gray with colored threads HMP, handmade

Edition: 6

Proofs: 2AP, 6TP, RTP, PPI, A

Plate preparation, processing, proofing, and edition printing by Betty Fiske

Signed *Heizer* in pencil lower right; numbered lower left; chop mark lower right; workshop number MH76-272II lower left verso

1 run: 1 color; 1 run from 1 copper plate:
 1 brown; methods 6, 9 (BF); IV

224:MH2

Michael Heizer
Circle II 1977

Etching, aquatint (1)

41 × 30½ (104.1 × 77.5)

Paper: gray with colored threads HMP, handmade

Edition: 21

Proofs: 10AP, 2TP, RTP, PPI, A

Plate preparation, processing, proofing, and edition printing by Betty Fiske

Signed *Heizer* in pencil lower right; numbered lower left; chop mark lower right; workshop number MH76-262III lower left verso

1 run: 1 color; 1 run from 1 copper plate:
 1 black; methods 6, 9 (BF); IV

225:MH3

Michael Heizer
Circle III 1977

Etching, aquatint (1)

41 × 30½ (104.1 × 77.5)

Paper: gray with colored threads HMP, handmade

Edition: 14

Proofs: 6AP, TP, 2CTP, RTP, PPI, A, C

Plate preparation, processing, proofing, and edition printing by Betty Fiske

Signed *Heizer* in pencil lower right, numbered lower left; chop mark lower right; workshop number MH76-273 lower left verso

1 run: 1 color; 1 run from 1 assembled plate made from 8 irregularly shaped copper plates:
 1 black; methods 6, 9 (BF), 15b; IV

Paper Collage Series

226:MH4

Michael Heizer
Circle IV 1977

Lithograph (5)
36½ × 31 (92.7 × 78.7)
Paper: white Rives BFK, mould-made
Edition: 15
Proofs: 6AP, 6TP, 6CTP, RTP, PPI, A, C

Stone and plate preparation, processing, and proofing by Kenneth Tyler on press I; proofing and edition printing by John Hutcheson on press II

Signed *Heizer* in pencil lower right, numbered lower left; chop mark lower right; workshop number MH76-271 lower left verso

5 runs: 5 colors; 5 runs from 4 stones and 1 aluminum plate:
 1 light brown-orange; method 1a; IIa
 2 medium brown-orange; method 1a; IIa
 3 yellow-ocher, method 1a; IIa
 4 yellow-brown; method 1a; IIa
 5 dark-brown; method 1b; IIa

Michael Heizer created twenty-four unique paper collages in April 1979, using cut and torn fragments from different offset lithographic and monotype screen printings he made in 1976 in collaboration with Kenneth Tyler, John Hutcheson, and Kim Halliday. Heizer arranged his cut and torn collage elements and, assisted by Lindsay Green, Rodney Konopaki, and Tyler, glued them onto off-white four-ply rag board. The collages were pressed flat in a platen press. The artist then selected some for hand-coloring with oil and acrylic paints.

Each collage is signed *Heizer* and dated in pencil lower right of center, with the chop mark and series number lower right verso.

227:MH17

Michael Heizer
#13 Untitled, from the Monotype, Collage Series 1979

Monotype, collage
30 × 30 (76.2 × 76.2)
Paper: white Rives BFK, mould-made; mounted on four-ply white rag board

Press assistance for lithographs and monotype screenprints made in 1976 by Kenneth Tyler, John Hutcheson, and Kim Halliday; collage project assistance by Lindsay Green, Rodney Konopaki, and Tyler

Signed *Heizer* and dated in pencil lower right of center; chop mark and series number lower right verso

Cut and torn elements made from lithographs and monotype screenprints; method 36a; III

45°, 90°, 180°
MONOPRINTS

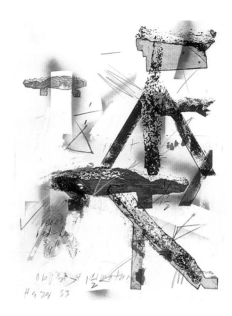

Michael Heizer completed a group of fifty-three unique works entitled 45°, 90°, 180° Monoprints in 1983. The monoprints were printed from four irregularly cut, photoetched magnesium plates, hand-drawn screens and photo screens, and assorted rubber stamps made from Heizer's drawings and from found objects. The title refers to the sculpture site 45°, 90°, 180°, which the artist developed in Montana. The photographs used for the etched magnesium plates were of sculptural models relating to the site. Rodney Konopaki and Bob Cross printed the plates and screens. Heizer hand-colored the monoprints with Paintstiks, graphite, colored pencils, crayons, and acrylic paints. The artist, assisted by Kenneth Tyler, stamped and spray-painted sections of the prints with acrylic colors.

The works in the series are grouped in nine categories, each designated by a Roman numeral, and each work within a category is numbered with an Arabic numeral (I: four works; II: ten works; III: nine works; V: four works; VI: three works; VII: fifteen works; VIII: six works; IX: one work; X: one work). Each monoprint is signed *Heizer* and dated lower right or left, with the chop mark next to the signature and the series number verso.

228:MH50

Michael Heizer
III-8, from 45°, 90°, 180° Monoprints
1983

Monoprint, hand-colored
Two sheets: 25¾ × 47 (65.4 × 119.4); each: 25¾ × 23½ (65.4 × 59.7)
Paper: white TGL, handmade

Papermaking by Steve Reeves and Tom Strianese; preparation of magnesium plates and rubber stamps by Swan Engraving; printing of plates by Rodney Konopaki, Bob Cross, and Kenneth Tyler; project assistance by Tyler, Konopaki, and Cross

Signed *Heizer* and dated in pencil lower right of right panel; chop mark lower right of right panel; series number (with right ["r"] or left ["l"] indicated) lower left verso of each panel

6 runs: 9 ink colors; 5 runs from 3 magnesium plates:
1 black; methods 21c, 23b; III
2 black; methods 21c, 23b; III
3 black; methods 21c, 23b; III
 [runs 1–3 on left panel]
4 turquoise blue; methods 21c, 23b (same plate as run 1), 16a; III
5 red and brown; methods 21c, 23b (same plate as run 2), 16a; III
6 yellow, pink, and black; method 33 (4 rubber stamps)
 [runs 4–6 on right panel]
During and after printing, the artist hand-colored the panels with colored pencils, Paintstiks, and liquid and spray acrylic paints.

229:MH52

Michael Heizer
V-1, from 45°, 90°, 180° Monoprints
1983

Monoprint, hand-colored
36¾ × 29 (93.3 × 73.7)
Paper: white TGL, handmade

Papermaking by Steve Reeves and Tom Strianese; preparation of magnesium plates and rubber stamps by Swan Engraving; printing of plates by Rodney Konopaki, Bob Cross, and Kenneth Tyler; project assistance by Tyler, Konopaki, and Cross

Signed *Heizer* and dated in pencil lower left; chop mark lower left; series number lower right verso

5 runs: 11 ink colors; 4 runs from 4 magnesium plates:
1 black; methods 21c, 23b; III
2 black; methods 21c, 23b; III
3 black; methods 21c, 23b; III
4 black; methods 21c, 23b; III
5 yellow, orange, red, orange-brown, red-brown, brown, green; method 33 (5 rubber stamps)

During and after printing, the artist hand-colored the work with colored pencils, graphite, acrylic paints, and acrylic spray paints.

230:MH71

Michael Heizer
VII-13, from 45°, 90°, 180° Monoprints
1983

Monoprint, hand-colored
29 × 37 (73.7 × 94)
Paper: white TGL, handmade

Papermaking by Steve Reeves and Tom Stri-
anese; preparation of magnesium plates
and rubber stamps by Swan Engraving;
printing of plates by Rodney Konopaki,
Bob Cross, and Kenneth Tyler; project
assistance by Tyler, Konopaki, and Cross

Signed *Heizer* and dated lower right; chop
mark lower right; series number lower left
verso

5 runs: 8 ink colors; 4 runs from 4 magne-
sium plates:
 1 black; methods 21c, 23b; III
 2 black; methods 21c, 23b; III
 3 black; methods 21c, 23b; III
 4 red; methods 21c, 23b; III
 5 red, pink, blue, and brown; method 33
 (5 rubber stamps)

During and after printing, the artist
hand-colored the work with Paintstiks,
colored pencils, graphite, crayons, acrylic
paints, and acrylic spray paints.

231:MH75

Michael Heizer
VIII-2, from 45°, 90°, 180° Monoprints
1983

Monoprint, hand-colored
25 × 30 (63.5 × 76.2)
Paper: white TGL, handmade

Papermaking by Steve Reeves and Tom Stri-
anese; plate preparation and processing by
Lee Funderburg; screens supplied by artist
were commercially made; printing by Roger
Campbell and Funderburg; project assist-
ance by Kenneth Tyler

Signed *Heizer* and dated in pencil lower
right; chop mark lower right; series
number lower left verso

5 runs: 7 ink colors; 4 runs from 2
aluminum plates and 2 screens:
 1 blue; method 5c; IIa
 2 blue; method 5c; IIa
 3 brown; commercial screen; VI
 4 red; commercial screen; VI
 5 brown, blue, and black; method 33 (2
 rubber stamps)

During and after printing, the artist
hand-colored the work with pastels,
colored pencils, graphite, and acrylic spray
paints.

232:MH80

Michael Heizer
IX-1, from 45°, 90°, 180° Monoprints
1983

Monoprint, collage, hand-colored
28 × 56¼ (71.1 × 142.9)
Paper: white TGL, handmade

Papermaking by Steve Reeves and Tom Stri-
anese; preparation of magnesium plates
and rubber stamp by Swan Engraving;
printing of plates by Rodney Konopaki,
Bob Cross, and Kenneth Tyler; project
assistance by Tyler, Konopaki, and Cross

Signed *Heizer* and dated in pencil lower
right of left collage sheet; chop mark lower
right of left collage sheet

5 runs: 4 ink colors; 3 runs from 3 magne-
sium plates:
 1 black; methods 21c, 23; III
 2 red; method 33 (rubber stamp)
 3 black; methods 21c, 23; III
 4 black; methods 21c, 23; III
 5 printed papers from runs 1–4; method
 36a; III

During and after printing, the artist
hand-colored the work with colored
pencils, graphite, and acrylic spray paints.

233:MH82

Michael Heizer
45°, 90°, 180° 1983

Lithograph, screenprint, etching, stamping (16)

32 × 46½ (81.3 × 118.1)	
Paper: white TGL, handmade	
Edition: 40	
Proofs: 10AP, 6TP, 2CTP, RTP, PPI, PPII, A, C	

Papermaking by Steve Reeves and Tom Strianese; prep work for continuous-tone lithography by Kenneth Tyler; plate preparation and processing by Lee Funderburg; proofing and edition printing by Roger Campbell and Funderburg; magnesium plate processing by Swan Engraving; proofing and edition printing by Rodney Konopaki and Bob Cross; screens supplied by artist were commercially made; screen proofing and edition printing by Campbell, Funderburg, and Tyler

Signed *Heizer*, numbered, and dated in pencil lower right; chop mark lower right; workshop number MH83-691 lower left verso

16 runs: 16 colors; 15 runs from 9 aluminum plates, 2 screens, 2 irregularly shaped magnesium plates, and 1 assembled plate made from 2 irregularly shaped magnesium plates:

1. blue-silver; method 5a; IIa
2. light blue; method 5a; IIa
3. medium blue-green; method 5a; IIa
4. transparent light yellow; method 5a; IIa
5. yellow; method 5a; IIa
6. dark violet-red; method 5a; IIa
7. medium blue-green; method 5a; IIa
8. black; method 5a; IIa
9. dark blue; method 5a; IIa
10. orange-red; method 29c; VI
11. yellow-brown; methods 21c (irregularly shaped magnesium plate), 33
12. dark brown; method 33 (rubber stamp, LF)
13. red-brown; method 33 (rubber stamp, RC)
14. purple; methods 21c, 15a (magnesium plate and assembled plate printed simultaneously); III
15. light pink; method 29a; VI
16. light blue; method 29a (same screen as run 15); VI

234:MH83

Michael Heizer
Levitated Mass 1983

Lithograph, screenprint, etching (21)

32 × 46½ (81.3 × 118.1)	
Paper: white TGL, handmade	
Edition: 40	
Proofs: 8AP, RTP, PPI, PPII, A, C	

Papermaking by Steve Reeves and Tom Strianese; prep work for continuous-tone lithography by Kenneth Tyler; plate preparation and processing by Lee Funderburg; proofing and edition printing by Roger Campbell and Funderburg; magnesium plate processing by Swan Engraving; proofing and edition printing by Rodney Konopaki; screens supplied by artist were commercially made; screen proofing and edition printing by Campbell and Funderburg

Signed *Heizer*, numbered, and dated in pencil lower right; chop mark lower right; workshop number MH83-692 lower left verso

18 runs: 21 colors; 18 runs from 14 aluminum plates, 2 screens, and 1 irregularly shaped magnesium plate:

 1 medium gray; method 5a; IIa
 2 light blue; method 5a; IIa
 3 turquoise green; method 5a; IIa
 4 pale yellow; method 5a; IIa
 5 orange-yellow; method 5a; IIa
 6 pink; method 5a; IIa
 7 metallic silver; method 5a; IIa
 8 yellow-green; method 5a; IIa
 9 black; method 5a; IIa
10 metallic gold; method 5a; IIa
11 ultramarine blue; method 5a; IIa
12 light cyan blue; method 5a; IIa
13 metallic copper; method 5a; IIa
14 red-orange; method 5a; IIa
15 dark red, purple, gray-blue, and black; methods 21c, 16a; III
16 light blue; method 29a; VI
17 red; methods 29a (same screen as run 16), 27 (LF); VI
18 medium yellow; method 29a; VI

235:MH84

Michael Heizer
Dragged Mass 1983

Lithograph, screenprint, etching (19)
32 × 46½ (81.3 × 118.1)
Paper: white TGL, handmade
Edition: 40
Proofs: 10AP, CTP, RTP, PPI, PPII, A, C

Papermaking by Steve Reeves and Tom Strianese; prep work for continuous-tone lithography by Kenneth Tyler; plate preparation and processing by Lee Funderburg; proofing and edition printing by Roger Campbell and Funderburg; magnesium plate processing by Swan Engraving; proofing and edition printing by Bob Cross; screens supplied by artist were commercially made; screen proofing and edition printing by Campbell and Funderburg

Signed *Heizer*, numbered, and dated in pencil lower right; chop mark lower right; workshop number MH83-693 lower left verso

19 runs: 19 colors; 19 runs from 15 aluminum plates, 2 screens, and 1 irregularly shaped magnesium plate:

 1 light blue-green; method 5a; IIa
 2 medium blue; method 5a; IIa
 3 pale yellow; method 5a; IIa
 4 dark yellow; method 5a; IIa
 5 red-violet; method 5a; IIa
 6 vermilion; method 5a; IIa
 7 yellow-green; method 5a; IIa
 8 black; method 5a; IIa
 9 metallic gold; method 5a; IIa
10 medium gray; method 5a; IIa
11 black; method 5a; IIa
12 metallic gray; method 5a; IIa
13 medium blue; method 5a; IIa
14 dark violet-red; method 5a; IIa
15 orange; method 5a; IIa
16 dark blue; method 29a; IV
17 dark red; methods 29a (same screen as run 16), 27 (LF); VI
18 orange; method 29a; VI
19 purple; method 21c; III

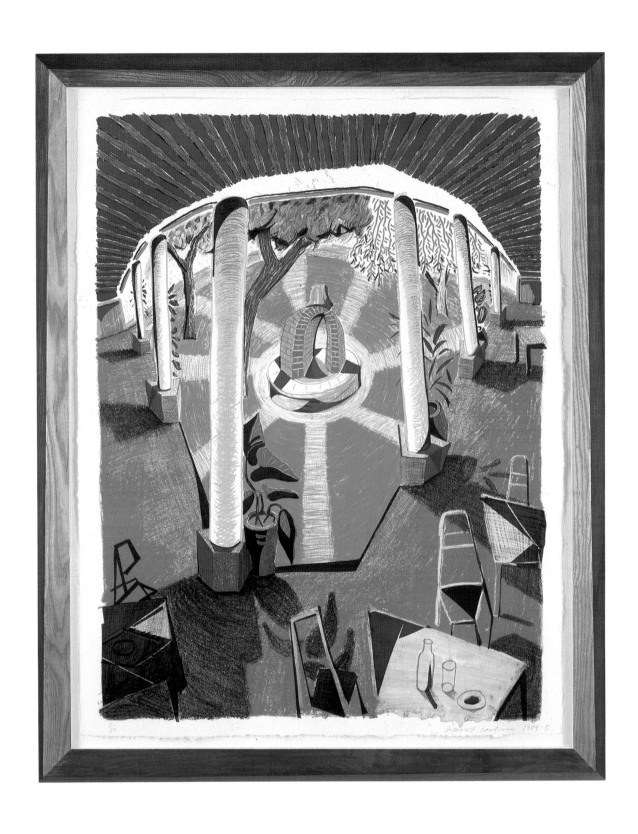

Views of Hotel Well III 1985
See 282:DH69

David Hockney

1937 Born in Bradford, England

1948 Receives scholarship to Bradford Grammar School

1953–57 Attends Bradford College of Art

1959–62 Attends Royal College of Art, London

1961 Receives Guinness Award, first prize, for his print *Three Kings and a Queen*, which enables him to go to New York for the first time

1962 Receives Royal College of Art Gold Medal; included in third International Biennial of Prints at National Museum of Art, Tokyo

1963 Completes portfolio of etchings A Rake's Progress, printed by C. H. Welsh, London, and published by Editions Alecto, London, for which he receives graphics prize at sixth Biennale des Jeunes Artistes, Paris; solo exhibition *Painting with People In*, Kasmin Gallery, London

1964 Teaches at University of Iowa, Iowa City; completes lithograph *Pacific Mutual Life* at Tamarind Lithography Workshop, Los Angeles; completes screenprint *Cleanliness Is next to Godliness* at Kelpra Studio, London, published by Institute of Contemporary Arts, London

1965 Teaches at University of Colorado, Boulder; completes lithograph series A Hollywood Collection at Gemini Ltd., Los Angeles

1966 Teaches at University of California, Los Angeles; included in first International Print Biennial, Cracow; designs set and costumes for *Ubu Roi*, Royal Court Theatre, London

1967 Receives first prize at John Moores Exhibition, Liverpool; teaches at University of California, Berkeley

1968 Included in thirty-fourth Venice Biennale

1970 Traveling exhibition *David Hockney: Paintings, Prints, and Drawings, 1960–1970*, originating at Whitechapel Art Gallery, London; completes Illustrations for Six Fairy Tales from the Brothers Grimm, a portfolio of etchings, at Petersburg Press Ltd., London

1971 Included in exhibition *British Sculpture and Painting, 1960–1970* at National Gallery of Art, Washington, D.C.

1973 Completes Weather Series lithographs and lithograph-screenprint at Gemini G.E.L., Los Angeles

1973–75 Completes group of etchings at Atelier Crommelynk, Paris

1974 Retrospective exhibition at Musée des Arts Décoratifs, Palais du Louvre, Paris

1976 Completes lithograph series Portraits of Friends at Gemini G.E.L., Los Angeles

1977 Completes The Blue Guitar, a set of etchings, at Petersburg Press Ltd., London

1978 Completes Paper Pools, a series of unique paper-pulp works, at Tyler Graphics; designs sets and costumes for *The Magic Flute*, Glyndebourne Opera; retrospective exhibition at Tate Gallery, London

1980 Completes lithographs at Tyler Graphics

1981 Designs sets for *Parade, Le Sacre du printemps, Le Rossignol*, and *Oedipus Rex*, Metropolitan Opera, New York

1981–83 Experiments with photocollage and produces more than 350 works in this medium

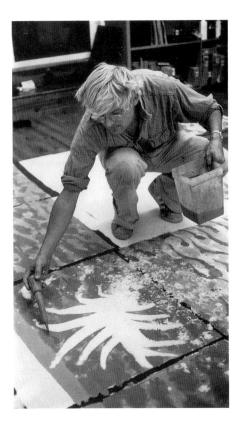

1982 Retrospective exhibition of photographs at Centre National d'Art et de Culture Georges Pompidou, Paris

1983 Receives Skowhegan Medal for graphics

1984 Included in exhibition *Prints from Tyler Graphics* at Walker Art Center, Minneapolis; included in exhibition *Gemini G.E.L.: Art and Collaboration* at National Gallery of Art, Washington, D.C.

1984–85 Completes lithographs, lithographs with collage, some with hand-painted frames

1985 Included in exhibition *Ken Tyler: Printer Extraordinary* at Australian National Gallery, Canberra

Currently lives and works in Los Angeles

PAPER POOLS

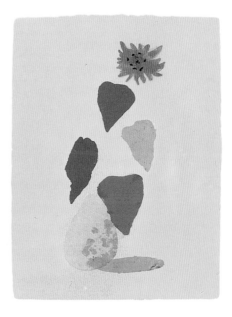

The Paper Pools are a group of ninety-five (including variations) paper-pulp works created during a three-month period of collaboration in 1978. David Hockney spent several days experimenting with this new medium, adapting to it, and learning how to control the technique of forming images using cookie-cutter molds. After making numerous studies to test colors and techniques, he made his first images. The project began with *Sunflower, Steps with Shadow, Green Pool with Diving Board and Shadow,* and *Gregory in the Pool,* which became editions of fifteen to twenty variations each.

The process developed involved six different steps in which newly made pulp sheets were couched and then colored. First, image molds constructed from galvanized metal strips were cut and shaped following the artist's line drawings and soldered together. The molds were placed on newly made pulp base sheets, and colored pulps and dyes were applied. After removing the molds, Hockney applied pulps and dyes freehand using a variety of tools, including spoons, turkey basters, soup ladles, brushes, and dog combs. The pulp sheets were repeatedly pressed, with Hockney constantly adding, removing, and altering the colored pulp. Once he completed a work, the sheets were dried between blotters.

After the *Sunflower* variations, Hockney concentrated on the Tyler swimming pool. He photographed, sketched, and studied it. He recorded the water's light qualities and how they changed at different times of day, under artificial illumination at night, and in different weather conditions. Metal molds were again fabricated, conforming to outline shapes from Hockney's charcoal sketches. White base sheets were couched, and groups of three, six, or twelve sheets were arranged side by side, spanning seven to fourteen feet across. To accommodate the multipanel works, Kenneth Tyler built a platform on the driveway between the paper mill and the swimming pool. This brought the artist and the work out of the studio, brought the artist and his subject closer, and provided more space for the project.

During the project Lindsay Green and Tyler, directed by Hockney, mixed hundreds of gallons of pigmented pulp. Hockney made numerous small trial pictures to work out his palette, which changed daily. Each of the three-, six-, and twelve-panel works was made in one day, using the colored pulps made that day specifically for the work.

The Paper Pools series includes sixty-eight single-panel works making up the four variant editions, one three-panel image, twenty-three six-panel images, and three twelve-panel images. Each of the multipaneled works is signed *D. H.* and dated in white ink lower right of the lower right panel and signed *David Hockney* and numbered in pencil lower left verso of the lower right panel, with the chop mark lower left verso of the lower right panel.

Nine of the works are documented in full here, and the remainder are documented in abbreviated form in the Appendix.

236:DH1

David Hockney
Sunflower L, Paper Pool 1 1978

Colored, pressed paper pulp (v)
42 × 32 (106.7 × 81.3)
Paper: yellow TGL, handmade, hand-colored
Edition: 17 variations

Papermaking by Kenneth Tyler and Lindsay Green; image mold constructed by Duane Mitch and John Hutcheson; paper coloring by artist assisted by Tyler and Green

Signed *D. H.* and dated in pencil lower right; signed *David Hockney* and lettered in pencil lower left verso; chop mark lower left verso

Newly made yellow pulp base sheet with colored pulps and dyes applied through an image mold constructed from galvanized metal strips soldered together; mold removed and paper pressed

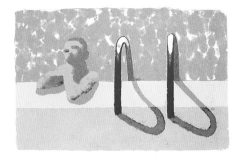

237:DH2

David Hockney
Steps with Shadow N, Paper Pool 2 1978

Colored, pressed paper pulp (v)
50½ × 33½ (128.3 × 85.1)
Paper: white TGL, handmade,
hand-colored
Edition: 16 variations

Papermaking by Kenneth Tyler and Lindsay
Green; image mold constructed by Duane
Mitch and John Hutcheson; paper coloring
by artist assisted by Tyler and Green

Signed *D. H.* and dated in white ink lower
right; signed *David Hockney* and lettered
in pencil lower left verso; chop mark lower
left verso

Newly made white pulp base sheet with
colored pulps and dyes applied through an
image mold constructed from galvanized
metal strips soldered together; mold
removed and paper pressed

238:DH3

David Hockney
*Green Pool with Diving Board and
Shadow C*, Paper Pool 3 1978

Colored, pressed paper pulp (v)
50¼ × 32½ (127.6 × 82.6)
Paper: white TGL, handmade,
hand-colored
Edition: 15 variations

Papermaking by Kenneth Tyler and Lindsay
Green; image mold constructed by Duane
Mitch and John Hutcheson; paper coloring
by artist assisted by Tyler and Green

Signed *D. H.* and dated in white ink lower
right; signed *David Hockney* and lettered
in pencil lower left verso; chop mark lower
left verso

Newly made white pulp base sheet with
colored pulps and dyes applied through an
image mold constructed from galvanized
metal strips soldered together; mold
removed and additional pulps and dyes
applied freehand; paper pressed

239:DH4

David Hockney
Gregory in the Pool I, Paper Pool 4 1978

Colored, pressed paper pulp (v)
32 × 50 (81.3 × 127)
Paper: white TGL, handmade,
hand-colored
Edition: 20 variations

Papermaking by Kenneth Tyler and Lindsay
Green; image mold constructed by Duane
Mitch and John Hutcheson; paper coloring
by artist assisted by Tyler and Green

Signed *D. H.* and dated in white ink lower
right; signed *David Hockney* and lettered
in pencil lower left verso; chop mark lower
left verso

Newly made white pulp base sheet with
colored pulps and dyes applied through an
image mold constructed from galvanized
metal strips soldered together; mold
removed and additional pulps and dyes
applied freehand; paper pressed

240:DH7

David Hockney
Day Pool with Three Blues, Paper Pool 7
1978

Colored, pressed paper pulp
Six sheets: 72 × 85½ (182.9 × 217.2);
each: 36 × 28 (91.4 × 71.1)
Paper: white TGL, handmade,
hand-colored

Papermaking by Kenneth Tyler and Lindsay
Green; image molds constructed by Duane
Mitch, John Hutcheson, and Lee Funder-
burg; paper coloring by artist assisted by
Tyler and Green

Signed *D. H.* and dated in white ink lower
right of lower right sheet; signed *David
Hockney* in pencil lower left verso of lower
right sheet; chop mark lower left verso of
lower right sheet

6 newly made white pulp base sheets with
colored pulps and dyes applied repeatedly
between paper pressings; colors applied
through image molds constructed from
galvanized metal strips soldered together;
molds removed and additional pulps and
dyes applied freehand; papers pressed

241:DH15

David Hockney
Diving Board with Shadow, Paper Pool 15
1978

Colored, pressed paper pulp
Six sheets: 72 × 85½ (182.9 × 217.2);
each: 36 × 28 (91.4 × 71.1)
Paper: white TGL, handmade,
hand-colored

Papermaking by Kenneth Tyler and Lindsay
Green; image molds constructed by Duane
Mitch, John Hutcheson, and Lee Funder-
burg; paper coloring by artist assisted by
Tyler and Green

Signed *D. H.* and dated in white ink lower
right of lower right sheet; signed *David
Hockney* in pencil lower left verso of lower
right sheet; chop mark lower left verso of
lower right sheet

6 newly made white pulp base sheets with
colored pulps and dyes applied repeatedly
between paper pressings; colors applied
through image molds constructed from
galvanized metal strips soldered together;
molds removed and additional pulps and
dyes applied freehand; papers pressed

242:DH16

David Hockney
Swimmer Underwater, Paper Pool 16
1978

Colored, pressed paper pulp
Six sheets: 72 × 85½ (182.9 × 217.2);
each: 36 × 28 (91.4 × 71.1)
Paper: white TGL, handmade,
hand-colored

Papermaking by Kenneth Tyler and Lindsay
Green; image molds constructed by Duane
Mitch, John Hutcheson, and Lee Funder-
burg; paper coloring by artist assisted by
Tyler and Green

Signed *D. H.* and dated in white ink lower
right of lower right sheet; signed *David
Hockney* in pencil lower left verso of lower
right sheet; chop mark lower left verso of
lower right sheet

6 newly made white pulp base sheets with
colored pulps and dyes applied repeatedly
between paper pressings; colors applied
through image molds constructed from
galvanized metal strips soldered together;
molds removed and additional pulps and
dyes applied freehand; papers pressed

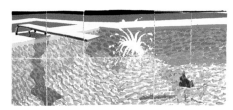

243:DH19

David Hockney
Piscine à minuit, Paper Pool 19 1978

Colored, pressed paper pulp
Six sheets: 72 × 85½ (182.9 × 217.2);
each: 36 × 28 (91.4 × 71.1)
Paper: white TGL, handmade,
hand-colored

Papermaking by Kenneth Tyler and Lindsay
Green; image molds constructed by Duane
Mitch, John Hutcheson, and Lee Funder-
burg; paper coloring by artist assisted by
Tyler and Green

Signed *D. H.* and dated in white ink lower
right of lower right sheet; signed *David
Hockney* in pencil lower left verso of lower
right sheet; chop mark lower left verso of
lower right sheet

6 newly made white pulp base sheets with
colored pulps and dyes applied repeatedly
between paper pressings; colors applied
through image molds constructed from
galvanized metal strips soldered together;
molds removed and additional pulps and
dyes applied freehand; papers pressed

244:DH27

David Hockney
A Large Diver, Paper Pool 27 1978

Colored, pressed paper pulp
Twelve sheets: 72 × 171 (182.9 × 434.3);
each: 36 × 28 (91.4 × 71.1)
Paper: white TGL, handmade,
hand-colored

Papermaking by Kenneth Tyler and Lindsay
Green; image molds constructed by Duane
Mitch, John Hutcheson, and Lee Funder-
burg; cut-paper stencil made by artist;
paper coloring by artist assisted by Tyler
and Green

Signed *D. H.* and dated in white ink lower
right of lower right sheet; signed *David
Hockney* in pencil lower left verso of lower
right sheet; chop mark lower left verso of
lower right sheet

12 newly made white pulp base sheets with
colored pulps and dyes applied repeatedly
between paper pressings; colors applied
through image molds constructed from
galvanized metal strips soldered together;
molds removed and additional pulps and
dyes applied freehand; papers pressed

245:DH32

David Hockney
*Lithograph of Water made of thick and
thin lines, a green wash, a light blue wash,
and a dark blue wash* 1980

Lithograph (7)
26 × 34½ (66 × 87.6)
Paper: white TGL, handmade
Edition: 80
Proofs: 18AP, RTP, PPI, PPII, A

Papermaking by Steve Reeves and Kim
Halliday; stone and plate preparation,
processing, and proofing by Kenneth Tyler
on press I; photo plate preparation and
processing by Lee Funderburg; proofing
and edition printing by Roger Campbell,
Funderburg, and Tyler on press II

Signed *David Hockney* and dated in pencil
lower right; numbered lower left; chop
mark lower right; workshop number
DH78-474 lower left verso

7 runs: 7 colors; 7 runs from 4 stones and
3 aluminum plates:
1 light cyan blue; method 1a; IIa
2 medium cyan blue; method 1a; IIa
3 cyan blue; method 1b; IIa
4 dark green; method 1a; IIa
5 transparent cyan blue; method 3c (LF);
 IIa
6 transparent cyan blue; method 3b (LF);
 IIa
7 medium green; method 1a; IIa

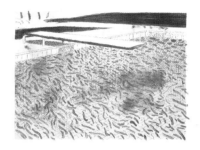

246:DH33

David Hockney
Lithograph of Water made of lines 1980

Lithograph (2)

26 × 34½ (66 × 87.6)	
Paper: white TGL, handmade	
Edition: 39	
Proofs: 12AP, RTP, PPI, PPII, A, C	

Papermaking by Steve Reeves and Kim
Halliday; stone and plate preparation,
processing, and proofing by Kenneth Tyler
on press I; proofing and edition printing by
Roger Campbell, Lee Funderburg, and
Tyler on press II

Signed *David Hockney* and dated in pencil
lower right; numbered lower left; chop
mark lower right; workshop number
DH78-474A lower left verso

2 runs: 2 colors; 2 runs from 1 stone and 1
aluminum plate:
 1 cyan blue; method 1b; IIa
 2 medium cyan blue; method 1a; IIa

247:DH34

David Hockney
*Lithograph of Water made of lines and a
green wash* 1980

Lithograph (3)

26 × 34½ (66 × 87.6)	
Paper: white TGL, handmade	
Edition: 36	
Proofs: 10AP, RTP, PPI, PPII, A	

Papermaking by Steve Reeves and Kim
Halliday; stone and plate preparation,
processing, and proofing by Kenneth Tyler
on press I; proofing and edition printing by
Roger Campbell, Lee Funderburg, and
Tyler on press II

Signed *David Hockney* and dated in pencil
lower right; numbered lower left; chop
mark lower right; workshop number
DH78-474B lower left verso

3 runs: 3 colors; 3 runs from 2 stones and
1 aluminum plate:
 1 cyan blue; method 1b; IIa
 2 dark green; method 1a; IIa
 3 medium green; method 1a; IIa

248:DH35

David Hockney
*Lithograph of Water made of lines, a green
wash, and a light blue wash* 1980

Lithograph (5)

26 × 34½ (66 × 87.6)	
Paper: white TGL, handmade	
Edition: 37	
Proofs: 12AP, RTP, PPI, PPII, A	

Papermaking by Steve Reeves and Kim
Halliday; stone and plate preparation,
processing, and proofing by Kenneth Tyler
on press I; photo plate preparation and
processing by Lee Funderburg; proofing
and edition printing by Roger Campbell,
Funderburg, and Tyler on press II

Signed *David Hockney* and dated in pencil
lower right; numbered lower left; chop
mark lower right; workshop number
DH78-474C lower left verso

5 runs: 5 colors; 5 runs from 2 stones and
3 aluminum plates:
 1 cyan blue; method 1b; IIa
 2 dark green; method 1a; IIa
 3 transparent cyan blue; method 3c (LF);
 IIa
 4 transparent cyan blue; method 3b (LF);
 IIa
 5 medium green; method 1a; IIa

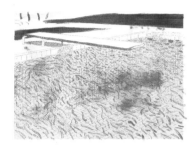

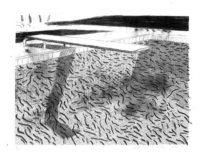

249:DH36

David Hockney
Lithograph of Water made of lines with two light blue washes 1980

Lithograph (5)
26 × 34½ (66 × 87.6)
Paper: white TGL, handmade
Edition: 35
Proofs: 12AP, RTP, PPI, PPII, A

Papermaking by Steve Reeves and Kim Halliday; stone and plate preparation, processing, and proofing by Kenneth Tyler on press I; photo plate preparation and processing by Lee Funderburg; proofing and edition printing by Roger Campbell, Funderburg, and Tyler on press II

Signed *David Hockney* and dated in pencil lower right; numbered lower left; chop mark lower right; workshop number DH78-474D lower left verso

5 runs: 5 colors; 5 runs from 2 stones and 3 aluminum plates:
 1 cyan blue; method 1b; IIa
 2 dark green; method 1a; IIa
 3 transparent cyan blue; method 3c (LF); IIa
 4 transparent cyan blue; method 3b (LF); IIa
 5 turquoise blue; method 1a; IIa

250:DH37

David Hockney
Lithograph of Water made of thick and thin lines and two light blue washes 1980

Lithograph (6)
26 × 34½ (66 × 87.6)
Paper: white TGL, handmade
Edition: 40
Proofs: 16AP, TP, RTP, PPI, PPII, A

Papermaking by Steve Reeves and Kim Halliday; stone and plate preparation, processing, and proofing by Kenneth Tyler on press I; photo plate preparation and processing by Lee Funderburg; proofing and edition printing by Roger Campbell and Tyler on press II

Signed *David Hockney* and dated in pencil lower right; numbered lower left; chop mark lower right; workshop number DH78-474E lower left verso

6 runs: 6 colors; 6 runs from 3 stones and 3 aluminum plates:
 1 medium cyan blue; method 1a; IIa
 2 cyan blue; method 1b; IIa
 3 dark green; method 1a; IIa
 4 transparent cyan blue; method 3c (LF); IIa
 5 transparent cyan blue; method 3b (LF); IIa
 6 turquoise blue; method 1a; IIa

251:DH38

David Hockney
Lithograph of Water made of thick and thin lines and a light blue and a dark blue wash 1980

Lithograph (6)
26 × 34½ (66 × 87.6)
Paper: white TGL, handmade
Edition: 34
Proofs: 10AP, RTP, PPI, PPII, A

Papermaking by Steve Reeves and Kim Halliday; stone and plate preparation, processing, and proofing by Kenneth Tyler on press I; photo plate preparation and processing by Lee Funderburg; proofing and edition printing by Roger Campbell, Funderburg, and Tyler on press II

Signed *David Hockney* and dated in pencil lower right; numbered lower left; chop mark lower right; workshop number DH78-474F lower left verso

6 runs: 6 colors; 6 runs from 3 stones and 3 aluminum plates:
 1 light cyan blue; method 1a; IIa
 2 medium cyan blue; method 1a; IIa
 3 cyan blue; method 1b; IIa
 4 dark green; method 1a; IIa
 5 transparent cyan blue; method 3c (LF); IIa
 6 transparent cyan blue; method 3a (LF); IIa

252:DH39

David Hockney
Lithographic Water made of lines, crayon, and two blue washes 1980

Lithograph (7)
29¾ × 34 (75.6 × 86.4)
Paper: white TGL, handmade
Edition: 85
Proofs: 18AP, TP, RTP, PPI, PPII, A

Papermaking by Steve Reeves and Tom Strianese; stone and plate preparation, processing, and proofing by Kenneth Tyler on press I; photo plate preparation and processing by Lee Funderburg; proofing and edition printing by Roger Campbell, Rodney Konopaki, and Tyler on press II

Signed *David Hockney* and dated in pencil lower right; numbered lower left; chop mark lower right; workshop number DH78-475 lower left verso

7 runs: 7 colors; 7 runs from 4 stones and 3 aluminum plates:
 1 light cyan blue; method 1a; IIa
 2 medium cyan blue; method 1a; IIa
 3 dark cyan blue; method 1a; IIa
 4 cyan blue; method 1b; IIa
 5 medium green; method 1a; IIa
 6 transparent cyan blue; method 3c (LF); IIa
 7 transparent cyan blue; method 3b (LF); IIa

253:DH40

David Hockney
Lithographic Water made of lines 1980

Lithograph (1)
29¼ × 34 (74.3 × 86.4)
Paper: white TGL, handmade
Edition: 42
Proofs: 12AP, SP, RTP, PPI, PPII, A, C

Papermaking by Steve Reeves and Tom Strianese; plate preparation, processing, and proofing by Kenneth Tyler on press I; edition printing by Roger Campbell, Lee Funderburg, and Tyler on press II

Signed *David Hockney* and dated in pencil lower right; numbered lower left; chop mark lower right; workshop number DH78-475A lower left verso

1 run: 1 color; 1 run from 1 aluminum plate:
 1 cyan blue; method 1b; IIa

254:DH41

David Hockney
Lithographic Water made of lines and crayon 1980

Lithograph (2)
29¼ × 34 (74.3 × 86.4)
Paper: white TGL, handmade
Edition: 42
Proofs: 12AP, RTP, PPI, PPII, A

Papermaking by Steve Reeves and Tom Strianese; stone and plate preparation, processing, and proofing by Kenneth Tyler on press I; proofing and edition printing by Roger Campbell, Lee Funderburg, and Tyler on press II

Signed *David Hockney* and dated in pencil lower right; numbered lower left; chop mark lower right; workshop number DH78-475B lower left verso

2 runs: 2 colors; 2 runs from 1 stone and 1 aluminum plate:
 1 medium blue; method 1a; IIa
 2 cyan blue; method 1b; IIa

255:DH42

David Hockney
Lithographic Water made of lines, crayon, and a blue wash 1980

Lithograph (5)
29¾ × 34½ (75.6 × 87.6)
Paper: white TGL, handmade
Edition: 48
Proofs: 14AP, RTP, PPI, PPII, A

Papermaking by Steve Reeves and Tom Strianese; stone and plate preparation, processing, and proofing by Kenneth Tyler on press I; photo plate preparation and processing by Lee Funderburg; proofing and edition printing by Roger Campbell and Tyler on press II

Signed *David Hockney* and dated in pencil lower right; numbered lower left; chop mark lower right; workshop number DH78-475C lower left verso

5 runs: 5 colors; 5 runs from 2 stones and 3 aluminum plates:
 1 medium cyan blue; method 1a; IIa
 2 cyan blue; method 1b; IIa
 3 medium green; method 1a; IIa
 4 transparent cyan blue; method 3c (LF); IIa
 5 transparent cyan blue; method 3b (LF); IIa

256:DH43

David Hockney
Bora Bora 1980

Lithograph (5)
34½ × 48 (87.6 × 121.9)
Paper: white Arches 88, mould-made
Edition: 100
Proofs: 22AP, 2CTP, 2SP, RTP, PPI, PPII, A, C

Plate preparation, processing, and proofing by Kenneth Tyler and Lee Funderburg on press I; proofing and edition printing by Roger Campbell, Kim Halliday, and Rodney Konopaki on press II

Signed *David Hockney* and dated in pencil lower right; numbered lower left; chop mark lower right; workshop number DH79-473 lower left verso

5 runs: 5 colors; 5 runs from 5 aluminum plates:
 1 dark green; method 1b; IIa
 2 yellow-green; method 1b; IIa
 3 orange; method 1b; IIa
 4 light blue; method 1b; IIa
 5 dark blue; method 1b; IIa

257:DH44

David Hockney
Green Bora Bora 1980

Lithograph (2)
35 × 42 (88.9 × 106.7)
Paper: white Rives BFK, mould-made
Edition: 50
Proofs: 14AP, SP, RTP, PPI, A, C

Plate preparation, processing, and proofing by Kenneth Tyler on press I; photo plate preparation and processing by Lee Funderburg; proofing and edition printing by Roger Campbell, Funderburg, and Tyler on press II

Signed *David Hockney* and dated in pencil lower right; numbered lower left; chop mark lower right; workshop number DH79-465 lower left verso

2 runs: 2 colors; 2 runs from 2 aluminum plates:
 1 blue-green; method 1b; IIa
 2 transparent green; method 3b (KH); IIa

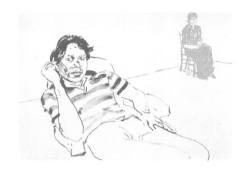

258:DH45

David Hockney
Black Tulips 1980

Lithograph (1)
44 × 30 (111.8 × 76.2)
Paper: cream Rives BFK, mould-made
Edition: 100
Proofs: 20AP, TP, SP, RTP, PPI, A, C

Plate preparation, processing, proofing, and edition printing by Kenneth Tyler

Signed *David Hockney* and dated in pencil lower right; numbered lower left; chop mark lower right; workshop number DH80-524 lower left verso

1 run: 1 color; 1 run from 1 aluminum plate:
 1 black; method 1b; I

259:DH46

David Hockney
Potted Daffodils 1980

Lithograph (1)
44 × 30 (111.8 × 76.2)
Paper: cream Rives BFK, mould-made
Edition: 98
Proofs: 18AP, 2TP, RTP, PPI, A, C

Stone preparation, processing, proofing, and edition printing by Kenneth Tyler

Signed *David Hockney*, numbered, and dated in pencil lower left; chop mark lower right; workshop number DH80-525 lower left verso

1 run: 1 color; 1 run from 1 stone:
 1 black; method 1a; I

260:DH47

David Hockney
Johnny and Lindsay 1980

Lithograph (2)
30 × 44 (76.2 × 111.8)
Paper: cream Rives BFK, mould-made
Edition: 54
Proofs: 14AP, 2SP, RTP, PPI, PPII, A, C

Plate preparation, processing, and proofing by Kenneth Tyler on press I; photo plate preparation and processing by Lee Funderburg; proofing and edition printing by Roger Campbell, Funderburg, and Tyler on press II

Signed *David Hockney*, numbered, and dated in pencil lower left; chop mark lower right; workshop number DH79-460 lower left verso

2 runs: 2 colors; 2 runs from 2 aluminum plates:
 1 red; method 1b; IIa
 2 yellow-pink; method 3a (LF); IIa

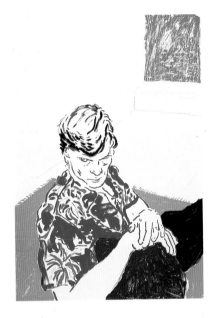

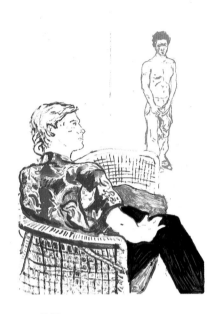

261:DH48

David Hockney
Joe with Green Window 1980

Lithograph (6)	
44 × 30 (111.8 × 76.2)	
Paper: cream Rives BFK, mould-made	
Edition: 54	
Proofs: 16AP, 5TP, 2SP, RTP, PPI, A, C	

Plate preparation, processing, and proofing by Kenneth Tyler on press I; photo plate preparation and processing by Lee Funderburg; proofing and edition printing by Roger Campbell, Funderburg, and Steve Reeves on press II

Signed *David Hockney*, numbered, and dated in pencil lower left; chop mark lower right; workshop number DH79-451 lower left verso

6 runs: 6 colors; 6 runs from 6 aluminum plates:
 1 blue; method 1b; IIa
 2 orange; method 3a; IIa
 3 light green; method 3a; IIa
 4 gray-purple; method 3a; IIa
 5 black; method 3a; IIa
 6 blue; method 3a; IIa

262:DH49

David Hockney
Joe with David Harte 1980

Lithograph (7)	
47¼ × 31⅝ (120.7 × 80.3)	
Paper: white Arches Cover, mould-made	
Edition: 39	
Proofs: 12AP, SP, WP, RTP, PPI, A, C	

Plate preparation, processing, and proofing by Kenneth Tyler on press I; photo plate preparation and processing by Lee Funderburg; proofing and edition printing by Roger Campbell, Steve Reeves, and Tyler on press II

Signed *David Hockney*, numbered, and dated in pencil upper left; chop mark lower left; workshop number DH79-449 lower right verso

7 runs: 7 colors; 7 runs from 7 aluminum plates:
 1 blue; method 1b; IIa
 2 red-blue; method 3a; IIa
 3 red-orange; method 3a; IIa
 4 light blue; method 3a; IIa
 5 green; method 3a; IIa
 6 violet-red; method 3a; IIa
 7 black; method 3a; IIa

263:DH50

David Hockney
Study of Byron 1980

Lithograph (1)	
20 × 16 (50.8 × 40.6)	
Paper: multicolored green TGL, handmade	
Edition: 60	
Proofs: 16AP, 2TP, 2SP, RTP, PPI, A, C	

Papermaking by Steve Reeves; stone preparation, processing, proofing, and edition printing by Kenneth Tyler

Signed *David Hockney* and dated in pencil lower center; numbered lower left; chop mark lower right; workshop number DH79-439 lower left verso

1 run: 1 color; 1 run from 1 stone:
 1 black; method 1a; I

264:DH51

David Hockney
Byron on Hand 1980

Lithograph (1)
13½ × 12 (34.3 × 30.5)
Paper: white Chinese Traditional Tissue,
handmade
Edition: 60
Proofs: 14AP, 2TP, 2SP, RTP, PPI, A, C

Stone preparation, processing, proofing,
and edition printing by Kenneth Tyler

Signed *David Hockney*, numbered, and
dated in pencil lower center; chop mark
lower left; workshop number DH79-438
lower right verso

1 run: 1 color; 1 run from 1 stone:
 1 black; method 1a; I

265:DH52

David Hockney
The Commissioner 1980

Lithograph (1)
16 × 20 (40.6 × 50.8)
Paper: light orange TGL, handmade
Edition: 50
Proofs: 15AP, 2TP, SP, RTP, PPI, A, C

Papermaking by Steve Reeves; plate prepa-
ration, processing, and proofing by Kenneth
Tyler on press I; edition printing by Roger
Campbell and Tyler on press II

Signed *David Hockney* and dated in pencil
lower right; numbered lower left; chop
mark lower right; workshop number
DH79-450 lower left verso

1 run: 1 color; 1 run from 1 aluminum
plate:
 1 red-brown; method 1b; IIa

266:DH53

David Hockney
Afternoon Swimming 1980

Lithograph (8)
31¾ × 39½ (80.6 × 100.3)
Paper: white Arches Cover, mould-made
Edition: 55
Proofs: 18AP, 6TP, WP, RTP, PPI, PPII,
A, C

Plate preparation, processing, and proofing
by Kenneth Tyler on press I; photo plate
preparation and processing by Lee Funder-
burg; proofing and edition printing by
Roger Campbell, Funderburg, Rodney
Konopaki, and Tyler on press II

Signed *David Hockney*, numbered, and
dated in white pencil lower right; chop
mark lower right; workshop number
DH79-448 lower left verso

8 runs: 8 colors; 8 runs from 8 aluminum
plates:
 1 cyan blue; method 1b; IIa
 2 pink; method 3a; IIa
 3 transparent cyan blue; method 3a; IIa
 4 blue-green; method 3a; IIa
 5 purple; method 3a; IIa
 6 yellow; method 3a; IIa
 7 red; method 3a; IIa
 8 black; method 3a; IIa

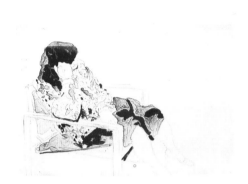

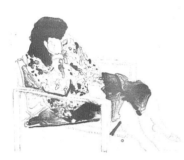

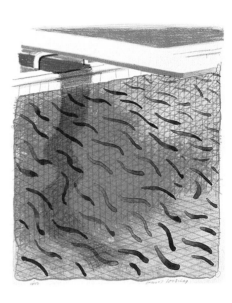

267:DH54

David Hockney
Ann Seated in Director's Chair 1980

Lithograph (1)
30 × 44 (76.2 × 111.8)
Paper: gray Rives BFK, mould-made
Edition: 5
Proofs: 4AP, SP, RTP, A

Plate preparation, processing, and proofing by Kenneth Tyler on press I; color proofing and edition printing by Roger Campbell and Tyler on press II

Signed *David Hockney*, numbered, and dated in pencil lower right; chop mark lower left; workshop number DH79-440 lower right verso

1 run: 1 color; 1 run from 1 aluminum plate:
 1 magenta; method 1b; IIa

268:DH55

David Hockney
Ann Seated in Director's Chair, State I 1980

Lithograph (1)
30 × 44 (76.2 × 111.8)
Paper: brown Rives BFK, mould-made
Edition: 4
Proofs: WP, RTP, A

Plate preparation, processing, and proofing by Kenneth Tyler on press I; proofing and edition printing by Roger Campbell and Tyler on press II

Signed *David Hockney*, numbered, and dated in pencil lower right; chop mark lower left; workshop number DH79-440A lower right verso

1 run: 1 color; 1 run from 1 aluminum plate:
 1 brown; method 1b; IIa

269:DH56

David Hockney
Pool made with paper and blue ink for book 1980

Lithograph (6)
10½ × 9 (26.7 × 22.9)
Paper: white Arches Cover, mould-made
Edition: 1,000
Proofs: 100AP, 5TP, 8SP, 5WP, PPI, PPII, A, C

Stone and plate preparation, processing, and proofing by Kenneth Tyler on press I; proofing and edition printing by Roger Campbell, Lee Funderburg, and Tyler on press II

Signed *David Hockney* and dated in pencil lower right; numbered lower left; chop mark lower right; workshop number DH80-460 lower left verso

6 runs: 6 colors; 6 runs from 3 stones and 3 aluminum plates:
 1 cyan blue; method 1a; IIa
 2 blue; method 1a; IIa
 3 cyan blue; method 1a; IIa
 4 orange; method 1b; IIa
 5 green; method 1b; IIa
 6 red; method 1b; IIa

This edition was printed for the special-edition book *Paper Pools*, by David Hockney, edited by Nikos Stangos and published in 1980 by Thames and Hudson in a limited edition of 1,000 plus 122 proofs.

270:DH57

David Hockney
Ann Looking at Her Picture 1984

Lithograph (2)
44 × 30 (111.8 × 76.2)
Paper: cream BFK, mould-made
Edition: 50
Proofs: 14AP, TP, RTP, PPI, PPII, A, C

Plate preparation, processing, and proofing by Kenneth Tyler on press I; edition printing by Roger Campbell and Lee Funderburg on press II

Signed *David Hockney* and dated in pencil lower right; numbered lower left; chop mark lower right; workshop number DH80-516 lower left verso

2 runs: 2 colors; 2 runs from 1 aluminum plate:
 1 black; method 1b; IIa
 2 transparent black; method 1b (same plate as run 1); IIa

271:DH58

David Hockney
Conversation in the Studio 1984

Lithograph, hand-painted frame (13)
24 × 29 (61 × 73.7);
frame: 26½ × 31½ (67.3 × 80)
Paper: white TGL, handmade
Edition: 45
Proofs: 12AP, 2TP, RTP, PPI, PPII, A, C

Papermaking by Steve Reeves and Tom Strianese; prep work for continuous-tone lithography by Kenneth Tyler; plate preparation and processing by Lee Funderburg; proofing and edition printing by Roger Campbell and Funderburg

Signed *David Hockney* and dated in pencil lower right; numbered lower left; chop mark lower right; workshop number DH84-739 lower left verso

7 runs: 7 colors; 7 runs from 7 aluminum plates:
 1 yellow-orange; method 5a; IIa
 2 medium yellow; method 5a; IIa
 3 yellow; method 5a; IIa
 4 red-brown; method 5a; IIa
 5 red; method 5a; IIa
 6 light blue; method 5a; IIa
 7 black; method 5a; IIa

The artist painted the natural ash frame with yellow, red, blue, white, gray, and black acrylic paints.

272:DH59

David Hockney
Amaryllis in Vase 1985

Lithograph (10)
50 × 36 (127 × 91.4)
Paper: white TGL, handmade
Edition: 80
Proofs: 16AP, 9TP, 2SP, RTP, PPI, PPII, A, C

Papermaking by Steve Reeves and Tom Strianese; prep work for continuous-tone lithography by Kenneth Tyler; plate preparation and processing by Lee Funderburg; proofing and edition printing by Roger Campbell and Funderburg

Signed *David Hockney* and dated in pencil lower right; numbered lower left; chop mark lower right; workshop number DH84-812 lower left verso

10 runs: 10 colors; 10 runs from 10 aluminum plates:
 1 light violet-red; method 5a; IIa
 2 pink; method 5a; IIa
 3 medium red; method 5a; IIa
 4 yellow-orange; method 5a; IIa
 5 blue-green; method 5a; IIa
 6 blue; method 5a; IIa
 7 violet-magenta; method 5a; IIa
 8 black; method 5a; IIa
 9 dark blue; method 5a; IIa
10 black; method 5a; IIa

273:DH60

David Hockney
Red Celia 1985

Lithograph (4)
30 × 21½ (76.2 × 54.6)
Paper: white HMP, handmade
Edition: 82
Proofs: 18AP, 3TP, SP, WP, RTP, PPI, PPII, A, C

Prep work for continuous-tone lithography by Kenneth Tyler; plate preparation and processing by Lee Funderburg; proofing and edition printing by Roger Campbell and Funderburg

Signed *David Hockney* and dated in pencil lower right; numbered lower right; chop mark lower right; workshop number DH84-808 lower left verso

4 runs: 4 colors; 4 runs from 4 aluminum plates:
1 light red; method 5a; IIa
2 medium red; method 5a; IIa
3 red; method 5a; IIa
4 dark red; method 5a; IIa

274:DH61

David Hockney
Celia with Green Hat 1985

Lithograph (13)
30 × 22 (76.2 × 55.9)
Paper: white HMP, handmade
Edition: 98
Proofs: 18AP, 2TP, 2CTP, 3SP, WP, RTP, PPI, PPII, A, C

Prep work for continuous-tone lithography by Kenneth Tyler; plate preparation and processing by Lee Funderburg; proofing and edition printing by Roger Campbell and Funderburg

Signed *David Hockney* and dated in pencil lower right; numbered lower left; chop mark lower right; workshop number DH84-804 lower left verso

13 runs: 13 colors; 13 runs from 13 aluminum plates:
1 light orange-yellow; method 5a; IIa
2 pink; method 5a; IIa
3 light blue; method 5a; IIa
4 dark pink; method 5a; IIa
5 red; method 5a; IIa
6 dark red; method 5a; IIa
7 orange-brown; method 5a; IIa
8 yellow-green; method 5a; IIa
9 blue-green; method 5a; IIa
10 medium blue; method 5a; IIa
11 dark blue; method 5a; IIa
12 black; method 5a; IIa
13 black; method 5a; IIa

275:DH62

David Hockney
Pembroke Studio with Blue Chairs and Lamp 1985

Lithograph (14)
18½ × 22 (47 × 55.9)
Paper: white HMP, handmade
Edition: 98
Proofs: 18AP, 2TP, 2SP, 2RTP, PPI, PPII, A, C

Prep work for continuous-tone lithography by Kenneth Tyler; plate preparation and processing by Lee Funderburg; proofing and edition printing by Roger Campbell and Funderburg

Signed *David Hockney* and dated in pencil lower right; numbered lower left; chop mark lower right; workshop number DH85-822 lower left verso

14 runs: 14 colors; 14 runs from 14 aluminum plates:
1 red-brown; method 5a; IIa
2 light yellow-gray; method 5a; IIa
3 medium blue-gray; method 5a; IIa
4 medium yellow-gray; method 5a; IIa
5 medium yellow; method 5a; IIa
6 yellow-orange; method 5a; IIa
7 light green-gray; method 5a; IIa
8 dark blue; method 5a; IIa
9 cyan blue; method 5a; IIa
10 turquoise blue; method 5a; IIa
11 red; method 5a; IIa
12 ultramarine blue; method 5a; IIa
13 dark blue-gray; method 5a; IIa
14 black; method 5a; IIa

276:DH63

David Hockney
Two Pembroke Studio Chairs 1985

Lithograph (4)
18½ × 22 (47 × 55.9)
Paper: white HMP, handmade
Edition: 98
Proofs: 18AP, 3TP, 2SP, 2RTP, PPI, PPII, A, C

Prep work for continuous-tone lithography by Kenneth Tyler; plate preparation and processing by Lee Funderburg; proofing and edition printing by Roger Campbell and Funderburg

Signed *David Hockney* and dated in pencil lower right; numbered lower left; chop mark lower right; workshop number DH85-826 lower left verso

4 runs: 4 colors; 4 runs from 4 aluminum plates:
 1 red-brown; method 5a; IIa
 2 blue-green; method 5a; IIa
 3 yellow-ocher; method 5a; IIa
 4 black; method 5a; IIa

277:DH64

David Hockney
Pembroke Studio Interior 1985

Lithograph, hand-painted frame (19)
40½ × 49½ (102.9 × 125.7);
frame: 46⅛ × 55⅛ (117.2 × 140)
Paper: white TGL, handmade
Edition: 70
Proofs: 18AP, 2TP, 2CTP, 3SP, RTP, PPI, PPII, A, C

Papermaking by Steve Reeves and Tom Strianese; prep work for continuous-tone lithography by Kenneth Tyler; plate preparation and processing by Lee Funderburg; proofing and edition printing by Roger Campbell and Funderburg

Signed *David Hockney* and dated in pencil lower right; numbered lower left; chop mark lower right; workshop number DH85-820 lower left verso

9 runs: 10 colors; 9 runs from 9 aluminum plates:
 1 yellow-ocher; method 5a; IIa
 2 yellow; method 5a; IIa
 3 light yellow; method 5a; IIa
 4 red; method 5a; IIa
 5 blue-gray; method 5a; IIa
 6 blue-green; method 5a; IIa
 7 blue; method 5a; IIa
 8 dark red and magenta; methods 5a, 16c; IIa
 9 black; method 5a; IIa
The artist, in collaboration with Jerry Solomon Enterprises, painted the wood and plaster frame with yellow, yellow-ocher, red, blue, green, white, light gray, medium gray, and black acrylic paints.

278:DH65

David Hockney
Tyler Dining Room 1985

Lithograph (14)
33 × 40 (81.3 × 101.6)
Paper: white TGL, handmade
Edition: 98
Proofs: 18AP, 7CTP, 2SP, RTP, PPI, PPII, A, C

Papermaking by Steve Reeves and Tom Strianese; prep work for continuous-tone lithography by Kenneth Tyler; plate preparation and processing by Lee Funderburg; proofing and edition printing by Roger Campbell and Funderburg

Signed *David Hockney* and dated in pencil lower right; numbered lower left; chop mark lower right; workshop number DH84-809 lower left verso

14 runs: 14 colors; 14 runs from 14 aluminum plates:
 1 yellow; method 5a; IIa
 2 pink; method 5a; IIa
 3 dark yellow; method 5a; IIa
 4 light blue; method 5a; IIa
 5 orange-brown; method 5a; IIa
 6 orange; method 5a; IIa
 7 red; method 5a; IIa
 8 yellow-ocher; method 5a; IIa
 9 medium blue-gray; method 5a; IIa
 10 dark brown; method 5a; IIa
 11 blue; method 5a; IIa
 12 dark blue; method 5a; IIa
 13 medium purple; method 5a; IIa
 14 black; method 5a; IIa

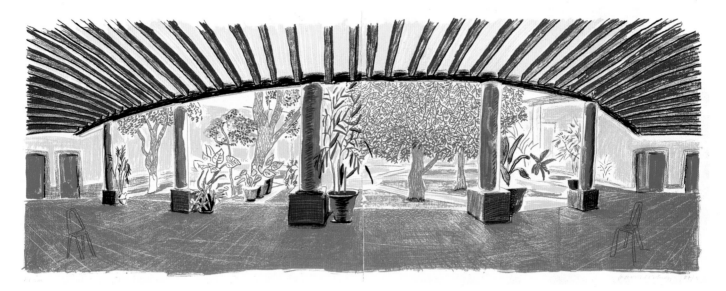

279:DH66

David Hockney
Hotel Acatlán: First Day 1985

Lithograph (24)
Two sheets: 28¾ × 74½ (73 × 189.2);
each: 28¾ × 37¼ (73 × 94.6)
Paper: white HMP, handmade
Edition: 70
Proofs: 18AP, TP, 4CTP, 2SP, RTP, PPI,
PPII, A, C

Prep work for continuous-tone lithography
by Kenneth Tyler; plate preparation and
processing by Lee Funderburg; proofing
and edition printing by Roger Campbell
and Funderburg

Signed *David Hockney* and dated in pencil
lower right; numbered lower left; chop
mark lower right; workshop number
DH84-792 lower left verso

43 runs: 24 colors printed on 2 sheets; 43
runs from 43 aluminum plates:
 1 medium yellow (on left sheet); method
 5a; IIa
 2 medium yellow (on right sheet); method
 5a; IIa
 3 yellow (on left sheet); method 5a; IIa
 4 yellow (on right sheet); method 5a; IIa
 5 light yellow (on left sheet); method 5a;
 IIa
 6 light yellow (on right sheet); method
 5a; IIa
 7 brown (on left sheet); method 5a; IIa
 8 brown (on right sheet); method 5a; IIa
 9 red (on left sheet); method 5a; IIa
10 red (on right sheet); method 5a; IIa

11 yellow-green (on left sheet); method 5a;
 IIa
12 yellow-green (on right sheet); method
 5a; IIa
13 green (on left sheet); method 5a; IIa
14 green (on right sheet); method 5a; IIa
15 dark green (on left sheet); method 5a;
 IIa
16 dark green (on right sheet); method 5a;
 IIa
17 medium green (on left sheet); method
 5a; IIa
18 medium green (on right sheet); method
 5a; IIa
19 blue (on left sheet); method 5a; IIa
20 blue (on right sheet); method 5a; IIa
21 medium blue (on left sheet); method
 5a; IIa
22 medium blue (on right sheet); method
 5a; IIa
23 light green (on left sheet); method 5a;
 IIa
24 light green and viridian (on right
 sheet); methods 5a, 16c; IIa
25 gray-green (on left sheet); method 5a;
 IIa
26 gray-green (on right sheet); method 5a;
 IIa
27 dark blue (on left sheet); method 5a;
 IIa
28 dark blue (on right sheet); method 5a;
 IIa
29 brown (on left sheet); method 5a; IIa
30 brown (on right sheet); method 5a; IIa
31 tan (on left sheet); method 5a; IIa
32 tan (on right sheet); method 5a; IIa
33 magenta (on right sheet); method 5a;
 IIa
34 violet (on left sheet); method 5a; IIa
35 dark red (on left sheet); method 5a; IIa

36 gray-red (on left sheet); method 5a; IIa
37 gray-red (on right sheet); method 5a;
 IIa
38 dark magenta (on left sheet); method
 5a; IIa
39 dark magenta (on right sheet); method
 5a; IIa
40 ultramarine blue (on left sheet); method
 5a; IIa
41 ultramarine blue (on right sheet);
 method 5a; IIa
42 black (on left sheet); method 5a; IIa
43 black (on right sheet); method 5a; IIa

280:DH67

David Hockney
Views of Hotel Well I 1985

Lithograph (16)
31¼ × 41½ (79.4 × 105.4)
Paper: white TGL, handmade
Edition: 75
Proofs: 14AP, 4TP, 2SP, WP, RTP, PPI,
PPII, A, C

Papermaking by Steven Reeves and Tom
Strianese; prep work for continuous-tone
lithography by Kenneth Tyler; plate prepa-
ration and processing by Lee Funderburg;
proofing and edition printing by Roger
Campbell and Funderburg

Signed *David Hockney* and dated in pencil
lower right; numbered lower left; chop
mark lower right; workshop number
DH84-791 lower left verso

16 runs: 16 colors; 16 runs from 16
aluminum plates:
 1 yellow; method 5a; IIa
 2 yellow-orange; method 5a; IIa
 3 pink; method 5a; IIa
 4 blue; method 5a; IIa

 5 light blue; method 5a; IIa
 6 dark blue-green; method 5a; IIa
 7 yellow-green; method 5a; IIa
 8 medium blue-green; method 5a; IIa
 9 vermilion; method 5a; IIa
10 medium red; method 5a; IIa
11 transparent blue-violet; method 5a; IIa
12 dark purple-blue; method 5a; IIa
13 brown; method 5a; IIa
14 ultramarine blue; method 5a; IIa
15 dark red; method 5a; IIa
16 black; method 5a; IIa

The artist, in collaboration with Jerry
Solomon Enterprises, designed a sculptural
wood frame stained in yellow, red, white,
and blue or green. This frame was offered
as an alternative to conventional framing.

281:DH68

David Hockney
Views of Hotel Well II 1985

Lithograph (14)
25 × 32 (63.5 × 81.3)
Paper: white HMP, handmade
Edition: 75
Proofs: 14AP, TP, 2SP, WP, RTP, PPI, PPII,
A, C

Prep work for continuous-tone lithography
by Kenneth Tyler; plate preparation and
processing by Lee Funderburg; proofing
and edition printing by Roger Campbell
and Funderburg

Signed *David Hockney* and dated in pencil
lower right; numbered lower left; chop
mark lower right; workshop number
DH84-803 lower left verso

13 runs: 14 colors; 13 runs from 13
aluminum plates:
 1 light yellow; method 5a; IIa
 2 orange-yellow; method 5a; IIa
 3 blue; method 5a; IIa
 4 red; method 5a; IIa

5 blue-green; method 5a; IIa
6 medium blue; method 5a; IIa
7 dark red; method 5a; IIa
8 orange-brown and dark red-brown;
 methods 5a, 16c; IIa
9 magenta; method 5a; IIa
10 purple; method 5a; IIa
11 dark blue; method 5a; IIa
12 black; method 5a; IIa
13 light blue; method 5a; IIa

The artist, in collaboration with Jerry Solomon Enterprises, designed a sculptural wood frame stained in yellow, red, white, and blue or green. This frame was offered as an alternative to conventional framing.

282:DH69

David Hockney
Views of Hotel Well III 1985

Lithograph (24)	
48½ × 38½ (123.2 × 97.8)	
Paper: white TGL, handmade	
Edition: 80	
Proofs: 18AP, 2TP, 4CTP, 2SP, RTP, PPI, PPII, A, C	

Papermaking by Steve Reeves and Tom Strianese; prep work for continuous-tone lithography by Kenneth Tyler; plate preparation and processing by Lee Funderburg; proofing and edition printing by Roger Campbell and Funderburg

Signed *David Hockney* and dated in pencil lower right; numbered lower left; chop mark lower right; workshop number DH84-795 lower left verso

24 runs: 24 colors; 24 runs from 24 aluminum plates:
 1 yellow; method 5a; IIa
 2 orange-yellow; method 5a; IIa
 3 transparent yellow-green; method 5a; IIa
 4 blue; method 5a; IIa
 5 light blue-green; method 5a; IIa
 6 red; method 5a; IIa
 7 orange-red; method 5a; IIa
 8 pink; method 5a; IIa
 9 red-brown; method 5a; IIa
10 dark blue; method 5a; IIa
11 magenta; method 5a; IIa
12 dark brown; method 5a; IIa
13 light blue; method 5a; IIa
14 violet; method 5a; IIa
15 transparent yellow; method 5a; IIa
16 dark blue-green; method 5a; IIa
17 turquoise blue; method 5a; IIa
18 transparent green; method 5a; IIa
19 viridian; method 5a; IIa
20 transparent magenta; method 5a; IIa
21 dark red; method 5a; IIa
22 ultramarine blue; method 5a; IIa
23 black; method 5a; IIa
24 transparent ultramarine blue; method 5a; IIa

The artist, in collaboration with Jerry Solomon Enterprises, designed a sculptural wood frame stained in yellow, red, white, and blue or green. This frame was offered as an alternative to conventional framing.

283:DH70

David Hockney
Hotel Acatlán: Second Day 1985

Lithograph (28)
Two sheets: 28¾ × 76 (73 × 193);
each: 28¾ × 38 (73 × 96.5)
Paper: white TGL, handmade
Edition: 98
Proofs: 20AP, 4TP, 4CTP, 2SP, RTP, PPI,
PPII, A, C

Papermaking by Steve Reeves and Tom Stri-
anese; prep work for continuous-tone
lithography by Kenneth Tyler; plate prepa-
ration and processing by Lee Funderburg;
proofing and edition printing by Roger
Campbell and Funderburg

Signed *David Hockney* and dated in pencil
lower right; numbered lower left; chop
mark lower right; workshop number
DH84-793 lower left verso

48 runs: 28 colors printed on 2 sheets; 48
runs from 48 aluminum plates:
1 light pink (on left sheet); method 5a;
 IIa
2 light pink (on right sheet); method 5a;
 IIa
3 medium pink (on left sheet); method
 5a; IIa
4 medium pink (on right sheet); method
 5a; IIa
5 dark pink (on right sheet); method 5a;
 IIa
6 light yellow (on left sheet); method 5a;
 IIa
7 light yellow (on right sheet); method
 5a; IIa
8 medium green (on left sheet); method
 5a; IIa
9 medium green (on right sheet); method
 5a; IIa
10 light brown (on left sheet); method 5a;
 IIa
11 red-brown (on right sheet); method 5a;
 IIa
12 red-gray (on left sheet); method 5a; IIa
13 red-gray (on right sheet); method 5a;
 IIa
14 orange (on left sheet); method 5a; IIa
15 orange (on right sheet); method 5a; IIa
16 light blue (on left sheet); method 5a; IIa
17 light blue (on right sheet); method 5a;
 IIa
18 violet (on left sheet); method 5a; IIa
19 violet (on right sheet); method 5a; IIa
20 blue-gray (on left sheet); method 5a; IIa
21 red and dark red (on left sheet);
 methods 5a, 16c; IIa
22 red and dark red (on right sheet);
 methods 5a, 16c; IIa
23 dark brown (on left sheet); method 5a;
 IIa
24 dark brown (on right sheet); method
 5a; IIa
25 magenta (on left sheet); method 5a; IIa
26 magenta (on right sheet); method 5a;
 IIa
27 dark red (on left sheet); method 5a; IIa
28 blue (on left sheet); method 5a; IIa
29 blue (on right sheet); method 5a; IIa
30 turquoise green (on left sheet); method
 5a; IIa
31 turquoise green (on right sheet);
 method 5a; IIa
32 transparent cyan blue (on left sheet);
 method 5a; IIa
33 transparent cyan blue (on right sheet);
 method 5a; IIa
34 transparent yellow (on left sheet);
 method 5a; IIa
35 transparent yellow (on right sheet);
 method 5a; IIa
36 yellow-ocher (on left sheet); method 5a;
 IIa
37 yellow-ocher (on right sheet); method
 5a; IIa
38 yellow-green (on left sheet); method 5a;
 IIa
39 yellow-green (on right sheet); method
 5a; IIa
40 dark green (on left sheet); method 5a;
 IIa
41 transparent green and dark green (on
 left sheet); methods 5a, 16c; IIa
42 transparent green and dark green (on
 right sheet); methods 5a, 16c; IIa
43 transparent purple (on left sheet);
 method 5a; IIa
44 transparent purple (on right sheet);
 method 5a; IIa
45 dark purple (on left sheet); method 5a;
 IIa
46 dark purple (on right sheet); method
 5a; IIa
47 black (on left sheet); method 5a; IIa
48 black (on right sheet); method 5a; IIa

284:DH71

David Hockney
The Perspective Lesson 1985

Lithograph (4)

30 × 22 (76.2 × 55.9)

Paper: gray HMP, handmade

Edition: 50

Proofs: 18AP, 2TP, 2SP, RTP, PPI, PPII, A, C

Prep work for continuous-tone lithography by Kenneth Tyler; plate preparation and processing by Lee Funderburg; proofing and edition printing by Roger Campbell and Funderburg

Signed *David Hockney* and dated in pencil lower right; numbered lower left; chop mark lower right; workshop number DH85-830 lower left verso

4 runs: 4 colors; 4 runs from 4 aluminum plates:
1 black; method 5a; IIa
2 yellow; method 5a; IIa
3 blue; method 5a; IIa
4 red; method 5a; IIa

285:DH72

David Hockney
An Image of Gregory 1985

Lithograph, collage (27)

Two sheets: 78 × 35 (198.1 × 88.9); top: 32 × 25½ (81.3 × 64.8); bottom: 46 × 35 (116.8 × 88.9)

Paper: white TGL, handmade; white St. Armand, handmade; white HMP, handmade

Edition: 75

Proofs: 18AP, 5TP, 3SP, RTP, PPI, PPII, A, C

Papermaking by Steve Reeves and Tom Strianese; prep work for continuous-tone lithography by Kenneth Tyler; plate preparation and processing by Lee Funderburg; proofing and edition printing by Roger Campbell and Funderburg; preparation and adhering of collage elements by Reeves, Strianese, and Marabeth Cohen

Signed *David Hockney* and dated in pencil lower right of top sheet; numbered lower left of top sheet; chop marks lower right of both sheets; workshop number DH85-827 lower left verso of both sheets

30 runs: 27 colors on 5 sheets; 29 runs from 29 aluminum plates:
1 pink (on white HMP paper); method 5a; IIa
2 light pink (printed simultaneously on white HMP and St. Armand papers); method 5a; IIa
3 vermilion (on same paper as run 1); method 5a; IIa
4 vermilion (on same papers as run 2); method 5a; IIa
5 light blue (on same paper as run 1); method 5a; IIa
6 blue (on same papers as run 2); method 5a; IIa
7 dark blue (on same paper as run 1); method 5a; IIa
8 dark blue (on same papers as run 2); method 5a; IIa
9 gray (on same paper as run 1); method 5a; IIa
10 gray (on same papers as run 2); method 5a; IIa
11 light brown (on same paper as run 1); method 5a; IIa
12 brown and red-brown (on same papers as run 2); methods 5a, 16c; IIa
13 printed papers from runs 1–12 cut and torn; method 36a (SR, TS, MC); III
14 cyan blue; method 5a; IIa
15 blue-gray; method 5a; IIa
16 magenta; method 5a; IIa
17 dark pink; method 5a; IIa
18 ultramarine blue; method 5a; IIa
19 black; method 5a; IIa
 [runs 1–19 on top sheet]
20 dark gray; method 5a; IIa
21 cyan blue; method 5a; IIa
22 brown; method 5a; IIa
23 pink; method 5a; IIa
24 light gray; method 5a; IIa
25 light purple; method 5a; IIa
26 light red; method 5a; IIa
27 orange; method 5a; IIa
28 dark purple; method 5a; IIa
29 magenta; method 5a; IIa
30 black; method 5a; IIa
 [runs 20–30 on bottom sheet]

The artist, in collaboration with Jerry Solomon Enterprises, designed a two-part sculptural wood frame finished in white and gray lacquers.

286:DH73

David Hockney
Hotel Acatlán: Two Weeks Later 1985

Lithograph (21)

Two sheets: 28¾ × 74 (73 × 188);
each: 28¾ × 37 (73 × 94)

Paper: white HMP, handmade

Edition: 98

Proofs: 20AP, 3TP, 2SP, RTP, PPI, PPII,
A, C

Prep work for continuous-tone lithography
by Kenneth Tyler; plate preparation and
processing by Lee Funderburg; proofing
and edition printing by Roger Campbell
and Funderburg

Signed *David Hockney* and dated in pencil
lower right; numbered lower left; chop
mark lower right; workshop number
DH85-819 lower left verso

41 runs: 21 colors on 2 sheets; 41 runs
from 41 aluminum plates:
1 light yellow (on left sheet); method 5a;
IIa
2 light yellow (on right sheet); method
5a; IIa
3 transparent green (on left sheet);
method 5a; IIa
4 transparent green (on right sheet);
method 5a; IIa
5 dark yellow (on left sheet); method 5a;
IIa
6 dark yellow (on right sheet); method
5a; IIa
7 light red (on left sheet); method 5a; IIa

8 light red (on right sheet); method 5a;
IIa
9 medium red (on left sheet); method 5a;
IIa
10 medium red (on right sheet); method
5a; IIa
11 medium green (on left sheet); method
5a; IIa
12 medium green (on right sheet); method
5a; IIa
13 dark green (on left sheet); method 5a;
IIa
14 dark green (on right sheet); method 5a;
IIa
15 dark red (on left sheet); method 5a; IIa
16 dark red (on right sheet); method 5a;
IIa
17 transparent brown (on left sheet);
method 5a; IIa
18 transparent brown (on right sheet);
method 5a; IIa
19 light blue (on left sheet); method 5a; IIa
20 light blue (on right sheet); method 5a;
IIa
21 cyan blue (on left sheet); method 5a; IIa
22 cyan blue (on right sheet); method 5a;
IIa
23 purple (on left sheet); method 5a; IIa
24 purple (on right sheet); method 5a; IIa
25 medium blue (on left sheet); method
5a; IIa
26 medium blue (on right sheet); method
5a; IIa
27 dark brown (on right sheet); method
5a; IIa
28 light orange (on left sheet); method 5a;
IIa
29 light orange (on right sheet); method
5a; IIa

30 pink (on left sheet); method 5a; IIa
31 pink (on right sheet); method 5a; IIa
32 transparent violet (on left sheet);
method 5a; IIa
33 transparent violet (on right sheet);
method 5a; IIa
34 transparent purple (on left sheet);
method 5a; IIa
35 transparent purple (on right sheet);
method 5a; IIa
36 transparent yellow (on left sheet);
method 5a; IIa
37 transparent yellow (on right sheet);
method 5a; IIa
38 dark blue (on left sheet); method 5a;
IIa
39 dark blue (on right sheet); method 5a;
IIa
40 ultramarine blue (on left sheet); method
5a; IIa
41 ultramarine blue (on right sheet);
method 5a; IIa

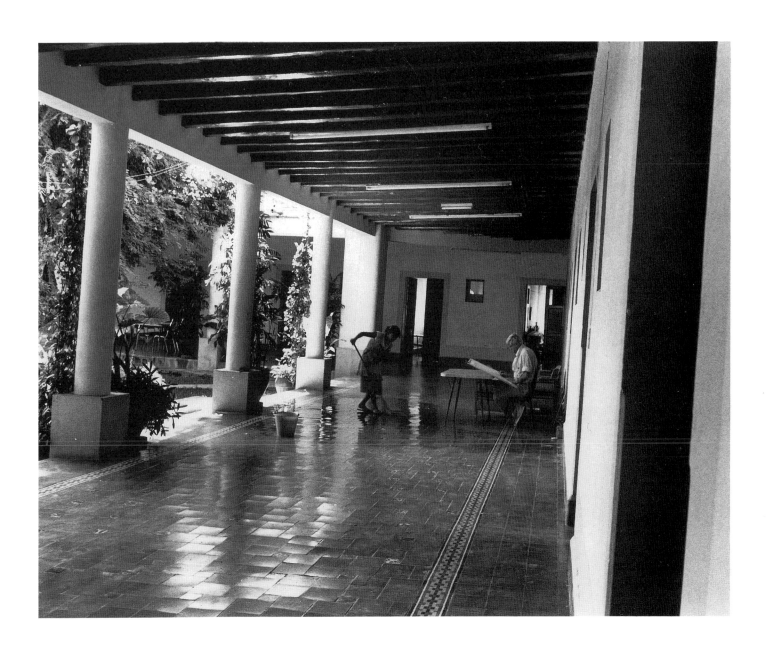

David Hockney sketching on the veranda of
the Hotel Romano Angeles, Acatlán,
Mexico, 1984.

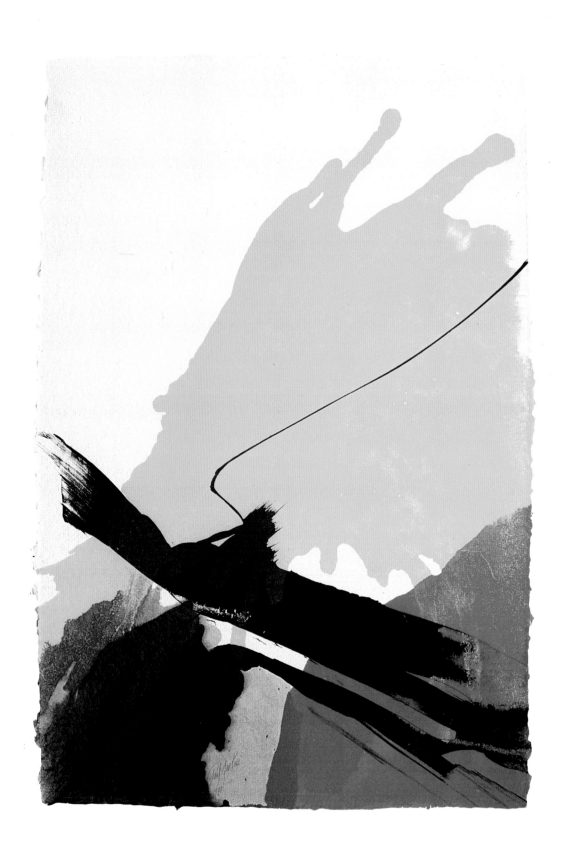

Four Winds (I) 1980
See 288:PJ2

Paul Jenkins

1923 Born in Kansas City, Missouri

1938–41 Studies at Kansas City Art Institute; serves as apprentice in ceramic factory

1943–45 Serves in United States Naval Reserve (Air Corps)

1948–52 Studies with Morris Kantor and Yasuo Kuniyoshi at Art Students League, New York

1953 Travels in Europe and settles in Paris

1954 First solo exhibition at Studio Paul Facchetti, Paris

1956 Returns to New York; first solo exhibition in United States at Martha Jackson Gallery, New York

1958 Begins writing play *Strike the Puma*, which is published by Gonthier, Paris, in 1966

1964 First European retrospective at Kestner-Gesellschaft, Hannover, West Germany

1966 *The Ivory Knife: Paul Jenkins*, a film produced with the Martha Jackson Gallery, receives Golden Eagle Award at Venice Film Festival

1967 Receives silver medal for painting at thirtieth biennial exhibition, Corcoran Gallery of Art, Washington, D.C.; *Strike the Puma* is produced off-Broadway

1971 Traveling retrospective exhibition organized by Museum of Fine Arts, Houston

1973 Receives honorary doctorate in humanities from Lindenwood Colleges, Saint Charles, Missouri

1976 Completes lithograph *Phenomena Franklin's Kite* at Imprimerie Mourlot, Paris, published by Transworld Art Corporation, New York

1977 Included in exhibition *American Postwar Painting* at Solomon R. Guggenheim Museum, New York; included in exhibition *Quelques Américains en Paris* at Centre National d'Art et de Culture Georges Pompidou, Paris

1979 Completes variant monoprint editions and intaglio prints at Tyler Graphics

1980 Receives Officier des Arts et Lettres from Republic of France

1982 Completes lithographs at Sword Street Press Ltd., published by Transworld Art Corporation, New York

1983 Invited by Jack Lang, French minister of culture, to participate in colloquium "Culture in Crisis" at the Sorbonne, Paris

1984 Solo exhibition of collages at Musée d'Art, Dunkerque, France

Currently lives and works in New York and Paris

287:PJ1

Paul Jenkins
Katherine Wheel 1979

Monoprint, lithograph, screenprint (v)
43 × 29½ (109.2 × 74.9)
Paper: white Duchene, handmade
Edition: 50 variations

Stone preparation, processing, proofing, and edition printing by Kenneth Tyler assisted by Rodney Konopaki; screen preparation, processing, proofing, and edition printing by Kim Halliday

Signed *Paul Jenkins* and dated in pencil lower right; numbered verso; chop mark lower left; workshop number PJ78-371 lower right verso

5 runs: ink colors; 4 runs from 3 screens and 1 stone:
 1 variant inking from palette: yellow, medium yellow, orange, red, dark red, brown, light blue, ultramarine blue, yellow-green, blue-green, transparent white, white, and black; methods 29a, 16e; VI
 2 variant inking from palette; methods 29a, 16e; VI

3 transparent yellow; method 28 (KH); VI
4 unique painting of each wet impression by artist
5 black; method 1a; I

The artist applied water-base screen inks from his palette onto screen stencils, which were then squeegeed onto paper. After the prints were dry, Jenkins applied water to them, partially dissolving the inks and forcing them to bleed into the paper and pool in certain areas. The prints were then dried and printed on further.

FOUR WINDS,
EAST WINDS,
AND WEST WINDS

Paul Jenkins dyed handmade papers and blotters in preparation for printing *Four Winds (I), East Winds (II),* and *West Winds (III),* completed in 1980. The artist positioned handmade paper on top of 100 percent rag blotters placed on tilted backing boards and freely applied liquid dyes to create patterns of color. Dyes that spread over the edges of the papers for *Four Winds (I)* and *East Winds (II)* were often absorbed by the blotters Jenkins placed beneath the papers. This "runoff" created a colored border on the white blotters, which Jenkins added to with direct applications of dyes. Some of these colorful blotters were used as the edition papers for *West Winds (III).* Those not used for the edition were destroyed.

288:PJ2

Paul Jenkins
Four Winds (I) 1980

Monoprint, relief (v)
48 × 33 (121.9 × 83.8)
Paper: white TGL, handmade,
hand-colored
Edition: 58 variations

Papermaking by Steve Reeves and Tom Strianese; paper coloring by artist assisted by Reeves, Strianese, and Kenneth Tyler; plate preparation by Tyler; processing by Swan Engraving; proofing and edition printing by Reeves and Strianese

Signed *Paul Jenkins* and dated in pencil lower left; numbered lower left verso (I-1 to I-45; I-46A to I-54A; I-55A; I-56A; I-57C; I-58D); chop mark lower left; workshop number PJ80-376 lower right verso

2 runs: dye colors; 1 ink color, 1 run from 1 magnesium plate:
 1 variant coloring from palette: yellow, orange, red, violet, purple, brown, blue, and green dyes
 2 black; methods 20, 23a; III

289:PJ3

Paul Jenkins
East Winds (II) 1980

Monoprint, lithograph (v)
47½ × 35½ (120.7 × 90.2)
Paper: white Twinrocker, handmade,
hand-colored
Edition: 18 variations

Paper coloring by artist assisted by Steve Reeves, Tom Strianese, and Kenneth Tyler; plate preparation and processing by Tyler; proofing and edition printing by Tyler assisted by Kim Halliday

Signed *Paul Jenkins* and dated in pencil lower left; numbered lower left verso (II-1 to II-15; II-16A to II-18A); chop mark lower left; workshop number PJ80-379 lower right verso

3 runs: dye colors; 2 ink colors, 2 runs from 2 aluminum plates:
 1 variant coloring from palette: yellow, orange, red, violet, purple, brown, blue, and green dyes
 2 black; method 1b; I
 3 black; method 1b; I

290:PJ4

Paul Jenkins
West Winds (III) 1980

Monoprint, relief (v)
51 × 37⅜ (129.5 × 94.9)
Paper: white Process Materials Corp.
100% cotton linters blotter, machine-made,
hand-colored
Edition: 53 variations

Paper coloring by artist assisted by Steve Reeves, Tom Strianese, and Kenneth Tyler; plate preparation by Tyler; processing by Swan Engraving; edition printing by Reeves and Strianese

Signed *Paul Jenkins* and dated in pencil lower left; numbered lower left verso (III-1 to III-51; III-52A; III-53A); chop mark lower left; workshop number PJ80-377 lower right verso

2 runs: dye colors; 1 ink color, 1 run from 1 magnesium plate:
 1 variant coloring from palette: yellow, orange, red, violet, purple, brown, blue, and green dyes
 2 black; methods 20, 23a; III

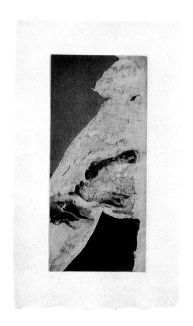

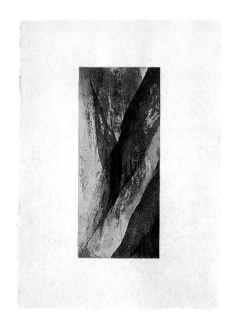

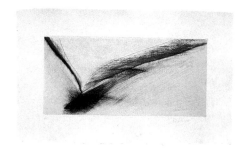

291:PJ5

Paul Jenkins
Emissary 1980

Etching, aquatint (4)	
26 × 16 (66 × 40.6)	
Paper: cream HMP, handmade	
Edition: 20	
Proofs: 10AP, TP, RTP, PPI, A, C	

Plate preparation, processing, proofing, and edition printing by Rodney Konopaki

Signed *Paul Jenkins* and dated in pencil lower right; numbered lower left; chop mark lower right; workshop number PJ79-374 lower left verso

1 run: 4 colors; 1 run from 1 copper plate:
 1 yellow-ocher, gray-pink, violet, and
 black; methods 7, 9 (RK), 16a; IV

292:PJ6

Paul Jenkins
Himalayan Hourglass 1980

Etching, aquatint (8)	
30 × 22 (76.2 × 55.9)	
Paper: white Moulin du Verger, handmade	
Edition: 20	
Proofs: 10AP, TP, RTP, PPI, A, C	

Plate preparation, processing, proofing, and edition printing by Rodney Konopaki

Signed *Paul Jenkins* and dated in pencil lower right; numbered lower left; chop mark lower right; workshop number PJ79-373 lower left verso

4 runs: 8 colors; 4 runs from 4 copper plates:
 1 black; method 6; IV
 2 red, blue-violet, Prussian blue, and
 medium green; methods 6, 16a; IV
 3 blue and Prussian blue; methods 7, 9
 (RK), 16a; IV
 4 blue-violet; methods 7, 9 (RK); IV

293:PJ7

Paul Jenkins
Over the Cusp 1980

Drypoint, mezzotint, etching (4)	
16 × 26 (40.6 × 66)	
Paper: cream HMP, handmade	
Edition: 20	
Proofs: 10AP, CTP, 2WP, PPI, A, C	

Plate preparation, processing, proofing, and edition printing by Rodney Konopaki

Signed *Paul Jenkins* and dated in pencil lower right; numbered lower left; chop mark lower right; workshop number PJ79-372 lower left verso

1 run: 4 colors; 1 run from 1 copper plate:
 1 red, light red-tan, blue, and black;
 methods 13, 14, 6, 16a; IV

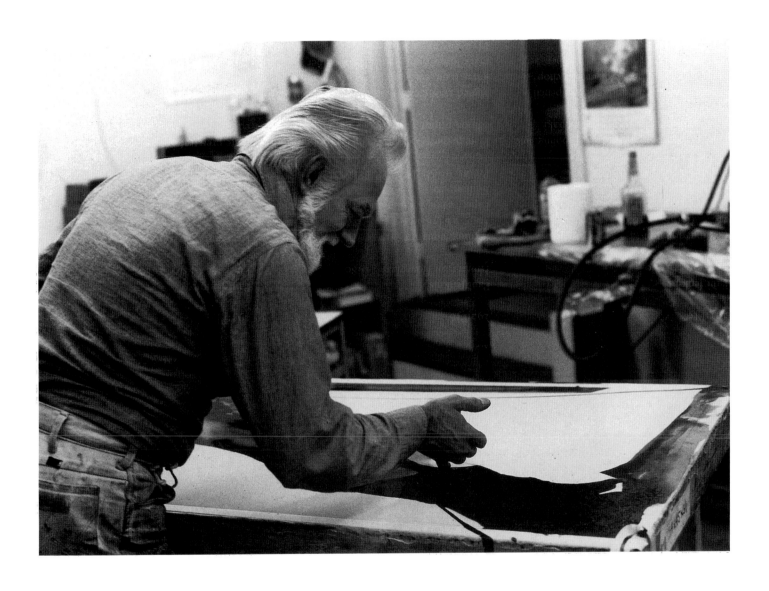

Paul Jenkins manipulating wet tusche on
stone for *Katherine Wheel*, 1979.

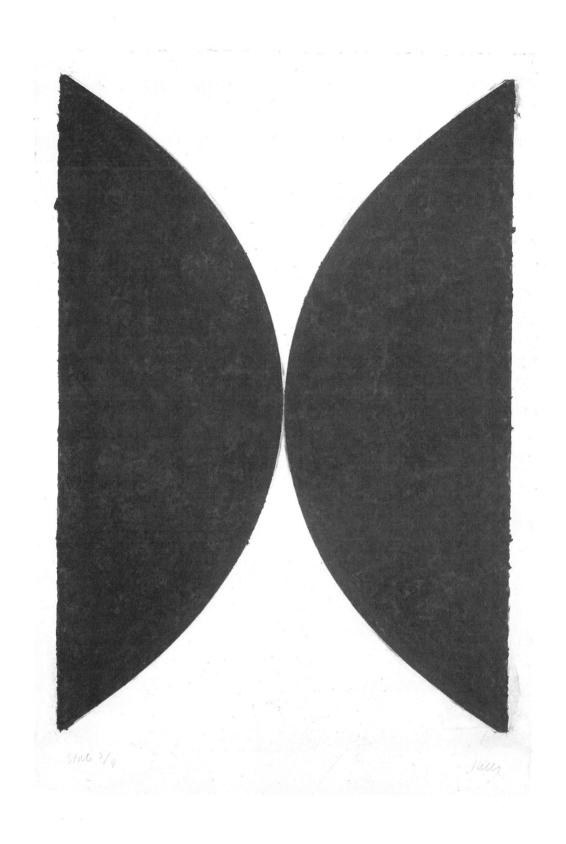

Colored Paper Image II, State 1976
See 297:EK4

Ellsworth Kelly

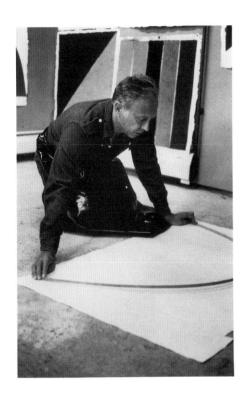

1923 Born in Newburgh, New York

1941–42 Studies at Pratt Institute, Brooklyn

1943–44 Drafted into United States Army and sent to England; visits Paris

1945 Returns to United States

1946–48 Studies drawing and painting at School of the Museum of Fine Arts, Boston; gives evening classes at his studio in Norfolk House Center, Roxbury, Massachusetts

1948 Moves to France; studies at Ecole des Beaux-Arts, Paris

1949 Completes his first lithograph at Ecole des Beaux-Arts, Paris

1950–51 Teaches at American School in Paris; first solo exhibition at Galerie Arnaud, Paris

1954 Returns to United States; shares studio in Coenties Slip, New York, with Robert Indiana, Agnes Martin, and Jack Youngerman

1956 First solo exhibition in United States at Betty Parsons Gallery, New York

1964 Completes first screenprint in United States, *Red Blue*, published by Wadsworth Atheneum, Hartford, for exhibition *A Portfolio of Ten Works by Ten Painters*; completes suite of lithographs at Maeght Editeur, Paris

1964–66 Completes suite of plant lithographs at Maeght Editeur, Paris

1966 Included in thirty-third Venice Biennale and *Two Decades of American Painting* at National Museum of Modern Art, Tokyo

1967 Included in traveling exhibition *Guggenheim International Exhibition, 1967: Sculpture from Twenty Nations*, originating at Solomon R. Guggenheim Museum, New York

1969 Moves to Spensertown, New York; completes mural commissioned by UNESCO, Paris

1970 Completes suite of lithographs at Gemini G.E.L., Los Angeles

1970–72 Completes sculpture edition at Gemini G.E.L., Los Angeles

1971 Included in exhibition *Technics and Creativity: Gemini G.E.L.* at Museum of Modern Art, New York

1972 Completes group of lithographs at Gemini G.E.L., Los Angeles

1973 Retrospective exhibition *Ellsworth Kelly* at Museum of Modern Art, New York

1973–75 Completes lithographs at Gemini G.E.L., Los Angeles

1974 Elected member of National Institute of Arts and Letters

1976 Completes Colored Paper Images, a series of paper-pulp works, and screenprint at Tyler Graphics; completes Third Curve Series of mixed-media prints at Gemini G.E.L., Los Angeles

1977 Completes paper-pulp works and screenprint-lithograph at Tyler Graphics; included in exhibition *Art Off the Picture Press* at Emily Lowe Gallery, Hofstra University, New York

1978–79 Completes sculpture edition and prints at Tyler Graphics

1979 Exhibition *Ellsworth Kelly: Recent Paintings and Sculpture* at Metropolitan Museum of Art, New York; traveling exhibition *Ellsworth Kelly: Recent Painting and Sculpture*, originating at Stedelijk Museum, Amsterdam

1980 Completes lithographs at Tyler Graphics

1981 Completes sculpture, *Curve XXII*, for Lincoln Park, Chicago, commissioned by Friends of Lincoln Park

1982 Retrospective exhibition *Ellsworth Kelly: Sculpture* at Whitney Museum of American Art, New York

1983 Completes sculpture, *Untitled*, commissioned for Dallas Museum of Art, Dallas

1984 Included in exhibition *Prints from Tyler Graphics* at Walker Art Center, Minneapolis; included in exhibition *Gemini G.E.L.: Art and Collaboration* at National Gallery of Art, Washington, D.C.

1985 Included in exhibition *Ken Tyler: Printer Extraordinary* at Australian National Gallery, Canberra; sculpture commission for the city of Barcelona, Spain; completes painted metal wall relief multiples fabricated by Peter Carlson, published by Gemini G.E.L., Los Angeles

Currently lives and works in Spensertown, New York

294:EK1

Ellsworth Kelly
Colors on a Grid, Screenprint 1976 1976

Screenprint, lithograph (15)
48¼ × 48¼ (122.6 × 122.6)
Paper: white Arches 88, mould-made
Edition: 46
Proofs: 10AP, WP, RTP, PPI, A, C

Plate preparation, processing, proofing, and edition printing by John Hutcheson; screen preparation, processing, proofing, and edition printing by Kim Halliday

Signed *Kelly* in pencil lower right; numbered lower left; chop mark lower right; workshop number EK75-251 lower left verso

16 runs: 15 colors; 16 runs from 2 aluminum plates and 5 screens:
 1 gray (on left side); method 3c; IIa
 2 gray (on right side); method 3c; IIa
 3 yellow; methods 28 (KH), 27 (KH); VI
 4 pink; methods 28 (same screen as run 3), 27 (KH); VI
 5 dark green; methods 28 (KH), 27 (KH); VI

 6 light orange; methods 28 (same screen as run 5), 27 (KH); VI
 7 violet; methods 28 (same screen as run 5), 27 (KH); VI
 8 dark orange; methods 28 (same screen as run 5), 27 (KH); VI
 9 light green; methods 28 (same screen as run 5), 27 (KH); VI
 10 purple; methods 28 (KH), 27 (KH); VI
 11 light blue; methods 28 (same screen as run 10), 27 (KH); VI
 12 medium blue; methods 28 (same screen as run 10), 27 (KH); VI
 13 dark blue; methods 28 (KH), 27 (KH); VI
 14 red; methods 28 (same screen as run 13), 27 (KH); VI
 15 brown; methods 28 (same screen as run 13), 27 (KH); VI
 16 black; method 28 (KH); VI

Ellsworth Kelly created the twenty-three Colored Paper Images over an eight-month period in 1976, collaborating with Kenneth Tyler, John Koller, and Kathleen Koller at the HMP paper mill. Some fifty colors of pigmented pulp were mixed for use in these editions, as Kelly, John Koller, and Tyler experimented with different coloring agents—powdered pigments, water-base vinyl paints, and dyes—and their effects. Kelly wanted to preserve the quality of certain colored-pulp mixtures that ran during pressing and wanted to stabilize others. To do this, he and Koller altered some colored-pulp mixtures with mordants and varied the degree of press force to adjust the amount of color bleeding. Kelly also experimented with loosely hand-mixing some of the pulps, which, when the pulps were applied on the newly made white pulp base sheets through image molds and then pressed, resulted in mottled color fields.

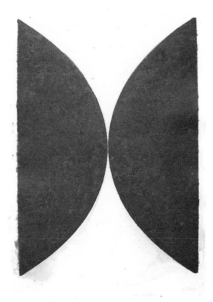

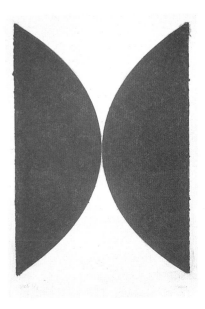

295:EK2

Ellsworth Kelly
Colored Paper Image I 1976

Colored, pressed paper pulp (3)
46½ × 32½ (118.1 × 82.6)
Paper: white HMP, handmade,
hand-colored
Edition: 20 variations
Proofs: 10AP, TP, SP, RTP, PPI, C

Papermaking by John and Kathleen Koller
at HMP; experimental trials and standard
proof paper coloring by artist assisted by
Kenneth Tyler and John Koller; paper
coloring by John and Kathleen Koller

Signed *Kelly* in pencil lower right;
numbered lower left; chop marks of work-
shop and artist lower right; workshop
number EK76-254 lower left verso

Newly made white pulp base sheet with
white pulp and mix of gray and black pulps
applied through an image mold constructed
from a bent metal ruler and masking tape;
paper pressed

296:EK3

Ellsworth Kelly
Colored Paper Image II 1976

Colored, pressed paper pulp (2)
46½ × 32½ (118.1 × 82.6)
Paper: white HMP, handmade,
hand-colored
Edition: 17 variations
Proofs: 8AP, TP, 2CTP, RTP, PPI, A

Papermaking by John and Kathleen Koller
at HMP; experimental trials and standard
proof paper coloring by artist assisted by
Kenneth Tyler and John Koller; paper
coloring by John and Kathleen Koller

Signed *Kelly* in pencil lower right;
numbered lower left; chop marks of work-
shop and artist lower right; workshop
number EK76-255 lower left verso

Newly made white pulp base sheet with
mix of light green and green pulps applied
through an image mold constructed from a
bent metal ruler and masking tape; paper
pressed

297:EK4

Ellsworth Kelly
Colored Paper Image II, State 1976

Colored, pressed paper pulp (2)
46½ × 32½ (118.1 × 82.6)
Paper: white HMP, handmade,
hand-colored
Edition: 9 variations
Proofs: TP, RTP

Papermaking by John and Kathleen Koller
at HMP; experimental trials and standard
proof paper coloring by artist assisted by
Kenneth Tyler and John Koller; paper
coloring by John and Kathleen Koller

Signed *Kelly* in pencil lower right;
numbered and titled (*State*) lower left; chop
marks of workshop and artist lower right;
workshop number EK76-255A lower left
verso

Newly made white pulp base sheet with
mix of light green and green pulps applied
through an image mold constructed from a
bent metal ruler and masking tape; paper
pressed

298:EK5

Ellsworth Kelly
Colored Paper Image III 1976

Colored, pressed paper pulp (3)
32½ × 46½ (82.6 × 118.1)
Paper: white HMP, handmade,
hand-colored
Edition: 21 variations
Proofs: 8AP, TP, 5CTP, RTP, PPI, A

Papermaking by John and Kathleen Koller
at HMP; experimental trials and standard
proof paper coloring by artist assisted by
Kenneth Tyler and John Koller; paper
coloring by John and Kathleen Koller

Signed *Kelly* in pencil lower right;
numbered lower left; chop marks of work-
shop and artist lower right; workshop
number EK76-256 lower left verso

Newly made white pulp base sheet with
blue pulp and mix of gray-black and black
pulps applied through an image mold
constructed from a bent metal ruler and
masking tape; paper pressed

299:EK6

Ellsworth Kelly
Colored Paper Image IV 1976

Colored, pressed paper pulp (1)
46½ × 32½ (118.1 × 82.6)
Paper: white HMP, handmade,
hand-colored
Edition: 20 variations
Proofs: 9AP, 2TP, RTP, PPI, A

Papermaking by John and Kathleen Koller
at HMP; experimental trials and standard
proof paper coloring by artist assisted by
Kenneth Tyler and John Koller; paper
coloring by John and Kathleen Koller

Signed *Kelly* in pencil lower right;
numbered lower left; chop marks of work-
shop and artist lower right; workshop
number EK76-257 lower left verso

Newly made white pulp base sheet with red
pulp applied through an image mold
constructed from a bent metal ruler and
masking tape; paper pressed

300:EK7

Ellsworth Kelly
Colored Paper Image V 1976

Colored, pressed paper pulp (2)
46½ × 32½ (118.1 × 82.6)
Paper: white HMP, handmade,
hand-colored
Edition: 19 variations
Proofs: 7AP, TP, 2CTP, RTP, PPI, A

Papermaking by John and Kathleen Koller
at HMP; experimental trials and standard
proof paper coloring by artist assisted by
Kenneth Tyler and John Koller; paper
coloring by John and Kathleen Koller

Signed *Kelly* in pencil lower right;
numbered lower left; chop marks of work-
shop and artist lower right; workshop
number EK76-258 lower left verso

Newly made white pulp base sheet with
mix of blue and dark blue pulps applied
through an image mold constructed from a
bent metal ruler and masking tape; paper
pressed

301:EK8

Ellsworth Kelly
Colored Paper Image VI 1976

Colored, pressed paper pulp (3)
46½ × 32½ (118.1 × 82.6)
Paper: white HMP, handmade,
hand-colored
Edition: 23 variations
Proofs: 8AP, TP, 4CTP, RTP, PPI, A

Papermaking by John and Kathleen Koller
at HMP; experimental trials and standard
proof paper coloring by artist assisted by
Kenneth Tyler and John Koller; paper
coloring by John and Kathleen Koller

Signed *Kelly* in pencil lower right;
numbered lower left; chop marks of work-
shop and artist lower right; workshop
number EK76-259 lower left verso

Newly made white pulp base sheet with
white pulp and mix of gray-black and
black pulps applied through an image mold
constructed from a bent metal ruler and
masking tape; paper pressed

302:EK9

Ellsworth Kelly
Colored Paper Image VII 1976

Colored, pressed paper pulp (3)
46½ × 32½ (118.1 × 82.6)
Paper: white HMP, handmade,
hand-colored
Edition: 20 variations
Proofs: 8AP, TP, RTP, PPI, A

Papermaking by John and Kathleen Koller
at HMP; experimental trials and standard
proof paper coloring by artist assisted by
Kenneth Tyler and John Koller; paper
coloring by John and Kathleen Koller

Signed *Kelly* in pencil lower right;
numbered lower left; chop marks of work-
shop and artist lower right; workshop
number EK76-260 lower left verso

Newly made white pulp base sheet with
yellow pulp and mix of light gray and gray
pulps applied through an image mold
constructed from a bent metal ruler and
masking tape; paper pressed

303:EK10

Ellsworth Kelly
Colored Paper Image VIII 1976

Colored, pressed paper pulp (5)
46½ × 32½ (118.1 × 82.6)
Paper: white HMP, handmade,
hand-colored
Edition: 20 variations
Proofs: 7AP, TP, RTP, PPI, A

Papermaking by John and Kathleen Koller
at HMP; experimental trials and standard
proof paper coloring by artist assisted by
Kenneth Tyler and John Koller; paper
coloring by John and Kathleen Koller

Signed *Kelly* in pencil lower right;
numbered lower left; chop marks of work-
shop and artist lower right; workshop
number EK76-261 lower left verso

Newly made white pulp base sheet with
yellow dye and mix of light blue-green and
blue-green pulps and mix of light gray and
gray pulps applied through an image mold
constructed from a bent strip of wood and
masking tape; paper pressed

304:EK11

Ellsworth Kelly
Colored Paper Image IX 1976

Colored, pressed paper pulp (10)
46½ × 32½ (118.1 × 82.6)
Paper: white HMP, handmade,
hand-colored
Edition: 18 variations
Proofs: 8AP, TP, RTP, PPI, A

Papermaking by John and Kathleen Koller
at HMP; experimental trials and standard
proof paper coloring by artist assisted by
Kenneth Tyler and John Koller; paper
coloring by John and Kathleen Koller

Signed *Kelly* in pencil lower right;
numbered lower left; chop marks of work-
shop and artist lower right; workshop
number EK76-262 lower left verso

Newly made white pulp base sheet with
mix of 2 light gray pulps, mix of 2 medium
gray pulps, mix of 2 dark gray pulps, mix
of 2 black-gray pulps, and mix of 2 black
pulps applied through an image mold
constructed from Plexiglas strips glued
together; paper pressed

305:EK12

Ellsworth Kelly
Colored Paper Image IX, State 1976

Colored, pressed paper pulp (9)
46½ × 32½ (118.1 × 82.6)
Paper: white HMP, handmade,
hand-colored
Edition: 10 variations
Proof: RTP

Papermaking by John and Kathleen Koller
at HMP; experimental trials and standard
proof paper coloring by artist assisted by
Kenneth Tyler and John Koller; paper
coloring by John and Kathleen Koller

Signed *Kelly* in pencil lower right;
numbered and titled (*State*) lower left; chop
marks of workshop and artist lower right;
workshop number EK76-262A lower left
verso

Newly made white pulp base sheet with
mix of 2 light blue-gray pulps, mix of 2
medium blue-gray pulps, mix of 2
blue-gray pulps, mix of 2 light gray pulps,
and black pulp applied through an image
mold constructed from Plexiglas strips
glued together; paper pressed

306:EK13

Ellsworth Kelly
Colored Paper Image X 1976

Colored, pressed paper pulp (5)
46½ × 32½ (118.1 × 82.6)
Paper: white HMP, handmade,
hand-colored
Edition: 20 variations
Proofs: 7AP, TP, RTP, PPI, A

Papermaking by John and Kathleen Koller
at HMP; experimental trials and standard
proof paper coloring by artist assisted by
Kenneth Tyler and John Koller; paper
coloring by John and Kathleen Koller

Signed *Kelly* in pencil lower right;
numbered lower left; chop marks of work-
shop and artist lower right; workshop
number EK76-263 lower left verso

Newly made white pulp base sheet with
mix of light blue, medium blue, and dark
blue pulps, and mix of 2 light gray pulps
applied through an image mold constructed
from Plexiglas strips glued together; paper
pressed

307:EK14

Ellsworth Kelly
Colored Paper Image XI 1976

Colored, pressed paper pulp (3)
46½ × 32½ (118.1 × 82.6)
Paper: white HMP, handmade,
hand-colored
Edition: 18 variations
Proofs: 7AP, TP, RTP, PPI, A

Papermaking by John and Kathleen Koller
at HMP; experimental trials and standard
proof paper coloring by artist assisted by
Kenneth Tyler and John Koller; paper
coloring by John and Kathleen Koller

Signed *Kelly* in pencil lower right;
numbered lower left; chop marks of work-
shop and artist lower right; workshop
number EK76-264 lower left verso

Newly made white pulp base sheet with
brown pulp and mix of light gray and gray
pulps applied through an image mold
constructed from a bent metal ruler and
masking tape; paper pressed

308:EK15

Ellsworth Kelly
Colored Paper Image XII 1976

Colored, pressed paper pulp (6)
46½ × 32½ (118.1 × 82.6)
Paper: white HMP, handmade,
hand-colored
Edition: 20 variations
Proofs: 8AP, TP, RTP, PPI, A

Papermaking by John and Kathleen Koller
at HMP; experimental trials and standard
proof paper coloring by artist assisted by
Kenneth Tyler and John Koller; paper
coloring by John and Kathleen Koller

Signed *Kelly* in pencil lower right;
numbered lower left; chop marks of work-
shop and artist lower right; workshop
number EK76-265 lower left verso

Newly made white pulp base sheet with
mix of 2 brown pulps, mix of 2 blue pulps,
and mix of 2 gray pulps applied through an
image mold constructed from a bent metal
ruler and masking tape; paper pressed

309:EK16

Ellsworth Kelly
Colored Paper Image XIII 1976

Colored, pressed paper pulp (6)
32¼ × 31¼ (81.9 × 79.4)
Paper: white HMP, handmade,
hand-colored
Edition: 23 variations
Proofs: 9AP, TP, RTP, PPI, A

Papermaking by John and Kathleen Koller
at HMP; experimental trials and standard
proof paper coloring by artist assisted by
Kenneth Tyler and John Koller; paper
coloring by John and Kathleen Koller

Signed *Kelly* in pencil lower right;
numbered lower left; chop marks of work-
shop and artist lower right; workshop
number EK76-306 lower left verso

Newly made white pulp base sheet with
yellow, orange, blue, and black pulps and
mix of 2 gray-green pulps applied through
an image mold constructed from Plexiglas
strips glued together; paper pressed

310:EK17

Ellsworth Kelly
Colored Paper Image XIV 1976

Colored, pressed paper pulp (1)
32¼ × 31¼ (81.9 × 79.4)
Paper: white HMP, handmade, hand-colored
Edition: 24 variations
Proofs: 8AP, TP, RTP, PPI, A

Papermaking by John and Kathleen Koller at HMP; experimental trials and standard proof paper coloring by artist assisted by Kenneth Tyler and John Koller; paper coloring by John and Kathleen Koller

Signed *Kelly* in pencil lower right; numbered lower left; chop marks of workshop and artist lower right; workshop number EK76-310 lower left verso

Newly made white pulp base sheet with yellow pulp applied through an image mold constructed from a bent metal ruler and masking tape; paper pressed

311:EK18

Ellsworth Kelly
Colored Paper Image XV 1976

Colored, pressed paper pulp (4)
32¼ × 31¼ (81.9 × 79.4)
Paper: white HMP, handmade, hand-colored
Edition: 23 variations
Proofs: 8AP, 2TP, RTP, PPI, A

Papermaking by John and Kathleen Koller at HMP; experimental trials and standard proof paper coloring by artist assisted by Kenneth Tyler and John Koller; paper coloring by John and Kathleen Koller

Signed *Kelly* in pencil lower right; numbered lower left; chop marks of workshop and artist lower right; workshop number EK76-311 lower left verso

Newly made white pulp base sheet with mix of light blue and blue pulps, and mix of gray and gray-black pulps applied through an image mold constructed from Plexiglas strips glued together; paper pressed

312:EK19

Ellsworth Kelly
Colored Paper Image XVI 1976

Colored, pressed paper pulp (5)
32¼ × 31¼ (81.9 × 79.4)
Paper: white HMP, handmade, hand-colored
Edition: 24 variations
Proofs: 8AP, 2TP, RTP, PPI, A

Papermaking by John and Kathleen Koller at HMP; experimental trials and standard proof paper coloring by artist assisted by Kenneth Tyler and John Koller; paper coloring by John and Kathleen Koller

Signed *Kelly* in pencil lower right; numbered lower left; chop marks of workshop and artist lower right; workshop number EK76-312 lower left verso

Newly made white pulp base sheet with yellow pulp, mix of light red and red pulps, and mix of light blue and blue pulps applied through an image mold constructed from Plexiglas strips glued together; paper pressed

313:EK20

Ellsworth Kelly
Colored Paper Image XVII 1976

Colored, pressed paper pulp (6)
32¼ × 31¼ (81.9 × 79.4)
Paper: white HMP, handmade,
hand-colored
Edition: 22 variations
Proofs: 8AP, TP, RTP, PPI, A

Papermaking by John and Kathleen Koller
at HMP; experimental trials and standard
proof paper coloring by artist assisted by
Kenneth Tyler and John Koller; paper
coloring by John and Kathleen Koller

Signed *Kelly* in pencil lower right;
numbered lower left; chop marks of work-
shop and artist lower right; workshop
number EK76-309 lower left verso

Newly made white pulp base sheet with
mix of 2 brown pulps, mix of 2 blue pulps,
and mix of 2 black pulps applied through
an image mold constructed from Plexiglas
strips glued together; paper pressed

314:EK21

Ellsworth Kelly
Colored Paper Image XVIII 1976

Colored, pressed paper pulp (4)
32¼ × 31¼ (81.9 × 79.4)
Paper: white HMP, handmade,
hand-colored
Edition: 22 variations
Proofs: 8AP, TP, CTP, RTP, PPI, A

Papermaking by John and Kathleen Koller
at HMP; experimental trials and standard
proof paper coloring by artist assisted by
Kenneth Tyler and John Koller; paper
coloring by John and Kathleen Koller

Signed *Kelly* in pencil lower right;
numbered lower left; chop marks of work-
shop and artist lower right; workshop
number EK76-307 lower left verso

Newly made white pulp base sheet with
mix of light green and green pulps and mix
of gray and black pulps applied through an
image mold constructed from Plexiglas
strips glued together; paper pressed

315:EK22

Ellsworth Kelly
Colored Paper Image XIX 1976

Colored, pressed paper pulp (8)
32¼ × 31¼ (81.9 × 79.4)
Paper: white HMP, handmade,
hand-colored
Edition: 17 variations
Proofs: 7AP, TP, RTP, PPI, A

Papermaking by John and Kathleen Koller
at HMP; experimental trials and standard
proof paper coloring by artist assisted by
Kenneth Tyler and John Koller; paper
coloring by John and Kathleen Koller

Signed *Kelly* in pencil lower right;
numbered lower left; chop marks of work-
shop and artist lower right; workshop
number EK76-305 lower left verso

Newly made white pulp base sheet with
blue and black pulps, mix of 2 purple
pulps, mix of 2 brown pulps, and mix of 2
green pulps applied through an image mold
constructed from Plexiglas strips glued
together; paper pressed

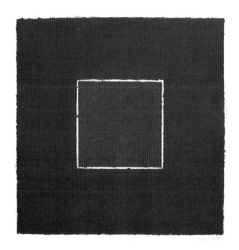

316:EK23	317:EK24	318:EK25

Ellsworth Kelly
Colored Paper Image XX 1976

Colored, pressed paper pulp (3)
32¼ × 31¼ (81.9 × 79.4)
Paper: white HMP, handmade,
hand-colored
Edition: 22 variations
Proofs: 8AP, 2TP, RTP, PPI, A

Papermaking by John and Kathleen Koller
at HMP; experimental trials and standard
proof paper coloring by artist assisted by
Kenneth Tyler and John Koller; paper
coloring by John and Kathleen Koller

Signed *Kelly* in pencil lower right;
numbered lower left; chop marks of work-
shop and artist lower right; workshop
number EK76-308 lower left verso

Newly made white pulp base sheet with
blue pulp and mix of light brown and
brown pulps applied through an image
mold constructed from Plexiglas strips
glued together; paper pressed

Ellsworth Kelly
Colored Paper Image XXI 1976

Colored, pressed paper pulp (8)
32¼ × 31¼ (81.9 × 79.4)
Paper: white HMP, handmade,
hand-colored
Edition: 10 variations
Proofs: 7AP, TP, RTP, PPI, A

Papermaking by John and Kathleen Koller
at HMP; experimental trials and standard
proof paper coloring by artist assisted by
Kenneth Tyler and John Koller; paper
coloring by John and Kathleen Koller

Signed *Kelly* in pencil lower right;
numbered lower left; chop marks of work-
shop and artist lower right; workshop
number EK75-226 lower left verso

Newly made white pulp base sheet with
orange and blue pulps, mix of 2 brown
pulps, mix of 2 gray-green pulps, and mix
of 2 black pulps applied through an image
mold constructed from Plexiglas strips
glued together; paper pressed

Ellsworth Kelly
Blue/Green/Yellow/Orange/Red 1977

Colored, pressed paper pulp (7)
13½ × 46 (34.3 × 116.8)
Paper: white HMP, handmade,
hand-colored
Edition: 14 variations
Proofs: 8AP, 3TP, 2CTP, WP, RTP, PPI, A

Papermaking by John and Kathleen Koller
at HMP; experimental trials and standard
proof paper coloring by artist assisted by
Kenneth Tyler and John Koller; paper
coloring by John and Kathleen Koller

Signed *Kelly* in pencil lower right;
numbered lower left; chop mark lower
right; workshop number EK75-225 lower
left verso

Newly made white pulp base sheet with
yellow, orange-red, and dark blue pulps,
mix of 2 yellow-green pulps, and mix of 2
dark red pulps applied through an image
mold constructed from Plexiglas strips
glued together; paper pressed

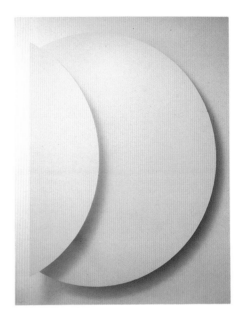

319:EK26

Ellsworth Kelly
Nine Colors 1977

Colored, pressed paper pulp (13)
30 × 30 (76.2 × 76.2)
Paper: white HMP, handmade,
hand-colored
Edition: 10 variations
Proofs: 7AP, 2CTP, RTP, PPI, A

Papermaking by John and Kathleen Koller
at HMP; experimental trials and standard
proof paper coloring by artist assisted by
Kenneth Tyler and John Koller; paper
coloring by John and Kathleen Koller

Signed *Kelly* in pencil lower right;
numbered lower left; chop mark lower
right; workshop number EK75-224 lower
left verso

Newly made white pulp base sheet with
yellow, medium blue, dark blue,
yellow-green, and blue-green pulps, mix of
2 red-orange pulps, mix of 2 medium red
pulps, mix of 2 purple pulps, and mix of 2
black pulps applied through an image mold
constructed from Plexiglas strips glued
together; paper pressed

320:EK27

Ellsworth Kelly
Nine Squares 1977

Screenprint, lithograph (10)
40½ × 40½ (102.9 × 102.9)
Paper: white Rives BFK, mould-made
Edition: 44
Proofs: 12AP, 4CTP, RTP, PPI, A

Plate preparation, processing, proofing, and
edition printing by John Hutcheson; screen
preparation, processing, proofing, and
edition printing by Kim Halliday

Signed *Kelly* and numbered in pencil lower
right; chop mark lower right; workshop
number EK76-223 lower left verso

11 runs: 10 colors; 11 runs from 2
aluminum plates and 3 screens:
1 gray (on left side); method 3c; IIa
2 gray (on right side); method 3c; IIa
3 yellow; methods 28 (KH), 27 (KH); VI
4 light green; methods 28 (same screen as
 run 3), 27 (KH); VI
5 black; methods 28 (KH), 27 (KH); VI
6 red; methods 28 (same screen as run
 5), 27 (KH); VI
7 blue; methods 28 (same screen as run
 5), 27 (KH); VI
8 orange; methods 28 (same screen as
 run 5), 27 (KH); VI
9 green; methods 28 (KH), 27 (KH); VI
10 purple; methods 28 (same screen as run
 9), 27 (KH); VI
11 dark blue; method 28 (same screen as
 run 9); VI

321:EK28

Ellsworth Kelly
Untitled Relief 1978

Welded aluminum shell with honeycomb
aluminum core; aluminum tubes; white
lacquer finish
72 × 54 × 7 (182.9 × 137.2 × 17.8)
Edition: 4 (with 2 additional copies for the
artist and the publisher)

Original wood maquette constructed by
Tyler Graphics Ltd.; aluminum fabrication
and painting of edition by Crystalizations,
Ltd.

Engraved *Kelly*, with number and copyright
information (© copyright Ellsworth Kelly
Fabricated and published Tyler Graphics
Ltd.) photoetched on a stainless-steel plate

Work on *Untitled Relief* began in 1976 as a
series of wood maquettes of various sizes
for a proposed sculpture project for the city
of Buffalo. In 1977 Kelly decided on a
six-foot-high model, which was
constructed in aluminum. This model was
hand-polished and numbered 2/4. Later the
artist decided to paint all of the other
sculptures with white lacquer.

322:EK29

Ellsworth Kelly
Wall 1979

Aquatint, etching (1)
31½ × 28 (80 × 71.1)
Paper: white Arches Cover, mould-made
Edition: 50
Proofs: 16AP, 2TP, SP, RTP, A, C

Plate preparation, processing, and proofing of trial proofs by Betty Fiske in 1976; edition printing by Rodney Konopaki in 1979 after he and artist filed plate edges to accept ink

Signed *Kelly* in pencil lower right; numbered lower left; chop mark lower right; workshop number EK76-255 lower left verso

1 run: 1 color; 1 run from 1 copper plate:
 1 black; methods 6, 9 (BF); IV

323:EK30

Ellsworth Kelly
Woodland Plant 1979

Lithograph (1)
31⅝ × 47 (80.3 × 119.4)
Paper: white Arches Cover, mould-made
Edition: 100
Proofs: 15AP, 6SP, RTP, PPI, A, C

Plate preparation, processing, proofing, and edition printing by Kenneth Tyler

Signed *Kelly* and numbered in pencil lower left; chop mark lower right; workshop number EK79-429 lower left verso

1 run: 1 color; 1 run from 1 aluminum plate:
 1 black; method 2b; I

The edition was printed for the Metropolitan Museum of Art, New York.

324:EK31

Ellsworth Kelly
Saint Martin Landscape 1979

Lithograph, screenprint, collage (14)
26⅞ × 33½ (68.3 × 85.1)
Paper: white Arches 88, mould-made;
white Rives Satine, mould-made
Edition: 39
Proofs: 12AP, 8CTP, RTP, PPI, A

Plate preparation, processing, proofing, and edition printing by John Hutcheson; screen preparation, processing, proofing, and edition printing by Kim Halliday and Kenneth Tyler; preparation and adhering of collage elements by Halliday, Tyler, and Rodney Konopaki

Signed *Kelly* in pencil lower right; numbered lower left; chop mark lower right; workshop number EK75-220 lower left verso

15 runs: 14 colors; 14 runs from 11 aluminum plates and 3 screens:
 1 light blue; method 28 (KH); VI
 2 transparent turquoise green; method 28 (KH); VI



3 process magenta; method 3c; IIa

4 process yellow; method 3c; IIa

5 cyan blue; method 3c; IIa

6 blue; method 3c; IIa

7 blue-black; method 3c; IIa

8 transparent light yellow; method 3b (KT); IIa

9 yellow (on Rives Satine paper); method 3c; IIa

10 transparent yellow (on same paper as run 9); method 3b (KT); IIa

11 process magenta (on same paper as run 9); method 3c; IIa

12 blue (on same paper as run 9); method 3c; IIa

13 transparent orange (on same paper as run 9); method 28 (KH); VI

14 blue-black (on same paper as run 9); method 3c; IIa

15 printed paper from runs 9–14 torn; method 36a (KH, KT, RK); III



325:EK32

Ellsworth Kelly
Saint Martin Landscape, State I-A 1979

Lithograph, screenprint (14)

26⅞ × 33½ (68.3 × 85.1)

Paper: white Arches 88, mould-made

Edition: 9

Proof: A

Signed *Kelly* in pencil lower right; numbered and titled (*State I-A*) lower left; workshop number EK75-220A lower left verso

14 runs: 14 colors; 14 runs from 3 screens and 11 aluminum plates:

 1 light blue; methods 28 (KH); VI

 2 transparent turquoise green; method 28 (KH); VI

 3 process magenta; method 3c; IIa

 4 process yellow; method 3c; IIa

 5 cyan blue; method 3c; IIa

 6 blue; method 3c; IIa

 7 blue-black; method 3c; IIa

 8 transparent light yellow; method 3b (KT); IIa

 9 yellow; method 3c; IIa

 10 transparent yellow; method 3b (KT); IIa

 11 process magenta; method 3c; IIa

 12 blue; method 3c; IIa

 13 transparent orange; method 28 (KH); VI

 14 blue-black; method 3c; IIa

The edition and state prints for *Saint Martin Landscape* are identical except that in the states a darker range of colors was used and the nude image was not a collage element.

326:EK33

Ellsworth Kelly
Saint Martin Landscape, State I-B 1979

Lithograph, screenprint (14)

26⅞ × 33½ (68.3 × 85.1)

Paper: white Arches 88, mould-made

Edition: 9

Signed *Kelly* in pencil lower right; numbered and titled (*State B-I*) lower left; workshop number EK75-220B lower left verso

14 runs: 14 colors; 14 runs from 3 screens and 11 aluminum plates:

 1 light blue; methods 28 (KH); VI

 2 transparent turquoise green; method 28 (KH); VI

 3 process magenta; method 3c; IIa

 4 process yellow; method 3c; IIa

 5 cyan blue; method 3c; IIa

 6 blue; method 3c; IIa

 7 blue-black; method 3c; IIa

 8 transparent light yellow; method 3b (KT); IIa

 9 yellow; method 3c; IIa

 10 transparent yellow; method 3b (KT); IIa

 11 process magenta; method 3c; IIa

 12 blue; method 3c; IIa

 13 transparent orange; method 28 (KH); VI

 14 blue-black; method 3c; IIa

The edition and state prints for *Saint Martin Landscape* are identical except that in the states a darker range of colors was used and the nude image was not a collage element.

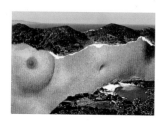

327:EK34

Ellsworth Kelly
Saint Martin Landscape, State I-C 1979

Lithograph, screenprint (14)
26⅞ × 33½ (68.3 × 85.1)
Paper: white Arches 88, mould-made
Edition: 1

Signed *Kelly* in pencil lower right; numbered and titled (*State I-C*) lower left; workshop number EK75-220C lower left verso

14 runs: 14 colors; 14 runs from 3 screens and 11 aluminum plates:
 1 light blue; methods 28 (KH); VI
 2 transparent turquoise green; method 28 (KH); VI
 3 process magenta; method 3c; IIa
 4 process yellow; method 3c; IIa
 5 cyan blue; method 3c; IIa
 6 blue; method 3c; IIa
 7 blue-black; method 3c; IIa
 8 transparent light yellow; method 3b (KT); IIa
 9 yellow; method 3c; IIa
 10 transparent yellow; method 3b (KT); IIa
 11 process magenta; method 3c; IIa
 12 blue; method 3c; IIa
 13 transparent orange; method 28 (KH); VI
 14 blue-black; method 3c; IIa

The edition and state prints for *Saint Martin Landscape* are identical except that in the states a darker range of colors was used and the nude image was not a collage element.

328:EK35

Ellsworth Kelly
Dark Gray and White 1979

Screenprint, collage (2)
30 × 42 (76.2 × 106.7)
Paper: gray Rives BFK, mould-made; white Duchene, handmade
Edition: 41
Proofs: 10AP, RTP, PPI, A, C

Screen preparation, processing, proofing, and edition printing by Kim Halliday; paper preparation and adhering of collage elements by Halliday

Signed *Kelly* and numbered in pencil lower right; chop mark lower right; workshop number EK77-313 lower left verso

2 runs: 2 colors, including 1 white paper; 1 run from 1 screen:
 1 transparent black; method 30c; VI
 2 white Duchene paper cut; methods 28 (KH), 36b (KH); III

329:EK36

Ellsworth Kelly
Daffodil 1980

Lithograph (1)
39¼ × 28¼ (99.7 × 71.8)
Paper: white Arches Cover, mould-made
Edition: 50
Proofs: 12AP, RTP, PPI, A, C

Plate preparation, processing, and proofing by Kenneth Tyler; edition printing by Lee Funderburg

Signed *Kelly* in pencil lower right; numbered lower left; chop mark lower right; workshop number EK79-431 lower left verso

1 run: 1 color; 1 run from 1 aluminum plate:
 1 black; method 2b; I

330:EK37

Ellsworth Kelly
Sarsaparilla 1980

Lithograph (1)
31¾ × 47¾ (80.6 × 121.3)
Paper: white Arches Cover, mould-made
Edition: 50
Proofs: 12AP, RTP, PPI, A, C

Stone preparation, processing, proofing, and edition printing by Kenneth Tyler

Signed *Kelly* in pencil lower right; numbered lower left; chop mark lower right; workshop number EK79-430 lower left verso

1 run: 1 color; 1 run from 1 stone:
 1 black; method 2a; I

331:EK38

Ellsworth Kelly
Mulberry Leaf 1980

Lithograph (1)
36½ × 26½ (92.7 × 67.3)
Paper: white Arches Cover, mould-made
Edition: 50
Proofs: 14AP, RTP, PPI, A, C

Plate preparation, processing, and proofing by Kenneth Tyler; edition printing by Lee Funderburg

Signed *Kelly* in pencil lower right; numbered lower left; chop mark lower right; workshop number EK79-432 lower left verso

1 run: 1 color; 1 run from 1 aluminum plate:
 1 black; method 2b; I

332:EK39

Ellsworth Kelly
Wild Grape Leaf 1980

Lithograph (1)
27½ × 24¾ (69.6 × 62.9)
Paper: white Arches Cover, mould-made
Edition: 50
Proofs: 13AP, TP, RTP, PPI, A, C

Stone preparation, processing, and proofing by Kenneth Tyler; edition printing by Lee Funderburg

Signed *Kelly* in pencil lower right; numbered lower left; chop mark lower right; workshop number EK79-433 lower left verso

1 run: 1 color; 1 run from 1 stone:
 1 black; method 2a; I

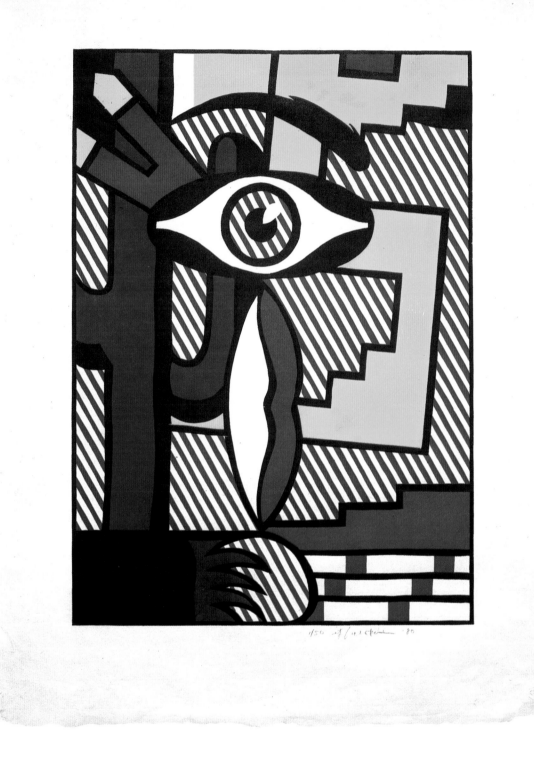

American Indian Theme III 1980
See 348:RL16

Roy Lichtenstein

1923 Born in New York

1940 Studies with Reginald Marsh at Art Students League, New York

1940–43 Attends Ohio State University, Columbus

1943–46 Serves in United States Army in Europe

1946 Returns to Ohio State University and receives B.F.A.

1949 Receives M.F.A. from Ohio State University; first solo exhibition at Ten Thirty Gallery, Cleveland

1949–51 Teaches at Ohio State University

1951 First solo exhibition in New York at Carlebach Gallery

1951–57 Lives in Cleveland and works as graphic and engineering draftsman, window designer, and sheet-metal designer

1957–60 Assistant professor at State University of New York, Oswego

1960–64 Assistant professor at Rutgers University, New Brunswick, New Jersey

1962 Completes first etching, *On*, printed by Georges Leblanc, Paris, and published by Galeria Schwarz, Milan

1963 Included in traveling exhibition *Six Painters and the Object*, originating at Solomon R. Guggenheim Museum, New York

1964 Resigns from faculty of Rutgers University to devote more time to painting

1966 Included in United States Pavilion, thirty-third Venice Biennale

1967 Retrospective exhibition *Roy Lichtenstein: 1961–1967* at Pasadena Art Museum, Pasadena, California; completes Ten Landscapes screenprint series, published by Original Editions, New York

1969 Exhibition *Roy Lichtenstein: 1961–1969* at Solomon R. Guggenheim Museum, New York; completes Cathedrals and Haystacks lithograph series at Gemini G.E.L., Los Angeles

1970 Elected to American Academy of Arts and Letters; completes Peace through Chemistry series of lithographs, screenprints, and bronze relief, and Modern Head mixed-media print and sculpture series at Gemini G.E.L., Los Angeles

1971 Included in exhibition *Technics and Creativity: Gemini G.E.L.* at Museum of Modern Art, New York

1972 Completes Mirror mixed-media print series at Gemini G.E.L., Los Angeles

1973 Completes Bull Profile lithograph-screenprint series at Gemini G.E.L., Los Angeles

1976 Completes Entablatures mixed-media print series at Tyler Graphics

1977 Receives Skowhegan Medal for painting

1980 Completes American Indian Theme woodcut series and group of intaglio prints at Tyler Graphics; completes Expressionistic woodcut series at Gemini G.E.L., Los Angeles

1981 Traveling exhibition *Roy Lichtenstein: 1970–1980*, originating at Saint Louis Art Museum

1983 Completes Painting lithograph series at Gemini G.E.L., Los Angeles

1984 Exhibition *Roy Lichtenstein: A Drawing Retrospective* at James Goodman Gallery, New York

1985 Completes Landscape mixed-media print series at Gemini G.E.L., Los Angeles

Currently lives and works in New York

Entablatures

333:RL1

Roy Lichtenstein
Homage to Max Ernst 1975

Screenprint (6)
26 × 20 (66 × 50.8)
Paper: white Arches 88, mould-made
Edition: 100
Proofs: 12AP, RTP, PPI, A, C

Screen preparation, proofing, and edition printing by Charles Hanley assisted by Igor Zakowortny and Don Carli

Signed *RF Lichtenstein*, numbered, and dated in pencil lower right; chop mark lower right; workshop number RL75-200 lower left verso

6 runs: 6 colors; 6 runs from 6 screens:
 1 light blue; method 28 (DC); VI
 2 light tan; method 28 (DC); VI
 3 dark blue; method 28 (DC); VI
 4 gray-blue; method 28 (DC); VI
 5 gray; method 28 (DC); VI
 6 black; method 30c; VI

The idea for the Entablatures, a series of metallic, textured-relief color prints, was conceived by Roy Lichtenstein in collaboration with Kenneth Tyler in May 1974. Extensive research, developmental work, and proofing took place at the workshop from September 1974 to April 1976 before the desired qualities of relief, texture, and color were achieved. During this period of interaction with the workshop and outside collaborators, the artist developed the printing and embossing elements for his images. Mechanical processes and technical problems were explored and resolved to create a standard for each of the eleven editions. The artist created one or more collages for each edition for the printers to use as models in making the plates and screens.

Production processes for the Entablatures included offset lithography and screen printing, bonding of lacquered metallic foils under pressure to Rives paper with polymer adhesive, embossing from die assemblies consisting of etched magnesium relief plates mounted on aluminum plates with removable inserts made from machined aluminum and cast-bronze parts.

Because of the fragility of the relief and collage areas of the Entablatures, each print is mounted in a recessed metal frame finished in white enamel and fitted with ultraviolet-filtering Plexiglas.

The ten embossing die assemblies are in the permanent collection of the print department of the Australian National Gallery, Canberra, as a gift from Tyler.

334:RL2

Roy Lichtenstein
Entablature I 1976

Screenprint, collage, embossing (6)
29¼ × 45 (74.3 × 114.3)
Paper: white Rives BFK, mould-made; .0035 gloss gold foil laminated onto 69# paper, machine-made
Edition: 16
Proofs: 9AP, RTP, PPI, A

Plate preparation by Kenneth Tyler, with processing by Swan Engraving; screen preparation and processing by Tyler and Kim Halliday; proofing and edition printing by Halliday and Betty Fiske; collage by Fiske; embossing by Tyler; patternmaking by Tyler, with machining of metal die part by Tompkins Tooling; bronze casting by Tallix Foundry

Signed *RF Lichtenstein* and dated in pencil lower right; numbered lower left; chop mark lower right; workshop number RL75-192 lower left verso

7 runs: 6 colors, including 1 colored foil; 6 runs from 5 screens and 1 embossing die assembly constructed from 1 magnesium relief plate with 2 inserts made from 1 machined aluminum part and 1 cast-bronze textured part mounted on a half-inch aluminum plate:

1 light gray-tan; method 30b (KH); VI
2 yellow; method 30b (KH); VI
3 light blue; method 30b (KH); VI
4 red; method 28 (KH); VI
5 black; method 28 (KT); VI
6 gloss gold foil machine-cut; methods 28 (KH), 36b (BF); III
7 inkless; methods 15a, 24; III

335:RL3

Roy Lichtenstein
Entablature II 1976

Screenprint, lithograph, collage, embossing (6)

29¼ × 45 (74.3 × 114.3)
Paper: white Rives BFK, mould-made; .0035 mat pink foil laminated onto 69# paper, machine-made; .0035 gloss copper foil laminated onto 69# paper, machine-made
Edition: 30
Proofs: 9AP, SP, RTP, PPI, A

Magnesium plate preparation by Kenneth Tyler, with processing by Swan Engraving; aluminum plate preparation, processing, proofing, and edition printing by John Hutcheson; screen preparation and processing by Tyler and Kim Halliday; proofing and edition printing by Halliday and Betty Fiske; collage by Fiske; embossing by Tyler; patternmaking by Tyler, with machining of metal die part by Tomkins Tooling

Signed *RF Lichtenstein* and dated in pencil lower right; numbered lower left; chop mark lower right; workshop number RL75-198 lower left verso

7 runs: 6 colors, including 2 colored foils; 6 runs from 3 screens, 1 aluminum plate, and 1 embossing die assembly constructed from 1 magnesium relief plate with 1 removable insert made from a machined aluminum part mounted on a half-inch aluminum plate:

1 light yellow; method 28 (KH); VI
2 dark red; method 28 (KH); VI
3 black; method 30b (KT); VI
4 mat pink foil machine-cut; methods 28 (KH), 36b (BF); III
5 gloss copper foil machine-cut; methods 28 (KH), 36b (BF); III
6 transparent white; method 3c; IIa
7 inkless; methods 15a, 24; III

336:RL4

Roy Lichtenstein
Entablature III 1976

Screenprint, collage, embossing (6)
29¼ × 45 (74.3 × 114.3)
Paper: white Rives BFK, mould-made;
.0035 gloss gold foil laminated onto 69#
paper, machine-made; .0035 mat gold foil
laminated onto 69# paper, machine-made
Edition: 16
Proofs: 9AP, SP, RTP, PPI, A

Plate preparation by Kenneth Tyler, with
processing by Swan Engraving; screen prep-
aration and processing by Tyler and Kim
Halliday; proofing and edition printing by
Halliday and Betty Fiske; collage by Fiske;
embossing by Tyler assisted by Fiske;
patternmaking by Tyler, with machining of
metal die part by Tompkins Tooling

Signed *RF Lichtenstein* and dated in pencil
lower right; numbered lower left; chop
mark lower right; workshop number
RL75-193 lower left verso

7 runs: 6 colors, including 2 colored foils; 5
runs from 4 screens and 1 embossing die
assembly constructed from 1 magnesium
relief plate with 1 removable insert made
from a machined aluminum part mounted
on a half-inch aluminum plate:
1 light yellow; method 28 (KH); VI
2 medium yellow; method 28 (KH); VI
3 green; method 28 (KH); VI
4 black; method 30b (KT); VI
5 mat gold foil machine-cut; methods 28
(KH), 36b (BF); III
6 gloss gold foil machine-cut; methods
28 (KH), 36b (BF); III
7 inkless; methods 15a, 24; III

337:RL5

Roy Lichtenstein
Entablature IV 1976

Screenprint, collage, embossing (6)
29¼ × 45 (74.3 × 114.3)
Paper: white Rives BFK, mould-made;
.0035 mat pink foil laminated onto 69#
paper, machine-made
Edition: 30
Proofs: 9AP, RTP, PPI, A

Plate preparation by Kenneth Tyler, with
processing by Swan Engraving; screen prep-
aration and processing by Tyler and Kim
Halliday; proofing and edition printing by
Halliday and Betty Fiske; collage and
embossing by Tyler

Signed *RF Lichtenstein* and dated in pencil
lower right; numbered lower left; chop
mark lower right; workshop number
RL75-197 lower left verso

7 runs: 6 colors, including 1 colored foil; 6
runs from 5 screens and 1 embossing die
assembly constructed from 1 magnesium
relief plate mounted on a half-inch
aluminum plate:
1 light green; method 28 (KH); VI
2 gray-blue; method 28 (KH); VI
3 dark blue; method 28 (KH); VI
4 yellow; method 28 (KH); VI
5 black; method 30b (KT); VI
6 mat pink foil machine-cut; methods 28
(KH), 36b (KT); III
7 inkless; methods 15a, 24; III

338:RL6

Roy Lichtenstein
Entablature V 1976

Screenprint, lithograph, collage, embossing (5)

29¼ × 45 (74.3 × 114.3)

Paper: white Rives BFK, mould-made; .0035 gloss silver foil laminated onto 69# paper, machine-made

Edition: 30

Proofs: 9AP, RTP, PPI, A

Plate preparation by Kenneth Tyler, with processing by Swan Engraving; aluminum plate preparation, processing, proofing, and edition printing by John Hutcheson; screen preparation and processing by Tyler and Kim Halliday; proofing and edition printing by Halliday and Betty Fiske; collage by Fiske; embossing by Tyler; patternmaking by Tyler, with machining of metal die part by Drake Engineering

Signed *RF Lichtenstein* and dated in pencil lower right; numbered lower left; chop mark lower right; workshop number RL75-196 lower left verso

6 runs: 5 colors, including 1 colored foil; 5 runs from 3 screens, 1 aluminum plate, and 1 embossing die assembly constructed from 1 magnesium relief plate with 1 removable insert made from a machined aluminum part mounted on a half-inch aluminum plate:

1 tan; method 28 (KH); VI
2 blue; method 28 (KH); VI
3 black; methods 30b, 30c (KT); VI
4 gloss silver foil machine-cut; methods 28 (KH), 36b (BF); III
5 transparent white; method 3c; IIa
6 inkless; methods 15a, 24; III

339:RL7

Roy Lichtenstein
Entablature VI 1976

Screenprint, collage, embossing (7)

29¼ × 45 (74.3 × 114.3)

Paper: white Rives BFK, mould-made; .0035 gloss gold foil laminated onto 69# paper, machine-made

Edition: 30

Proofs: 9AP, 2CTP, RTP, PPI, A

Plate preparation by Kenneth Tyler, with processing by Swan Engraving; screen preparation and processing by Tyler and Kim Halliday; proofing and edition printing by Halliday and Betty Fiske; collage by Fiske; embossing by Tyler; patternmaking by Tyler, with machining of metal die parts by Drake Engineering

Signed *RF Lichtenstein* and dated in pencil lower right; numbered lower left; chop mark lower right; workshop number RL75-199 lower left verso

9 runs: 7 colors, including 1 colored foil; 7 runs from 6 screens and 1 embossing die assembly constructed from 1 magnesium relief plate with 4 removable inserts made from 4 machined aluminum parts mounted on a half-inch aluminum plate:

1 light blue-green; method 28 (KH); VI
2 yellow; method 28 (KH); VI
3 tan; method 28 (KH); VI
4 blue; method 28 (KH); VI
5 black; method 30b (KT); VI
6 gloss gold foil machine-cut; methods 28 (KH), 36b (BF); III
7 light blue-green; method 28 (KT); VI
8 gloss gold foil machine-cut; methods 28 (KH), 36b (BF); III
9 inkless; methods 15a, 24; III

340:RL8

Roy Lichtenstein
Entablature VII　1976

Screenprint, collage, embossing (4)

29¼ × 45 (74.3 × 114.3)

Paper: white Rives BFK, mould-made; .0035 mat silver foil laminated onto 69# paper, machine-made; .0035 gloss silver foil laminated onto 69# paper, machine-made

Edition: 30

Proofs: 9AP, RTP, PPI, A

Plate preparation by Kenneth Tyler, with processing by Swan Engraving; screen preparation and processing by Tyler and Kim Halliday; proofing and edition printing by Halliday and Betty Fiske; collage by Fiske; embossing by Tyler; patternmaking by Tyler, with machining of metal die part by Drake Engineering and bronze casting by Tallix Foundry

Signed *RF Lichtenstein* and dated in pencil lower right; numbered lower left; chop mark lower right; workshop number RL75-195 lower left verso

5 runs: 4 colors, including 2 colored foils; 3 runs from 2 screens and 1 embossing die assembly constructed from 1 magnesium relief plate with 2 removable inserts made from 1 machined aluminum part and 1 cast-bronze textured part:

1 gray-blue; method 28 (KH); VI
2 black; methods 30b, 30c (KT); VI
3 mat silver foil machine-cut; methods 28 (KH), 36b (BF); III
4 gloss silver foil machine-cut; methods 28 (KH), 36b (BF); III
5 inkless; methods 15a, 24; III

341:RL9

Roy Lichtenstein
Entablature VIII 1976

Screenprint, collage, embossing (7)
29¼ × 45 (74.3 × 114.3)
Paper: white Rives BFK, mould-made;
.0035 gloss gold foil laminated onto 69#
paper, machine-made
Edition: 30
Proofs: 10AP, CTP, RTP, PPI, A

Plate preparation by Kenneth Tyler, with
processing by Swan Engraving; screen prep-
aration and processing by Tyler and Kim
Halliday; proofing and edition printing by
Halliday and Betty Fiske; collage and
embossing by Tyler; patternmaking by
Tyler, with machining of metal die part by
Drake Engineering

Signed *RF Lichtenstein* and dated in pencil
lower right; numbered lower left; chop
mark lower right; workshop number
RL75-191 lower left verso

8 runs: 7 colors, including 1 colored foil; 7
runs from 6 screens and 1 embossing die
assembly constructed from 1 magnesium
relief plate with 1 removable insert made
from a machined aluminum part mounted
on a half-inch aluminum plate:
1 light tan; method 28 (KH); VI
2 yellow; method 28 (KH); VI
3 orange; method 28 (KH); VI
4 pink; method 28 (KH); VI
5 gray; method 28 (KH); VI
6 black; method 30b (KT); VI
7 gloss gold foil machine-cut; methods
28 (KH), 36b (KT); III
8 inkless; methods 15a, 24; III

342:RL10

Roy Lichtenstein
Entablature IX 1976

Screenprint, lithograph, collage, embossing
(6)
29¼ × 45 (74.3 × 114.3)
Paper: white Rives BFK, mould-made;
.0035 gloss black foil laminated onto 69#
paper, machine-made; .0035 gloss silver
foil laminated onto 69# paper,
machine-made
Edition: 30
Proofs: 9AP, RTP, PPI, A

Plate preparation by Kenneth Tyler, with
processing by Swan Engraving; aluminum
plate preparation, processing, proofing, and
edition printing by John Hutcheson; screen
preparation and processing by Tyler and
Kim Halliday; proofing and edition
printing by Halliday and Betty Fiske;
collage and embossing by Tyler; pattern-
making by Tyler, with machining of metal
die parts by Drake Engineering

Signed *RF Lichtenstein* and dated in pencil
lower right; numbered lower left; chop
mark lower right; workshop number
RL75-200 lower left verso

7 runs: 6 colors, including 2 colored foils; 5 runs from 3 screens, 1 aluminum plate, and 1 embossing die assembly constructed from 1 magnesium relief plate with 2 removable inserts made from 2 machined aluminum parts mounted on a half-inch aluminum plate:

1 light blue; method 28 (KH); VI
2 dark blue; method 28 (KH); VI
3 black; method 28 (KH); VI
4 gloss black foil machine-cut; methods 28 (KH), 36b (KT); III
5 gloss silver foil machine-cut; methods 28 (KH), 36b (KT); III
6 white; method 3c; IIa
7 inkless; methods 15a, 24; III

343:RL11

Roy Lichtenstein
Entablature X 1976

Screenprint, lithograph, collage, embossing (6)

29¼ × 45 (74.3 × 114.3)
Paper: white Rives BFK, mould-made; .0035 mat silver foil laminated onto 69# paper, machine-made; .0035 gloss silver foil laminated onto 69# paper, machine-made; .0035 gloss black foil laminated onto 69# paper, machine-made
Edition: 18
Proofs: 9AP, 2CTP, RTP, PPI, A

Magnesium plate preparation by Kenneth Tyler, with processing by Swan Engraving; aluminum plate preparation, processing, proofing, and edition printing by John Hutcheson; screen preparation and processing by Tyler and Kim Halliday; proofing and edition printing by Halliday and Betty Fiske; collage and embossing by Tyler assisted by Fiske; patternmaking by Tyler, with machining of metal die part by Drake Engineering

Signed *RF Lichtenstein* and dated in pencil lower right; numbered lower left; chop mark lower right; workshop number RL75-205 lower left verso

7 runs: 6 colors, including 3 colored foils; 4 runs from 2 screens, 1 aluminum plate, and 1 embossing die assembly constructed from 1 magnesium relief plate with 1 removable insert made from a machined aluminum part mounted on a half-inch aluminum plate:

1 light yellow; method 28 (KH); VI
2 mat silver foil machine-cut; methods 28 (KH), 36b (KT, BF); III
3 gloss silver foil machine-cut; methods 28 (KH), 36b (KT, BF); III
4 gloss black foil machine-cut; methods 28 (KH), 36b (KT, BF); III
5 white; method 3b (KT); IIa
6 black; method 30b (KT); VI
7 inkless; methods 15a, 24; III

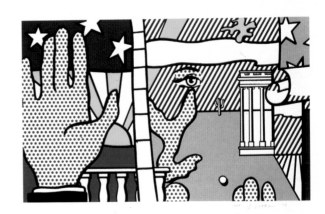

344:RL12

Roy Lichtenstein
Entablature XA 1976

Screenprint, lithograph, collage, embossing
(5)

29¼ × 45 (74.3 × 114.3)
Paper: white Rives BFK, mould-made;
.0035 mat silver foil laminated onto 69#
paper, machine-made; .0035 gloss silver
foil laminated onto 69# paper,
machine-made
Edition: 18
Proofs: 9AP, RTP, PPI, A

Magnesium plate preparation by Kenneth
Tyler, with processing by Swan Engraving;
aluminum plate preparation, processing,
proofing, and edition printing by John
Hutcheson; screen preparation and
processing by Tyler and Kim Halliday;
proofing and edition printing by Halliday
and Betty Fiske; collage and embossing by
Tyler assisted by Fiske; patternmaking by
Tyler, with machining of metal die part by
Drake Engineering

Signed *RF Lichtenstein* and dated in pencil
lower right; numbered lower left; chop
mark lower right; workshop number
RL75-205A lower left verso

6 runs: 5 colors, including 2 colored foils; 4
runs from 2 screens, 1 aluminum plate, and
1 embossing die assembly constructed from
1 magnesium relief plate with 1 removable
insert made from a machined aluminum
part mounted on a half-inch aluminum
plate:
1 gray; method 28 (KH); VI
2 black; method 30b (KT); VI
3 mat silver foil machine-cut; methods 28
 (KH), 36b (KT, BF); III
4 gloss silver foil machine-cut; methods
 28 (KH), 36b (KT, BF); III
5 transparent gray; method 3b (KT); IIa
6 inkless; methods 15a, 24; III

345:RL13

Roy Lichtenstein
Inaugural Print 1977

Screenprint (5)
20 × 30 (50.8 × 76.2)
Paper: white Arches 88, mould-made
Edition: 100
Proofs: 20AP, RTP, PPI, A, C

Screen preparation, proofing, and edition
printing by Kim Halliday

Signed *RF Lichtenstein*, numbered, and
dated in pencil lower right; chop mark
lower right; workshop number RL77-316
lower left verso

5 runs: 5 colors; 5 runs from 5 screens:
1 yellow; method 30b (KH); VI
2 silver; method 28 (KH); VI
3 red; method 30b (KH); VI
4 blue; method 30b (KH); VI
5 black; method 30b (KH); VI

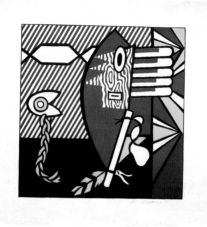

346:RL14

Roy Lichtenstein
American Indian Theme I 1980

Woodcut (4)
32¾ × 32 (83.2 × 81.3)
Paper: white Suzuki, handmade
Edition: 50
Proofs: 18AP, RTP, PPI, A, C

Proofing and edition printing by Roger
Campbell and Lee Funderburg

Signed *RF Lichtenstein*, numbered, and
dated in pencil lower right; chop mark
lower right; workshop number RL79-479
lower left verso

4 runs: 4 colors; 4 runs from 4
woodblocks:
 1 yellow; method 19a (birchwood; RC,
 LF); IIa
 2 red; method 19a (birchwood; RC, LF);
 IIa
 3 blue; method 19a (birchwood; RC,
 LF); IIa
 4 black; method 19a (birchwood); IIb

347:RL15

Roy Lichtenstein
American Indian Theme II 1980

Woodcut (7)
32½ × 37½ (82.6 × 95.3)
Paper: white Suzuki, handmade
Edition: 50
Proofs: 18AP, RTP, PPI, A, C

Proofing and edition printing by Roger
Campbell and Lee Funderburg

Signed *RF Lichtenstein*, numbered, and
dated in pencil lower right; chop mark
lower right; workshop number RL79-478
lower left verso

7 runs: 7 colors; 7 runs from 7
woodblocks:
 1 light yellow; method 19a (birchwood;
 RC, LF); IIa
 2 dark yellow; method 19a (birchwood;
 RC, LF); IIa
 3 light blue; method 19a (birchwood;
 RC, LF); IIa
 4 gray-silver; method 19a (birchwood;
 RC, LF); IIa
 5 red; method 19a (birchwood; RC, LF);
 IIa
 6 blue; method 19a (birchwood; RC,
 LF); IIa
 7 black; method 19a (birchwood); IIb

348:RL16

Roy Lichtenstein
American Indian Theme III 1980

Woodcut (5)
35 × 27 (88.9 × 68.6)
Paper: white Suzuki, handmade
Edition: 50
Proofs: 18AP, RTP, PPI, PPII, A, C

Proofing and edition printing by Roger
Campbell and Lee Funderburg

Signed *RF Lichtenstein*, numbered, and
dated in pencil lower right; chop mark
lower right; workshop number RL79-481
lower left verso

5 runs: 5 colors; 5 runs from 5
woodblocks:
 1 yellow; method 19a (birchwood; RC,
 LF); IIa
 2 green; method 19a (birchwood; RC,
 LF); IIa
 3 red; method 19a (birchwood; RC, LF);
 IIa
 4 blue; method 19a (birchwood; RC,
 LF); IIa
 5 black; method 19a (birchwood); IIb

349:RL17

Roy Lichtenstein
American Indian Theme IV 1980

Woodcut, lithograph (5)
37 × 36 (94 × 91.4)
Paper: white Suzuki, handmade
Edition: 50
Proofs: 18AP, RTP, PPI, A, C

Plate preparation and processing by Lee Funderburg; proofing and edition printing of woodblocks and plate by Roger Campbell and Funderburg

Signed *RF Lichtenstein*, numbered, and dated in pencil lower right; chop mark lower right; workshop number RL79-480 lower left verso

5 runs: 5 colors; 5 runs from 4 woodblocks and 1 aluminum plate:
 1 white; method 3b (LF); IIa
 2 yellow; method 19a (birchwood; RC, LF); IIa
 3 light blue; method 19a (birchwood; RC, LF); IIa
 4 red; method 19a (birchwood; RC, LF); IIa
 5 black; method 19a (birchwood); IIb

350:RL18

Roy Lichtenstein
American Indian Theme V 1980

Woodcut (6)
31¾ × 41 (80.6 × 104.1)
Paper: white Suzuki, handmade
Edition: 50
Proofs: 18AP, RTP, PPI, A, C

Proofing and edition printing by Roger Campbell and Lee Funderburg

Signed *RF Lichtenstein*, numbered, and dated in pencil lower right; chop mark lower right; workshop number RL79-477 lower left verso

6 runs: 6 colors; 6 runs from 6 woodblocks:
 1 yellow; method 19a (birchwood; RC, LF); IIa
 2 pink; method 19a (birchwood; RC, LF); IIa
 3 gray-silver; method 19a (birchwood; RC, LF); IIa
 4 red; method 19a (birchwood; RC, LF); IIa
 5 blue; method 19a (birchwood; RC, LF); IIa
 6 black; method 19a (birchwood); IIb

351:RL19

Roy Lichtenstein
American Indian Theme VI 1980

Woodcut (5)
37½ × 50¼ (95.3 × 127.6)
Paper: white Suzuki, handmade
Edition: 50
Proofs: 18AP, RTP, PPI, A, C

Proofing and edition printing by Roger Campbell and Lee Funderburg

Signed *RF Lichtenstein*, numbered, and dated in pencil lower right; chop mark lower right; workshop number RL79-476 lower left verso

5 runs: 5 colors; 5 runs from 5 woodblocks:
 1 light yellow; method 19a (birchwood; RC, LF); IIa
 2 dark yellow; method 19a (birchwood; RC, LF); IIa
 3 red; method 19a (birchwood; RC, LF); IIa
 4 blue; method 19a (birchwood; RC, LF); IIa
 5 black; method 19a (birchwood); IIb

352:RL20	353:RL21	354:RL22

Roy Lichtenstein
Head with Feathers and Braid 1980

Roy Lichtenstein
Figure with Teepee 1980

Roy Lichtenstein
Night Scene 1980

Etching, aquatint, engraving (4)
24 × 19¾ (61 × 50.2)
Paper: white Lana, mould-made
Edition: 32
Proofs: 12AP, 2TP, RTP, PPI, A, C

Etching, engraving (3)
24¼ × 21 (61.6 × 53.3)
Paper: white Lana, mould-made
Edition: 32
Proofs: 12AP, 8TP, RTP, PPI, A, C

Etching, aquatint, engraving (7)
20¾ × 21½ (52.7 × 54.6)
Paper: white Lana, mould-made
Edition: 32
Proofs: 12AP, RTP, PPI, A, C

Plate preparation, processing, proofing, and edition printing by Rodney Konopaki

Plate preparation, processing, proofing, and edition printing by Rodney Konopaki

Plate preparation, processing, proofing, and edition printing by Rodney Konopaki

Signed *RF Lichtenstein*, numbered, and dated in pencil lower center; chop mark lower right; workshop number RL79-483 lower left verso

Signed *RF Lichtenstein*, numbered, and dated in pencil lower center; chop mark lower right; workshop number RL79-484 lower left verso

Signed *RF Lichtenstein*, numbered, and dated in pencil lower center; chop mark lower right; workshop number RL79-487 lower left verso

3 runs: 4 colors; 3 runs from 3 copper plates:
 1 dark red; method 8; IV
 2 yellow and dark yellow; methods 9 (RK), 16a; IV
 3 black; methods 8, 12; IV

3 runs: 3 colors; 3 runs from 3 copper plates:
 1 light yellow; method 8; IV
 2 red; method 8; IV
 3 black; methods 8, 12; IV

5 runs: 7 colors; 5 runs from 5 copper plates:
 1 tan and light blue; methods 9 (RK), 16a; IV
 2 yellow; method 9 (RK); IV
 3 blue; method 8; IV
 4 red and green; methods 8, 16a; IV
 5 black; methods 8, 12; IV

355:RL23

Roy Lichtenstein
Two Figures with Teepee 1980

Etching, aquatint, engraving (5)
23½ × 20¾ (59.7 × 52.7)
Paper: white Lana, mould-made
Edition: 32
Proofs: 12AP, RTP, PPI, A, C

Plate preparation, processing, proofing, and edition printing by Rodney Konopaki

Signed *RF Lichtenstein*, numbered, and dated in pencil lower center; chop mark lower right; workshop number RL79-486 lower left verso

4 runs: 5 colors; 4 runs from 4 copper plates:
 1 yellow and green; methods 9 (RK), 16a; IV
 2 blue; method 8; IV
 3 red; method 8; IV
 4 black; methods 8, 12; IV

356:RL24

Roy Lichtenstein
Dancing Figures 1980

Etching, aquatint, engraving (5)
25 × 22½ (63.5 × 57.2)
Paper: white Lana, mould-made
Edition: 32
Proofs: 12AP, RTP, PPI, A, C

Plate preparation, processing, proofing, and edition printing by Rodney Konopaki

Signed *RF Lichtenstein*, numbered, and dated in pencil lower center; chop mark lower right; workshop number RL79-488 lower left verso

5 runs: 5 colors; 5 runs from 5 copper plates:
 1 light blue; method 9 (RK); IV
 2 yellow; method 9 (RK); IV
 3 blue; method 8; IV
 4 red; method 9 (RK); IV
 5 black; methods 8, 12; IV

357:RL25

Roy Lichtenstein
Head with Braids 1980

Etching, aquatint, engraving (5)
24¼ × 20¼ (61.6 × 51.4)
Paper: white Lana, mould-made
Edition: 32
Proofs: 12AP, RTP, PPI, A, C

Plate preparation, processing, proofing, and edition printing by Rodney Konopaki

Signed *RF Lichtenstein*, numbered, and dated in pencil lower center; chop mark lower right; workshop number RL79-485 lower left verso

4 runs: 5 colors; 4 runs from 4 copper plates:
 1 light blue; method 9 (RK); IV
 2 yellow and light green; methods 9 (RK), 16a; IV
 3 red; method 8; IV
 4 black; methods 8, 12; IV

<table>
<tr><td>

358:RL26

Roy Lichtenstein
Untitled I 1981

Etching (4)
23 × 20¾ (58.4 × 52.7)
Paper: white Lana, mould-made
Edition: 8
Proofs: 4AP, TP, RTP, PPI, A, C

Plate preparation, processing, proofing, and edition printing by Rodney Konopaki

Signed *RF Lichtenstein*, numbered, and dated in pencil lower center; chop mark lower right; workshop number RL79-482 lower left verso

4 runs: 4 colors; 4 runs from 4 copper plates:
 1 yellow; method 8; IV
 2 blue; method 8; IV
 3 red; method 8; IV
 4 black; method 8; IV

</td><td>

359:RL27

Roy Lichtenstein
Untitled II 1981

Etching (4)
23 × 20¾ (58.4 × 52.7)
Paper: white Lana, mould-made
Edition: 8
Proofs: 5AP, TP, RTP, PPI, A, C

Plate preparation, processing, proofing, and edition printing by Rodney Konopaki

Signed *RF Lichtenstein*, numbered, and dated in pencil lower center; chop mark lower right; workshop number RL79-482A lower left verso

4 runs: 4 colors; 4 runs from 4 copper plates:
 1 yellow; method 8; IV
 2 blue; method 8; IV
 3 red; method 8; IV
 4 black; method 8; IV

</td><td>

360:RL28

Roy Lichtenstein
Lamp 1981

Woodcut (4)
25 × 18¼ (63.5 × 46.4)
Paper: natural Okawara, handmade
Edition: 30
Proofs: 10AP, SP, RTP, PPI, PPII, A, C

Proofing by Kenneth Tyler, Roger Campbell, and Lee Funderburg; edition printing by Campbell and Funderburg; carving of new block by Campbell and reworking of existing blocks by Funderburg

Signed *RF Lichtenstein*, numbered, and dated in pencil lower right; chop mark lower right; workshop number RL80-512 lower left verso

4 runs: 4 colors; 4 runs from 4 woodblocks:
 1 white; method 19a (walnut wood, RC); IIa
 2 yellow; method 19a (teakwood, LF); IIa
 3 green; method 19a (teakwood, LF); IIa
 4 black; method 19a (teakwood, LF); IIa

The three teakwood blocks were carved by artisans in Ahmadabad, India, in 1978, under the supervision of the artist. In 1980 Lichtenstein brought the unproofed blocks to the workshop for printing. The blocks were laminated to plywood panels to remove the warping that had occurred and to prevent further splitting and distortion. The blocks were reworked to improve registration, and one new walnut block was also carved.

</td></tr>
</table>

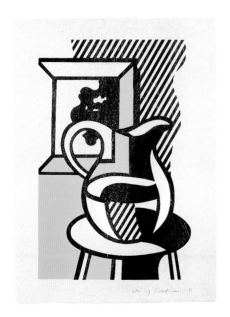

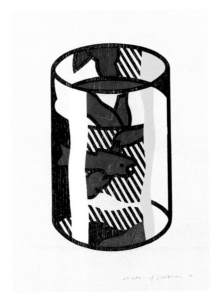

361:RL29

Roy Lichtenstein
Picture and Pitcher 1981

Woodcut (3)
25 × 18½ (63.5 × 47)
Paper: natural Okawara, handmade
Edition: 30
Proofs: 10AP, SP, RTP, PPI, PPII, A, C

Proofing by Kenneth Tyler, Roger Campbell, and Lee Funderburg; edition printing by Campbell and Funderburg; carving of new block by Campbell and reworking of existing blocks by Funderburg

Signed *RF Lichtenstein*, numbered, and dated in pencil lower right; chop mark lower right; workshop number RL80-513 lower left verso

3 runs: 3 colors; 3 runs from 3 woodblocks:
 1 white; method 19a (walnut wood, RC); IIa
 2 yellow; method 19a (teakwood, LF); IIa
 3 black; method 19a (teakwood, LF); IIa

The two teakwood blocks were carved by artisans in Ahmadabad, India, in 1978, under the supervision of the artist. In 1980 Lichtenstein brought the unproofed blocks to the workshop for printing. The blocks were laminated to plywood panels to remove the warping that had occurred and to prevent further splitting and distortion. The blocks were reworked to improve registration, and one new walnut block was also carved.

362:RL30

Roy Lichtenstein
Goldfish Bowl 1981

Woodcut (6)
25 × 18¼ (63.5 × 46.4)
Paper: natural Okawara, handmade
Edition: 30
Proofs: 10AP, SP, RTP, PPI, PPII, A, C

Proofing by Kenneth Tyler, Roger Campbell, and Lee Funderburg; edition printing by Campbell and Funderburg; carving of new block by Campbell and reworking of existing blocks by Campbell and Funderburg

Signed *RF Lichtenstein*, numbered, and dated in pencil lower right; chop mark lower right; workshop number RL80-511 lower left verso

6 runs: 6 colors; 6 runs from 6 woodblocks:
 1 yellow; method 19a (teakwood, LF); IIa
 2 green; method 19a (teakwood, RC); IIa
 3 red; method 19a (teakwood, LF); IIa
 4 blue; method 19a (teakwood, LF); IIa
 5 white; method 19a (teakwood, RC); IIa
 6 black; method 19a (teakwood, LF); IIa

The six teakwood blocks were carved by artisans in Ahmadabad, India, in 1978, under the supervision of the artist. In 1980 Lichtenstein brought the unproofed blocks to the workshop for printing. The blocks were laminated to plywood panels to remove the warping that had occurred and to prevent further splitting and distortion. The blocks were also reworked to improve registration.

Bedford I,
From the Bedford Series 1981
See 363:JM1

Joan Mitchell

1926 Born in Chicago

1942–46 Attends Smith College, Northampton, Massachusetts

1944–50 Attends Art Institute of Chicago; receives B.F.A. in 1947 and M.F.A. in 1950

1949 Receives prize from Art Institute of Chicago for study in Paris

1951 Moves to New York; first solo exhibition at New Gallery, New York

1955 Returns to France

1957 Included in sixty-second annual exhibition, Art Institute of Chicago, and annual exhibition, Whitney Museum of American Art, New York

1958 Included in twenty-ninth Venice Biennale

1959 Included in twentieth São Paulo Bienal; settles in France

1961 Included in exhibition *American Abstract Expressionists and Imagists* at Solomon R. Guggenheim Museum, New York

1966 Included in traveling exhibition *Two Decades of American Painting*, organized by Museum of Modern Art International Council, New York

1969 Moves studio from Paris to Vétheuil, a village Claude Monet lived in before moving to nearby Giverny

1971 Receives honorary doctorate from Miami University, Oxford, Ohio

1973 Included in biennial exhibition, Whitney Museum of American Art, New York

1974 Retrospective exhibition *Joan Mitchell* at Whitney Museum of American Art, New York; receives Brandeis Award

1980 Included in exhibition *The Fifties: Painting in New York, 1950–1960* at Hirshhorn Museum and Sculpture Garden, Smithsonian Institution, Washington, D.C.

1981 Completes Bedford Series lithographs at Tyler Graphics; included in thirty-seventh biennial exhibition, Corcoran Gallery of Art, Washington, D.C.

1982 Solo exhibition at Musée d'Art Moderne, Paris

1983 Included in biennial exhibition, Whitney Museum of American Art, New York

1984 Included in exhibition *Prints from Tyler Graphics* at Walker Art Center, Minneapolis

Currently lives and works in Vétheuil, France

363:JM1

Joan Mitchell
Bedford I, from the Bedford Series 1981

Lithograph (10)
42½ × 32½ (108 × 82.6)
Paper: white Arches 88, mould-made
Edition: 70
Proofs: 16AP, 5TP, CTP, SP, RTP, PPI, A, C

Prep work for continuous-tone lithography by Kenneth Tyler; plate preparation and processing by Lee Funderburg; proofing by Roger Campbell, Funderburg, and Tyler; edition printing by Campbell and Funderburg

Signed *Joan Mitchell* and numbered in pencil lower right; chop mark lower right; workshop number JM81-534 lower left verso

10 runs: 10 colors; 10 runs from 10 aluminum plates:
1 magenta; method 5a; IIa
2 ultramarine blue; method 5a; IIa
3 same ink as run 2; method 5a; IIa
4 same ink as run 2; method 5a; IIa
5 same ink as run 2; method 5a; IIa
6 same ink as run 2; method 5a; IIa
7 light yellow-ocher; method 5a; IIa
8 orange-red; method 5a; IIa
9 ocher-green; method 5a; IIa
10 black; method 5a; IIa

364:JM2

Joan Mitchell
Bedford II, from the Bedford Series 1981

Lithograph (8)
42½ × 32½ (108 × 82.6)
Paper: white Arches 88, mould-made
Edition: 70
Proofs: 16AP, SP, RTP, PPI, A, C

Prep work for continuous-tone lithography by Kenneth Tyler; plate preparation and processing by Lee Funderburg; proofing by Roger Campbell, Funderburg, and Tyler; edition printing by Campbell and Funderburg

Signed *Joan Mitchell* and numbered in pencil lower right; chop mark lower right; workshop number JM81-537 lower left verso

8 runs: 8 colors; 8 runs from 8 aluminum plates:
1 transparent magenta; method 5a; IIa
2 ultramarine blue; method 5a; IIa
3 same ink as run 2; method 5a; IIa
4 same ink as run 2; method 5a; IIa
5 yellow-green; method 5a; IIa
6 magenta; method 5a; IIa
7 dark magenta; method 5a; IIa
8 black; method 5a; IIa

365:JM3

Joan Mitchell
Bedford III, from the Bedford Series 1981

Lithograph (7)
42½ × 32½ (108 × 82.6)
Paper: white Arches 88, mould-made
Edition: 70
Proofs: 16AP, TP, CTP, SP, RTP, PPI, A, C

Prep work for continuous-tone lithography by Kenneth Tyler; plate preparation and processing by Lee Funderburg; proofing by Roger Campbell, Funderburg, and Tyler; edition printing by Campbell and Funderburg

Signed *Joan Mitchell* and numbered in pencil lower right; chop mark lower right; workshop number JM81-533 lower left verso

7 runs: 7 colors; 7 runs from 7 aluminum plates:
1 ultramarine blue; method 5a; IIa
2 same ink as run 1; method 5a; IIa
3 medium blue; method 5a; IIa
4 magenta; method 5a; IIa
5 green; method 5a; IIa
6 gray; method 5a; IIa
7 black; method 5a; IIa

366:JM4

Joan Mitchell
Sides of a River I, from the Bedford
Series 1981

Lithograph (5)
42½ × 32½ (108 × 82.6)
Paper: white Arches 88, mould-made
Edition: 70
Proofs: 2TP, SP, RTP, PPI, A, C

Prep work for continuous-tone lithography
by Kenneth Tyler; plate preparation and
processing by Lee Funderburg; proofing by
Roger Campbell, Funderburg, and Tyler;
edition printing by Campbell and
Funderburg

Signed *Joan Mitchell* and numbered in
pencil lower right; chop mark lower right;
workshop number JM81-535 lower left
verso

5 runs: 5 colors; 5 runs from 5 aluminum
plates:
 1 pink; method 5a; IIa
 2 magenta; method 5a; IIa
 3 ultramarine blue; method 5a; IIa
 4 dark gray-green; method 5a; IIa
 5 black; method 5a; IIa

367:JM5

Joan Mitchell
Sides of a River II, from the Bedford
Series 1981

Lithograph (7)
42½ × 32½ (108 × 82.6)
Paper: white Arches 88, mould-made
Edition: 70
Proofs: 16AP, CTP, SP, RTP, PPI, A, C

Prep work for continuous-tone lithography
by Kenneth Tyler; plate preparation and
processing by Lee Funderburg; proofing by
Roger Campbell, Funderburg, and Tyler;
edition printing by Campbell and
Funderburg

Signed *Joan Mitchell* and numbered in
pencil lower right; chop mark lower right;
workshop number JM81-536 lower left
verso

7 runs: 7 colors; 7 runs from 7 aluminum
plates:
 1 light blue-green; method 5a; IIa
 2 purple; method 5a; IIa
 3 light yellow; method 5a; IIa
 4 yellow; method 5a; IIa
 5 dark blue-green; method 5a; IIa
 6 green-black; method 5a; IIa
 7 black; method 5a; IIa

368:JM6

Joan Mitchell
Sides of a River III, from the Bedford
Series 1981

Lithograph (2)
42½ × 32½ (108 × 82.6)
Paper: white Arches 88, mould-made
Edition: 70
Proofs: 16AP, SP, RTP, PPI, A, C

Prep work for continuous-tone lithography
by Kenneth Tyler; plate preparation and
processing by Lee Funderburg; proofing by
Roger Campbell, Funderburg, and Tyler;
edition printing by Campbell and
Funderburg

Signed *Joan Mitchell* and numbered in
pencil lower right; chop mark lower right;
workshop number JM81-540 lower left
verso

2 runs: 2 colors; 2 runs from 2 aluminum
plates:
 1 purple; method 5a; IIa
 2 dark gray-green; method 5a; IIa

369:JM7

Joan Mitchell
Flower I, from the Bedford Series 1981

Lithograph (8)

42½ × 32½ (108 × 82.6)	
Paper: white Arches 88, mould-made	
Edition: 70	
Proofs: 16AP, 5TP, CTP, SP, RTP, PPI, A, C	

Prep work for continuous-tone lithography by Kenneth Tyler; plate preparation and processing by Lee Funderburg; proofing by Roger Campbell, Funderburg, and Tyler; edition printing by Campbell and Funderburg

Signed *Joan Mitchell* and numbered in pencil lower right; chop mark lower right; workshop number JM81-532 lower left verso

8 runs: 8 colors; 8 runs from 8 aluminum plates:
 1 light pink; method 5a; IIa
 2 medium pink; method 5a; IIa
 3 yellow-ocher; method 5a; IIa
 4 light orange; method 5a; IIa
 5 dark orange; method 5a; IIa
 6 dark yellow-green; method 5a; IIa
 7 magenta; method 5a; IIa
 8 black; method 5a; IIa

370:JM8

Joan Mitchell
Flower II, from the Bedford Series 1981

Lithograph (2)

42½ × 32½ (108 × 82.6)	
Paper: white Arches 88, mould-made	
Edition: 70	
Proofs: 16AP, SP, RTP, PPI, A, C	

Prep work for continuous-tone lithography by Kenneth Tyler; plate preparation and processing by Lee Funderburg; proofing by Roger Campbell, Funderburg, and Tyler; edition printing by Campbell and Funderburg

Signed *Joan Mitchell* and numbered in pencil lower right; chop mark lower right; workshop number JM81-541 lower left verso

2 runs: 2 colors; 2 runs from 2 aluminum plates:
 1 orange; method 5a; IIa
 2 black; method 5a; IIa

371:JM9

Joan Mitchell
Flower III, from the Bedford Series 1981

Lithograph (4)

42½ × 32½ (108 × 82.6)	
Paper: white Arches 88, mould-made	
Edition: 70	
Proofs: 16AP, SP, RTP, PPI, A, C	

Prep work for continuous-tone lithography by Kenneth Tyler; plate preparation and processing by Lee Funderburg; proofing by Roger Campbell, Funderburg, and Tyler; edition printing by Campbell and Funderburg

Signed *Joan Mitchell* and numbered in pencil lower right; chop mark lower right; workshop number JM81-538 lower left verso

4 runs: 4 colors; 4 runs from 4 aluminum plates:
 1 yellow-ocher; method 5a; IIa
 2 orange-red; method 5a; IIa
 3 dark gray-green; method 5a; IIa
 4 black; method 5a; IIa

372:JM10

Joan Mitchell
Brush, from the Bedford Series 1981

Lithograph (4)

42½ × 32½ (108 × 82.6)

Paper: white Arches 88, mould-made

Edition: 70

Proofs: 16AP, CTP, SP, RTP, PPI, A

Prep work for continuous-tone lithography by Kenneth Tyler; plate preparation and processing by Lee Funderburg; proofing by Roger Campbell, Funderburg, and Tyler; edition printing by Campbell and Funderburg

Signed *Joan Mitchell* and numbered in pencil lower right; chop mark lower right; workshop number JM81-539 lower left verso

4 runs: 4 colors; 4 runs from 4 aluminum plates:
 1 gray-blue; method 5a; IIa
 2 dark gray-blue; method 5a; IIa
 3 transparent orange; method 5a; IIa
 4 black; method 5a; IIa

373:JM11

Joan Mitchell
Brush, State I, from the Bedford Series 1981

Lithograph (4)

42½ × 32½ (108 × 82.6)

Paper: white Arches 88, mould-made

Edition: 35

Proofs: 10AP, SP, RTP, PPI, A, C

Prep work for continuous-tone lithography by Kenneth Tyler; plate preparation and processing by Lee Funderburg; proofing by Roger Campbell, Funderburg, and Tyler; edition printing by Campbell and Funderburg

Signed *Joan Mitchell* and numbered in pencil lower right; chop mark lower right; workshop number JM81-539A lower left verso

4 runs: 4 colors; 4 runs from 4 aluminum plates:
 1 light gray; method 5a; IIa
 2 medium gray; method 5a; IIa
 3 dark gray; method 5a; IIa
 4 black; method 5a; IIa

Beach Scene 1982
See 374:MM1

Malcolm Morley

1931 Born in Highgate, London

1952–53 Attends Camberwell School of Arts and Crafts, London

1954–57 Attends Royal College of Art, London

1958 Moves to New York

1964 First solo exhibition at Kornblee Gallery, New York

1965 Invents term *superrealist* to describe his work (until 1970); differs from photorealists in that he does not rely on a projector for enlargement; subject matter often derived from travel agency literature

1965–66 Teaches at Ohio State University, Columbus

1966 Included in exhibition *The Photographic Image* at Solomon R. Guggenheim Museum, New York

1967–69 Teaches at School of Visual Arts, New York

1971 Included in exhibition *Radical Realism* at Museum of Contemporary Art, Chicago

1972–74 Teaches at State University of New York, Stony Brook

1973–74 Completes three-dimensional foldout paintings

1976 For exhibition at Clocktower Gallery, Institute for Art and Urban Resources, New York, paints scenes of catastrophe; uses images from earlier works and images of toy trains and planes

1977 Included in exhibition *British Painting: 1952–1977* at Royal Academy of Arts, London

1977–79 Lives in Florida

1981 Exhibition *Malcolm Morley: Paintings* at Akron Art Museum

1982 Completes lithographs at Tyler Graphics

1983 Traveling retrospective *Malcolm Morley: Paintings, 1965–1982*, originating at Whitechapel Art Gallery, London; included in exhibition *New Art* at Tate Gallery, London

1984 Included in exhibition *Prints from Tyler Graphics* at Walker Art Center, Minneapolis; included in exhibition *An International Survey of Painting and Sculpture* at Museum of Modern Art, New York

Currently lives and works in New York

374:MM1

Malcolm Morley
Beach Scene 1982

Lithograph (16)
38¼ × 51⅛ (97.2 × 129.6)
Paper: white Arches 88, mould-made
Edition: 58
Proofs: 18AP, 2TP, 3CTP, SP, RTP, PPI, PPII, A, C

Prep work for continuous-tone lithography by Kenneth Tyler; plate preparation and processing by Lee Funderburg; proofing by Roger Campbell, Funderburg, and Tyler; edition printing by Campbell and Funderburg

Signed *Malcolm Morley* and numbered in pencil lower right; chop mark lower right; workshop number MM81-608 lower left verso

10 runs: 16 colors; 10 runs from 10 aluminum plates:
 1 blend of yellow, pink, and tan; methods 5a, 16d; IIa
 2 blend of light blue, ultramarine blue, and turquoise blue; methods 5a, 16d; IIa
 3 red; method 5a; IIa
 4 blend of yellow and orange; methods 5a, 16d; IIa
 5 blend of magenta and violet; methods 5a, 16d; IIa
 6 green; method 5a; IIa
 7 purple; method 5a; IIa
 8 brown; method 5a; IIa
 9 ultramarine blue; method 5a; IIa
 10 dark blue; method 5a; IIa

375:MM2

Malcolm Morley
Parrots 1982

Lithograph (11)
42½ × 39½ (108 × 100.3)
Paper: white Arches 88, mould-made
Edition: 55
Proofs: 16AP, 2TP, 5CTP, SP, WP, RTP, PPI, PPII, A, C

Prep work for continuous-tone lithography by Kenneth Tyler; plate preparation and processing by Lee Funderburg; proofing by Roger Campbell, Funderburg, and Tyler; edition printing by Campbell and Funderburg

Signed *Malcolm Morley* in pencil lower right; numbered lower left; chop mark lower right; workshop number MM81-627 lower left verso

8 runs: 11 colors; 8 runs from 8 aluminum plates:
 1 blend of yellow and tan; methods 5a, 16d; IIa
 2 light green; method 5a; IIa
 3 light blue; method 5a; IIa
 4 red; method 5a; IIa
 5 dark blue; method 5a; IIa
 6 yellow; method 5a; IIa
 7 blend of orange and green; methods 5a, 16d; IIa
 8 blend of brown and black; methods 5a, 16d; IIa

376:MM3

Malcolm Morley
Devonshire Bullocks 1982

Lithograph (25)
47¾ × 35 (121.3 × 88.9)
Paper: white Rives BFK, mould-made
Edition: 58
Proofs: 14AP, 2TP, 4CTP, SP, RTP, PPI, PPII, A, C

Prep work for continuous-tone lithography by Kenneth Tyler; plate preparation and processing by Lee Funderburg; proofing by Roger Campbell, Funderburg, and Tyler; edition printing by Campbell and Funderburg

Signed *Malcolm Morley* in pencil lower right; numbered lower left; chop mark lower right; workshop number MM81-600 lower left verso

14 runs: 25 colors; 14 runs from 14 aluminum plates:
 1 blend of purple, brown, green, and light gray; methods 5a, 16d; IIa
 2 blend of red-orange, blue, and green; methods 5a, 16d; IIa
 3 yellow-green; methods 5a, 16c; IIa

4 brown; method 5a; IIa
5 blend of pink and yellow-white;
 methods 5a, 16d; IIa
6 blend of yellow and orange; methods
 5a, 16d; IIa
7 blend of cyan blue and ultramarine
 blue; methods 5a, 16d; IIa
8 red; method 5a; IIa
9 blend of blue and green; methods 5a,
 16d; IIa
10 dark green; method 5a; IIa
11 black; method 5a; IIa
12 gray; method 5a (same plate as run 7);
 IIa
13 black; method 5a; IIa
14 blend of purple, red-brown, and blue;
 methods 5a, 16d; IIa

377:MM4

Malcolm Morley
Devonshire Cows 1982

Lithograph (13)

46¼ × 34⅜ (117.5 × 86.8)

Paper: white Rives BFK, mould-made

Edition: 65

Proofs: 16AP, 5TP, 4CTP, 2SP, RTP, PPI,
PPII, A, C

Prep work for continuous-tone lithography
by Kenneth Tyler; plate preparation and
processing by Lee Funderburg; proofing by
Roger Campbell, Funderburg, and Tyler;
edition printing by Campbell and
Funderburg

Signed *Malcolm Morley* in pencil lower
right; numbered lower left; chop mark
lower right; workshop number MM81-601
lower left verso

8 runs: 13 colors; 8 runs from 8 aluminum
plates:
 1 pink and yellow-green; methods 5a,
 16c; IIa
 2 black; method 5a; IIa
 3 light blue and green-blue; methods 5a,
 16c; IIa
 4 orange-yellow; method 5a; IIa
 5 yellow, red, and yellow-green; methods
 5a, 16c; IIa
 6 red; method 5a; IIa
 7 orange and light pink; methods 5a,
 16c; IIa
 8 pink-brown; method 5a; IIa

378:MM5

Malcolm Morley
Fish 1982

Lithograph (1)

26 × 39 (66 × 99.1)

Paper: white Pur Charve Nacre, handmade

Edition: 30

Proofs: 10AP, 4TP, RTP, PPI, PPII, A, C

Prep work for continuous-tone lithography
by Kenneth Tyler; plate preparation and
processing by Lee Funderburg; proofing
and edition printing by Roger Campbell
and Funderburg

Signed *Malcolm Morley* in pencil lower
right; numbered lower left; chop mark
lower right; workshop number MM81-606
lower left verso

1 run: 1 color; 1 run from 1 aluminum
plate:
 1 blue-gray; method 5a; IIa

379:MM6

Malcolm Morley
Goat 1982

Lithograph (2)
31½ × 40½ (80 × 102.9)
Paper: gray with colored threads HMP,
handmade
Edition: 30
Proofs: 14AP, 2TP, RTP, PPI, PPII, A, C

Stone preparation and processing by
Kenneth Tyler on press I; prep work for
continuous-tone lithography by Tyler; plate
preparation and processing by Lee Funder-
burg; proofing and edition printing of stone
and plate by Roger Campbell and Funder-
burg on press II

Signed *Malcolm Morley* in pencil lower
right; numbered lower left; chop mark
lower right; workshop number MM81-603
lower left verso

2 runs: 2 colors; 2 runs from 1 stone and 1
aluminum plate:
 1 gray-black; method 1a; IIa
 2 black; method 5a; IIa

380:MM7

Malcolm Morley
Horses 1982

Lithograph (1)
38¾ × 28½ (98.4 × 72.4)
Paper: cream TGL, handmade
Edition: 35
Proofs: 10AP, TP, RTP, PPI, PPII, A, C

Papermaking by Steve Reeves and Tom Stri-
anese; prep work for continuous-tone
lithography by Kenneth Tyler; plate prepa-
ration and processing by Lee Funderburg;
proofing and edition printing by Roger
Campbell and Funderburg

Signed *Malcolm Morley* in pencil lower
right; numbered lower left; chop mark
lower right; workshop number MM81-602
lower right verso

1 run: 1 color; 1 run from 1 aluminum
plate:
 1 red-black; method 5a; IIa

381:MM8

Malcolm Morley
Goats in a Shed 1982

Lithograph (1)
28½ × 40 (72.4 × 101.6)
Paper: white Nimaizuki, handmade
Edition: 30
Proofs: 10AP, 5TP, RTP, PPI, PPII, A, C

Prep work for continuous-tone lithography
by Kenneth Tyler; plate preparation and
processing by Lee Funderburg; proofing
and edition printing by Roger Campbell
and Funderburg

Signed *Malcolm Morley* and numbered in
pencil lower right; chop mark lower left;
workshop number MM81-605 lower right
verso

1 run: 1 color; 1 run from 1 aluminum
plate:
 1 black; method 5a; IIa

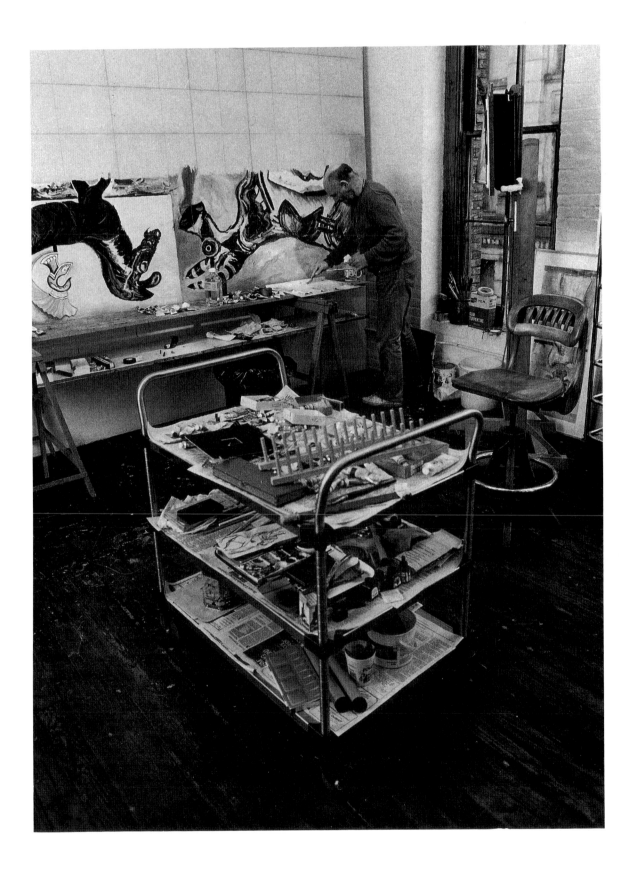

Malcolm Morley working in his New York
studio, 1984.

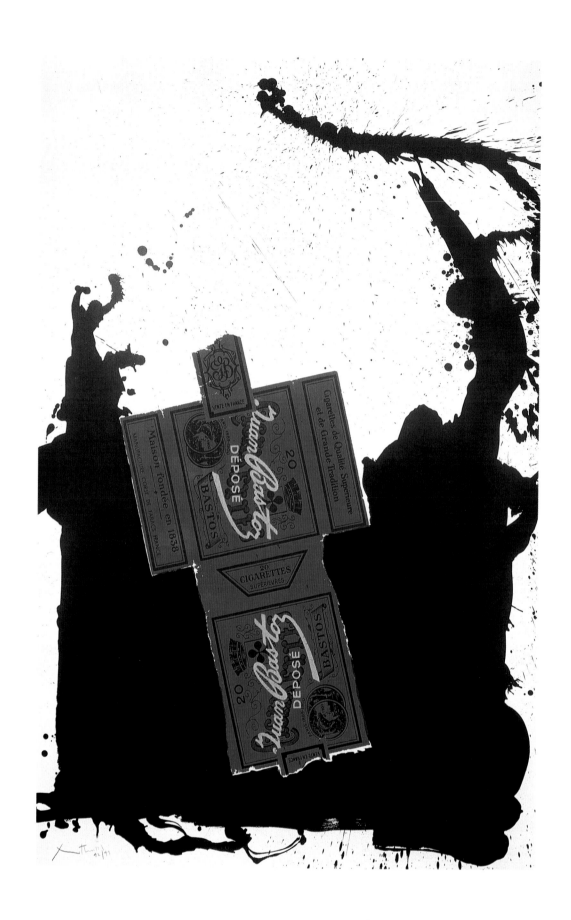

Bastos 1975
See 383:RM2

Robert Motherwell

1915 Born in Aberdeen, Washington

1932–36 Studies at Stanford University, Stanford, California, and receives B.A. in philosophy, 1937

1937 Enters Graduate School of Arts and Sciences at Harvard University, Cambridge, Massachusetts

1939 First solo exhibition at Raymond Duncan Gallery, Paris

1940 Enters graduate department of art history and archaeology at Columbia University, New York; studies under Meyer Schapiro

1941 Studies engraving with Kurt Seligmann

1943 Completes first two collages at Jackson Pollock's studio; studies engraving with Stanley William Hayter at Atelier 17, New York

1944 Begins editing the Documents of Modern Art, a series of writings by twentieth-century artists, published by Wittenborn, Schultz; solo exhibition at Peggy Guggenheim's Art of This Century Gallery, New York

1945 Teaches at Black Mountain College, Black Mountain, North Carolina

1949 Starts school of fine art in New York

1951–58 Teaches at Hunter College of the City University of New York

1953 Included in second São Paulo Bienal

1961 Begins making prints at Universal Limited Art Editions, West Islip, New York; retrospective exhibition organized by Museum of Modern Art, New York, at sixth São Paulo Bienal

1964 Included in exhibition *Contemporary Painters and Sculptors as Printmakers* at Museum of Modern Art, New York

1965 Traveling retrospective exhibition *Robert Motherwell*, originating at

Museum of Modern Art, New York; retrospective exhibition *Collages by Robert Motherwell* at Phillips Collection, Washington, D.C.; completes Madrid Suite and group of lithographs at Hollander Workshop, New York

1969 Elected member of National Institute of Arts and Letters; Special Adviser, National Council on the Arts, Washington, D.C.

1970–71 Completes The African Suite, The Basque Suite, and London Series I and II screenprint series at Kelpra Studio, London, published by Marlborough Gerson Gallery, New York

1971 Moves to Greenwich, Connecticut

1972 Completes A la pintura, a portfolio of intaglio prints with a text by Rafael Alberti, at Universal Limited Art Editions, West Islip, New York

1973 Completes Summer Light Series mixed-media prints at Gemini G.E.L., Los Angeles; installs etching press in Greenwich studio and works with printer Catherine Mousley

1974–75 Completes lithographs, lithograph-screenprints, and hand-colored mixed-media print at Tyler Graphics

1976 Installs lithography press in Greenwich studio and works with printer Robert Bigelow

1977 Included in exhibition *Art Off the Picture Press* at Emily Lowe Gallery, Hofstra University, New York

1979–80 Completes group of prints at Tyler Graphics

1980 Traveling retrospective exhibition *The Painter and the Printer: Robert Motherwell's Graphics, 1943–1980*, organized by American Federation of Arts, New York

1981 Receives Skowhegan Medal for graphics

1981–82 Completes group of prints at Tyler Graphics

1982 Completes *El Negro*, a book with lithographs and a text by Rafael Alberti, at Tyler Graphics; retrospective exhibition at Albright-Knox Art Gallery, Buffalo

1983–84 Completes America–La France Variations lithograph-collage series and group of prints at Tyler Graphics

1984 Included in exhibition *Prints from Tyler Graphics* at Walker Art Center, Minneapolis; included in exhibition *Gemini G.E.L.: Art and Collaboration* at National Gallery of Art, Washington, D.C.

1985 Completes group of prints at Tyler Graphics; included in exhibition *Ken Tyler: Printer Extraordinary* at Australian National Gallery, Canberra; traveling exhibition *Robert Motherwell: The Collaged Image*, originating at Walker Art Center, Minneapolis

Currently lives and works in Greenwich, Connecticut

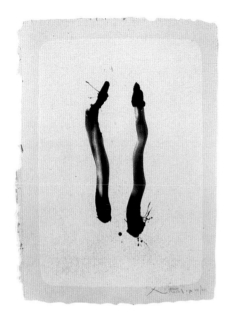

382:RM1
Belknap 136

Robert Motherwell
The Stoneness of the Stone　1974

Lithograph (3)
41 × 30 (104.1 × 76.2)
Paper: light gray Twinrocker laminated to medium gray Twinrocker, handmade
Edition: 75
Proofs: 8AP, 2TP, RTP, PPI, A, C

Stone preparation, processing, proofing, and edition printing by Kenneth Tyler assisted by Don Carli

Signed *Motherwell* and numbered in pencil lower right; chop marks of workshop and artist lower right; workshop number RM74-138 lower left verso

1 run: 3 colors, including a 2-color paper; 1 run from 1 stone:
　1　black; method 1a; I

383:RM2
Belknap 138

Robert Motherwell
Bastos　1975

Lithograph (6)
62⅜ × 40 (158.4 × 101.6)
Paper: white Arjomari, mould-made
Edition: 49
Proofs: 12AP, 3TP, 6CTP, WP, RTP, PPI, A, C

Plate preparation, processing, proofing, and edition printing by Kenneth Tyler assisted by Don Carli

Signed *Motherwell* and numbered in pencil lower left; chop marks of workshop and artist lower left; workshop number RM75-139 lower right verso

6 runs: 6 colors; 6 runs from 6 aluminum plates:
　1　red-blue; method 3c; I
　2　green-blue; method 3c; I
　3　yellow-ocher; method 3b (KT); I
　4　black; method 3c; I
　5　dark brown; method 1b; I
　6　black; method 1b; I

384:RM3
Belknap 139

Robert Motherwell
Monster　1975

Lithograph (1)
41 × 31 (104.1 × 78.7)
Paper: gray with colored threads HMP, handmade
Edition: 26
Proofs: 8AP, 3TP, RTP, PPI, A, C

Stone preparation, processing, proofing, and edition printing by Kenneth Tyler

Signed *RM* and numbered in pencil upper right; chop marks of workshop and artist lower left; workshop number RM74-141 lower right verso

1 run: 1 color; 1 run from 1 stone:
　1　black; method 1a; I

385:RM4
Belknap 140

Robert Motherwell
Tobacco Roth-Händle 1975

Lithograph, screenprint (4)
41 × 31 (104.1 × 78.7)
Paper: cream HMP, handmade
Edition: 45
Proofs: 7AP, 5TP, 2CTP, WP, RTP, PPI, A, C

Stone preparation, processing, and proofing
by Kenneth Tyler; screen preparation,
processing, and proofing by Kim Halliday;
edition printing by Robert Bigelow and
Tyler

Signed *Motherwell* and numbered in pencil
lower right; chop marks of workshop and
artist lower right; workshop number
RM75-145 lower left verso

4 runs: 4 colors; 4 runs from 2 stones and
2 screens:
 1 black; method 1a; I
 2 brown; method 2a; I
 3 transparent brown; method 28 (KH);
 VI
 4 black; method 30c; VI

While still moist, the newly made paper
was pressed between linen canvases to add
texture.

386:RM5
Belknap 141

Robert Motherwell
Le Coq 1975

Lithograph, screenprint (3)
37¾ × 25¼ (95.9 × 64.1)
Paper: white Arches Cover, mould-made
Edition: 40
Proofs: 12AP, 3TP, RTP, PPI, A, C

Stone preparation and processing by
Kenneth Tyler; proofing by Tyler and
Robert Bigelow; edition printing by
Bigelow; screen preparation, processing,
proofing, and edition printing by Tyler

Signed *RM* and numbered in pencil lower
right; chop marks of workshop and artist
lower right; workshop number RM75-149
lower left verso

3 runs: 3 colors; 3 runs from 2 stones and
1 screen:
 1 black; method 1a; I
 2 red; method 1a; I
 3 transparent red; method 28 (KT); VI

387:RM6
Belknap 142

Robert Motherwell
Poe's Abyss 1975

Lithograph (2)
46 × 42 (116.8 × 106.7)
Paper: white Arjomari, mould-made
Edition: 16
Proofs: 7AP, 5TP, RTP, PPI, A, C

Stone and plate preparation, processing,
and proofing by Kenneth Tyler; edition
printing by Robert Bigelow assisted by Igor
Zakowortny

Signed *Motherwell* and numbered in pencil
lower right; chop marks of workshop and
artist lower right; workshop number
RM75-143 lower left verso

2 runs: 2 colors; 2 runs from 1 stone and 1
aluminum plate:
 1 dark brown; method 1a; I
 2 black; method 1b; I

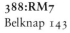

388:RM7
Belknap 143

Robert Motherwell
Spanish Elegy I 1975

Lithograph (1)

18 × 31 (45.7 × 78.7)	
Paper: brown HMP, handmade	
Edition: 38	
Proofs: 12AP, 3SP, RTP, PPI, A	

Stone preparation, processing, and proofing by Kenneth Tyler; edition printing by Robert Bigelow

Signed *Motherwell* and numbered in pencil lower right; chop marks of workshop and artist lower right; workshop number RM75-164 lower left verso

1 run: 1 color; 1 run from 1 stone:
 1 black; method 2a; I

After a few prints from this edition were released, the artist requested that the rest be withheld so that he could paint on each one.

389:RM8
Belknap 144

Robert Motherwell
Spanish Elegy II 1975

Lithograph (2)

22½ × 32½ (57.2 × 82.6)	
Paper: cream HMP, handmade	
Edition: 38	
Proofs: 12AP, TP, RTP, PPI, A, C	

Stone and plate preparation, processing, and proofing by Kenneth Tyler; edition printing by Robert Bigelow

Signed *Motherwell* and numbered in pencil lower right; chop marks of workshop and artist lower right; workshop number RM75-165 lower left verso

2 runs: 2 colors; 2 runs from 1 stone and 1 irregular rectangular relief zinc plate:
 1 black; method 2a; I
 2 white; method 23a (zinc plate, unprepared surface inked; RB); III

390:RM9
Belknap 145

Robert Motherwell
Djarum 1975

Lithograph, screenprint, collage, hand-colored (6)

47½ × 31½ (120.7 × 80)	
Paper: white Arches Cover, mould-made; light tan HMP, handmade	
Edition: 18	
Proofs: 10AP, 4TP, RTP, PPI, A, C	

Plate and screen preparation, processing, proofing, and edition printing by Kenneth Tyler assisted by Don Carli; paper preparation and adhering of collage elements by Tyler assisted by Carli

Signed *Motherwell* and numbered in pencil lower right; chop marks of workshop and artist lower right; workshop number RM75-161 lower left verso

5 runs: 5 colors, including 1 colored paper; 4 runs from 3 aluminum plates and 1 screen:
 1 tan (on light tan paper); method 3c; I
 2 transparent blue (on same paper as run 1); method 3a; I

3 black (on same paper as run 1); method 1b; I

4 blue (on same paper as run 1); method 29a; VI

5 printed paper from runs 1–4 (on white paper); methods 28 (KT), 36b (KT, DC); III

While still moist, the newly made paper was pressed between linen canvases to add texture. After printing, the artist painted each impression with blue acrylic paint.

391:RM10
Belknap 146

Robert Motherwell
Mediterranean 1975

Lithograph, screenprint (8)
46½ × 31½ (118.1 × 80)
Paper: white Arches Cover, mould-made
Edition: 26
Proofs: 8AP, 2TP, RTP, PPI, A, C

Stone, plate, and screen preparation and processing by Kenneth Tyler; proofing and edition printing by Tyler and Robert Bigelow

Signed *Motherwell* and numbered in pencil lower right; titled lower left; chop marks of workshop and artist lower right; workshop number RM73-163 lower left verso

8 runs: 8 colors; 8 runs from 3 stones, 1 aluminum plate, and 4 screens:
 1 dark yellow; method 2a; I
 2 ultramarine blue; method 2a; I
 3 dark gray; method 2a; I
 4 black; method 3c; I
 5 transparent blue; method 30a; VI
 6 orange; method 30a; VI
 7 medium gray; method 30a; VI
 8 dark orange; method 30a; VI

Some prints in the edition are inscribed *Mediterranean (White) I* or *State I.*

392:RM11
Belknap 147

Robert Motherwell
Mediterranean, State I White 1975

Lithograph, screenprint (8)
46½ × 31½ (118.1 × 80)
Paper: white Arches Cover, mould-made
Edition: 26
Proofs: 8AP, 2TP, RTP, PPI, A

Stone, plate, and screen preparation and processing by Kenneth Tyler; proofing and edition printing by Tyler and Robert Bigelow

Signed *Motherwell* and numbered in pencil lower right; titled lower left; chop marks of workshop and artist lower right; workshop number RM75-163A lower left verso

8 runs: 8 colors; 8 runs from 3 stones, 1 aluminum plate, and 4 screens:
 1 medium yellow; method 2a; I
 2 ultramarine blue; method 2a; I
 3 light gray; method 2a; I
 4 black; method 3c; I
 5 transparent blue; method 30a; VI
 6 orange; method 30a; VI
 7 light gray; method 30a; VI
 8 yellow; method 30a; VI

Some prints in the edition are inscribed *Mediterranean (Fawn) II, State I,* or *I.* Title placement varies from print to print.

393:RM12
Belknap 148

Robert Motherwell
Mediterranean, State II Yellow 1975

Lithograph, screenprint (9)

46½ × 31½ (118.1 × 80)	
Paper: white Arches Cover, mould-made	
Edition: 26	
Proofs: 8AP, 2TP, RTP, PPI, A	

Stone, plate, and screen preparation and processing by Kenneth Tyler; proofing and edition printing by Tyler and Robert Bigelow

Signed *Motherwell* and numbered in pencil lower right; titled lower left; chop marks of workshop and artist lower right; workshop number RM75-163B lower left verso

9 runs: 9 colors; 9 runs from 4 stones, 1 aluminum plate, and 4 screens:
 1 medium yellow; method 2a; I
 2 ultramarine blue; method 2a; I
 3 light blue; method 2a; I
 4 light gray; method 2a; I
 5 black; method 3c; I
 6 transparent blue; method 30a; VI
 7 orange; method 30a; VI
 8 transparent yellow; method 30a; VI
 9 yellow; method 30a; VI

394:RM13
Belknap 149

Robert Motherwell
Hermitage 1975

Lithograph, screenprint (6)

46½ × 31½ (118.1 × 80)	
Paper: white Arches Cover, mould-made	
Edition: 200	
Proofs: 30AP, 6CTP, RTP, PPI, A, C	

Stone and plate preparation and processing by Kenneth Tyler; screen preparation and processing by Kim Halliday; proofing and edition printing by Tyler, Robert Bigelow, and Halliday

Signed *Motherwell* and numbered in pencil lower right; chop marks of workshop and artist lower right; workshop number RM75-166 lower left verso

6 runs: 6 colors; 6 runs from 1 stone, 2 aluminum plates, and 3 screens:
 1 red; method 1a; I
 2 yellow-ocher; method 3b; I
 3 red; method 3b; I
 4 transparent red; method 28 (KH); VI
 5 tan; method 28 (KH); VI
 6 black; method 30c; VI

This edition was commissioned by M. Knoedler & Co., New York, to celebrate a loan exhibition of Russian art.

395:RM14
Belknap 203

Robert Motherwell
St. Michael I, State I 1979

Lithograph, screenprint, monoprint (v)

62⅞ × 25⅜ (159.9 × 64.4)	
Paper: white Arches Cover, mould-made	
Edition: 14	
Proofs: AP, 3WP, RTP	

Plate preparation, processing, proofing, and edition printing by Kenneth Tyler assisted by Robert Bigelow; screen preparation, processing, proofing, and edition printing by Kim Halliday

Signed *RM* and numbered in pencil lower right; chop mark lower right; workshop number RM75-147A lower left verso

8 runs: 6 colors plus monoprint colors; 8 runs from 5 aluminum plates and 2 screens:
 1 pink; method 3b; I
 2 yellow-ocher; method 3b; I
 3 green; method 3b; I
 4 black; method 3b; I
 5 black; method 1b; I
 6 variant inking from a palette of grays (KT); methods 28 (KH), 16e; VI
 7 variant inking from a palette of grays (KT); methods 28 (same screen as run 6), 16e; VI
 8 transparent gray; method 28 (KH); VI

396:RM15
Belknap 204

Robert Motherwell
St. Michael I, State II 1979

Lithograph, screenprint, monoprint (v)
62⅞ × 25⅜ (159.9 × 63.9)
Paper: white Arches Cover, mould-made
Edition: 34
Proofs: 9AP, 3TP, 3CTP, RTP, PPI, A

Plate preparation, processing, proofing, and
edition printing by Kenneth Tyler assisted
by Robert Bigelow; screen preparation,
processing, proofing, and edition printing
by Kim Halliday

Signed *RM* and numbered in pencil lower
right; chop mark lower right; workshop
number RM75-147 lower left verso

9 runs: 7 colors plus monoprint colors; 9
runs from 5 aluminum plates and 2
screens:
 1 pink; method 3b; I
 2 yellow-ocher; method 3b; I
 3 green; method 3b; I
 4 black; method 3b; I
 5 black; method 1b; I
 6 variant inking from a palette of grays
 (KT); methods 28 (KH), 16e; VI
 7 variant inking from a palette of grays
 (KT); methods 28 (same screen as run
 6), 16e; VI
 8 transparent gray; method 28 (KH); VI
 9 transparent gray; method 28 (same
 screen as run 8); VI

397:RM16
Belknap 205

Robert Motherwell
St. Michael II 1979

Lithograph, screenprint, monoprint (v)
60¼ × 17¾ (153 × 45.1)
Paper: white Arches Cover, mould-made
Edition: 46
Proofs: 14AP, CTP, SP, RTP, PPI, A

Plate preparation, processing, proofing, and
edition printing by Kenneth Tyler and John
Hutcheson; screen preparation, processing,
proofing, and edition printing by Kim
Halliday

Signed *RM* and numbered in white pencil
lower left; chop mark lower left; workshop
number RM75-146 lower right verso

10 runs: 8 colors plus monoprint colors; 10
runs from 5 aluminum plates and 2
screens:
 1 pink; method 3b; I
 2 yellow-ocher; method 3b; I
 3 green; method 3b; I
 4 black; method 3b; I
 5 black; method 1b; I
 6 variant inking from a palette of grays
 (KT); methods 28 (KH), 16e; VI
 7 variant inking from a palette of grays
 (KT); methods 28 (same screen as run
 6), 16e; VI
 8 transparent gray; method 28 (KH); VI
 9 transparent gray; method 28 (same
 screen as run 8); VI
 10 transparent black; method 28 (same
 screen as run 8); VI

398:RM17
Belknap 206

Robert Motherwell
St. Michael III 1979

Lithograph, screenprint (6)
41½ × 31½ (105.4 × 80)
Paper: gray HMP, handmade
Edition: 99
Proofs: 20AP, 11WP, RTP, PPI, A, C

Plate preparation, processing, and proofing
by John Hutcheson and Kenneth Tyler on
press I; edition printing by Hutcheson
on press II; screen preparation, processing,
proofing, and edition printing by Kim
Halliday

Signed *RM* and numbered in white pencil
lower right; chop mark lower right; work-
shop number RM75-148 lower left verso

6 runs: 6 colors; 6 runs from 5 aluminum
plates and 1 screen:
 1 gray; method 2b; IIa
 2 yellow-ocher; method 3c; IIa
 3 green; method 3c; IIa
 4 black; method 3c; IIa
 5 pink; method 28 (KH); VI
 6 black; method 3c; IIa

The stone image from the edition *Monster*
(384:RM3) was transferred directly to a
metal plate for run 1.

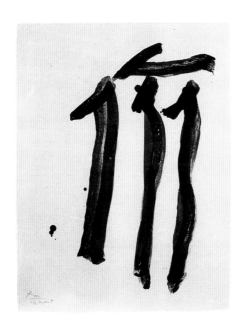

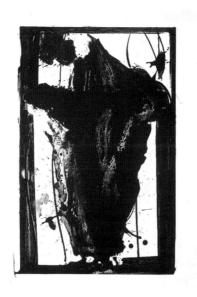

399:RM18
Belknap 208

Robert Motherwell
The Dalton Print 1979

Lithograph (1)

25¾ × 19¾ (65.4 × 50.2)
Paper: tan Rives BFK, mould-made
Edition: 150
Proofs: 20AP, 7TP, RTP, PPI, A, C

Stone preparation and processing by
Kenneth Tyler on press I; proofing and
edition printing by Tyler, Roger Campbell,
and Lee Funderburg on press II

Signed *RM* and numbered in pencil lower
left; chop marks of workshop and artist
lower right; workshop number
RM79-386A lower left verso

1 run: 1 color; 1 run from 1 stone:
 1 black; method 1a; IIa

400:RM19
Belknap 212

Robert Motherwell
Easter Day 1979 1980

Lithograph (1)

39 × 30 (99.1 × 76.2)
Paper: white Lana, mould-made
Edition: 75
Proofs: 18AP, TP, WP, RTP, PPI, A

Stone preparation, processing, and proofing
by Kenneth Tyler; edition printing by Lee
Funderburg

Signed *Motherwell* and numbered in pencil
lower right; chop mark lower right; work-
shop number RM79-386 lower left verso

1 run: 1 color; 1 run from 1 stone:
 1 black; method 1a; I

401:RM20
Belknap 213

Robert Motherwell
Samurai II 1980

Lithograph, collage (1)

57 × 24½ (144.8 × 62.2)
Paper: natural Nepal, handmade; natural
Sekishu, handmade
Edition: 49
Proofs: 16AP, 4TP, RTP, PPI, A

Stone preparation and processing by
Kenneth Tyler; proofing and edition
printing by Lee Funderburg; screen prepa-
ration by Kim Halliday; paper preparation
and adhering by Halliday and Steve Reeves

Signed *RM* and numbered in ink upper
left; chop mark lower right; workshop
number RM79-390 lower left verso

3 runs: 1 color; 1 run from 1 stone:
 1 Nepal papers joined in pairs to make long backing sheets; method 36a (KH, SR)
 2 black (on natural Sekishu paper); method 1a; I
 3 printed paper from run 2 (on Nepal papers); methods 28 (KH), 36b (KH, SR); III

Three natural Oriental papers were assembled and adhered for each print. The papers were carefully selected so that the Nepal papers would match and the lighter Sekishu papers would contrast in brightness.

402:RM21

Robert Motherwell
El General, State I 1980

Lithograph (1)

54 × 27½ (137.2 × 69.9)	
Paper: natural Sekishu, handmade	
Edition: 4	
Proofs: 6TP, RTP	

Stone preparation, processing, proofing, and edition printing by Kenneth Tyler

Signed *RM* and numbered in pencil lower right; chop mark lower right; workshop number RM79-392A lower left verso

1 run: 1 color; 1 run from 1 stone:
 1 black; method 1a; I

403:RM22
Belknap 214

Robert Motherwell
El General 1980

Lithograph (2)

40½ × 27½ (102.9 × 69.9)	
Paper: white Kizuki Hanga Dosa, handmade	
Edition: 49	
Proofs: 16AP, 2TP, RTP, PPI, A	

Stone and plate preparation, processing, and proofing by Kenneth Tyler; edition printing by Lee Funderburg

Signed *RM* and numbered in pencil upper right; chop mark lower right; workshop number RM79-392 lower left verso

2 runs: 2 colors; 2 runs from 1 stone and 1 aluminum plate:
 1 light tan; method 1b; I
 2 dark brown; method 1a; I

404:RM23
Belknap 215

Robert Motherwell
Rite of Passage I　1980

Lithograph (2)	
25½ × 29¼ (64.8 × 74.3)	
Paper: white TGL, handmade, hand-colored	
Edition: 50	
Proofs: 14AP, 2TP, RTP, PPI, A	

Papermaking by Steve Reeves; stone preparation and processing by Kenneth Tyler; proofing and edition printing by Lee Funderburg

Signed *Motherwell* and numbered in pencil lower right; chop mark lower right; workshop number RM79-385 lower left verso

2 runs: 1 pulp color, 1 paper pressing; 1 ink color, 1 run from 1 stone:
 1 red pulp (applied on newly made white pulp base sheet through an image mold constructed from a galvanized metal strip bent into a rectangular shape and set in a wood frame); III [paper dried]
 2 black; method 1a; I

405:RM24
Belknap 216

Robert Motherwell
Rite of Passage II　1980

Lithograph (2)	
31¼ × 39 (79.4 × 99.1)	
Paper: white TGL, handmade, hand-colored	
Edition: 51	
Proofs: 12AP, 2TP, RTP, PPI, A, C	

Papermaking by Steve Reeves; stone preparation, processing, and proofing by Kenneth Tyler and Lee Funderburg; edition printing by Funderburg

Signed *Motherwell* and numbered lower right; chop mark lower right; workshop number RM79-391 lower left verso

2 runs: 1 pulp color, 1 paper pressing; 1 ink color, 1 run from 1 stone:
 1 red pulp (applied on newly made white pulp base sheet through an image mold constructed from a galvanized metal strip bent into a rectangular shape and set in a wood frame); III [paper dried]
 2 black; method 1a; I

406:RM25
Belknap 217

Robert Motherwell
Rite of Passage III　1980

Lithograph, chine appliqué (2)	
24¾ × 34 (62.9 × 86.4)	
Paper: white Mulberry, handmade; tan kozo-fiber TGL, handmade	
Edition: 98	
Proofs: 20AP, 8TP, RTP, PPI, A	

Papermaking by Steve Reeves; paper preparation and adhering by Rodney Konopaki and Lindsay Green; stone preparation and processing by Kenneth Tyler and Lee Funderburg; proofing and edition printing by Funderburg

Signed *RM* and numbered in ink upper left; chop mark lower right; workshop number RM79-394 lower left verso

2 runs: 2 colors, including 1 colored paper; 1 run from 1 stone:
 1 tan paper on white paper; methods 28 (RK), 36b (RK, LG); III
 2 black; method 1a; I

407:RM26
Belknap 218

Robert Motherwell
Brushstroke 1980

Lithograph (1)
31½ × 16 (80 × 40.6)
Paper: white Arches Cover, mould-made
Edition: 49
Proofs: 16AP, 4TP, RTP, PPI, A

Stone preparation, processing, and proofing by Kenneth Tyler; edition printing by Lee Funderburg

Signed *RM* and numbered in pencil upper right; chop mark lower right; workshop number RM79-387 lower left verso

1 run: 1 color; 1 run from 1 stone:
 1 black; method 1a; I

408:RM27
Belknap 219

Robert Motherwell
La Guerra I 1980

Lithograph (1)
37 × 49 (94 × 124.5)
Paper: white Suzuki, handmade
Edition: 50
Proofs: 16AP, 4TP, WP, RTP, PPI, A

Stone preparation and processing by Kenneth Tyler; proofing by Tyler and Lee Funderburg; edition printing by Funderburg

Signed *RM* and numbered in ink upper left; chop mark lower right; workshop number RM79-388 lower left verso

1 run: 1 color; 1 run from 1 stone:
 1 black; method 1a; I

409:RM28
Belknap 220

Robert Motherwell
La Guerra II 1980

Lithograph (3)
31¾ × 44½ (80.6 × 113)
Paper: white Arches Cover, mould-made
Edition: 48
Proofs: 18AP, 8TP, CTP, 2WP, RTP, PPI, A

Stone and plate preparation and processing by Kenneth Tyler on press I; stone proofing and edition printing by Lee Funderburg on press I; plate edition printing by Roger Campbell and Lee Funderburg on press II

Signed *Motherwell* and numbered in pencil lower right; chop mark lower right; workshop number RM79-389 lower left verso

3 runs: 3 colors; 3 runs from 2 aluminum plates and 1 stone:
 1 light tan; method 1b; IIa
 2 dark tan; method 1b; IIa
 3 black; method 1a; I

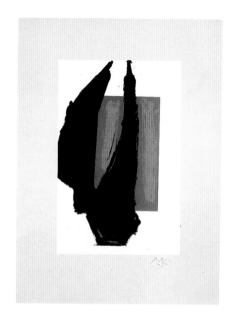

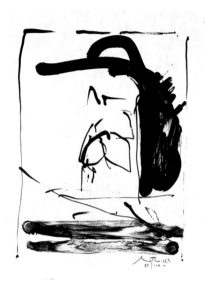

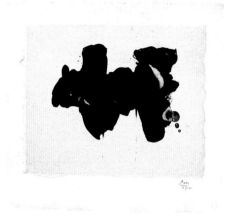

410:RM29
Belknap 249

Robert Motherwell
Art 1981 Chicago Print 1981

Lithograph (4)
34 × 25 (86.4 × 63.5)
Paper: white Arches Cover, mould-made
Edition: 150
Proofs: 25AP, 5TP, RTP, PPI, PPII, A, C

Prep work for continuous-tone lithography
by Kenneth Tyler; plate preparation and
processing by Lee Funderburg; proofing
and edition printing by Roger Campbell
and Funderburg

Signed *Motherwell* and numbered in pencil
lower right; chop mark lower right; work-
shop number RM81-526 lower left verso

4 runs: 4 colors; 4 runs from 4 aluminum
plates:
 1 yellow-pink; method 5b; IIa
 2 orange; method 5a; IIa
 3 red; method 5c (KT); IIa
 4 black; method 5a; IIa

This edition was commissioned by the
Lakeside Group for the 1981 Chicago
International Art Exposition. The image
was also reproduced, with lettering added,
as the official exposition poster.

411:RM30
Belknap 250

Robert Motherwell
The Robinson Jeffers Print 1981

Lithograph (1)
11⅝ × 9⅝ (29.6 × 24.5)
Paper: natural Kitakata, handmade
Edition: 100
Proofs: 20AP, RTP, PPI, PPII, A, C

Prep work for continuous-tone lithography
by Kenneth Tyler; plate preparation and
processing by Lee Funderburg; proofing
and edition printing by Roger Campbell
and Funderburg

Signed *Motherwell* and numbered in pencil
lower right; chop mark lower left; work-
shop number RM81-550 lower right verso

1 run: 1 color, 1 run from 1 aluminum
plate:
 1 black; method 5a; IIa

This edition was printed for *Apropos
Robinson Jeffers*, a *livre d'artiste* published
by the Art Museum and Galleries, Cali-
fornia State University, Long Beach.

412:RM31
Belknap 253

Robert Motherwell
Alberti Elegy 1982

Lithograph, chine appliqué (2)
14 × 15 (35.6 × 38.1)
Paper: white TGL, handmade; natural
Okawara, handmade
Edition: 100
Proofs: 20AP, 4TP, RTP, PPI, PPII, A, C

Papermaking by Steve Reeves and Tom Stri-
anese; prep work for continuous-tone
lithography by Kenneth Tyler; plate prepa-
ration and processing by Lee Funderburg;
proofing by Roger Campbell, Funderburg,
and Tyler; paper preparation and adhering
by Strianese, Rodney Konopaki, and Tyler

Signed *RM* and numbered in pencil lower
right; chop mark lower right; workshop
number RM81-631 lower left verso

2 runs: 2 colors, including 1 colored paper;
1 run from 1 aluminum plate:
 1 black; method 5a; IIa
 2 natural paper on white paper; methods
 28 (TS), 36b (TS, RK, KT); III

413:RM32
Belknap 254

Robert Motherwell
Lament for Lorca 1982

Lithograph (5)

44 × 61 (111.8 × 154.9)	
Paper: white TGL, handmade	
Edition: 52	
Proofs: 17AP, 2TP, WP, RTP, PPI, A	

Papermaking by Steve Reeves and Tom Strianese; stone preparation and processing by Kenneth Tyler; prep work for continuous-tone lithography by Tyler; plate preparation and processing by Lee Funderburg; proofing and edition printing by Tyler and Funderburg on press I; proofing and edition printing by Roger Campbell and Funderburg on press II

Signed *RM* and numbered in pencil lower right; chop mark lower right; workshop number RM81-632 lower left verso

5 runs: 5 colors; 5 runs from 1 stone and 4 aluminum plates:
 1 black; method 1a; I
 2 black; method 1b; I
 3 red-brown; method 5a; IIa
 4 black; method 5a; IIa
 5 black; method 5a; IIa

414:RM33
Belknap 260

Robert Motherwell
Untitled 1982

Lithograph, embossing (8)

30 × 22½ (76.2 × 57.2)	
Paper: white Arches Cover, mould-made	
Edition: 250	
Proofs: 35AP (I–XXXV), 25AP (1–25), 10AP (1–10), 10TP, RTP, PPI, PPII, A, C	

Prep work for continuous-tone lithography by Kenneth Tyler; aluminum plate preparation and processing by Lee Funderburg; aluminum plate proofing and edition printing by Roger Campbell and Funderburg; embossing die parts, proofing, and embossing by Campbell

Signed *Motherwell* and numbered in pencil lower right; chop mark lower right; workshop number RM82-680 lower left verso

9 runs: 8 colors; 9 runs from 8 aluminum plates and 1 embossing die assembly constructed from 1 magnesium relief plate and 1 plastic cutout:
 1 light blue; method 5b; IIa
 2 turquoise blue; method 5b; IIa
 3 dark turquoise blue; method 5c (KT); IIa
 4 blue; method 5b; IIa
 5 brown; method 5c (KT); IIa
 6 red; method 5a; IIa
 7 yellow-ocher; method 5a; IIa
 8 black; method 5b; IIa
 9 inkless; method 24 (RC); V

Motherwell was commissioned by the New York Graphic Society to make this edition for New York Portfolio, a collection of graphic work by leading New York artists.

EL NEGRO

Robert Motherwell and Kenneth Tyler collaborated from 1981 to 1983 on the design and creation of the book *El Negro*. Motherwell made his images on prepared Mylar and acetate sheets, using Paintstiks, grease pencils, and alcohol tusche applied with brushes or a bamboo pen. Lee Funderburg transferred these images to aluminum plates and, with Roger Campbell, printed the lithographs on a flatbed offset press on handmade papers made by Steve Reeves and Tom Strianese.

The poem "El Negro Motherwell," by Rafael Alberti, with translation by Vincente Lléo Cañal, was printed by offset lithography, with the Spanish text printed in black ink and the English text in gray. The book includes a preface by Jack D. Flam.

El Negro was printed in an edition of fifty-one plus proofs (10 AP, TP, 3 SP, RTP, PPI, PPII, A, C, 3 HC). The book was designed by Tyler with three page sizes— 15 by 15 inches (38.1 by 38.1 cm; single page), 15 by 25¾ inches (38.1 by 65.4 cm; double page, folds once), and 15 by 37¾ inches (38.1 by 95.9 cm; triple page, folds twice)—and a binding with a device that

allows the pages to be removed. The hand-made buckram-covered binding was made by Walden-Lang Company. Antony Drobinski and Roberta Savage of Emsworth Studios designed the text, using Bodoni Bold phototypositor typeface set by Stamford Typesetting Corporation.

Seven lithographs from *El Negro* were also published individually as separate signed and numbered editions of ninety-eight: *Elegy Black Black*, *Black Wall of Spain*, *Airless Black*, *Black Concentrated*, *Black with No Way Out*, *Gypsy Curse*, and *Through Black Emerge Purified*.

415:RM34
Belknap 268

Robert Motherwell
Front endleaf from *El Negro* 1983

Lithograph (3)

15 × 29 (38.1 × 73.7)

Paper: white TGL, handmade

Edition: 51

Unsigned; workshop watermark lower right; workshop number RM81-620A

3 runs: 3 colors; 3 runs from 3 aluminum plates:
 1 yellow-ocher; method 5a; IIa
 2 red; method 5a; IIa
 3 black; method 5a; IIa

This is the first and last image of the book; it also appears on the back endleaf.

415:RM34

419:RM38

416:RM35

417:RM36

EL NEGRO

EL NEGRO

LITHOGRAPHS BY
ROBERT MOTHERWELL

POEM BY
RAFAEL ALBERTI

PUBLISHED BY
TYLER GRAPHICS LTD.

1983

418:RM37

416:RM35

Robert Motherwell
Half title page from *El Negro* 1983

Lithograph (1)
15 × 15 (38.1 × 38.1)
Paper: white TGL, handmade
Edition: 51

1 run: 1 color; 1 run from 1 aluminum
plate:
 1 black; method 5a; IIa

417:RM36

Robert Motherwell
Title page from *El Negro* 1983

Lithograph (1)
15 × 15 (38.1 × 38.1)
Paper: white TGL, handmade
Edition: 51

1 run: 1 color; 1 run from 1 aluminum
plate:
 1 black; method 5a; IIa

418:RM37
Belknap 269

Robert Motherwell
Negro, from *El Negro* 1983

Lithograph (3)
15 × 15 (38.1 × 38.1)
Paper: white TGL, handmade
Edition: 51

Unsigned; workshop watermark lower
right; workshop number RM81-684A

3 runs: 3 colors; 3 runs from 3 aluminum
plates:
 1 yellow-ocher; method 5a; IIa
 2 red; method 5a; IIa
 3 black; method 5a; IIa

This is the second image of the book, litho-
graphed on the verso of the title page.

419:RM38
Belknap 270

Robert Motherwell
Preface from *El Negro* 1983

Lithograph (1)
15 × 25¾ (38.1 × 65.4)
Paper: white TGL, handmade
Edition: 51

1 run: 1 color; 1 run from 1 aluminum
plate:
 1 black; method 5a; IIa

This is the preface written by Jack D. Flam.

421:RM40

422:RM41

420:RM39
Belknap 271

Robert Motherwell
Mourning, from *El Negro* 1983

Lithograph (3)
15 × 25¾ (38.1 × 65.4)
Paper: white TGL, handmade
Edition: 51

Unsigned; workshop watermark lower
right; workshop number RM81-622A

3 runs: 3 colors; 3 runs from 3 aluminum
plates:
 1 yellow-ocher; method 5a; IIa
 2 red; method 5a; IIa
 3 black; method 5a; IIa

This is the third image of the book, litho-
graphed on the verso of the preface.

421:RM40
Belknap 272

Robert Motherwell
Poem from *El Negro* 1983

Lithograph (2)
15 × 25¾ (38.1 × 65.4)
Paper: white TGL, handmade
Edition: 51

2 runs: 2 colors; 2 runs from 2 aluminum
plates:
 1 gray; method 5a; IIa
 2 black; method 5a; IIa

This is the complete poem "El Negro
Motherwell," by Rafael Alberti, with
English translation by Vincente Lléo Cañal.
The first stanza of the poem is also litho-
graphed on the verso.

422:RM41
Belknap 273

Robert Motherwell
Night Arrived, from *El Negro* 1983

Lithograph, chine appliqué (2)
15 × 15 (38.1 × 38.1)
Paper: white TGL, handmade; natural
Kitakata, handmade
Edition: 51

Unsigned; workshop watermark lower
right; workshop number RM81-628A

2 runs: 2 colors, including 1 colored paper;
1 run from 1 aluminum plate:
 1 natural paper; methods 28 (LF), 36b
 (RC, LF); III
 2 black; method 5a; IIa

This is the fourth image of the book. The
second stanza of the poem is lithographed
on the verso.

423:RM42

424:RM43 425:RM44

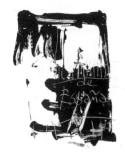

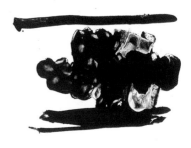

423:RM42
Belknap 274

Robert Motherwell
Elegy Black Black, from *El Negro* 1983

Lithograph (3)
15 × 37¾ (38.1 × 95.9)
Paper: white TGL, handmade
Edition: 51

Unsigned; workshop watermark lower
right; workshop number RM81-629A

3 runs: 3 colors; 3 runs from 3 aluminum
plates:
 1 black; method 5a; IIa
 2 white; method 5a; IIa
 3 black; method 5a; IIa

This is the fifth image of the book. The
third stanza of the poem is lithographed on
the verso.

A separate edition of ninety-eight was
printed during the production of the book
on the same paper used for the book, not
folded and without verse. (Proofs: 14AP,
RTP, PPI, PPII, A, C; signed *Motherwell*
and numbered in pencil lower right; chop
mark lower right; workshop number
RM81-629 lower left verso.)

424:RM43
Belknap 275

Robert Motherwell
Black Banners, from *El Negro* 1983

Lithograph (1)
15 × 15 (38.1 × 38.1)
Paper: white TGL, handmade
Edition: 51

Unsigned; workshop watermark lower
right; workshop number RM81-630A

1 run: 1 color; 1 run from 1 aluminum
plate:
 1 black; method 5a; IIa

This is the sixth image of the book. The
fourth stanza of the poem is lithographed
on the verso.

425:RM44
Belknap 276

Robert Motherwell
Black of the Echo, from *El Negro* 1983

Lithograph (1)
15 × 25¾ (38.1 × 65.4)
Paper: white TGL, handmade
Edition: 51

Unsigned; workshop watermark lower
right; workshop number RM81-625A

1 run: 1 color; 1 run from 1 aluminum
plate:
 1 black; method 5a; IIa

This is the seventh image of the book. The
fifth stanza of the poem is lithographed on
the verso.

426:RM45

428:RM47

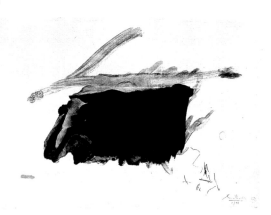

426:RM45
Belknap 277

Robert Motherwell
Eternal Black, from *El Negro* 1983

Lithograph (1)
15 × 15 (38.1 × 38.1)
Paper: white TGL, handmade
Edition: 51

Unsigned; workshop watermark lower right; workshop number RM81-632A

1 run: 1 color; 1 run from 1 aluminum plate:
 1 black; method 5a; IIa

This is the eighth image of the book. The sixth stanza of the poem is lithographed on the verso.

427:RM46
Belknap 278

Robert Motherwell
Black Wall of Spain, from *El Negro* 1983

Lithograph (3)
15 × 37¾ (38.1 × 95.9)
Paper: white TGL, handmade
Edition: 51

Unsigned; workshop watermark lower right; workshop number RM81-633A

3 runs: 3 colors; 3 runs from 3 aluminum plates:
 1 red; method 5a; IIa
 2 yellow-ocher; method 5a; IIa
 3 black; method 5a; IIa

This is the ninth image of the book. The seventh stanza of the poem is lithographed on the verso.

A separate edition of ninety-eight was printed during the production of the book on the same paper used for the book, not folded and without verse. (Proofs: 14AP, RTP, PPI, PPII, A, C; signed *Motherwell* and numbered in pencil lower left; chop mark lower left; workshop number RM81-633 lower right verso.)

428:RM47
Belknap 279

Robert Motherwell
Airless Black, from *El Negro* 1983

Lithograph (2)
15 × 25¾ (38.1 × 65.4)
Paper: white TGL, handmade
Edition: 51

Unsigned; workshop watermark lower right; workshop number RM81-634A

2 runs: 2 colors; 2 runs from 2 aluminum plates:
 1 yellow-ocher; method 5a; IIa
 2 black; method 5a; IIa

This is the tenth image of the book. The eighth stanza of the poem is lithographed on the verso.

A separate edition of ninety-eight was printed during the production of the book on the same paper used for the book, not folded and without verse. (Proofs: 14AP, RTP, PPI, PPII, A, C; signed *Motherwell* and numbered in pencil lower right; chop mark lower right; workshop number RM81-634 lower left verso.)

429:RM48

430:RM49

431:RM50

429:RM48
Belknap 280

Robert Motherwell
Black Concentrated, from *El Negro* 1983

Lithograph (1)

15 × 37¾ (38.1 × 95.9)	
Paper: white TGL, handmade	
Edition: 51	

Unsigned; workshop watermark lower right; workshop number RM81-635A

1 run: 1 color; 1 run from 1 aluminum plate:
 1 black; method 5a; IIa

This is the eleventh image of the book. The ninth stanza of the poem is lithographed on the verso.

A separate edition of ninety-eight was printed during the production of the book on the same paper used for the book, not folded and without verse. (Proofs: 14AP, RTP, PPI, PPII, A, C; signed *Motherwell* and numbered in pencil lower left; chop mark lower left; workshop number RM81-635 lower right verso.)

430:RM49
Belknap 281

Robert Motherwell
Black in Black, from *El Negro* 1983

Lithograph (1)

15 × 15 (38.1 × 38.1)	
Paper: white TGL, handmade	
Edition: 51	

Unsigned; workshop watermark lower right; workshop number RM81-636A

1 run: 1 color; 1 run from 1 aluminum plate:
 1 black; method 5a; IIa

This is the twelfth image of the book. The tenth stanza of the poem is lithographed on the verso.

431:RM50
Belknap 282

Robert Motherwell
Forever Black, from *El Negro* 1983

Lithograph (3)

15 × 37¾ (38.1 × 95.9)	
Paper: white TGL, handmade	
Edition: 51	

Unsigned; workshop watermark lower right; workshop number RM81-637A

3 runs: 3 colors; 3 runs from 3 aluminum plates:
 1 black; method 5a; IIa
 2 yellow-ocher; method 5a; IIa
 3 red; method 5a; IIa

This is the thirteenth image of the book. The eleventh stanza of the poem is lithographed on the verso.

432:RM51

434:RM53

432:RM51
Belknap 283

Robert Motherwell
Invisible Stab, from *El Negro* 1983

Lithograph (3)

15 × 15 (38.1 × 38.1)

Paper: white TGL, handmade

Edition: 51

Unsigned; workshop watermark lower right; workshop number RM81-638A

3 runs: 3 colors; 3 runs from 3 aluminum plates:
 1 blue; method 5a; IIa
 2 black; method 5a; IIa
 3 red; method 5a; IIa

This is the fourteenth image of the book. The twelfth stanza of the poem is lithographed on the verso.

433:RM52
Belknap 284

Robert Motherwell
Black Lament, from *El Negro* 1983

Lithograph (6)

15 × 25¾ (38.1 × 65.4)

Paper: white TGL, handmade

Edition: 51

Unsigned; workshop watermark lower right; workshop number RM81-639A

6 runs: 6 colors; 6 runs from 6 aluminum plates:
 1 blue-gray; method 5a; IIa
 2 green-black; method 5a; IIa
 3 red-black; method 5a; IIa
 4 red-black; method 5a; IIa
 5 yellow-ocher; method 5a; IIa
 6 red; method 5a; IIa

This is the fifteenth image of the book. The thirteenth stanza of the poem is lithographed on the verso.

434:RM53
Belknap 285

Robert Motherwell
Black with No Way Out, from *El Negro*
1983

Lithograph (3)

15 × 37¾ (38.1 × 95.9)

Paper: white TGL, handmade

Edition: 51

Unsigned; workshop watermark lower right; workshop number RM81-640A

3 runs: 3 colors; 3 runs from 3 aluminum plates:
 1 black; method 5a; IIa
 2 red; method 5a; IIa
 3 dark red; method 5a; IIa

This is the sixteenth image of the book. The fourteenth stanza of the poem is lithographed on the verso.

A separate edition of ninety-eight was printed during the production of the book on the same paper used for the book, not folded and without verse. (Proofs: 14AP, RTP, PPI, PPII, A, C; signed *Motherwell* and numbered in pencil lower right; chop mark lower right; workshop number RM81-640 lower left verso.)

436:RM55

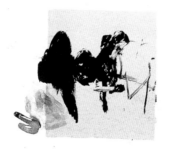

435:RM54

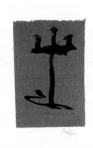

437:RM56

435:RM54
Belknap 286

Robert Motherwell
Gypsy Curse, from *El Negro* 1983

Lithograph, chine appliqué (2)
15 × 15 (38.1 × 38.1)
Paper: white TGL, handmade; red Moriki,
handmade
Edition: 51

Unsigned; workshop watermark lower
right; workshop number RM81-641A

2 runs: 2 colors, including 1 colored paper;
1 run from 1 aluminum plate:
 1 red paper; methods 28 (KT), 36b (KT);
 III
 2 black; method 5a; IIa

This is the seventeenth image of the book.
The fifteenth stanza of the poem is litho-
graphed on the verso.

A separate edition of ninety-eight was
printed during the production of the book
on the same paper used for the book but
without verse. (Proofs: 14AP, RTP, PPI,
PPII, A, C; signed *Motherwell* and
numbered in pencil lower right; chop mark
lower right; workshop number RM81-641
lower left verso.)

436:RM55
Belknap 287

Robert Motherwell
Black Undone by Tears, from *El Negro*
1983

Lithograph, chine appliqué (2)
15 × 15 (38.1 × 38.1)
Paper: white TGL, handmade; natural
Kitakata, handmade
Edition: 51

Unsigned; workshop watermark lower
right; workshop number RM81-642A

2 runs: 2 colors, including 1 colored paper;
1 run from 1 aluminum plate:
 1 natural paper; methods 28 (LF), 36b
 (RC, LF); III
 2 black; method 5a; IIa

This is the eighteenth image of the book.
The sixteenth stanza of the poem is litho-
graphed on the verso.

437:RM56
Belknap 288

Robert Motherwell
Through Black Emerge Purified, from
El Negro 1983

Lithograph (3)
15 × 37¾ (38.1 × 95.9)
Paper: white TGL, handmade
Edition: 51

Unsigned; workshop watermark lower
right; workshop number RM81-643A

3 runs: 3 colors; 3 runs from 3 aluminum
plates:
 1 red; method 5a; IIa
 2 black; method 5a; IIa
 3 blue; method 5a; IIa

This is the nineteenth image of the book.
The seventeenth stanza of the poem is litho-
graphed on the verso.

A separate edition of ninety-eight was
printed during the production of the book
on the same paper used for the book, not
folded and without verse. (Proofs: 14AP,
RTP, PPI, PPII, A, C; signed *Motherwell*
and numbered in pencil lower right; chop
mark lower right; workshop number
RM81-643 lower left verso.)

438:RM57

439:RM58 440:RM59

438:RM57
Belknap 289

Robert Motherwell
Poor Spain, from *El Negro* 1983

Lithograph (2)
15 × 37¾ (38.1 × 95.9)
Paper: white TGL, handmade
Edition: 51

Unsigned; workshop watermark lower
right; workshop number RM81-644A

2 runs: 2 colors; 2 runs from 2 aluminum
plates:
 1 red; method 5a; IIa
 2 black; method 5a; IIa

This is the twentieth image of the book.

439:RM58
Belknap 290

Robert Motherwell
Colophon page from *El Negro* 1983

Lithograph (1)
15 × 15 (38.2 × 38.2)
Paper: white TGL, handmade
Edition: 51

1 run: 1 color; 1 run from 1 aluminum
plate:
 1 black; method 5a; IIa

440:RM59
Belknap 291

Robert Motherwell
Back endleaf from *El Negro* 1983

Lithograph (3)
15 × 25¾ (38.1 × 65.4)
Paper: white TGL, handmade
Edition: 51

3 runs: 3 colors; 3 runs from 3 aluminum
plates:
 1 yellow-ocher; method 5a; IIa
 2 red; method 5a; IIa
 3 black; method 5a; IIa

This is the first and last image of the book;
it also appears on the front endleaf.

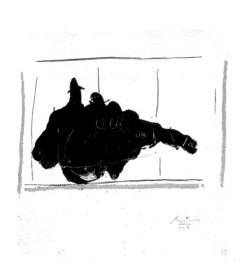

441:RM60
Belknap 293

Robert Motherwell
On Stage 1983

Lithograph (4)

15 × 15 (38.1 × 38.1)	
Paper: white TGL, handmade	
Edition: 50	
Proofs: 16AP, TP, 5SP, RTP, PPI, PPII, A, C	

Papermaking by Steve Reeves and Tom
Strianese; prep work for continuous-tone
lithography by Kenneth Tyler; plate prepa-
ration and processing by Lee Funderburg;
proofing and edition printing by Roger
Campbell and Funderburg

Signed *Motherwell* and numbered in pencil
lower right; chop mark lower right; work-
shop number RM81-620 lower left verso

4 runs: 4 colors; 4 runs from 4 aluminum
plates:
 1 black; method 5a; IIa
 2 yellow-ocher; method 5a; IIa
 3 red; method 5a; IIa
 4 blue; method 5a; IIa

This print is a special edition to commemo-
rate the Robert Motherwell retrospective
exhibition held at the Albright-Knox Art
Gallery, Buffalo, October 1 through
November 27, 1983.

442:RM61
Belknap 294

Robert Motherwell
The Quarrel 1983

Lithograph (5)

40 × 26 (101.6 × 66)	
Paper: white Arches Cover, mould-made	
Edition: 100	
Proofs: 20AP, 4CTP, RTP, PPI, PPII, A, C	

Prep work for continuous-tone lithography
by Kenneth Tyler; plate preparation and
processing by Lee Funderburg; proofing by
Roger Campbell and Funderburg

Signed *Motherwell* and numbered in pencil
lower right; chop mark lower right; work-
shop number RM83-686 lower left verso

5 runs: 5 colors; 5 runs from 5 aluminum
plates:
 1 tan; method 5a; IIa
 2 transparent gray; method 5b (KT); IIa
 3 black; method 5a; IIa
 4 black; method 5c; IIa
 5 red; method 5c; IIa

This edition was commissioned by *The
American Poetry Review*. The poem "The
Quarrel," by Stanley Kunitz, was set in
Bodoni Bold type by Emsworth Studio.

443:RM62
Belknap 297

Robert Motherwell
America–La France Variations I 1984

Lithograph, collage (12)
46½ × 32⅛ (118.1 × 81.6)
Paper: white TGL, handmade; white
Arches Cover, mould-made
Edition: 70
Proofs: 20AP, RTP, PPI, PPII, A, C

Papermaking by Steve Reeves and Tom Stri-
anese; prep work for transfer from artist's
original paper collage material to print
processes by Kenneth Tyler; preparation of
film copy from collage elements for plate-
making by Lee Funderburg; plate prepara-
tion and processing by Funderburg;
proofing and edition printing by Roger
Campbell and Funderburg; preparation and
adhering of collage elements by Campbell,
Funderburg, and Tyler

Signed *Motherwell* and numbered in pencil
lower right; chop mark lower right; work-
shop number RM83-708 lower left verso

13 runs: 12 colors; 12 runs from 12
aluminum plates:
 1 tan; method 5a (LF); IIa
 2 yellow-ocher; method 5a (LF); IIa
 3 red; method 5a (LF); IIa
 4 dark tan; method 5a (LF); IIa
 5 brown; method 5c; IIa
 6 red; method 5c; IIa
 7 gray; method 5c; IIa
 8 blue; method 5c; IIa
 9 black; method 5a; IIa
 10 medium tan (on Arches Cover paper);
 method 5a; IIa
 11 green (on same paper as run 10);
 method 5c; IIa
 12 blue (on same paper as run 10);
 method 5a; IIa
 13 printed paper (from runs 10–12) cut;
 method 36a (RC, LF, KT); III

444:RM63
Belknap 298

Robert Motherwell
America–La France Variations II 1984

Lithograph, collage (12)
45½ × 29 (115.6 × 73.7)
Paper: white TGL, handmade; blue with
multicolored fibers TGL, handmade
Edition: 70
Proofs: 18AP, RTP, PPI, PPII, A, C

Papermaking by Steve Reeves and Tom Stri-
anese; prep work for transfer from artist's
original collage material to print processes
by Kenneth Tyler; preparation of film copy
from collage elements for platemaking by
Lee Funderburg; plate preparation and
processing by Funderburg; proofing and
edition printing by Roger Campbell and
Funderburg; preparation and adhering of
collage elements by Campbell, Funderburg,
and Tyler

Signed *Motherwell* and numbered in pencil
lower left; chop mark lower left; workshop
number RM83-712 lower right verso

12 runs: 12 colors, including 1 colored paper; 11 runs from 11 aluminum plates:
1 light tan; method 5a (LF); IIa
2 tan; method 5a (LF); IIa
3 green; method 5c; IIa
4 brown; method 5a (LF); IIa
5 dark brown; method 5c; IIa
6 orange-red; method 5a (LF); IIa
7 red; method 5c; IIa
8 dark red; method 5a; IIa
9 gray; method 5c; IIa
10 blue; method 5c; IIa
11 black; method 5a; IIa
12 blue paper torn; method 36a (RC, LF, KT); III

445:RM64
Belknap 299

Robert Motherwell
America–La France Variations III 1984

Lithograph, collage (10)

48 × 30¾ (121.9 × 78.1)

Paper: white Arches Cover, mould-made; blue with multicolored fibers TGL, handmade

Edition: 70

Proofs: 20AP, SP, RTP, PPI, PPII, A, C

Papermaking by Steve Reeves and Tom Strianese; prep work for transfer from artist's original paper collage material to print processes by Kenneth Tyler; preparation of film copy from collage elements for plate-making by Lee Funderburg; plate preparation and processing by Funderburg; proofing and edition printing by Roger Campbell and Funderburg; preparation and adhering of collage elements by Campbell, Funderburg, and Tyler

Signed *Motherwell* and numbered in pencil lower right; chop mark lower right; workshop number RM83-714 lower left verso

10 runs: 10 colors, including 1 colored paper; 9 runs from 9 aluminum plates:
1 light green-tan; method 5a (LF); IIa
2 gray; method 5a (LF); IIa
3 tan; method 5a (LF); IIa
4 brown; method 5c; IIa
5 yellow-orange; method 5a (LF); IIa
6 red; methods 5a, 5c (LF); IIa
7 blue-gray; method 5c; IIa
8 blue; method 5c; IIa
9 black; method 5a; IIa
10 blue paper torn; method 36a (RC, LF, KT); III

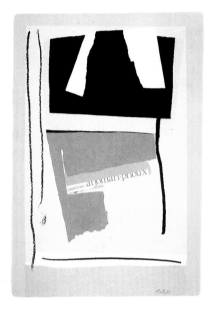

446:RM65
Belknap 300

Robert Motherwell
America–La France Variations IV 1984

Lithograph, collage (11)
46½ × 32⅛ (118.1 × 81.5)
Paper: white TGL, handmade; black
German Etching, mould-made
Edition: 68
Proofs: 18AP, TP, RTP, PPI, PPII, A, C

Papermaking by Steve Reeves and Tom Stri-
anese; prep work for transfer from artist's
original paper collage material to print
processes by Kenneth Tyler; preparation of
film copy from collage elements for plate-
making by Lee Funderburg; plate prepara-
tion and processing by Funderburg;
proofing and edition printing by Roger
Campbell and Funderburg; preparation and
adhering of collage elements by Campbell,
Funderburg, and Tyler

Signed *Motherwell* and numbered in pencil
lower right; chop mark lower right; work-
shop number RM83-715 lower left verso

11 runs: 11 colors, including 1 colored
paper; 10 runs from 10 aluminum plates:
 1 pale tan; method 5a (LF); IIa
 2 light tan; method 5a (LF); IIa
 3 tan; method 5a (LF); IIa
 4 dark tan; method 5a (LF); IIa
 5 brown; method 5c; IIa
 6 red; method 5c; IIa
 7 dark red; method 5a; IIa
 8 gray; method 5c; IIa
 9 blue; method 5c; IIa
 10 black; method 5a; IIa
 11 black paper cut and torn; method 36a
 (RC, LF, KT); III

447:RM66
Belknap 301

Robert Motherwell
America–La France Variations V 1984

Lithograph, collage (8)
46 × 31½ (116.8 × 80)
Paper: white TGL, handmade; blue with
multicolored fibers TGL, handmade
Edition: 60
Proofs: 16AP, RTP, PPI, PPII, A, C

Papermaking by Steve Reeves and Tom Stri-
anese; prep work for transfer from artist's
original paper collage material to print
processes by Kenneth Tyler; preparation of
film copy from collage elements for plate-
making by Lee Funderburg; plate prepara-
tion and processing by Funderburg;
proofing and edition printing by Roger
Campbell and Funderburg; preparation and
adhering of collage elements by Campbell,
Funderburg, and Tyler

Signed *Motherwell* and numbered in pencil
lower right; chop mark lower right; work-
shop number RM83-716 lower left verso

8 runs: 8 colors, including 1 colored paper;
7 runs from 7 aluminum plates:
 1 light green-tan; method 5a (LF); IIa
 2 gray; method 5a (LF); IIa
 3 tan; method 5a (LF); IIa
 4 gray; method 5a (LF); IIa
 5 brown; method 5c; IIa
 6 red; method 5c; IIa
 7 black; method 5a; IIa
 8 blue paper cut and torn; method 36a
 (RC, LF, KT); III

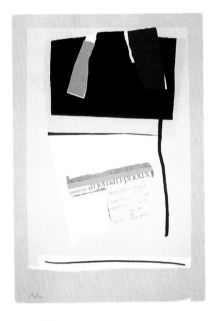

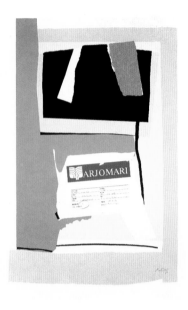

448:RM67
Belknap 302

Robert Motherwell
America–La France Variations VI 1984

Lithograph, collage (12)

46 × 31½ (116.8 × 80)

Paper: white Arches Cover, mould-made;
blue with multicolored fibers TGL,
handmade

Edition: 60

Proofs: 18AP, RTP, PPI, PPII, A, C

Papermaking by Steve Reeves and Tom Stri-
anese; prep work for transfer from artist's
original paper collage material to print
processes by Kenneth Tyler; preparation of
film copy from collage elements for plate-
making by Lee Funderburg; plate prepara-
tion and processing by Funderburg;
proofing and edition printing by Roger
Campbell and Funderburg; preparation and
adhering of collage elements by Campbell,
Funderburg, and Tyler

Signed *Motherwell* and numbered in pencil
lower left; chop mark lower left; workshop
number RM83-717 lower right verso

12 runs: 12 colors, including 1 colored
paper; 11 runs from 11 aluminum plates:
1 light tan; method 5a (LF); IIa
2 light gray; method 5a (LF); IIa
3 tan; method 5a (LF); IIa
4 dark gray; method 5a (LF); IIa
5 brown; method 5a (LF); IIa
6 dark brown; method 5c; IIa
7 red; method 5c; IIa
8 gray; method 5c; IIa
9 blue; method 5c; IIa
10 black; method 5a; IIa
11 dark blue; method 5a (LF); IIa
12 blue paper cut and torn; method 36a
(RC, LF, KT); III

449:RM68
Belknap 303

Robert Motherwell
America–La France Variations VII 1984

Lithograph, collage (11)

52¾ × 36 (134 × 91.4)

Paper: white Arches Cover, mould-made;
black German Etching, mould-made; blue
with multicolor fibers TGL, handmade;
gray Zaan, handmade

Edition: 68

Proofs: 20AP, 3SP, RTP, PPI, PPII, A, C

Papermaking by Steve Reeves and Tom Stri-
anese; prep work for transfer from artist's
original paper collage material to print
processes by Kenneth Tyler; preparation of
film copy from collage elements for plate-
making by Lee Funderburg; plate prepara-
tion and processing by Funderburg;
proofing and edition printing by Roger
Campbell and Funderburg; preparation and
adhering of collage elements by Campbell,
Funderburg, and Tyler

Signed *Motherwell* and numbered in pencil
lower right; chop mark lower right; work-
shop number RM83-718 lower left verso

9 runs: 11 colors, including 3 colored
papers; 8 runs from 8 aluminum plates:
 1 light brown; method 5a (LF); IIa
 2 pale brown; method 5a (LF); IIa
 3 pale gray; method 5a (LF); IIa
 4 light green-tan; method 5a (LF); IIa
 5 black; method 5a; IIa
 6 green (on white paper); method 5c; IIa
 7 blue (on same paper as run 6); method
 5c; IIa
 8 red (on same paper as run 6); method
 5c; IIa
 9 printed paper (from runs 6–8) torn,
 black paper cut and torn, blue and gray
 papers torn; method 36a (RC, LF, KT);
 III

450:RM69
Belknap 304

Robert Motherwell
America–La France Variations VIII 1984

Lithograph, collage (5)

$50 \times 21\frac{1}{2}$ (127×54.6)	
Paper: white Arches Cover, mould-made; black German Etching, mould-made	
Edition: 69	
Proofs: 20AP, SP, RTP, PPI, PPII, A, C	

Papermaking by Steve Reeves and Tom Stri-
anese; prep work for transfer from artist's
original paper collage material to print
processes by Kenneth Tyler; preparation of
film copy from collage elements for plate-
making by Lee Funderburg; plate prepara-
tion and processing by Funderburg;
proofing and edition printing by Roger
Campbell and Funderburg; preparation and
adhering of collage elements by Campbell,
Funderburg, and Tyler

Signed *Motherwell* and numbered in pencil
lower right; chop mark lower right; work-
shop number RM83-710 lower left verso

5 runs: 5 colors, including 1 colored paper;
4 runs from 4 aluminum plates:
 1 tan; method 5a (LF); IIa
 2 green; method 5c; IIa
 3 blue; method 5a (LF); IIa
 4 black; method 5a; IIa
 5 black paper torn; method 36a (RC, LF,
 KT); III

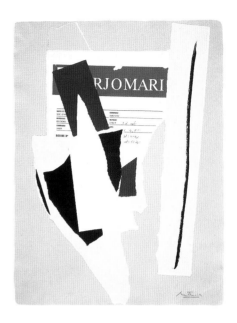

451:RM70
Belknap 305

Robert Motherwell
America–La France Variations IX 1984

Lithograph, collage (6)

$28\frac{1}{2} \times 21\frac{3}{4}$ (72.4×55.2)	
Paper: mottled tan Bemboka, handmade; white Arches Cover, mould-made	
Edition: 60	
Proofs: 18AP, CTP, SP, RTP, PPI, PPII, A, C	

Papermaking by Steve Reeves and Tom Stri-
anese; prep work for transfer from artist's
original paper collage material to print
processes by Kenneth Tyler; preparation of
film copy from collage elements for plate-
making by Lee Funderburg; plate prepara-
tion and processing by Funderburg;
proofing and edition printing by Roger
Campbell and Funderburg; preparation and
adhering of collage elements by Campbell,
Funderburg, and Tyler

Signed *Motherwell* and numbered in pencil
lower right; chop mark lower right; work-
shop number RM83-719 lower left verso

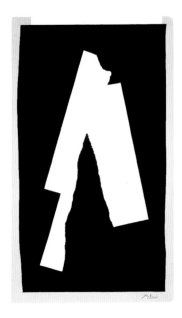

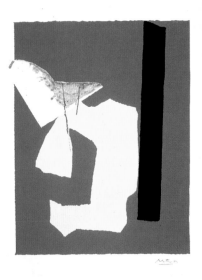

6 runs: 6 colors, including 1 white paper; 5 runs from 5 aluminum plates:

1 green (on white paper); method 5c; IIa
2 light tan (on same paper as run 1); method 5a (LF); IIa
3 light green-tan (on same paper as run 1); method 5a (LF); IIa
4 blue (on same paper as run 1); methods 5a (LF), 5c; IIa
5 black (on same paper as run 1); method 5a; IIa
6 printed paper (from runs 1–5) torn; method 36a (RC, LF, KT); III

452:RM71
Belknap 306

Robert Motherwell
Black Sounds 1984

Lithograph, relief, collage (3)

39 × 25 (99.1 × 63.5)

Paper: white Arches Cover, mould-made; white TGL, handmade

Edition: 60

Proofs: 12AP, TP, 3SP, RTP, PPI, PPII, A, C

Papermaking by Steve Reeves and Tom Strianese; prep work for transfer from artist's original paper collage material to print processes by Kenneth Tyler; preparation of film copy from collage elements for platemaking by Lee Funderburg; plate preparation and processing by Funderburg; proofing and edition printing by Roger Campbell and Funderburg; preparation and adhering of collage elements by Campbell, Funderburg, and Tyler

Signed *Motherwell* and numbered in pencil lower right; chop mark lower right; workshop number RM83-700 lower left verso

3 runs: 3 colors, including 1 white paper; 2 runs from 1 aluminum plate and 1 magnesium plate:

1 tan; method 5a (LF); IIa
2 black; method 21b (KT); V
3 TGL paper cut and torn; method 36a (RC, LF, KT); III

453:RM72
Belknap 307

Robert Motherwell
Water's Edge 1984

Lithograph, relief, embossing, collage (4)

33 × 26½ (83.8 × 67.3)

Paper: white TGL, handmade; black German Etching, mould-made

Edition: 62

Proofs: 12AP, 3SP, RTP, PPI, PPII, A, C

Papermaking by Steve Reeves and Tom Strianese; prep work for transfer from artist's original paper collage material to print processes by Kenneth Tyler; preparation of film copy from collage elements for platemaking by Lee Funderburg; plate preparation and processing by Funderburg; proofing and edition printing by Roger Campbell and Funderburg; preparation and adhering of collage elements by Campbell, Funderburg, and Tyler

Signed *Motherwell* and numbered in pencil lower right; chop mark lower right; workshop number RM83-707 lower left verso

5 runs: 4 colors, including 1 colored paper; 4 runs from 2 aluminum plates, 1 relief magnesium plate, and 1 embossing die made from 1 shaped relief copper plate:

1 pale yellow; method 5a (LF); IIa
2 gray; methods 5a, 5c; IIa
3 light blue; method 21b (KT); V
4 inkless; methods 15a (embossing die, RC), 24; V
5 black paper torn; method 36a (RC, LF, KT); III

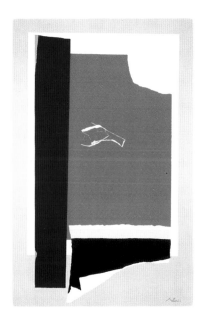

454:RM73
Belknap 309

Robert Motherwell
On the Wing 1984

Lithograph, embossing, collage (7)
46¾ × 30½ (118.7 × 77.5)
Paper: white Arches Cover, mould-made;
black German Etching, mould-made
Edition: 70
Proofs: 20AP, SP, RTP, PPI, PPII, A, C

Papermaking by Steve Reeves and Tom Stri-
anese; prep work for transfer from artist's
original paper collage material to print
processes by Kenneth Tyler; preparation of
film copy from collage elements for plate-
making by Lee Funderburg; plate prepara-
tion and processing by Funderburg;
proofing and edition printing by Roger
Campbell and Funderburg; preparation and
adhering of collage elements by Campbell,
Funderburg, and Tyler

Signed *Motherwell* and numbered in pencil
lower right; chop mark lower right; work-
shop number RM83-718 lower left verso

8 runs: 7 colors, including 1 colored paper;
7 runs from 6 aluminum plates and 1
embossing die assembled from 3 cut and
shaped copper plates:
 1 tan; method 5a (LF); IIa
 2 blue; method 5a (LF); IIa
 3 red; method 5a; IIa
 4 vermilion; method 5a; IIa
 5 yellow-brown; method 5a (LF); IIa
 6 gray; method 5a (LF); IIa
 7 inkless; methods 15a (embossing die,
 RC), 24; V
 8 black paper cut; method 36a (RC, LF,
 KT); III

455:RM74
Belknap 323

Robert Motherwell
Untitled, A 1984

Lithograph (3)
19¾ × 13¾ (50.2 × 34.9)
Paper: white Rives BFK, mould-made
Edition: 100
Proofs: 13AP, 10TP, RTP, PPI, PPII, PPIII,
PPIV, A, C

Prep work for continuous-tone lithography
by Kenneth Tyler; plate preparation and
processing by Lee Funderburg; proofing
and edition printing by Roger Campbell
and Funderburg

Signed *RM* and numbered in red pencil
lower right; chop mark lower right; work-
shop number RM84-789A lower left verso

3 runs: 3 colors; 3 runs from 3 aluminum
plates:
 1 blue-black; method 5a; IIa
 2 red-black; method 5a; IIa
 3 red; method 5a; IIa

Editions *Untitled, A*, *Untitled, B*, and
Untitled, C are part of a portfolio of artist's
prints commissioned by the Spanish
government to celebrate the fifth centenary
of the birth of Fray Bartolomeo dey las
Casas, the first Spanish priest to come to
the Americas.

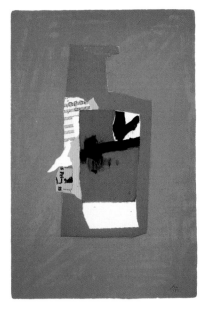

456:RM75
Belknap 324

Robert Motherwell
Untitled, B 1984

Lithograph (3)
19¾ × 13¾ (50.2 × 34.9)
Paper: white Rives BFK, mould-made
Edition: 100
Proofs: 13AP, 10TP, RTP, PPI, PPII, PPIII, PPIV, A, C

Prep work for continuous-tone lithography by Kenneth Tyler; plate preparation and processing by Lee Funderburg; proofing and edition printing by Roger Campbell and Funderburg

Signed *RM* and numbered in pencil lower right; chop mark lower right; workshop number RM84-789B lower left verso

3 runs: 3 colors; 3 runs from 3 aluminum plates:
 1 blue-black; method 5a; IIa
 2 red-black; method 5a; IIa
 3 red; method 5a; IIa

Editions *Untitled, A*, *Untitled, B*, and *Untitled, C* are part of a portfolio of artist's prints commissioned by the Spanish government to celebrate the fifth centenary of the birth of Fray Bartolomeo dey las Casas, the first Spanish priest to come to the Americas.

457:RM76
Belknap 325

Robert Motherwell
Untitled, C 1984

Lithograph (3)
19¾ × 13¾ (50.2 × 34.9)
Paper: white Rives BFK, mould-made
Edition: 100
Proofs: 13AP, 10TP, RTP, PPI, PPII, PPIII, PPIV, A, C

Prep work for continuous-tone lithography by Kenneth Tyler; plate preparation and processing by Lee Funderburg; proofing and edition printing by Roger Campbell and Funderburg

Signed *RM* and numbered in white pencil lower right; chop mark lower right; workshop number RM84-789C lower left verso

3 runs: 3 colors; 3 runs from 3 aluminum plates:
 1 blue-black; method 5a; IIa
 2 red-black; method 5a; IIa
 3 red; method 5a; IIa

Editions *Untitled, A*, *Untitled, B*, and *Untitled, C* are part of a portfolio of artist's prints commissioned by the Spanish government to celebrate the fifth centenary of the birth of Fray Bartolomeo dey las Casas, the first Spanish priest to come to the Americas.

458:RM77
Belknap 326

Robert Motherwell
Redness of Red 1985

Lithograph, screenprint, collage (9)
24 × 16 (61 × 40.6)
Paper: white Arches Cover, mould-made; white Rives BFK, mould-made; red Moriki, handmade
Edition: 100
Proofs: 24AP, TP, 10CTP, 2WP, RTP, PPI, PPII, 10HC, A, C

Prep work for transfer from artist's original paper collage material to print processes by Kenneth Tyler; preparation of film copy from collage elements for platemaking by Lee Funderburg; plate preparation and processing by Funderburg; proofing and edition printing by Roger Campbell and Funderburg; screen preparation, proofing, and edition printing by Tyler assisted by Chris Brown; preparation and adhering of collage elements by Campbell, Funderburg, and Brown

Signed *RM* and numbered in pencil lower right; chop mark lower right; workshop number RM84-809 lower left verso

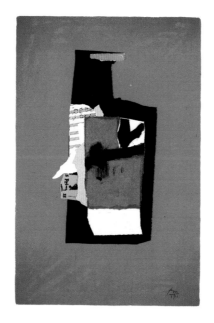

9 runs: 9 colors, including 1 colored paper;
8 runs from 1 screen and 7 aluminum
plates:
 1 transparent red; method 28 (KT); VI
 2 red; method 5a; IIa
 3 light tan (on Rives paper); method 5c;
 IIa
 4 dark tan (on same paper as run 3);
 method 5a (LF); IIa
 5 light orange and dark orange (on same
 paper as run 3); methods 5c, 16c; IIa
 6 red (on same paper as run 3); method
 5b (LF); IIa
 7 black (on same paper as run 3);
 method 5c; IIa
 8 printed paper (from runs 3–7) and red
 paper torn; method 36a (RC, LF, CB);
 III
 9 black; method 5a (LF); IIa

459:RM78
Belknap 327

Robert Motherwell
Redness of Red, State I 1985

Lithograph, screenprint, collage (10)
24 × 16 (61 × 40.6)
Paper: white Arches Cover, mould-made;
white Rives BFK, mould-made; red Moriki,
handmade
Edition: 10

Prep work and transfer from artist's orig-
inal paper collage material to print
processes by Kenneth Tyler; preparation of
film copy from collage elements for plate-
making by Lee Funderburg; plate prepara-
tion and processing by Funderburg;
proofing and edition printing by Roger
Campbell and Funderburg; screen prepara-
tion, proofing, and edition printing by Tyler
assisted by Chris Brown; preparation and
adhering of collage elements by Campbell,
Funderburg, and Brown

Signed *RM* and numbered in pencil lower
right; chop mark lower right; workshop
number RM84-809A lower left verso

10 runs: 10 colors, including 1 colored
paper; 9 runs from 1 screen and 8
aluminum plates:
 1 transparent red-orange; method 28
 (KT); VI
 2 red; method 5a; IIa
 3 light tan (on Rives paper); method 5c;
 IIa
 4 dark tan (on same paper as run 3);
 method 5a (LF); IIa
 5 light orange and dark orange (on same
 paper as run 3); methods 5c, 16c; IIa
 6 red (on same paper as run 3); method
 5b (LF); IIa
 7 black (on same paper as run 3);
 method 5c; IIa
 8 black (on same paper as run 3);
 method 5b; IIa
 9 printed paper (from runs 3–7) and red
 paper torn; method 36a (RC, LF, CB);
 III
 10 black; method 5a (LF); IIa

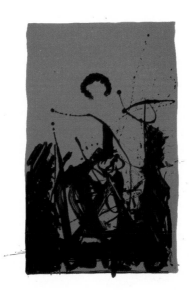

460:RM79
Belknap 308

Robert Motherwell
Black Rumble 1985

Lithograph (3)

38 × 29¼ (96.5 × 74.3)

Paper: white Arches Cover, mould-made

Edition: 65

Proofs: 12AP, TP, RTP, PPI, PPII, A, C

Prep work for continuous-tone lithography
by Kenneth Tyler; plate preparation and
processing by Lee Funderburg; proofing
and edition printing by Roger Campbell
and Funderburg

Signed *Motherwell* and numbered in pencil
lower left; chop mark lower left; workshop
number RM83-701 lower right verso

3 runs: 3 colors; 3 runs from 3 aluminum
plates:
 1 red; method 5a; IIa
 2 yellow; method 5a; IIa
 3 black; method 5a; IIa

461:RM80
Belknap 310

Robert Motherwell
Burning Sun 1985

Lithograph (2)

43 × 29 (109.2 × 73.7)

Paper: white Arches Cover, mould-made

Edition: 25

Proofs: 10AP, TP, RTP, PPI, PPII, A, C

Prep work for continuous-tone lithography
by Kenneth Tyler; plate preparation and
processing by Lee Funderburg; proofing
and edition printing by Roger Campbell
and Funderburg

Signed *Motherwell* and numbered in pencil
lower right; chop mark lower right; work-
shop number RM83-702 lower left verso

2 runs: 2 colors; 2 runs from 2 aluminum
plates:
 1 red; method 5a (KT); IIa
 2 black; method 5a; IIa

Horizontal Stripes I-7,
from the Handmade Paper Project 1978
See 466:KN229

Kenneth Noland

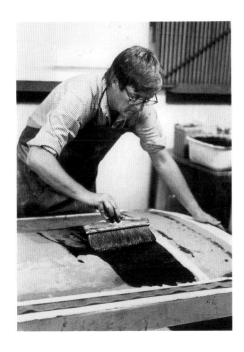

1924 Born in Asheville, North Carolina

1942–46 Serves in armed forces, first as a glider pilot and then as a cryptographer

1946–48 Studies with Ilya Bolotowsky at Black Mountain College, Black Mountain, North Carolina

1948–49 Studies with Ossip Zadkine in Paris

1949 Solo exhibition at Galerie Creuze, Paris

1949–51 Student teacher at Institute of Contemporary Art, Washington, D.C.

1951–60 Teaches at Catholic University, Washington, D.C.

1952–56 Teaches evening classes at Washington Workshop Center of the Arts

1956 Included in traveling exhibition *Young American Painters*, organized by Museum of Modern Art, New York

1957 First solo exhibition at Tibor de Nagy Gallery, New York

1959 Included in biennial exhibition, Corcoran Gallery of Art, Washington, D.C.

1961 Moves to New York; included in annual exhibition, Whitney Museum of American Art, New York (also included in 1962, 1963, 1965, 1967, 1969, 1970, 1972, and 1973)

1964 Retrospective exhibition *Kenneth Noland* at Jewish Museum, New York

1965 Included in traveling exhibition *The Responsive Eye*, organized by Museum of Modern Art, New York

1966 Included in exhibition *Systemic Painting* at Solomon R. Guggenheim Museum, New York; included in traveling exhibition *Two Decades of American Painting*, organized by Museum of Modern Art International Council, New York

1968 Included in exhibition *Kenneth Noland, Morris Louis, Anthony Caro* at Metropolitan Museum of Art, New York; included in traveling exhibition *Serial Imagery*, organized by Pasadena Art Museum, Pasadena, California

1970 Included in traveling exhibition *Color and Field: 1890–1970*, organized by Albright-Knox Art Gallery, Buffalo

1975 Included in thirty-fourth biennial exhibition, Corcoran Gallery of Art, Washington, D.C.

1976 Works with Garner Tullis at Institute of Experimental Printmaking, Santa Cruz, California, and learns how to make paper; teaches course in papermaking with Tullis at Bennington College, Bennington, Vermont

1977 Traveling exhibition *Kenneth Noland: A Retrospective*, originating at Solomon R. Guggenheim Museum, New York; sets up his first paper mill, Gully Paper, North Hoosick, New York; makes paper at Institute of Experimental Printmaking, San Francisco

1978 Completes first series of monoprints at Institute of Experimental Printmaking, San Francisco; included in traveling exhibition *Paper as Medium*, organized by Smithsonian Institution Traveling Exhibition Service

1978–82 Completes lithograph, aquatint with embossing, and Handmade Paper Project paper-pulp–monoprint series at Tyler Graphics

1979 Moves to Lewisboro, New York; sets up Kitchawan paper mill, South Salem, New York; completes paper-relief series exhibited in 1980 at André Emmerich Gallery, New York

1982 Completes monoprint series at Institute of Experimental Printmaking, San Francisco; completes Winds monoprint series at Taller de Grafica Mexicana, Mexico City; included in traveling exhibition *New American Paperworks*, organized by World Print Council, San Francisco

1983 Completes three monoprint series at Ediciones Poligrafa, Barcelona, which are exhibited at Galeria Joan Prats, Barcelona, in 1984

1984 Included in exhibition *Prints from Tyler Graphics* at Walker Art Center, Minneapolis

1985 Included in exhibition *Ken Tyler: Printer Extraordinary* at Australian National Gallery, Canberra; completes Montes Colorados monoprint series at Ediciones Poligrafa, Barcelona, and exhibits them at Museo de Pellasartes de Bilbao, Bilbao, Spain

Currently lives and works in Lewisboro, New York

HANDMADE PAPER PROJECT

462:KN1

Kenneth Noland
Blush 1978

Lithograph (13)	
36 × 30 (91.4 × 76.2)	
Paper: white Rives BFK, mould-made	
Edition: 50	
Proofs: 25AP, RTP, PPI, A, C	

Plate preparation, processing, proofing, and edition printing by John Hutcheson

Signed *Kenneth Noland* and dated in pencil lower right; numbered lower left; chop mark lower right; workshop number KN77-380 lower left verso

13 runs: 13 colors; 13 runs from 13 aluminum plates:
1 light tan; method 1b; IIa
2 light gray; method 1b; IIa
3 blue; method 3c; IIa
4 red; method 3c; IIa
5 yellow; method 3c; IIa
6 pink; method 3c; IIa
7 pink; method 3c; IIa
8 yellow; method 3c; IIa
9 red; method 1b; IIa
10 blue-violet; method 3c; IIa
11 clear varnish; method 3c; IIa
12 blue; method 1b; IIa
13 red; method 1b; IIa

This edition was commissioned by the Institute of Contemporary Art at the University of Pennsylvania for an annual fund-raising benefit, June 1978.

463:KN2

Kenneth Noland
Echo 1978

Aquatint, embossing (6)	
20 × 24 (50.8 × 61)	
Paper: white Arches Cover, mould-made	
Edition: 50	
Proofs: 14AP, 2TP, 3CTP, 3WP, RTP, PPI, A, C	

Plate preparation, processing, proofing, and edition printing by Rodney Konopaki

Signed *Kenneth Noland* and dated in pencil lower right; numbered lower left; workshop number KN78-380 lower left verso

4 runs: 6 colors; 4 runs from 3 copper plates and 1 irregularly shaped Plexiglas plate:
1 transparent ocher; method 9 (RK); IV
2 yellow, red, and light blue; methods 9 (RK), 16a; IV
3 cadmium yellow and green; methods 9 (RK), 16a; IV
4 inkless; method 24 (Plexiglas plate, RK); IV

The Handmade Paper Project was the first papermaking collaboration to take place at the workshop in the paper mill Kenneth Tyler designed and completed in 1978. Kenneth Noland collaborated with Tyler and Lindsay Green for several months that year, creating nearly four hundred unique paperworks in five series: Circle I (110 works), Circle II (110 works), Horizontal Stripes (104 works), Diagonal Stripes (27 works), and Pairs (21 works). The three papermakers were assisted by Duane Mitch, Anthony D'Ancona, Rodney Konopaki, and Susan Millar.

Noland experimented with colors and textures, mixing pulp slurries with a variety of pigments and dyes. He often added bits of colored paper, wool, and silk thread to the pulp and placed bits of material on the couched and applied layers. This material was embedded in the pulp by direct application and pressing or by pressing and then couching layers of cotton gauze or colored pulp on top of it, as in Circle I, Circle II, and Horizontal Stripes. For Circle I, Circle II, and Horizontal Stripes V and VII, Kim Halliday screen-printed or John Hutcheson lithographed monoprint layers of transparent inks on some of the papers after they had been pressed and dried.

Each work is signed *K. Noland* and dated in pencil, with the chop marks of workshop and artist lower right and the series number lower left verso.

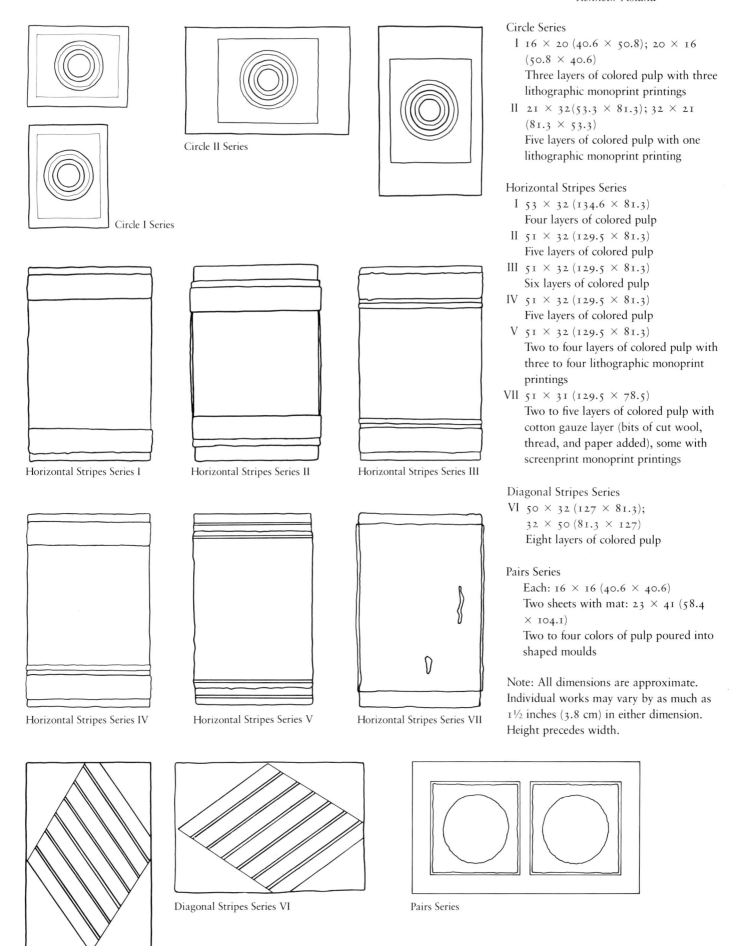

Circle I Series

Circle II Series

Circle Series
 I 16 × 20 (40.6 × 50.8); 20 × 16
 (50.8 × 40.6)
 Three layers of colored pulp with three
 lithographic monoprint printings
 II 21 × 32(53.3 × 81.3); 32 × 21
 (81.3 × 53.3)
 Five layers of colored pulp with one
 lithographic monoprint printing

Horizontal Stripes Series
 I 53 × 32 (134.6 × 81.3)
 Four layers of colored pulp
 II 51 × 32 (129.5 × 81.3)
 Five layers of colored pulp
 III 51 × 32 (129.5 × 81.3)
 Six layers of colored pulp
 IV 51 × 32 (129.5 × 81.3)
 Five layers of colored pulp
 V 51 × 32 (129.5 × 81.3)
 Two to four layers of colored pulp with
 three to four lithographic monoprint
 printings
 VII 51 × 31 (129.5 × 78.5)
 Two to five layers of colored pulp with
 cotton gauze layer (bits of cut wool,
 thread, and paper added), some with
 screenprint monoprint printings

Diagonal Stripes Series
 VI 50 × 32 (127 × 81.3);
 32 × 50 (81.3 × 127)
 Eight layers of colored pulp

Pairs Series
 Each: 16 × 16 (40.6 × 40.6)
 Two sheets with mat: 23 × 41 (58.4
 × 104.1)
 Two to four colors of pulp poured into
 shaped moulds

Note: All dimensions are approximate.
Individual works may vary by as much as
1½ inches (3.8 cm) in either dimension.
Height precedes width.

Horizontal Stripes Series I

Horizontal Stripes Series II

Horizontal Stripes Series III

Horizontal Stripes Series IV

Horizontal Stripes Series V

Horizontal Stripes Series VII

Diagonal Stripes Series VI

Pairs Series

464:KN100

465:KN121

466:KN229

Kenneth Noland
Circle I, II-43, from the Handmade Paper
Project 1978

Colored, pressed paper pulp; monoprint
20 × 16 (50.8 × 40.6)

Papermaking by Kenneth Tyler and Lindsay
Green; project assistance by Duane Mitch,
Anthony D'Ancona, Rodney Konopaki, and
Susan Millar

Signed *K. Noland* and dated in pencil lower
right; chop marks of workshop and artist
lower right; series number lower left verso

Newly made light yellow-pink pulp base
sheet with circular light blue and white
mixed-pulp sheet couched on top; bits of
cut rag, wool, thread, and paper applied;
1 natural Oriental pulp sheet (smaller than
base sheet) couched over circular layer; 1
paper pressing and 3 lithographic mono-
print runs in light red, light blue, and gray
transparent inks (method 3b, JH)

Kenneth Noland
Circle II, I-9, from the Handmade Paper
Project 1978

Colored, pressed paper pulp; monoprint
21 × 32 (53.3 × 81.3)

Papermaking by Kenneth Tyler and Lindsay
Green; project assistance by Duane Mitch,
Anthony D'Ancona, Rodney Konopaki, and
Susan Millar

Signed *Noland* and dated in pencil lower
right; chop marks of workshop and artist
lower right; series number lower left verso

Newly made green pulp base sheet with
circular yellow, orange, light blue, and
green pulp sheets couched on top; bits of
cut rag, wool, thread, and paper applied;
1 paper pressing and 1 lithographic mono-
print run in blue transparent ink (method
3b, JH)

Kenneth Noland
Horizontal Stripes I-7, from the Handmade
Paper Project 1978

Colored, pressed paper pulp
53 × 32 (134.6 × 81.3)

Papermaking by Kenneth Tyler and Lindsay
Green; project assistance by Duane Mitch,
Anthony D'Ancona, Rodney Konopaki, and
Susan Millar

Signed *K. Noland* and dated in pencil lower
right; chop marks of workshop and artist
lower right; series number lower left verso

Newly made tan pulp base sheet with 3
rectangular pieces of colored pulp couched
on top; bits of cut wool, thread, and paper
and dyes applied; 1 paper pressing

467:KN274

Kenneth Noland
Horizontal Stripes II-18, from the
Handmade Paper Project 1978

Colored, pressed paper pulp
51 × 32 (129.5 × 81.3)

Papermaking by Kenneth Tyler and Lindsay
Green; project assistance by Duane Mitch,
Anthony D'Ancona, Rodney Konopaki, and
Susan Millar

Signed *K. Noland* and dated in pencil lower
right; chop marks of workshop and artist
lower right; series number lower left verso

Newly made gray-blue pulp base sheet with
4 rectangular pieces of colored pulp
couched on top; bits of cut wool, thread,
and paper and dyes applied; 1 paper
pressing

468:KN278

Kenneth Noland
Horizontal Stripes III-3, from the
Handmade Paper Project 1978

Colored, pressed paper pulp
51 × 32 (129.5 × 81.3)

Papermaking by Kenneth Tyler and Lindsay
Green; project assistance by Duane Mitch,
Anthony D'Ancona, Rodney Konopaki, and
Susan Millar

Signed *K. Noland* and dated in pencil lower
right; chop marks of workshop and artist
lower right; series number lower left verso

Newly made green-ocher pulp base sheet
with 5 rectangular pieces of colored pulp
couched on top; bits of cut wool, thread,
and paper and dyes applied; 1 paper
pressing

469:KN309

Kenneth Noland
Horizontal Stripes IV-6, from the
Handmade Paper Project 1978

Colored, pressed paper pulp
51 × 32 (129.5 × 81.3)

Papermaking by Kenneth Tyler and Lindsay
Green; project assistance by Duane Mitch,
Anthony D'Ancona, Rodney Konopaki, and
Susan Millar

Signed *K. Noland* and dated in pencil lower
right; chop marks of workshop and artist
lower right; series number lower left verso

Newly made gray pulp base sheet with 4
rectangular pieces of colored pulp couched
on top; bits of cut wool, thread, and paper
and dyes applied; 1 paper pressing

470:KN311

Kenneth Noland
Horizontal Stripes V-2, from the
Handmade Paper Project 1978

Colored, pressed paper pulp; monoprint
51 × 32 (129.5 × 81.3)

Papermaking by Kenneth Tyler and Lindsay
Green; project assistance by Duane Mitch,
Anthony D'Ancona, Rodney Konopaki, and
Susan Millar

Signed *K. Noland* and dated in pencil lower
right; chop marks of workshop and artist
lower right; series number lower left verso

Newly made yellow-ocher pulp base sheet
with rectangular piece of orange pulp
couched on top; bits of cut wool, thread,
and paper and dyes applied; 1 paper
pressing, 1 lithographic monoprint run in
red transparent ink (method 3b, [JH]), and
2 screenprint monoprint runs in blue-green
transparent inks (method 28, [JH])

471:KN325

Kenneth Noland
Horizontal Stripes VII-5, from the
Handmade Paper Project 1978

Colored, pressed paper pulp
51 × 32 (129.5 × 81.3)

Papermaking by Kenneth Tyler and Lindsay
Green; project assistance by Duane Mitch,
Anthony D'Ancona, Rodney Konopaki, and
Susan Millar

Signed *K. Noland* and dated in pencil lower
right; chop marks of workshop and artist
lower right; series number lower left verso

Newly made yellow and white mixed-pulp
base sheet with a cotton gauze layer and
light pink, light blue, and white pulp sheets
(with bits of cut wool, thread, and paper
applied), and 3 small colored pulp pieces
couched on top; 1 paper pressing

472:KN331

Kenneth Noland
Diagonal Stripes VI-5, from the Handmade
Paper Project 1978

Colored, pressed paper pulp
50 × 32 (127 × 81.3)

Papermaking by Kenneth Tyler and Lindsay
Green; project assistance by Duane Mitch,
Anthony D'Ancona, Rodney Konopaki, and
Susan Millar

Signed *K. Noland* and dated in pencil lower
right; chop marks of workshop and artist
lower right; series number lower left verso

Newly made gray pulp base sheet with
yellow, orange, light purple, purple, blue,
light turquoise green, and white pulps
applied through an image mold constructed
from Plexiglas strips glued together; 1
paper pressing

To make the forty-two unique paperworks for the twenty-one Pairs, Kenneth Noland first poured colored pulp onto a felt through a round mold, then poured the surrounding pulp areas through a square mold. He manipulated the pulps, sometimes loosely hand-mixing them before pouring to create a mottled, multicolor effect. After pouring, Noland lifted the molds and adjusted the pulps with his hands. Each circle centered in each square was subtly broken by pulps or dyes deviating from the formal geometry. The papers were pressed and dried.

Each work is signed *Kenneth Noland*, numbered, dated, and designated "right" or "left" in felt-tip pen on the middle verso. There are no chop marks.

473:KN363

Kenneth Noland
Pairs 10, from the Handmade Paper Project 1982

Colored, pressed paper pulp
Two sheets with mat: 23 × 41 (58.4 × 104.1); each: 16 × 16 (40.6 × 40.6)

Papermaking by Kenneth Tyler and Lindsay Green; project assistance by Duane Mitch, Anthony D'Ancona, Rodney Konopaki, and Susan Millar

Signed *Kenneth Noland*, numbered, dated, and designated "right" or "left" in felt-tip pen verso

Light turquoise blue pulp poured through round mould onto felt with light tan pulp poured around the circle through a square mould; light gray-red pulp poured through a round mould onto felt with dark gray-ocher pulp poured around the circle through a square mould

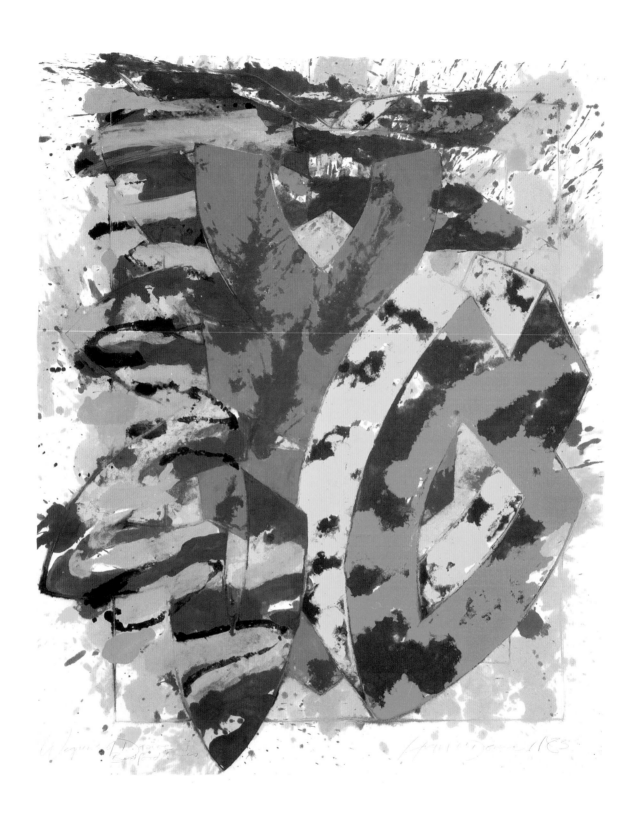

III-9, from Weapons of Desire,
Bedford Series 1983
See 476:HO'D19

276

Hugh O'Donnell

1950 Born in London

1968–69 Attends Camberwell College of Art, London

1969–72 Attends Falmouth School of Art, Cornwall, England, and receives B.A.

1972 Completes ceramic installation for Artists Constructor, Wrington, Somerset, England

1972–73 Attends Birmingham School of Art, Birmingham, England

1973 Receives first prize, Sir Whitworth Wallace Trust, Birmingham, England

1973–74 Attends Gloucestershire College of Art, Gloucestershire, England, on fellowship

1974–76 Receives fellowship to Kyoto University of Arts, Kyoto, Japan

1976 Solo exhibition at Nishimura Gallery, Tokyo; begins to lecture at Falmouth School of Art; Birmingham Polytechnic; Reading University; Bath Academy of Art, Corsham; Wimbledon College of Art; Croydon College of Art, London; and other academic institutions in England

1976–79 Attends Royal College of Art, London

1978 Receives Arts Council Award; lectures at Brighton Polytechnic

1980 Included in exhibition *British Art Now: An American Perspective, 1980 Exxon International Exhibition* at Solomon R. Guggenheim Museum

(his first show in United States); receives Purchase Award, Arts Council of Great Britain

1983 Completes Weapons of Desire, Bedford Series group of unique paper-pulp works at Tyler Graphics; included in exhibition *Britain Salutes New York* at Solomon R. Guggenheim Museum, New York

1984 Solo exhibition *Works on Paper* at Marlborough Graphics, London

1985 Included in exhibition *Ten Years: A Retrospective* at Air Gallery, London

Currently lives and works in London

WEAPONS OF DESIRE, BEDFORD SERIES

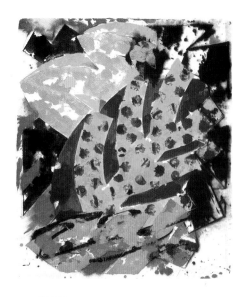

Weapons of Desire, Bedford Series is a group of twenty-five unique paper-pulp works. Twenty-one are grouped in three basic configurations, each designated by a Roman numeral, and four are titled *A*, *B*, *C*, and *IV*.

All of the works were formed using similar papermaking and coloring techniques. A mold constructed from galvanized metal strips soldered together was made for each image configuration by Duane Mitch and Roger Campbell. These molds were placed on newly made white pulp base sheets, and colored pulps and dyes were applied through the molds. The artist applied additional pulps and dyes freehand. He also used a metal strip as a straightedge to push colored pulps against. For some of the pieces the artist began by tracing the mold design on the pulp base sheets with water-soluble pencils. Pulps were then applied freehand, and the mold was used only for additional pulp applications. Iridescent powders were added in several works, and wood veneer was laminated between the pulp layers in *C*.

Most of the works required several pressings due to the repeated application of pulps and dyes. The pulps remained wet through all of the pressings, so that when dry, the layers fused into a single paper-pulp sheet.

Assisting the artist during the project were Kenneth Tyler, Steve Reeves, and Tom Strianese. Each work is signed *Hugh O'Donnell* and dated in pencil lower right. The Roman numerals designating the configuration, variation numbers, and chop marks are on the lower left verso.

474:HO'D1

Hugh O'Donnell
I-3, from Weapons of Desire, Bedford Series 1983

Colored, pressed paper pulp
$47\frac{1}{2} \times 40\frac{1}{2}$ (120.7 \times 102.9)
Paper: white TGL, handmade, hand-colored

Papermaking by Kenneth Tyler, Steve Reeves, and Tom Strianese; image mold constructed by Duane Mitch, Reeves, and Strianese; paper coloring by artist assisted by Tyler, Reeves, and Strianese

Signed *Hugh O'Donnell* and dated in pencil lower right; series number and chop mark lower left verso

Newly made white pulp base sheet with colored pulps and dyes applied repeatedly between paper pressings; colors applied through an image mold constructed from galvanized metal strips soldered together; mold removed and additional pulps and dyes applied freehand; paper pressed

475:HO'D11	476:HO'D19

Hugh O'Donnell
II-12, from Weapons of Desire, Bedford
Series 1983

Colored, pressed paper pulp
48¼ × 40½ (122.6 × 102.9)
Paper: white TGL, handmade,
hand-colored

Papermaking by Kenneth Tyler, Steve
Reeves, and Tom Strianese; image mold
constructed by Duane Mitch, Reeves, and
Strianese; paper coloring by artist assisted
by Tyler, Reeves, and Strianese

Signed *Hugh O'Donnell* and dated in
pencil lower right; series number and chop
mark lower left verso

Newly made white pulp base sheet with
colored pulps and dyes applied repeatedly
between paper pressings; colors applied
through an image mold constructed from
galvanized metal strips soldered together;
mold removed and additional pulps and
dyes applied freehand; paper pressed

Hugh O'Donnell
III-9, from Weapons of Desire, Bedford
Series 1983

Colored, pressed paper pulp
49⅜ × 40¼ (125.4 × 102.2)
Paper: white TGL, handmade,
hand-colored

Papermaking by Kenneth Tyler, Steve
Reeves, and Tom Strianese; image mold
constructed by Duane Mitch, Reeves, and
Strianese; paper coloring by artist assisted
by Tyler, Reeves, and Strianese

Signed *Hugh O'Donnell* and dated in
pencil lower right; series number and chop
mark lower left verso

Newly made white pulp base sheet with
colored pulps and dyes applied repeatedly
between paper pressings; colors applied
through an image mold constructed from
galvanized metal strips soldered together;
mold removed and additional pulps and
dyes applied freehand; paper pressed

Chicago Stuffed with Numbers 1977
See 477:CO1 (opposite)

Claes Oldenburg

477:CO1

Claes Oldenburg
Chicago Stuffed with Numbers 1977

Lithograph (9)
47½ × 30½ (120.7 × 77.5)
Paper: white Arches Cover, mould-made
Edition: 85
Proofs: 20AP, 5TP, 6CTP, 17PP (2 sets), RTP, PPI, A, C

Four drawn stones and three drawn plates prepared, processed, and proofed by Kenneth Tyler on press I; two photo plates processed and proofed by John Hutcheson on press II; edition printing by Tyler on press I; edition printing by Hutcheson assisted by Rodney Konopaki on press II

Signed *Oldenburg* in pencil lower right; numbered lower left; chop mark lower right; workshop number CO76-301 lower left verso

9 runs: 9 colors; 9 runs from 3 stones and 6 aluminum plates:
 1 yellow-orange; method 1b; IIa
 2 gray-green; method 1b; IIa
 3 transparent gray-green; method 3c; IIa
 4 blue; method 1a; I
 5 transparent blue; method 3b (JH); IIa
 6 green; method 1b; IIa
 7 red-violet; method 1a; IIa
 8 yellow; method 1a; IIa
 9 brown-red; method 1b; IIa

This edition was printed for the artist as a donation to the Art Institute of Chicago. The progressive proofs are unsigned.

1929 Born in Stockholm

1936 Family moves to Chicago

1946–50 Studies at Yale University, New Haven, Connecticut, and receives B.A. in art and English

1950 Moves to Chicago; is apprentice reporter at City News Bureau

1952–56 Becomes full-time art student at Art Institute of Chicago; studies painting with Paul Wieghardt; becomes United States citizen

1956 Moves to New York

1959 Solo exhibition at Cooper Union's Museum Library and Judson Gallery, New York

1962 Participates in Happenings; first exhibition of large-scale soft sculptures at Green Gallery, New York

1964 Included in thirty-second Venice Biennale

1966 Completes *Teabag* screenprint on felt and plastic, published by Multiples, Inc., New York

1968 Completes Notes, a portfolio of lithographs, at Gemini G.E.L., Los Angeles

1969 Traveling retrospective *Claes Oldenburg: 1954–1960*, originating at Museum of Modern Art, New York; completes three-dimensional multiple *Profile Airflow* at Gemini G.E.L., Los Angeles

1970 Completes sculpture *Ice Bag* for Art and Technology Exhibition, United States Pavilion at world's fair, Osaka, Japan, in collaboration with Gemini G.E.L., Los Angeles

1971 Retrospective exhibition *Claes Oldenburg: Object into Monument* at Pasadena Art Museum, Pasadena, California; included in exhibition *Art and Technology* at Los Angeles County Museum of Art; included in exhibition *Technics and Creativity: Gemini G.E.L.* at Museum of Modern Art, New York

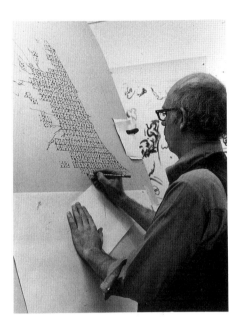

1972 Completes lithographs, screenprints, and three-dimensional multiple at Gemini G.E.L., Los Angeles

1976 Completes intaglio print series published by Multiples, Inc., New York

1977 Completes lithograph at Tyler Graphics; included in exhibition *Art Off the Picture Press* at Emily Lowe Gallery, Hofstra University, New York; traveling solo exhibition *The Mouse Museum and the Ray Gun Wing*, originating at Museum of Contemporary Art, Chicago

1981 Included in exhibition *American Prints: Process and Proofs* at Whitney Museum of American Art, New York

1984 Included in exhibition *Prints from Tyler Graphics* at Walker Art Center, Minneapolis; included in exhibition *Gemini G.E.L.: Art and Collaboration* at National Gallery of Art, Washington, D.C.

1985 Included in exhibition *Ken Tyler: Printer Extraordinary* at Australian National Gallery, Canberra

Currently lives and works in New York

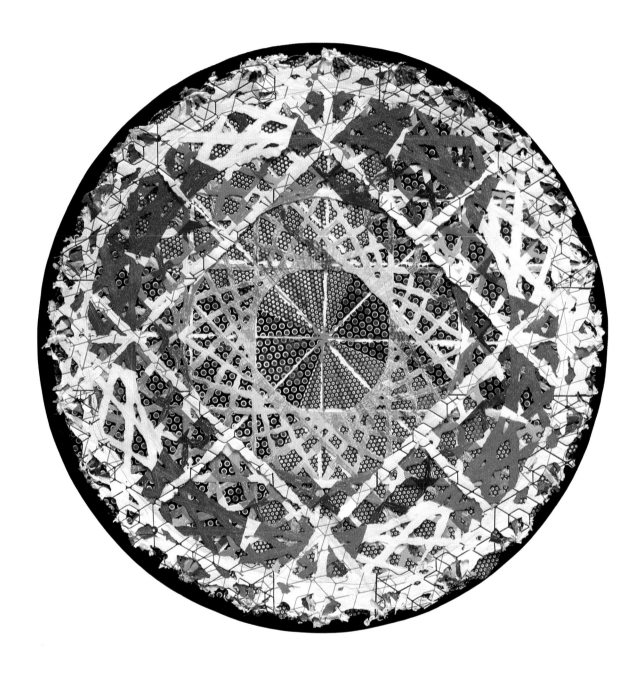

Polar Route, from The Raggedy
Circumnavigation Series 1985
See 512:AS35

Alan Shields

1944 Born in Herington, Kansas

1963 Attends Kansas State University, Manhattan; enrolls in civil engineering program and takes studio art courses

1968 Moves to New York

1968–69 Attends summer theater workshops at University of Maine, Orono; involved with stage design and scenery painting

1969 First solo exhibition at Paula Cooper Gallery, New York; completes first print, a screenprint, at Maurel Studios, New York, for the Ten New York '69 Portfolio, published by Tanglewood Press, New York

1971 Completes first mixed-media print with William Weege at Jones Road Print Shop and Stable, Barneveld, Wisconsin

1972 Moves to Shelter Island, New York; completes first papermaking project with Joe Wilfer at Upper United States paper mill, Oregon, Wisconsin

1973 Receives John Simon Guggenheim Memorial Foundation Fellowship; included in biennial exhibition, Whitney Museum of American Art, New York; included in eighth biennial exhibition, Musée d'Art Moderne, Paris

1975 Included in thirty-fourth biennial exhibition, Corcoran Gallery of Art, Washington, D.C.

1976 Included in thirty-eighth Venice Biennale

1977 Included in thirteenth International Exhibition of Graphic Art, Ljubljana, Yugoslavia; completes mixed-media prints at Jones Road Print Shop and Stable, Barneveld, Wisconsin

1978 Experiments with papermaking techniques with John Koller of HMP paper mill, Woodstock, Connecticut; releases first group of mixed-media prints at Tyler Graphics; completes monotype series at Institute of Experimental Printmaking, San Francisco

1980 Completes second group of mixed-media prints at Tyler Graphics; included in fortieth Venice Biennale; is invited to work at Gandhi Ashram paper mill, Ahmadabad, India, and later uses some of the paper made there in The Castle Window Set series made at Tyler Graphics

1981 Completes The Castle Window Set series of mixed-media prints at Tyler Graphics

1983 Included in traveling exhibition *Paper as Image*, organized by Arts Council of Great Britain, London

1984 Completes mixed-media, multilayered prints on handmade paper at Tyler Graphics; included in exhibition *Prints from Tyler Graphics* at Walker Art Center, Minneapolis

1985 Completes The Raggedy Circumnavigation Series—mixed-media, multilayered prints on handmade paper—at Tyler Graphics; included in exhibition *Ken Tyler: Printer Extraordinary* at Australian National Gallery, Canberra

Currently lives and works in Shelter Island, New York

BOX SWEET JANE'S EGG TRIUMVIRATE

Alan Shields's elaborate project entitled *Box Sweet Jane's Egg Triumvirate*, completed in 1978, used two hundred sheets of special cream/gray HMP duplex paper. The paper was printed on both sides in sixteen different printing sessions that alternated the use of eight stones and seven screens. After the printing was completed, there were eight different sets of twenty-five prints each. These prints were mechanically cut into strips and slotted with a power saw into an interlocking grid pattern for assembly into three-dimensional configurations.

From the eighty sets of twenty-four cut and slotted strips, Shields randomly selected seventy-two sets to make the three different *Box Sweet Jane's Egg Triumvirate* editions of eighteen. The configurations were assembled and clamped together in jigs, and the edges were stamped with inked squeegees. The artist manipulated an example from each of the assembled editions to form three different sculptural designs: *I, Moose Set* has a diamond shape; *II, Roosevelt Set* hangs from two corners like a hammock; *III, Kool Set* is upright and square.

Shields collaborated with Jerry Solomon Enterprises on the design of the Plexiglas boxes that encase the works.

Moose Set

Roosevelt Set

478:AS1–480:AS3

Alan Shields
*Box Sweet Jane's Egg Triumvirate:
I, Moose Set; II, Roosevelt Set;
III, Kool Set* 1978

Lithograph, screenprint, stamping (40)

I: 21 × 46 × 3¼ (53.3 × 116.8 × 8.3)	
II: 18½ × 22½ × 19 (47 × 57.2 × 48.3)	
III: 25 × 24¾ × 2½ (63.5 × 62.9 × 6.4)	

Paper: cream/gray HMP duplex, handmade
Edition: 18 each

Proofs: I: 6AP, PPI; II: 6AP, RTP; III: 6AP, PPI, A

Stone preparation, processing, and proofing by Kenneth Tyler on press I; edition printing by Tyler and John Hutcheson on press II; screen preparation, processing, proofing, edition printing, and print assembly by Kim Halliday; stamping by Rodney Konopaki

Signed *Alan J. Shields* and numbered in pencil lower edge of folded construction; workshop stamp lower edge; workshop number AS77-361 not marked

33 runs: 40 colors; 31 runs from 8 stones and 7 screens:

1 yellow; method 1a; IIa
2 magenta; method 1a; IIa
3 brown-orange; method 1a (same stone as run 2); IIa
4 orange; method 1a; IIa
5 gray; method 1a; IIa
6 gray–turquoise green; method 1a (same stone as run 5); IIa
7 blue; method 1a; IIa
8 dark blue–magenta; method 1a (same stone as run 7); IIa
 [runs 1–8 on cream side of paper]
9 blue; method 28 (KH); VI
10 gray-red; method 28 (same screen as run 9); VI
11 yellow; method 28 (KH); VI
12 orange; method 28 (same screen as run 9); VI
13 dark blue; method 28 (same screen as run 9); VI
14 green; method 28 (KH); VI
15 green; method 28 (KH); VI
16 white; methods 28 (same screen as run 11), 27 (KH); VI
17 red; method 28 (KH); VI
18 pink; method 28 (same screen as run 11); VI
 [runs 9–18 on gray side of paper]

Kool Set

19 purple; method 1a; IIa

20 orange; method 1a (same stone as run 19); IIa

21 red; method 1a; IIa

22 magenta; method 1a; IIa

23 magenta; method 1a (same stone as run 21); IIa

24 brown; method 1a (same stone as run 22); IIa

25 turquoise green; method 1a (same stone as run 19); IIa
 [runs 19–25 on gray side of paper]

26 magenta Glitterflex; method 28 (KH); VI

27 red; method 28 (KH); VI

28 green; method 28 (same screen as run 27); VI

29 silver Glitterflex; method 28 (same screen as run 27); VI

30 yellow; method 29 (same screen as run 27); VI

31 blue; method 28 (same screen as run 27); VI
 [runs 26–31 on cream side of paper]

32 printed paper cut, slotted, and assembled

33 medium yellow, orange, red, purple, brown, turquoise blue, yellow-green, green, and black; method 33 (squeegees)

All repeated colors in the edition runs are the same ink mixes.

481:AS4

Alan Shields
Two Birds, Woodcock I 1978

Lithograph (7)
20½ × 24 (52.1 × 61)
Paper: cream/gray HMP duplex, handmade
Edition: 11
Proofs: 6AP, TP, 4CTP, RTP, PPI, A

Stone preparation, processing, proofing, and edition printing by John Hutcheson

Signed *Alan J. Shields*, numbered, and dated in pencil lower right; workshop number AS78-365 lower left verso

7 runs: 7 colors; 7 runs from 7 stones:
 1 magenta; method 1a; IIa
 2 green; method 1a; IIa
 3 red; method 1a; IIa
 4 orange; method 1a; IIa
 5 yellow; method 1a; IIa
 6 silver; method 1a; IIa
 7 blue; method 1a; IIa
 [runs 1–7 on cream side of paper]

482:AS5

Alan Shields
Two Birds, Woodchuck II 1978

Lithograph (7)
20½ × 24 (52.1 × 61)
Paper: cream/gray HMP duplex, handmade
Edition: 11
Proofs: 4AP, RTP, PPI, A, C

Stone preparation, processing, proofing, and edition printing by John Hutcheson

Signed *Alan J. Shields*, numbered, and dated in pencil lower right; chop mark lower right; workshop number AS78-365A lower left verso

7 runs: 7 colors; 7 runs from 7 stones:
 1 blue; method 1a; IIa
 2 gray; method 1a; IIa
 3 yellow-ocher; method 1a; IIa
 4 orange; method 1a; IIa
 5 yellow; method 1a; IIa
 6 silver; method 1a; IIa
 7 red; method 1a; IIa
 [runs 1–7 on gray side of paper]

483:AS6

Alan Shields
Armie's Tough Course 1978

Etching, aquatint, mezzotint, drypoint,
engraving, stamping (24)
22 × 20½ (55.9 × 52.1)
Paper: yellow and orange Upper U.S.,
handmade
Edition: 8
Proofs: 4AP, 4TP, RTP, PPI, PPII, A

Plate preparation, processing, proofing, and
edition printing by Paul Sanders and
Rodney Konopaki; stamping by Konopaki

Signed *Alan J. Shields*, numbered, and
dated in pencil lower center; workshop
stamp lower center verso; workshop
number AS77-362 lower center verso

3 runs: 24 colors, including 2 paper colors;
2 runs from 1 assembled plate made from 3
circular copper plates:
 1 plate 1: red; methods 15b, 14; plate 2:
 light cobalt blue; methods 6, 9 (RK);
 plate 3: yellow-green; method 6; IV
 [run 1 on yellow sections of paper]
 2 plate 1, reworked: light violet; methods
 14, 6, 12; plate 2, reworked: dark
 medium yellow; methods 6, 9 (RK);
 plate 3, reworked: orange; methods 6,
 13, 14; IV
 [run 2 on orange sections of paper]
 3 light yellow, yellow, yellow-orange,
 orange, red, dark red, pink, violet,
 purple, light red-tan, light blue, ultra-
 marine blue, Prussian blue, light green,
 green, and gray; method 33 (pencil
 erasers and rubber drain plugs)

484:AS7

Alan Shields
Rare Pyramyd 1978

Aquatint, etching, screenprint, engraving
(8)
10 (25.4) diameter
Paper: gray with multicolored fibers HMP,
handmade
Edition: 20
Proofs: 8AP, 2TP, 2CTP, RTP, PPI, A

Plate preparation, processing, proofing, and
edition printing by Paul Sanders; screen
preparation by Kim Halliday; proofing and
edition printing by Rodney Konopaki and
Halliday

Signed *Alan J. Shields*, numbered, and
dated in pencil lower center; workshop
stamp lower center verso; workshop
number AS77-363 lower center

4 runs: 8 colors; 4 runs from 2 copper
plates and 2 screens:
 1 white; method 9 (RK); IV
 2 red, violet, blue-green, green, and
 black; methods 6, 8, 12, 16a; IV
 3 green; method 29a (KH); VI
 4 yellow; method 29a (KH); VI

Intaglio and screen printing were done on
the edition paper after it was moistened.

485:AS8

Alan Shields
Guardian Mole 1978

Etching, aquatint, relief (4)
10 (25.4) diameter
Paper: gray Zaan, handmade
Edition: 34
Proofs: 10AP, CTP, 2WP, RTP, PPI, A, C

Plate preparation, processing, proofing, and
edition printing by Rodney Konopaki

Signed *Alan J. Shields*, numbered, and
dated in pencil lower center; workshop
stamp lower center verso; workshop
number AS77-364 lower center verso

1 run: 4 colors; 1 run from 1 copper and 1
aluminum plate printed simultaneously:
 1 yellow, yellow-ocher, red, and blue;
 methods 6, 9 (RK), 17, 16a; IV

The aluminum plate was used to print
along the edges of the paper and to register
the copper intaglio plate.

486:AS9

Alan Shields
TV Rerun, A 1978

Linocut, silver leaf, perforations (9)

10 (25.4) diameter

Paper: colored TGL, handmade

Edition: 10

Proofs: 2AP, 3TP, 2CTP, WP, RTP, PPI, A

Papermaking by Kenneth Tyler; proofing, edition printing, application of silver leaf, and hole punching by Rodney Konopaki

Signed *Alan Shields*, numbered, dated, and paper color identified in pencil lower center; chop mark lower center verso; workshop number AS78-367A lower center verso

3 runs: 9 colors; 1 run from 1 linoleum block:
 1 yellow, orange, yellow-ocher, red, purple, light blue, blue, and green; methods 18, 17, 16a; III
 2 silver leaf applied (RK)
 3 paper perforated along edges by hand with hole punch (RK)

Within the TV Rerun editions, paper colors vary. For each print the artist selected one of the five colored papers that he and Tyler designed and made for the editions. Shields assigned Roman numerals to the prints identifying the papers: I for lavender, II for blue, III for yellow-pink, IV for orange, and V for yellow-green.

In printing the editions, Shields used a ghost impression technique. He inked the linoleum block for a first run for *TV Rerun, A,* followed by a second run, without reinking, for *TV Rerun, B,* and a third and final run for *TV Rerun, C.* The first application of ink, for *TV Rerun, A,* was heavy so that the colors bled beyond the incised, inked grooves in the block.

487:AS10

Alan Shields
TV Rerun, B 1978

Linocut, mezzotint, drypoint, perforations (10)

10 (25.4) diameter

Paper: colored TGL, handmade

Edition: 10

Proofs: 2AP, TP, 3CTP, RTP, PPI, A

Papermaking by Kenneth Tyler; plate preparation and processing by Rodney Konopaki; proofing, edition printing, and hole punching by Konopaki

Signed *Alan Shields*, numbered, dated, and paper color identified in pencil lower center; chop mark lower center verso; workshop number AS78-367B lower center verso

3 runs: 10 colors; 2 runs from 1 linoleum block and 1 copper plate:
 1 yellow, orange, yellow-ocher, red, purple, light blue, blue, and green; method 34 (from 486:AS9, run 1); silver; method 23a; III
 2 green; methods 13, 14; IV
 3 paper perforated along edges by hand with hole punch (RK)

Within the TV Rerun editions, paper colors vary. For each print the artist selected one of the five colored papers that he and Tyler designed and made for the editions. Shields assigned Roman numerals to the prints identifying the papers: I for lavender, II for blue, III for yellow-pink, IV for orange, and V for yellow-green.

488:AS11

Alan Shields
TV Rerun, C 1978

Linocut, mezzotint, drypoint, stamping (17)
10 (25.4) diameter
Paper: colored TGL, handmade
Edition: 10
Proofs: 2AP, TP, RTP, PPI, A, C

Papermaking by Kenneth Tyler; plate preparation and processing by Rodney Konopaki; proofing, edition printing, and stamping by Konopaki

Signed *Alan Shields*, numbered, dated, and paper color identified in pencil lower center; chop mark lower center verso; workshop number AS78-367C lower center verso

3 runs: 17 colors; 2 runs from 1 linoleum block and 1 copper plate:
 1 yellow, orange, yellow-ocher, red, purple, light blue, blue, and green; method 34 (from 486:AS9, run 1); silver; method 23a; III
 2 black; methods 13, 14; IV
 3 yellow, orange, red, brown-red, purple, blue, and green; method 33 (pencil erasers, RK)

Within the TV Rerun editions, paper colors vary. For each print the artist selected one of the five colored papers that he and Tyler designed and made for the editions. Shields assigned Roman numerals to the prints identifying the papers: I for lavender, II for blue, III for yellow-pink, IV for orange, and V for yellow-green.

489:AS12

Alan Shields
Hazel's Witch Hat 1980

Screenprint, relief, stamping, stitching, collage (14)
23 × 17½ (58.4 × 44.5)
Paper: top layer: gray HMP, handmade; bottom layer: white Upper U.S., handmade
Edition: 9
Proofs: 3AP, CTP, RTP, PPI, A

Screen preparation, processing, proofing, and edition printing by Kim Halliday; plate preparation, processing, proofing, edition printing, and stamping by Rodney Konopaki and Lee Funderburg; preparation and assembly of collage elements by Halliday and Konopaki

Signed *Alan J. Shields*, numbered, dated, and titled in pencil lower edge top layer; chop mark lower left; workshop number AS79-461 lower right verso

10 runs: 14 colors, including 1 colored paper; 8 runs from 7 screens and 1 zinc plate:
 1 yellow; method 28 (KH); VI
 2 green; method 28 (KH); VI
 3 silver; method 28 (KH); VI
 [runs 1–3 on top layer]

 4 blue; method 28 (KH); VI
 5 yellow; method 28 (KH); VI
 6 green; method 28 (KH); VI
 7 magenta; method 28 (KH); VI
 8 black; method 23a (zinc plate, unprepared surface inked); IV
 9 orange, red, violet, green, and gold; method 33 (pencil erasers; RK, LF) [runs 4–9 on bottom layer]
 10 top and bottom layers; method 36c (colored thread)

490:AS13

Alan Shields
Alice in Grayland 1980

Etching, aquatint, screenprint, stamping, stitching, collage (13)

23½ × 19½ (59.7 × 49.5)

Paper: top layer: gray Upper U.S., hand-made; bottom layer: white TGL, hand-made, hand-colored

Edition: 13

Proofs: 5AP, CTP, RTP, PPI, PPII, A

Papermaking by Lee Funderburg; assembled plate preparation, processing, proofing, and edition printing by Rodney Konopaki; screen preparation, processing, proofing, and edition printing by Kim Halliday; stamping by Konopaki; assembly of collage elements by Halliday and Konopaki

Signed *Alan J. Shields*, numbered, dated, and titled in pencil lower edge; chop mark lower center; workshop number AS79-462 lower center verso

5 runs: 3 pulp colors, 1 paper pressing: 9 ink colors and 1 colored paper; 2 runs from 1 screen and 1 assembled plate made from 10 copper strips:
 1 silver; method 28 (KH); VI
 2 yellow, orange, violet, blue, and green; methods 9 (RK), 15b (copper strips), 16a; IV
 [runs 1 and 2 on top layer]
 3 yellow, magenta, and blue pulps (applied on newly made white pulp base sheet through an image mold constructed from galvanized metal strips); III
 [run 3 on bottom layer]
 4 top and bottom layers; method 36c (colored thread)
 5 red, purple, and green; method 33 (bathtub drain plugs, RK)

491:AS14

Alan Shields
Soft Action 1980

Linocut, relief, stitching, collage (26)

24 × 28 (61 × 71.1)

Paper: top layer: gray Upper U.S., hand-made; bottom layer: gray-blue/white Upper U.S. duplex, handmade

Edition: 10

Proofs: 4AP, TP, CTP, 2WP, RTP, PPI, A

Linoleum block and assembled plate preparation and processing by Rodney Konopaki; proofing and edition printing by Konopaki; preparation and assembly of collage elements by Kim Halliday and Konopaki

Signed *Alan J. Shields*, numbered, and titled in pencil lower edge; chop mark lower center; workshop number AS79-463 lower center verso

15 runs: 26 colors, including 1 white paper and 2 colored papers; 13 runs from 1 donut-shaped linoleum block, 1 assembled plate made from triangular and square linoleum blocks, 1 assembled plate made from small hexagonal and square linoleum blocks, 1 assembled plate made from 1 linoleum block with a soldered-wire insert, 1 assembled plate made from soldered copper wire, 1 assembled plate made from 2 square linoleum blocks, and 1 assembled plate made from 6 circular linoleum blocks:
 1 yellow, orange, orange-red, and blue; methods 15a (triangular and square blocks), 16a; III

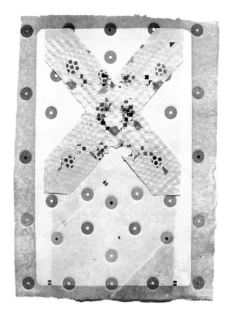

2 turquoise blue; method 18
(donut-shaped block); III

3 gray-green (paper turned 90°); method
18 (same block as run 2); III

4 violet (paper turned 90°); method 18
(same block as run 2); III

5 gray-green (paper turned 90°); method
18 (same block as run 2); III

6 medium brown; method 18 (hexagonal
and square blocks); III

7 green (paper turned 90°); method 18
(same plate as run 6); III

8 magenta (paper turned 90°); method
18 (same plate as run 6); III

9 blue (paper turned 90°); method 18
(same plate as run 6); III
[runs 1–9 on top layer]

10 magenta and brown; methods 15a
(linoleum block with wire insert), 16a;
III

11 green; method 15b (copper wire); III

12 yellow and transparent blue; methods
15a (square blocks), 16a; III

13 yellow, yellow-ocher, vermilion, purple,
blue, and green; methods 15a (circular
blocks), 16a; III
[runs 10–13 on bottom layer]

14 bottom layer torn, rearranged; method
36c (colored thread)

15 top and bottom layers; method 36c
(colored thread)

492:AS15

Alan Shields
Treasure Rute I 1980

Relief, stamping, linocut, collage (31)
24 × 18 (61 × 45.7)
Paper: white TGL, handmade,
hand-colored; natural Kitakata, handmade
Edition: 11
Proofs: 2AP, 9TP, RTP, PPI, A

Papermaking by Lee Funderburg; linoleum
block, zinc plate, and assembled plate prep-
aration and processing by Rodney Kono-
paki; proofing, edition printing, and
stamping by Konopaki; preparation and
adhering of collage elements by Kim
Halliday and Konopaki

Signed *Alan Shields*, numbered, dated, and
titled in pencil lower edge; chop mark
lower left; workshop number AS79-464
lower right verso

14 runs: 5 dye colors, 1 paper pressing; 25
ink colors and 1 colored paper, 11 runs
from 1 zinc plate, 1 donut-shaped linoleum
block, 1 assembled plate made from 37
metal washers, 1 assembled plate made
from triangular and square linoleum
blocks, and 1 assembled plate made from
small hexagonal and square linoleum
blocks:

1 yellow, pink, magenta, purple, and
green dyes (on newly made white pulp
base sheet); III

2 pink (on verso of same paper as run 1);
method 23a (zinc plate, unprepared
surface inked); IV

3 yellow-ocher, red, violet, blue, green,
and gray (on same paper as run 1);
methods 15a (washers), 16a; III

4 yellow, orange, orange-red, and blue
(on natural paper); methods 15a (trian-
gular and square blocks), 16a; III

5 turquoise blue (on same paper as run
4); method 18 (donut-shaped block);
III

6 gray-green (on same paper as run 4;
paper turned 90°); method 18 (same
block as run 5); III

7 violet (on same paper as run 4; paper
turned 90°); method 18 (same block as
run 5); III

8 gray-green (on same paper as run 4;
paper turned 90°); method 18 (same
block as run 5); III

9 medium brown; method 18 (hexagonal
and square blocks); III

10 green (on same paper as run 4; paper
turned 90°); method 18 (same plate as
run 9); III

11 magenta (on same paper as run 4;
paper turned 90°); method 18 (same
plate as run 9); III

12 blue (on same paper as run 4; paper
turned 90°); method 18 (same plate as
run 9); III

13 printed paper from runs 4–12 cut;
method 36b (KH, RK); III

14 yellow, orange, red, brown, blue, and
green; method 33 (pencil erasers)

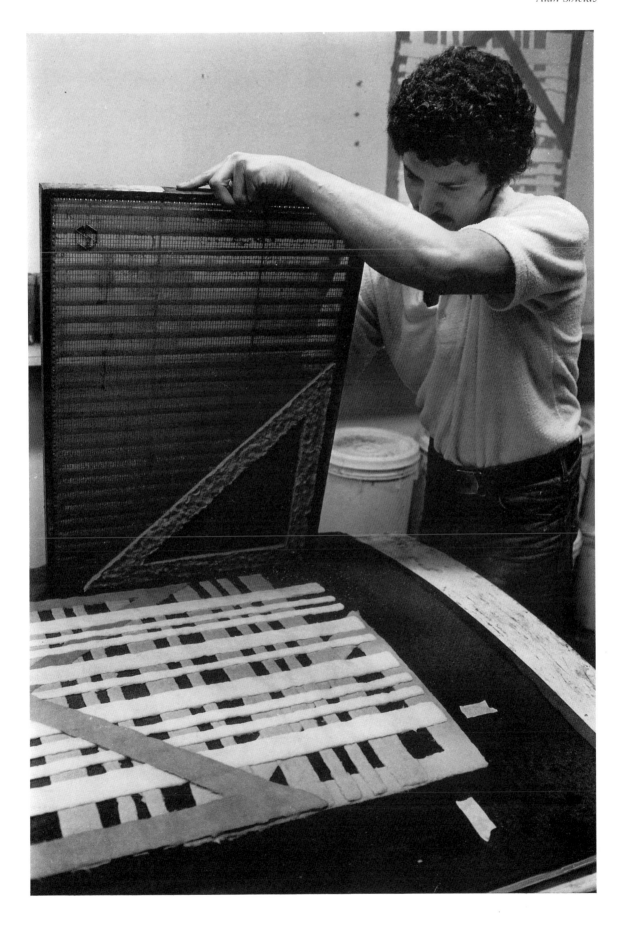

Lee Funderburg couching a layer of colored
pulp onto the base sheet for Alan Shields's
Color Radar Smile series, 1980.

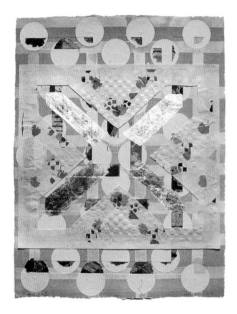

493:AS16

Alan Shields
Treasure Rute II 1980

Relief, aquatint, linocut, silver leaf, collage
(20)
24 × 18½ (61 × 47)
Paper: buff/gray HMP duplex, handmade;
natural Kitakata, handmade
Edition: 11
Proofs: 2AP, 4TP, 2CTP, RTP, PPI, A

Zinc and assembled plate preparation by
Rodney Konopaki; proofing and edition
printing by Konopaki; preparation and
adhering of collage elements by Kim
Halliday and Konopaki

Signed *Alan Shields*, numbered, dated, and
titled in pencil lower edge; chop mark
lower left; workshop number AS79-465
lower right verso

13 runs: 20 colors, including 1 colored
paper; 11 runs from 1 zinc plate, 1
donut-shaped linoleum block, 1 assembled
plate made from 10 copper strips, 1 assem-
bled plate made from triangular and square
linoleum blocks, and 1 assembled plate
made from small hexagonal and square
linoleum blocks:
 1 yellow, orange, violet, blue, and green;
 methods 15a (copper strips), 16a; IV
 2 gray; methods 6, 9 (zinc plate, RK); IV

3 yellow, orange, orange-red, and blue
 (on Kitakata paper); methods 15a
 (triangular and square blocks), 16a; III
4 turquoise blue (on same paper as run
 3); method 18 (donut-shaped block);
 III
5 gray-green (on same paper as run 3;
 paper turned 90°); method 18 (same
 block as run 4); III
6 violet (on same paper as run 3; paper
 turned 90°); method 18 (same block as
 run 4); III
7 gray-green (on same paper as run 3;
 paper turned 90°); method 18 (same
 block as run 4); III
8 medium brown (on same paper as run
 3); method 18 (hexagonal and square
 blocks); III
9 green (on same paper as run 3; paper
 turned 90°); method 18 (same plate as
 run 8); III
10 magenta (on same paper as run 3;
 paper turned 90°); method 18 (same
 plate as run 8); III
11 blue (on same paper as run 3; paper
 turned 90°); method 18 (same plate as
 run 8); III
12 printed paper from runs 3–11 cut;
 method 36b (KH, RK); III
13 silver leaf applied

Side A

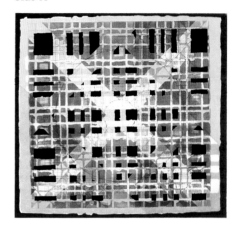

494:AS17

Alan Shields
Color Radar Smile A 1980

Etching, aquatint, linocut (15)
25 × 25 (63.5 × 63.5)
Paper: multicolored TGL, handmade
Edition: 8
Proofs: 2AP, A

Papermaking by Lee Funderburg; assem-
bled plate preparation and processing by
Rodney Konopaki; proofing and edition
printing by Konopaki

Signed *Alan J. Shields*, numbered, dated,
and titled in pencil lower edge on side B;
chop mark lower right on side B; workshop
number AS79-469A lower left on side A

5 runs: 6 pulp colors, 1 paper pressing; 9
ink colors, 4 runs from 1 linoleum block, 1
assembled plate made from 4 triangular
copper plates, 1 assembled plate made from
4 square copper plates, and 1 assembled
plate made from 1 square copper plate with
3 concentric circular copper plates:
 1 orange, pink, tan, green, white, and
 gray pulps (couched from wove moulds
 sectioned off with masking tape to
 form a pattern); III

Side B

Side A

Side B

2 red and green; methods 15b (triangular
 plates), 6, 9 (RK), 16a; IV
3 yellow, yellow-ocher, orange, and violet;
 methods 15b (square plates), 6, 9 (RK),
 16a; IV
4 gray and black; methods 15b (square
 and circular plates), 6, 16a; IV
 [runs 2–4 on side A]
5 blue-gray; method 18; III
 [run 5 on side B]

The printing elements, sequence, and ink
colors used for the Color Radar Smile
editions are the same. The papers used for
these editions differ in color and design.
Impressions were made on both sides of the
paper. Instead of front and back, print sides
are referred to by the letters A and B.

495:AS18

Alan Shields
Color Radar Smile B 1980

Etching, aquatint, linocut (17)
25 × 25 (63.5 × 63.5)
Paper: multicolored TGL, handmade
Edition: 8
Proofs: 2AP, A

Papermaking by Lee Funderburg; assem-
bled plate preparation and processing by
Rodney Konopaki; proofing and edition
printing by Konopaki

Signed *Alan J. Shields*, numbered, dated,
and titled in pencil lower edge on side B;
chop mark lower right on side B; workshop
number AS79-469B lower left on side A

5 runs: 8 pulp colors, 1 paper pressing; 9
ink colors, 4 runs from 1 linoleum block, 1
assembled plate made from 4 triangular
copper plates, 1 assembled plate made from
4 square copper plates, and 1 assembled
plate made from 1 square copper plate with
3 concentric circular copper plates:
1 yellow, orange, pink, purple, blue,
 green, light yellow-green, and gray
 pulps (couched from wove moulds
 sectioned off with masking tape to
 form a pattern); III

2 red and green; methods 15b (triangular
 plates), 6, 9 (RK), 16a; IV
3 yellow, yellow-ocher, orange, and violet;
 methods 15b (square plates), 6, 9 (RK),
 16a; IV
4 gray and black; methods 15b (square
 and circular plates), 6, 16a; IV
 [runs 2–4 on side A]
5 blue-gray; method 18; III
 [run 5 on side B]

The printing elements, sequence, and ink
colors used for the Color Radar Smile
editions are the same. The papers for these
editions differ in color and design. Impres-
sions were made on both sides of the paper.
Instead of front and back, print sides are
referred to by the letters A and B.

Side A

Side B

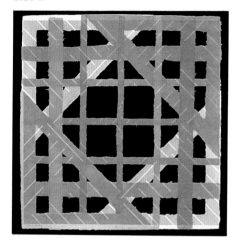

496:AS19

Alan Shields
Color Radar Smile C 1980

Etching, aquatint, linocut (16)	
25 × 25 (63.5 × 63.5)	
Paper: multicolored TGL, handmade	
Edition: 8	
Proofs: 2AP, A	

Papermaking by Lee Funderburg; assembled plate preparation and processing by Rodney Konopaki; proofing and edition printing by Konopaki

Signed *Alan J. Shields*, numbered, dated, and titled in pencil lower edge on side B; chop mark lower right on side B; workshop number AS79-469C lower right on side A

5 runs: 7 pulp colors, 1 paper pressing; 9 ink colors, 4 runs from 1 linoleum block, 1 assembled plate made from 4 triangular copper plates, 1 assembled plate made from 4 square copper plates, and 1 assembled plate made from 1 square copper plate with 3 concentric circular copper plates:
 1 yellow, pink, purple, blue, blue-gray, green-gray, and gray colored pulps (couched from wove moulds sectioned off with masking tape to form a pattern); III

2 red and green; methods 15b (triangular plates), 6, 9 (RK), 16a; IV
3 yellow, yellow-ocher, orange, and violet; methods 15b (square plates), 6, 9 (RK), 16a; IV
4 gray and black; methods 15b (square and circular plates), 6, 16a; IV
 [runs 2–4 on side A]
5 blue-gray; method 18; III
 [run 5 on side B]

The printing elements, sequence, and ink colors used for the Color Radar Smile editions are the same. The papers for these editions differ in color and design. Impressions were made on both sides of the paper. Instead of front and back, print sides are referred to by the letters A and B.

497:AS20

Alan Shields
Rickshaw Radar 1980

Etching, aquatint, linocut (19)	
Three sheets: 25¼ × 70½ (64.1 × 179.1); each: 25¼ × 23½ (64.1 × 59.7)	
Paper: natural Chiri, handmade	
Edition: 5	
Proofs: 2AP, RTP, PPI, A	

Assembled plate preparation and processing by Rodney Konopaki; proofing and edition printing by Konopaki

Signed *Alan J. Shields* in pencil lower left of right sheet; numbered lower right of left sheet; titled lower center of middle sheet; chop mark lower right of each sheet; workshop number AS79-468 lower left verso of each sheet

5 runs: 19 colors; 5 runs from 1 linoleum block, 1 assembled plate made from 4 triangular copper plates, 1 assembled plate made from 4 square copper plates, and 1 assembled plate made from 1 square copper plate with 3 concentric circular copper plates:
 1 red and green (printed simultaneously on 3 sheets); methods 15b (triangular plates), 6, 9 (RK), 16a; IV

THREE PRINT GROUPS

LAYERED PRINTED-PAPER SERIES

2 yellow, yellow-ocher, orange, and violet (printed simultaneously on 3 sheets); methods 15b (square plates), 6, 9 (RK), 16a; IV

3 gray and black (printed simultaneously on 3 sheets); methods 15b (square and circular plates), 6, 16a; IV

4 violet (on verso of left sheet); method 18; III

5 yellow, orange, red, pink, brown, light blue, blue, light green, green, and gray (printed simultaneously on middle sheet and verso of right sheet); methods 18, 16a; III

The three print groups that Alan Shields completed between 1981 and 1985—The Castle Window Set and *Santa's Collar*; *Odd-Job*, *Gas-Up*, *Bull-Pen*, and *Milan Fog*; and The Raggedy Circumnavigation Series—share an unconventional approach to printmaking. Each print is an assemblage of layers of paper with printed images. These layers were selected from a large inventory of printed papers that were the result of numerous printings. The artist began each series by designing printing elements and by directing the making of special papers. As each paper was printed, the artist developed a printed vocabulary unique to each series, and he began to assemble the papers in various configurations. Once the artist had created the edition standard, the workshop commenced papermaking and printmaking. Because of the unusual manner in which Shields colored his white papers, the unprinted white areas of the papers are counted as colors in the entries for these editions.

The Castle Window Set and *Santa's Collar* are a series of eight prints with related images and printing methods, completed in 1981. Each of the seven prints from The Castle Window Set is made up of two sheets of handmade paper that are hinged together along the upper edge on the verso with acid-free, double-sided tape. The bottom layers are colored TGL paper, made by Steve Reeves and Tom Strianese. The papers for the top layers were created by the artist for this project in 1980 while collaborating with papermakers at the Gandhi Ashram paper mill in Ahmadabad, India. These papers have unique designs of negative shapes made when the paper was formed. Shields covered areas of the papermaking mould with tape to create a pattern of small "window" openings.

The artist devised a system for printing the Castle Window editions that made use of the special character of the papers and printing elements. Two layers of paper were printed simultaneously during each print run. A handmade TGL paper was used as a backing sheet instead of the standard newsprint backing sheet that is traditionally discarded. Because of the openings in the Gandhi Ashram papers, inks printed through to the TGL sheets. These "collection sheets" were used as the edition paper for *Santa's Collar*.

In printing The Castle Window Set and *Santa's Collar*, the artist employed a combination of woodcut, linocut, intaglio, relief, and ghost printing.

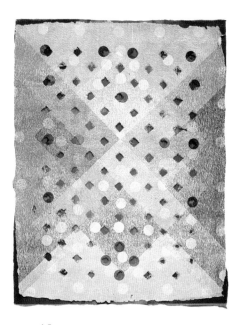

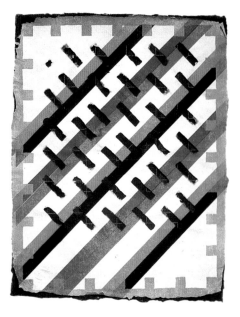

498:AS21

Alan Shields
Ahmadabad Silk, from The Castle Window
Set 1981

Woodcut, relief, etching, aquatint, collage
(16)

35¾ × 27¾ (90.8 × 70.5)

Paper: top layer: white Gandhi Ashram,
handmade; bottom layer: blue TGL,
handmade

Edition: 33

Proofs: 6AP, TP, RTP, PPI, A

Papermaking by Steve Reeves and Jeb
Baum; woodblock preparation by Reeves;
magnesium plate preparation and
processing by Swan Engraving; assembled
plate preparation and processing by Rodney
Konopaki; proofing and edition printing by
Konopaki; adhering of collage elements by
Konopaki

Signed *Alan Shields* in pencil lower center;
numbered lower left; chop mark lower
right; workshop number AS80-571 lower
left verso

5 runs: 16 colors, including 1 white paper
and 1 colored paper; 4 runs from 1 magne-
sium plate, 1 assembled plate made from
irregularly shaped woodblocks, and 1
assembled plate made from 9 rectangular
copper plates:

1 yellow, violet, blue, and yellow-green;
 methods 15b (woodblocks), 19b (luan
 plywood), 16a; IV
2 yellow, red, blue, yellow-green, and
 silver; methods 15b, 19b (same plate as
 run 1, reworked), 16a; IV
3 red, green, and black; methods 21b,
 23a, 16a; IV
 [runs 1–3 on white paper]
4 red and ultramarine blue (on blue
 paper); methods 15b (rectangular
 plates), 6, 9 (RK), 16a; IV
5 papers from runs 1–4; method 36a
 (RK); III

499:AS22

Alan Shields
Kite Riddle, from The Castle Window
Set 1981

Linocut, woodcut, relief, collage (13)

35¾ × 27¾ (90.8 × 70.5)

Paper: top layer: white Gandhi Ashram,
handmade; bottom layer: black TGL,
handmade

Edition: 40

Proofs: 6AP, RTP, PPI, A

Papermaking by Steve Reeves and Tom Stri-
anese; woodblock preparation and magne-
sium plate preparation and processing by
Swan Engraving; assembled plate prepara-
tion by Rodney Konopaki; proofing and
edition printing by Konopaki; adhering of
collage elements by Konopaki

Signed *Alan Shields* in pencil lower center;
numbered lower left; chop mark lower
right; workshop number AS80-572 lower
left verso

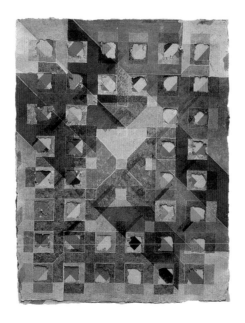

8 runs: 13 colors, including 1 white paper and 1 colored paper; 7 runs from 2 magnesium plates, 1 woodblock, and 1 assembled plate made from diagonally cut linoleum strips:

1 white; methods 21a, 23a; IIa
2 yellow; methods 21c, 23a; IIa
 [runs 1 and 2 on black paper]
3 red and black; methods 15a (linoleum strips), 18, 16a; IV
4 green and orange (paper moved forward 4 inches [10.2 cm]); methods 15a (linoleum strips), 18, 16a; IV
5 yellow and cyan blue (on verso); methods 15a (same plate as run 4), 18, 16a; IV
6 light red and purple (on verso, paper moved forward 4 inches [10.2 cm]); methods 15a (same plate as run 4), 18, 16a; IV
7 gray; method 19c (birchwood); IV
 [runs 3–7 on white paper]
8 papers from runs 1–7; method 36a (RK); III

500:AS23

Alan Shields
Fran Tarkington's Tie, from The Castle Window Set 1981

Woodcut, linocut, aquatint, collage (32)
35¾ × 27¾ (90.8 × 70.5)
Paper: top layer: gray Gandhi Ashram, handmade; bottom layer: pink TGL, handmade
Edition: 23
Proofs: 6AP, 8TP, RTP, PPI, A

Papermaking by Steve Reeves and Jeb Baum; woodblock preparation and magnesium plate preparation and processing by Swan Engraving; assembled plate preparation and processing by Rodney Konopaki; proofing and edition printing by Konopaki; adhering of collage elements by Konopaki

Signed *Alan Shields* in pencil lower center; numbered lower left; chop mark lower right; workshop number AS80-573 lower left verso

9 runs: 32 colors, including 2 colored papers; 8 runs from 1 assembled plate made from 93 rectangular woodblocks, 2 assembled plates made from diagonally cut linoleum strips, and 1 assembled plate made from diagonally cut copper plates:

1 yellow, red, blue, green, gray, silver, and gold; method 34 (from 501:AS24, run 1); V
2 yellow and cyan blue; methods 15a (linoleum strips), 18, 16a; IV
3 light red and purple (paper moved forward 4 inches [10.2 cm]); methods 15a (same plate as run 2), 18, 16a; IV
4 ultramarine blue; methods 15b (copper plates), 9 (RK); IV
 [runs 1–4 on gray paper]
5 dark red-purple, cerulean blue, copper, gold, and dark gold; methods 15a (same plate as run 2), 18, 16a; IV
6 dark red-purple, cerulean blue, copper, gold, and dark gold; methods 15a (linoleum strips), 18, 16a; IV
7 light yellow, yellow, red, and green (paper moved forward 4 inches [10.2 cm]); methods 15a (same plate as run 2), 18, 16a; IV
8 light yellow, yellow, red, and green (paper moved forward 4 inches [10.2 cm]); methods 15a (same plate as run 6), 18, 16a; IV
 [runs 5–8 on pink paper]
9 papers from runs 1–8; method 36b (RK); III

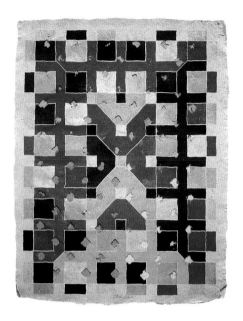

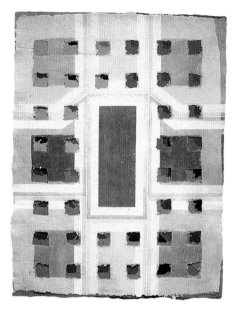

501:AS24

Alan Shields
Fire Escape Plan, from The Castle Window
Set 1981

Woodcut, collage (13)

35¾ × 27¾ (90.8 × 70.5)

Paper: top layer: gray Gandhi Ashram,
handmade; bottom layer: gray TGL, hand-
made, hand-colored

Edition: 23

Proofs: 6AP, 2TP, CTP, RTP, PPI, A

Papermaking by Steve Reeves and Kim
Halliday; woodblock preparation and
magnesium plate preparation and
processing by Swan Engraving; proofing
and edition printing by Rodney Konopaki;
adhering of collage elements by Konopaki

Signed *Alan Shields* in pencil lower center;
numbered lower left; chop mark lower
right; workshop number AS80-574 lower
left verso

3 runs: 4 pulp colors, 1 paper pressing; 7
ink colors and 2 colored papers, 1 run from
1 assembled plate made from 93 rectan-
gular woodblocks:

1 yellow, red, blue, green, gray, silver, and
 gold (on Gandhi Ashram paper);
 methods 15b (rectangular blocks), 19c
 (birchwood), 16a; V

2 orange, violet, brown, and green pulps
 (on newly made TGL paper); III

3 papers from runs 1 and 2; method 36a
 (RK); III

502:AS25

Alan Shields
Chicago Tenement, from The Castle
Window Set 1981

Relief, etching, aquatint, collage (13)

35¾ × 27½ (90.8 × 69.9)

Paper: top layer: white Gandhi Ashram,
handmade; bottom layer: gray TGL, hand-
made, hand-colored

Edition: 23

Proofs: 6AP, RTP, PPI, A

Papermaking by Steve Reeves and Kim
Halliday; magnesium plate preparation and
processing by Swan Engraving; assembled
plate preparation and processing by Rodney
Konopaki; proofing and edition printing by
Konopaki; adhering of collage elements by
Konopaki

Signed *Alan Shields* in pencil lower center;
numbered lower left; chop mark lower
right; workshop number AS80-575 lower
left verso

5 runs: 4 pulp colors, 1 paper pressing; 7
ink colors, 1 white paper, and 1 colored
paper, 3 runs from 1 magnesium plate, 1
assembled plate made from 9 rectangular
copper plates, and 1 assembled plate made
from diagonally cut copper plates:

1 yellow; methods 21c, 23a; III

2 yellow-ocher, magenta, medium brown,
 dark brown, and turquoise blue;
 method 34 (from 503:AS26, run 2); IV
 [runs 1 and 2 on white paper]

3 orange, violet, brown, and green pulps
 (on newly made gray paper); III

4 ultramarine blue (on same paper as run
 3); methods 15b (diagonally cut copper
 plates), 6, 9 (RK); IV

5 papers from runs 1–4; method 36a
 (RK); III

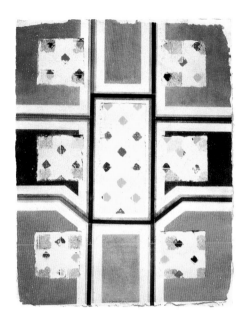

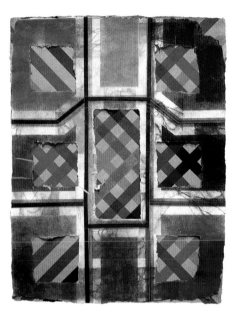

503:AS26

Alan Shields
Jason's Rabbit Holler with Flying Rabbits,
from The Castle Window Set 1981

Woodcut, relief, aquatint, collage (25)
35¾ × 27¾ (90.8 × 70.5)
Paper: top layer: white Gandhi Ashram,
handmade; bottom layer: pale yellow TGL,
handmade
Edition: 25
Proofs: 6AP, RTP, PPI, A

Papermaking by Steve Reeves and Tom Stri-
anese; woodblock preparation and magne-
sium plate preparation and processing by
Swan Engraving; copper plate preparation
and processing by Rodney Konopaki;
proofing and edition printing by Konopaki;
adhering of collage elements by Konopaki

Signed *Alan Shields* in pencil lower center;
numbered lower left; chop mark lower
right; workshop number AS80-576 lower
left verso

5 runs: 25 colors, including 1 white paper
and 1 colored paper; 4 runs from 1 magne-
sium plate, 1 assembled plate made from 9
copper plates, and 1 assembled plate made
from 93 rectangular woodblocks:
1 orange, violet, green, and black;
 methods 21a, 23a, 16a; III
2 yellow-ocher, magenta, medium brown,
 dark brown, and turquoise blue;
 methods 15b (copper plates), 9 (RK),
 16a; IV
 [runs 1 and 2 on white paper]
3 yellow, red, blue, green, gray, silver, and
 gold; methods 15a (woodblocks), 19c
 (birchwood), 16a; V
4 yellow, red, blue, green, gray, silver, and
 gold; method 34 (from run 3); V
 [runs 3 and 4 on yellow paper]
5 papers from runs 1–4; method 36a
 (RK); III

504:AS27

Alan Shields
Plastic Bucket, from The Castle Window
Set 1981

Linocut, etching, aquatint, relief, collage
(34)
36¼ × 27½ (92.1 × 69.6)
Paper: top layer: white Gandhi Ashram,
handmade; bottom layer: pink TGL,
handmade
Edition: 10
Proofs: 4AP, RTP, A

Papermaking by Steve Reeves and Tom Stri-
anese; magnesium plate preparation and
processing by Swan Engraving; assembled
plate preparation, processing, proofing, and
edition printing by Rodney Konopaki;
adhering of collage elements by Konopaki

Signed *Alan Shields* in pencil lower center;
numbered lower left; chop mark lower
right; workshop number AS80-576A lower
left verso

8 runs: 34 colors, including 1 white paper and 1 colored paper; 7 runs from 1 magnesium plate, 2 assembled plates made from diagonally cut linoleum strips, and 1 assembled plate made from 9 rectangular copper plates:

1 orange, violet, green, and black; methods 21a, 23a, 16a; IV
2 yellow-ocher, magenta, medium brown, dark brown, and turquoise blue; methods 15b (copper plates), 6, 9 (RK), 16a; IV
3 orange, red, violet, blue, and green; methods 15b (same plate as run 2, reworked), 6, 9 (RK), 16a; IV
 [runs 1–3 on white paper]
4 dark red-purple, cerulean blue, light gold, gold, and copper; methods 15a (linoleum strips), 18, 16a; IV
5 repeat of run 4
6 light yellow, yellow, red, and green (paper moved forward 4 inches [10.2 cm]); methods 15a (same plate as run 4), 18; IV
7 repeat of run 6 with paper moved forward 4 inches (10.2 cm)
 [runs 4–7 on pink paper]
8 top and bottom layers; method 36a (RK); III

505:AS28

Alan Shields
Santa's Collar 1981

Relief, woodcut, linocut, aquatint, stitching, collage (40)
43¼ × 36½ (109.9 × 92.7)
Paper: white with straw TGL, handmade, with blue TGL, handmade, border
Edition: 32
Proofs: 6AP, 8CTP, RTP, PPI, PPII, A

Papermaking by Steve Reeves and Tom Strianese; magnesium plate preparation and processing by Swan Engraving; assembled plate preparation, processing, proofing, and edition printing by Rodney Konopaki; assembly of collage elements by Konopaki

Signed *Alan Shields* in pencil lower center; numbered lower left; chop mark lower right; workshop number AS80-577 lower left verso

11 runs: 40 colors, including 1 colored paper; 10 runs from 1 magnesium plate, 1 assembled plate made from irregularly shaped woodblocks, 2 assembled plates made from diagonally cut linoleum strips, and 1 assembled plate made from 9 rectangular copper plates:

1 yellow, violet, blue, yellow-green, and silver; methods 15b (woodblocks), 19b (luan plywood), 16a; IV
2 yellow, light red, blue, and yellow-green; methods 15b (same plate as run 1, reworked), 19b (luan plywood), 16a; IV
3 red and black; methods 15a (linoleum strips), 18, 16a; IV
4 orange and green (paper moved forward 4 inches [10.2 cm]); methods 15a (same plate as run 3), 18, 16a; IV
5 dark red-purple, cerulean blue, light gold, gold, and copper; methods 15a (same plate as run 3), 18, 16a; IV
6 repeat of run 5
7 light yellow, yellow, red, and green (paper moved forward 4 inches [10.2 cm]); methods 15a (same plate as run 3), 18, 16a; IV
8 repeat of run 7
9 yellow-ocher, magenta, medium brown, dark brown, turquoise blue; methods 15b (copper plates), 9 (RK), 16a; IV
10 red, green, and black; methods 21b, 23a, 16a; IV
 [runs 1–10 on white paper]
11 white and blue papers; method 36c (colored thread)

LATTICE PAPER MIXED-MEDIA PRINT SERIES

For the editions *Odd-Job*, *Gas-Up*, *Bull-Pen*, and *Milan Fog*, completed in 1984, Alan Shields created eleven different hand-made papers. Two papers were made with unique designs of negative shapes, window-like openings made by taping over areas of the papermaking mould. Six types of TGL lattice paper were made by submerging geometric yarn constructions strung on steel frames in pulp slurries and lifting them from the vats with pulp adhered to the yarn. (Four of the lattice papers were air-dried without pressing, and two were pressed and then dried.) Three TGL papers were made from a wove deckle mould. A twelfth handmade paper, HMP, was also used.

The artist designed nine different printing elements, including assembled plates, laser-cut woodblocks, and etched magnesium and copper plates. Relief, intaglio, ghost, and viscosity printing methods were employed in inking the different elements, and, as in The Castle Window Set, the artist devised a printing system that took advantage of the special character of the papers and printing elements. Several layers of paper were printed simultaneously during each print run, with inks printing through the openings in the window and lattice papers. The printed layers were separated after printing and reassembled. Each print is made up of three layers of paper adhered, stitched, or tied together with colored thread.

506:AS29

Alan Shields
Odd-Job 1984

Woodcut, etching, relief, stitching, collage
(24)

42 × 42 (106.7 × 106.7)

Paper: top layer: light yellow-ocher TGL, handmade; middle layer: white lattice-string TGL, handmade; bottom layer: blue TGL, handmade

Edition: 46

Proofs: 17AP, TP, RTP, PPI, PPII, A

Papermaking by Steve Reeves and Tom Strianese; laser-cut woodblock preparation and magnesium plate preparation by Swan Engraving; proofing and edition printing by Rodney Konopaki and Bob Cross; preparation and adhering of collage elements by Konopaki and Cross

Signed *Alan Shields*, numbered, dated, and titled in pencil lower edge; chop mark lower right; workshop number AS83-720 lower left verso

8 runs: 24 colors, including 1 white paper and 2 colored papers; 6 runs from 1 copper plate, 2 magnesium plates, 1 assembled plate made from 20 concentric wood rings in rectangular frame, 1 assembled plate made from carved woodblock in rectangular frame, and 1 assembled plate made from diamond-shaped woodblocks:

1 green and gray; methods 15b (concentric rings), 19c (birchwood), 16a; III
2 red and metallic green; methods 15b (carved block), 19a (birchwood), 16a; III
3 yellow, orange, red, blue, green, and yellow-green; methods 11a, 16a; III [runs 1–3 on yellow-ocher paper]
4 yellow, orange, red, pink, purple, blue, and gray (on white paper); methods 15b (diamond-shaped blocks), 19c (birchwood), 16a; III
5 red and cerulean blue; methods 21b, 23a, 17; III
6 brown and gray; methods 21b, 23a, 17; III
[runs 5 and 6 on blue paper]
[printed paper from runs 5 and 6 torn in 2 pieces]
7 top, middle, and bottom layers; method 36a (RK, BC); III
8 papers from runs 1–7; method 36c (colored thread)

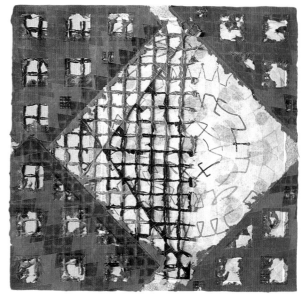

507:AS30

Alan Shields
Gas-Up 1984

Woodcut, etching, aquatint, relief, knotting, collage (33)

56½ × 40½ (143.5 × 102.9)
Paper: top layer: light yellow-ocher lattice-string TGL, handmade; middle layer: white lattice-string TGL, handmade; bottom layer: gray HMP, handmade, and dark green TGL, handmade
Edition: 46
Proofs: 17AP, RTP, PPI, PPII, A

Papermaking by Steve Reeves and Tom Strianese, laser-cut woodblock preparation and magnesium plate preparation and processing by Swan Engraving; proofing and edition printing by Rodney Konopaki and Bob Cross; preparation and adhering of collage elements by Konopaki and Cross

Signed *Alan Shields*, numbered, dated, and titled lower edge; chop mark lower right; workshop number AS83-722 lower left verso

10 runs: 33 colors, including 1 white paper and 3 colored papers; 8 runs from 2 magnesium plates, 1 assembled plate made from 2 irregularly shaped woodblocks, 1 assembled plate made from 20 concentric wood rings, 1 assembled plate made from circular woodblocks, 1 assembled plate made from 20 concentric wood rings cut

into quadrants, 1 assembled plate made from diamond-shaped woodblocks, and 1 assembled plate made from 1 magnesium plate with 24 rectangular copper inserts:

1 violet, light blue, and green (on yellow-ocher paper); methods 15b (irregularly shaped woodblocks), 19c (birchwood), 16a; III
2 brown and gray (on white paper); methods 21c, 23a, 17; III
3 green and gray; method 34 (from 506:AS29, run 1); III
4 red and metallic green; method 34 (from 506:AS29, run 2); III
5 red and cerulean blue; method 34 (from 506:AS29, run 5); III
[runs 3–5 on green paper]
6 yellow, orange, purple, blue, and gold; methods 15b (quadrant rings), 19c (birchwood), 16a; III
7 yellow, orange, red, pink, purple, blue, and gray; method 34 (from 506:AS29, run 4); III
8 yellow, yellow-ocher, red, blue, viridian, and black; methods 15b (plate with copper inserts), 6, 9 (RK), 21b, 23b, 16a; III
[runs 6–8 on gray paper]
9 printed paper from runs 3–5 torn and printed paper from runs 6–8; method 36a (RK, BC); III
10 paper from run 1 tied to papers from runs 2–9; method 36c (colored thread)

508:AS31

Alan Shields
Bull-Pen 1984

Woodcut, etching, aquatint, collage (32)

40¼ × 41¾ (102.2 × 106)
Paper: top layer: dark green TGL, handmade; middle layer: light yellow-ocher lattice-string TGL, handmade; bottom layer: white TGL, handmade, and gray HMP, handmade
Edition: 46
Proofs: 17AP, RTP, PPI, PPII, A

Papermaking by Steve Reeves and Tom Strianese; laser-cut woodblock preparation and magnesium plate preparation and processing by Swan Engraving; copper plate preparation and processing by Rodney Konopaki; proofing and edition printing by Konopaki and Bob Cross; preparation and adhering of collage elements by Konopaki and Cross

Signed *Alan Shields*, numbered, dated, and titled in pencil lower edge; chop mark lower right; workshop number AS83-723 lower left verso

7 runs: 32 colors, including 1 white paper and 3 colored papers; 6 runs from 1 copper plate, 1 assembled plate made from diamond-shaped woodblocks, 1 assembled

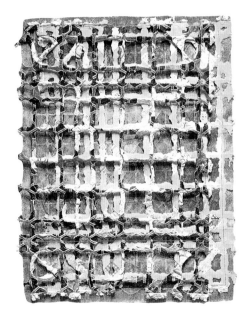

plate made from 1 magnesium plate with 24 rectangular copper inserts, 1 assembled plate made from 20 concentric wood rings cut into quadrants, 1 assembled plate made from 20 concentric wood rings, and 1 assembled plate made from circular woodblocks:

1 yellow, orange, red, pink, purple, blue, and gray; method 34 (from 506:AS29, run 4); III

2 yellow, yellow-ocher, red, blue, viridian, and black; methods 15b (plate with copper inserts), 6, 9 (RK), 21b, 23b, 16a; III
[runs 1 and 2 on dark green paper]
[printed paper from runs 1 and 2 torn]

3 yellow, orange, purple, blue, and gold (on yellow-ocher paper); methods 15b (quadrant rings), 19c (birchwood), 16a; III

4 green and gray; method 34 (from 506:AS29, run 1); III

5 red and metallic green; method 34 (from 506:AS29, run 2); III

6 yellow, orange, red, blue, green, and yellow-green; method 34 (from 506:AS29, run 3); III
[runs 4–6 on white and gray papers]

7 papers from runs 1–6; method 36a (RK, BC); III

509:AS32

Alan Shields
Milan Fog 1984

Woodblock, etching, aquatint, stitching, collage (26)

39¾ × 32 (101 × 81.3)
Paper: top and middle layers: white lattice-string TGL, handmade; bottom layer: white TGL, handmade
Edition: 46
Proofs: 16AP, 3SP, RTP, PPI, PPII, A

Papermaking by Steve Reeves and Tom Strianese, laser-cut woodblock preparation and magnesium plate preparation and processing by Swan Engraving; proofing and edition printing by Rodney Konopaki and Bob Cross; assembly of collage elements by Konopaki and Cross

Signed *Alan Shields*, numbered, dated, and titled in pencil lower edge; chop mark lower right; workshop number AS83-724 lower left verso

6 runs: 26 colors, including 3 white papers; 5 runs from 1 magnesium plate, 1 assembled plate made from 1 magnesium

plate with 24 rectangular copper inserts, 1 assembled plate made from 20 concentric wood rings cut into quadrants, 1 assembled plate made from diamond-shaped woodblocks, and 1 assembled plate made from 2 irregularly shaped woodblocks:

1 red and cerulean blue (on lattice-string paper); methods 21b, 17; III

2 yellow, yellow-ocher, red, blue, viridian, and black (on lattice-string paper); method 34 (from 507:AS30, run 8); III

3 yellow, orange, purple, blue, and gold; method 34 (from 507:AS30, run 6); III

4 yellow, orange, red, pink, purple, blue, and gray; method 34 (from 506:AS29, run 4); III

5 violet, light blue, and green; method 34 (from 507:AS30, run 1); III
[runs 3–5 on white paper]

6 papers from runs 1–5; method 36c (colored thread)

THE RAGGEDY CIRCUMNAVIGATION SERIES

Combinations for The Raggedy Circumnavigation Series

1 white yarn paper, multicolored yarn
2 white wove sheet with blue yarn paper, yellow yarn
3 white yarn paper, green yarn
4 blue yarn paper, green yarn
5 white wove sheet with blue yarn paper, yellow yarn
6 white yarn paper, yellow yarn
7 white yarn paper, yellow yarn
8 white yarn paper, multicolored yarn
9 white yarn paper, green yarn
10 white yarn paper, blue yarn
11 half-circle; white yarn paper, red yarn
12 half-circle; white yarn paper, combination red and pink yarn

The seven print editions in the series are constructed of these yarn papers in various layered combinations.

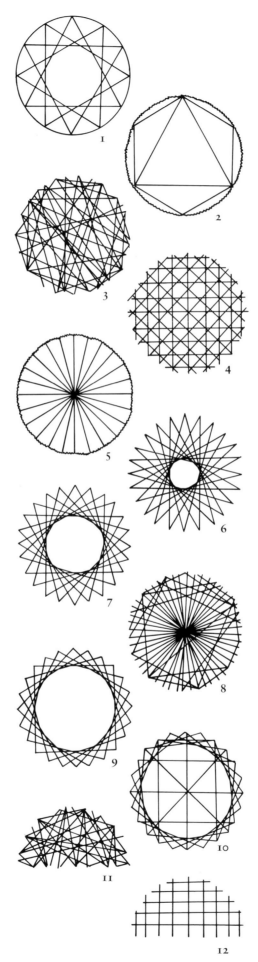

In 1985 Alan Shields collaborated with Kenneth Tyler, Steve Reeves, Tom Strianese, Rodney Konopaki, and Bob Cross, assisted by Marabeth Cohen, to make The Raggedy Circumnavigation Series, a group of seven print editions with circular formats. The artist designed a variety of special hand-made papers for the series that were printed using unconventional printing elements and systems.

Shields began by designing eighteen different kinds of paper, including ten varieties of lattice paper. Other kinds of paper were also developed: paper was vacuum-molded and colored with six pulp mixtures applied through plastic grids; star-shaped paper was made by spraying kozo fiber from a pattern pistol through a stencil onto fabric, allowing it to dry, and peeling it off the fabric; and newly made mould-made papers were laminated with wet colored lattice papers.

Shields designed and made fourteen printing elements: three screen stencils, one star-shaped woodblock, and ten assembled plates. He constructed these plates from laser-cut woodblocks, wood planks with drilled holes, aluminum strips, and various found objects, such as plastic and metal grids and metal washers. In this series, as in his earlier print series, Shields combined and manipulated different media—woodcut, screen printing, and relief printing—and he varied inking techniques. He applied different inks on separate parts of assembled plates, brought the parts together, and printed them. Shields and the printers also made ghost impressions—printing with ink remaining on printing elements after a run—and overprinted impressions, at times rotating papers 30, 60, or 180 degrees while layering inks. Two sheets of paper were layered on one printing element so that the top sheet would receive ink over its entire surface and ink passing around the paper (in the case of the star-shaped paper) or through the openings of the lattice paper would print on the sheet behind it. The seven editions evolved simultaneously as the artist freely interchanged papers from his large inventory of proofs for these combined and repeated printings.

After printing, the artist separated the layers and then reassembled them. Layers were adhered or stitched together with colored thread. Several editions were printed on further after adhering.

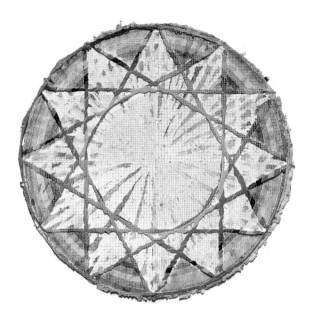

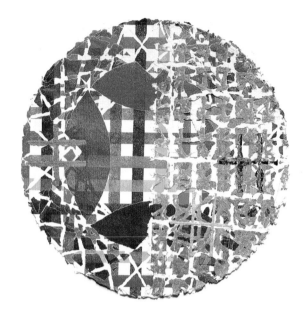

510:AS33

Alan Shields
Equatorial Route, from The Raggedy
Circumnavigation Series 1985

Relief, woodcut, stitching, collage (42)
47 (119.4) diameter
Paper: top layer: white lattice-string TGL,
handmade; bottom layer: light gray TGL,
handmade
Edition: 20
Proofs: AP, RTP, PPI, PPII, A

Papermaking by Steve Reeves, Tom Stri-
anese, and Marabeth Cohen; woodblock
preparation by Swan Engraving; wood-
block and aluminum strips proofing and
edition printing by Rodney Konopaki, Bob
Cross, and Reeves; metal grid proofing and
edition printing by Cross and Strianese;
assembly of collage elements by Konopaki,
Cross, Reeves, and Strianese

Signed *Alan Shields,* numbered, and dated
in pencil lower center; chop mark lower
center; workshop number AS85-868 lower
center verso

6 runs: 42 colors, including 1 white paper
and 1 colored paper, 5 runs from 1 assem-
bled plate made from 24 concentric wood
rings, 1 assembled plate made from 4
square metal grids, and 1 assembled plate
made from 48 aluminum strips:
1 medium yellow, red, dark red, light
 blue, ultramarine blue, and dark green
 (on white paper); methods 15b (rings),
 19c (birchwood); III
2 yellow and metallic green-silver (simul-
 taneously on white and gray papers);
 methods 15b (grids), 16a; III
3 medium yellow, red, dark red, light
 blue, ultramarine blue, and dark green;
 method 34 (from 513:AS36, run 4); III
4 yellow, orange, vermilion, magenta,
 pink, purple, tan, green-brown, light
 blue, dark blue, turquoise blue,
 yellow-green, and gray; methods 15b
 (strips), 16a; III
5 repeat of run 4 with paper turned 30°
 [runs 3–5 on gray paper]
6 papers from runs 1–5; method 36c
 (colored thread)

511:AS34

Alan Shields
Josh's Route, from The Raggedy
Circumnavigation Series 1985

Relief, screenprint, stitching, collage (22)
47 (119.4) diameter
Paper: top layer: white lattice-string TGL,
handmade; bottom layer: white TGL,
handmade
Edition: 20
Proofs: 9AP, RTP, PPI, PPII, A

Papermaking by Steve Reeves, Tom Stri-
anese, and Marabeth Cohen; assembled
plate proofing and edition printing by
Rodney Konopaki, Bob Cross, and Reeves;
screen preparation by Strianese; proofing
and edition printing by Strianese and
Cross; assembly and adhering of collage
elements by Konopaki, Cross, Reeves, and
Strianese

Signed *Alan Shields,* numbered, and dated
in pencil lower center; chop mark lower
center; workshop number AS85-869 lower
center verso

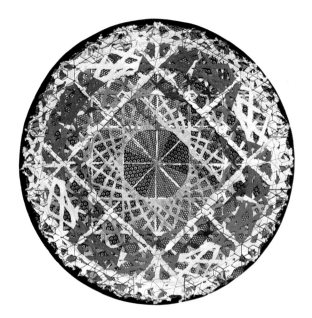

7 runs: 22 colors, including 2 white papers; 5 runs from 2 screens and 1 assembled plate made from 12 aluminum strips:

1 gold Glitterflex (on lattice-string paper); method 27 (TS); VI

2 purple Glitterflex and green Glitterflex; methods 27 (TS), 16e; IV

3 silver-blue Glitterflex and copper Glitterflex (paper turned 180°); methods 27 (same screen as run 2), 16e; IV

4 yellow, red, dark red, blue, turquoise blue, and green; methods 15b (strips), 16a; III

5 repeat of run 4 with paper turned 90° [runs 2–5 on white paper]

6 papers from runs 1–5; method 36c (colored thread)

7 silver, gold, and black Glitterflex elements from 515:AS38; method 36a (RK, BC, SR, TS); III

512:AS35

Alan Shields
Polar Route, from The Raggedy Circumnavigation Series 1985

Relief, screenprint, stitching, collage (48)
47 (119.4) diameter
Paper: top layer–4th layer: white lattice-string TGL, handmade; bottom layer: blue and white TGL, handmade
Edition: 20
Proofs: 8AP, RTP, PPI, PPII, A

Papermaking by Steve Reeves, Tom Strianese, and Marabeth Cohen; aluminum strips proofing and edition printing by Rodney Konopaki; Bob Cross, and Reeves; screen preparation by Strianese; proofing and edition printing of screen and plastic grids by Cross and Strianese; oak plank proofing and edition printing by Konopaki, Cross, and Reeves; assembly of collage elements by Konopaki, Cross, Reeves, and Strianese

Signed *Alan Shields*, numbered, and dated in pencil lower center; chop mark lower center; workshop number AS85-870 lower center verso

10 runs: 48 colors, including 4 white papers and 1 colored paper; 9 runs from 1 screen, 1 assembled plate made from 4 plastic hexagonal grids, 1 assembled plate made from 24 aluminum strips, 1 assembled plate made from 48 aluminum strips, 1 assembled plate made from 10 oak planks with drilled holes, and 1 assembled plate made from 4 metal circular grids and 1 Plexiglas plate:

1 dark purple, dark blue, dark turquoise blue, and black; methods 15b (hexagonal grids), 16a; III

2 orange; method 15b (same plate as run 1); III
[runs 1 and 2 on lattice-string paper]

3 green Glitterflex and copper Glitterflex; methods 27 (TS), 16e; VI

4 magenta Glitterflex and silver-blue Glitterflex; methods 27 (same screen as run 3), 16e; VI
[runs 3 and 4 on lattice-string paper]

5 yellow, red, dark red, light blue, ultramarine blue, and dark green; methods 15b (24 strips), 16a; III

6 yellow, red, dark red, light blue, ultramarine blue, and dark green (paper turned 90°); methods 15b (same plate as run 5), 16a; III
[runs 5 and 6 on lattice-string paper]

7 yellow, orange, vermilion, magenta, pink, purple, tan, green-brown, light blue, dark blue, turquoise blue, yellow-green, and gray; method 15b (48 strips); III
[run 7 on lattice-string paper]

8 yellow, orange, blue, metallic green, silver, and gold; methods 15b (planks), 16a; III

9 red-brown, dark blue, and brown-green; methods 15b (metal grids), 16a; III
[runs 8 and 9 on blue and white paper]

10 papers from runs 1–9; method 36c (colored thread)

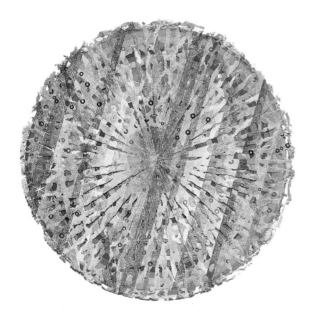

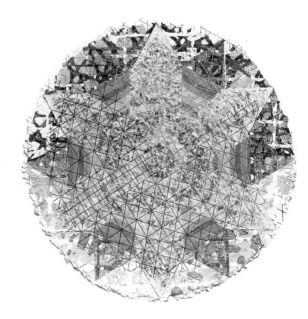

513:AS36

Alan Shields
Rain Dance Route, from The Raggedy
Circumnavigation Series 1985

Relief, woodcut, stitching, collage (46)
47 (119.4) diameter
Paper: top layer: white lattice-string TGL,
handmade; bottom layer: white TGL,
handmade, hand-colored
Edition: 20
Proofs: 10AP, TP, RTP, PPI, PPII, A

Papermaking by Steve Reeves, Tom Stri-
anese, and Marabeth Cohen; woodblock
preparation by Swan Engraving; proofing
and edition printing by Rodney Konopaki,
Bob Cross, and Reeves; assembly of collage
elements by Konopaki, Cross, Reeves, and
Strianese

Signed *Alan Shields,* numbered, and dated
in pencil lower center; chop mark lower
center; workshop number AS85-871 lower
center verso

6 runs: 6 pulp colors, 1 paper pressing; 38
ink colors and 2 white papers, 4 runs from
1 assembled plate made from 48 aluminum
strips, 1 assembled plate made from 24

concentric wood rings, and 1 assembled
plate made from metal washers:

1 yellow, orange, vermilion, magenta,
 pink, purple, tan, green-brown, light
 blue, dark blue, turquoise blue,
 yellow-green, and gray; methods 15b
 (strips), 16a; III
2 yellow, orange, vermilion, magenta,
 pink, purple, tan, green-brown, light
 blue, dark blue, turquoise blue,
 yellow-green, and gray; methods 15b
 (strips), 16a; III
 [runs 1 and 2 on lattice-string paper]
3 yellow, orange, red, blue, green, and
 brown pulps (on newly made white
 TGL paper); III
4 medium yellow, red, dark red, light
 blue, ultramarine blue, and dark green
 (on same paper as run 3); methods 15b
 (rings), 19c (birchwood), 16a; III
5 yellow, orange, dark red, blue, light
 green, and gold (simultaneously on
 lattice-string and hand-colored papers);
 methods 15b (washers), 16a; III
6 papers from runs 1–5; method 36c
 (colored thread)

514:AS37

Alan Shields
Uncle Ferdinand's Route, from The
Raggedy Circumnavigation Series 1985

Relief, screenprint, woodcut, collage (23)
47 (119.4) diameter
Paper: top layer: white kozo-fiber TGL,
handmade; middle layer: white lattice-
string TGL, handmade; bottom layer:
white grid-embossed TGL, handmade
Edition: 20
Proofs: 10AP, RTP, PPI, PPII, A

Papermaking by Steve Reeves, Tom Stri-
anese, and Marabeth Cohen; laser-cut
woodblock preparation by Swan
Engraving; proofing and edition printing by
Rodney Konopaki, Bob Cross, and Reeves;
hand-cut woodblock and screen prepara-
tion by Strianese; proofing and edition
printing by Reeves and Cross; adhering of
collage elements by Reeves and Cross

Signed *Alan Shields,* numbered, and dated
in pencil lower right quadrant; chop mark
lower center; workshop number AS85-872
lower center verso

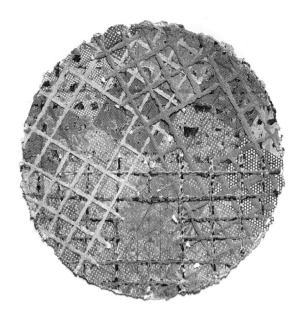

11 runs: 23 colors, including 3 white papers; 10 runs from 2 screens, 1 star-shaped woodblock, 1 assembled plate made from 24 concentric wood rings, 1 assembled plate made from 2 metal gratings, 1 assembled plate made from 4 plastic hexagonal grids, and 1 assembled plate made from 4 plastic irregular polygonal grids:

1. medium yellow, red, dark red, light blue, ultramarine blue, and dark green (on verso of kozo paper); method 34 (from 513:AS36, run 4); III
2. black Glitterflex; method 27 (TS); VI
3. silver Glitterflex; method 27 (TS); VI [runs 2 and 3 on lattice-string paper]
4. green Glitterflex and copper Glitterflex; methods 27 (TS), 16e; IV
5. magenta Glitterflex and turquoise blue Glitterflex (same screen as run 4); methods 27 (TS), 16e; VI
6. dark blue and dark green; method 15b (polygonal grids); III [runs 4–7 on embossed paper]
7. papers from runs 2–6; method 36a (SR, BC); III
8. magenta (on same papers as run 7); method 19b (star-shaped block); III
9. green (on same papers as run 8); method 19b (same block as run 8); III
10. paper from run 1; method 36a (SR, BC); III
11. medium yellow, ultramarine blue, green, and black; methods 15b (polygonal grids), 16; III [run 11 on papers from runs 1–10]

515:AS38

Alan Shields
Home Route, from The Raggedy Circumnavigation Series 1985

Relief, screenprint, stitching, collage (13)
47 (119.4) diameter
Paper: top layer: 3 sheets white lattice-string TGL, handmade; bottom layer: white and blue TGL, handmade
Edition: 20
Proofs: 8AP, RTP, PPI, PPII, A

Papermaking by Steve Reeves, Tom Strianese, and Marabeth Cohen; screen preparation by Strianese; proofing and edition printing by Strianese and Bob Cross; adhering and assembly of collage elements by Konopaki, Cross, Reeves, and Strianese

Signed *Alan Shields,* numbered, and dated in pencil lower center; chop mark lower center; workshop number AS85-873 lower center verso

9 runs: 13 colors, including 3 white papers and 1 colored paper; 7 runs from 2 screens, 1 assembled plate made from 16 metal grids, and 1 assembled plate made from 4 plastic hexagonal grids:

1. silver Glitterflex; method 27 (TS); VI
2. gold Glitterflex; method 27 (TS); VI
3. black Glitterflex; method 27 (TS); VI [runs 1–3 on lattice-string papers]
4. gold Glitterflex; method 27 (TS); VI
5. silver Glitterflex; method 27 (TS); VI
6. black Glitterflex; method 27 (TS); VI
7. magenta and blue; method 15b (metal grids); III
8. red; method 15b (hexagonal grids); III [runs 4–8 on blue and white paper]
9. papers from runs 1–8; methods 36a (RK, BC), 36c (colored thread); III

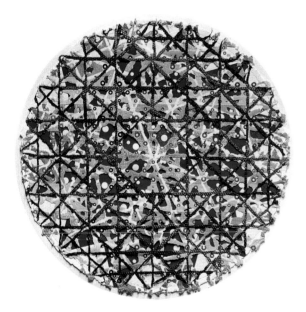

516:AS39

Alan Shields
Trade Route (Roman), from The Raggedy
Circumnavigation Series 1985

Relief, screenprint, woodcut, stitching,
collage (16)
47 (119.4) diameter
Paper: top layer: blue lattice-string TGL,
handmade; middle layer: white
lattice-string TGL, handmade; bottom
layer: white TGL, handmade
Edition: 20
Proofs: 8AP, RTP, PPI, PPII, A

Papermaking by Steve Reeves, Tom Stri-
anese, and Marabeth Cohen; woodblock
preparation, proofing, and edition printing
by Strianese; assembled plate proofing and
edition printing by Rodney Konopaki,
Reeves, Bob Cross, and Strianese; assembly
of collage material by Konopaki, Cross,
Reeves, and Strianese

Signed *Alan Shields*, numbered, and dated
in pencil lower center; chop mark lower
center; workshop number AS85-874 lower
center verso

5 runs: 16 colors, including 2 white papers
and 1 colored paper; 5 runs from 1
star-shaped woodblock, 1 assembled plate
made from 4 circular metal grids and 1
Plexiglas plate, 1 assembled plate made
from 10 oak planks with drilled holes, and
1 assembled plate made from metal
washers:
 1 red-brown, dark blue, and dark green
 (on blue paper); methods 15b (grids),
 16a; III
 2 green, brown-green, and silver (simul-
 taneously on blue and white
 lattice-string papers); methods 15b
 (planks), 16a; III
 3 yellow, orange, magenta, brown, dark
 blue, and light green (on white
 lattice-string paper); methods 15a
 (washers), 16a; III
 4 green (on white paper); method 19b
 (mahogany plywood); III
 5 papers from runs 1–4; method 36c
 (colored thread)

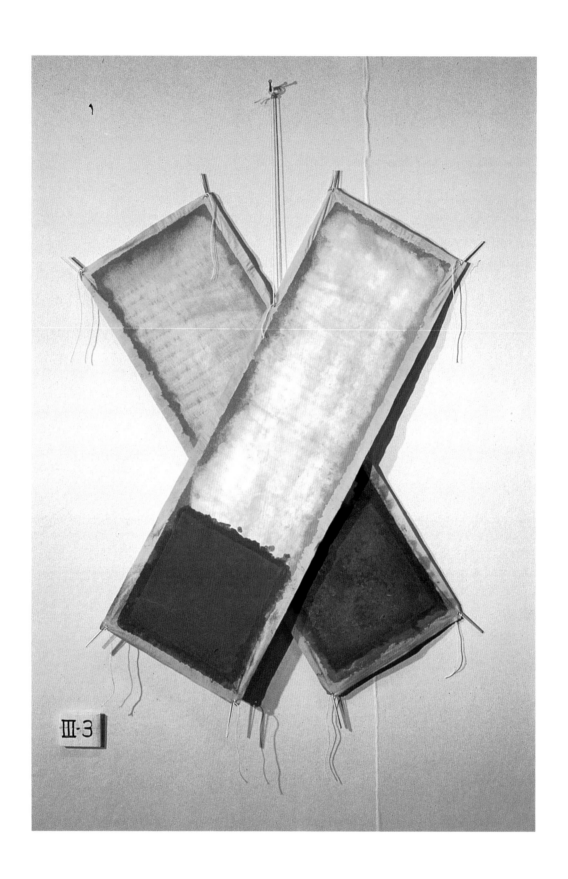

Cartouche III-3,
from the Cartouche Series 1980
See 519:RS33

Richard Smith

1931 Born in Letchworth, Hertfordshire, England

1948–50 Attends Luton School of Art, Bedfordshire, England

1950–52 Serves in Royal Air Force, Hong Kong

1952–54 Attends St. Albans School of Art, Hertfordshire, England

1954–57 Attends Royal College of Art, London

1957–58 Teaches at Hammersmith College of Art, London

1959 Receives Harkness Fellowship of the Commonwealth Fund for travel in the United States

1961 First solo exhibition at Green Gallery, New York

1961–63 Teaches at St. Martin's School of Art, London

1963 Completes first screenprint, *Philip Morris*, at Kelpra Studio, London, published by Institute of Contemporary Arts, London

1966 Receives the Mr. and Mrs. Robert C. Scull Award, thirty-third Venice Biennale

1967 Receives grand prize at ninth São Paulo Bienal

1970 Included in British Pavilion, thirty-fifth Venice Biennale

1971 Awarded Commander of the British Empire

1976 Receives first prize at fourth British International Print Biennial, Bradford Galleries and Museums, Bradford, England

1978 Solo exhibition at Hayden Gallery, Massachusetts Institute of Technology, Cambridge

1979 Solo exhibition at Walker Art Center, Minneapolis; sculpture commission for Atlanta Airport

1980 Completes Cartouche Series of unique paper-pulp-on-cloth wall hangings at Tyler Graphics; solo exhibition at Kornblee Gallery, New York; sculpture commission for Mobil Corporation, Dallas

1981 Completes Towers Series cast-paper constructions at Institute of Experimental Printmaking, San Francisco; completes lithographs at Derrière l'Etoile Studio, New York

1982 Completes Field and Streams intaglio print–lithograph series at Tyler Graphics; sculpture commission for IBM headquarters, Portsmouth, England

1984 Included in exhibition *Prints from Tyler Graphics* at Walker Art Center, Minneapolis

1985 Sculpture commission for Landmark Building, Orlando, Florida; completes intaglio print series based on the ballet *Wild Life* at Crown Point Press, Oakland

Currently lives and works in New York

CARTOUCHE SERIES

Cartouche I
Three-part vertical configuration:
15 works
Dimensions: 60 × 42 (152.4 × 106.7)
Each panel:
 Front: 19½ × 19½ (49.5 × 49.5)
 Center: 37 × 19½ (94 × 49.5)
 Back: 53 × 19½ (134.6 × 49.5)

Cartouche II
Three-part horizontal configuration:
15 works
Dimensions: 37 × 60 (94 × 152.4)
Each panel:
 Front: 19½ × 19½ (49.5 × 49.5)
 Center: 19½ × 37 (49.5 × 94)
 Back: 19½ × 53 (49.5 × 134.6)

Cartouche III
Cross configuration: 8 works
Dimensions: 60 × 50 (152.4 × 127)
Each panel: 53 × 16 (134.6 × 40.6)

Cartouche IV
Three-part long configuration: 4 works
Dimensions: 60 × 60 (152.4 × 152.4)
Each panel: 53 × 19½ (134.6 × 49.5)

Cartouche V
Two-part long configuration: 13 works
Dimensions: 60 × 60 (152.4 × 152.4)
Each panel: 53 × 17 (134.6 × 43.2)

Note: The overall dimensions may vary by as much as 15 inches (38 cm). Height precedes width.

Richard Smith's Cartouche Series, completed in 1980, is a group of fifty-five wall hangings, each made of two or three separate overlapping panels. Within the series there are five basic configurations for hanging the panels, each designated by a Roman numeral.

The same techniques were used to make each panel. First a base sheet of newly made white pulp was couched onto a felt. Then a wet layer of dyed cotton fabric was spread over the base sheet. Some of the fabric had been previously dyed and soaked in water prior to use, but most of the fabric layers were dyed and immediately placed on the base sheet, allowing the colors to bleed. A second sheet of pulp was couched onto the fabric in registration with the white base sheet. This sheet was made of colored pulps that were formed or poured on the wove mould. Smith also applied pulps and dyes freehand and made multiple couchings of small cotton-pulp and kozo-fiber sheets from simply constructed wire screen moulds. The fabric, dyes, and layers of pulp were pressed and dried.

During assembly the fabric was trimmed, and metal grommets were placed in the four corners of each panel. The panels were positioned in one of the five overlapping configurations, and a fifth grommet was added to each panel, with cotton twine and a plastic ring attached for hanging. Two anodized aluminum tubes were attached in an X configuration to the back of each panel with cotton twine tied to the corner grommets. The finished works were then hung on the wall and adjusted for their correct hanging position.

The paper used for the project was made by the artist in collaboration with Kenneth Tyler, Lindsay Green, and Steve Reeves. Also assisting the artist with the constructions were Tom Strianese, Duane Mitch, Kim Halliday, and Lee Funderburg. The front panel of each hanging is signed *R. Smith* in pencil on the lower edge. Each panel is identified by a Roman numeral designating the configuration, a variation number, and a chop mark in the lower corner on the verso.

Five works are documented in full here, and the remainder are documented in abbreviated form in the Appendix.

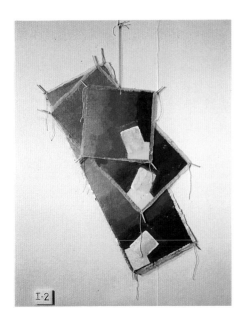

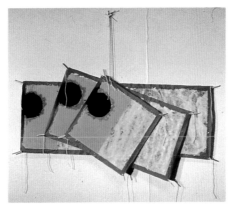

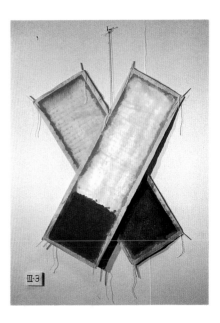

517:RS2

Richard Smith
Cartouche I-2, from the Cartouche
Series 1980

Colored, pressed paper pulp; fabric; grommets; string; aluminum tubes

Three panels: 60 × 42 (152.4 × 106.7);
panel 1: 19½ × 19½ (49.5 × 49.5);
panel 2: 37 × 19½ (94 × 49.5);
panel 3: 53 × 19½ (134.6 × 49.5)

Papermaking and general project assistance by Kenneth Tyler, Lindsay Green, and Steve Reeves

Signed *R. Smith* in pencil lower edge of front panel; configuration Roman numeral, variation number, and chop mark lower corner verso of each panel

Each panel formed with newly made white pulp base sheet; blue-dyed fabric stretched over base sheet; colored pulps and dyes poured into wove mould and couched onto fabric; yellow and light pink square cotton and Oriental pulp sheets couched onto previous layers; additional coloring with dyes and pulps freehand; panel pressed and dried; fabric trimmed; grommets attached to corners

For assembly: panels positioned in configuration; a fifth grommet added to each panel; twine and plastic ring added for hanging; two anodized aluminum tubes attached to each panel in an "X" configuration; panels hung on wall and adjusted for correct hanging position

518:RS24

Richard Smith
Cartouche II-9, from the Cartouche
Series 1980

Colored, pressed paper pulp; fabric; grommets; string; aluminum tubes

Three panels: 37 × 60 (94 × 152.4);
panel 1: 19½ × 19½ (49.5 × 49.5);
panel 2: 19½ × 37 (49.5 × 94);
panel 3: 19½ × 53 (49.5 × 134.6)

Papermaking and general project assistance by Kenneth Tyler, Lindsay Green, and Steve Reeves

Signed *R. Smith* in pencil lower edge of front panel; configuration Roman numeral, variation number, and chop mark lower corner verso of each panel

Each panel formed with newly made white pulp base sheet; red-dyed fabric stretched over base sheet; light orange pulp couched and colored pulps and dyes poured into wove mould and couched onto fabric; black circular cotton pulp sheets couched onto previous layers; additional coloring with dyes and pulps freehand; panel pressed and dried; fabric trimmed; grommets attached to corners

For assembly: panels positioned in configuration; a fifth grommet added to each panel; twine and plastic ring added for hanging; two anodized aluminum tubes attached to each panel in an "X" configuration; panels hung on wall and adjusted for correct hanging position

519:RS33

Richard Smith
Cartouche III-3, from the Cartouche
Series 1980

Colored, pressed paper pulp; grommets; string; aluminum tubes

Two panels: 60 × 50 (152.4 × 127);
each: 53 × 16 (134.6 × 40.6)

Papermaking and general project assistance by Kenneth Tyler; Lindsay Green, and Steve Reeves

Signed *R. Smith* in pencil lower edge of front panel; configuration Roman numeral, variation number, and chop mark lower corner verso of each panel

Each panel formed with newly made white pulp base sheet; light orange–dyed fabric stretched over base sheet; colored pulps and dyes poured into wove mould and couched onto fabric; dark gray square cotton and Oriental pulp sheets couched onto previous layers; additional coloring with dyes and pulps freehand; panel pressed and dried; fabric trimmed; grommets attached to corners

For assembly: panels positioned in configuration; a fifth grommet added to each panel; twine and plastic ring added for hanging; two anodized aluminum tubes attached to each panel in an "X" configuration; panels hung on wall and adjusted for correct hanging position

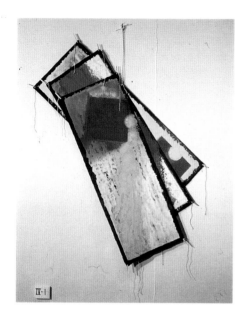

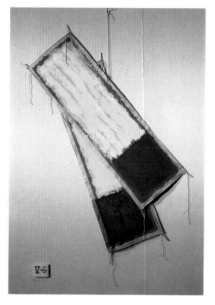

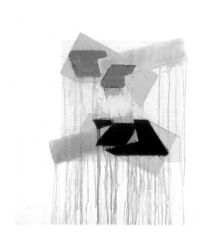

520:RS39

Richard Smith
Cartouche IV-1, from the Cartouche
Series 1980

Colored, pressed paper pulp; fabric; grommets; string; aluminum tubes

Three panels: 60 × 60 (152.4 × 152.4);
each: 53 × 19½ (134.6 × 49.5)

Papermaking and general project assistance
by Kenneth Tyler, Lindsay Green, and Steve
Reeves

Signed *R. Smith* in pencil lower edge of
front panel; configuration Roman numeral,
variation number, and chop mark lower
corner verso of each panel

Each panel formed with newly made white
pulp base sheet; dark gray–dyed fabric
stretched over base sheet; colored pulps and
dyes poured into wove mould and couched
onto fabric; various cotton and Oriental
pulp sheets couched onto previous layers;
additional coloring with dyes and pulps
freehand; panel pressed and dried; fabric
trimmed; grommets attached to corners

For assembly: panels positioned in configuration; a fifth grommet added to each
panel; twine and plastic ring added for
hanging; two anodized aluminum tubes
attached to each panel in an "X" configuration; panels hung on wall and adjusted
for correct hanging position

521:RS48

Richard Smith
Cartouche V-6, from the Cartouche
Series 1980

Colored, pressed paper pulp; fabric; grommets; string; aluminum tubes

Two panels: 60 × 60 (152.4 × 152.4);
each: 53 × 17 (134.6 × 43.2)

Papermaking and general project assistance
by Kenneth Tyler, Lindsay Green, and Steve
Reeves

Signed *R. Smith* in pencil lower edge of
front panel; configuration Roman numeral,
variation number, and chop mark lower
corner verso of each panel

Each panel formed with newly made white
pulp base sheet; light orange–dyed fabric
stretched over base sheet; colored pulps and
dyes poured into wove mould and couched
onto fabric; various cotton and Oriental
pulp sheets couched onto previous layers;
additional coloring with dyes and pulps
freehand; panel pressed and dried; fabric
trimmed; grommets attached to corners

For assembly: panels positioned in configuration; a fifth grommet added to each
panel; twine and plastic ring added for
hanging; two anodized aluminum tubes
attached to each panel in an "X" configuration; panels hung on wall and adjusted
for correct hanging position

522:RS56

Richard Smith
Ick, from the Field and Streams
Series 1982

Etching, aquatint, lithograph (8)	
30 × 22¼ (76.2 × 56.5)	
Paper: white Arches watercolor, mould-made	
Edition: 38	
Proofs: 12AP, 2TP, 3CTP, RTP, PPI, A, C	

Copper plate preparation, processing,
proofing, and edition printing by Rodney
Konopaki; aluminum plate preparation and
processing by Lee Funderburg; proofing
and edition printing by Roger Campbell
and Funderburg

Signed *R. Smith*, numbered, and dated in
pencil lower right; chop mark lower left;
workshop number RS81-610 lower right
verso

5 runs: 8 colors; 5 runs from 1 aluminum
plate and 4 copper plates:
1. tan; method 5b; IIa
2. red, light turquoise blue, and black; methods 8, 16a; IV
3. yellow; methods 6, 9 (RK), 10; IV
4. red and black; methods 6, 9 (RK), 16a, 10; IV
5. green; methods 9 (RK), 10; IV

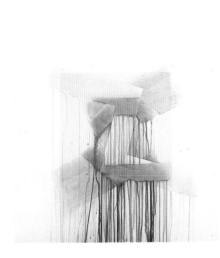

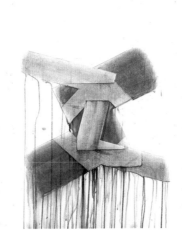

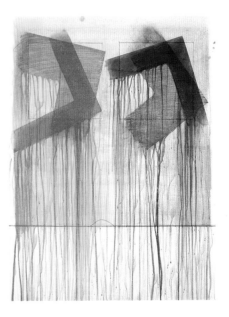

523:RS57

Richard Smith
Pix, from the Field and Streams
Series 1982

Aquatint, lithograph, drypoint (5)
30 × 22¼ (76.2 × 56.5)
Paper: white Arches Watercolor,
mould-made
Edition: 34
Proofs: 12AP, 4CTP, RTP, PPI, A, C

Copper plate preparation, processing,
proofing, and edition printing by Rodney
Konopaki; aluminum plate preparation and
processing by Lee Funderburg; proofing
and edition printing by Roger Campbell
and Funderburg

Signed *R. Smith*, numbered, and dated in
pencil lower right; chop mark lower left;
workshop number RS81-611 lower right
verso

5 runs: 5 colors; 5 runs from 4 copper
plates and 1 aluminum plate:
 1 light pink-tan; method 5b; IIa
 2 blue; methods 9 (RK), 10, 13; IV
 3 light blue; methods 9 (RK), 10; IV
 4 red; methods 9 (RK), 10; IV
 5 dark green; methods 9 (RK), 10; IV

524:RS58

Richard Smith
Pix, State I, from the Field and Streams
Series 1982

Aquatint, drypoint (2)
30 × 22¼ (76.2 × 56.5)
Paper: white Arches Watercolor,
mould-made
Edition: 20
Proofs: 9AP, 3CTP, RTP, PPI, A, C

Plate preparation, processing, proofing, and
edition printing by Rodney Konopaki

Signed *R. Smith*, numbered, and dated in
pencil lower right; chop mark lower left;
workshop number RS81-611A lower right
verso

2 runs: 2 colors; 2 runs from 2 copper
plates:
 1 black; methods 9 (RK), 10, 13; IV
 2 black; methods 9 (RK), 10, 13; IV

525:RS59

Richard Smith
Double Meadow, from the Field and
Streams Series 1982

Aquatint, etching, lithograph (7)
30 × 22¼ (76.2 × 56.5)
Paper: white Arches Watercolor,
mould-made
Edition: 44
Proofs: 12AP, 4TP, 2CTP, RTP, PPI, A, C

Copper plate preparation, processing,
proofing, and edition printing by Rodney
Konopaki; aluminum plate preparation and
processing by Lee Funderburg; proofing
and edition printing by Roger Campbell
and Funderburg

Signed *R. Smith*, numbered, and dated in
pencil lower right; chop mark lower left;
workshop number RS81-612 lower right
verso

5 runs: 7 colors; 5 runs from 4 copper
plates and 1 aluminum plate:
 1 tan; method 5b; IIa
 2 red; method 8; IV
 3 light red; methods 9 (RK), 10; IV
 4 red and ultramarine blue; methods 8, 9
 (RK), 10, 16a; IV
 5 orange and turquoise blue; methods 9
 (RK), 10, 16a; IV

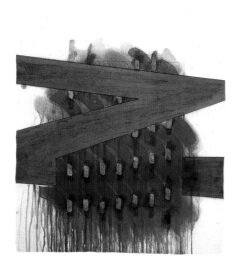

526:RS60

Richard Smith
Ouse, from the Field and Streams Series
1982

Aquatint, etching, lithograph (5)	
30 × 22¼ (76.2 × 56.5)	
Paper: white Arches Watercolor, mould-made	
Edition: 44	
Proofs: 12AP, TP, SP, RTP, PPI, A, C	

Copper plate preparation and processing by
Rodney Konopaki; proofing and edition
printing by Konopaki and Bob Cross;
aluminum plate preparation and processing
by Lee Funderburg; proofing and edition
printing by Roger Campbell and
Funderburg

Signed *R. Smith*, numbered, and dated in
pencil lower right; chop mark lower left;
workshop number RS81-613 lower right
verso

5 runs: 5 colors; 5 runs from 4 copper
plates and 1 aluminum plate:
 1 tan; method 5b; IIa
 2 gray; methods 8, 9 (RK), 10; IV
 3 red-violet; methods 6, 9 (RK), 10; IV
 4 turquoise blue; methods 6, 9 (RK), 10; IV
 5 ultramarine blue; methods 6, 9 (RK), 10; IV

527:RS61

Richard Smith
Cam, from the Field and Streams Series
1982

Aquatint, etching, lithograph (5)	
30 × 22¼ (76.2 × 56.5)	
Paper: white Arches Watercolor, mould-made	
Edition: 34	
Proofs: 12AP, 4TP, RTP, PPI, A, C	

Copper plate preparation, processing,
proofing, and edition printing by Rodney
Konopaki; aluminum plate preparation and
processing by Lee Funderburg; proofing
and edition printing by Roger Campbell
and Funderburg

Signed *R. Smith*, numbered, and dated in
pencil lower right; chop mark lower left;
workshop number RS81-614 lower right
verso

5 runs: 5 colors; 5 runs from 1 aluminum
plate and 4 copper plates:
 1 tan; method 5b; IIa
 2 copper-brown; methods 9 (RK), 10; IV
 3 red; methods 9 (RK), 10; IV
 4 red-brown; methods 8, 9 (RK), 10; IV
 5 yellow; method 8; IV

528:RS62

Richard Smith
Hiz, from the Field and Streams Series
1982

Aquatint, etching, lithograph (5)	
30 × 22¼ (76.2 × 56.5)	
Paper: white Arches Watercolor, mould-made	
Edition: 27	
Proofs: 10AP, TP, 2CTP, RTP, PPI, A, C	

Copper plate preparation, processing,
proofing, and edition printing by Rodney
Konopaki; aluminum plate preparation and
processing by Lee Funderburg; proofing
and edition printing by Roger Campbell
and Funderburg

Signed *R. Smith*, numbered, and dated in
pencil lower right; chop mark lower left;
workshop number RS81-615 lower right
verso

5 runs: 5 colors; 5 runs from 1 aluminum
plate and 4 copper plates:
 1 transparent red; method 5b; IIa
 2 green; methods 9 (RK), 10; IV
 3 magenta; methods 9 (RK), 10; IV
 4 gray; method 8; IV
 5 black; method 8; IV

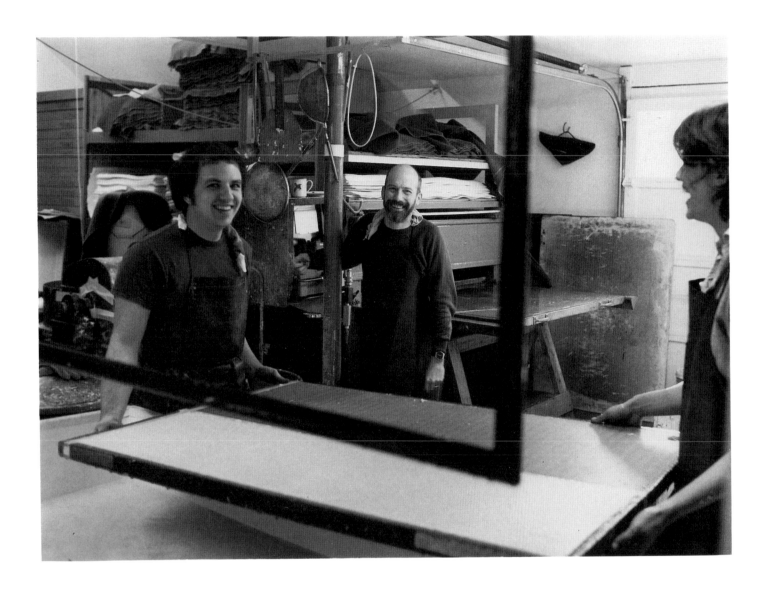

Steve Reeves, Richard Smith, and Lindsay
Green in the Tyler Graphics paper mill
pulling sheets for the Cartouche Series,
1980.

Psyche: The Blue Martin 1985
See 529:TS1 (opposite)

T. L. Solien

529:TS1

T. L. Solien
Psyche: The Blue Martin 1985

Woodcut, aquatint, etching (23)
23 × 23 (58.4 × 58.4)
Paper: white TGL, handmade,
hand-colored
Edition: 50
Proofs: 16AP, 8PP, WP, RTP, PPI, PPII,
PPIII, 2HC, A, C

Papermaking by Steve Reeves; plate preparation and processing by Rodney Konopaki; proofing and edition printing by Konopaki and Bob Cross; proofing and edition printing of woodblocks by Reeves, Tom Strianese, Konopaki, and Cross

Signed *TL Solien*, numbered, and dated in pencil lower edge; chop mark lower right; workshop number TS85-860 lower left verso

8 runs: 3 dye colors, 1 paper pressing; 20 ink colors; 8 runs from 3 woodblocks and 4 copper plates:
1 dark yellow, red-brown, and gray dyes (on newly made white pulp base sheet); III
2 red-brown; method 6; IV
3 yellow, red-ocher, and black; methods 9 (RK), 10, 16a; IV
4 orange-yellow, red-ocher, and blue; methods 9 (RK), 10, 16a; IV
5 orange, red, purple, turquoise blue, and black; methods 19a (plywood), 16a; III
6 black; methods 6, 9 (RK); IV
7 yellow, red-brown, dark brown, and blue; methods 19a (plywood), 16a; III
8 yellow, red-brown, and gray; methods 19a (plywood), 16a; III

This edition was printed specially for Walker Art Center.

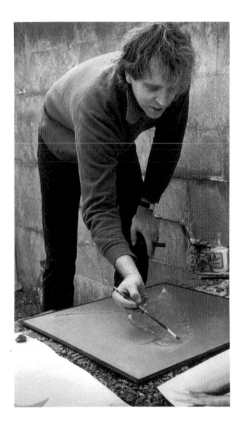

1983 Included in biennial exhibition, Whitney Museum of American Art, New York; designs set and costumes for *The Mirror*, by Leigh Dillard, performed by New Dance Ensemble, Walker Art Center, Minneapolis

1984 Included in exhibition *Images and Impressions* at Walker Art Center, Minneapolis

1985 Included in thirty-ninth biennial exhibition, Corcoran Gallery of Art, Washington, D.C.; completes intaglio-woodcut print at Tyler Graphics, commissioned by Walker Art Center, Minneapolis

Currently lives and works in Pelican Rapids, Minnesota

1949 Born in Fargo, North Dakota

1973 Receives B.A. in art from Moorhead State University, Moorhead, Minnesota

1977 Receives M.F.A. from University of Nebraska, Lincoln

1980 First solo exhibition at Fort Worth Art Center, Fort Worth, Texas

1981 Receives Jerome Foundation and Bush Foundation grants

1982 Completes Fragments of Hope, a portfolio of drypoints, at Vermillion Editions Limited, Minneapolis; receives Rockefeller Foundation Studio Fellowship, Paris

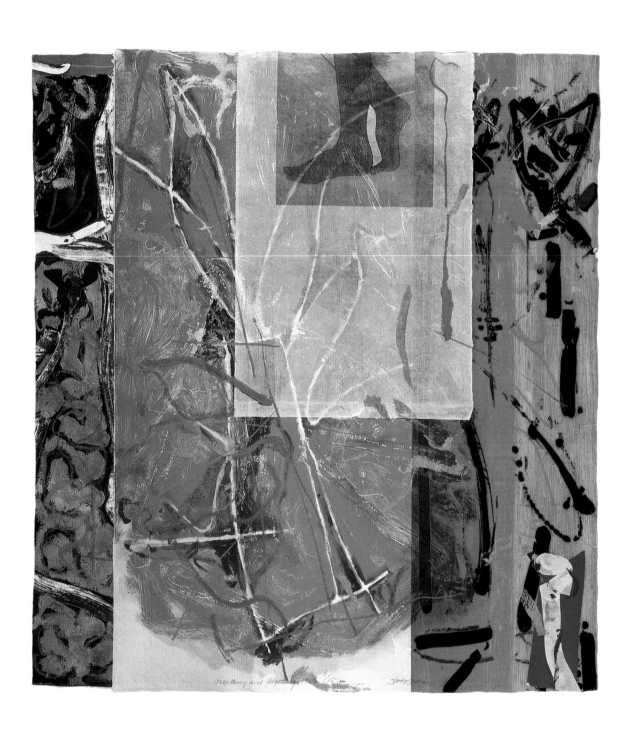

Forgetting and Forgetting 1985
See 539:SS23

Steven Sorman

1948 Born in Minneapolis

1971 Receives B.F.A. from University of Minnesota, Minneapolis

1972–74 Works as a gallery assistant at Dayton's Gallery 12, Minneapolis

1972–76 Makes first relief prints at his studio

1974–79 Teaches at Minneapolis College of Art and Design

1975 Included in thirty-fourth biennial exhibition, Corcoran Gallery of Art, Washington, D.C.; first solo exhibition at Fendrick Gallery, Washington, D.C

1977 Completes mixed-media print series at Vermillion Editions Limited, Minneapolis

1978 Completes print *Spaces between Words a Deaf Man Sees* at Vermillion Editions Limited, Minneapolis, which receives merit award in the 1980 exhibition *World Print II*, organized by World Print Council, San Francisco

1979 Receives Minnesota State Arts Board and Bush Foundation grants

1981 Moves to Marine on St. Croix, Minnesota; completes group of lithographs, some with collage, at Tamarind Institute, Albuquerque, New Mexico

1982 Receives Rockefeller Foundation Studio Fellowship, Paris; completes mixed-media prints at Echo Press, Bloomington, Indiana; completes mixed-media print *What's This What's That* at Vermillion Editions Limited, Minneapolis

1984 Completes first group of mixed-media collage monoprints at Tyler Graphics; included in exhibition *Prints from Tyler Graphics* at Walker Art Center, Minneapolis; included in eighth British International Print Biennial, Bradford Galleries and Museums, Bradford, England

1985 Completes second group of mixed-media collage monoprints and first mixed-media collage edition prints at Tyler Graphics; included in exhibition *Ken Tyler: Printer Extraordinary* at Australian National Gallery, Canberra

Currently lives and works in Marine on St. Croix, Minnesota

MONOPRINT COLLAGE SERIES

The fourteen unique collages completed by Steven Sorman in 1984 were assembled from monoprint impressions and painted materials that the artist prepared in his studio and brought to the workshop. For the impressions Sorman painted lithographic inks on a polished magnesium plate and on carved woodblocks, etched magnesium plates, and etched copper plates. He hand-colored many of the works with acrylic paints and Paintstiks.

Assisting in the preparation of printing elements, the printing, and the adhering of papers were Kenneth Tyler, Steve Reeves, Tom Strianese, Rodney Konopaki, Bob Cross, Roger Campbell, and Lee Funderburg. Each work is signed *Steven Sorman*, dated, and titled in pencil lower edge (the exact location in each work varies), with the chop mark lower right.

530:SS2

Steven Sorman
Outside the House (Inside the Yard) 1984

Monoprint, collage, hand-colored
71⅝ × 32¼ (182 × 81.9)
Paper: white TGL, handmade; Oriental paper; painted sheer drapery fabric (with gold leaf) from the artist's studio

Papermaking by Steve Reeves and Tom Strianese; magnesium plate preparation by Kenneth Tyler, with processing by Swan Engraving; preparation of printing elements, printing, and adhering of papers by Tyler, Reeves, Strianese, Rodney Konopaki, Bob Cross, Roger Campbell, and Lee Funderburg

Signed *Steven Sorman*, titled, and dated in pencil center right; chop mark lower right.

The etched plate was wiped by the artist and printed on white TGL paper by Konopaki using an etching press. Before and after printing, the artist hand-colored the collage elements with lithographic and etching inks and Paintstiks.

EDITION AND MONOPRINT COLLAGE SERIES

The nine editioned and twenty unique monoprint collages completed by Steven Sorman in 1985 were assembled from impressions made on Oriental and Western papers and materials the artist prepared in his studio and brought to the workshop. He created his print imagery using found architectural wood ornaments and drawn copper, magnesium, and aluminum plates.

Sorman layered papers, contrasting shades of white and off-white, natural, and yellow-ocher. His compositions involve a complex range of tones and colors that result from collaged papers, printed inks, and painted or drawn areas.

531:SS15

Steven Sorman
In Residence (In the United States) 1985

Woodcut, relief, lithograph, etching, collage (17)
56¾ × 46 (144.1 × 116.8)
Paper: white Ise Dosa, handmade; white Wakasa Dosa, handmade; natural Mitsumata, handmade; white Suzuki, handmade; natural Torinoko, handmade
Edition: 28
Proofs: 10AP, RTP, PPI, PPII, A

Papermaking by Steve Reeves and Tom Strianese; woodblock proofing and edition printing by Roger Campbell and Lee Funderburg; copper plate preparation and processing by Rodney Konopaki; proofing and edition printing by Konopaki and Bob

Cross; magnesium plate preparation by Kenneth Tyler, with processing by Swan Engraving; proofing and edition printing by Konopaki and Cross; prep work for continuous-tone lithography by Tyler; aluminum plate preparation and processing by Funderburg; proofing and edition printing by Campbell and Funderburg; preparation and adhering of collage elements by Reeves and Strianese

Signed *Steven Sorman*, numbered, dated, and titled in pencil lower right; chop mark lower right; workshop number SS84-777 lower left verso

8 runs: 17 colors, including 7 white and natural papers; 7 runs from 2 woodblocks, 2 copper plates, 2 magnesium plates, and 2 aluminum plates:

1. blue and blue-black (on 2 sheets Ise Dosa paper); methods 19a (poplar wood), 16a; III
2. red (on Wakasa Dosa paper); method 19a (fir plywood); III
 [printed paper from run 2 cut]
3. dark gray and black (on Mitsumata paper); methods 6, 16a (2 plates printed simultaneously); III
4. red and blue-black (on Suzuki and Torinoko papers); method 34 (from 537:SS21, run 1); III
5. red (on Suzuki paper from run 4); method 5a (LF); IIa
6. light blue (on same paper as run 5); method 5a (LF); IIa
7. printed papers from runs 1–6; method 36a (SR, TS); III
8. red; methods 21a, 23b; III

532:SS16

Steven Sorman
Years and When 1985

Woodcut, relief, etching, lithograph, collage (12)

58 × 38 (147.3 × 96.5)
Paper: white Arches Cover, mould-made; white Mulberry, handmade; white Masa Dosa, machine-made; natural Torinoko, machine-made; white Oriental, handmade
Edition: 28
Proofs: 12AP, TP, RTP, PPI, PPII, A

Woodblock proofing and edition printing by Steve Reeves and Tom Strianese; prep work for continuous-tone lithography by Kenneth Tyler; aluminum plate preparation and processing by Lee Funderburg; proofing and edition printing by Roger Campbell and Funderburg; magnesium plate preparation by Tyler, with processing by Swan Engraving; proofing and edition printing by Reeves and Strianese; copper plate preparation and processing by Rodney Konopaki; proofing and edition printing by Konopaki and Bob Cross; preparation and adhering of collage elements by Reeves and Strianese

Signed *Steven Sorman*, numbered, dated, and titled in pencil lower right; chop mark lower right; workshop number SS84-781 lower left verso

7 runs: 12 colors, including 5 white and natural papers; 6 runs from 2 woodblocks, 1 aluminum plate, 1 copper plate, and 2 magnesium plates:

1. red (on Mulberry paper); method 19b (fir plywood); III
2. light blue (on 2 sheets Masa Dosa paper); method 5a (LF); IIa
3. dark blue and blue-black (on same paper as run 2); methods 19a (poplar wood), 16a; III
4. red-orange (on Torinoko paper); methods 20, 23a; III
5. yellow-orange (on same paper as run 4); methods 20, 23a; III
6. blue-black (on Oriental paper); method 6; IV
7. printed papers from runs 1–6; method 36a (SR, TS); III

533:SS17

Steven Sorman
Trees Blowing and Blowing like Arms Akimbo 1985

Woodcut, etching, relief, lithograph, collage, hand-colored (23)
59 × 37 (149.9 × 94)
Paper: white TGL, handmade; painted Shibugami paper from the artist's studio; white Ise Dosa, handmade; white Mulberry, handmade; white Pur Charve Nacre, handmade
Edition: 42
Proofs: 12AP, TP, RTP, PPI, PPII, A

Papermaking by Steve Reeves and Tom Strianese; woodblock proofing and edition printing by Roger Campbell, Reeves, and Strianese; copper plate preparation and processing by Rodney Konopaki; proofing and edition printing by Konopaki and Bob Cross; magnesium plate preparation by Kenneth Tyler, with processing by Swan Engraving; proofing and edition printing by Strianese; prep work for continuous-tone lithography by Tyler; aluminum plate preparation and processing by Lee Funderburg; proofing and edition printing by Campbell and Funderburg; preparation and adhering of collage elements by Reeves and Strianese

Signed *Steven Sorman*, numbered, dated, and titled in pencil lower right; chop mark lower right; workshop number SS84-792 lower left verso

8 runs: 20 colors, including 8 white papers and painted materials from the artist's studio; 7 runs from 4 woodblocks, 1 copper plate, 1 magnesium plate, and 1 aluminum plate:
1 dark purple and dark blue (on white TGL paper); methods 19b (basswood), 16a; III
 [printed paper from run 1 cut]
2 green (on Ise Dosa paper); method 6; IV
3 white; methods 20, 23a; III
4 light blue (on Mulberry paper); method 5a (LF); IIa
 [printed paper from run 4 cut]
5 red (on Mulberry paper); method 19b (fir plywood); III
 [printed paper from run 5 cut]
6 red (on Nacre paper); method 19b (same block as run 5); III
7 printed papers from runs 1–6 and materials prepared by artist in his studio (blue and gold painted paper and sheer drapery fabric painted with light green Liquitex medium with gold leaf applied); method 36a (SR, TS); III
8 yellow-ocher; method 19a (2 redwood blocks); III

After printing and collaging, the artist hand-colored each print with blue and black acrylic paints and green Paintstik.

534:SS18

Steven Sorman
Still Standing Still 1985

Relief, etching, woodcut, lithograph, collage, hand-colored (23)
66¼ × 43 (168.3 × 109.2)
Paper: light yellow-ocher TGL, handmade; white Masa Dosa, machine-made; white Mulberry, handmade; painted Shibugami papers from the artist's studio
Edition: 20
Proofs: 9AP, TP, RTP, PPI, A

Papermaking by Steve Reeves and Tom Strianese; magnesium plate preparation by Kenneth Tyler, with processing by Swan Engraving; proofing and edition printing by Reeves, Strianese, and Rodney Konopaki; prep work for continuous-tone lithography by Tyler; aluminum plate preparation and processing by Lee Funderburg; proofing and edition printing by Roger Campbell and Funderburg; woodblock proofing and edition printing by Reeves and Strianese; preparation and adhering of collage elements by Reeves and Strianese

Signed *Steven Sorman*, numbered, dated, and titled in pencil lower right; chop mark lower right; workshop number SS84-773 lower left verso

10 runs: 18 colors, including 5 white and colored papers and painted materials from the artist's studio; 7 runs from 5 magnesium plates, 1 aluminum plate, and 1 woodblock:

1 red and blue-black (on yellow-ocher paper); methods 20, 23c, 16a; III

2 printed area of paper from run 1 cut down middle; method 36a (SR, TS); III

3 dark red and turquoise green (on paper from runs 1 and 2); methods 20, 23c, 16a; III

4 light orange-pink (on Masa Dosa paper); methods 20, 23a; III

5 transparent orange (on same paper as run 4); methods 20, 23a; III

6 printed paper from runs 4 and 5; method 36b (TS); III

7 dark blue; methods 20, 23a; III

8 transparent pale blue; method 5a (LF); IIa

9 black (on Mulberry paper); method 19a (fir plywood); III
[printed paper from run 9 torn]

10 printed papers from runs 1–9 and 2 blue and gold painted Shibugami papers; method 36a (SR, TS); III

After printing and collaging, the artist hand-colored each print with pale yellow and light blue acrylic paints and white, black, and gold Paintstiks.

535:SS19

Steven Sorman
Trees like Men Walking 1985

Relief, woodcut, etching, collage, hand-colored (18)

93½ × 40½ (237.5 × 102.2)

Paper: white TGL, handmade; light yellow-ocher TGL, handmade; white Pur Charve Nacre, handmade; natural Nepal, handmade

Edition: 10

Proofs: 4AP, TP, RTP, PPI, PPII, A

Papermaking by Steve Reeves and Tom Strianese; woodblock proofing and edition printing by Roger Campbell; magnesium plate preparation by Kenneth Tyler, with processing by Swan Engraving; proofing and edition printing by Rodney Konopaki, Bob Cross, and Reeves; copper plate preparation and processing by Konopaki; proofing and edition printing by Konopaki and Cross; preparation and adhering of collage elements by Reeves

Signed *Steven Sorman*, numbered, dated, and titled in pencil lower center; chop mark lower right; workshop number SS84-778 lower left verso

8 runs: 15 colors, including 6 white and colored papers; 7 runs from 1 woodblock, 1 wood architectural ornament, 1 copper plate, and 4 magnesium plates:

1 dark blue (on white TGL paper); method 19a (basswood); III

2 blue and black (on Nacre paper); methods 19a (architectural ornament), 16a; III

3 red-brown (on white paper); methods 20, 23a; III

4 transparent light blue (on same paper as run 3); methods 20, 23a; III

5 white (on same paper as run 3); methods 20, 23a; III

6 red-brown and black (on natural paper); methods 6, 16a; IV

7 red (on torn yellow-ocher paper); methods 20, 23a; III

8 printed papers from runs 1–7 and unprinted yellow-ocher paper; method 36a (SR); III

After printing and collaging, the artist hand-colored each print with red acrylic paint and red and green Paintstiks.

536:SS20

Steven Sorman
This: Stand within Feet 1985

Woodcut, relief, etching, collage,
hand-colored (15)

66¼ × 49¼ (168.3 × 125.1)

Paper: white TGL, handmade; natural
Torinoko, handmade; white Unryu, hand-
made; white Chochin, handmade

Edition: 18

Proofs: 17AP, TP, RTP, PPI, PPII, A

Papermaking by Steve Reeves and Tom Stri-
anese; woodblock proofing and edition
printing by Reeves, Strianese, and Lee
Funderburg; magnesium plate preparation
by Kenneth Tyler, with processing by Swan
Engraving; proofing and edition printing by
Reeves, Strianese, and Funderburg; copper
plate preparation by Konopaki; proofing
and edition printing by Bob Cross; prepa-
ration and adhering of collage elements by
Strianese

Signed *Steven Sorman*, numbered, dated,
and titled in pencil lower center; chop mark
lower right; workshop number SS84-779
lower left verso

9 runs: 13 colors, including 3 white papers
and 1 natural paper; 8 runs from 3 wood-
blocks, 1 copper plate, and 4 magnesium
plates:

1 dark blue (on TGL paper); method 19a
(2 teakwood blocks); III
2 transparent pink (on same paper as run
1); methods 20, 23a; III
3 red (on Torinoko paper); method 19b
(fir plywood); III
4 light blue (on same paper as run 3);
methods 20, 23a; III
5 transparent orange-pink (on same
paper as run 3); methods 20, 23a; III
6 blue-black (on Unryu paper); method
19a (poplar wood); III
7 brown-red and black (on Chochin
paper); methods 6, 16a; IV
8 printed papers from runs 1–7; method
36b (TS); III
9 black; methods 20, 23b; III

After printing and collaging, the artist
hand-colored each print with light
yellow-ocher and white acrylic paints.

537:SS21

Steven Sorman
*I Am Looking at You, I Am Looking at
You* 1985

Relief, etching, lithograph, collage,
hand-colored (12)

66¼ × 43 (168.3 × 109.2)

Paper: light yellow-ocher TGL, handmade;
white Masa Dosa, machine-made

Edition: 10

Proofs: 6AP, TP, RTP, PPI, PPII, A

Papermaking by Steve Reeves and Tom Stri-
anese; magnesium plate preparation by
Kenneth Tyler, with processing by Swan
Engraving; proofing and edition printing by
Rodney Konopaki, Bob Cross, Reeves, and
Strianese; prep work for continuous-tone
lithography by Tyler; plate preparation and
processing by Lee Funderburg; proofing
and edition printing by Roger Campbell
and Funderburg; preparation and adhering
of collage elements by Reeves and Strianese

Signed *Steven Sorman*, numbered, dated,
and titled in pencil lower center; chop mark
lower right; workshop number SS84-786
lower left verso

9 runs: 11 colors, including 1 white paper and 2 colored papers; 7 runs from 2 aluminum plates and 5 magnesium plates:

1 red and blue-black (on yellow-ocher paper); methods 20, 23c, 16a; III
2 printed area of paper from run 1 cut down middle; method 36a (SR, TS); III
3 red-orange (on white paper); methods 20, 23a; III
4 yellow-orange (on same paper as run 3); methods 20, 23a; III
5 printed paper from runs 3 and 4; method 36b (TS); III
6 blue-green (on yellow-ocher paper); methods 20, 23b; III
7 blue; method 5a (LF); IIa
8 light blue; method 5a (LF); IIa
9 copper; methods 20, 23b; III

After printing and collaging, the artist hand-colored each print with red etching ink.

538:SS22

Steven Sorman
Now at First and When 1985

Woodcut, relief, etching, collage (12)	
66¼ × 52 (168.3 × 132.1)	
Paper: white TGL, handmade; light yellow-ocher TGL, handmade; white Sekishu, handmade; white Pur Charve Nacre, handmade; white Chochin, handmade	
Edition: 18	
Proofs: 6AP, TP, RTP, PPI, PPII, A	

Papermaking by Steve Reeves and Tom Strianese; woodblock proofing and edition printing by Roger Campbell, Reeves, and Strianese; magnesium plate preparation by Kenneth Tyler, with processing by Swan Engraving; proofing and edition printing by Rodney Konopaki and Bob Cross; copper plate preparation, processing, proofing, and edition printing by Konopaki; preparation and adhering of collage elements by Strianese

Signed *Steven Sorman*, numbered, dated, and titled in pencil lower center; chop mark lower right; workshop number SS84-789 lower left verso

6 runs: 12 colors, including 6 white and colored papers; 5 runs from 4 woodblocks, 2 wood architectural ornaments, 1 magnesium plate, and 1 copper plate:

1 dark blue (on white TGL paper); method 19a (2 teakwood blocks); III
2 dark green (on yellow-ocher paper); method 19a (2 redwood blocks); III
3 dark blue (on Sekishu paper); method 19a (architectural ornaments); III
4 black-purple (on Nacre paper); methods 20, 23a; III
5 red-brown and black (on Chochin paper); methods 6, 16a; IV
6 printed papers from runs 1–5; method 36b (TS); III

539:SS23

Steven Sorman
Forgetting and Forgetting 1985

Relief, etching, collage, hand-colored (22)
66¼ × 60¼ (168.3 × 153)
Paper: light yellow-ocher TGL, handmade;
white Suzuki, handmade; white TGL,
handmade; blue painted paper from the
artist's studio; white Oriental, handmade
Edition: 15
Proofs: 6AP, TP, RTP, PPI, PPII, A

Papermaking by Steve Reeves and Tom Stri-
anese; magnesium plate preparation by
Kenneth Tyler, with processing by Swan
Engraving; proofing and edition printing by
Rodney Konopaki, Bob Cross, and Reeves;
copper plate preparation, processing,
proofing, and edition printing by Konopaki;
preparation and adhering of collage
elements by Reeves and Strianese

Signed *Steven Sorman*, numbered, dated,
and titled in pencil lower center; chop mark
lower right; workshop number SS84-787
lower left verso

6 runs: 14 colors, including 1 paint color, 6
white and colored papers, and material
from the artist's studio; 4 runs from 1
copper plate and 3 magnesium plates:
 1 white Suzuki paper (on newly made
 yellow-ocher paper); method 35; III
 2 red and black; methods 20, 23c, 16a;
 III
 3 blue and green; methods 20, 16a
 (unique painting on plate by artist); III
 4 brown (on white TGL paper); methods
 20, 23b; III
 5 black (on Oriental paper); method 6;
 IV
 [gold paint applied to printed paper
 from run 5]
 6 printed papers from runs 1–5, blue
 painted paper, and Oriental paper;
 method 36a (SR, TS); III

After printing and collaging, the artist
hand-colored each print with red etching
ink; blue, green, pale gold, and gold acrylic
paints; and green, oxide green, and gold
Paintstiks.

540:SS30

Steven Sorman
After Whom Still after Whom 1985

Monoprint, relief, etching, woodcut,
collage, hand-colored
48 × 100¼ (121.9 × 254.6)
Paper: light yellow TGL, handmade; white
Oriental papers, handmade; painted sheer
drapery fabric from the artist's studio

Papermaking by Steve Reeves and Tom Stri-
anese; magnesium plate preparation by
Kenneth Tyler, with processing by Swan
Engraving; proofing and printing by
Rodney Konopaki, Bob Cross, and Reeves;
copper plate preparation and processing by
Konopaki; proofing and printing by Kono-
paki and Cross; woodblock proofing and
printing by Roger Campbell; preparation
and adhering of collage elements by Reeves
and Strianese

Signed *Steven Sorman*, numbered, dated,
and titled in pencil lower center; chop mark
lower right; workshop number SS84-784
lower left verso

19 runs: 15 ink colors, white and colored
papers, and painted material from the
artist's studio; 13 runs from 1 copper plate,
7 magnesium plates, and 1 woodblock:
 1 white Oriental paper (on light yellow
 paper); method 36a (SR, TS); III
 2 white; methods 20, 23a; III
 3 red-orange (on Oriental paper);
 method 20, 23a; III
 4 orange-pink (on same paper as run 3);
 methods 20, 23a; III

5 printed paper from runs 3 and 4 (on papers from run 1); method 36a (SR, TS); III

6 orange-pink; method 34 (from run 4); III

7 red and dark blue (on light yellow paper); methods 20, 23c, 16a; III

8 printed paper from run 7; method 36a (SR, TS); III

9 red-brown; methods 20, 23a; III

10 gray (on white paper); method 6; IV

11 light blue (on same paper as run 10); methods 20, 23a; III

12 printed paper from runs 10 and 11 torn; method 36a (SR, TS); III

13 red and dark blue; method 34 (from run 7); III

14 light blue; method 34 (from 535:SS19, run 4); III

15 light pink (on white paper); methods 20, 23a; III

16 dark blue (on same paper as run 15); method 19a (architectural ornament); III

17 dark blue (on white paper); method 34 (from run 16); III

18 printed papers from runs 15–17 cut; method 36a (SR, TS); III

19 printed and collaged papers from runs 1–18 (on sheer drapery fabric painted with light green Liquitex medium); method 36a (SR, TS); III

Before and after printing and collaging, the artist hand-colored the work with orange, red, blue, and gold acrylic paints and light blue, green, white, and black Paintstiks.

541:SS37

Steven Sorman
Before Is Was Will Be 1985

Monoprint, relief, etching, woodcut, collage, hand-colored

75½ × 52 (191.8 × 132.1)

Paper: white TGL, handmade; white and natural Oriental papers; painted Shibugami paper from the artist's studio

Papermaking by Steve Reeves and Tom Strianese; magnesium plate preparation by Kenneth Tyler, with processing by Swan Engraving; proofing and printing by Rodney Konopaki and Bob Cross; woodblock proofing and printing by Reeves and Strianese; preparation and adhering of collage elements by Reeves and Strianese

Signed *Steven Sorman*, numbered, dated, and titled in pencil lower right; chop mark lower right; workshop number SS84-795 lower left verso

10 runs: 9 ink colors, white and natural papers, and painted paper from the artist's studio; 9 runs from 5 magnesium plates, 1 wood architectural ornament, and 2 woodblocks:

1 yellow-ocher; methods 20, 23a; III

2 red (on white TGL paper); methods 20, 23a; III

3 green (on same paper as run 2); methods 20, 23a; III
[printed paper from runs 2 and 3 torn]

4 blue (on white Oriental paper); method 19a (architectural ornament); III

5 repeat of run 4

6 pink (on white paper); methods 20, 23c; III

7 green (on natural Oriental paper); methods 20, 23c; III

8 green (on white Oriental paper); method 19a (redwood); III
[printed paper from run 8 torn]

9 blue (on white paper); method 19a (poplar wood); III
[printed paper from run 9 cut]

10 printed papers from runs 1–9 and blue and gold painted paper; method 36b (TS); III

After printing and collaging, the artist hand-colored the work with yellow-ocher, red, blue, green, and gold acrylic paints and red and blue Paintstiks.

Talladega Three II,
from the Circuits Series 1982
See 559:FS18

Frank Stella

1936 Born in Malden, Massachusetts

1950–54 Studies painting at Phillips Academy, Andover, Massachusetts

1954–58 Attends Princeton University, Princeton, New Jersey, and receives B.A. in history; moves to New York

1956 Studies with painter Stephen Greene

1960 First solo exhibition at Leo Castelli Gallery, New York

1961 First solo exhibition in Europe at Galerie Lawrence, Paris, of paintings from the Benjamin Moore Series

1963 Artist-in-residence at Dartmouth College, Hanover, New Hampshire; teaches advanced painting

1967 Appointed artist-in-residence at University of California, Irvine, but does not teach because of refusal to sign state loyalty oath; meets Kenneth Tyler and completes first lithographs—Star of Persia Series and Black Series I and II—at Gemini G.E.L., Los Angeles

1968 Completes V Series lithographs at Gemini G.E.L., Los Angeles

1970 Solo exhibition *Frank Stella* at Museum of Modern Art, New York; completes Aluminum Series lithographs, Copper Series lithographs, and Stacks series of lithographs and screenprint at Gemini G.E.L., Los Angeles

1971 Completes Newfoundland Series lithographs and lithograph-screenprints, and Benjamin Moore Series lithographs at Gemini G.E.L., Los Angeles; included in exhibition *Technics and Creativity: Gemini G.E.L.* at Museum of Modern Art, New York

1972 Completes Purple Series lithographs and Race Track Series screenprints at Gemini G.E.L., Los Angeles

1972–73 Completes Multicolored Squares I and II, his first offset lithograph series, at Petersburg Press Ltd., London

1974 Completes Eccentric Polygons lithograph series at Gemini G.E.L., Los Angeles; begins to work at Swan Engraving Company on etched metal maquettes for the Brazilian Series paintings

1975 Completes Paper Relief Project series in collaboration with Kenneth Tyler of Tyler Graphics and John Koller of HMP paper mill

1977 Completes Exotic Bird Series offset lithograph–screenprints at Tyler Graphics; included in exhibition *Art Off the Picture Press* at Emily Lowe Gallery, Hofstra University, New York; completes Sinjerli Variations offset lithograph–screenprint series at Petersburg Press, New York

1979 Completes hand-colored screenprints at Tyler Graphics

1980 Works at Swan Engraving Company on Circuits Series metal reliefs and begins work at Tyler Graphics on first Circuits Series mixed-media prints; completes Polar Co-ordinates for Ronnie Peterson offset lithograph–screenprint series at Petersburg Press, New York

1981 Begins work on the Swan Engraving Series at Tyler Graphics; completes Sinjerli Variations Squared with Colored Grounds offset lithograph–screenprint series at Petersburg Press, New York

1982 Traveling exhibition *Frank Stella: Prints, 1967–1982*, originating at University of Michigan Museum of Art, Ann Arbor; completes Shards offset lithograph–screenprint series at Petersburg Press, New York

1982–86 Completes Circuits Series mixed-media prints and Swan Engraving relief-intaglio print series at Tyler Graphics.

1982–83 Artist-in-residence, American Academy of Arts and Letters, Rome

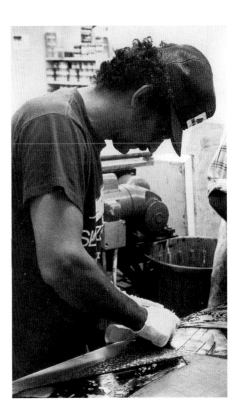

1983 Completes Playskool Series reliefs at Tyler Graphics

1983–84 Appointed Charles Eliot Norton Professor of Poetry, Harvard University, Cambridge, Massachusetts; presents lecture series entitled Working Space

1984 Included in exhibition *Prints from Tyler Graphics* at Walker Art Center, Minneapolis; included in exhibition *Gemini G.E.L.: Art and Collaboration* at National Gallery of Art, Washington, D.C.

1985 Included in exhibition *Ken Tyler: Printer Extraordinary* at Australian National Gallery, Canberra.

Currently lives and works in New York

PAPER RELIEF PROJECT

The Paper Reliefs are a series of six editioned paper-pulp reliefs with collage and hand-coloring, completed by Frank Stella in 1975. A special papermaking mould was constructed for each image from brass screening and mahogany slats sewn together with brass wire. The moulds were dipped into a cotton slurry to form a thick relief of pulp, which was hand-patted to improve edge definition. The pulp on the screen was colored both in the wet stage and after it was dried and removed from the mould.

Stella collaborated with Kenneth Tyler and John Koller at the HMP paper mill to develop a standard for each edition, although much of the coloring at the wet stage was done by the artist during frequent visits to HMP. All of the Paper Reliefs were hand-painted by the artist in his New York studio between September 1974 and November 1975.

542:FS1
Axsom IVA

Frank Stella
Grodno (I), from the Paper Relief Project
1975

Paper-pulp relief, collage, hand-colored (v)
26 × 21½ × 1¾ (66 × 54.6 × 4.4)
Paper: white HMP, handmade, hand-colored; colored HMP, handmade
Edition: 26
Proofs: 9TP, RTP, PPI, A

Relief mould constructed by Betty Fiske and Kim Tyler; first trials formed by John Koller and Kenneth Tyler; edition reliefs formed by John and Kathleen Koller at HMP

Signed *F. Stella* and dated in pencil lower right; numbered verso (I 1–26); chop mark lower right; workshop number FS75-208 lower left verso

The artist, assisted by John Koller and Kenneth Tyler, hand-colored the newly made pulp reliefs with pulps, dyes, and dry pigments and by applying small pieces of colored HMP paper. Once the reliefs were dry and removed from the moulds, the artist continued coloring them with acrylic, casein, watercolor, and metallic paints.

543:FS2
Axsom IVB

Frank Stella
Kozangrodek (II), from the Paper Relief Project 1975

Paper-pulp relief, collage, hand-colored (v)
26 × 21½ × 1¾ (66 × 54.6 × 4.4)
Paper: white HMP, handmade, hand-colored; colored HMP, handmade
Edition: 26
Proofs: 9TP, RTP, PPI, A

Relief mould constructed by Betty Fiske and Kim Tyler; first trials formed by John Koller and Kenneth Tyler; edition reliefs formed by John and Kathleen Koller at HMP

Signed *F. Stella* and dated in pencil lower right; numbered verso (II 1–26); chop mark lower right; workshop number FS75-211 lower left verso

The artist, assisted by John Koller and Kenneth Tyler, hand-colored the newly made pulp reliefs with pulps, dyes, and dry pigments and by applying small pieces of colored HMP paper. Once the reliefs were dry and removed from the moulds, the artist continued coloring them with acrylic, casein, watercolor, and metallic paints.

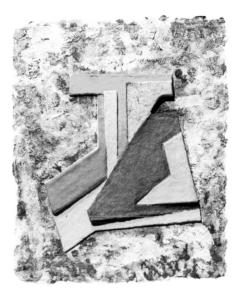

544:FS3
Axsom IVC

Frank Stella
Olyka (III), from the Paper Relief Project
1975

Paper-pulp relief, collage, hand-colored (v)
26 × 21½ × 1¾ (66 × 54.6 × 4.4)
Paper: white HMP, handmade,
hand-colored; colored HMP, handmade
Edition: 26
Proofs: 9TP, RTP, PPI, A

Relief mould constructed by Betty Fiske and
Kim Tyler; first trials formed by John Koller
and Kenneth Tyler; edition reliefs formed by
John and Kathleen Koller at HMP

Signed *F. Stella* and dated in pencil lower
right; numbered verso (III 1–26); chop
mark lower right; workshop number
FS75-207 lower left verso

The artist, assisted by John Koller and
Kenneth Tyler, hand-colored the newly
made pulp reliefs with pulps, dyes, and dry
pigments and by applying small pieces of
colored HMP paper. Once the reliefs were
dry and removed from the moulds, the
artist continued coloring them with acrylic,
casein, watercolor, and metallic paints.

545:FS4
Axsom IVD

Frank Stella
Nowe Miastro (IV), from the Paper Relief
Project 1975

Paper-pulp relief, collage, hand-colored (v)
26 × 21½ × 1¾ (66 × 54.6 × 4.4)
Paper: white HMP, handmade,
hand-colored; colored HMP, handmade
Edition: 26
Proofs: 9TP, RTP, PPI, A

Relief mould constructed by Betty Fiske and
Kim Tyler; first trials formed by John Koller
and Kenneth Tyler; edition reliefs formed by
John and Kathleen Koller at HMP

Signed *F. Stella* and dated in pencil lower
right; numbered verso (IV 1–26); chop
mark lower right; workshop number
FS75-210 lower left verso

The artist, assisted by John Koller and
Kenneth Tyler, hand-colored the newly
made pulp reliefs with pulps, dyes, and dry
pigments and by applying small pieces of
colored HMP paper. Once the reliefs were
dry and removed from the moulds, the
artist continued coloring them with acrylic,
casein, watercolor, and metallic paints.

546:FS5
Axsom IVE

Frank Stella
Lunna Wola (V), from the Paper Relief
Project 1975

Paper-pulp relief, collage, hand-colored (v)
26 × 21½ × 1¾ (66 × 54.6 × 4.4)
Paper: white HMP, handmade,
hand-colored; colored HMP, handmade
Edition: 26
Proofs: 14TP, RTP, PPI, A

Relief mould constructed by Betty Fiske and
Kim Tyler; first trials formed by John Koller
and Kenneth Tyler; edition reliefs formed by
John and Kathleen Koller at HMP

Signed *F. Stella* and dated in pencil lower
right; numbered verso (V 1–26); chop
mark lower right; workshop number
FS75-207 lower left verso

The artist, assisted by John Koller and
Kenneth Tyler, hand-colored the newly
made pulp reliefs with pulps, dyes, and dry
pigments and by applying small pieces of
colored HMP paper. Once the reliefs were
dry and removed from the moulds, the
artist continued coloring them with acrylic,
casein, watercolor, and metallic paints.

547:FS6
Axsom IVF

Frank Stella
Bogoria (VI), from the Paper Relief
Project 1975

Paper-pulp relief, collage, hand-colored (v)
22¼ × 29½ × 1¾ (56.5 × 74.9 × 4.4)
Paper: white HMP, handmade,
hand-colored; colored HMP, handmade
Edition: 8
Proofs: 9TP, RTP, PPI, A

Relief mould constructed by Betty Fiske;
first trials formed by John Koller and
Kenneth Tyler; edition reliefs formed by
John and Kathleen Koller at HMP

Signed *F. Stella*, dated, and numbered in
pencil verso (VI 1–8); chop mark lower
right

The artist, assisted by John Koller and
Kenneth Tyler, hand-colored the newly
made pulp reliefs with pulps, dyes, and dry
pigments and by applying small pieces of
colored HMP paper. Once the reliefs were
dry and removed from the moulds, the
artist continued coloring them with acrylic,
casein, watercolor, and metallic paints.

548:FS7
Axsom 107

Frank Stella
Eskimo Curlew, from the Exotic Bird
Series 1977

Lithograph, screenprint (34)
33⅞ × 45⅞ (86 × 116.5)
Paper: white Arches 88, mould-made
Edition: 50
Proofs: 14AP, 6TP, CTP, 2WP, RTP, PPI,
PPII, A, C

Stone and plate preparation and processing
by Kenneth Tyler; proofing and edition
printing by John Hutcheson; screen prepa-
ration, processing, proofing, and edition
printing by Kim Halliday

Signed *F. Stella*, numbered, and dated in
pencil lower right; chop mark lower right;
workshop number FS76-324 lower left
verso

34 runs: 34 colors; 34 runs from 15
aluminum plates, 1 stone, and 15 screens:
 1 gray; method 30a; VI
 2 red-brown; method 30a; VI
 3 silver; method 28 (KH); VI
 4 repeat of run 3
 5 silver; method 30a; VI
 6 repeat of run 5
 7 gold; method 28 (KH); VI
 8 yellow; method 28 (KH); VI
 9 turquoise blue; method 28 (KH); VI
10 orange; method 28 (KH); VI
11 red; method 28 (KH); VI
12 blue; method 28 (KH); VI
13 dark violet; method 28 (KH); VI
14 repeat of run 13
15 green; method 1a; IIa
16 light tan; method 1b; IIa
17 dark tan; method 1b; IIa
18 gray-green; method 1b; IIa
19 light blue; method 1b; IIa
20 blue-gray; method 1b; IIa
21 dark gray; method 1b; IIa
22 gray-green; method 1b; IIa
23 gold Glitterflex; method 30a; VI
24 medium brown; method 1b; IIa
25 brown; method 1b; IIa
26 transparent magenta; method 1b; IIa
27 transparent brown; method 28 (KH);
 VI
28 dark blue; method 1b; IIa
29 yellow-green; method 1b; IIa
30 white glaze; method 1b; IIa
31 blue; method 1b; IIa
32 red; method 30a; VI
33 magenta; method 1b; IIa
34 transparent green varnish; method 30a;
 VI

549:FS8
Axsom 108

Frank Stella
Puerto Rican Blue Pigeon, from the Exotic
Bird Series 1977

Lithograph, screenprint (51)
33⅞ × 45⅞ (86 × 116.5)
Paper: white Arches 88, mould-made
Edition: 50
Proofs: 14AP, 11CTP, WP, RTP, PPI, PPII,
A, C

Plate preparation and processing by
Kenneth Tyler; proofing and edition
printing by John Hutcheson; screen prepa-
ration, proofing, and edition printing by
Kim Halliday

Signed *F. Stella*, numbered, and dated in
pencil lower right; chop mark lower right;
workshop number FS76-325 lower left
verso

51 runs: 51 colors; 51 runs from 28
aluminum plates and 21 screens:
1 blue; method 30a; VI
2 red; method 30a; VI
3 white; method 28 (KH); VI
4 silver; method 28 (KH); VI
5 repeat of run 4
6 light blue; method 28 (KH); VI
7 turquoise blue; method 28 (KH); VI
8 purple; method 28 (KH); VI
9 blue; method 28 (KH); VI
10 light blue; method 1b; IIa
11 tan; method 28 (KH); VI
12 silver-gold; method 28 (KH); VI
13 gold; method 28 (KH); VI

14 repeat of run 13
15 medium blue; method 1b; IIa
16 blue-gray; method 1b; IIa
17 red-brown; method 1b; IIa
18 orange; method 28 (KH); VI
19 blue-green Glitterflex; method 30a; VI
20 medium brown; method 1b; IIa
21 copper Glitterflex; method 30a; VI
22 white; method 28 (KH); VI
23 dark brown; method 1b; IIa
24 yellow-green; method 1b; IIa
25 gold Glitterflex; method 30a; VI
26 blue-green; method 1b; IIa
27 green-yellow; method 1b; IIa
28 blue-gray; method 28 (KH); VI
29 magenta; method 28 (KH); VI
30 transparent gold; method 30a; VI
31 light tan; method 1b; IIa
32 light blue-purple; method 1b; IIa
33 transparent blue-violet; method 1b; IIa
34 yellow; method 30a; VI
35 light green; method 1b; IIa
36 green; method 1b; IIa
37 tan; method 1b; IIa
38 blue; method 1b; IIa
39 transparent gold; method 1b; IIa
40 medium yellow; method 1b; IIa
41 transparent pink; method 1b; IIa
42 transparent pink; method 1b; IIa
43 light pink; method 1b; IIa
44 red-pink; method 1b; IIa
45 red; method 1b; IIa
46 blue; method 1b; IIa
47 magenta; method 1b; IIa
48 yellow; method 1b; IIa
49 blue; method 1b; IIa
50 transparent red-pink; method 1b; IIa
51 clear varnish; method 30a; VI

550:FS9
Axsom 109

Frank Stella
Noguchi's Okinawa Woodpecker, from the
Exotic Bird Series 1977

Lithograph, screenprint (27)
33⅞ × 45⅞ (86 × 116.5)
Paper: white Arches 88, mould-made
Edition: 50
Proofs: 16AP, 4CTP, WP, RTP, PPI, PPII,
A, C

Plate preparation and processing by
Kenneth Tyler; proofing and edition
printing by John Hutcheson; screen prepa-
ration, proofing, and edition printing by
Kim Halliday

Signed *F. Stella*, numbered, and dated in
pencil lower right; chop mark lower right;
workshop number FS76-326 lower left
verso

27 runs: 27 colors; 27 runs from 15
aluminum plates and 11 screens:
1 pink; method 30a; VI
2 violet; method 30a; VI
3 white; method 28 (KH); VI
4 silver; method 28 (KH); VI
5 repeat of run 4
6 white; method 28 (KH); VI
7 white; method 28 (KH); VI
8 tan; method 28 (KH); VI
9 blue-gray; method 28 (KH); VI

10 magenta; method 28 (KH); VI
11 turquoise blue; method 28 (KH); VI
12 silver Glitterflex; method 30a; VI
13 transparent light tan; method 1b; IIa
14 light tan; method 1b; IIa
15 yellow-orange; method 1b; IIa
16 white; method 1b; IIa
17 blue; method 1b; IIa
18 blue; method 1b; IIa
19 magenta; method 1b; IIa
20 orange-yellow; method 1b; IIa
21 pink; method 1b; IIa
22 green; method 1b; IIa
23 light green; method 1b; IIa
24 yellow-green; method 1b; IIa
25 orange-yellow; method 1b; IIa
26 red; method 1b; IIa
27 brown; method 1b; IIa

551:FS10
Axsom 110

Frank Stella
Inaccessible Island Rail, from the Exotic
Bird Series 1977

Screenprint, lithograph (47)	
33⅞ × 45⅞ (86 × 116.5)	
Paper: white Arches 88, mould-made	
Edition: 50	
Proofs: 16AP, 4TP, 4CTP, 8WP, RTP, PPI, PPII, A, C	

Plate preparation and processing by
Kenneth Tyler; proofing and edition
printing by John Hutcheson; screen prepa-
ration, proofing, and edition printing by
Kim Halliday

Signed *F. Stella*, numbered, and dated in
pencil lower right; chop mark lower right;
workshop number FS76-327 lower left
verso

47 runs: 47 colors; 47 runs from 25
screens, 1 stone, and 20 aluminum plates:
 1 yellow-brown; method 30a; VI
 2 green; method 30a; VI
 3 white; method 28 (KH); VI
 4 silver; method 28 (KH); VI
 5 repeat of run 4
 6 tan; method 28 (KH); VI
 7 blue-gray; method 28 (KH); VI
 8 orange; method 28 (KH); VI
 9 blue-green; method 28 (KH); VI
10 magenta; method 28 (KH); VI
11 green; method 1b; IIa
12 green; method 1b; IIa
13 light pink; method 1b; IIa

14 pink; method 1b; IIa
15 brown; method 1b; IIa
16 light green; method 1b; IIa
17 green; method 1b; IIa
18 dark brown; method 1b; IIa
19 transparent green; method 28 (KH); VI
20 medium green; method 1b; IIa
21 green; method 1b; IIa
22 purple Glitterflex; method 30a; VI
23 dark green; method 1b; IIa
24 transparent dark magenta; method 1b; IIa
25 silver Glitterflex; method 30a; VI
26 dark magenta; method 1b; IIa
27 green; method 1b; IIa
28 Day-Glo yellow-orange; method 30a; VI
29 gold Glitterflex; method 30a; VI
30 bronze; method 1b; IIa
31 pale tan; method 1a; IIa
32 light tan; method 1b; IIa
33 black; method 1b; IIa
34 pink; method 30a; VI
35 blue; method 30a; VI
36 yellow; method 30a; VI
37 white; method 30a; VI
38 Day-Glo yellow; method 30a; VI
39 red; method 30a; VI
40 blue; method 30a; VI
41 transparent white; method 30a; VI
42 black; method 1b; IIa
43 yellow; method 1b; IIa
44 magenta; method 1b; IIa
45 pink; method 28 (KH); VI
46 pink; method 30a; VI
47 clear varnish; method 30a; VI

552:FS11
Axsom 111

Frank Stella
Mysterious Bird of Ulieta, from the Exotic
Bird Series 1977

Screenprint, lithograph (30)

33⅞ × 45⅞ (86 × 116.5)	

Paper: white Arches 88, mould-made

Edition: 50

Proofs: 16AP, 4TP, 9CTP, RTP, PPI, PPII,
A, C

Plate preparation and processing by
Kenneth Tyler; proofing and edition
printing by John Hutcheson; screen prepa-
ration, proofing, and edition printing by
Kim Halliday

Signed *F. Stella*, numbered, and dated in
pencil lower right; chop mark lower right;
workshop number FS76-328 lower left
verso

30 runs: 30 colors; 30 runs from 20
screens and 10 aluminum plates:
 1 orange; method 30a; VI
 2 dark brown; method 30a; VI
 3 yellow; method 28 (KH); VI
 4 yellow; method 30a; VI
 5 yellow-ocher; method 28 (KH); VI
 6 magenta; method 28 (KH); VI
 7 green; method 28 (KH); VI
 8 white; method 28 (KH); VI
 9 pink; method 30a; VI
10 black; method 30a; VI
11 black Glitterflex; method 30a; VI
12 gold; method 30a; VI
13 green; method 30a; VI
14 white; method 30a; VI
15 white; method 30a; VI
16 silver Glitterflex; method 30a; VI
17 green; method 30a; VI
18 gold Glitterflex; method 30a; VI
19 violet; method 1b; IIa
20 blue-violet; method 1b; IIa
21 mauve; method 1b; IIa
22 light tan; method 1b; IIa
23 yellow; method 1b; IIa
24 white; method 1b; IIa
25 light magenta; method 1b; IIa
26 transparent blue; method 1b; IIa
27 medium yellow; method 1b; IIa
28 Day-Glo magenta; method 1b; IIa
29 yellow; method 30a; VI
30 red; method 30a; VI

553:FS12
Axsom 112

Frank Stella
Steller's Albatross, from the Exotic Bird
Series 1977

Screenprint, lithograph (57)

33⅞ × 45⅞ (86 × 116.5)	

Paper: white Arches 88, mould-made

Edition: 50

Proofs: 14AP, 4TP, 4CTP, 8WP, RTP, PPI,
PPII, A, C

Stone and plate preparation and processing
by Kenneth Tyler; proofing and edition
printing by John Hutcheson; screen prepa-
ration, processing, proofing, and edition
printing by Kim Halliday

Signed *F. Stella*, numbered, and dated in
pencil lower right; chop mark lower right;
workshop number FS76-329 lower left
verso

57 runs: 57 colors; 57 runs from 31
screens, 1 stone, and 19 aluminum plates:
 1 green; method 30a; VI
 2 turquoise blue; method 30a; VI
 3 white; method 28 (KH); VI
 4 white; method 28 (KH); VI
 5 silver; method 28 (KH); VI
 6 repeat of run 5
 7 magenta; method 28 (KH); VI
 8 light yellow; method 28 (KH); VI
 9 orange; method 28 (KH); VI

10 light pink; method 28 (KH); VI
11 dark blue; method 28 (KH); VI
12 yellow-brown; method 28 (KH); VI
13 medium yellow; method 28 (KH); VI
14 red-orange; method 28 (KH); VI
15 gray–brown-green; method 28 (KH); VI
16 blue-green; method 30a; VI
17 silver; method 30a; VI
18 repeat of run 17
19 brown-green; method 1b; IIa
20 medium green; method 1b; IIa
21 medium yellow; method 1b; IIa
22 yellow-ocher; method 1b; IIa
23 gold Glitterflex; method 30a; VI
24 light yellow; method 28 (KH); VI
25 mauve; method 1b; IIa
26 mauve; method 1b; IIa
27 yellow-green; method 1b; IIa
28 yellow-ocher; method 1b; IIa
29 transparent silver-gray; method 1b; IIa
30 transparent green; method 1b; IIa
31 green; method 1b; IIa
32 pink; method 1b; IIa
33 pink; method 1b; IIa
34 magenta; method 1b; IIa
35 light tan; method 1b; IIa
36 green; method 1b; IIa
37 transparent gray; method 1a; IIa
38 white; method 28 (KH); VI
39 blue; method 28 (KH); VI
40 clear varnish; method 30a; VI
41 transparent light tan; method 28 (KH); VI
42 yellow; method 30a; VI
43 repeat of run 42

44 repeat of run 42
45 pink; method 30a; VI
46 repeat of run 45
47 orange; method 30a; VI
48 yellow; method 30a; VI
49 repeat of run 48
50 pink; method 30a; VI
51 pink; method 30a; VI
52 pink; method 30a; VI
53 green; method 1b; IIa
54 red; method 1b; IIa
55 black; method 1b; IIa
56 green; method 30a; IIa
57 blue; method 30a; IIa

554:FS13
Axsom IIIA

Frank Stella
Bermuda Petrel 1979

Screenprint, stencil, hand-colored (v)
61¾ × 85½ × ⅝ (156.8 × 217.2 × 1.6)
Paper: white Tycore panel, machine-made
Edition: 10
Proofs: AP, RTP, PPI, A

Screen preparation and processing by Kim Halliday; proofing and edition printing by Halliday assisted by Steve Reeves, Todd Johnston, and Kenneth Tyler

Signed *F. Stella*, numbered, and dated in ink lower left; chop mark lower left verso; workshop number FS76-323 lower left verso

33 runs: 33 colors; 33 runs from 32 screens:
1 blue; method 30a; VI
2 yellow; method 28 (KH); VI
3 white; method 28 (KH); VI
4 gray-brown; method 28 (KH); VI
5 blue-green; method 28 (KH); VI
6 pink; method 28 (KH); VI
7 red; method 28 (KH); VI
8 brown-green; method 28 (KH); VI
9 silver-gold; method 28 (KH); VI
10 yellow-ocher; method 30a; VI
11 dark brown and gold; method 32c (KH)

12 blue; method 32c (KH)
13 blue; method 32c (KH)
14 medium yellow; method 30a; VI
15 transparent gray-brown; method 30a; VI
16 transparent white; method 30a; VI
17 transparent red; method 30a; VI
18 transparent brown-green; method 30a; VI
19 transparent green; method 30a; VI
20 dark red; method 30a (same screen as run 18); VI
21 red; method 30a; VI
22 transparent base; method 30a; VI
23 blue-gray; method 30a; VI
24 white; method 30a; VI
25 brown; method 30a; VI
26 black; method 30a; VI
27 medium yellow; method 30a; VI
28 dark red; method 30a; VI
29 red-orange; method 30a; VI
30 light orange-brown; method 30a; VI
31 orange; method 30a; VI
32 gray–yellow-ocher; method 32c (KH)
33 gold; method 28 (KH); VI

Thirty-four panels were identically printed at the workshop. The artist uniquely hand-colored each work from the edition of ten plus the four proofs using oil paints and crayons. The remaining twenty printed panels were given to the artist for reworking and are not part of the published edition.

555:FS14
Axsom IIIB

Frank Stella
Wake Island Rail 1979

Screenprint, hand-colored (v)
61¾ × 85½ × ⅝ (156.8 × 217.2 × 1.6)
Paper: white Tycore panel, machine-made
Edition: 10
Proofs: AP, RTP, PPI, A

Screen preparation and processing by Kim Halliday; proofing and edition printing by Halliday assisted by Steve Reeves, Todd Johnston, and Kenneth Tyler

Signed *F. Stella*, numbered, and dated in ink lower left; chop mark lower left verso; workshop number FS76-330 lower left verso

34 runs: 34 colors; 34 runs from 34 screens:
 1 yellow-ocher; method 30a; VI
 2 light red; method 28 (KH); VI
 3 blue; method 28 (KH); VI
 4 yellow; method 28 (KH); VI
 5 red; method 28 (KH); VI
 6 pink; method 28 (KH); VI
 7 silver Glitterflex; method 28 (KH); VI
 8 blue-green Glitterflex; method 28 (KH); VI
 9 gray; method 28 (KH); VI
10 white; method 30a; VI
11 transparent tan; method 30a; VI

12 transparent green; method 30a; VI
13 gray; method 30a; VI
14 blue; method 30a; VI
15 light red; method 30a; VI
16 dark red; method 30a; VI
17 silver Glitterflex; method 30a; VI
18 blue-green Glitterflex; method 30a; VI
19 purple; method 30a; VI
20 dark red; method 30a; VI
21 gray-green; method 30a; VI
22 yellow; method 30a; VI
23 brown; method 30a; VI
24 black Glitterflex; method 30a; VI
25 ultramarine blue; method 30a; VI
26 orange; method 30a; VI
27 yellow-green; method 30a; VI
28 red; method 30a; VI
29 pink; method 30a; VI
30 orange; method 30a; VI
31 white; method 30a; VI
32 yellow; method 30a; VI
33 gray-black; method 30a; VI
34 white; method 30a; VI

Thirty-six panels were identically printed at the workshop. The artist uniquely hand-colored each work from the edition of ten plus the four proofs using oil paints and crayons. The remaining twenty-two printed panels were given to the artist for reworking and are not part of the published edition.

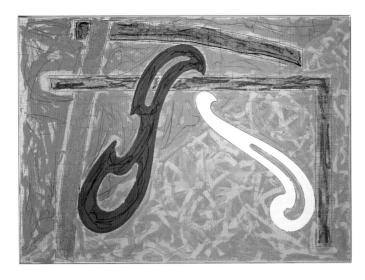 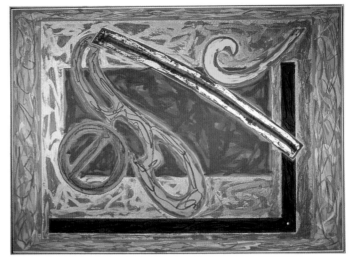

556:FS15
Axsom IIIC

Frank Stella
Green Solitaire 1979

Screenprint, stencil, hand-colored (v)
61¾ × 85½ × ⅝ (156.8 × 217.2 × 1.6)
Paper: white Tycore panel, machine-made
Edition: 10
Proofs: RTP, PPI, A

Screen preparation and processing by Kim Halliday; proofing and edition printing by Halliday assisted by Steve Reeves, Todd Johnston, and Kenneth Tyler

Signed *F. Stella*, numbered, and dated in ink upper left; chop mark lower left verso; workshop number FS76-331 lower left verso

23 runs: 23 colors; 23 runs from 23 screens:
 1 dark blue; method 30a; VI
 2 transparent silver Glitterflex; method 28 (KH); VI
 3 silver Glitterflex; method 32c (KH)
 4 gold Glitterflex; method 32c (KH)
 5 green Glitterflex; method 32c (KH)
 6 black Glitterflex; method 32c (KH)
 7 blue; method 28 (KH); VI
 8 white; method 28 (KH); VI
 9 blue; method 32 (KH)

 10 yellow-ocher; method 32 (KH)
 11 orange; method 30a; VI
 12 light green; method 30a; VI
 13 gray-green; method 30a; VI
 14 green; method 30a; VI
 15 gray; method 30a; VI
 16 black; method 30a; VI
 17 purple; method 30a; VI
 18 white; method 30a; VI
 19 gold Glitterflex; method 30a; VI
 20 dark green; method 30a; VI
 21 white; method 30a; VI
 22 green; method 30a; VI
 23 ultramarine blue; method 30a; VI

Thirty-four panels were identically printed at the workshop. The artist uniquely hand-colored each work from the edition of ten plus the three proofs using oil paints and crayons. The remaining twenty-one printed panels were given to the artist for reworking and are not part of the published edition.

557:FS16
Axsom IIID

Frank Stella
Bonin Night Heron 1979

Screenprint, stencil, hand-colored (v)
61¾ × 85½ × ⅝ (156.8 × 217.2 × 1.6)
Paper: white Tycore panel, machine-made
Edition: 10
Proofs: AP, RTP, PPI, A

Screen preparation and processing by Kim Halliday; proofing and edition printing by Halliday assisted by Rodney Konopaki, Lee Funderburg, and Kenneth Tyler

Signed *F. Stella*, numbered, and dated in ink lower right of center; chop mark lower left verso; workshop number FS76-332 lower left verso

34 runs: 34 colors; 34 runs from 34 screens:
 1 orange; method 30a; VI
 2 orange; method 28 (KH); VI
 3 brown; method 28 (KH); VI
 4 red; method 28 (KH); VI
 5 pink-magenta; method 28 (KH); VI
 6 orange-magenta; method 28 (KH); VI
 7 yellow-green; method 28 (KH); VI
 8 silver Glitterflex; method 28 (KH); VI
 9 light blue; method 30a; VI

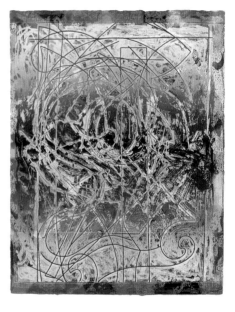

10 dark blue; method 30a; VI
11 transparent blue; method 28 (KH); VI
12 brown; method 30a; VI
13 red; method 30a; VI
14 blue-green; method 30a; VI
15 blue-green; method 30a; VI
16 dark orange; method 30a; VI
17 yellow; method 30a; VI
18 orange; method 30a; VI
19 black; method 30a; VI
20 purple; method 30a; VI
21 orange; method 30a; VI
22 pink; method 30a; VI
23 white; method 30a; VI
24 blue; method 30a; VI
25 purple; method 30a; VI
26 gray; method 30a; VI
27 red; method 30a; VI
28 ultramarine blue; method 28 (KH); VI
29 silver Glitterflex; method 32c (KH)
30 copper Glitterflex; method 30a; VI
31 blue; method 30a; VI
32 blue; method 30a; VI
33 orange; method 30a; VI
34 transparent red; method 30a; VI

Thirty-six panels were identically printed at the workshop. The artist uniquely hand-colored each work from the edition of ten plus the four proofs using oil paints and crayons. The remaining twenty-two printed panels were given to the artist for reworking and are not part of the published edition.

558:FS17
Axsom 135

Frank Stella
Talladega Three I, from the Circuits Series 1982

Etching (1)
66 × 52 (167.6 × 132.1)
Paper: white TGL, handmade
Edition: 30
Proofs: 10AP, TP, WP, RTP, PPI, PPII, A

Papermaking by Steve Reeves and Tom Strianese; plate preparation and processing by Kenneth Tyler and Pete Duchess; proofing by Tyler and Rodney Konopaki; edition printing by Konopaki and Bob Cross

Signed *F. Stella*, numbered, and dated in pencil lower right; chop mark lower right; workshop number FS81-581 lower left verso

1 run: 1 color; 1 run from 1 magnesium plate:
 1 black; methods 20, 21a, 23b; III

559:FS18
Axsom 136

Frank Stella
Talladega Three II, from the Circuits Series 1982

Relief (29)
66 × 52 (167.6 × 132.1)
Paper: white TGL, handmade, hand-colored
Edition: 30
Proofs: 10AP, 2TP, 5CTP, WP, RTP, PPI, PPII, A

Papermaking by Steve Reeves and Tom Strianese; plate preparation and processing by Kenneth Tyler and Pete Duchess; proofing by Tyler, Reeves, and Strianese; edition printing by Reeves and Strianese

Signed *F. Stella*, numbered, and dated in pencil lower right; chop mark lower right; workshop number FS81-582 lower left verso

5 runs: 8 dye colors, 1 paper pressing; 21 ink colors, 4 runs from 4 magnesium plates:
 1 yellow, light orange, red-orange, red, magenta, pale light purple, light purple, and yellow-green dyes (on newly made white pulp base sheet); III

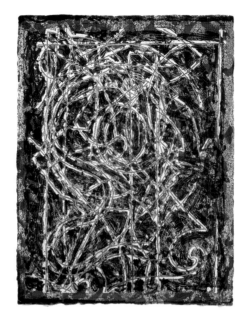

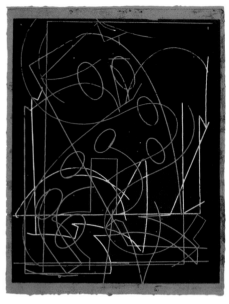

2 yellow, orange, red, medium red, purple, ultramarine blue, medium blue, green, and white; methods 21c, 23a, 16a; III

3 blend of white, light gray, medium gray, dark gray, and black; methods 21c, 23a, 16g; III

4 violet; methods 20, 21a, 21c, 23a; III

5 red and blend of white, light gray, medium light gray, medium gray, and black; methods 20, 21a, 23a, 16g; III

560:FS19
Axsom 137

Frank Stella
Talladega Three III, from the Circuits
Series 1982

Relief (4)

66×52 (167.6 × 132.1)	
Paper: white TGL, handmade	
Edition: 30	
Proofs: 10AP, 4TP, 6CTP, RTP, PPI, PPII, A	

Papermaking by Steve Reeves and Tom Strianese; plate preparation and processing by Kenneth Tyler and Pete Duchess; proofing by Reeves, Strianese, and Tyler; edition printing by Reeves and Strianese

Signed *F. Stella*, numbered, and dated in pencil lower right; chop mark lower right; workshop number FS81-592 lower left verso

4 runs: 4 colors; 4 runs from 4 magnesium plates:
1 medium yellow; methods 20, 21a, 23a; III
2 green; methods 21a, 21c, 23a; III
3 black; methods 20, 21a, 23a; III
4 violet; methods 20, 21a, 23a; III

561:FS20
Axsom 138

Frank Stella
Talladega Five I, from the Circuits
Series 1982

Relief, woodcut (10)

66×52 (167.6 × 132.1)	
Paper: white TGL, handmade, hand-colored	
Edition: 30	
Proofs: 10AP, 2WP, RTP, PPI, PPII, A	

Papermaking by Steve Reeves and Tom Strianese; plate preparation and processing by Kenneth Tyler and Pete Duchess; woodblock preparation by Swan Engraving; proofing by Reeves, Strianese, and Tyler; edition printing by Reeves and Strianese

Signed *F. Stella*, numbered, and dated in pencil lower right; chop mark lower right; workshop number FS81-584 lower left verso

4 runs: 1 dye color, 1 paper pressing; 9 ink colors, 3 runs from 2 magnesium plates and 1 woodblock:
1 red dye (on newly made white pulp base sheet); III
2 medium yellow, red, pink, violet, light blue, green, and fluorescent red; methods 21a, 23a, 16a; III
3 black; method 19b (birchwood); III
4 blue; methods 21a, 23a; III

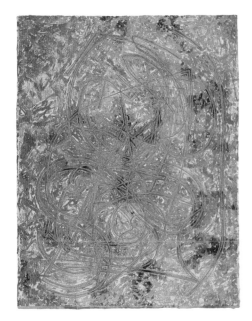

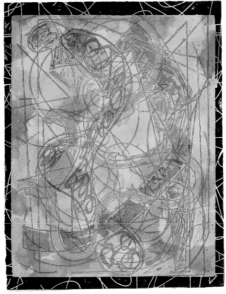

562:FS21
Axsom 139

Frank Stella
Estoril Three II, from the Circuits
Series 1982

Relief, engraving, woodcut (15)	
66 × 52 (167.6 × 132.1)	
Paper: white TGL, handmade, hand-colored	
Edition: 30	
Proofs: 10AP, 3CTP, RTP, PPI, PPII, A	

Papermaking by Steve Reeves and Tom Strianese; plate preparation and processing by Kenneth Tyler and Pete Duchess; woodblock preparation by Strianese; proofing of relief plates and woodblock by Reeves, Strianese, and Tyler; edition printing by Reeves and Strianese; proofing and edition printing of engraved plate by Bob Cross

Signed *F. Stella*, numbered, and dated in pencil lower right; chop mark lower right; workshop number FS81-585 lower left verso

7 runs: 9 dye colors, 1 paper pressing; 6 ink colors, 6 runs from 5 magnesium plates and 1 woodblock:
1 yellow, light orange, red-orange, magenta, pale light purple, light purple, purple, blue, and yellow-green dyes (on newly made white pulp base sheet); III
2 magenta; method 12; III
3 yellow; methods 20, 21a, 23a; III
4 gold; methods 20, 21a, 23a; III
5 green; methods 21a, 23a (SR); III
6 red; methods 21a, 23a (TS); III
7 fluorescent green; method 19a (pinewood, TS); III

563:FS22
Axsom 140

Frank Stella
Estoril Five I, from the Circuits
Series 1982

Relief, woodcut (20)	
67 × 52 (170.2 × 132.1)	
Paper: white TGL, handmade, hand-colored	
Edition: 30	
Proofs: 10AP, 3CTP, 6PP, 2WP, RTP, PPI, PPII, A	

Papermaking by Steve Reeves and Tom Strianese; woodblock preparation by Swan Engraving; plate preparation and processing by Kenneth Tyler and Pete Duchess; proofing by Reeves, Strianese, and Tyler; edition printing by Reeves and Strianese

Signed *F. Stella*, numbered, and dated in pencil lower right; chop mark lower right; workshop number FS81-587 lower left verso

7 runs: 9 dye colors, 1 paper pressing; 11 ink colors, 6 runs from 4 magnesium plates and 1 woodblock:
1 yellow, light orange, red-orange, magenta, pale light purple, light purple, purple, blue, and yellow-green dyes (on newly made white pulp base sheet); III
2 yellow; method 19b (birchwood); III
3 yellow, orange, light red, blue, and green; methods 20, 23a, 16a; III
4 red; methods 20, 23a (same plate as run 3); III
5 light yellow-ocher; methods 21a, 23a; III
6 violet; methods 20, 21c, 23a; III
7 yellow-ocher and black; methods 21a, 23a, 16a; III

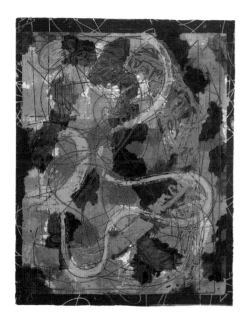

564:FS23
Axsom 141

Frank Stella
Estoril· Five II, from the Circuits
Series 1982

Relief, engraving (21)
66 × 52 (167.6 × 132.1)
Paper: white TGL, handmade,
hand-colored
Edition: 30
Proofs: 10AP, TP, 4CTP, WP, RTP, PPI,
PPII, A

Papermaking by Steve Reeves and Tom Stri-
anese; plate preparation and processing by
Kenneth Tyler and Pete Duchess; proofing
by Reeves, Strianese, and Tyler; edition
printing by Reeves and Strianese; proofing
and edition printing of engraved plate by
Bob Cross

Signed *F. Stella,* numbered, and dated in
pencil lower right; chop mark lower right;
workshop number FS81-583 lower left
verso

8 runs: 9 dye colors, 1 paper pressing; 12
ink colors, 7 runs from 5 magnesium
plates:
1 yellow, light orange, red-orange,
 magenta, pale light purple, light purple,
 purple, blue, and yellow-green dyes (on
 newly made white pulp base sheet); III
2 magenta; method 12; III
3 transparent gray; methods 21a, 23a; III
4 violet; methods 20, 21c, 23a; III
5 yellow-orange, light orange, light violet,
 blue, and light green; methods 20, 21a,
 23a, 16a; III
6 red; methods 20, 21a (same plate as
 run 5), 23a; III
7 yellow-ocher and violet; methods 21a,
 23a, 16a; III
8 blue-green; methods 21a (same plate as
 run 7), 23a; III

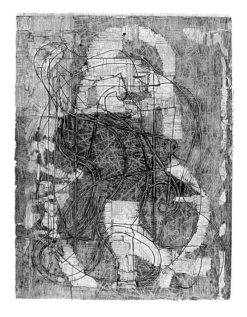

565:FS24
Axsom 142

Frank Stella
Imola Three I, from the Circuits
Series 1982

Relief, engraving (5)
66 × 52 (167.6 × 132.1)
Paper: white TGL, handmade
Edition: 30
Proofs: 10AP, TP, 4CTP, 2WP, RTP, PPI,
PPII, A

Papermaking by Steve Reeves and Tom Stri-
anese; plate preparation and processing by
Kenneth Tyler and Pete Duchess; proofing
by Tyler, Reeves, and Strianese; edition
printing by Reeves and Strianese; edition
printing of engraved plate by Bob Cross

Signed *F. Stella,* numbered, and dated in
pencil lower right; chop mark lower right;
workshop number FS81-593 lower left
verso

5 runs: 5 colors; 5 runs from 4 magnesium
plates:
1 black; method 12; III
2 silver; methods 21a, 21c, 23a; III
3 light yellow; methods 21c, 23a; III
4 white; methods 21c (same plate as run
 3), 23a; III
5 black; methods 21c, 20a, 23a; III

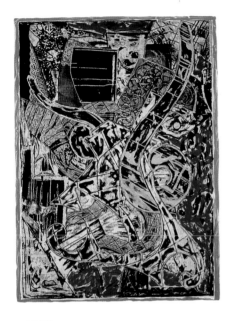

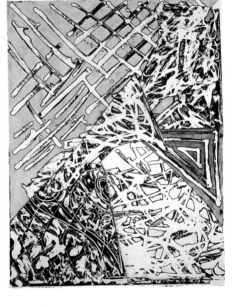

566:FS25
Axsom 162

Frank Stella
Yellow Journal 1982

Lithograph (15)
52½ × 38½ (133.5 × 97.8)
Paper: white Arches Cover, mould-made
Edition: 50
Proofs: 16AP, 4TP, 2CTP, 2WP, RTP, PPI, PPII, A

Prep work for continuous-tone lithography by Kenneth Tyler; plate preparation and processing by Lee Funderburg; proofing by Tyler, Funderburg, and Roger Campbell; edition printing by Campbell and Funderburg

Signed *F. Stella*, numbered, and dated in pencil lower right; chop mark lower right; workshop number FS82-649 lower left verso

15 runs: 15 colors; 15 runs from 14 aluminum plates:
1 light yellow; method 5a; IIa
2 blue; method 5a; IIa
3 silver-gray; method 5a; IIa
4 dark green; method 5a; IIa
5 black; method 5c; IIa
6 red; method 5a; IIa
7 transparent blue varnish; method 5a; IIa
8 clear varnish; method 5a (same plate as run 7); IIa
9 pale green-blue; method 5a; IIa
10 light orange-ocher; method 5a; IIa
11 light red; method 5a; IIa
12 white; method 5a; IIa
13 light green; method 5a; IIa
14 medium yellow; method 5a; IIa
15 red-brown; method 5a; IIa

567:FS26
Axsom 153

Frank Stella
Swan Engraving I, from the Swan Engraving Series 1982

Etching (1)
65¾ × 51 (167 × 129.5)
Paper: white TGL, handmade
Edition: 30
Proofs: 10AP, RTP, PPI, PPII, A, C

Papermaking by Steve Reeves and Tom Strianese; plate preparation and processing by Kenneth Tyler and Pete Duchess; proofing and edition printing by Rodney Konopaki and Bob Cross

Signed *F. Stella*, numbered, and dated in pencil lower right of center; chop mark lower right; workshop number FS81-653 lower left verso

1 run: 1 color; 1 run from 1 assembled plate made from 7 irregularly shaped magnesium plates:
1 black; methods 15a, 20, 21c, 21a, 23b; III

The magnesium plates used to make the assembled plate were cut and mounted on plywood backing by the artist assisted by Tyler, Duane Mitch, Roger Campbell, Lee Funderburg, Konopaki, and Cross.

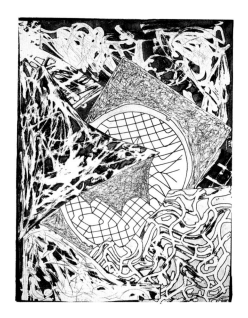

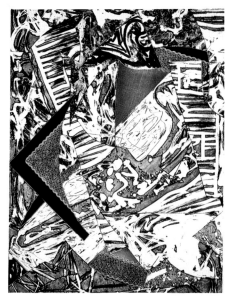

568:FS27
Axsom 154

Frank Stella
Swan Engraving II, from the Swan
Engraving Series 1982

Etching (1)
66½ × 51½ (168.9 × 130.8)
Paper: white TGL, handmade
Edition: 30
Proofs: 10AP, 3TP, RTP, PPI, PPII, A, C

Papermaking by Steve Reeves and Tom Stri-
anese; plate preparation and processing by
Kenneth Tyler and Pete Duchess; proofing
and edition printing by Rodney Konopaki
and Bob Cross

Signed *F. Stella*, numbered, and dated in
pencil lower left of center; chop mark lower
right; workshop number FS81-652 lower
left verso

1 run: 1 color; 1 run from 1 assembled
plate made from 7 irregularly shaped
magnesium plates:
 1 black; methods 15a, 12, 20, 21c, 23b;
 III

The magnesium plates used to make the
assembled plate were cut and mounted on
plywood backing by the artist assisted by
Tyler, Duane Mitch, Roger Campbell, Lee
Funderburg, Konopaki, and Cross. Sections
of the plywood border were inked and
printed with the assembled plate.

569:FS28
Axsom 155

Frank Stella
Swan Engraving III, from the Swan
Engraving Series 1982

Etching, relief (1)
66 × 51½ (167.6 × 130.8)
Paper: white TGL, handmade
Edition: 30
Proofs: 10AP, 2TP, RTP, PPI, PPII, A, C

Papermaking by Steve Reeves and Tom Stri-
anese; plate preparation and processing by
Kenneth Tyler and Pete Duchess; proofing
and edition printing by Rodney Konopaki
and Bob Cross

Signed *F. Stella*, numbered, and dated in
pencil lower left of center; chop mark lower
right; workshop number FS81-652 lower
left verso

1 run: 1 color; 1 run from 1 assembled
plate made from 27 irregularly shaped
magnesium plates:
 1 black; methods 15a, 20, 21c, 23c; III

The magnesium plates used to make the
assembled plate were cut and mounted on
plywood backing by the artist assisted by
Tyler, Duane Mitch, Roger Campbell, Lee
Funderburg, Konopaki, and Cross.

570:FS29
Axsom 156

Frank Stella
Swan Engraving IV, from the Swan
Engraving Series 1982

Etching, relief (1)
66¾ × 51 (169.5 × 129.5)
Paper: white TGL, handmade
Edition: 30
Proofs: 10AP, 2TP, RTP, PPI, PPII, A, C

Papermaking by Steve Reeves and Tom Stri-
anese; plate preparation and processing by
Kenneth Tyler and Pete Duchess; proofing
and edition printing by Rodney Konopaki
and Bob Cross

Signed *F. Stella*, numbered, and dated in
pencil lower right; chop mark lower right;
workshop number FS81-654 lower left
verso

1 run: 1 color; 1 run from 1 assembled
plate made from 50 irregularly shaped
magnesium plates:
 1 black; methods 15a, 20, 21c, 23c; III

The magnesium plates used to make the
assembled plate were cut and mounted on
plywood backing by the artist assisted by
Tyler, Duane Mitch, Roger Campbell, Lee
Funderburg, Konopaki, and Cross.

571:FS30
Axsom 157

Frank Stella
Swan Engraving Square I, from the Swan
Engraving Series 1982

Etching (1)
53½ × 52 (135.9 × 132.1)
Paper: white TGL, handmade
Edition: 20
Proofs: 10AP, 2TP, RTP, PPI, PPII, A, C

Papermaking by Steve Reeves and Tom Stri-
anese; plate preparation and processing by
Kenneth Tyler and Pete Duchess; proofing
and edition printing by Rodney Konopaki
and Bob Cross

Signed *F. Stella*, numbered, and dated in
pencil lower center; chop mark lower right;
workshop number FS81-657 lower left
verso

1 run: 1 color; 1 run from 1 assembled
plate made from 26 irregularly shaped
magnesium plates:
 1 black; methods 15a, 20, 21c, 21a, 23b;
 III

The magnesium plates used to make the
assembled plate were cut and mounted on
plywood backing by the artist assisted by
Tyler, Duane Mitch, Roger Campbell, Lee
Funderburg, Konopaki, and Cross. The
horizontal borders of the plywood were
inked and printed with the assembled plate.

572:FS31
Axsom 158

Frank Stella
Swan Engraving Square II, from the Swan
Engraving Series 1982

Etching, relief (1)
53½ × 52 (135.9 × 132.1)
Paper: white TGL, handmade
Edition: 20
Proofs: 10AP, 2TP, RTP, PPI, PPII, A, C

Papermaking by Steve Reeves and Tom Stri-
anese; plate preparation and processing by
Kenneth Tyler and Pete Duchess; proofing
and edition printing by Rodney Konopaki
and Bob Cross

Signed *F. Stella*, numbered, and dated in
pencil lower left of center; chop mark lower
right; workshop number FS81-656 lower
left verso

1 run: 1 color; 1 run from 1 assembled
plate made from 13 irregularly shaped
magnesium plates:
 1 black; methods 15a, 20, 21c, 21a, 23c;
 III

The magnesium plates used to make the
assembled plate were cut and mounted on
plywood backing by the artist assisted by
Tyler, Duane Mitch, Roger Campbell, Lee
Funderburg, Konopaki, and Cross. The
horizontal borders of the plywood were
inked and printed with the assembled plate.

573:FS32
Axsom 160

Frank Stella
Swan Engraving Square III, from the Swan
Engraving Series 1982

Etching (1)
52 × 54 (132.1 × 137.2)
Paper: white TGL, handmade
Edition: 20
Proofs: 8AP, 2TP, RTP, PPI, PPII, A, C

Papermaking by Steve Reeves and Tom Stri-
anese; plate preparation and processing by
Kenneth Tyler and Pete Duchess; proofing
and edition printing by Rodney Konopaki
and Bob Cross

Signed *F. Stella*, numbered, and dated in
pencil lower left; chop mark lower right;
workshop number FS81-659 lower left
verso

1 run: 1 color; 1 run from 1 assembled
plate made from 11 irregularly shaped
magnesium plates:
 1 black; methods 15a, 20, 21c, 21a, 23b;
 III

The magnesium plates used to make the
assembled plate were cut and mounted on
plywood backing by the artist assisted by
Tyler, Duane Mitch, Roger Campbell, Lee
Funderburg, Konopaki, and Cross. The
vertical borders of the plywood were inked
and printed with the assembled plate.

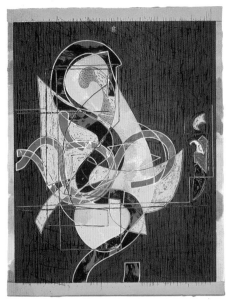

574:FS33
Axsom 159

Frank Stella
Swan Engraving Square IV, from the Swan
Engraving Series 1982

Etching, relief (1)
52 × 54 (132.1 × 137.2)
Paper: white TGL, handmade
Edition: 20
Proofs: 8AP, 2TP, RTP, PPI, PPII, A, C

Papermaking by Steve Reeves and Tom Stri-
anese; plate preparation and processing by
Kenneth Tyler and Pete Duchess; proofing
and edition printing by Rodney Konopaki
and Bob Cross

Signed *F. Stella,* numbered, and dated in
pencil lower left; chop mark lower right;
workshop number FS81-658 lower left
verso

1 run: 1 color; 1 run from 1 assembled
plate made from 11 irregularly shaped
magnesium plates:
 1 black; methods 15a, 20, 21c, 21a, 23c;
 III

The magnesium plates used to make the
assembled plate were cut and mounted on
plywood backing by the artist assisted by
Tyler, Duane Mitch, Roger Campbell, Lee
Funderburg, Konopaki, and Cross. Sections
of the plywood border were inked and
printed with the assembled plates.

575:FS34
Axsom 143

Frank Stella
Pergusa Three, from the Circuits
Series 1983

Relief, woodcut (40)
66 × 52 (167.6 × 132.1)
Paper: white TGL, handmade,
hand-colored
Edition: 30
Proofs: 18AP, 2TP, 5CTP, WP, PPI, PPII, A

Papermaking by Steve Reeves and Tom
Strianese; woodblock preparation by the
artist and Kenneth Tyler, with magnesium
inlay by Tyler and Bob Cross; proofing by
Reeves, Strianese, and Tyler; edition
printing by Reeves and Strianese

Signed *F. Stella,* numbered, and dated in
pencil lower right; chop mark lower right;
workshop number FS81-588 lower left
verso

8 runs: 10 dye colors, 1 paper pressing; 30
ink colors, 7 runs from 5 magnesium plates
and 2 woodblocks with inlaid irregularly
shaped magnesium plates:
 1 yellow, yellow-ocher, red, magenta,
 light pink, light violet, purple, blue,
 green, and light yellow-green dyes (on
 newly made white pulp base sheet); III

2 orange, red, magenta, violet, green,
 gray, and black; methods 19b (birch-
 wood), 20, 23a, 16a; III
3 medium yellow, orange, red, dark
 magenta, violet, dark green, and
 blue-black; methods 19a (birchwood),
 20, 23a, 16a; III
4 yellow, red, pink, purple, blue, green,
 and white; methods 21a, 23a, 16a; III
5 red and black; methods 21a, 23a, 16a;
 III
6 blue; methods 21a, 23a; III
7 green; methods 21a, 23a; III
8 yellow, orange, red, dark blue, and
 white; methods 21a, 23a, 16a; III

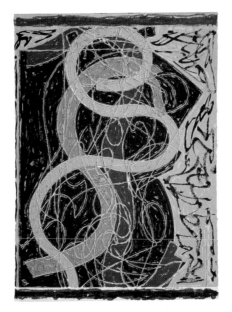

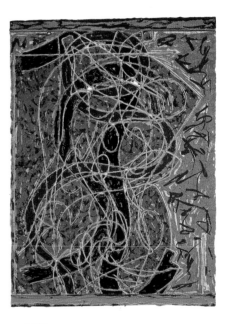

576:FS35
Axsom 168

Frank Stella
Swan Engraving Blue, from the Swan
Engraving Series 1983

Etching, relief, engraving (2)
38¾ × 31½ (98.4 × 80)
Paper: buff TGL, handmade
Edition: 30
Proofs: 6AP, 9TP, SP, WP, RTP, PPI,
PPII, A

Papermaking by Steve Reeves and Tom Stri-
anese; plate preparation and processing by
Kenneth Tyler and Pete Duchess; proofing
and edition printing by Rodney Konopaki
and Bob Cross

Signed *F. Stella,* numbered, and dated in
pencil lower right; chop mark lower right;
workshop number FS82-664 lower left
verso

1 run: 2 colors; 1 run from 1 assembled
plate made from 24 irregularly shaped
magnesium plates:
 1 blue and black; methods 15a, 12, 21c,
 23c, 16a; III

The magnesium plates used to make the
assembled plate were cut and mounted on
plywood backing by the artist assisted by
Tyler, Duane Mitch, Roger Campbell, Lee
Funderburg, Konopaki, and Cross. The
plywood border was inked and printed
with the assembled plate.

577:FS36
Axsom 166

Frank Stella
Imola Five II, from the Circuits
Series 1983

Relief, woodcut (15)
66 × 49 (167.6 × 124.5)
Paper: white TGL, handmade,
hand-colored
Edition: 30
Proofs: 10AP, 2TP, 2CTP, WP, RTP, PPI,
PPII, A

Papermaking by Steve Reeves and Tom Stri-
anese; woodblock preparation by Swan
Engraving; plate preparation and processing
by Kenneth Tyler and Pete Duchess;
proofing by Reeves, Strianese, and Tyler;
edition printing by Reeves and Strianese

Signed *F. Stella,* numbered, and dated in
pencil lower right; chop mark lower left;
workshop number FS81-591 lower right
verso

6 runs: 2 dye colors, 1 paper pressing; 13
ink colors, 5 runs from 4 magnesium plates
and 1 woodblock:
 1 yellow and green dyes (on newly made
 white pulp base sheet); III
 2 red, violet, blue, green, and black;
 methods 19b (beech wood), 16a; III
 3 transparent white; methods 20, 23a; III
 4 green and black; methods 20, 21a, 23a,
 16a; III
 5 light green, medium green, dark green,
 and black; methods 21a, 23a, 16a; III
 6 light blue; methods 21a, 23a; III

578:FS37
Axsom 166a

Frank Stella
Imola Five II, State I, from the Circuits
Series 1983

Relief, screenprint, woodcut (21)
66 × 49 (167.6 × 124.5)
Paper: white TGL, handmade,
hand-colored
Edition: 10
Proofs: TP, WP, RTP

Papermaking by Steve Reeves and Tom
Strianese; woodblock preparation by Swan
Engraving; plate preparation and
processing by Kenneth Tyler and Pete
Duchess; proofing and edition printing by
Reeves and Strianese; screen preparation by
Strianese; screen proofing and edition
printing by Kenneth Tyler, Rodney Kono-
paki, and Bob Cross

Signed *F. Stella,* numbered, dated, and
titled (*State I*) in pencil lower left; chop
mark lower left; workshop number
FS81-591A lower right verso

15 runs: 1 dye color, 1 paper pressing; 20
ink colors, 14 runs from 5 magnesium
plates, 2 screens, and 1 woodblock:
 1 red dye (on newly made white pulp
 base sheet); III
 2 orange, red, violet, green, and black;
 methods 19b (beech wood), 16a; III

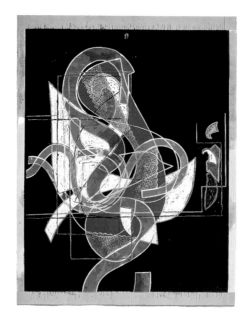

3 transparent white; methods 20, 23a; III

4 transparent thalo green; methods 20, 21a, 23a; III

5 dark green and black; methods 21a, 23a, 16a; III

6 yellow-orange; methods 21a, 23a; III

7 orange; method 29a; III

8 light blue; method 29a; III

9 dark blue; methods 29a (same screen as run 8), 27 (KT); VI

10 green; methods 29a (same screen as run 8), 27 (KT); VI

11 gray-violet; methods 29a (same screen as run 8), 27 (KT); VI

12 tan; methods 29a (same screen as run 8), 27 (KT); VI

13 dark green; methods 29a (same screen as run 8), 27 (KT); VI

14 black; methods 29a (same screen as run 8), 27 (KT); VI

15 blue and brown; methods 21a, 23a, 16a; III

579:FS38
Axsom 143a

Frank Stella
Pergusa Three, State I, from the Circuits
Series 1983

Relief, woodcut (40)	
66 × 52 (167.6 × 132.1)	
Paper: white TGL, handmade, hand-colored	
Edition: 10	
Proofs: TP, RTP	

Papermaking by Steve Reeves and Tom Strianese; plate preparation and processing by Kenneth Tyler and Pete Duchess; woodblock preparation by the artist and Tyler, with magnesium inlay by Bob Cross; proofing by Reeves, Strianese, and Tyler; edition printing by Reeves and Strianese

Signed *F. Stella*, numbered, dated, and titled (*State I*) in pencil lower left; chop mark lower right; workshop number FS81-588A lower left verso

9 runs: 10 dye colors, 1 paper pressing; 30 ink colors, 8 runs from 5 magnesium plates and 2 woodblocks with inlaid irregularly shaped magnesium plates:
 1 yellow, light orange, red-orange, vermilion, magenta, pale light violet, light violet, pale purple, blue, and yellow-green dyes (on newly made white pulp base sheet); III

2 orange, dark red, brown-red, violet, tan, and green; methods 19a (beech wood), 20, 23a, 16a; III

3 medium yellow, orange, dark magenta, blue, dark green, black, and gold; methods 19a (beech wood), 20, 23a, 16a; III

4 yellow, red, pink, purple, green, dark green, and white; methods 21a, 23a, 16a; III

5 yellow; methods 21a (same plate as run 4, printed over white area from run 4), 23a; III

6 red and black; methods 21a, 23a, 16a; III

7 blue; methods 21a, 23a; III

8 green; methods 21a, 23a; III

9 yellow, orange, red, dark blue, and white; methods 21a, 23a, 16a; III

PLAYSKOOL SERIES

Frank Stella's Playskool Series, completed in 1983, is a group of nine editioned wall reliefs made from cast-bronze parts, etched magnesium and honeycomb aluminum, and numerous found objects. To create an edition, the artist first constructed an original assemblage using found objects and irregularly shaped etched magnesium and honeycomb aluminum sheets. The assemblage was duplicated for the edition by selecting some of the found objects to be reproduced in cast bronze, by collecting similar found objects, and by making additional shaped metal sections. When all of the parts were assembled, each relief was painted by the artist with acrylic and vinyl paints and screen inks. Some of the etched magnesium parts were hand-wiped with inks by Rodney Konopaki and Bob Cross.

580:FS39

Frank Stella
Playskool Chair, from the Playskool Series 1983

Patinated cast bronze, fabricated aluminum, copper, wood dowels, etched magnesium, honeycomb aluminum, hand-colored (v)

31 × 31 × 14 (78.7 × 78.7 × 35.6)

Edition: 5 (with an additional relief numbered o/o)

Bronze castings and partial fabrication by Tallix Foundry; honeycomb metal and etched parts by Swan Engraving; completed assembly and hand-inking by Kenneth Tyler, Rodney Konopaki, and Bob Cross

Engraved *F. Stella,* numbered, and dated on a copper plate attached to the back of the relief

After inking and assembly, each relief was painted by the artist with acrylic paints.

581:FS40

Frank Stella
Playskool Sink, from the Playskool Series 1983

Patinated cast bronze, fabricated aluminum, plastic, steel hose hanger, cut wooden bowling pins, plastic and metal bracket, hand-colored (v)

31 × 36 × 29 (78.7 × 91.4 × 73.7)

Edition: 5 (with an additional relief numbered o/o)

Bronze castings and partial fabrication by Tallix Foundry; completed assembly and hand-inking by Kenneth Tyler, Rodney Konopaki, and Bob Cross

Engraved *F. Stella,* numbered, and dated on a copper plate attached to the back of the relief

After inking and assembly, each relief was painted by the artist with acrylic paints.

582:FS41

Frank Stella
Playskool Screen, from the Playskool Series
1983

Patinated cast bronze, fabricated
aluminum, steel, etched honeycomb, screen-
print, hand-colored (v)
47 × 47½ × 33 (119.4 × 120.7 × 83.8)
Edition: 5 (with an additional relief
numbered o/o)

Bronze castings and partial fabrication by
Tallix Foundry; honeycomb metal and
etched parts by Swan Engraving; screen
preparation by Tom Strianese; completed
assembly, screen printing, and hand-inking
by Kenneth Tyler, Rodney Konopaki, and
Bob Cross

Engraved *F. Stella*, numbered, and dated on
a copper plate attached to the back of the
relief

After inking, screen printing, and assembly,
each relief was painted by the artist with
acrylic paints.

583:FS42

Frank Stella
Playskool Clamp, from the Playskool Series
1983

Patinated cast bronze, fabricated
aluminum, plastic, steel, etched magnesium
honeycomb, screenprint, hand-colored (v)
39 × 24 × 20 (99.1 × 61 × 50.8)
Edition: 5 (with an additional relief
numbered o/o)

Bronze castings and partial fabrication by
Tallix Foundry; honeycomb metal and
etched parts by Swan Engraving; screen
preparation by Tom Strianese; completed
assembly, screen printing, and hand-inking
by Kenneth Tyler, Rodney Konopaki, and
Bob Cross

Engraved *F. Stella*, numbered, and dated on
a copper plate attached to the back of the
relief

After inking, screen printing, and assembly,
each relief was painted by the artist with
acrylic paints.

584:FS43

Frank Stella
Playskool Yard, from the Playskool Series
1983

Patinated cast bronze, wood dowels,
hand-colored (v)
32 × 28 × 9 (81.3 × 71.1 × 22.9)
Edition: 2 (with an additional relief
numbered o/o)

Bronze casting and partial fabrication by
Tallix Foundry; completed assembly by
Kenneth Tyler, Rodney Konopaki, and Bob
Cross

Engraved *F. Stella*, numbered, and dated on
a copper plate attached to the back of the
relief

After assembly, each relief was painted by
the artist with acrylic paints.

585:FS44

Frank Stella
Playskool Door, from the Playskool Series
1983

Patinated cast bronze, fabricated
aluminum, etched magnesium honeycomb,
aluminum screen, brass latch, steel hinge,
hand-colored (v)

33 × 24 × 17 (83.8 × 61 × 43.2)
Edition: 5 (with an additional relief
numbered o/o)

Bronze castings and partial fabrication by
Tallix Foundry; honeycomb metal and
etched parts by Swan Engraving; completed
assembly and hand-inking by Kenneth
Tyler, Rodney Konopaki, and Bob Cross

Engraved *F. Stella,* numbered, and dated on
a copper plate attached to the back of the
relief

After inking and assembly, each relief was
painted by the artist with acrylic paints.

586:FS45

Frank Stella
Playskool Gym, from the Playskool Series
1983

Patinated cast bronze, fabricated
aluminum, wood, steel, plastic, screenprint,
hand-colored (v)

28 × 26 × 12 (71.1 × 66 × 30.5)
Edition: 5 (with an additional relief
numbered o/o)

Bronze castings and partial fabrication by
Tallix Foundry; honeycomb metal and
etched parts by Swan Engraving; screen
preparation by Tom Strianese; completed
assembly and screen printing by Kenneth
Tyler, Rodney Konopaki, and Bob Cross

Engraved *F. Stella,* numbered, and dated on
a copper plate attached to the back of the
relief

After screen printing and assembly, each
relief was painted by the artist with acrylic
paints.

587:FS46

Frank Stella
Playskool Hose, from the Playskool
Series 1983

Patinated cast bronze, wood, honeycomb
aluminum, etched honeycomb magnesium,
rubber, hand-colored

42 × 35¾ × 18¾ (106.7 × 90.8 × 47.6)
Edition: 5 (with an additional relief
numbered o/o)

Bronze castings and partial fabrication by
Tallix Foundry; honeycomb metal and
etched parts by Swan Engraving; completed
assembly and hand-inking by Kenneth
Tyler, Rodney Konopaki, and Bob Cross

Engraved *F. Stella,* numbered, and dated on
a copper plate attached to the back of the
relief

After inking and assembly, each relief was
painted by the artist with acrylic paints.

588:FS47

Frank Stella
Playskool Bobbin, from the Playskool
Series 1983

Patinated cast bronze, wood, etched honey-
comb aluminum, fiberglass, balsa wood
laminate, plastic, masking tape,
hand-colored (v)
35¾ × 47 × 33¼ (90.8 × 119.4 × 84.5)
Edition: 5 (with an additional relief
numbered o/o)

Bronze castings and partial fabrication by
Tallix Foundry; honeycomb metal and
etched parts by Swan Engraving; completed
assembly and hand-inking by Kenneth
Tyler, Rodney Konopaki, and Bob Cross

Engraved *F. Stella,* numbered, and dated on
a copper plate attached to the back of the
relief

After inking and assembly, each relief was
painted by the artist with acrylic paints.

589:FS48
Axsom 169

Frank Stella
Swan Engraving Circle I, from the Swan
Engraving Series 1983

Etching, relief, engraving (1)
52 (132.1) diameter
Paper: white TGL, handmade
Edition: 5
Proofs: 2AP, 2TP, 2CTP, 2WP, RTP, PPI,
PPII, A

Papermaking by Steve Reeves and Tom Stri-
anese; plate preparation and processing by
Kenneth Tyler and Pete Duchess; proofing
and edition printing by Rodney Konopaki
and Bob Cross

Signed *F. Stella,* numbered, and dated in
pencil lower right; chop mark lower center;
workshop number FS81-660 lower center
verso

1 run: 1 color; 1 run from 1 assembled
plate made from 14 irregularly shaped
magnesium plates:
 1 black; methods 15a, 12, 20, 21a, 21c,
 23c; III

The magnesium plates used to make the
assembled plate were cut and mounted on
plywood backing by the artist assisted by
Tyler, Duane Mitch, Roger Campbell, Lee
Funderburg, Konopaki, and Cross. Sections
of the plywood border were inked and
printed with the assembled plate.

590:FS49
Axsom 169A

Frank Stella
Swan Engraving Circle I, State I, from the
Swan Engraving Series 1983

Etching, relief, engraving (5)
52 (132.1) diameter
Paper: light yellow TGL, handmade
Edition: 5
Proofs: TP, A

Papermaking by Steve Reeves and Tom Stri-
anese; plate preparation and processing by
Kenneth Tyler and Pete Duchess; proofing
and edition printing by Rodney Konopaki
and Bob Cross

Signed *F. Stella,* numbered, and dated in
pencil lower right; chop mark lower center;
workshop number FS81-660A lower center
verso

4 runs: 5 colors; 4 runs from 1 assembled
plate made from 14 irregularly shaped
magnesium plates, and 3 magnesium
plates:
 1 yellow and black; methods 15a, 12, 20,
 21a, 21c, 23c, 16a; III
 2 gold; methods 21a, 23a; III
 3 brown; methods 21a, 23a; III
 4 black; methods 21a, 23a; III

The magnesium plates used to make the
assembled plate were cut and mounted on
plywood backing by the artist assisted by
Tyler, Duane Mitch, Roger Campbell, Lee
Funderburg, Konopaki, and Cross. Sections
of the plywood border were inked and
printed with the assembled plate.

591:FS50
Axsom 169B

Frank Stella
Swan Engraving Circle I, State II, from the
Swan Engraving Series 1983

Etching, relief, engraving (5)	
52 (132.1) diameter	
Paper: gray TGL, handmade	
Edition: 5	
Proofs: TP, A	

Papermaking by Steve Reeves and Tom Stri-
anese; plate preparation and processing by
Kenneth Tyler and Pete Duchess; proofing
and edition printing by Rodney Konopaki
and Bob Cross

Signed *F. Stella*, numbered, and dated in
pencil lower right; chop mark lower center;
workshop number FS81-660B lower center
verso

4 runs: 5 colors; 4 runs from 1 assembled
plate made of 14 irregularly shaped
magnesium plates, and 3 magnesium
plates:
 1 orange and red; methods 15a, 12, 20,
 21a, 21c, 23c, 16a; III
 2 gold; methods 21a, 23a; III
 3 violet, methods 21a, 23a; III
 4 black; methods 21a, 23a; III

The magnesium plates used to make the
assembled plate were cut and mounted on
plywood backing by the artist assisted by
Tyler, Duane Mitch, Roger Campbell, Lee
Funderburg, Konopaki, and Cross. Sections
of the plywood border were inked and
printed with the assembled plate.

592:FS51
Axsom 169C

Frank Stella
Swan Engraving Circle I, State III, from
the Swan Engraving Series 1983

Etching, relief, engraving (5)	
52 (132.1) diameter	
Paper: light blue TGL, handmade	
Edition: 5	
Proofs: TP, A	

Papermaking by Steve Reeves and Tom Stri-
anese; plate preparation and processing by
Kenneth Tyler and Pete Duchess; proofing
and edition printing by Rodney Konopaki
and Bob Cross

Signed *F. Stella*, numbered, and dated in
pencil lower right; chop mark lower center;
workshop number FS81-660C lower center
verso

4 runs: 5 colors; 4 runs from 1 assembled
plate made from 14 irregularly shaped
magnesium plates, and 3 magnesium
plates:
 1 blue and black; methods 15a, 12, 20,
 21a, 21c, 23c, 16a; III
 2 medium blue; methods 21a, 23a; III
 3 green; methods 21a, 23a; III
 4 black; methods 21a, 23a; III

The magnesium plates used to make the
assembled plate were cut and mounted on
plywood backing by the artist assisted by
Tyler, Duane Mitch, Roger Campbell, Lee
Funderburg, Konopaki, and Cross. Sections
of the plywood border were inked and
printed with the assembled plate.

593:FS52
Axsom 169D

Frank Stella
Swan Engraving Circle I, State IV, from the
Swan Engraving Series 1983

Etching, relief, engraving (5)	
52 (132.1) diameter	
Paper: light green TGL, handmade	
Edition: 5	
Proof: A	

Papermaking by Steve Reeves and Tom Stri-
anese; plate preparation and processing by
Kenneth Tyler and Pete Duchess; proofing
and edition printing by Rodney Konopaki
and Bob Cross

Signed *F. Stella*, numbered, and dated in
pencil lower right; chop mark lower center;
workshop number FS81-660D lower center
verso

4 runs: 5 colors; 4 runs from 1 assembled
plate made of 14 irregularly shaped
magnesium plates, and 3 magnesium
plates:
 1 red-brown and black; methods 15a, 12,
 20, 21a, 21c, 23c, 16a; III
 2 gold; methods 21a, 23a; III
 3 brown; methods 21a, 23a; III
 4 black; methods 21a, 23a; III

The magnesium plates used to make the
assembled plate were cut and mounted on
plywood backing by the artist assisted by
Tyler, Duane Mitch, Roger Campbell, Lee
Funderburg, Konopaki, and Cross. Sections
of the plywood border were inked and
printed with the assembled plate.

594:FS53
Axsom 169E

Frank Stella
Swan Engraving Circle I, State V, from the
Swan Engraving Series 1983

Etching, relief, engraving (5)	
52 (132.1) diameter	
Paper: light mauve TGL, handmade	
Edition: 5	
Proof: A	

Papermaking by Steve Reeves and Tom Stri-
anese, plate preparation and processing by
Kenneth Tyler and Pete Duchess; proofing
and edition printing by Rodney Konopaki
and Bob Cross

Signed *F. Stella*, numbered, and dated in
pencil lower right; chop mark lower center;
workshop number FS81-660E lower center
verso

4 runs: 5 colors; 4 runs from 1 assembled
plate made from 14 irregularly shaped mag-
nesium plates, and 3 magnesium plates:
 1 red and black; methods 15a, 12, 20,
 21a, 21c, 23c, 16a; III
 2 gold; methods 21a, 23a; III
 3 dark brown; methods 21a, 23a; III
 4 black; methods 21a, 23a; III

The magnesium plates used to make the
assembled plate were cut and mounted on
plywood backing by the artist assisted by
Tyler, Duane Mitch, Roger Campbell, Lee
Funderburg, Konopaki, and Cross. Sections
of the plywood border were inked and
printed with the assembled plate.

595:FS54
Axsom 170

Frank Stella
Swan Engraving Circle II, from the Swan
Engraving Series 1983

Etching, relief, engraving (1)	
52 (132.1) diameter	
Paper: white TGL, handmade	
Edition: 5	
Proofs: 2AP, 2TP, CTP, RTP, PPI, PPII, A	

Papermaking by Steve Reeves and Tom Stri-
anese; plate preparation and processing by
Kenneth Tyler and Pete Duchess; proofing
and edition printing by Rodney Konopaki
and Bob Cross

Signed *F. Stella*, numbered, and dated in
pencil upper right center; chop mark lower
center; workshop number FS81-661 lower
center verso

1 run: 1 color; 1 run from 1 assembled
plate made from 8 irregularly shaped
magnesium plates:
 1 black; methods 15a, 12, 20, 21a, 21c,
 23c; III

The magnesium plates used to make the
assembled plate were cut and mounted on
plywood backing by the artist assisted by
Tyler, Duane Mitch, Roger Campbell, Lee
Funderburg, Konopaki, and Cross. Sections
of the plywood border were inked and
printed with the assembled plate.

596:FS55
Axsom 170A

Frank Stella
Swan Engraving Circle II, State I, from the
Swan Engraving Series 1983

Etching, relief, engraving (6)	
52 (132.1) diameter	
Paper: light yellow TGL, handmade	
Edition: 5	
Proof: A	

Papermaking by Steve Reeves and Tom Stri-
anese; plate preparation and processing by
Kenneth Tyler and Pete Duchess; proofing
and edition printing by Rodney Konopaki
and Bob Cross

Signed *F. Stella*, numbered, and dated in
pencil lower right; chop mark lower center;
workshop number FS81-661A lower center
verso

4 runs: 6 colors: 4 runs from 1 assembled
plate made from 8 irregularly shaped
magnesium plates, and 3 magnesium
plates:
 1 blue, dark blue, and black; methods
 15a, 12, 20, 21a, 21c, 23c, 16a; III
 2 silver; methods 21a, 23a; III
 3 green; methods 21a, 23a; III
 4 black; methods 21a, 23a; III

The magnesium plates used to make the
assembled plate were cut and mounted on
plywood backing by the artist assisted by
Tyler, Duane Mitch, Roger Campbell, Lee
Funderburg, Konopaki, and Cross. Sections
of the plywood border were inked and
printed with the assembled plate.

597:FS56
Axsom 170B

Frank Stella
Swan Engraving Circle II, State II, from
the Swan Engraving Series 1983

Etching, relief, engraving (6)
52 (132.1) diameter
Paper: medium yellow TGL, handmade
Edition: 5
Proof: A

Papermaking by Steve Reeves and Tom Stri-
anese; plate preparation and processing by
Kenneth Tyler and Pete Duchess; proofing
and edition printing by Rodney Konopaki
and Bob Cross

Signed *F. Stella*, numbered, and dated in
pencil lower right; chop mark lower center;
workshop number FS81-661B lower center
verso

4 runs: 6 colors; 4 runs from 1 assembled
plate made from 8 irregularly shaped
magnesium plates, and 3 magnesium
plates:
 1 brown, light blue, and black; methods
 15a, 12, 20, 21a, 21c, 23c, 16a; III
 2 gold; methods 21a, 23a; III
 3 magenta; methods 21a, 23a; III
 4 black; methods 21a, 23a; III

The magnesium plates used to make the
assembled plate were cut and mounted on
plywood backing by the artist assisted by
Tyler, Duane Mitch, Roger Campbell, Lee
Funderburg, Konopaki, and Cross. Sections
of the plywood border were inked and
printed with the assembled plate.

598:FS57
Axsom 170C

Frank Stella
Swan Engraving Circle II, State III, from
the Swan Engraving Series 1983

Etching, relief, engraving (6)
52 (132.1) diameter
Paper: light yellow-orange TGL, handmade
Edition: 5
Proof: A

Papermaking by Steve Reeves and Tom Stri-
anese; plate preparation and processing by
Kenneth Tyler and Pete Duchess; proofing
and edition printing by Rodney Konopaki
and Bob Cross

Signed *F. Stella*, numbered, and dated in
pencil lower right; chop mark lower center;
workshop number FS81-661C lower center
verso

4 runs: 6 colors; 4 runs from 1 assembled
plate made from 8 irregularly shaped mag-
nesium plates, and 3 magnesium plates:
 1 magenta, light blue, and black;
 methods 15a, 12, 20, 21a, 21c, 23c,
 16a; III
 2 gold; methods 21a, 23a; III
 3 yellow; methods 21a, 23a; III
 4 black; methods 21a, 23a; III

The magnesium plates used to make the
assembled plate were cut and mounted on
plywood backing by the artist assisted by
Tyler, Duane Mitch, Roger Campbell, Lee
Funderburg, Konopaki, and Cross. Sections
of the plywood border were inked and
printed with the assembled plate.

599:FS58
Axsom 170D

Frank Stella
Swan Engraving Circle II, State IV, from
the Swan Engraving Series 1983

Etching, relief, engraving (6)
52 (132.1) diameter
Paper: light pink-gray TGL, handmade
Edition: 5
Proof: A

Papermaking by Steve Reeves and Tom Stri-
anese; plate preparation and processing by
Kenneth Tyler and Pete Duchess; proofing
and edition printing by Rodney Konopaki
and Bob Cross

Signed *F. Stella*, numbered, and dated in
pencil lower right; chop mark lower center;
workshop number FS81-661D lower center
verso

4 runs: 6 colors; 4 runs from 1 assembled
plate made from 8 irregularly shaped
magnesium plates, and 3 magnesium
plates:
 1 purple, green, and black; methods 15d,
 12, 20, 21a, 21c, 23c, 16a; III
 2 silver; methods 21a, 23a; III
 3 light blue; methods 21a, 23a; III
 4 black; methods 21a, 23a; III

The magnesium plates used to make the
assembled plate were cut and mounted on
plywood backing by the artist assisted by
Tyler, Duane Mitch, Roger Campbell, Lee
Funderburg, Konopaki, and Cross. Sections
of the plywood border were inked and
printed with the assembled plate.

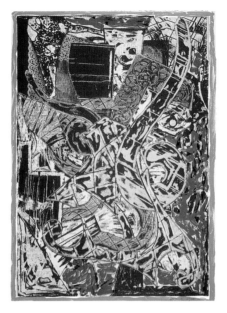

600:FS59
Axsom 170E

Frank Stella
Swan Engraving Circle II, State V, from the
Swan Engraving Series 1983

Etching, relief, engraving (6)
52 (132.1) diameter
Paper: light green TGL, handmade
Edition: 5
Proofs: CTP, A

Papermaking by Steve Reeves and Tom Stri-
anese; plate preparation and processing by
Kenneth Tyler and Pete Duchess; proofing
and edition printing by Rodney Konopaki
and Bob Cross

Signed *F. Stella,* numbered, and dated in
pencil lower right; chop mark lower center;
workshop number FS81-661E lower center
verso

4 runs: 6 colors; 4 runs from 1 assembled
plate made from 8 irregularly shaped mag-
nesium plates, and 3 magnesium plates:
 1 brown, blue, and black; methods 15d,
 12, 20, 21a, 21c, 23c, 16a; III
 2 silver; methods 21a, 23c; III
 3 red; methods 21a, 23c; III
 4 black; methods 21a, 23c; III

The magnesium plates used to make the
assembled plate were cut and mounted on
plywood backing by the artist assisted by
Tyler, Duane Mitch, Roger Campbell, Lee
Funderburg, Konopaki, and Cross. Sections
of the plywood border were inked and
printed with the assembled plate.

601:FS60
Axsom 162A

Frank Stella
Yellow Journal, State I 1984

Lithograph (20)
52½ × 38½ (133.5 × 97.8)
Paper: white Arches Cover, mould-made
Edition: 16
Proofs: 2TP, 2CTP, WP, RTP, A, C

Prep work for continuous-tone lithography
by Kenneth Tyler; plate preparation and
processing by Lee Funderburg; proofing by
Tyler, Funderburg, and Roger Campbell;
edition printing by Campbell and
Funderburg

Signed *F. Stella,* numbered, dated, and
titled (*State I*) in pencil lower right; chop
mark lower right; workshop number
FS81-649A lower left verso

20 runs: 20 colors; 20 runs from 19
aluminum plates:
 1 light yellow; method 5a; IIa
 2 yellow; method 5a; IIa
 3 silver-gray; method 5a; IIa
 4 dark green; method 5a; IIa
 5 black; method 5c; IIa
 6 red; method 5a; IIa
 7 transparent blue varnish; method 5a;
 IIa
 8 clear varnish; method 5a (same plate as
 run 7); IIa
 9 light blue; method 5a; IIa
 10 light orange-ocher; method 5a; IIa
 11 light red; method 5a; IIa
 12 white; method 5a; IIa
 13 light green; method 5a; IIa
 14 medium yellow; method 5a; IIa
 15 medium red; method 5a; IIa
 16 green; method 5a; IIa
 17 brown; method 5a; IIa
 18 blue; method 5a; IIa
 19 green; method 5a; IIa
 20 medium blue; method 5a; IIa

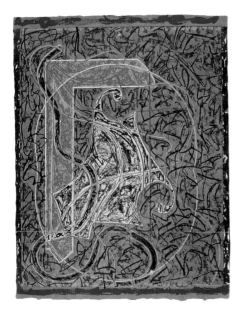

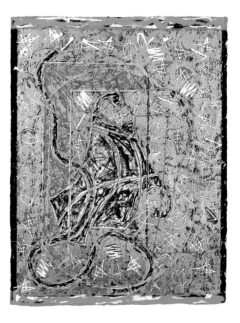

602:FS61
Axsom 164

Frank Stella
Imola Three II, from the Circuits
Series 1984

Relief, woodcut (29)

66 × 52 (167.6 × 132.1)

Paper: white TGL, handmade,
hand-colored

Edition: 30

Proofs: 10AP, 6TP, RTP, PPI, PPII, A

Papermaking by Steve Reeves and Tom Stri-
anese; laser-cut woodblock preparation by
Swan Engraving; plate preparation and
processing by Kenneth Tyler and Pete
Duchess; proofing by Tyler, Reeves, and
Strianese; edition printing by Reeves and
Strianese

Signed *F. Stella,* numbered, and dated in
pencil lower left; chop mark lower left;
workshop number FS81-594 lower right
verso

8 runs: 1 dye color, 1 paper pressing; 28
ink colors, 7 runs from 5 magnesium plates
and 2 woodblocks:
 1 red dye (on newly made white pulp
 base sheet); III

2 light yellow, red, blue, and black;
 methods 19b (birchwood), 16a; III
3 red, transparent white, and black;
 methods 20, 23a, 16a; III
4 blend of yellow, orange, red, violet, light
 blue, dark blue, green, and white;
 methods 19a (birchwood), 16g; III
5 light yellow, light yellow-orange, light
 magenta, light blue, dark green,
 yellow-green, white, and gray; methods
 21c, 23a, 16a; III
6 dark green and black; methods 21a,
 23a, 16a; III
7 red; methods 20, 21c, 23a; III
8 blue and black; methods 21a, 23a, 16a;
 III

603:FS62
Axsom 164A

Frank Stella
Imola Three II, State I, from the Circuits
Series 1984

Relief, woodcut, stencil, screenprint (35)

66 × 52 (167.6 × 132.1)

Paper: white TGL, handmade,
hand-colored

Edition: 10

Proofs: TP, RTP

Papermaking by Steve Reeves and Tom Stri-
anese; plate preparation and processing by
Kenneth Tyler and Pete Duchess; wood-
block preparation by Swan Engraving;
proofing and edition printing by Reeves and
Strianese; screen proofing and edition
printing by Tyler, Rodney Konopaki, and
Bob Cross; stenciling by Tyler and Mark
Mahaffey

Signed *F. Stella,* numbered, dated, and
titled (*State*) in pencil lower left; chop mark
lower left; workshop number FS81-594A
lower right verso

12 runs: 1 dye color, 1 paper pressing; 34
ink colors; 11 runs from 8 magnesium
plates, 2 screens, and 1 woodblock:
 1 red dye (on newly made white pulp
 base sheet); III
 2 yellow, red, blue, and black; methods
 19b (birchwood), 16a; III

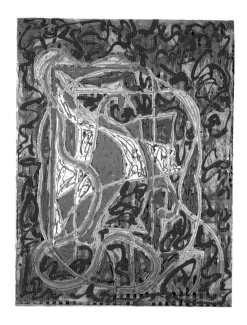

3 red, transparent white, and black; methods 20, 23a, 16a; III

4 silver; methods 21a, 21c, 23a; III

5 light yellow, light yellow-orange, light magenta, light blue, dark green, yellow-green, gray, and white; methods 21c, 23a, 16a; III

6 black and dark green; methods 21a, 23a, 16a; III

7 red; methods 20, 21c, 23a; III

8 blue and silver; methods 21a, 23a, 16a; III

9 white; methods 21a, 23a; III

10 orange; method 20 (same plate as run 3 with only borders printed); III

11 yellow, orange, red, magenta, purple, tan, blue, light green, green, and dark green; methods 29a, 32c

12 white; method 29a; VI

604:FS63
Axsom 165

Frank Stella
Imola Three IV, from the Circuits Series 1984

Relief, screenprint (27)	
66 × 52 (167.6 × 132.1)	
Paper: white TGL, handmade, hand-colored	
Edition: 30	
Proofs: 10AP, 2TP, 5WP, RTP, PPI, PPII, A	

Papermaking by Steve Reeves and Tom Strianese; plate preparation and processing by Kenneth Tyler and Pete Duchess; proofing and edition printing by Reeves and Strianese; screen proofing and edition printing by Tyler, Reeves, Strianese, and Mark Mahaffey

Signed *F. Stella*, numbered, and dated in pencil lower left; chop mark lower left; workshop number FS81-667 lower right verso

14 runs: 2 dye colors, 1 paper pressing; 25 ink colors, 13 runs from 8 magnesium plates and 4 screens:

1 yellow and blue dyes (on newly made white pulp base sheet); III

2 dark blue; methods 21a, 21c, 23a; III

3 orange; methods 20, 21c, 23a; III

4 copper; methods 20, 21a, 23a; III

5 repeat of run 4

6 yellow, orange, and white; methods 21a, 23a, 16a; III

7 red; methods 20, 21c, 23a; III

8 orange and pink; methods 21a, 23a; III

9 brown, light blue, dark blue, blue-green, and green; methods 21a, 23a, 16a; III

10 yellow, dark yellow-ocher, dark red, blue-green, green, and white; methods 21a, 23a, 16a; III

11 red gloss enamel; method 29a; VI

12 black; method 29a; VI

13 tan; method 29a; VI

14 gray; method 29a; VI

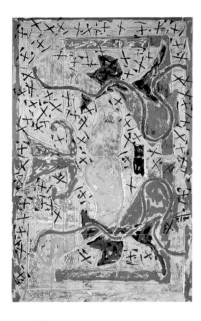

605:FS64
Axsom 167

Frank Stella
Pergusa Three Double, from the Circuits
Series 1984

Relief, screenprint, woodcut, engraving (74)
2 sheets: 102 × 66 (259.1 × 167.6),
each: 52 × 66 (132.1 × 167.6), hinged
together
Paper: white TGL, handmade,
hand-colored
Edition: 30
Proofs: 10AP, 3TP, 2WP, RTP, PPI, PPII, A

Papermaking by Steve Reeves and Tom
Strianese; plate preparation and processing
by Kenneth Tyler and Pete Duchess;
laser-cut woodblock preparation by Swan
Engraving; proofing and edition printing by
Reeves and Strianese

Signed *F. Stella,* numbered, and dated in
pencil lower right; chop mark lower right;
workshop number FS81-666 lower left
verso

25 runs: 10 dye colors, 1 paper pressing;
64 ink colors; 24 runs from 7 magnesium
plates, 9 screens, and 1 woodblock:
1 yellow, light orange, red-orange, red,
 magenta, pale light purple, light purple,
 purple, blue, and yellow-green dyes (on
 newly made white pulp base sheets); III
2 silver (on bottom sheet); methods 12,
 20, 21a, 23a; III
3 silver (on top sheet); methods 19a, 19b
 (birchwood); III
4 yellow (on bottom sheet); method 29a;
 III
5 yellow (on top sheet); method 29a; III
6 yellow-ocher, red, red-violet, blue,
 blue-green, and black (on top sheet);
 methods 21a, 23a, 16a; III
7 light yellow, medium yellow, green, and
 black (on top sheet); methods 21a, 23a,
 16a; III
8 red and blue (on top sheet); methods
 21a, 23a, 16a; III
9 light yellow, yellow-ocher, orange, light
 red, red, magenta, violet, blue, green,
 yellow-green, gray, and black (on top
 sheet); methods 20, 23a, 16a; III
10 light yellow, yellow-ocher, orange, light
 red, red, magenta, violet, blue, green,
 yellow-green, gray, and black (on bot-
 tom sheet); methods 21a, 23a, 16a; III
11 yellow, medium yellow, blue, and black
 (on bottom sheet); methods 21a, 23a,
 16a; III

12 yellow-ocher, red, red-violet, yellow-
 green, and black (on bottom sheet);
 methods 21a, 23a, 16a; III
13 light blue (on top sheet); method 29a;
 VI
14 blue-green (on top sheet); method 29a;
 VI
15 light blue-green (on top sheet); method
 29a; VI
16 black (on top sheet); method 29a; VI
17 red (on top sheet); method 29a; VI
18 medium yellow and red (on top sheet);
 methods 29a, 16e; VI
19 orange (on bottom sheet); method 29a;
 VI
20 violet (on bottom sheet); method 29a;
 VI
21 pink (on bottom sheet); method 29a;
 VI
22 green (on bottom sheet); method 29a;
 VI
23 yellow and red (on bottom sheet);
 methods 29a, 16e; VI
24 black (on bottom sheet); method 29a;
 VI
25 red (on bottom sheet); method 29a; VI

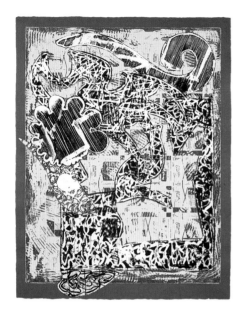

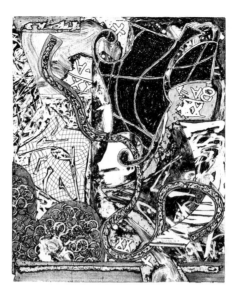

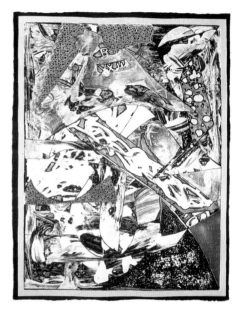

606:FS65
Axsom 163

Frank Stella
Green Journal 1985

Etching, screenprint, relief (3)

66 × 51 (167.6 × 129.5)	
Paper: white TGL, handmade	
Edition: 25	
Proofs: 8AP, 4TP, RTP, PPI, PPII, A	

Papermaking by Steve Reeves and Tom Strianese; plate preparation and processing by Kenneth Tyler and Pete Duchess; proofing and edition printing by Rodney Konopaki and Bob Cross; screen preparation by Reeves and Strianese; proofing and edition printing by Reeves, Strianese, Konopaki, Cross, Tyler, and Mark Mahaffey

Signed *F. Stella*, numbered, and dated in pencil lower right; chop mark lower right; workshop number FS81-596 lower left verso

2 runs: 3 colors; 2 runs from 1 assembled plate made from 5 irregularly shaped magnesium plates, and 1 screen:
 1 green and black; methods 15a, 20, 21a, 21c, 23b, 16a; III
 2 yellow; method 28 (SR); VI

The magnesium plates used to make the assembled plate were cut and mounted on plywood backing by the artist assisted by Tyler, Duane Mitch, Roger Campbell, Lee Funderburg, Konopaki, and Cross. Sections of the plywood border were inked and printed with the assembled plate.

607:FS66
Axsom 161

Frank Stella
Swan Engraving V, from the Swan Engraving Series 1985

Relief, etching, engraving (1)

59½ × 49¾ (151.1 × 126.4)	
Paper: white TGL, handmade	
Edition: 25	
Proofs: 8AP, TP, RTP, PPI, PPII, A	

Papermaking by Steve Reeves and Tom Strianese; plate preparation and processing by Kenneth Tyler and Pete Duchess; proofing and edition printing by Rodney Konopaki and Bob Cross

Signed *F. Stella*, numbered, and dated in pencil lower right; chop mark lower right; workshop number FS81-650 lower left verso

1 run: 1 color; 1 run from 1 assembled plate made from 32 irregularly shaped magnesium plates:
 1 black; methods 15a, 20, 21a, 21c, 23c, 12; III

The magnesium plates used to make the assembled plate were cut and mounted on plywood backing by the artist assisted by Tyler, Duane Mitch, Roger Campbell, Lee Funderburg, Konopaki, and Cross.

608:FS67
Axsom 171

Frank Stella
Swan Engraving Framed I, from the Swan Engraving Series 1985

Relief, etching (2)

51½ × 39½ (130.8 × 100.3)	
Paper: white TGL, handmade	
Edition: 20	
Proofs: 8AP, RTP, PPI, PPII, A	

Papermaking by Steve Reeves and Tom Strianese; plate preparation and processing by Kenneth Tyler and Pete Duchess; proofing and edition printing by Rodney Konopaki and Bob Cross

Signed *F. Stella*, numbered, and dated in pencil lower right; chop mark lower right; workshop number FS81-662 lower left verso

1 run: 2 colors; 1 run from 1 assembled plate made from 33 irregularly shaped magnesium plates:
 1 tan and black; methods 15a, 20, 21a, 23c, 16a; III

The magnesium plates used to make the assembled plate were cut and mounted on plywood backing by the artist assisted by Tyler, Duane Mitch, Roger Campbell, Lee Funderburg, Konopaki, and Cross. The plywood border was inked and printed with the assembled plate.

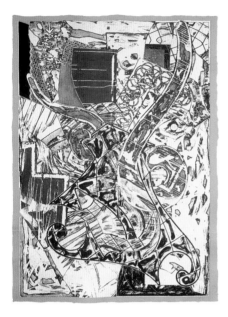

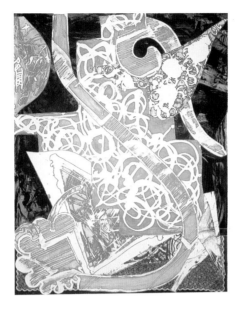

609:FS68
Axsom 172

Frank Stella
Swan Engraving Framed II, from the Swan
Engraving Series 1985

Relief, etching (3)	
57½ × 42½ (146.1 × 108)	
Paper: light tan TGL, handmade	
Edition: 15	
Proofs: 6AP, 2TP, 6CTP, RTP, PPI, PPII, A	

Papermaking by Steve Reeves and Tom Stri-
anese; plate preparation and processing by
Kenneth Tyler and Pete Duchess; proofing
and edition printing by Rodney Konopaki
and Bob Cross

Signed *F. Stella,* numbered, and dated in
pencil lower left; chop mark lower right;
workshop number FS82-666 lower left
verso

1 run: 3 colors; 1 run from 1 assembled
plate made from 40 irregularly shaped
magnesium plates:
 1 brown, dark brown, and blue; methods
 15a, 20, 21a, 21c, 23c, 16a; III

The magnesium plates used to make the
assembled plate were cut and mounted on
plywood backing by the artist assisted by
Tyler, Duane Mitch, Roger Campbell, Lee
Funderburg, Konopaki, and Cross. The
plywood border was inked and printed
with the assembled plate.

610:FS69
Axsom 173

Frank Stella
Swan Engraving Blue, Green, Grey, from
the Swan Engraving Series 1985

Relief, etching (5)	
66 × 51 (167.6 × 129.5)	
Paper: white TGL, handmade	
Edition: 20	
Proofs: 10AP, SP, RTP, PPI, PPII, A	

Papermaking by Steve Reeves and Tom Stri-
anese; plate preparation and processing by
Kenneth Tyler and Pete Duchess; proofing
and edition printing by Rodney Konopaki
and Bob Cross

Signed *F. Stella,* numbered, and dated in
pencil lower left; chop mark lower right;
workshop number FS82-665 lower left
verso

1 run: 5 colors; 1 run from 1 assembled
plate made from 33 irregularly shaped
magnesium plates:
 1 blue, dark blue, green, gray, and black;
 methods 15a, 20, 21a, 21c, 23c, 16a;
 III

The magnesium plates used to make the
assembled plate were cut and mounted on
plywood backing by the artist assisted by
Tyler, Duane Mitch, Roger Campbell, Lee
Funderburg, Konopaki, and Cross. The
plywood border was inked and printed
with the assembled plate.

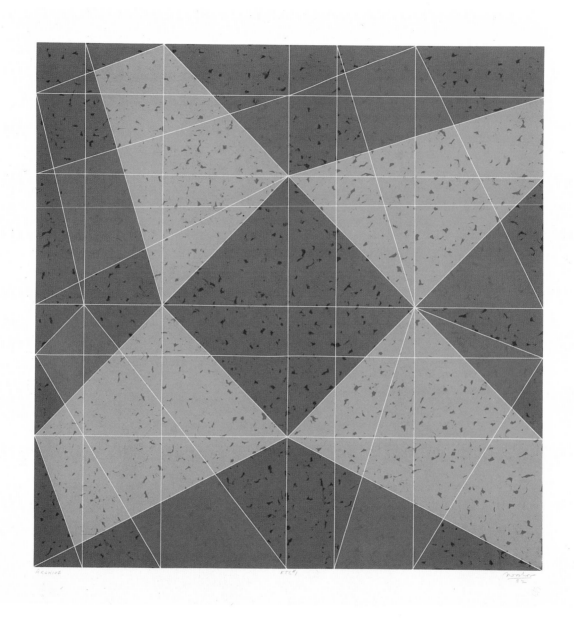

KTL #1 1982
See 611:JT1 (opposite)

Jack Tworkov

611:JT1

Jack Tworkov
KTL #1 1982

Lithograph (4)
27½ × 27½ (69.9 × 69.9)
Paper: white Arches Cover, mould-made
Edition: 150
Proofs: 25 AP, SP, RTP, PPI, PPII, A, C

Plate preparation, processing, and proofing by Kenneth Tyler, Roger Campbell, and Lee Funderburg; edition printing by Campbell and Funderburg

Signed *Tworkov*, numbered, dated, and titled in pencil lower edge; chop mark lower right; workshop number JT82-626 lower left verso

4 runs: 4 colors; 4 runs from 4 aluminum plates:
 1 tan; method 5b; IIa
 2 gray; method 5c; IIa
 3 dark brown; method 5c; IIa
 4 light brown; method 5c; IIa

This edition was commissioned by the Lakeside Group for the 1982 Chicago International Art Exposition. This image was also reproduced, with lettering added, as the official exposition poster.

1900 Born Jacob Tworkovsky in Biala, Poland

1920–23 Studies at Columbia College, New York

1923–24 Studies with Ivan Olinsky at National Academy of Design, New York

1925 Studies with Guy Pène du Bois and Boardman Robinson at Art Students League, New York

1928 Becomes United States citizen

1931 Teaches at Fieldston School of Ethical Culture, Bronx, New York

1934 Joins Treasury Department's Public Works of Art Project, New York

1935–41 Works in easel division of WPA Federal Art Project, New York

1940 First solo exhibition at ACA Gallery, New York

1942 Works as tool designer during World War II

1948 First solo museum exhibition at Baltimore Museum of Art

1949 Cofounder of Eighth Street Club, which becomes a center for the artists of the New York school

1954 Teaches at Indiana University, Bloomington, and at University of Mississippi, Oxford

1955–58 Teaches life drawing at Pratt Institute, Brooklyn

1963 Receives William A. Clark Prize from Corcoran Gallery of Art, Washington, D.C.; appointed chairman of art department of School of Art and Architecture and named William C. Leffingwell Professor of Painting, Yale University, New Haven, Connecticut; awarded M.F.A. in privatum by Yale University

1964 Traveling exhibition *Jack Tworkov* at Whitney Museum of American Art, New York

1969 Elected William C. Leffingwell Professor of Painting, emeritus, Yale University

1970 Receives John Simon Guggenheim Memorial Foundation Fellowship

1971 Solo exhibition at Whitney Museum of American Art, New York; receives honorary doctorate in fine arts from Maryland Institute of Art, Baltimore

1972 Artist-in-residence, American Academy of Arts and Letters, Rome; awarded honorary doctorate of humane letters, Columbia University, New York

1973 Artist-in-residence, Dartmouth College, Hanover, New Hampshire

1974 Receives Painter of the Year Award, Skowhegan School of Painting and Sculpture, Skowhegan, Maine

1977 Completes T.L. #I–V lithograph series at Tamarind Institute, Albuquerque, New Mexico

1979 Receives honorary degree, Rhode Island School of Design, Providence

1981 Elected member of American Academy and Institute of Arts and Letters

1982 Completes lithograph at Tyler Graphics; solo exhibition at Solomon R. Guggenheim Museum, New York

1984 Included in exhibition *Prints from Tyler Graphics* at Walker Art Center, Minneapolis.

Jack Tworkov died on September 4, 1982

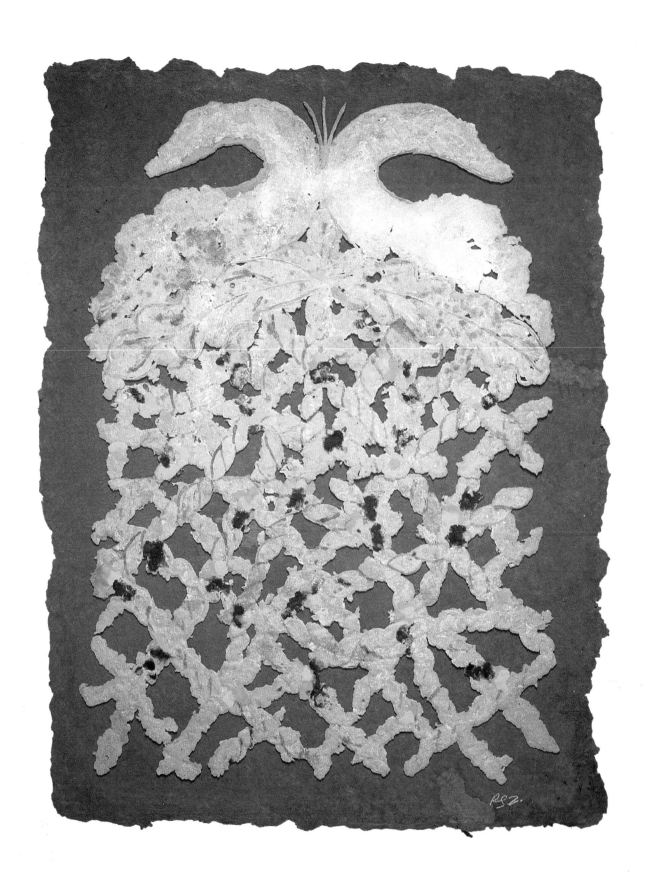

Double Green Geese (Braided),
from the Paper Pulp Series 1981
See 847:RZ43 (Appendix)

Robert Zakanitch

1935 Born in Elizabeth, New Jersey

1954–57 Attends Newark School of Fine and Industrial Arts; graduates from nondegree program in commercial art

1957–58 Works as a commercial artist

1958–60 Drafted; serves in United States Army special services

1961–62 Commercial artist for D'Arcy Advertising Corporation, New York

1962 Leaves advertising to paint full-time; works in Abstract Expressionist style

1965 First solo exhibition at Henri Gallery, Alexandria, Virginia

1967 Included in annual exhibition, Whitney Museum of American Art, New York (also included in 1969 and 1973)

1971 Meets Miriam Schapiro in La Jolla, California

1973 Included in thirty-third biennial exhibition, Corcoran Gallery of Art, Washington, D.C.

1975 Meets with "pattern" painters at his home (group includes Joyce Kozloff, Robert Kushner, and Miriam Schapiro) to discuss the issue of "decoration"

1976 Visiting artist-lecturer at Art Institute of Chicago; included in first exhibition about "decoration," organized by Jane Kaufman at Alessandra Gallery, New York

1977 Completes screenprint *Untitled*, published by HKL/Ltd., Boston

1978 Completes first hand-colored screenprint, published by Brooke Alexander, New York

1980 Included in thirty-ninth Venice Biennale; included in traveling exhibition *The Morton G. Neumann Family Collection: Selected Works*, organized by National Gallery of Art, Washington, D.C.

1980–81 Completes prints and unique paper-pulp works at Tyler Graphics

1981 Solo exhibition at Institute of Contemporary Art, University of Pennsylvania, Philadelphia; included in biennial exhibition, Whitney Museum of American Art, New York

1984 Included in exhibition *Prints from Tyler Graphics* at Walker Art Center, Minneapolis

Currently lives and works in Brooklyn

612:RZ1

Robert Zakanitch
Hearts of Swan (Black) 1981

Screenprint, lithograph, stencil (15)
27¼ × 22½ (69.2 × 57.2)
Paper: white TGL, handmade
Edition: 75
Proofs: 16AP, TP, 4CTP, SP, RTP, PPI, PPII, PPIII, A, C

Papermaking by Kim Halliday; screen preparation, processing, proofing, and edition printing by Tom Strianese; plate preparation and processing by Kenneth Tyler and Lee Funderburg; proofing and edition printing by Roger Campbell and Funderburg; stenciling by Tyler

Signed *RS Zakanitch* and dated in pencil lower right; numbered lower left; chop mark lower right; workshop number RZ80-490 lower left verso

14 runs: 15 colors; 14 runs from 8 screens, 5 aluminum plates, and 1 stencil:
 1 blend of light tan and black; methods 1b, 16d; IIa
 2 white; method 32a
 3 yellow-ocher; method 29a; VI
 4 pink; method 29a; VI
 5 gray; method 29a; VI
 6 white; method 29a; VI
 7 dark green; method 29a; VI
 8 light green; method 29a; VI
 9 white; method 29a; VI
10 magenta; method 29a; VI
11 magenta; method 1b; IIa
12 brown; method 1b; IIa
13 medium gray; method 1b; IIa
14 light gray; method 1b; IIa

613:RZ2

Robert Zakanitch
Hearts of Swan (Red) 1981

Screenprint, lithograph (19)
27¼ × 22½ (69.2 × 57.2)
Paper: white TGL, handmade
Edition: 75
Proofs: 14AP, TP, 6CTP, WP, RTP, PPI, PPII, PPIII, A, C

Papermaking by Kim Halliday; screen preparation, processing, proofing, and edition printing by Tom Strianese; plate preparation and processing by Kenneth Tyler and Lee Funderburg; proofing and edition printing by Roger Campbell and Funderburg

Signed *RS Zakanitch* and dated in pencil lower right; numbered lower left; chop mark lower right; workshop number RZ80-492 lower left verso

17 runs: 19 colors; 17 runs from 10
screens and 7 aluminum plates:
 1 dark red; method 1b; IIa
 2 blend of light pink and pink; methods
 1b, 16d; IIa
 3 white; method 29a; VI
 4 green; method 29a; VI
 5 red-brown; method 29a; IV
 6 medium green; method 29a; VI
 7 medium dark green; method 29a; VI
 8 dark green; method 29a; VI
 9 light gray; method 29a; VI
 10 yellow; method 29a; VI
 11 pink; method 29a; VI
 12 blend of light red and red; methods
 29a, 16f; VI
 13 white; method 29a; VI
 14 medium gray; method 1b; IIa
 15 black; method 1b; IIa
 16 tan; method 1b; IIa
 17 light tan; method 1b; IIa

614:RZ3

Robert Zakanitch
Double Geese Mountain 1981

Screenprint, lithograph, stencil (16)	
27¼ × 22½ (69.2 × 57.2)	
Paper: white TGL, handmade	
Edition: 75	
Proofs: 15AP, 4TP, 2CTP, WP, RTP, PPI, PPII, PPIII, A, C	

Papermaking by Kim Halliday; screen
preparation, processing, proofing, and
edition printing by Tom Strianese; plate
preparation and processing by Kenneth
Tyler and Lee Funderburg; proofing and
edition printing by Roger Campbell and
Funderburg; stenciling by Tyler

Signed *RS Zakanitch* and dated in pencil
lower right; numbered lower left; chop
mark lower right; workshop number
RZ80-493 lower left verso

16 runs: 16 colors; 16 runs from 11
screens, 4 aluminum plates, and 1 stencil:
 1 dark brown; method 29a; VI
 2 light green; method 29a; VI
 3 pink; method 29a; VI
 4 light purple-blue; method 29a; VI
 5 light pink; method 29a; VI
 6 magenta; method 29a; VI
 7 gloss white; method 29a; VI
 8 medium green; method 29a; VI
 9 light green; method 29a; VI
 10 dark green; method 29a; VI
 11 pink-brown; method 29a; VI
 12 gray; method 1b; IIa
 13 brown; method 1b; IIa
 14 pink; method 1b; IIa
 15 transparent brown; method 1b; IIa
 16 pink; method 32a

615:RZ4

Robert Zakanitch
How I Love Ya, How I Love Ya 1981

Screenprint, lithograph, stencil (22)

42 × 120 (106.7 × 304.8)

Paper: white Rives BFK; mould-made

Edition: 43

Proofs: 10AP, 7CTP, WP, RTP, PPI, PPII, A, C

Screen preparation by Tom Strianese; proofing and edition printing by Strianese, Rodney Konopaki, Kenneth Tyler, and Steve Reeves; plate preparation and processing by Tyler; proofing and edition printing by Tyler and Konopaki

Signed *RS Zakanitch* and dated in pencil lower right; numbered lower left; chop mark lower right; workshop number RZ80-561 lower left verso

35 runs: 22 colors; 35 runs from 23 screens, 8 aluminum plates, and 2 stencils:
 1 black (on left side); method 1b; I
 2 black (on right side); method 1b; I
 3 gray-black (on left side); method 1b; I
 4 gray-black (on right side); method 1b; I
 5 green-black (on left side); method 1b; I
 6 green-black (on right side); method 1b; I
 7 pale pink (on left side); method 29a; VI
 8 pale pink (on right side); method 29a; VI
 9 medium pink (on left side); method 1b; I
10 medium pink (on right side); method 1b; I
11 pale light pink (on left side); method 29a; VI
12 pale light pink (on right side); method 29a; VI
13 light brown-green; method 29a; VI
14 dark green (on left side); method 29a; VI
15 dark green (on right side); method 29a; VI
16 light green (on left side); method 29a; VI
17 light green (on right side); method 29a; VI
18 white (on left side); method 29a; VI
19 white (on right side); method 29a; VI
20 light pink (on left side); method 29a; VI
21 light pink (on right side); method 29a; VI
22 pink (on left side); method 29a; VI
23 pink (on right side); method 29a; VI
24 medium pink (on left side); method 29a; VI
25 medium pink (on right side); method 29a; VI
26 light pink-brown; methods 29a (same screen as run 9), 27 (TS); VI
27 white (on left side); method 29a; VI
28 white (on right side); method 29a; VI
29 pink-brown; methods 29a (same screen as run 9), 27 (TS); VI
30 light brown (on left side); method 29a; VI
31 light brown (on right side); method 29a; VI
32 white; method 29a; VI (wet ink smeared by the artist with a rag immediately after each impression was pulled)
33 white and gold; methods 29a, 16e; VI
34 yellow; method 32a (SR, TS)
35 dark orange; method 32a (SR, TS)

616:RZ5

Robert Zakanitch
How I Love Ya, How I Love Ya, State I
1981

Screenprint, lithograph, stencil (14)
42 × 120 (106.7 × 304.8)
Paper: white Rives BFK, mould-made
Edition: 5

Screen preparation by Tom Strianese;
edition printing by Strianese, Rodney
Konopaki, Kenneth Tyler, and Steve Reeves;
plate preparation and processing by Tyler;
edition printing by Tyler and Rodney
Konopaki

Signed *RS Zakanitch*, numbered, dated,
and titled (*State I*) in pencil lower right;
chop mark lower right; workshop number
RZ80-561A lower left verso

27 runs: 14 colors; 27 runs from 18
screens, 8 aluminum plates, and 1 stencil:
 1 black (on left side); method 1b; I
 2 black (on right side); method 1b; I
 3 gray-black (on left side); method 1b; I
 4 gray-black (on right side); method 1b; I
 5 green-black (on left side); method 1b; I
 6 green-black (on right side); method 1b; I
 7 pale gray (on left side); method 29a; VI
 8 pale gray (on right side); method 29a; VI
 9 light gray (on left side); method 29a; VI
10 light gray (on right side); method 29a; VI
11 gray (on left side); method 1b; I
12 gray (on right side); method 1b; I
13 white (on left side); method 29a; VI
14 white (on right side); method 29a; VI
15 light gray (on left side); method 29a; VI
16 light gray (on right side); method 29a; VI
17 dark green (on left side); method 29a; VI
18 dark green (on right side); method 29a; VI
19 light green (on left side); method 29a; VI
20 light green (on right side); method 29a; VI
21 medium gray (on left side); method 29a; VI

22 medium gray (on right side); method 29a; VI
23 dark gray (on left side); method 29a; VI
24 dark gray (on right side); method 29a; VI
25 white (on left side); method 29a; VI
26 white (on right side); method 29a; VI
27 pale gray; method 32a

After the artist stenciled the pale gray color,
he added the same color to other areas of
the print using his thumb.

617:RZ6

Robert Zakanitch
How I Love Ya, How I Love Ya, State II
1981

Screenprint, lithograph, stencil (15)	
42 × 120 (106.7 × 304.8)	
Paper: white Rives BFK, mould-made	
Edition: 5	

Screen preparation by Tom Strianese; edition printing by Strianese, Rodney Konopaki, Kenneth Tyler, and Steve Reeves; plate preparation and processing by Tyler; edition printing by Tyler and Konopaki

Signed *RS Zakanitch*, numbered, dated, and titled (*State II*) in pencil lower right; chop mark lower right; workshop number RZ80-561B lower left verso

28 runs: 15 colors; 28 runs from 19 screens, 8 aluminum plates, and 1 stencil:
 1 black (on left side); method 1b; I
 2 black (on right side); method 1b; I
 3 gray-black (on left side); method 1b; I
 4 gray-black (on right side); method 1b; I
 5 green-black (on left side); method 1b; I
 6 green-black (on right side); method 1b; I
 7 medium red-violet (on left side); method 29a; VI
 8 medium red-violet (on right side); method 29a; VI
 9 dark red-violet (on left side); method 29a; VI
 10 dark red-violet (on right side); method 29a; VI
 11 blue-violet; method 29a; VI
 12 white (on left side); method 29a; VI
 13 white (on right side); method 29a; VI
 14 dark red (on left side); method 1b; I
 15 dark red (on right side); method 1b; I
 16 dark green (on left side); method 29a; VI
 17 dark green (on right side); method 29a; VI
 18 light green (on left side); method 29a; VI
 19 light green (on right side); method 29a; VI
 20 light red-violet (on left side); method 29a; VI
 21 light red-violet (on right side); method 29a; VI
 22 red-violet (on left side); method 29a; VI
 23 red-violet (on right side); method 29a; VI
 24 blue-violet (on left side); method 29a; VI
 25 blue-violet (on right side); method 29a; VI
 26 light gray–blue-purple (on left side); method 29a; VI
 27 light gray–blue-purple (on right side); method 29a; VI
 28 yellow; method 32a

After the artist stenciled the yellow color, he added the same color to other areas of the print using his thumb.

DOUBLE PEACOCK AND PAPER PULP SERIES

In 1981 Robert Zakanitch completed two series of unique paper-pulp works: the Double Peacock Series (twenty-one works) and the Paper Pulp Series (twenty-three works). Similar techniques were used in making both series. The artist applied colored pulps and dyes onto felts, using various devices as image guides. Several small metal molds were constructed from strips of galvanized metal cut and soldered together. Zakanitch positioned these molds in different configurations to create his images. He began some of the pulp works by tracing a paper pattern directly on the wet base sheet with watercolor pencils, while he began others by placing molds on a newly made white pulp base sheet. He applied pulps and dyes, removed the molds, and colored further, applying pulp by hand against strips of metal he used as straight-edges or bent to create a rounded edge. Zakanitch also formed some of the pulp shapes with his hands.

In the Double Peacock Series each work is a color variation of the same image, since the same mold configuration was used repeatedly. Zakanitch applied colored pulps and dyes through molds positioned on newly made white pulp base sheets. After removing the molds, he applied additional pulps and dyes freehand.

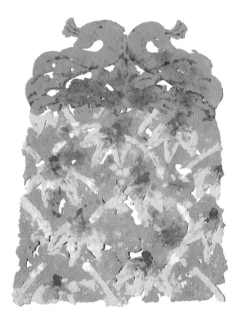

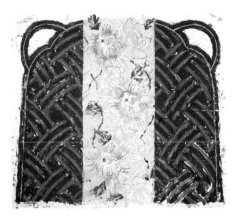

For the Paper Pulp Series the artist employed a wide variety of methods to make his images. The works are not color variations of the same image, although several are similar. For twelve of the images a white pulp base sheet was couched, and Zakanitch applied colored pulps and dyes to the sheet using various guides. For the others molds were placed directly on felts, and the artist applied colored pulps and dyes through molds. In each work he also applied additional pulps and dyes freehand. He made the colored backing sheets by pouring pulp onto a felt and then pressing it into a sheet.

Each work is signed *RSZ* in pencil lower right (some of the dark images are signed in white pencil), with the series number and chop mark lower left verso.

Six works are documented in full here, and the remainder are documented in abbreviated form in the Appendix.

618:RZ17

Robert Zakanitch
Double Peacock 11, from the Double Peacock Series 1981

Colored, pressed paper pulp
48 × 36 (121.9 × 91.4)

Pulp preparation by Steve Reeves and Tom Strianese; image mold constructed by Duane Mitch and Reeves; application of colored pulps and dyes by artist assisted by Reeves, Strianese, and Kenneth Tyler

Signed *RSZ* in pencil lower right; series number and chop mark lower left verso

Pink, light tan, and gray colored pulps applied directly onto felt through an image mold constructed from galvanized metal strips soldered together; mold removed and additional pulps and dyes applied freehand; paper pressed

619:RZ28

Robert Zakanitch
Sapphire, from the Paper Pulp Series 1981

Colored, pressed paper pulp
Six sheets: 83½ × 97½ (212.1 × 247.7); each: 42 × 32 (106.7 × 81.3)

Papermaking by Steve Reeves and Tom Strianese; image molds constructed by Duane Mitch and Reeves; paper coloring by artist assisted by Reeves, Strianese, and Kenneth Tyler

Signed *RSZ* in pencil lower right of lower right sheet; chop mark lower left verso of lower right sheet

6 newly made white pulp base sheets with colored pulps and dyes applied through image molds constructed from galvanized metal strips soldered together; molds removed and additional pulps and dyes applied freehand around a bent metal strip used as a guide; papers pressed

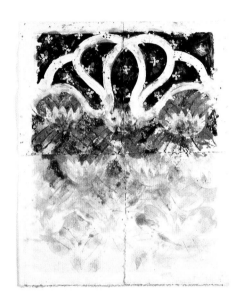

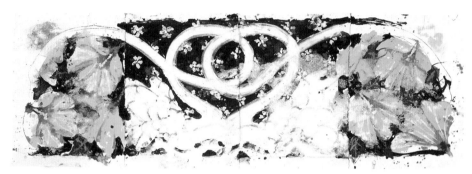

620:RZ34

Robert Zakanitch
Straightback Swans II, from the Paper Pulp
Series 1981

Colored, pressed paper pulp
Four sheets: 85 × 70 (215.9 × 177.8);
each: 42 × 32 (106.7 × 81.3)

Papermaking by Steve Reeves and Tom Stri-
anese; image molds constructed by Duane
Mitch and Reeves; paper coloring by artist
assisted by Reeves, Strianese, and Kenneth
Tyler

Signed *RSZ* in pencil lower right of lower
right sheet; signed *R. S. Zakanitch* and
dated in pencil lower left verso of lower
right sheet; chop mark lower left verso of
lower right sheet

4 newly made white pulp base sheets;
paper stencils traced with watercolor
pencils on base sheets; colored pulps and
dyes applied through image molds
constructed from galvanized metal strips
soldered together; molds removed and addi-
tional pulps and dyes applied freehand;
papers pressed

621:RZ39

Robert Zakanitch
Swan Mallow, from the Paper Pulp Series
1981

Colored, pressed paper pulp
Four sheets: 42½ × 125½ (108 × 318.8);
each: 42 × 32 (106.7 × 81.3)

Papermaking by Steve Reeves and Tom Stri-
anese; image molds constructed by Duane
Mitch and Reeves; paper coloring by artist
assisted by Reeves, Strianese, and Kenneth
Tyler

Signed *RSZ* in pencil lower right of right
sheet; chop mark lower left verso of right
sheet

4 newly made white pulp base sheets;
paper stencils traced with watercolor
pencils on base sheets; colored pulps and
dyes applied through image molds
constructed from galvanized metal strips
soldered together; molds removed and addi-
tional pulps and dyes applied freehand;
papers pressed

622:RZ40

Robert Zakanitch
Thrush, from the Paper Pulp Series 1981

Colored, pressed paper pulp
32 × 42 (81.3 × 106.7)

Pulp preparation by Steve Reeves and Tom
Strianese; image mold constructed by
Duane Mitch and Reeves; application of
colored pulps and dyes by artist assisted by
Reeves, Strianese, and Kenneth Tyler

Signed *RSZ* in white pencil lower right;
chop mark lower left verso

Colored pulps applied directly onto felt
through an image mold constructed from
galvanized metal strips soldered together;
mold removed and additional pulps and
dyes applied freehand; paper pressed

623:RZ48

Robert Zakanitch
Veranda, from the Paper Pulp Series 1981

Colored, pressed paper pulp
Backing sheet: 62 × 46 (157.5 × 116.8)

Pulp preparation by Steve Reeves and Tom
Strianese; image molds constructed by
Duane Mitch and Reeves; application of
colored pulps and dyes by artist assisted by
Reeves, Strianese, and Kenneth Tyler

Signed *RSZ* in white pencil lower right of
lower paper section; chop mark lower left
verso of backing sheet

2 colored paper sections attached to
backing sheet: sections made from colored
pulps hand-formed directly on felt or
applied through image molds constructed
from galvanized metal strips soldered
together; molds removed; papers pressed;
backing sheet made from white pulp
poured directly on felt and hand-formed
into sized sheet; paper pressed; once dried,
colored paper sections attached to backing
sheet with archival tape

Appendix

The Appendix contains abbreviated entries for the following unique works: Anthony Caro's paper sculptures, David Hockney's Paper Pools, Richard Smith's Cartouche Series, and Robert Zakanitch's Double Peacock Series and Paper Pulp Series. Discussions of the fabrication of these works, as well as full-length entries for selected works from these series, appear in the body of the catalogue. Additional information about works in the Appendix can be obtained from Tyler Graphics.

624:AC1
Blume 1375
Anthony Caro
#1. Number One 1982
Sculpture, hand-colored
Materials: chalk, acrylic paints, corrugated board, handmade paper, wood on Tycore panel
24¼ × 35½ × 7 (61.6 × 90.2 × 17.8)

627:AC4
Blume 1378
Anthony Caro
#5. Untitled 1982
Sculpture, hand-colored
Materials: chalk, acrylic paints, handmade paper on corrugated board
28 × 30 × 8½ (71.1 × 76.2 × 21.6)

625:AC2
Blume 1376
Anthony Caro
#3. Untitled 1982
Sculpture, hand-colored
Materials: pencil, chalk, acrylic paints, handmade paper on Tycore panel
32½ × 27 × 6 (82.6 × 68.6 × 15.2)

628:AC5
Blume 1379
Anthony Caro
#6. Burst 1982
Sculpture, hand-colored
Materials: chalk, acrylic paints, handmade paper on Tycore panel
24 × 25½ × 7 (61 × 64.8 × 17.8)

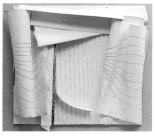

626:AC3
Blume 1377
Anthony Caro
#4. Big White 1982
Sculpture, hand-colored
Materials: pencil, chalk, acrylic paints, handmade paper on Tycore panel
32 × 38⅜ × 7½ (81.3 × 96.9 × 19.1)

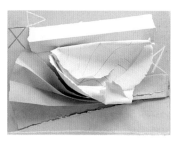

629:AC6
Blume 1380
Anthony Caro
#7. Fours 1982
Sculpture, hand-colored
Materials: pencil, chalk, acrylic paints, corrugated board, handmade paper on Tycore panel
24 × 32 × 10 (61 × 81.3 × 25.4)

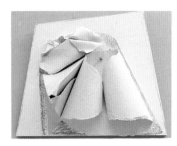

630:AC7
Blume 1381
Anthony Caro
#8. Untitled 1982
Sculpture, hand-colored
Materials: pencil, acrylic paints, aluminum pushpin, handmade paper on Tycore panel
15½ × 19½ × 9 (39.4 × 49.5 × 22.9)

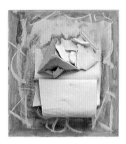

633:AC10
Blume 1384
Anthony Caro
#11. White Marks 1982
Sculpture, hand-colored
Materials: pencil, chalk, acrylic paints, aluminum pushpin, handmade paper, Tycore panel on plywood
28½ × 25½ × 9 (72.4 × 64.8 × 22.9)

636:AC13
Blume 1387
Anthony Caro
#14. Surprise Number 1982
Sculpture, hand-colored
Materials: pencil, chalk, acrylic paints, handmade paper, wood on Tycore panel
28½ × 30⅜ × 8 (72.4 × 76.6 × 20.3)

631:AC8
Blume 1382
Anthony Caro
#9. Coif 1982
Sculpture, hand-colored
Materials: pencil, chalk, acrylic paints, aluminum pushpin, handmade paper, wood on Tycore panel
32½ × 25½ × 7 (82.6 × 64.8 × 17.8)

634:AC11
Blume 1385
Anthony Caro
#12. Untitled 1982
Sculpture, hand-colored
Materials: pencil, chalk, handmade paper, acrylic spray paints, Tycore panel in wood frame
31½ × 25½ × 6 (80 × 64.8 × 15.2)

637:AC14
Blume 1388
Anthony Caro
#15. Excel 1982
Sculpture, hand-colored
Materials: acrylic paints, handmade paper, corrugated board in wood frame
37¾ × 29 × 7½ (95.9 × 73.7 × 19.1)

632:AC9
Blume 1383
Anthony Caro
#10. Untitled 1982
Sculpture, hand-colored
Materials: chalk, acrylic paints, graphite flakes, handmade paper on Tycore panel
22½ × 31 × 4½ (57.2 × 78.7 × 11.4)

635:AC12
Blume 1386
Anthony Caro
#13. Sutton 1982
Sculpture, hand-colored
Materials: acrylic paints, aluminum pushpin, handmade paper on Tycore panel
38 × 25 × 7 (96.5 × 63.5 × 17.8)

638:AC15
Blume 1389
Anthony Caro
#16. Hide and Seek 1982
Sculpture, hand-colored
Materials: handmade paper, chalk, Tycore panel, and wood
34 × 20 × 9½ (86.4 × 50.8 × 24.1)

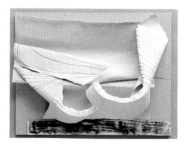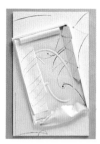

639:AC16
Blume 1390
Anthony Caro
#17. Untitled 1982
Sculpture, hand-colored
Materials: pencil, chalk, acrylic paints, corrugated board, handmade paper on Tycore panel
38½ × 24 × 8½ (97.8 × 61 × 21.6)

642:AC19
Blume 1393
Anthony Caro
#20. Untitled 1982
Sculpture, hand-colored
Materials: pencil, chalk, acrylic paints, corrugated board, handmade paper on Tycore panel
22¼ × 29½ × 11½ (56.5 × 74.9 × 29.2)

645:AC22
Blume 1396
Anthony Caro
#24. As You Are 1982
Sculpture, hand-colored
Materials: pencil, acrylic paints, handmade paper on Tycore panel
38¼ × 24 × 4 (97.2 × 61 × 10.2)

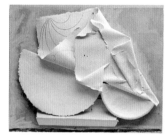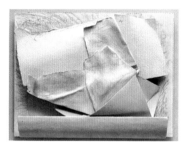

640:AC17
Blume 1391
Anthony Caro
#18. Prometheus 1982
Sculpture, hand-colored
Materials: pencil, chalk, acrylic paints, aluminum pushpin, handmade paper, wood on Tycore panel
30 × 38¼ × 8½ (76.2 × 97.2 × 21.6)

643:AC20
Blume 1394
Anthony Caro
#22. Untitled 1982
Sculpture, hand-colored
Materials: pencil, chalk, acrylic paints, acrylic spray paints, handmade paper on Tycore panel
19¼ × 25½ × 7 (48.9 × 64.8 × 17.8)

646:AC23
Blume 1397
Anthony Caro
#25. Untitled 1982
Sculpture, hand-colored
Materials: chalk, pencil, acrylic paints, aluminum pushpin, handmade paper, wood on Tycore panel
24½ × 30½ × 10 (62.2 × 77.5 × 25.4)

641:AC18
Blume 1392
Anthony Caro
#19. Inside Outside 1982
Sculpture, hand-colored
Materials: pencil, acrylic paints, handmade paper on Tycore panel
35 × 21 × 6 (88.9 × 53.3 × 15.2)

644:AC21
Blume 1395
Anthony Caro
#23. Untitled 1982
Sculpture, hand-colored
Materials: pencil, chalk, aluminum pushpin, Tycore panel, handmade paper, corrugated board, wood on Tycore panel
22 × 24 × 9 (55.9 × 61 × 22.9)

647:AC24
Blume 1398
Anthony Caro
#26. Untitled 1982
Sculpture, hand-colored
Materials: pencil, acrylic paints, handmade paper on Tycore panel
14½ × 25⅛ × 7 (36.8 × 63.6 × 17.8)

648:AC25
Blume 1399
Anthony Caro
#27. Box Tree 1982
Sculpture, hand-colored
Materials: chalk, acrylic paints, handmade paper, wood on Tycore panel
33 × 23¾ × 9½ (83.8 × 60.3 × 24.1)

651:AC29
Blume 1403
Anthony Caro
#33. Untitled 1982
Sculpture, hand-colored
Materials: pencil, acrylic paints, handmade paper, wood on Tycore panel
20¾ × 24 × 7½ (52.7 × 61 × 19.1)

654:AC32
Blume 1406
Anthony Caro
#36. Untitled 1982
Sculpture, hand-colored
Materials: pencil, chalk, acrylic paints, handmade paper on Tycore panel
22 × 16 × 7½ (55.9 × 40.6 × 19.1)

649:AC27
Blume 1401
Anthony Caro
#29. Untitled 1982
Sculpture, hand-colored
Materials: pencil, acrylic paints, handmade paper on Tycore panel
18 × 28 × 5 (45.7 × 71.1 × 12.7)

652:AC30
Blume 1404
Anthony Caro
#34. Untitled 1982
Sculpture, hand-colored
Materials: acrylic paints, acrylic spray paints, handmade paper on Tycore panel in wood frame
19¼ × 16¾ × 7 (48.9 × 42.5 × 17.8)

655:AC33
Blume 1407
Anthony Caro
#37. Sheet 1982
Sculpture, hand-colored
Materials: acrylic paints, handmade paper on Tycore panel in wood box
24½ × 22½ × 4½ (62.2 × 57.2 × 11.4)

650:AC28
Blume 1402
Anthony Caro
#30. Crush 1982
Sculpture, hand-colored
Materials: chalk, acrylic paints, wood dowel, handmade paper on Tycore panel
25½ × 22½ × 7 (64.8 × 57.2 × 17.8)

653:AC31
Blume 1405
Anthony Caro
#35. Splay 1982
Sculpture, hand-colored
Materials: pencil, chalk, acrylic paints, acrylic spray paints, handmade paper on Tycore panel
18 × 23 × 4½ (45.7 × 58.4 × 11.4)

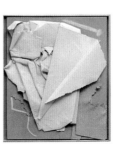

656:AC34
Blume 1408
Anthony Caro
#38. Presser 1982
Sculpture, hand-colored
Materials: chalk, acrylic paints, corrugated board, handmade paper in wood box
24½ × 21½ × 3 (62.2 × 54.6 × 7.6)

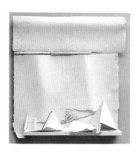

657:AC35
Blume 1409
Anthony Caro
#39. Untitled 1982
Sculpture, hand-colored

Materials: pencil, acrylic paints, acrylic spray paints, handmade paper on Tycore panel

27¼ × 26 × 10½ (69.2 × 66 × 26.7)

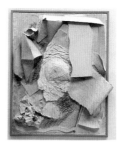

660:AC38
Blume 1412
Anthony Caro
#42. Untitled 1982
Sculpture, hand-colored

Materials: pencil, chalk, acrylic paints, acrylic spray paints, corrugated board on Tycore panel in wood frame

30½ × 24½ × 5½ (77.5 × 62.2 × 14)

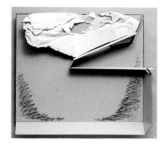

663:AC42
Blume 1416
Anthony Caro
#47. Untitled 1982
Sculpture, hand-colored

Materials: chalk, acrylic paints, handmade paper on corrugated board on Tycore panel

28½ × 32½ × 5½ (72.4 × 82.6 × 14)

658:AC36
Blume 1410
Anthony Caro
#40. Three Times 1982
Sculpture, hand-colored

Materials: pencil, chalk, acrylic paints, handmade paper, wood on Tycore panel

17 × 26 × 7 (43.2 × 66 × 17.8)

661:AC39
Blume 1413
Anthony Caro
#44. Untitled 1982
Sculpture, hand-colored

Materials: pencil, acrylic paints, aluminum pushpin, handmade paper on Tycore panel

15 × 31½ × 7 (38.1 × 80 × 17.8)

664:AC43
Blume 1417
Anthony Caro
#48. Bandit 1982
Sculpture, hand-colored

Materials: pencil, chalk, acrylic paints, corrugated board, handmade paper, Tycore panel in wood box

32¾ × 27 × 5 (83.2 × 68.6 × 12.7)

659:AC37
Blume 1411
Anthony Caro
#41. Floor Paper Sculpture 1982
Sculpture, hand-colored

Materials: handmade paper, blotter on Tycore panel

21 × 24 × 21 (53.3 × 61 × 53.3)

662:AC40
Blume 1414
Anthony Caro
#45. Untitled 1982
Sculpture, hand-colored

Materials: pencil, chalk, acrylic paints, handmade paper on Tycore panel

11½ × 42 × 17½ (29.2 × 106.7 × 44.5)

665:AC44
Blume 1418
Anthony Caro
#49. Untitled 1982
Sculpture, hand-colored

Materials: pencil, acrylic paints, handmade paper on Tycore panel

12 × 42 × 9 (30.5 × 106.7 × 22.9)

666:AC45
Blume 1419
Anthony Caro
#50. Untitled 1982
Sculpture, hand-colored
Materials: acrylic paints, handmade paper
on Tycore panel
12 × 19 × 4½ (30.5 × 48.3 × 11.4)

669:AC49
Blume 1423
Anthony Caro
#54. Untitled 1982
Sculpture, hand-colored
Materials: chalk, acrylic paints, handmade
paper on Tycore panel
14 × 30 × 9 (35.6 × 76.2 × 22.9)

672:AC52
Blume 1426
Anthony Caro
#57. Red Streak 1982
Sculpture, hand-colored
Materials: chalk, acrylic paints, Paintstik,
handmade paper on Tycore panel
23¾ × 36 × 5 (60.3 × 91.4 × 12.7)

667:AC46
Blume 1420
Anthony Caro
#51. Untitled 1982
Sculpture, hand-colored
Materials: acrylic paints, handmade paper
on Tycore panel with cardboard tubes
attached
19 × 21 × 19½ (48.3 × 53.3 × 49.5)

670:AC50
Blume 1424
Anthony Caro
#55. Untitled 1982
Sculpture, hand-colored
Materials: acrylic paints, acrylic spray
paints, handmade paper, corrugated board
on cardboard tubes
28¾ × 24 × 12 (73 × 61 × 30.5)

673:AC53
Blume 1427
Anthony Caro
#58. Winter 1982
Sculpture, hand-colored
Materials: chalk, pencil, acrylic paints,
handmade paper, wood, Tycore panel on
Tycore panel
26 × 30¾ × 7½ (66 × 78.1 × 19.1)

668:AC48
Blume 1422
Anthony Caro
#53. Untitled 1982
Sculpture, hand-colored
Materials: chalk, graphite flakes, acrylic
paints, handmade paper, wood on Tycore
panel
26¼ × 31½ × 3 (66.7 × 80 × 7.6)

671:AC51
Blume 1425
Anthony Caro
#56. Upright 1982
Sculpture, hand-colored
Materials: graphite, handmade paper in
wood box
32 × 22⅝ × 9½ (81.3 × 56.5 × 24.1)

674:AC54
Blume 1428
Anthony Caro
#59. Banjo 1982
Sculpture, hand-colored
Materials: acrylic paints, handmade paper,
Tycore panel on Tycore panel
23 × 28 × 3½ (58.4 × 71.1 × 8.9)

675:AC55
Blume 1429
Anthony Caro
#60. Untitled 1982
Sculpture, hand-colored
Materials: pencil, chalk, acrylic paints,
handmade paper on Tycore panel
30 × 18¾ × 5½ (76.2 × 47.6 × 14)

678:AC59
Blume 1433
Anthony Caro
#64. Remember Blue 1982
Sculpture, hand-colored
Materials: pencil, acrylic paints, acrylic
spray paints, handmade paper on Tycore
panel in wood box
26¾ × 32¾ × 8½ (67.9 × 83.2 × 21.6)

681:AC62
Blume 1436
Anthony Caro
#67. I Never Saw It 1982
Sculpture, hand-colored
Materials: chalk, acrylic paints, red
aluminum pushpin, wood on Tycore panel
22¾ × 28 × 5¾ (57.8 × 71.1 × 14.6)

676:AC57
Blume 1431
Anthony Caro
#62. Untitled 1982
Sculpture, hand-colored
Materials: pencil, chalk, acrylic paints,
handmade paper on Tycore panel
19¾ × 21¾ × 7½ (50.2 × 55.2 × 19.1)

679:AC60
Blume 1434
Anthony Caro
#65. Untitled 1982
Sculpture, hand-colored
Materials: acrylic paints, handmade paper,
wood on Tycore panel
18 × 33 × 5½ (45.7 × 83.8 × 14)

682:AC63
Blume 1437
Anthony Caro
#68. Untitled 1982
Sculpture, hand-colored
Materials: pencil, chalk, acrylic paints,
handmade paper, wood on Tycore panel
36¼ × 22 × 6 (92.1 × 55.9 × 15.2)

677:AC58
Blume 1432
Anthony Caro
#63. Untitled 1982
Sculpture, hand-colored
Materials: acrylic paints, handmade paper
on Tycore panel in wood box
19¼ × 26½ × 6 (48.9 × 67.3 × 15.2)

680:AC61
Blume 1435
Anthony Caro
#66. Float 1982
Sculpture, hand-colored
Materials: acrylic paints, handmade paper
on Tycore panel
10 × 28 × 4 (25.4 × 71.1 × 10.2)

683:AC64
Blume 1438
Anthony Caro
#69. Pierrot 1982
Sculpture, hand-colored
Materials: chalk, acrylic paints, handmade
paper, wood on Tycore panel
22¼ × 33½ × 3½ (56.5 × 85.1 × 8.9)

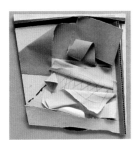

684:AC65
Blume 1439
Anthony Caro
#70. Red Line 1982
Sculpture, hand-colored
Materials: pencil, Paintstik, acrylic paints, handmade paper, Tycore panel on Tycore panel
28¾ × 27½ × 5½ (73 × 69.9 × 14)

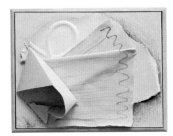

687:AC68
Blume 1442
Anthony Caro
#73. Untitled 1982
Sculpture, hand-colored
Materials: pencil, chalk, acrylic paints, handmade paper on Tycore panel in wood box
18¼ × 23¼ × 8½ (46.4 × 59.1 × 21.6)

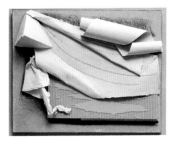

690:AC71
Blume 1445
Anthony Caro
#76. Untitled 1982
Sculpture, hand-colored
Materials: pencil, chalk, acrylic paints, corrugated board, handmade paper on Tycore panel
19 × 23¾ × 6 (48.3 × 60.3 × 15.2)

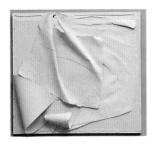

685:AC66
Blume 1440
Anthony Caro
#71. The Bed 1982
Sculpture, hand-colored
Materials: pencil, chalk, acrylic paints, handmade paper on Tycore panel
26 × 28 × 4 (66 × 71.1 × 10.2)

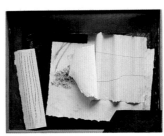

688:AC69
Blume 1443
Anthony Caro
#74. Untitled 1982
Sculpture, hand-colored
Materials: pencil, chalk, acrylic paints, handmade paper, wood on rag board
29¼ × 38 × 5 (74.3 × 96.5 × 12.7)

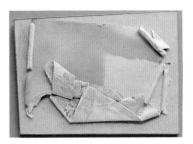

691:AC72
Blume 1446
Anthony Caro
#77. Untitled 1982
Sculpture, hand-colored
Materials: acrylic paints, handmade paper on Tycore panel
12½ × 17 × 1¾ (31.8 × 43.2 × 4.4)

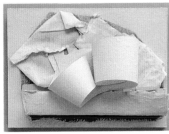

686:AC67
Blume 1441
Anthony Caro
#72. Bubbly 1982
Sculpture, hand-colored
Materials: pencil, acrylic paints, handmade paper on Tycore panel
17 × 22 × 7½ (43.2 × 55.9 × 19.1)

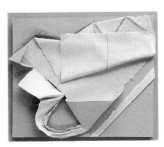

689:AC70
Blume 1444
Anthony Caro
#75. Untitled 1982
Sculpture, hand-colored
Materials: pencil, acrylic paints, handmade paper on Tycore panel
19 × 22¾ × 6 (48.3 × 57.8 × 15.2)

692:AC73
Blume 1447
Anthony Caro
#78. Untitled 1982
Sculpture, hand-colored
Materials: pencil, chalk, acrylic paints, handmade paper on Tycore panel
26 × 28 × 8½ (66 × 71.1 × 21.6)

693:AC74
Blume 1448
Anthony Caro
#79. Untitled 1982
Sculpture, hand-colored
Materials: chalk, acrylic paints, handmade
paper on Tycore panel in wood box
22¼ × 34⅝ × 5 (56.5 × 87 × 12.7)

696:AC77
Blume 1451
Anthony Caro
#83. Untitled 1982
Sculpture, hand-colored
Materials: pencil, chalk, acrylic paints,
handmade paper on Tycore panel in wood
box
23¾ × 14½ × 7½ (60.3 × 36.8 × 19.1)

699:AC80
Blume 1454
Anthony Caro
#86. Untitled 1982
Sculpture, hand-colored
Materials: acrylic paints, handmade paper
on Tycore panel
14 × 37½ × 6 (35.6 × 95.3 × 15.2)

694:AC75
Blume 1449
Anthony Caro
#81. Fleece 1982
Sculpture, hand-colored
Materials: chalk, acrylic paints, aluminum
pushpin, corrugated board, handmade
paper, wood on Tycore panel
28½ × 35¾ × 5½ (72.4 × 90.8 × 14)

697:AC78
Blume 1452
Anthony Caro
#84. Pebble Beach 1982
Sculpture, hand-colored
Materials: pencil, chalk, acrylic paints,
handmade paper on Tycore panel
26¾ × 30 × 7 (67.9 × 76.2 × 17.8)

700:AC81
Blume 1455
Anthony Caro
#87. Untitled 1982
Sculpture, hand-colored
Materials: pencil, chalk, acrylic paints,
handmade paper on Tycore panel
26 × 34¼ × 9 (66 × 87 × 22.9)

695:AC76
Blume 1450
Anthony Caro
#82. Untitled 1982
Sculpture, hand-colored
Materials: chalk, acrylic paints, handmade
paper on Tycore panel
20½ × 28 × 4½ (52.1 × 71.1 × 11.4)

698:AC79
Blume 1453
Anthony Caro
#85. Untitled 1982
Sculpture, hand-colored
Materials: pencil, chalk, acrylic paints,
handmade paper, wood on Tycore panel
18¼ × 38 × 4½ (46.4 × 96.5 × 11.4)

701:AC82
Blume 1456
Anthony Caro
#88. Piano Music 1982
Sculpture, hand-colored
Materials: pencil, chalk, acrylic paints,
corrugated board, handmade paper on rag
board in wood box
26¼ × 41¼ × 6 (66.7 × 104.8 × 15.2)

702:AC83
Blume 1457
Anthony Caro
#89. Point 1982
Sculpture, hand-colored
Materials: pencil, acrylic paints, handmade paper on Tycore panel
28 × 30¾ × 7 (71.1 × 78.1 × 17.8)

703:AC84
Blume 1458
Anthony Caro
#90. Untitled 1982
Sculpture, hand-colored
Materials: chalk, acrylic paints, handmade paper, wood on Tycore panel
22 × 34 × 7 (55.9 × 86.4 × 17.8)

704:AC85
Blume 1459
Anthony Caro
#91. First Colour 1982
Sculpture, hand-colored
Materials: pencil, chalk, acrylic paints, handmade paper, wood on corrugated board
20 × 21½ × 5 (50.8 × 54.6 × 12.7)

705:AC86
Blume 1460
Anthony Caro
#92. Untitled 1982
Sculpture, hand-colored
Materials: pencil, acrylic paints, red and blue aluminum pushpins, handmade paper, Tycore panel on wood
36½ × 27 × 7 (92.7 × 68.6 × 17.8)

706:AC87
Blume 1461
Anthony Caro
#93. Harlequin 1982
Sculpture, hand-colored
Materials: chalk, acrylic paints, handmade paper on Tycore panel
21 × 32 × 4 (53.3 × 81.3 × 10.2)

707:AC88
Blume 1462
Anthony Caro
#94. Untitled 1982
Sculpture, hand-colored
Materials: pencil, chalk, handmade paper, corrugated board on Tycore panel
27¾ × 20¾ × 5 (70.5 × 52.7 × 12.7)

708:AC89
Blume 1463
Anthony Caro
#95. Untitled 1982
Sculpture, hand-colored
Materials: pencil, chalk, acrylic paints, corrugated board, handmade paper on Tycore panel
26¼ × 18½ × 9 (66.7 × 47 × 22.9)

709:AC90
Blume 1464
Anthony Caro
#96. Picture 1982
Sculpture, hand-colored
Materials: chalk, glue, acrylic paints, handmade paper on Tycore panel
40½ × 29¾ × 2½ (102.9 × 75.6 × 6.4)

710:AC91
Blume 1465
Anthony Caro
#97. Untitled 1982
Sculpture, hand-colored
Materials: pencil, acrylic paints, acrylic spray paints, handmade paper on Tycore panel
25½ × 25½ × 6½ (64.8 × 64.8 × 16.5)

711:AC92
Blume 1466
Anthony Caro
#98. Untitled 1982
Sculpture, hand-colored

Materials: pencil, chalk, acrylic paints, handmade paper, Tycore panel on cardboard tubes filled with lead shot

30 × 15 × 16 (76.2 × 38.1 × 40.6)

714:AC95
Blume 1469
Anthony Caro
#102. French 1982
Sculpture, hand-colored

Materials: chalk, acrylic paints, handmade paper in wood box

25½ × 28½ × 6 (64.8 × 72.4 × 15.2)

717:AC98
Blume 1472
Anthony Caro
#105. Punch and Judy 1982
Sculpture, hand-colored

Materials: pencil, chalk, acrylic paints, aluminum pushpins, Tycore panel, handmade paper in wood box

34½ × 21 × 8½ (87.6 × 53.3 × 21.6)

712:AC93
Blume 1467
Anthony Caro
#100. Piccolo 1982
Sculpture, hand-colored

Materials: pencil, chalk, acrylic paints, corrugated board, handmade paper on Tycore panel

10½ × 8¼ × 4½ (26.7 × 21 × 11.4)

715:AC96
Blume 1470
Anthony Caro
#103. Untitled 1982
Sculpture, hand-colored

Materials: pencil, chalk, acrylic paints, handmade paper on Tycore panel

22½ × 32 × 6 (57.2 × 81.3 × 15.2)

718:AC99
Blume 1473
Anthony Caro
#106. Untitled 1982
Sculpture, hand-colored

Materials: pencil, acrylic paints, handmade paper, wood on Tycore panel

20 × 24½ × 7 (50.8 × 62.2 × 17.8)

713:AC94
Blume 1468
Anthony Caro
#101. Untitled 1982
Sculpture, hand-colored

Materials: pencil, acrylic paints, handmade paper on Tycore panel

41¾ × 23 × 6 (106 × 58.4 × 15.2)

716:AC97
Blume 1471
Anthony Caro
#104. Valance 1982
Sculpture, hand-colored

Materials: pencil, chalk, acrylic paints, handmade paper, Tycore panel, wood on rag board

26½ × 28½ × 7½ (67.3 × 72.4 × 19.1)

719:AC100
Blume 1474
Anthony Caro
#107. Brushed Black 1982
Sculpture, hand-colored

Materials: pencil, chalk, acrylic paints, handmade paper, wood on Tycore panel

30¾ × 30 × 4½ (78.1 × 76.2 × 11.4)

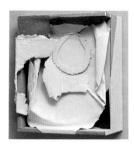

720:AC101
Blume 1475
Anthony Caro
#108. Corner 1982
Sculpture, hand-colored
Materials: acrylic paints, handmade paper,
aluminum pushpin on Tycore panel
24½ × 23 × 11½ (62.2 × 58.4 × 29.2)

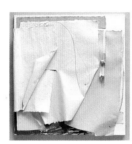

723:AC104
Blume 1478
Anthony Caro
#111. Untitled 1982
Sculpture, hand-colored
Materials: pencil, chalk, acrylic paints,
handmade paper, wood on Tycore panel
36 × 34 × 5½ (91.4 × 86.4 × 14)

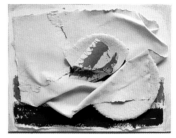

726:AC107
Blume 1481
Anthony Caro
#114. Untitled 1982
Sculpture, hand-colored
Materials: chalk, acrylic paints, handmade
paper on Tycore panel
24 × 32 × 7 (61 × 81.3 × 17.8)

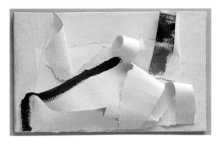

721:AC102
Blume 1476
Anthony Caro
#109. Oats 1982
Sculpture, hand-colored
Materials: chalk, acrylic paints, handmade
paper on Tycore panel
18¾ × 31 × 7 (47.6 × 78.7 × 17.8)

724:AC105
Blume 1479
Anthony Caro
#112. Untitled 1982
Sculpture, hand-colored
Materials: pencil, acrylic paints, handmade
paper on Tycore panel
39 × 24¾ × 3 (99.1 × 62.9 × 7.6)

727:AC108
Blume 1482
Anthony Caro
#115. Calico 1982
Sculpture, hand-colored
Materials: pencil, chalk, acrylic paints,
handmade paper, wood on Tycore panel
28½ × 32⅛ × 4 (72.4 × 81.4 × 10.2)

722:AC103
Blume 1477
Anthony Caro
#110. Untitled 1982
Sculpture, hand-colored
Materials: pencil, chalk, acrylic paints,
handmade paper on Tycore panel
20 × 28 × 5½ (50.8 × 71.1 × 14)

725:AC106
Blume 1480
Anthony Caro
#113. Untitled 1982
Sculpture, hand-colored
Materials: pencil, chalk, acrylic paints,
handmade paper on Tycore panel
34 × 21½ × 5½ (86.4 × 54.6 × 14)

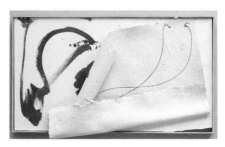

728:AC109
Blume 1483
Anthony Caro
#116. Swirl 1982
Sculpture, hand-colored
Materials: pencil, acrylic paints, handmade
paper, wood on Tycore panel
21¾ × 37¼ × 4½ (55.2 × 94.6 × 11.4)

729:AC110
Blume 1484
Anthony Caro
#117. Violin 1982
Sculpture, hand-colored
Materials: pencil, acrylic paints, handmade
paper, wood on Tycore panel
32¾ × 24½ × 8 (83.2 × 62.2 × 20.3)

732:AC113
Blume 1487
Anthony Caro
#120. Scoop 1982
Sculpture, hand-colored
Materials: pencil, acrylic paints, handmade
paper, wood on Tycore panel
26¾ × 27 × 4 (67.9 × 68.6 × 10.2)

735:AC116
Blume 1490
Anthony Caro
#123. Sienna 1982
Sculpture, hand-colored
Materials: pencil, chalk, acrylic paints,
handmade paper on Tycore panel
18½ × 30 × 7 (47 × 76.2 × 17.8)

730:AC111
Blume 1485
Anthony Caro
#118. Untitled 1982
Sculpture, hand-colored
Materials: chalk, acrylic paints, handmade
paper, wood on Tycore panel
40 × 20 × 5 (101.6 × 50.8 × 12.7)

733:AC114
Blume 1488
Anthony Caro
#121. Jap Fall 1982
Sculpture, hand-colored
Materials: chalk, acrylic paints, handmade
paper, wood on Tycore panel
23 × 35 × 6½ (58.4 × 88.9 × 16.5)

736:AC117
Blume 1491
Anthony Caro
#124. Autumnal 1982
Sculpture, hand-colored
Materials: chalk, acrylic paints, handmade
paper, wood dowels on Tycore panel
30 × 40 × 6½ (76.2 × 101.6 × 16.5)

731:AC112
Blume 1486
Anthony Caro
#119. Untitled 1982
Sculpture, hand-colored
Materials: pencil, chalk, acrylic paints,
aluminum pushpin, handmade paper on
Tycore panel
31½ × 25¾ × 4½ (80 × 65.4 × 11.4)

734:AC115
Blume 1489
Anthony Caro
#122. Marine 1982
Sculpture, hand-colored
Materials: chalk, acrylic paints, handmade
paper, wood on Tycore panel
24½ × 30 × 4½ (62.2 × 76.2 × 11.4)

737:AC118
Blume 1492
Anthony Caro
#125. Untitled 1982
Sculpture, hand-colored
Materials: pencil, chalk, acrylic paints,
handmade paper on silver handmade paper
38¼ × 25¼ × 9½ (97.2 × 64.1 × 24.1)

738:AC119
Blume 1493
Anthony Caro
#126. Boudoir Gray 1982
Sculpture, hand-colored
Materials: acrylic paints, acrylic spray
paints, handmade paper, wood on Tycore
panel
25 × 30¾ × 9 (63.5 × 78.1 × 22.9)

741:AC122
Blume 1496
Anthony Caro
#129. Untitled 1982
Sculpture, hand-colored
Materials: chalk, acrylic paints, handmade
paper in wood box
22½ × 37½ × 5 (57.2 × 95.3 × 12.7)

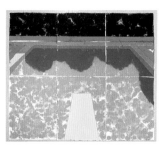

744:DH5
David Hockney
Swimming Pool with Reflection, Paper
Pool 5 1978
Colored, pressed paper pulp
Six sheets: 72 × 85½ (182.9 × 217.2);
each: 36 × 28 (91.4 × 71.1)
Paper: white TGL, handmade,
hand-colored

739:AC120
Blume 1494
Anthony Caro
#127. Untitled 1982
Sculpture, hand-colored
Materials: pencil, chalk, acrylic paints,
handmade paper, wood on Tycore panel
30 × 28 × 5 (76.2 × 71.1 × 12.7)

742:AC123
Blume 1497
Anthony Caro
#130. Untitled 1982
Sculpture, hand-colored
Materials: pencil, acrylic paints, acrylic
spray paints, aluminum pushpin, hand-
made paper on Tycore panel
33 × 24 × 10 (83.8 × 61 × 25.4)

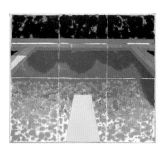

745:DH6
David Hockney
Piscine avec trois bleus, Paper Pool 6
1978
Colored, pressed paper pulp
Six sheets: 72 × 85½ (182.9 × 217.2);
each: 36 × 28 (91.4 × 71.1)
Paper: white TGL, handmade,
hand-colored

740:AC121
Blume 1495
Anthony Caro
#128. Untitled 1982
Sculpture, hand-colored
Materials: chalk, acrylic paints, handmade
paper, wood on Tycore panel
24¾ × 30½ × 4 (62.9 × 77.5 × 10.2)

743:AC124
Blume 1498
Anthony Caro
#131. Untitled 1982
Sculpture, hand-colored
Materials: chalk, acrylic paints, wood
dowel, wood, handmade paper on Tycore
panel
26 × 31½ × 4 (66 × 80 × 10.2)

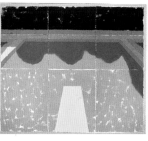

746:DH8
David Hockney
Pool with Reflection of Trees and Sky,
Paper Pool 8 1978
Colored, pressed paper pulp
Six sheets: 72 × 85½ (182.9 × 217.2);
each: 36 × 28 (91.4 × 71.1)
Paper: white TGL, handmade,
hand-colored

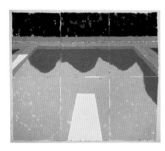

747:DH9
David Hockney
Pool with Reflection and Still Water, Paper
Pool 9 1978
Colored, pressed paper pulp
Six sheets: 72 × 85½ (182.9 × 217.2);
each: 36 × 28 (91.4 × 71.1)
Paper: white TGL, handmade,
hand-colored

750:DH12
David Hockney
*Diving Board with Still Water on Blue
Paper*, Paper Pool 12 1978
Colored, pressed paper pulp
Six sheets: 72 × 85½ (182.9 × 217.2);
each: 36 × 28 (91.4 × 71.1)
Paper: white TGL, handmade,
hand-colored

753:DH17
David Hockney
A Diver, Paper Pool 17 1978
Colored, pressed paper pulp
Twelve sheets: 72 × 171 (182.9 × 434.3);
each: 36 × 28 (91.4 × 71.1)
Paper: white TGL, handmade,
hand-colored

748:DH10
David Hockney
Midnight Pool, Paper Pool 10 1978
Colored, pressed paper pulp
Six sheets: 72 × 85½ (182.9 × 217.2);
each: 36 × 28 (91.4 × 71.1)
Paper: white TGL, handmade,
hand-colored

751:DH13
David Hockney
Plongeoir avec ombre, Paper Pool 13
1978
Colored, pressed paper pulp
Six sheets: 72 × 85½ (182.9 × 217.2);
each: 36 × 28 (91.4 × 71.1)
Paper: white TGL, handmade,
hand-colored

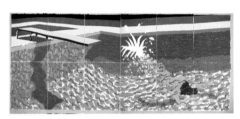

754:DH18
David Hockney
Le Plongeur, Paper Pool 18 1978
Colored, pressed paper pulp
Twelve sheets: 72 × 171 (182.9 × 434.3);
each: 36 × 28 (91.4 × 71.1)
Paper: white TGL, handmade,
hand-colored

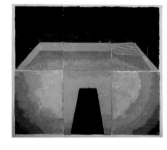

749:DH11
David Hockney
Schwimmbad Mitternacht, Paper Pool 11
1978
Colored, pressed paper pulp
Six sheets: 72 × 85½ (182.9 × 217.2);
each: 36 × 28 (91.4 × 71.1)
Paper: white TGL, handmade,
hand-colored

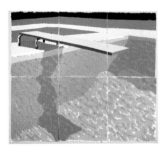

752:DH14
David Hockney
Sprungbrett mit Schatten, Paper Pool 14
1978
Colored, pressed paper pulp
Six sheets: 72 × 85½ (182.9 × 217.2);
each: 36 × 28 (91.4 × 71.1)
Paper: white TGL, handmade,
hand-colored

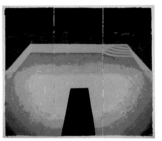

755:DH20
David Hockney
Une autre piscine à minuit, Paper Pool 20
1978
Colored, pressed paper pulp
Six sheets: 72 × 85½ (182.9 × 217.2);
each: 36 × 28 (91.4 × 71.1)
Paper: white TGL, handmade,
hand-colored

756:DH21
David Hockney
Pool on a Cloudy Day, Paper Pool 21
1978
Colored, pressed paper pulp
Six sheets: 72 × 85½ (182.9 × 217.2);
each: 36 × 28 (91.4 × 71.1)
Paper: white TGL, handmade,
hand-colored

757:DH22
David Hockney
Pool on a Cloudy Day with Rain, Paper
Pool 22 1978
Colored, pressed paper pulp
Six sheets: 72 × 85½ (182.9 × 217.2);
each: 36 × 28 (91.4 × 71.1)
Paper: white TGL, handmade,
hand-colored

758:DH23
David Hockney
Oversized Pool, Paper Pool 23 1978
Colored, pressed paper pulp
Six sheets: 82 × 92 (208.3 × 233.7);
each: 40 × 30 (101.6 × 76.2)
Paper: white TGL, handmade,
hand-colored

759:DH24
David Hockney
*Piscine on Sprayed Blue Paper with Green
Top,* Paper Pool 24 1978
Colored, pressed paper pulp
Six sheets: 72 × 85½ (182.9 × 217.2);
each: 36 × 28 (91.4 × 71.1)
Paper: white TGL, handmade,
hand-colored

760:DH25
David Hockney
*Pool on Sprayed Blue Paper with Purple
Top,* Paper Pool 25 1978
Colored, pressed paper pulp
Six sheets: 72 × 85½ (182.9 × 217.2);
each: 36 × 28 (91.4 × 71.1)
Paper: white TGL, handmade,
hand-colored

761:DH26
David Hockney
Pool with Cloud Reflections, Paper Pool 26
1978
Colored, pressed paper pulp
Six sheets: 72 × 85½ (182.9 × 217.2);
each: 36 × 28 (91.4 × 71.1)
Paper: white TGL, handmade,
hand-colored

762:DH28
David Hockney
Fall Pool with Two Flat Blues, Paper
Pool 28 1978
Colored, pressed paper pulp
Six sheets: 72 × 85½ (182.9 × 217.2);
each: 36 × 28 (91.4 × 71.1)
Paper: white TGL, handmade,
hand-colored

763:DH29
David Hockney
Autumn Pool, Paper Pool 29 1978
Colored, pressed paper pulp
Six sheets: 72 × 85½ (182.9 × 217.2);
each: 36 × 28 (91.4 × 71.1)
Paper: white TGL, handmade,
hand-colored

764:DH30
David Hockney
Piscine de medianoche, Paper Pool 30
1978
Colored, pressed paper pulp
Six sheets: 72 × 85½ (182.9 × 217.2);
each: 36 × 28 (91.4 × 71.1)
Paper: white TGL, handmade,
hand-colored

765:DH31
David Hockney
Three-Panel Diving Board, Paper Pool 31
1978
Colored, pressed paper pulp
Three sheets: 51 × 96 (129.5 × 243.8);
each: 51 × 32 (129.5 × 81.3)
Paper: white TGL, handmade,
hand-colored

768:RS4
Richard Smith
Cartouche I-4, from the Cartouche
Series 1980
Colored, pressed paper pulp; fabric; grommets; string; aluminum tubes
Three panels: 60 × 42 (152.4 × 106.7);
panel 1: 19½ × 19½ (49.5 × 49.5);
panel 2: 37 × 19½ (94 × 49.5);
panel 3: 53 × 19½ (134.6 × 49.5)

771:RS7
Richard Smith
Cartouche I-7, from the Cartouche
Series 1980
Colored, pressed paper pulp; fabric; grommets; string; aluminum tubes
Three panels: 60 × 42 (152.4 × 106.7);
panel 1: 19½ × 19½ (49.5 × 49.5);
panel 2: 37 × 19½ (94 × 49.5);
panel 3: 53 × 19½ (134.6 × 49.5)

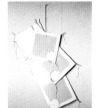

766:RS1
Richard Smith
Cartouche I-1, from the Cartouche
Series 1980
Colored, pressed paper pulp; fabric; grommets; string; aluminum tubes
Three panels: 60 × 42 (152.4 × 106.7);
panel 1: 19½ × 19½ (49.5 × 49.5);
panel 2: 37 × 19½ (94 × 49.5);
panel 3: 53 × 19½ (134.6 × 49.5)

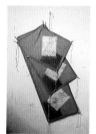

769:RS5
Richard Smith
Cartouche I-5, from the Cartouche
Series 1980
Colored, pressed paper pulp; fabric; grommets; string; aluminum tubes
Three panels: 60 × 42 (152.4 × 106.7);
panel 1: 19½ × 19½ (49.5 × 49.5);
panel 2: 37 × 19½ (94 × 49.5);
panel 3: 53 × 19½ (134.6 × 49.5)

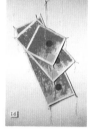

772:RS8
Richard Smith
Cartouche I-8, from the Cartouche
Series 1980
Colored, pressed paper pulp; fabric; grommets; string; aluminum tubes
Three panels: 60 × 42 (152.4 × 106.7);
panel 1: 19½ × 19½ (49.5 × 49.5);
panel 2: 37 × 19½ (94 × 49.5);
panel 3: 53 × 19½ (134.6 × 49.5)

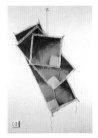

767:RS3
Richard Smith
Cartouche I-3, from the Cartouche
Series 1980
Colored, pressed paper pulp; fabric; grommets; string; aluminum tubes
Three panels: 60 × 42 (152.4 × 106.7);
panel 1: 19½ × 19½ (49.5 × 49.5);
panel 2: 37 × 19½ (94 × 49.5);
panel 3: 53 × 19½ (134.6 × 49.5)

770:RS6
Richard Smith
Cartouche I-6, from the Cartouche
Series 1980
Colored, pressed paper pulp; fabric; grommets; string; aluminum tubes
Three panels: 60 × 42 (152.4 × 106.7);
panel 1: 19½ × 19½ (49.5 × 49.5);
panel 2: 37 × 19½ (94 × 49.5);
panel 3: 53 × 19½ (134.6 × 49.5)

773:RS9
Richard Smith
Cartouche I-9, from the Cartouche
Series 1980
Colored, pressed paper pulp; fabric; grommets; string; aluminum tubes
Three panels: 60 × 42 (152.4 × 106.7);
panel 1: 19½ × 19½ (49.5 × 49.5);
panel 2: 37 × 19½ (94 × 49.5);
panel 3: 53 × 19½ (134.6 × 49.5)

774:RS10
Richard Smith
Cartouche I-10, from the Cartouche
Series 1980
Colored, pressed paper pulp; fabric; grom-
mets; string; aluminum tubes
Three panels: 60 × 42 (152.4 × 106.7);
panel 1: 19½ × 19½ (49.5 × 49.5);
panel 2: 37 × 19½ (94 × 49.5);
panel 3: 53 × 19½ (134.6 × 49.5)

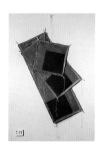

777:RS13
Richard Smith
Cartouche I-13, from the Cartouche
Series 1980
Colored, pressed paper pulp; fabric; grom-
mets; string; aluminum tubes
Three panels: 60 × 42 (152.4 × 106.7);
panel 1: 19½ × 19½ (49.5 × 49.5);
panel 2: 37 × 19½ (94 × 49.5);
panel 3: 53 × 19½ (134.6 × 49.5)

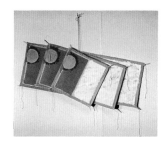

780:RS16
Richard Smith
Cartouche II-1, from the Cartouche
Series 1980
Colored, pressed paper pulp; fabric; grom-
mets; string; aluminum tubes
Three panels: 37 × 60 (94 × 152.4);
panel 1: 19½ × 19½ (49.5 × 49.5);
panel 2: 19½ × 37 (49.5 × 94);
panel 3: 19½ × 53 (49.5 × 134.6)

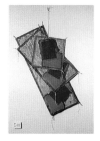

775:RS11
Richard Smith
Cartouche I-11, from the Cartouche
Series 1980
Colored, pressed paper pulp; fabric; grom-
mets; string; aluminum tubes
Three panels: 60 × 42 (152.4 × 106.7);
panel 1: 19½ × 19½ (49.5 × 49.5);
panel 2: 37 × 19½ (94 × 49.5);
panel 3: 53 × 19½ (134.6 × 49.5)

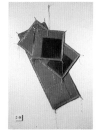

778:RS14
Richard Smith
Cartouche I-14, from the Cartouche
Series 1980
Colored, pressed paper pulp; fabric; grom-
mets; string; aluminum tubes
Three panels: 60 × 42 (152.4 × 106.7);
panel 1: 19½ × 19½ (49.5 × 49.5);
panel 2: 37 × 19½ (94 × 49.5);
panel 3: 53 × 19½ (134.6 × 49.5)

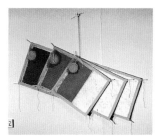

781:RS17
Richard Smith
Cartouche II-2, from the Cartouche
Series 1980
Colored, pressed paper pulp; fabric; grom-
mets; string; aluminum tubes
Three panels: 37 × 60 (94 × 152.4);
panel 1: 19½ × 19½ (49.5 × 49.5);
panel 2: 19½ × 37 (49.5 × 94);
panel 3: 19½ × 53 (49.5 × 134.6)

776:RS12
Richard Smith
Cartouche I-12, from the Cartouche
Series 1980
Colored, pressed paper pulp; fabric; grom-
mets; string; aluminum tubes
Three panels: 60 × 42 (152.4 × 106.7);
panel 1: 19½ × 19½ (49.5 × 49.5);
panel 2: 37 × 19½ (94 × 49.5);
panel 3: 53 × 19½ (134.6 × 49.5)

779:RS15
Richard Smith
Cartouche I-15, from the Cartouche
Series 1980
Colored, pressed paper pulp; fabric; grom-
mets; string; aluminum tubes
Three panels: 60 × 42 (152.4 × 106.7);
panel 1: 19½ × 19½ (49.5 × 49.5);
panel 2: 37 × 19½ (94 × 49.5);
panel 3: 53 × 19½ (134.6 × 49.5)

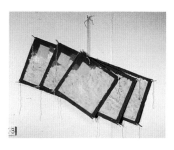

782:RS18
Richard Smith
Cartouche II-3, from the Cartouche
Series 1980
Colored, pressed paper pulp; fabric; grom-
mets; string; aluminum tubes
Three panels: 37 × 60 (94 × 152.4);
panel 1: 19½ × 19½ (49.5 × 49.5);
panel 2: 19½ × 37 (49.5 × 94);
panel 3: 19½ × 53 (49.5 × 134.6)

783:RS19
Richard Smith
Cartouche II-4, from the Cartouche
Series 1980
Colored, pressed paper pulp; fabric; grommets; string; aluminum tubes
Three panels: 37 × 60 (94 × 152.4);
panel 1: 19½ × 19½ (49.5 × 49.5);
panel 2: 19½ × 37 (49.5 × 94);
panel 3: 19½ × 53 (49.5 × 134.6)

786:RS22
Richard Smith
Cartouche II-7, from the Cartouche
Series 1980
Colored, pressed paper pulp; fabric; grommets; string; aluminum tubes
Three panels: 37 × 60 (94 × 152.4);
panel 1: 19½ × 19½ (49.5 × 49.5);
panel 2: 19½ × 37 (49.5 × 94);
panel 3: 19½ × 53 (49.5 × 134.6)

789:RS26
Richard Smith
Cartouche II-11, from the Cartouche
Series 1980
Colored, pressed paper pulp; fabric; grommets; string; aluminum tubes
Three panels: 37 × 60 (94 × 152.4);
panel 1: 19½ × 19½ (49.5 × 49.5);
panel 2: 19½ × 37 (49.5 × 94);
panel 3: 19½ × 53 (49.5 × 134.6)

784:RS20
Richard Smith
Cartouche II-5, from the Cartouche
Series 1980
Colored, pressed paper pulp; fabric; grommets; string; aluminum tubes
Three panels: 37 × 60 (94 × 152.4);
panel 1: 19½ × 19½ (49.5 × 49.5);
panel 2: 19½ × 37 (49.5 × 94);
panel 3: 19½ × 53 (49.5 × 134.6)

787:RS23
Richard Smith
Cartouche II-8, from the Cartouche
Series 1980
Colored, pressed paper pulp; fabric; grommets; string; aluminum tubes
Three panels: 37 × 60 (94 × 152.4);
panel 1: 19½ × 19½ (49.5 × 49.5);
panel 2: 19½ × 37 (49.5 × 94);
panel 3: 19½ × 53 (49.5 × 134.6)

790:RS27
Richard Smith
Cartouche II-12, from the Cartouche
Series 1980
Colored, pressed paper pulp; fabric; grommets; string; aluminum tubes
Three panels: 37 × 60 (94 × 152.4);
panel 1: 19½ × 19½ (49.5 × 49.5);
panel 2: 19½ × 37 (49.5 × 94);
panel 3: 19½ × 53 (49.5 × 134.6)

785:RS21
Richard Smith
Cartouche II-6, from the Cartouche
Series 1980
Colored, pressed paper pulp; fabric; grommets; string; aluminum tubes
Three panels: 37 × 60 (94 × 152.4);
panel 1: 19½ × 19½ (49.5 × 49.5);
panel 2: 19½ × 37 (49.5 × 94);
panel 3: 19½ × 53 (49.5 × 134.6)

788:RS25
Richard Smith
Cartouche II-10, from the Cartouche
Series 1980
Colored, pressed paper pulp; fabric; grommets; string; aluminum tubes
Three panels: 37 × 60 (94 × 152.4);
panel 1: 19½ × 19½ (49.5 × 49.5);
panel 2: 19½ × 37 (49.5 × 94);
panel 3: 19½ × 53 (49.5 × 134.6)

791:RS28
Richard Smith
Cartouche II-13, from the Cartouche
Series 1980
Colored, pressed paper pulp; fabric; grommets; string; aluminum tubes
Three panels: 37 × 60 (94 × 152.4);
panel 1: 19½ × 19½ (49.5 × 49.5);
panel 2: 19½ × 37 (49.5 × 94);
panel 3: 19½ × 53 (49.5 × 134.6)

792:RS29
Richard Smith
Cartouche II-14, from the Cartouche
Series 1980
Colored, pressed paper pulp; fabric; grommets; string; aluminum tubes
Three panels: 37 × 60 (94 × 152.4);
panel 1: 19½ × 19½ (49.5 × 49.5);
panel 2: 19½ × 37 (49.5 × 94);
panel 3: 19½ × 53 (49.5 × 134.6)

795:RS32
Richard Smith
Cartouche III-2, from the Cartouche
Series 1980
Colored, pressed paper pulp; fabric; grommets; string; aluminum tubes
Two panels: 60 × 50 (152.4 × 127);
each: 53 × 16 (134.6 × 40.6)

798:RS36
Richard Smith
Cartouche III-6, from the Cartouche
Series 1980
Colored, pressed paper pulp; fabric; grommets; string; aluminum tubes
Two panels: 60 × 50 (152.4 × 127);
each: 53 × 16 (134.6 × 40.6)

793:RS30
Richard Smith
Cartouche II-15, from the Cartouche
Series 1980
Colored, pressed paper pulp; fabric; grommets; string; aluminum tubes
Three panels: 37 × 60 (94 × 152.4);
panel 1: 19½ × 19½ (49.5 × 49.5);
panel 2: 19½ × 37 (49.5 × 94);
panel 3: 19½ × 53 (49.5 × 134.6)

796:RS34
Richard Smith
Cartouche III-4, from the Cartouche
Series 1980
Colored, pressed paper pulp; fabric; grommets; string; aluminum tubes
Two panels: 60 × 50 (152.4 × 127);
each: 53 × 16 (134.6 × 40.6)

799:RS37
Richard Smith
Cartouche III-7, from the Cartouche
Series 1980
Colored, pressed paper pulp; fabric; grommets; string; aluminum tubes
Two panels: 60 × 50 (152.4 × 127);
each: 53 × 16 (134.6 × 40.6)

794:RS31
Richard Smith
Cartouche III-1, from the Cartouche
Series 1980
Colored, pressed paper pulp; fabric; grommets; string; aluminum tubes
Two panels: 60 × 50 (152.4 × 127);
each: 53 × 16 (134.6 × 40.6)

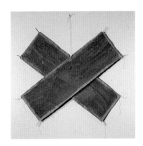

797:RS35
Richard Smith
Cartouche III-5, from the Cartouche
Series 1980
Colored, pressed paper pulp; fabric; grommets; string; aluminum tubes
Two panels: 60 × 50 (152.4 × 127);
each: 53 × 16 (134.6 × 40.6)

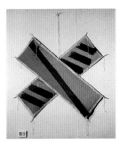

800:RS38
Richard Smith
Cartouche III-8, from the Cartouche
Series 1980
Colored, pressed paper pulp; fabric; grommets; string; aluminum tubes
Two panels: 60 × 50 (152.4 × 127);
each: 53 × 16 (134.6 × 40.6)

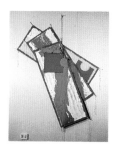

801:RS40
Richard Smith
Cartouche IV-2, from the Cartouche
Series 1980
Colored, pressed paper pulp; fabric; grommets; string; aluminum tubes
Three panels: 60 × 60 (152.4 × 152.4);
each: 53 × 19½ (134.6 × 49.5)

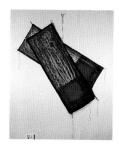

804:RS43
Richard Smith
Cartouche V-1, from the Cartouche
Series 1980
Colored, pressed paper pulp; fabric; grommets; string; aluminum tubes
Two panels: 60 × 60 (152.4 × 152.4);
each: 53 × 17 (134.6 × 43.2)

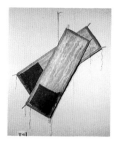

807:RS46
Richard Smith
Cartouche V-4, from the Cartouche
Series 1980
Colored, pressed paper pulp; fabric; grommets; string; aluminum tubes
Two panels: 60 × 60 (152.4 × 152.4);
each: 53 × 17 (134.6 × 43.2)

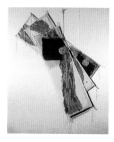

802:RS41
Richard Smith
Cartouche IV-3, from the Cartouche
Series 1980
Colored, pressed paper pulp; fabric; grommets; string; aluminum tubes
Three panels: 60 × 60 (152.4 × 152.4);
each: 53 × 19½ (134.6 × 49.5)

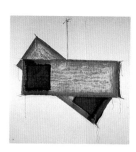

805:RS44
Richard Smith
Cartouche V-2, from the Cartouche
Series 1980
Colored, pressed paper pulp; fabric; grommets; string; aluminum tubes
Two panels: 60 × 60 (152.4 × 152.4);
each: 53 × 17 (134.6 × 43.2)

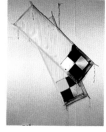

808:RS47
Richard Smith
Cartouche V-5, from the Cartouche
Series 1980
Colored, pressed paper pulp; fabric; grommets; string; aluminum tubes
Two panels: 60 × 60 (152.4 × 152.4);
each: 53 × 17 (134.6 × 43.2)

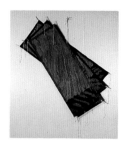

803:RS42
Richard Smith
Cartouche IV-4, from the Cartouche
Series 1980
Colored, pressed paper pulp; fabric; grommets; string; aluminum tubes
Three panels: 60 × 60 (152.4 × 152.4);
each: 53 × 19½ (134.6 × 49.5)

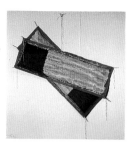

806:RS45
Richard Smith
Cartouche V-3, from the Cartouche
Series 1980
Colored, pressed paper pulp; fabric; grommets; string; aluminum tubes
Two panels: 60 × 60 (152.4 × 152.4);
each: 53 × 17 (134.6 × 43.2)

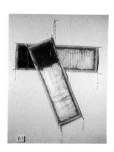

809:RS49
Richard Smith
Cartouche V-7, from the Cartouche
Series 1980
Colored, pressed paper pulp; fabric; grommets; string; aluminum tubes
Two panels: 60 × 60 (152.4 × 152.4);
each: 53 × 17 (134.6 × 43.2)

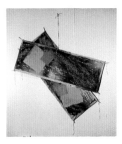

810:RS50
Richard Smith
Cartouche V-8, from the Cartouche
Series 1980
Colored, pressed paper pulp; fabric; grommets; string; aluminum tubes
Two panels: 60 × 60 (152.4 × 152.4);
each: 53 × 17 (134.6 × 43.2)

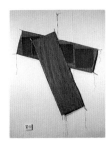

813:RS53
Richard Smith
Cartouche V-11, from the Cartouche
Series 1980
Colored, pressed paper pulp; fabric; grommets; string; aluminum tubes
Two panels: 60 × 60 (152.4 × 152.4);
each: 53 × 17 (134.6 × 43.2)

816:RZ7
Robert Zakanitch
Double Peacock 1, from the Double
Peacock Series 1981
Colored, pressed paper pulp
48 × 36 (121.9 × 91.4)

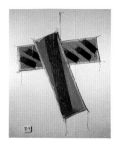

811:RS51
Richard Smith
Cartouche V-9, from the Cartouche
Series 1980
Colored, pressed paper pulp; fabric; grommets; string; aluminum tubes
Two panels: 60 × 60 (152.4 × 152.4);
each: 53 × 17 (134.6 × 43.2)

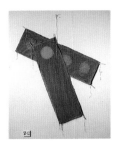

814:RS54
Richard Smith
Cartouche V-12, from the Cartouche
Series 1980
Colored, pressed paper pulp; fabric; grommets; string; aluminum tubes
Two panels: 60 × 60 (152.4 × 152.4);
each: 53 × 17 (134.6 × 43.2)

817:RZ8
Robert Zakanitch
Double Peacock 2, from the Double
Peacock Series 1981
Colored, pressed paper pulp
48 × 36 (121.9 × 91.4)

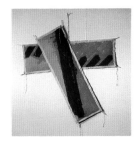

812:RS52
Richard Smith
Cartouche V-10, from the Cartouche
Series 1980
Colored, pressed paper pulp; fabric; grommets; string; aluminum tubes
Two panels: 60 × 60 (152.4 × 152.4);
each: 53 × 17 (134.6 × 43.2)

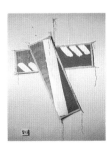

815:RS55
Richard Smith
Cartouche V-13, from the Cartouche
Series 1980
Colored, pressed paper pulp; fabric; grommets; string; aluminum tubes
Two panels: 60 × 60 (152.4 × 152.4);
each: 53 × 17 (134.6 × 43.2)

818:RZ9
Robert Zakanitch
Double Peacock 3, from the Double
Peacock Series 1981
Colored, pressed paper pulp
48 × 36 (121.9 × 91.4)

819:RZ10
Robert Zakanitch
Double Peacock 4, from the Double
Peacock Series 1981
Colored, pressed paper pulp
48 × 36 (121.9 × 91.4)

822:RZ13
Robert Zakanitch
Double Peacock 7, from the Double
Peacock Series 1981
Colored, pressed paper pulp
48 × 36 (121.9 × 91.4)

825:RZ16
Robert Zakanitch
Double Peacock 10, from the Double
Peacock Series 1981
Colored, pressed paper pulp
48 × 36 (121.9 × 91.4)

820:RZ11
Robert Zakanitch
Double Peacock 5, from the Double
Peacock Series 1981
Colored, pressed paper pulp
48 × 36 (121.9 × 91.4)

823:RZ14
Robert Zakanitch
Double Peacock 8, from the Double
Peacock Series 1981
Colored, pressed paper pulp
48 × 36 (121.9 × 91.4)

826:RZ18
Robert Zakanitch
Double Peacock 12, from the Double
Peacock Series 1981
Colored, pressed paper pulp
48 × 36 (121.9 × 91.4)

821:RZ12
Robert Zakanitch
Double Peacock 6, from the Double
Peacock Series 1981
Colored, pressed paper pulp
48 × 36 (121.9 × 91.4)

824:RZ15
Robert Zakanitch
Double Peacock 9, from the Double
Peacock Series 1981
Colored, pressed paper pulp
48 × 36 (121.9 × 91.4)

827:RZ19
Robert Zakanitch
Double Peacock 13, from the Double
Peacock Series 1981
Colored, pressed paper pulp
48 × 36 (121.9 × 91.4)

828:RZ20
Robert Zakanitch
Double Peacock 14, from the Double
Peacock Series 1981
Colored, pressed paper pulp
48 × 36 (121.9 × 91.4)

831:RZ23
Robert Zakanitch
Double Peacock 17, from the Double
Peacock Series 1981
Colored, pressed paper pulp
48 × 36 (121.9 × 91.4)

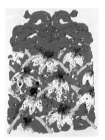

834:RZ26
Robert Zakanitch
Double Peacock 20, from the Double
Peacock Series 1981
Colored, pressed paper pulp
48 × 36 (121.9 × 91.4)

829:RZ21
Robert Zakanitch
Double Peacock 15, from the Double
Peacock Series 1981
Colored, pressed paper pulp
48 × 36 (121.9 × 91.4)

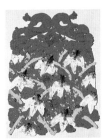

832:RZ24
Robert Zakanitch
Double Peacock 18, from the Double
Peacock Series 1981
Colored, pressed paper pulp
48 × 36 (121.9 × 91.4)

835:RZ27
Robert Zakanitch
Double Peacock 21, from the Double
Peacock Series 1981
Colored, pressed paper pulp
48 × 36 (121.9 × 91.4)

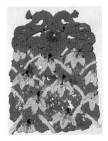

830:RZ22
Robert Zakanitch
Double Peacock 16, from the Double
Peacock Series 1981
Colored, pressed paper pulp
48 × 36 (121.9 × 91.4)

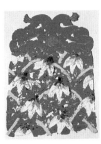

833:RZ25
Robert Zakanitch
Double Peacock 19, from the Double
Peacock Series 1981
Colored, pressed paper pulp
48 × 36 (121.9 × 91.4)

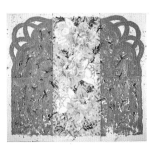

836:RZ29
Robert Zakanitch
Hussy, from the Paper Pulp Series 1981
Colored, pressed paper pulp
Six sheets: 84½ × 101¼ (214.6 × 257.2);
each: 42 × 32 (106.7 × 81.3)

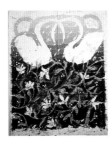

837:RZ30
Robert Zakanitch
Hearts of Swan (Marooned), from the Paper
Pulp Series 1981
Colored, pressed paper pulp
Four sheets: 83 × 66 (210.8 × 167.6);
each: 42 × 32 (106.7 × 81.3)

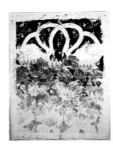

840:RZ33
Robert Zakanitch
Straightback Swans I, from the Paper Pulp
Series 1981
Colored, pressed paper pulp
Four sheets: 85 × 70 (215.9 × 177.8);
each: 42 × 32 (106.7 × 81.3)

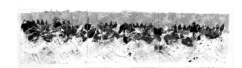

843:RZ37
Robert Zakanitch
Longwater Lilies, from the Paper Pulp
Series 1981
Colored, pressed paper pulp
Three sheets: 33¾ × 123 (85.7 × 312.4);
each: 32 × 42 (81.3 × 106.7)

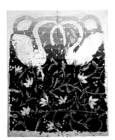

838:RZ31
Robert Zakanitch
Hearts of Swan (Black Bottom), from the
Paper Pulp Series 1981
Colored, pressed paper pulp
Four sheets: 82¼ × 67 (208.9 × 170.2);
each: 42 × 32 (106.7 × 81.3)

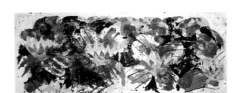

841:RZ35
Robert Zakanitch
Frog Lilies Sofa, from the Paper Pulp
Series 1981
Colored, pressed paper pulp
Two sheets: 33 × 84½ (83.8 × 214.6);
each: 32 × 42 (81.3 × 106.7)

844:RZ38
Robert Zakanitch
Glories of Morning, from the Paper Pulp
Series 1981
Colored, pressed paper pulp
42 × 32 (106.7 × 81.3)

839:RZ32
Robert Zakanitch
Hearts of Swan (Bottom Lined), from the
Paper Pulp Series 1981
Colored, pressed paper pulp
Four sheets: 83 × 67½ (210.8 × 171.5);
each: 42 × 32 (106.7 × 81.3)

842:RZ36
Robert Zakanitch
Pickled Mallows, from the Paper Pulp
Series 1981
Colored, pressed paper pulp
42½ × 33 (108 × 83.8)

845:RZ41
Robert Zakanitch
Cameo Basket, from the Paper Pulp
Series 1981
Colored, pressed paper pulp
39½ × 44½ (100.3 × 111.8)

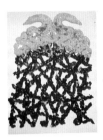

846:RZ42
Robert Zakanitch
Double Green Geese (Dark Braid), from
the Paper Pulp Series 1981
Colored, pressed paper pulp
Backing sheet: 62 × 46 (157.5 × 116.8)

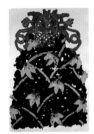

849:RZ45
Robert Zakanitch
Night Stepper I, from the Paper Pulp
Series 1981
Colored, pressed paper pulp
Backing sheet: 69 × 47 (175.3 × 119.4)

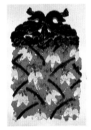

852:RZ49
Robert Zakanitch
Shadrack, from the Paper Pulp
Series 1981
Colored, pressed paper pulp
Backing sheet: 67 × 46 (170.2 × 116.8)

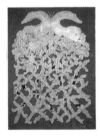

847:RZ43
Robert Zakanitch
Double Green Geese (Braided), from the
Paper Pulp Series 1981
Colored, pressed paper pulp
Backing sheet: 61 × 44 (154.9 × 111.8)

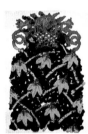

850:RZ46
Robert Zakanitch
Night Stepper II, from the Paper Pulp
Series 1981
Colored, pressed paper pulp
Backing sheet: 67 × 46 (170.2 × 116.8)

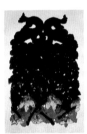

853:RZ50
Robert Zakanitch
Red Thunder, from the Paper Pulp
Series 1981
Colored, pressed paper pulp
Backing sheet: 67 × 46 (170.2 × 116.8)

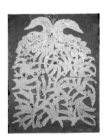

848:RZ44
Robert Zakanitch
Double Green Geese (Palmed), from the
Paper Pulp Series 1981
Colored, pressed paper pulp
Backing sheet: 62 × 46 (157.5 × 116.8)

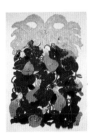

851:RZ47
Robert Zakanitch
Double Geese Gourds, from the Paper Pulp
Series 1981
Colored, pressed paper pulp
Backing sheet: 67 × 46 (170.2 × 116.8)

List of Presses

I Direct Hydraulic Lithography
Press

II **Flatbed Offset Lithography Press**
a Indirect impression transferred
from the printing element to the
blanket cylinder and set off onto
paper
b Direct impression transferred
from the printing element directly
to paper

III **Hydraulic Platen Press**

IV **Etching Press**

V **Vandercook Press**

VI **Vacuum Screen Press**

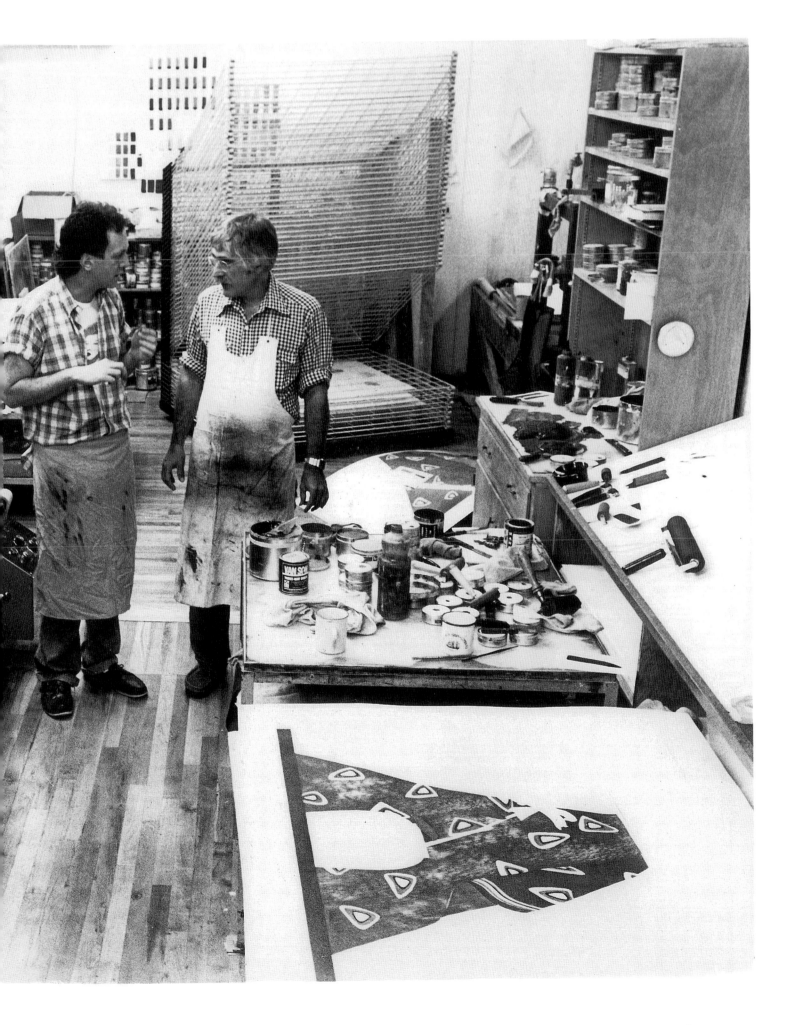

List of Methods

1 **Direct Lithography**
a Image drawn on stone
b Image drawn on aluminum plate

2 **Transfer Paper**
a Image drawn or printed on specially coated paper and transferred to stone
b Image drawn or printed on specially coated paper and transferred to an aluminum plate
c Image drawn or printed on specially coated paper and transferred to an intaglio plate

3 **Negative-working Wipe-on Aluminum Plate**
a Image drawn or printed on plastic sheet
b Image made from knife-cut masking film
c Image composed from photographically prepared line film, halftone film, or both

4 **Negative-working Presensitized Aluminum Plate**
a Image drawn or printed on plastic sheet
b Image made from knife-cut masking film
c Image composed from photographically prepared line film, halftone film, or both

5 **Positive-working Presensitized Continuous-Tone Aluminum Plate**
a Image drawn or printed on prepared acetate or Mylar sheet
b Image made from knife-cut masking film
c Image composed from photographically prepared line film, halftone film, continuous-tone film, or a combination thereof

6 **Etching**

7 **Lift-Ground Etching**

8 **Soft-Ground Etching**

9 **Aquatint**

10 **Spitbite Aquatint**

11 **Photosensitive-Resist Copper Intaglio Plate**
a Image drawn or printed on plastic sheet
b Image made from knife-cut masking film
c Image composed from either photographically prepared line film, halftone film, or both

12 **Engraving**

13 **Drypoint**

14 **Mezzotint**

15 **Assembled Plate**
a Parts assembled to form a printing element, then mounted on a flat wood or metal support
b Parts assembled in registration on a press bed for printing

16 **Multiple-Inking Technique**
 a Intaglio or relief printing: inked with multiple colors using a variety of tools
 b Direct lithography: inked with different colors
 c Offset lithography or Vandercook press: colors separated in ink fountain and printed
 d Offset lithography or Vandercook press: colors placed together in ink fountain, making a blend of inks
 e Screen printing: inks applied separately and squeegeed onto paper
 f Screen printing: inks applied together, making a blend of inks, and squeegeed onto paper
 g Any size hand roller with a blend of inks applied and rolled onto a printing element

17 **Viscosity Inking**

18 **Linocut**

19 **Woodcut**
 a Image hand-carved with tools
 b Image cut and shaped with power tools
 c A drawn or printed image mechanically cut by a laser machine

20 **Direct-Resist Magnesium Plate**

21 **Photosensitive-Resist Magnesium Plate**
 a Image drawn or printed on plastic sheet
 b Image made from knife-cut masking film
 c Image composed from photographically prepared line film, halftone film, or both

22 **Positive-working Presensitized Plastic Relief Plate**
 a Image drawn or printed on plastic sheet
 b Image made from knife-cut masking film
 c Image composed from photographically prepared line film, halftone film, or both

23 **Relief Plate Inking**
 a Raised level of plate or unprepared surface of a plate inked with a roller to print as a relief
 b Recess level wiped with ink to print as an etching
 c Both recessed and relief surfaces inked to print as an etching

24 **Inkless Embossing**

25 **Paper Stencil**

26 **Tusche Screen**

27 **Blockout Stencil**

28 **Knife-cut Stencil**

29 **Direct Photographic Screen Stencil**
 a Image drawn or printed on plastic sheet
 b Image composed from photographically prepared line film, halftone film, or both

30 **Indirect Photographic Screen Stencil**
 a Image drawn or printed on plastic sheet
 b Image made from knife-cut masking film
 c Image composed from photographically prepared line film, halftone film, or both

31 **Direct/Indirect Photographic Screen Stencil**
 a Image drawn or printed on plastic sheet
 b Image made from knife-cut masking film
 c Image composed from photographically prepared line film, halftone film, or both

32 **Stenciling**
 a Paper or plastic stencil
 b Metal stencil
 c Wide-mesh screen stencil

33 **Stamping**

34 **Ghost Impression**

35 **Wet-Pulp Collage**

36 **Collage**
 a Paper used as a full sheet, cut, or torn; assembled; and attached with adhesive applied by hand
 b Paper used as a full sheet, cut, or torn; assembled; and attached with adhesive screen-printed using a vacuum screen press
 c Paper used as a full sheet, cut, or torn; assembled; and attached with thread (by knotting or sewing)

(overleaf)
List of Methods

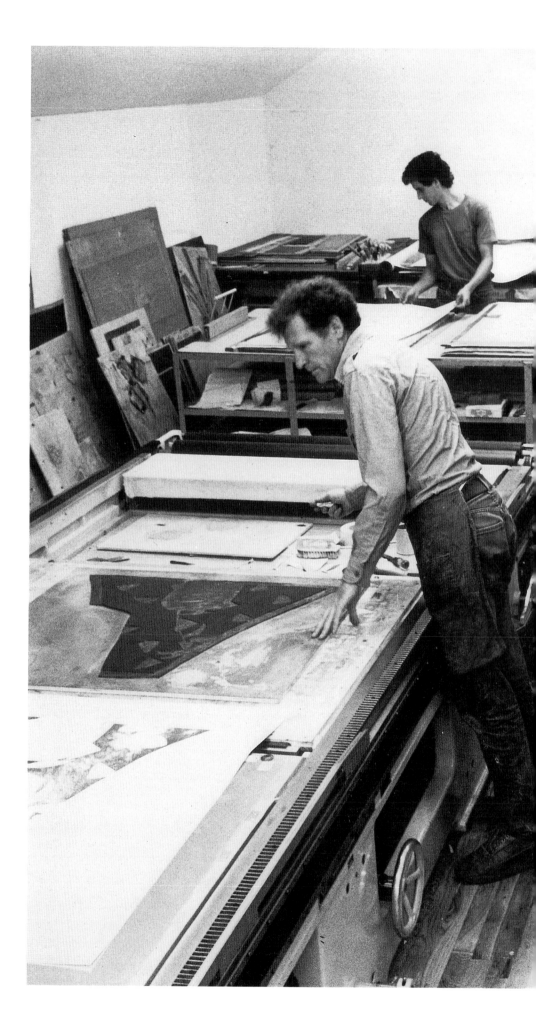

Roger Campbell, Tom Strianese, Ed Baynard, and Kenneth Tyler in the pressroom during the proofing of *The Print Scarf*, 1980.

Glossary

Words set in SMALL CAPITALS are defined elsewhere in the Glossary.

Acid Bath An acid solution contained in a shallow tray in which metal plates are immersed for ETCHING.

Agate A very hard shaped stone mounted in a wooden handle, used primarily to burnish paper, thin foil, and silver or gold leafing. Agates come in beveled flat, blunt rounded, and curved rounded shapes. *See also* **Burnisher.**

"A la Poupée" Method An intaglio technique for hand-depositing more than one color of ink onto a printing plate using a TARLATAN, BRAYER, brush, DABBER, or a combination of these, and printing the colors simultaneously. Stencils are often used when inking the plate to position the colors accurately. This method is sometimes called *dolly printing*. At the workshop it is commonly referred to as MULTIPLE-INKING TECHNIQUE.

Alum A complex salt, essentially a hydrate of potassium aluminum sulfate, used along with rosin in the SIZING of paper and as a MORDANT for fixing colors. Also called *papermaker's alum.*

Aniline Dye A dye of coal tar origin discovered by William Henry Perkin in England in 1856. Aniline dyes are prepared from benzol, which is a product of coal tar. Today the term is used broadly to designate synthetic organic dyes and pigments. A class of aniline dyes called *direct dyes* or *substantive dyes* have a high affinity for cellulose and are used to color paper pulps. *Acid dyes* are another class of aniline dyes that have no direct affinity for cellulose and require a MORDANT to fix the colors to the fibers. Acid dyes are used in surface coloring of paper.

Aquatint An INTAGLIO technique in which fine particles of acid-resistant material (powdered rosin, spray lacquer, or spray paint) are adhered to a plate to create tonal effects. The plate is first treated in an ACID BATH like an etching plate. Afterward the acid-resistant material is removed. The resulting etched, or *bitten*, surface produces a textured area rather than lines. An aquatint plate can be used to print even tones or

tones with gradation or blending effects. Aquatint is often used in combination with other intaglio techniques. The aquatint process using a rosin ground was invented by the Frenchman Jean Baptiste Le Prince around 1768.

Aquatint Chamber A chamber containing a shelf on which printing plates are placed to receive an even ground of rosin particles for aquatint processing. A paddle wheel or air device is used to circulate the rosin particles in the chamber, and while the particles are still airborne, the printing plate is placed on the shelf to receive the falling rosin. *See also* **Dust Bag.**

Archive Copy The print impression retained by the publisher as a permanent archive. In 1984 the McKnight Print Study Room was established at the Walker Art Center to house and maintain the Tyler Graphics Ltd. archive collection.

Artist's Proof A PROOF outside the numbered EDITION but equal in quality to it. Each artist's proof is inscribed by the artist *Artist Proof* or *A.P.* and consecutively numbered (e.g., 1/20, 2/20, etc., or I/XX, II/XX, etc.).

Asphaltum A greasy bituminous liquid used as an acid resist in INTAGLIO and for processing printing elements in LITHOGRAPHY. It is sometimes used as a drawing medium on stone and metal plates.

Assembled Plate A plate composed of parts such as fragments of manufactured objects, printing elements, FOUND OBJECTS, or other materials. The parts are attached or mounted on a rigid backing to form a single composite PRINTING ELEMENT or are assembled unattached on the press BED for printing. Assembled plates are made for EMBOSSING, INTAGLIO, and RELIEF PRINTING.

Bast Fiber A term commonly used to designate fibers obtained primarily from the inner bark of plants and trees. FLAX, GAMPI, HEMP, JUTE, and MITSUMATA are typical bast fibers. The bast fiber from various mulberry trees in the Far East is generally referred to as KOZO fiber.

Beater A machine designed to treat FIBERS for papermaking. A rounded oblong tank is partially divided by a vertical wall (midfeather). Mounted in the tank on one side of this wall is a heavy horizontal roll that revolves against a bedplate recessed in the bottom of the tank. Both the roll, which can be adjusted vertically, and the bedplate contain horizontal metal bars set on edge. These two units serve as impellers to circulate the water and pulp mass in the tank while passing it between the metal bars to cut, macerate, bruise, and separate the fibers during the beating operation. Beater designs vary, but the principal function is the same. The machine is sometimes called a *Hollander*, from the place of its invention in the late seventeenth century, when it began to supersede the stamper (stamping mill), which had been used in Europe since the twelfth century.

Lee Funderburg fitting one of the newly inked woodblocks into an assembled plate on the Vandercook press bed for Alan Shields's *Fire Escape Plan,* 1981.

Beating The principal operation involved in the preparation of FIBERS for paper-making, used both to control fiber length by cutting and to hydrate fibers by bruising or abrasion. Also used to mix additives (such as dyes, pigments, SIZING, or fillers) with the fiber and water SLURRY.

Bed The flat surface of a flatbed press, which carries the PRINTING ELEMENT.

Bevel The hand-filed or machined angle on the edge of a metal plate which prevents injury to the BLANKET and damp paper during the printing process. The bevel produces a distinctive embossed PLATE MARK on the print.

Blanket In INTAGLIO, the felt material placed between the paper and the press roller during printing in order to distribute pressure evenly over the plate surface, to prevent shifting of paper, and to provide cushioning and aid in pressing the paper into the lines of the plates. In OFFSET LITHOGRAPHY, the resilient rubberized covering of the press cylinder, which receives the ink impression from the plate or stone and transfers it to paper. *See also* **Felt.**

Bleed In printing, to print an inked impression beyond one or more edges of the paper. In papermaking, *bleeding* refers to the oozing of colored dyes from PULP that has been pigmented, which can occur before or after pressing. Bleeding can be regulated by adding a MORDANT to the pulp mixture.

Blend Inking A technique of consistently rolling out on a slab a set pattern of several different colored inks in such a way that the blend can be transferred identically to the PRINTING ELEMENT for each impression. This method of inking, usually referred to as a *split ink fountain*, can also be employed using the oscillating ink rollers of an offset press or VANDERCOOK PRESS. Blend inking can be achieved in screen printing by pressing several different colored inks through the screen with one wipe of the SQUEEGEE. Also called *rainbow roll* or *spectrum roll*.

Blind Printing Printing from uninked plates to create three-dimensional form.

Blockout In screen printing, any material, such as paper, film, tissue, glue, lacquer, or a photographically made stencil, that is applied to the screen fabric to prevent the penetration of ink. *See also* **Knife-cut Stencil.**

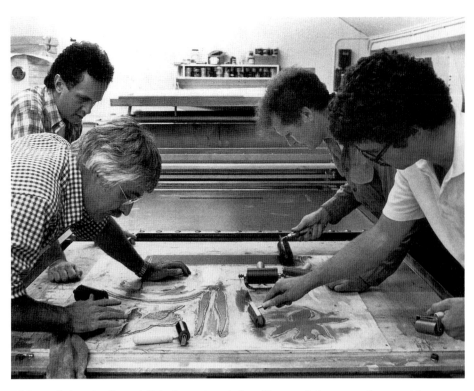

Ed Baynard observing Kenneth Tyler, Roger Campbell, and Lee Funderburg using fingers and brayers to multiple-ink the first woodblock for *The Dragonfly Vase*, 1980.

Blockout Compound A tough, elastic, fast-drying liquid screen filler for blocking out screens. The three kinds of blockout compounds generally used are the water-soluble, solvent-soluble, and solvent-resistant types.

Blockout Stencil Broadly speaking, all methods of stencil making employ blockout. The shop term *blockout* refers specifically to a stencil-making procedure in which a hard-drying fluid, such as lacquer, BLOCKOUT COMPOUND, or glue, is applied with a brush or spatula directly to the screen, selectively blocking out areas and preventing the penetration of ink during printing. Multiple printings from one stencil are achieved by masking selected areas of the stencil for printing, removing the blockout from the stencil, masking adjacent areas, and printing again. This technique is used when precise registration is required in color printing.

Blow Up To enlarge pictorial material by hand or photographic methods.

Brayer A small ROLLER fitted with a handle and used for applying ink to a PRINTING ELEMENT.

Brightness A term commonly used in the paper industry to describe the reflectivity of white papers or pulps under specific conditions and with a specific light source. Specialized laboratory instruments are used for measuring brightness, which is related to, but not a measure of, color. Brightness is the underlying reflectivity of paper in light. Measurement readings are expressed in relation to a known standard. A general guide to brightness readings follows.
100% brightness: magnesium-oxide standard
90%–95% brightness: fine mould-made print paper
85%–88% brightness: machine-made book paper
65%–68% brightness: newsprint

Bulk The thickness of paper expressed in terms of the number of sheets (or pages) per inch or centimeter under a specified pressure. *See also* **Caliper.**

Burin An engraving tool used on metal plates or woodblocks, consisting of a partially rounded wooden handle attached to a square or lozenge-shaped metal shaft, sharpened to an angle of approximately 45 degrees. A version of the burin is made with a varying number of tiny points

machined into the conventional angle and used for making multiple lines. These tools are made in a number of sizes. Also called a *graver*.

Burnisher A highly polished steel tool made in a variety of shapes: single or double ended, flat, spoon shaped, conical, or combined with a SCRAPER. A common type of burnisher has a round shaft mounted in a wood handle with one end of the shaft slightly flattened, tapering to a blunt point, and curving upwards. Used for repolishing the surface of a plate after scraping and for lightening tonal areas in AQUATINT, MEZZOTINT, or SOFT GROUND. An alternative method of burnishing makes use of a small power tool with buffing wheels and polishing compound or abrasive hones. *See also* **Agate.**

Burr Metal ridges forced up on one or both sides of the scored line in DRYPOINT or the cut line in ENGRAVING and forming the "tooth" of the roughened mass in MEZZOTINT. The burr is usually removed in engraving but retained in drypoint. In mezzotint the burr forms the entire surface of the plate after it has been worked by the ROCKER. The burr holds additional ink during printing and imparts a velvety look to the printed line or surface. The abrasiveness of inking and the pressure of the printing press contribute to the rapid disintegration of the burr; consequently the number of high-quality impressions that can be taken from such a plate is very limited. To increase the run, plates are often steel-faced before printing. *See also* **Steel Facing.**

Calendering The process of flattening and polishing paper to regulate its tooth or texture. A necessary step in preparing paper for certain printing processes, calendering influences the paper's receptivity to ink and helps to determine whether a paper will work in a printing operation. A calendered finish is achieved either by pressing individual sheets of paper in a LITHOGRAPHY PRESS between the press BED and the TYMPAN or by running paper through a series of polished rollers, which compress the paper as they smooth the surface.

Caliper The thickness of an individual sheet of paper, usually expressed in thousandths of an inch or millimeters.

Cancellation Proof A print made from the defaced PRINTING ELEMENT of an EDITION. In multicolored prints the practice is to cancel only one of the elements. Cancella-

tion proofs give collectors a guarantee that no additional images will be pulled and are signed or initialed and dated by the artist. When no cancellation proof is made for a given edition, the workshop notes the reason.

Carborundum The trade name for a powdered abrasive made from a hard compound of carbon and silicon, used for GRAINING lithography stones.

Casein Paint Paint made from pigment mixed with a binder made from casein, a protein found in milk. These paints are very opaque and dry to a mat finish. They can be thinned with water and, when dry, cannot be rewetted.

Cast Paper A type of three-dimensional paper made by dipping a shaped MOULD into a vat of PULP or by pouring, spooning, or patting pulp in or around a shaped mould. Once the pulp has dried it is separated from the mould. Moulds for cast paper can be constructed from a variety of materials, including FOUND OBJECTS. Shaped wire or plastic screening is the best material to use when moulds are dipped. Other methods of making cast paper employ moulds constructed from plaster, rubber, wood, and ceramic. One variation of cast paper is to laminate a newly made sheet over a mould and hand-press it into shape.

Chemical Cotton A term used in the paper industry for purified cotton linter pulp, the purest form of cellulose commercially available. Chemical cotton is available in various fiber lengths and as loose pulp, laps, rolls, or cut sheets. In preparation of the pulp in sheets, a higher proportion of shorter fibers may be present than in loose pulp.

Chemical Pulp A PULP made by cooking wood chips with steam and chemicals under high temperature and pressure to remove impurities, principally lignin, which deteriorates rapidly on exposure to light and air. Highly purified wood pulps, such as those used for rayon manufacture, are obtainable and are sometimes called *high-alpha pulps.*

Chine Appliqué A method of adhering one sheet of material (often thin paper) to another with glue under pressure. Paper used for this purpose has already been formed and dried. *See also* **Collage.**

Chine Collé A method of selectively adhering a thin sheet of paper to a larger

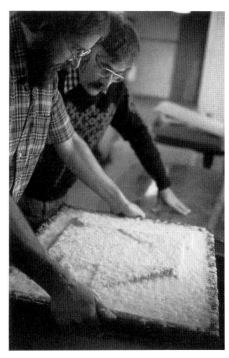

Kenneth Tyler observing John Koller of HMP paper mill as he lifts from the vat the shaped mould for Frank Stella's *Grodno (I)*, from the Paper Relief Project, 1975.

and heavier sheet using glue or GUM ARABIC during the printing process. Traditionally a thin, fragile Oriental paper with excellent printing qualities was adhered to a heavier European paper for added strength and color, and the printed image was designed to cover only the Oriental paper. This method is rarely used by the workshop and has been replaced by the technique of collaging papers before printing, which guarantees paper registration and uniform surface quality. *See also* **Chine Appliqué.**

Chisel The principal tool for shaping and cutting wood, LINOLEUM, or metal. Constructed of a blade with a beveled edge mounted in a wooden handle, chisels are made in different sizes for removing material by hand with the aid of a hammer.

Chop An identifying mark used by printers, artists, print workshops, and publishers. Chops are made as stamps and as embossing dies for marking prints.

Collage A technique introduced into fine art by Georges Braque and Pablo Picasso about 1909, in which fragments of commercially printed paper were incorporated into compositions. Collage was later developed by the artists of the Dada and Surrealist movements to include FOUND

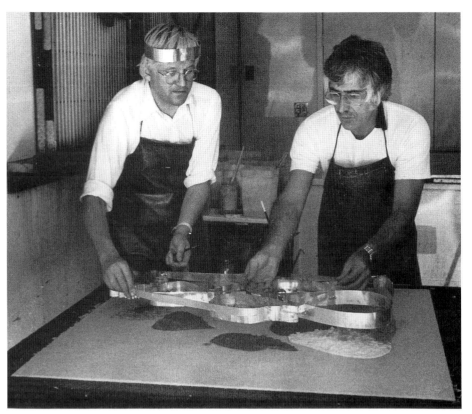

David Hockney and Kenneth Tyler lifting a cookie-cutter mold from the base sheet after applying colored pulps through the mold for *Sunflower,* from the Paper Pool series, 1978.

OBJECTS. Today any material fixed to a surface may be termed collage. *See also* **Chine Appliqué.**

Colophon　A brief statement usually placed on the last page of a book or portfolio, which often includes information on the typeface and design, the paper and printing techniques used, and other facts of production.

Colored, Pressed Paper Pulp　A term used at the workshop to refer to the use of dyes or dyed pulps in the making of unique handmade papers. Color is either added to the FURNISH in the VAT, applied directly freehand, or applied with the aid of a device such as a COOKIE-CUTTER MOLD, template, straightedge, or temporary frame placed on the newly couched or hand-cast pulp. This process often results in the creation of one-of-a-kind papers. *See also* **Colored Pulp; Embedding; Mixed Pulp; Staining; Vacuum Forming.**

Colored Pulp　A SLURRY that has any type of coloring matter, such as pigments, dyes, paints, or colored rags, added to it to make colored paper. Colored pulps may be intermixed in the BEATER, in the VAT, or in small containers to make uniform or nonuniform colored paper. *See also* **Colored, Pressed Paper Pulp; Mixed Pulp.**

Color Trial Proof　A PROOF made before the colors to be used in an EDITION have been determined. The proofs are inscribed *Color Trial Proof* or *C.T.P.* followed by an Arabic or Roman numeral.

Composition Roller　A type of ROLLER believed to have been invented in the early 1800s in England by Augustis Appligath. Nineteenth-century rollers for hand and machine lithographic printing were made from a mixture of glue and molasses poured into a metal mold encasing a wooden roller. Today composition rollers are made from a variety of rubber and plastic compounds.

Contact　To bring artwork and the printing side of a PLATE or screen into contact for exposure in a VACUUM CONTACT FRAME.

Continuous-Tone Film　A film without a halftone dot screen used to make a printing plate in which the drawn image presents all of the gradations of tone from dark to light, as in a wash drawing.

Continuous-Tone Image　An image with gradations of tone from dark to light like a wash drawing and unlike an opaque drawing, which has no gradations.

Cookie-Cutter Mold　A thin-walled sectioned plastic or metal mold used for coloring newly formed wet sheets of paper with pigmented pulps and dyes. The mold is registered on top of the newly made wet sheet, and PULP is spooned or hand-patted into the sections. The mold is then removed, and the applied COLORED PULP is fused with the base sheet as it is pressed between blotters and FELTS in a PLATEN PRESS. The paper is then dried on screen trays or blotters. *See also* **Colored, Pressed Paper Pulp.**

Cotton Fibers　The long, flat tubular fibers of the cotton plant, which grow from the end of the cotton seed as single slender hairs. Cotton fibers are the purest form of cellulose used in papermaking. These opaque white fibers produce a paper that is soft, flexible, and bulky. For papermaking, cotton may be used in the form of rags, LINTERS, or, less commonly, long-staple fibers. Cotton plants are cultivated principally in India, Egypt, and the United States.

Couching　Transferring the wet, newly formed sheet of paper from the MOULD to a wet FELT using pressure. Two or more newly formed sheets can be couched together to form a multilayered sheet. *See also* **Cast Paper; Duplex Paper.**

Counteretch　(1) To pretreat a plate or stone in order to clean and desensitize the surface. (2) To resensitize the nonprinting areas of a PRINTING ELEMENT to prepare for the addition of new image areas.

Counterproof　A printed proof offset onto another sheet of paper. The resulting image is reversed in relation to the printed proof but is identical to the plate it was printed from.

Curating　The procedure performed by the curator and the printers to prepare a predetermined number of prints for signing by the artist. This entails careful inspection of the paper and printed surface for any defects or deviations from the RIGHT TO PRINT standard established for the edition by the artist and the workshop director. The prints are then collated into an EDITION with proofs and signed. Finally each impression is marked with the workshop CHOP and numbered on the verso with the workshop number. *See also* **Print Documentation.**

Cylinder Mould Machine　The mechanism used for making MOULD-MADE PAPER, consisting of a wire-covered cylinder that

revolves in the VAT. Fibers cling to the cylinder, while the water is strained through. The cylinder mould machine was first patented in France in 1807 by a Frenchman from Normandy named Desestables.

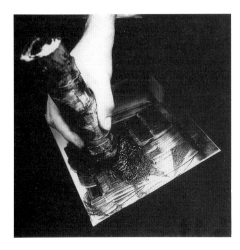

Dabber A mushroom-shaped device consisting of a wooden disk covered with leather, silk, or felt and attached to a handle. Used for spreading ink over a printing surface or for laying wax grounds on plates. Simple disposable dabbers are constructed from rolled felts taped together.

Deckle A wooden frame, separate from the MOULD, which acts as a rim. It controls the size and shape of the sheet of paper and the thickness or amount of pulp on the mould.

Deckle Edge The rough edge on handmade paper. Originally considered an imperfection and cut off. However, the deckle edge came back into fashion in the late nineteenth century with the handicraft revival. Many handmade sheets made today have very pronounced irregular deckle edges, which some artists and printers consider attractive.

Desensitizing The chemical process in LITHOGRAPHY in which the nonimage area of a plate or stone is made nonreceptive to ink (hydrophilic) through GUM ETCH treatment of the surface.

Developing For plates, a chemical process that removes the unhardened bichromated coating from the exposed plate in three stages: (1) it makes the image ink receptive (oleophilic), (2) desensitizes the nonimage areas, making them water receptive (hydrophilic), and (3) gums the surface in preparation for printing. For screens, the chemical process that further hardens the nonprinting areas of the stencil before washout. The

film is first exposed, then developed and WASHED OUT. *See also* **Exposure.**

Diamond Point A DRYPOINT NEEDLE fitted with a diamond tip, used primarily for drypoint drawing.

Diazo A photosensitive chemical used in photographic emulsions for making lightsensitive lithography plates. Diazo compounds were discovered in Germany in 1858, but no real advance in their use was made until the late 1920s. *See also* **Presensitized Plate; Wipe-on Aluminum Plate.**

Die Stamping The use of a die of brass, zinc, or other hard metal to stamp an image into material such as the cloth spine of a portfolio. Die stamping may be done without ink, with ink, or with foil.

Direct/Indirect Photographic Screen Stencil A screen stencil that combines features of both the direct and indirect photographic screen stencils. The six steps for making this type of stencil are: (1) indirect photographic film is placed, emulsion side up, on clean paper; (2) the printing side of the screen is placed on top of the unsensitized film; (3) direct-type lightsensitive emulsion is squeegeed across the screen fabric, adhering the film below; (4) the fabric-emulsion-film combination is dried in a horizontal position using a fan; (5) the film support sheet is peeled away. The positive image is contacted to the printing side of the coated screen in a VACUUM CONTACT FRAME and exposed; and (6) the unexposed emulsion is WASHED OUT, leaving the hardened emulsion on the screen fabric as the stencil. *See also* **Blockout Stencil; Direct Photographic Screen Stencil; Indirect Photographic Screen Stencil.**

Direct Photographic Screen Stencil A direct stencil made by applying a liquid photographic emulsion to the screen. To make the stencil, both sides of the screen fabric are hand-coated with positiveworking light-sensitive emulsion and dried. The positive image is then contacted to the printing side of the coated screen in a VACUUM CONTACT FRAME and exposed. The unexposed, soft emulsion is WASHED OUT with water, and the exposed, hardened emulsion remains on the screen fabric, forming the stencil. *See also* **Blockout Stencil; Direct/Indirect Photographic Screen Stencil; Indirect Photographic Screen Stencil.**

Direct Printing Press *See* **Lithography Press.**

Direct-Resist Magnesium Plate The result of a direct method of relief platemaking, in which an acid-resistant material is drawn on a polished magnesium plate, dried, and exposed to intense heat, which further dries and hardens the drawing material. The plate is then processed into a relief element using a POWDERLESS ETCHING process. The raised level of the plate can be inked with a roller to print as a relief, or the recessed level can be inked and wiped to print as an ETCHING. When these two inking techniques are combined on one plate, the print is an etching made from intaglio and relief surfaces.

Drypoint An INTAGLIO process in which marks are made on a plate with a sharp, pointed instrument. This tool creates a ragged curl, or BURR, on the side or sides of the incised line. Both the incised line and the burr receive ink when the plate is wiped, giving the printed line a distinctive velvety look. Drypoint is usually done on copper plates and is often combined with other intaglio techniques, such as ETCHING and AQUATINT. The first artist to work in the drypoint technique was the Master of the Housebook, who worked around 1480 in Germany. *See also* **Steel Facing.**

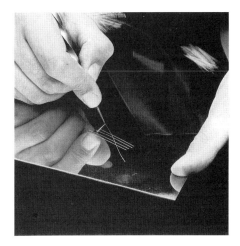

Drypoint Needle A solid steel tool with a tapered point used to inscribe or score lines into metal. *See also* **Diamond Point.**

Duplex Paper Two layers of paper, generally of different quality, size, and color, couched together in the wet state and pressed to form one solid sheet of paper. In commercial papermaking, duplex paper may be formed with two different sides or laminated in the dry state.

Dust Bag A small silk or nylon bag containing powdered rosin, used for laying aquatint grounds. To release the rosin, the bag is held over the plate and gently tapped with the hand.

Dyed Stuff PULP that has organic coloring matter added to the stock in the BEATER. Often the dyes are fixed with a MORDANT to prevent bleeding or to fix the color on the fibers. Dyed stuffs can be dried for later use as a FURNISH. They are reconstituted using a HYDRAPULPER, beater, or other mixing device.

Edition The series of images identical to the RIGHT TO PRINT proof. An edition of twenty-five contains twenty-five prints consecutively numbered 1/25, 2/25, etc. Edition prints are signed, numbered, and often dated by the artist.

Embedding The application of materials, such as rags, thread, or vegetation, to the surface of a newly couched sheet of paper. If placed in a press with the wet paper, the material becomes an integral part of the sheet, imparting its color and shape to the paper surface. *See also* **Colored, Pressed Paper Pulp; Duplex Paper.**

Embossing Any process used to create a raised or depressed surface. The techniques of ETCHING, stamping, carving, or casting are most often used to make embossing plates. However, FOUND OBJECTS, male and female dies, and metal rolls with engraved or etched designs can be used to create raised or depressed images or patterns in paper.

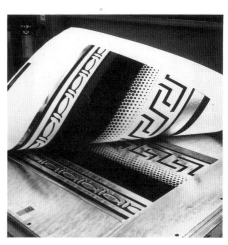

Roy Lichtenstein's *Entablature VII* being removed from the embossing plate, 1975.

Endpaper A folded sheet attached to the inside front and back covers of a book.

Engraving An INTAGLIO technique in which a metal plate is manually incised with a BURIN. The burin is pushed across the plate at various angles and with varying pressure, permitting the cutting action to range from a deep to a tapered stroke. The incised lines vary in width and darkness when printed. The technique of engraving metal dates from antiquity. It was employed by the Greeks, Romans, and Etruscans for decorating objects. It was not until about 1430 in Germany that engraved plates began to be used for making prints.

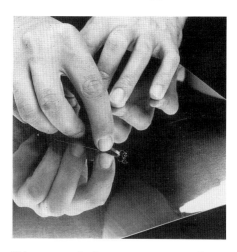

Using a square burin to engrave a copper plate.

Esparto A coarse grass native to North Africa, used in papermaking. The grass has short, relatively fine, wiry fibers, which produce a paper with finely compacted FORMATION.

Etching An INTAGLIO technique whereby drawn marks are bitten into the metal plate by chemical rather than mechanical action. An acid-resistant ground is thinly applied to the plate's surface and dried (except for SOFT-GROUND coatings, which are nondrying). Using various tools, the artist draws through the ground, exposing the metal. The plate is then immersed in an ACID BATH, which chemically dissolves the exposed metal and produces recessed areas in the plate surface. Using stop-out varnishes, selected areas of exposed metal can be etched to different depths. Etching is often combined with other intaglio techniques. The method for etching metal to decorate armor was well known before the fifteenth century. The technique of etching metal plates in order to print from them was not introduced until the sixteenth century in Germany. Urs Graf produced the first dated etching in 1513. *See also* **Foul Biting.**

Etching Ground Any acid-resistant substance made from various mixtures of wax, gum, varnish, ASPHALTUM, tallow, and resin. To make an even ground, the mixture is either poured over or painted on the metal plate, forming a coating. It can also be applied to the surface of a warm metal plate with a DABBER or ROLLER, after which it can be drawn through with a variety of tools. Etching grounds are often used to block out areas on an etching plate prior to acid treatment. *See also* **Hard Ground; Soft Ground.**

Etching Needle A tool used to draw through the ground on an etching plate. It consists of a light steel rod with a rounded point, set into a wooden holder. Needles can also be made from altered dental tools, sewing needles, and similar objects.

Etching Press *See* **Intaglio Press.**

Experimental Impression A unique IMPRESSION pulled to study the effect of a given printing process, which may or may not lead to the printing of an edition. An experimental impression is similar to a MONOTYPE and is often hand-colored.

Exposure The measured ultraviolet light units from a quartz iodine lamp used to harden light-sensitive coatings on plates or screen-coating solutions in photographic plate and screen methods that use a VACUUM CONTACT FRAME.

Felt A woven textile, usually of wool, onto which sheets of paper are couched. *See also* **Blanket; Couching.**

Felt Finish The impression on a paper surface created by pressing wet or partially dry sheets between FELTS.

Fibers The threadlike structures from which papermaking pulp is made; usually cellulose, but in modern usage sometimes synthetic. Cellulose fibers are derived from plants and have the unique property of forming a self-adherent mat when suspended in water. Synthetic fibers do not have this property and require the use of a binder. Fibers are prepared for papermaking in three steps: (1) separation by cooking the raw materials, then separating them mechanically; (2) beating, cutting, and bruising for better coherence and paper formation; and (3) refining and final cutting to optimum length.

Fillers In papermaking, nonfibrous, insoluble materials added to the fiber FURNISH in order to impart specific properties such as opacity, improved ink receptivity, whiteness, or surface smoothness. Among the materials used for this purpose are clay and calcium carbonate.

Flat A printing term used to describe an image that lacks contrast and prints as a solid tone.

Flax The BAST FIBER of the flax plant, the source of linen. Either flax fiber or linen rags may be used for papermaking.

Formation The appearance of paper when held up to the light, also called *look-through*. Formation is related to the evenness of fiber distribution in the sheet. It is influenced by fiber length and hydration (which are controlled by beating and refining), by additives such as FILLERS, and by the way the sheet is formed.

Foul Biting In ETCHING, corroding or pitting of a plate during biting as a result of faulty grounding. These irregularities are often of interest to the artist and may be incorporated into the final print.

Found Object An object found by the artist and employed in its original state or in an altered form in the assemblage of a work. Found objects can also be incorporated into an ASSEMBLED PLATE or used as a surface to print from. *See also* **Collage.**

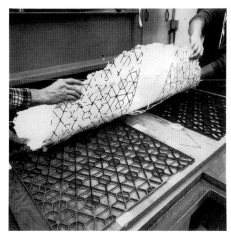

Parts of found plastic crates made into an assembled plate to print simultaneously two of the papers for Alan Shields's Raggedy Circumnavigation Series, 1985.

Frisket A piece of paper or plastic film that is placed between the inked PRINTING ELEMENT and the paper to keep areas free of ink during inking or printing. *Frisket paper* is also used to block out or mask portions of artwork during retouching or airbrushing.

Furnish The mixture of PULP and any other material suspended in water (after the pulp has been prepared in a BEATER or other type of macerating machine), creating a SLURRY from which paper is made. *See also* **Stuff; Vat.**

Gampi A BAST FIBER commonly used in JAPANESE PAPERMAKING. Derived from the shrub of the Thymelaeaceae family and characterized by long, fine, tough, glossy fibers.

Ghost Impression A term given to a PROOF pulled after the first IMPRESSION has been taken and before additional inking of the PRINTING ELEMENT. Usually a printing element that has been fully inked to print a good impression has sufficient ink left on its surface to print a very light second impression. With careful manipulation of ink layer and printing pressure, both the original and ghost impressions can be included in an EDITION.

Gouge A tool shaped like a CHISEL with a concave blade used for cutting grooves.

Stone-graining Machine

Graining In LITHOGRAPHY, the altering of a plate or stone surface to a rough finish consisting of many thousands of tiny "hills" and "valleys" necessary for holding water and image in the LITHOGRAPHY PRESS. There are a number of manufacturing methods used for roughening a metal surface: chemical graining, sandblasting, ball graining, dry brush graining, wet brush graining, and ball brush graining. For stone graining, a hand-driven or a manually operated and power-driven LEVIGATOR is used with water and CARBORUNDUM abrasive. The workshop uses a custom-made stone-graining machine designed by Kenneth Tyler in 1973, which consists of a power-driven levigator attached to a movable carriage that transverses a flat table that holds the stone for graining.

Graver *See* **Burin.**

Groundwood (Mechanical) Pulp A PULP made by grinding peeled or barked logs against a grindstone. Yields are high, but impurities remain. *See also* **Fibers.**

Gum Arabic A vegetable gum exuded from the bark of the acacia tree, which grows in the Middle East and North Africa. The gum is the principal ingredient in the manufacture of lithographic plate gum solutions and desensitizing plate etches. Used to "gum down" plates and stones and mixed in various acid formulas for DESENSITIZING plates and stones.

Gum Etch A solution of GUM ARABIC and acid used in DESENSITIZING lithography plates and stones.

Halftone A process whereby a CONTINUOUS-TONE IMAGE, such as a photograph, drawing, or painting, is photographed through a screen made with a graduated dot pattern. The screening simulates grays in printing by reducing the continuous tones to a series of dots. The size, shape, and spacing of the dots vary in direct proportion to the tones they represent. There are two types of halftone screens: ruled glass screens and contact film screens. Screens are defined and classified by the number of dots per linear inch. Fifty-five-, 65-, and 85-line screens contain fewer dots and produce coarser halftones than, for example, 150-, 200-, and 300-line screens. The halftone structure is transferred to a film, from which a halftone printing plate can be made.

Handmade Paper Paper that has been formed from PULP using a hand-held MOULD, matrix, or other device. *See also* **Cast Paper; Colored, Pressed Paper Pulp; Duplex Paper; Vacuum Forming.**

Hand-Wiping The technique of removing surface ink from an intaglio plate with the palm of the hand or a soft muslin rag, leaving ink only in the lines and areas to be printed.

Hard Ground An acid-resistant compound that is heated so that it becomes liquid, applied to a warm etching plate with a DABBER, and rolled to a thin, even coating. The coated plate is air-cooled, forming a hard ground. ETCHING NEEDLES or a variety of shaped metal instruments can be used to cut through the ground to expose the metal for ETCHING. Hard ground is often used in combination with other INTAGLIO techniques. *See also* **Etching Ground; Lift Ground; Soft Ground.**

Hemp The BAST FIBER of *Cannabis sativa*, also used to make rope. Can be used for papermaking in raw form or, more commonly, as waste from other processes.

Hog In papermaking, a slow-moving, paddle-wheel–like mechanical agitator that keeps the SLURRY in the vat in constant movement, preventing the fibers from settling.

Hors de Commerce An IMPRESSION pulled outside the EDITION for the personal use of the publisher or artist.

Hot-pressed Used to describe paper with a surface smoothed by hot plates or rollers.

Hydrapulper A cylindrical or cone-shaped vat with a power-driven agitator used to defiber and mix PULP for papermaking. Usually, dried COLORED PULP is returned to slurry form by adding water and mixing in this machine. *See also* **Beater.**

Hydration In papermaking, the process of altering cellulose fibers by increasing their absorption of water. Hydration takes place in a BEATER or other type of macerating machine, and the greater the degree of hydration, the more gelatinous the stock becomes and the slower its rate of drainage on the MOULD. Hydration has an important effect on sheet properties. Increased hydration improves FORMATION and sheet density but decreases porosity, opacity, BULK, and ink receptivity.

Hydraulic Platen Press *See* **Platen Press.**

Impression A print made by any printing method.

Indirect Photographic Screen Stencil A screen stencil made from a specially prepared presensitized film that is exposed and developed away from the screen and later transferred to the screen fabric as a stencil. The presensitized film is manufactured as a sensitized emulsion on a polyester or vinyl support sheet. The positive is contacted to the emulsion side of the film in a VACUUM CONTACT FRAME and exposed. After exposure the film is developed in a sensitizer bath of hydrogen peroxide solution. Then the unexposed emulsion layer is WASHED OUT with water, and the exposed hardened emulsion layer stuck to the screen is dried with a fan. Once the emulsion is dry, the plastic support sheet is peeled away from the stencil, and all open areas of the screen fabric and pinholes in the stencil are blocked out in preparation for printing. *See also* **Direct/Indirect Photographic Screen Stencil; Direct Photographic Screen Stencil.**

Applying ink to the automatic inking rollers of the indirect printing press.

Indirect Printing Press A motor-driven machine with two fixed horizontal BEDS, the first bed for the PRINTING ELEMENT, the second bed for the paper or other material to be printed. A pressure unit, termed a *carriage*, consisting of a series of automatic inking and dampening rollers and a large cylinder (covered with a rubber composition BLANKET), moves back and forth across the two beds under light pressure. It deposits ink and water on the printing element on the first bed from one

set of rollers as it passes over, and it lifts off the ink from the stone or plate with the blanket cylinder on its return movement. The blanket cylinder then deposits ink onto the paper on the second bed. The impression, since it is transferred from the printing element to the blanket and from the blanket to paper, is reversed twice and does not end up as a mirror image as it does in direct printing. The indirect printing press is often used where the stone or plate is hand-inked and the paper laid by hand directly on the printing element. The blanket-covered cylinder is then used only to apply pressure for making the impression. This results in a direct printing method. The workshop's indirect printing press, a specially designed Steinmesse and Stollberg press, prints from litho stone and plate and from any relief printing element.

Ink A printing medium composed of pigment in a carrier vehicle. The pigment may be organic or inorganic; the vehicle may be water, oil, emulsion, or natural or synthetic varnish. In the printing process the ink is a film that splits, one part transferring to the printing substrate, the other remaining on the PRINTING ELEMENT.

Intaglio A printing process in which the image is incised or etched into a metal plate using a variety of techniques and tools. Ink is applied to the recessed areas of the printing plate by wiping, dabbing, or a combination of both. The paper receives the ink from the incised marks and not from the top surface of the plate, although thin films of ink may be left on the surface to produce a variety of tonal effects. For intaglio printing, the paper is dampened so that under printing pressure it will be squeezed into all the inked recesses of the plate and around it (leaving a PLATE MARK if the plate is smaller than the paper). One of the distinguishing characteristics of this type of printing is that the dried ink impression stands up from the paper in very slight relief, perceptible by touching with the finger or by close inspection. AQUATINT, ENGRAVING, ETCHING, MEZZOTINT, and DRYPOINT are intaglio techniques.

Intaglio Press A hand- or motor-driven machine constructed of a flat BED that moves between two large cylinders of equal size. For printing, the inked plate is placed on the bed, then paper is laid on top of it and covered with a felt BLANKET. These elements are run through the two cylinders, which apply pressure, creating the impression.

Japanese Papermaking Two ancient methods are employed in the making of *washi*, Japanese handmade paper, called *tame-zuki* and *nagashi-zuki*. *Tame-zuki* originated in China around A.D. 100 and spread to Korea, Japan, and the West. Western handmade papers are made the *tame-zuki* way using different PULPS and MOULDS. A Buddhist monk named Tamfing introduced papermaking to Japan in A.D 610. Over the years the Japanese developed their own style for making paper the *tame-zuki* way, which has changed little. The papermaking mould (*sugeta*) is submerged in a pulp and water SLURRY and removed in one smooth upward movement. The papermaker immediately shakes the mould from side to side so that the slurry will distribute on the mould in an even layer. The *sugeta* is held still or propped on slats of wood while the water quickly drains. The screen (*su*) is then removed from the hinged frame (*keta*) and placed face down on a wet FELT or stack of newly made papers divided by felts. After pressing, the thick individual sheets are separated and dried. The *nagashi-zuki* method of paper-making is believed to have spread from Korea and developed in Japan around A.D. 800. A vegetable mucilage called NERI is an important ingredient in this process, controlling the even distribution of BAST FIBERS in the papermaking slurry and preventing the solution from draining too quickly through the *su*. The technique for making a sheet varies depending on the kind of paper, the thickness of the pulp solution, and the size of the paper. To form a typical sheet, the papermaker begins by plunging the mould at a forty-five-degree angle into a slurry. The papermaker then levels the submerged mould and draws it from the vat. As water slowly drains through the screen, the slurry is evenly and rhythmically tossed back and forth and from side to side, forming an even layer of fibers on the screen. The repeated dipping and tossing action causes the long bast fibers to cross and intertwine, strengthening the sheet in both directions. When the papermaker decides the sheet has been formed to the desired thickness, the process is completed with a tossing off of remaining liquid. The *su* is removed from the frame, and the sheet attached to it is laid down with slight pressure upon a pile of newly made sheets and given a gentle upward jerk to release one side of the sheet. The flexible *su* is then slowly peeled away, and the new sheet adheres to the stack of wet sheets. After pressing, the sheets are carefully separated and dried.

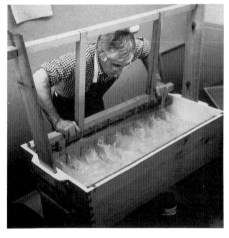

(top to bottom)
Bundles of raw kozo, gampi, and mitsumata bark; after the bark is boiled and beaten to macerate the fibers, they are separated and added to the vat with water; the slurry of kozo fibers is agitated and evenly distributed in preparation for papermaking.

(top to bottom)
A sheet of kozo fiber is formed using a *sugeta*; the *su* is removed from the frame; the sheet of kozo fiber is slowly released from the *su* onto another sheet of newly made paper.

Jute An Indian BAST FIBER used for the manufacture of coarse sacking, bags, and string. Old sacking and bags are used as raw materials in papermaking.

Key Block The most essential PRINTING ELEMENT in a color print, to which all other printing elements are registered.

Knife-cut Stencil A screen stencil made from a thin, transparent lacquer or synthetic resin-based layer laminated to a plastic sheet or wax paper. Areas of the layer that will be the image are cut away. The remaining layer on the plastic or paper support sheet is adhered to the mesh of the screen, and the support sheet is peeled away. Final touch-ups are made using BLOCKOUT COMPOUND, and the stencil is ready for printing.

Kozo A general term given to a variety of mulberry trees whose BAST FIBERS are used for papermaking. Kozo fibers are strong, sinewy, and very long. Paper made from this fiber is generally very strong and dimensionally stable.

Lampblack An oily, dull blue-black pigment used for making inks and paints produced by burning liquid hydrocarbons. From about 1400 lampblack was made by burning pitch resin or animal fat and collecting the soot on sheepskins or iron plates. The soot was scraped off and mixed with linseed oil to make a basic black ink or paint. Since the late 1800s lampblack has largely been superseded by carbon black produced commercially from the partial combustion of natural gas.

Laser-cut Woodblock A woodblock whose nonimage areas have been removed by burning with a carbon dioxide laser. The machine is driven by a computer equipped with an optical scanner that reads the drawing and programs the laser head to burn away the material around the image to a predetermined depth.

Letterpress A term broadly applied to all types of RELIEF PRINTING in which raised inked surfaces come in direct contact with the paper to transfer the impression or image. *See also* **Platen Press; Vandercook Press.**

Levigator A tool used to hand-grain lithography stones, made from a flat circular metal disk with a swivel handle mounted perpendicular to the outside edge. The disk is hand-rotated horizontally across the flat stone in a slurry of water and abrasive grit for GRAINING.

Lift Ground The only ETCHING technique in which it is possible to draw and print in positive. The drawing can be made with pen or brush. The process consists of drawing either on an aquatint ground or on a clean copper plate using a solution of sugar and India ink. After the solution is dry, the plate is thinly coated with an acid resist, dried, and immersed in a tray of warm water, which dissolves the sugar-ink mixture, lifting the resist coating off the plate. The exposed drawing is then etched and prepared for printing. Also called *sugar lift.*

Linecut A method of RELIEF PRINTING in which the nonimage areas are removed from the plate by such techniques as acid etching or cutting with tools.

Linocut A relief print cut in the same manner as a WOODCUT. The method became popular in the early 1920s but received serious attention only after Henri Matisse made linocut prints in the late 1930s followed by Pablo Picasso in 1939 and again in the late 1950s. The lino block consists of a thin layer of LINOLEUM mounted on wood. The soft linoleum can be cut in any direction without resistance and has a slightly textured surface that accepts ink evenly. Linoleum may be prepared and treated like an intaglio plate and etched with caustic soda (sodium hydroxide). Linoleum may also be surface-etched with the same acid to give it a rough texture.

Linoleum A material made from a composition of wood flour, oxidized linseed oil, gums, or other ingredients and coloring matter formed on a layer of burlap, canvas, or felt. Linoleum was patented in 1863 by an English rubber manufacturer, Frederick Walton, as a floor or wall covering.

Linters The short fibers left behind in the ginning of cotton, too short to be spun into yarn, but useful for papermaking.

Litho Crayons and Pencils Drawing materials consisting of pigments, binders, and fatty substances, used to create the grease image on the PRINTING ELEMENT in LITHOGRAPHY. These materials are manufactured in varying degrees of hardness. They are also used in creating hand-drawn screenprint stencils.

Lithography The planographic printing process based on the antipathy of grease and water, invented in 1798 in Munich by Alois Senefelder. The PRINTING ELEMENTS

Kenneth Tyler pulling an impression from a stone for Claes Oldenburg's *Chicago Stuffed with Numbers*, 1977.

used are slabs of Bavarian limestone or aluminum plates that are grained to varying degrees of roughness. Image areas can be created using pencils, crayons, tusche, or various grease, lacquer, or synthetic materials, as well as photochemical and transfer processes. After the stone or plate is drawn, a solution of GUM ARABIC and nitric acid is applied over the total surface, chemically producing water-receptive nonprinting areas and grease-receptive image areas. Once this procedure is carried out, the stone or plate must always be stored with a dried layer of gum arabic over its entire surface. Before printing, this gum film is washed off with water, and the printing element is kept continuously damp with water so that the ROLLER, which is charged with oil-base ink, can be rolled over the surface until the grease-receptive image area is sufficiently inked. Paper is laid directly on top of the inked stone or plate, which is then passed through a LITHOGRAPHY PRESS to print the image.

Lithography Press Modern hand lithography presses employ the same principle as the first lithography press, made in 1798 by Alois Senefelder. The lithography press has a movable horizontal BED that carries the PRINTING ELEMENT and a separate movable

SCRAPER BAR assembly that applies pressure directly to the printing element. During printing, the stone or metal plate is inked on the press bed, and the paper is placed directly on top of the printing element with a TYMPAN over it. The bed is then moved into position under the scraper bar. This type of press forces ink uniformly into the surface of the paper, creating a very sharp impression. The workshop uses a hydraulic lithography press developed by Kenneth Tyler in 1974 from his original 1965 design. The press uses hydraulic cylinders to drive the bed and scraper bar.

Lithotine A lithographic solvent developed by the Lithographic Technical Foundation in 1933 to replace turpentine. Lithotine is less toxic and irritating to the skin and is therefore less likely to cause dermatitis.

Litho Tusche A drawing medium manufactured in liquid and solid states, made from the same ingredients as LITHO CRAYONS AND PENCILS. Tusche can be diluted with water, LITHOTINE, or other solvents to produce a liquid medium for drawing on stone, aluminum plates, transfer paper, acetate, or Mylar. Tusche is also used in creating hand-drawn screenprint stencils. *See also* **Wash Drawing.**

Lost-Wax Process In foundry work, a system of casting whereby a wax master pattern is coated in a ceramic shell or other mold material and the wax is melted out of the mold (or "lost") preparatory to pouring in molten metal to fill the space the wax occupied.

Makeready The steps taken to prepare a press for printing.

Masking Film A clear polyester support sheet, machine-coated with a transparent red film of strippable material that is knife-cut to make the design. Masking film can be used in any of the photochemical processes.

Masking Stencil The screen-printing term for the nonprinting areas of the screen, which are made by applying glue and water or lacquer-base fillers directly to the screen. *See also* **Blockout; Knife-cut Stencil.**

Mattoir A steel engraving tool shaped like a club with sharp points projecting from the head, set in a long, round wood handle. Used directly on metal or through a ground, like a ROCKER, to produce marks made up of small dots similar to chalk lines.

Mezzotint An INTAGLIO method in which the surface of a metal plate is uniformly incised, roughened, or textured with a spurlike tool called a ROCKER. This creates patterns of tone on the polished plate. Gradations from dark to light are produced by scraping and burnishing. Mezzotint is often combined with other intaglio methods. The mezzotint technique was invented by a German soldier, Ludwig von Siegen, in 1642.

Mitsumata A BAST FIBER derived from the shrub of the Thymelaeaceae family, used in papermaking. The fibers are fine-grained, soft, absorbent, and slightly lustrous.

Mixed-Media In printmaking, used to describe prints made by a combination of techniques, such as screen printing, LITHOGRAPHY, EMBOSSING, casting, or any other method of duplication, which can be combined with one another or with COLLAGE, hand-coloring, and stitching. Mixed-media prints can be editioned or made as one-of-a-kind impressions.

Mixed Pulp A PULP made by mixing two or more contrasting colored pulps in the vat to create papers with a mottled effect.

Mold *See* **Colored, Pressed Paper Pulp; Cookie-Cutter Mold.**

Monoprint A print that has been altered by coloring the paper before printing or by varying each impression during or after printing. A monoprint derives all or part of its image from PRINTING ELEMENTS, whereas in a MONOTYPE the image is painted directly onto a plate and then transferred to paper in a press. These prints are often hand-colored and may include collage elements.

Monotype A unique image printed from a polished plate, glass, metal, or other material painted with ink. Although a monotype

impression is generally one of a kind, a second, lighter impression from the painted PRINTING ELEMENT can be made. This process was invented in the 1640s by the Genoese etcher Giovanni Castiglione. *See also* **Experimental Impression; Ghost Impression.**

Mordant In INTAGLIO, a compound usually consisting of potassium chlorate, hydrochloric acid, and water, used for etching copper plates. This mixture is called *Dutch mordant* and is used more frequently than nitric mordant (nitric acid and water) or ferric chloride (iron perchloride) mordant. Ferric chloride is diluted with water, and for some formulas hydrochloric acid is added to the saturated liquid solution. In papermaking, a chemical agent used to fix dyes on FIBERS. One of the more common mordants is ALUM applied in conjunction with a dye.

Mould The basic instrument of papermaking, the carrier on which the sheet of paper is formed, consisting of a frame of wood or other material covered with a cloth, polyester, brass, or bronze screen and wire so as to exert a sievelike action when dipped into and raised from a vat containing a PULP and water mixture. FIBERS collect in a layer on the surface of the mould as water drains through. In a laid mould, individual wires are stretched or laid over the frame, leaving laid lines and "chain" lines where they are sewn to the mould, transferring their impression to the paper. A wove mould is covered with a woven wire cloth or screen or a polyester screen, and the paper made on it has a

clean, unlined surface and FORMATION. *See also* **Deckle; Japanese Papermaking; Su; Watermark.**

Mould-made Paper A term for paper resembling handmade paper that is made on a CYLINDER MOULD MACHINE. It can be made with either a wove or laid finish and with a DECKLE EDGE. The machine forms a continuous sheet, which is passed between rollers to squeeze out the water. The sheet is then pressed against steam-heated cylinders and dried. Once dry, the sheet is either wound into a roll or, if mechanically marked for deckle edges, torn by hand with a wooden or bone slitter blade.

Multiple-Inking Technique One of various methods for depositing several colors on a PRINTING ELEMENT for simultaneous printing that have been developed for INTAGLIO and RELIEF PRINTING. Fingers, pieces of rolled felt or cloth, brushes, and BRAYERS are used to apply the colors to the plate.

Natural Colored A term applied to papers whose color results from the natural materials they are made from, with little or no coloring matter added. Many Oriental papers are termed *natural colored*.

Negative A image in which the black-and-white relationship of the original copy is reversed, as distinguished from a POSITIVE, in which the relationship is retained. In photographic processes this term is used to describe the exposed film made with a camera from which a positive print is made on photographic paper. A negative can be handmade with a brush using an opaque liquid or can be made from knife-cut film. *See also* **Positive and Negative.**

Neri A vegetable mucilage used in JAPANESE PAPERMAKING as a formation aid which allows the fibers to float evenly in the vat and controls the rate at which water filters through the screen. Neri also permits sheets to be stacked and later separated without the use of felts. Neri is manufactured from the root of the *tororo-aoi* plant or the inner bark of the *nori-utsugi* tree.

Offset Lithography An indirect printing process in which the inked image on the stone or plate is transferred to a cylindrical BLANKET, which then transfers the inked image to the paper. *See also* **Indirect Printing Press.**

Open Bite An intaglio plate on which no ground is used. A bold image is usually chosen for this technique. The drawing is

made with a resist, and the plate is deeply bitten. During inking, the broad, open areas have a tendency to wipe clean, with ink holding on to only the sloped edges, imparting a hollow look to the printed shape. Open bite is to be distinguished from FOUL BITING.

Overprinting A shop term for printing color or varnish over an existing printing. Also, in LITHOGRAPHY, a platemaking method in which a second NEGATIVE is exposed on an area of the plate previously exposed to a different negative; for example, combining line and halftone images on the same plate.

Paintstik A drawing stick made from oil paint, linseed oil, and solid additives to increase stiffness. Paintstiks can be mixed with turpentine or petroleum solvents. They are a favorite material for use in coloring prints and drawing images on PRINTING ELEMENTS. Paintstiks are trademarked products.

Palette A workshop term used to describe the range of colors used by an artist in a specific work.

Papermaking *See* **Japanese Papermaking; Western Papermaking.**

Paper Pressing The workshop term for the application of a fixed amount of pressure on a sheet of newly made paper in a PLATEN PRESS.

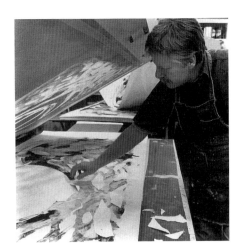

Robert Zakanitch making a paper stencil for *How I Love Ya, How I Love Ya,* 1981.

Paper Stencil A stencil made by sticking cut or torn pieces of paper to the screen to create nonprinting areas.

Papier-mâché Generally paper that has been repulped and mixed with a binder such as glue and is formed into a given shape by hand, by pressing into a mold, or by stamping with a die.

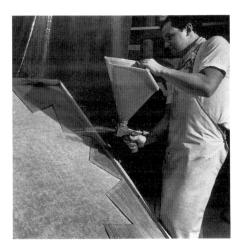

Steve Reeves using a pattern pistol to spray kozo pulp onto a mould with star-shaped deckle.

Pattern Pistol A specially designed air gun used for spraying PULP. The gun, powered by an air compressor, has a large orifice and an attached pulp tank for spraying short pulp fibers. With this device thin layers of pulp can be sprayed onto a variety of surfaces, such as shaped molds and cloth.

pH A measure of the acidity or alkalinity of a solution as indicated on the pH scale from 0 to 14. A pH value of 7 is considered *neutral*, while solutions of a lower pH value are termed *acidic* and those of a high pH value are *alkaline*. The degree of acidity or alkalinity present in a solution is determined by its hydrogen ion content, which can be measured by various electronic and color metric devices.

Photoengraving A process for making metal relief plates by using acid to etch a photographically produced image on the metal.

Photoetching *See* **Photosensitive Resist Intaglio Plate.**

Photographic Plate/Screen Making A shop term used to describe the process in which various types of film elements are assembled on a base sheet and placed in a VACUUM CONTACT FRAME with a sensitized plate or screen and exposed.

Photolithography on Stone A photochemical process based on the light-sensitive properties of bichromated albumin, invented in 1855 by Alphonse Louis Poitevin. However, the first successful photolithographic process was based on a bitumen process developed in Paris by the optician Lerebours and the lithographer Lemercier in 1852. The process was abandoned in favor of Poitevin's because only a limited number of proofs could be pulled. Another early investigator of bichromates was the English inventor William Henry Fox Talbot, who in 1852 discovered the light sensitivity of a mixture of potassium bichromate and gelatin. He first used his patented process for the production of photographic etchings on steel. To make a photolitho stone, a grained stone is prepared, exposed, and processed using the same technique developed for the WIPE-ON ALUMINUM PLATE. The artwork contacted to the negative-type coating can be hand-drawn or photomechanically made. Photo-lithography on stone cannot produce results as uniform as wipe-on plates and therefore is rarely used. The one advantage, however, is that additional artwork can be added with dependability and ease, which is not the case with wipe-on plates. *See also* **Screenless Lithography.**

Photomechanical A generic term for any reproduction process in which photography is employed in the making of a printing surface. The term embraces photolithography, photoengraving, photostencil, and photorelief printmaking.

Photosensitive-Resist Intaglio Plate A relief plate made by a photochemical etching process in which a polished plate is hand-coated with either a negative-working or positive-working photoresist. In this technique a photoresist is applied to the plate, artwork is contacted to the plate and exposed in a VACUUM CONTACT FRAME, the resist is chemically processed to form a stencil, and the plate is etched in a tray of acid. Finally the plate surface is cleaned of all coating and prepared for additional image work or printing.

Photosensitive-Resist Magnesium Plate A relief plate made by a photochemical etching process in which a polished plate has a negative-working light-sensitized resist coating applied by hand. The coating is made of polyvinyl alcohol (PVA) sensitized with a dichromate. The artwork is contacted directly to the plate's surface in a VACUUM CONTACT FRAME and exposed. The plate is developed by a spray of water, hardened with a chromic acid solution, heat-dried, and then processed into a relief

element using the POWDERLESS ETCHING method. This type of plate can be printed in the same manner as a DIRECT-RESIST MAGNESIUM PLATE.

Plate A general shop term used to describe any type of PRINTING ELEMENT, such as a lithography plate or stone; a copper, zinc, or magnesium plate; or a woodblock.

Plate Mark The imprint made by the surface and beveled outer edges of a PRINTING ELEMENT when it is impressed into paper during printing. A stronger plate mark is visible when the paper is damp, as it often is in INTAGLIO printing.

Platen Press A hydraulic machine constructed with two identically shaped horizontal BEDS. Two platen presses were custom-made for the workshop; one with a movable top bed, the other with a movable bottom bed. One bed is permanently fixed, and the other bed, power driven, moves in a vertical direction. The bottom printing bed has a movable tray that is extended during preparation of the PRINTING ELEMENT and retracted for printing. The print impression is created when the two beds are pressed together, with printing element and material to be printed placed between them. Pressure is measured by pounds per square inch (PSI) on a calibrated gauge. Printing pressures can be set at a few pounds for very light impressions or at a hundred thousand pounds or more for very heavy impressions.

Plate Tone Tone created in an intaglio print by deliberately leaving a film of ink on the plate in the wiping. Plates can be selectively wiped to add tone to parts of the image.

Pochoir A direct method for hand-coloring prints with paints, inks, crayons, or pastels applied through a stencil. A brush, DABBER, or spray can or gun can be used to apply paints. The stencil material is usually knife-cut from thin coated paper, paperboard, plastic, or metal. Designs can also be chemically etched in thin metal to make the stencil. *See also* **Stenciling.**

Positive An image in which the black parts of black-and-white copy appear as black opaque areas on a transparent base or film, as distinguished from a NEGATIVE, which reverses the relationship. In photography, a camera-prepared image, generally on acetate, vinyl, or other plastic transparent material. A positive can be handmade using a brush and opaque liquid or made from knife-cut film.

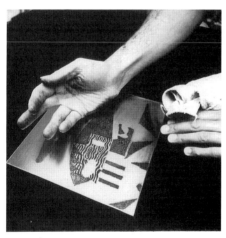

(top to bottom)
The copper plate for Roy Lichtenstein's *Untitled II* is first inked with a plastic spatula, then wiped with a tarlatan, and finished using the palm of the hand, 1985.

Positive and Negative In printmaking, the image area is termed a *positive* and the background area a *negative*. In photography, positive and negative refer to light value; i.e., whether light and dark areas appear in the image as in the original (a positive image), or reversed (a negative image). A photograph is a POSITIVE, and the black-and-white camera negative of the photograph is a NEGATIVE.

Post The pile of wet newly made sheets of paper couched between felts and ready for pressing.

Powderless Etching The commercial process developed for mechanically etching magnesium, copper, and zinc relief plates. The process involves adding banking materials to the ACID BATH to form a film on the shoulders of the image areas to prevent undercutting as the metal is etched deeper. These proprietary additives are complex organic compounds formulated for use in specially designed etching machines. These machines are equipped with paddles that throw the etching solution onto the suspended plate. Etching solution contains the additives and 14% to 22% of 42° Baumé nitric acid by volume, and the bath is maintained at 85° to 130° F (30° to 54° C).

Prep Work A shop term describing preparations made for the artist in relation to image making. These include the selection or preparation of drawing materials, the grinding of stones, the preparation of Mylar or acetate films for drawing, and the setup for REGISTRATION.

Presensitized Continuous-Tone Aluminum Plate A newly developed type of lithography plate used by the workshop since 1980 for SCREENLESS LITHOGRAPHY.

Presensitized Plastic Relief Plate A relief plate made by a photochemical etching process that uses a negative-working, water-soluble photopolymer plate composed of a thick layer of photosensitive resins adhered to an aluminum backing. The negative (artwork) is contacted directly to the plate's surface and exposed until light emitted through the negative hardens the image area resin all the way through to the base. After exposure the plate is washed out with water to remove all unexposed resin from the nonimage area, making a deep-recess plate.

Presensitized Plate A printing plate manufactured with a light-sensitive coating on its surface, ready for exposure and processing. The first generation of presensitized aluminum plates were manufactured in Germany by Kalle and Company, just

Lee Funderburg pouring an etching solution onto a newly developed continuous-tone lithography plate.

prior to World War II. These coated plates are either additive or subtractive types: an additive-type plate requires the platemaker to add image-reinforcing materials to the image areas during processing, and the coating on nonimage areas is either removed or rendered water-receptive during processing. With the subtractive-type plate, the image-reinforcing material is applied by the manufacturer, and during processing, the platemaker removes the unexposed coating from the background, simultaneously taking away the image-reinforcing material on the unexposed coating. Negative-type presensitized plates are made either as additive or subtractive plates. The processing steps for the additive plate are: (1) exposure through a NEGATIVE, (2) developing with an acidified gum solution to remove unexposed DIAZO coating and render the plate water-receptive, (3) application of lacquer emulsion to strengthen the image areas, (4) application of gum to the plate, and drying. In the processing of subtractive plates, exposure is also made through a negative, but for a longer period of time than required for the additive-type plate. A special developer removes the lacquer applied by the manufacturer during developing, which is followed by the application of a special gum solution that is rubbed smooth and completely dried. Positive-type presensitized plates are made so that the unexposed areas form the ink-receptive image. The processing steps are: (1) exposure through a POSITIVE, (2) developing with a special solution that removes all of the exposed sensitizer, (3) fixing with a solution that stops the action of the developer and renders the image insensitive to light, and (4) the application of gum to the plate.

Presentation Proof Occasionally an artist will dedicate an edition PROOF to a friend or collaborator. The dedication is usually inscribed on the front of the print in proximity to other signature information. It may include personal remarks, but it most often consists of a brief acknowledgment of the friend or collaborator. This proof is recorded as a *special proof* (SP).

Press A mechanical printing machine powered by hand or drive systems.

Print Documentation The permanent document prepared by the workshop and signed by both the artist and director to declare the information accurate. Included in this document are the number of impressions signed by the artist, dates of collaboration, print size, paper, medium, workshop print number, and a print description detailing printing elements and order, ink colors, collaborators' names and role in production, and how and where the print was signed and chopped. Special notes about the edition are often included as well. *See also* **Curating.**

Printer's Proof The print IMPRESSION(s) pulled for the printer(s) who collaborated with the artist and the workshop director in the creation and printing of an EDITION.

Printing Element Any material, such as a stone, screen, or metal plate, upon which a design is created for the purpose of making an impression. In prints involving more than one color, a separate printing element is usually drawn for each color. The exception is when a printing element has more than one color applied to it and transfers these colors to the paper in one pass through the press.

Progressive Proofs Prints documenting the sequential printing pattern of an edition that involves the printing of two or more stones, plates, or screens. These proofs usually bear notations by the artist or printer. They are numbered with Arabic numerals and capital letters (e.g., 1A, 1B, 1C, 2A, 2B, etc.).

Proof A term generally applied to all individual impressions pulled prior to the printing of the published edition. These impressions are made to test the progress of the image for inking and printability on various papers. *See also* **Color Trial Proof; Trial Proof.**

Pulp Reduced FIBERS that have been diluted with water and are ready to be formed into sheets of paper. Also called STUFF in the papermaking process.

Reference Proof An edition IMPRESSION, partially or completely printed, that is kept by the publisher and artist for reference. These proofs usually bear notations about printing and are chopped and dated. These proofs are not intended for sale or distribution and are not signed.

Registration The correct placement of one PRINTING ELEMENT with respect to another. Registration is both visually and mechanically assisted by the use of REGISTRATION MARKS, REGISTRATION NEEDLES, REGISTRATION PINS, and registration devices built into press BEDS. Simple registration consists of tracing the image on the printing plate onto tracing paper to position the printed image on the paper using registration marks. An improvement on this method is to pull an impression that has registration marks as part of the image from the printing plate on a transparent plastic sheet. The sheet is used to position the image being printed on paper. The most accurate method is to attach registration pins to the printing element to align the printing paper, which is punched to fit the pins.

Registration Marks A mark in the form of cross lines, a dot, a short line, or a T shape. These marks are placed on the printing paper and the PRINTING ELEMENT to facilitate visual registration by hand. In screen printing, the marks are on the printing table. A common shop practice is to produce registration marks by hand-ruling, cutting, scribing, or scratching. These marks will vary in size, thickness, and position and can be used only when accurate registration is not required. For accurate registration, commercial registration marks are available in a variety of configurations such as targets and cross lines. Registration marks permit the alignment of the artwork and the printing element with the printing paper. During hand printing, the marked paper is laid to the registration marks on the printing element. For large prints two registration marks are placed inside the paper margin on opposite ends of the back sides of the paper, and REGISTRATION NEEDLES are pushed through the paper marks and aligned with the marks on the printing element. The paper is then guided into position on the printing element, and the registration needles are removed.

Registration Needle Any handcrafted device consisting of a thin needle or wire attached to a wooden handle used for registering paper and PRINTING ELEMENT.

Registration Pins A registration system that consists of a three-hole punch with matching pins attached to flat tabs that fit into the material that is punched. By punching and pinning film, overlay sheets, plates, and paper, printers can maintain accurate registration of these materials. The pins can also be taped on surfaces such as stones and press BEDS. Adjustments in registration can be made simply by moving the pins.

Relief Printing A printing process in which the impression is created by the uncarved areas or the unprepared surface of the PRINTING ELEMENT, which has been inked with a ROLLER, BRAYER, or other tool. The cut, or incised, areas do not usually print, since they are recessed and are rarely inked. Nonetheless, during a run paper is often pushed into these sunken areas, creating an embossed effect. The recessed areas do print when the printing element is inked in the same manner as an etching plate, with the surface wiped clean, leaving ink in the recesses. WOODCUT and LINOCUT are usually used for relief printing.

Repoussage A technique for forcing up low sections of a printing plate. This is done by hammering in the area from the back of the plate. Metal or paper shims can be adhered to the back of the plate, which is then run through a press under heavy pressure to push up the low sections to their original level.

Right to Print The IMPRESSION that meets the aesthetic and technical standards of the artist and workshop director. The approved print is the standard for the EDITION printing. The French call this the *bon à tirer*.

An assortment of mezzotint rockers.

Rocker A wide, curved, multitoothed steel CHISEL mounted in a wooden handle, used to cut regular indentations into the metal plate for MEZZOTINT. By rocking in a set pattern, the teeth roughen the surface of the plate to produce the characteristic BURR of mezzotint.

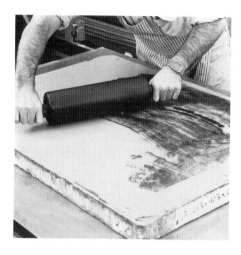

Roller A tool used for applying ink and grounds, cylindrical in shape, with one handle on each end or fitted in a holder with a single handle. Leather rollers have a solid wooden core wrapped in felt and covered with leather. COMPOSITION ROLLERS have a hollow metal core covered with rubber, gelatin, or plastic and are made in varying degrees of hardness. Rollers vary in diameter and length. *See also* **Brayer.**

Roulette A tool with a sharp raised and textured revolving wheel that is used to make lines or areas of dots in a metal plate or ground. Roulettes are made in various sizes.

Rubylith A trade name for ruby-colored masking film laminated to a transparent backing sheet, used in preparing hand-cut photopositives and negatives.

Scraper A triangular steel tool, hollow on three sides and tapering to a point at one end, mounted in a wooden handle. Used to shave off areas of metal such as a BURR or a faulty etching mark. Special scrapers made with only one or two cutting edges are employed to lighten mezzotint and aquatint grounds.

Scraper Bar The leather-covered blade of the direct LITHOGRAPHY PRESS, which exerts pressure against the inked stone or plate. A scraper bar may also be made from a beveled plastic bar. *See also* **Tympan.**

Screenless Lithography A technique dating to 1855, when the French chemist and civil engineer Alphonse Louis Poitevin discovered the light-sensitive properties of bichromated gelatin and invented both the photolithography and collotype processes. After the invention of the halftone screen in the 1880s, screenless lithography was abandoned. Until the end of World War II, two kinds of photomechanically made plates were used in lithography: albumin plates and deep-etch plates. Presensitized plates appeared in the 1950s, and wipe-on plates appeared in the 1960s. By the mid-1960s research on screenless lithography had successfully developed in Europe to the stage where continuous-tone plates could be manufactured for use with positive film images. Researchers discovered that under certain conditions the combination of fine plate grain and the newly developed plate coatings produced a plate capable of holding nearly all of the tones from a continuous-tone POSITIVE. Commercial use of this plate has not flourished; today it is still in limited use, primarily because the continuous-tone printing plate technology is expensive and necessitates stringent quality control. Since the late 1960s artists and printers have been experimenting with these new plates, using photomechanical film and handmade positives made from thin translucent or transparent plastic sheets and a variety of drawing and painting materials. Screenless lithography has been incorrectly referred to as *diazo plate lithography* and *Mylar lithography. See also* **Presensitized Continuous-Tone Aluminum Plate.**

Screenprint A print made by a stencil technique using fabric (silk or synthetic) stretched tightly over a frame. The nonprinting areas on the fabric are blocked out by adhering a stencil. The image areas are open fabric through which ink or paint is forced with a SQUEEGEE. The screen frame is hinged to a table (usually a vacuum table). The material to be printed is placed on the table, the screen is placed on top, and with the squeegee, ink is applied through the screen openings directly to the paper. Unlike many of the other printing media, screen printing can be done on almost any material.

Series A group of related prints that differs from a SUITE in that the prints are not published or sold as a group.

Serigraph The name coined for SILK SCREEN prints in the late 1930s in the United States. Credit for the name and much of the new interest in the medium is attributed to Anthony Velonis, a painter

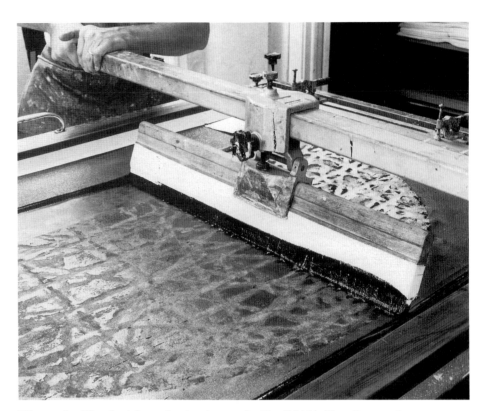

Silk-screening Glitterflex ink onto handmade paper for Alan Shields's *Home Route*, 1985.

and graphic designer. He was the leader of the federally sponsored art project for screen printing under the Works Project Administration (WPA). The art historian and print curator Carl Zigrosser adopted the new term in an attempt to distinguish artistic screen printing from commercial printing.

Setoff A shop term for an impression made on the back of a sheet of paper by the wet ink on the print below it. To register a newly drawn PRINTING ELEMENT to an existing one, the printing element is inked, and an impression is pulled, dusted with powdered red chalk, and set off onto the new printing element by running through the press.

Silk Screen A term originally used in the United States for screen printing. Since silk mesh has been almost completely replaced by synthetic mesh, the term is misleading and outdated. *See also* **Serigraph.**

Sizing Chemical agents added to paper during or after manufacture to provide water resistance; a hard, resistant surface; or a surface more receptive to ink or watercolor. In some craft techniques sizing may be applied during printing. Sizing materials applied during the papermaking process

may be added to PULP (*beater sizing* or *stock sizing*) or may be applied in a bath to the finished sheet (*tub sizing*). Materials conventionally used for beater sizing are rosin and ALUM or synthetic substances. Those used for tub sizing are starch, gelatin, or glue. In modern usage synthetic sizing materials may be applied to the paper surface uniformly or selectively.

Slurry In papermaking, a water suspension of FIBERS and other insoluble materials (fillers, pigments) prepared in a VAT. *See also* **Furnish; Stuff.**

Soft Ground A nondrying ground that is applied with a ROLLER to a warm plate but remains soft after the plate has cooled. Soft ground will adhere to paper or any other material pressed into it, freeing the metal of the coating for etching once the paper or material has been removed. The ground is also used for direct drawing, and anything that comes to hand can be used for marking the surface; for example, chalk, wood sticks, ends of screwdrivers, brushes, paper stumps, and fingertips. Soft ground is often combined with other INTAGLIO techniques. This process was invented in the 1640s by the Genoese etcher Giovanni Castiglione. *See also* **Etching Ground; Hard Ground.**

Special Proof *See* **Presentation Proof.**

Spitbite Aquatint A direct INTAGLIO method of painting the aquatint ground of an etching plate with a strong acid. Pale to dark tones can be achieved by varying the time and strength of the acid application. To break the surface tension of the acid flowing onto the plate and control its direction, small amounts of saliva, ethylene glycol, or Kodak Photoflo solution can be used with the acid. Traditionally a clean brush washed with water was coated with saliva and then dipped in concentrated nitric acid and brushed onto the ground.

Squeegee In screen printing, a device used to pull the reservoir of ink smoothly across the surface of the screen, forcing it through the open areas of the screen stencil to leave an evenly printed image on the printing stock. The squeegee is constructed of a flexible blade made from rubber or synthetic plastic composition and set in a metal holder or wooden handle.

Staining The application of liquid colors to the surface of a newly couched sheet of paper. During the pressing of the paper, the color matter may spread or bleed further into the surface fibers of the newly made sheet. Traditionally, coloring material is applied to the surface of dry paper, except in the making of marble paper. *See also* **Western Papermaking.**

Stamping Direct printing from any surface that can be inked, with the impression made by hand. Designs can be cast or cut from various materials and made into stamps. FOUND OBJECTS may be used in their original form or altered.

State Print A PROOF made to record progress during the proofing process. Any impression that shows the progress of work on a PRINTING ELEMENT, whether by the artist or the printer, may become a state print. In color printing, a state print may derive some or all of its printing plates and colors from an editioned image; the printing plates or colors as well as the printing order can be altered. New printing elements can also be introduced, altering the image further.

Steel Facing An electrolytic process patented in 1857 in which an extremely thin layer of hard iron is applied to the surface of a copper plate. The process increases resistance to wear, especially of plates made in the DRYPOINT technique. Steel-faced plates must always be kept coated with ink or ASPHALTUM to prevent

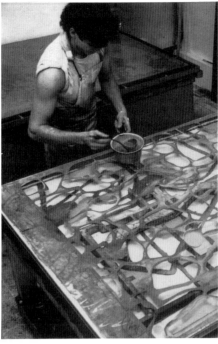

Tom Strianese spooning colored dyes through a plastic stencil onto a white pulp base sheet to make multicolored paper for Frank Stella's *Pergusa Three Double*, 1983.

rust and corrosion. To avoid this problem, plates today are faced with nickel or chrome, which offer a harder, brighter, and more resistant surface.

Stenciling A process for hand-coloring through a sheet of material with a cutout design. The simplest type of stencils are knife-cut from thin coated paper or plastic. Stencil designs can also be made on wide-mesh screens or etched through thin metal. A variety of tools are used for applying color to prints. *See also* **Pochoir.**

Stipple Engraving An INTAGLIO technique in which tone is created on the plate by numerous dots, flicks, or short strokes made with a stipple BURIN. The earliest method for this process was invented by the Venetian artist Giulio Campagnola around 1500. Stipple marks may be engraved directly on the metal or made through a ground before ETCHING. The plate can be inked and printed as a relief or as an etching plate.

Stuff Prepared paper pulp ready for use in the VAT. Depending on the degree of beating and its dilution, the paper stock may be referred to as *half stuff, first stuff, second stuff,* etc. *See also* **Furnish; Slurry.**

Su In JAPANESE PAPERMAKING, the removable flexible screen of the MOULD, held rigid by a clamshell-style frame equipped with copper hinges and catches. The screen is made of finely split and beveled bamboo splints woven together with silk threads and wooden strips attached to both ends.

Substrate The layer of material that serves as a base for a two-dimensional work, such as paper in prints and drawings and board, paper panel, and canvas in painting.

Sugar Lift *See* **Lift Ground.**

Suite A set of prints related by common imagery or theme and often by technique. A suite of prints is usually published in a portfolio with a title page and a COLOPHON page.

Surface Tone In INTAGLIO, printed tone caused by faulty wiping of the plate. *See also* **Plate Tone.**

Tarlatan A starched cotton fabric of open mesh, used for wiping away excess ink from the surface of intaglio plates.

Transfer Paper Specially prepared coated paper that can receive an image in various drawing media for the purpose of transferring it to a litho plate, stone, or intaglio plate. With transfer paper it is not necessary to draw the image in reverse, as it is with a direct-drawn litho or intaglio PRINTING ELEMENT.

Trial Proof A print, usually a unique impression in a single color such as black, pulled during proofing to document image changes. Notations regarding the quality of the printing or the image are often written on the print by the artist or printer. *See also* **Proof.**

Tusche *See* **Litho Tusche.**

Tusche Screen A stencil made by drawing an image directly on the screen fabric with tusche or crayon. The screen fabric is then evenly coated with glue and dried, and the drawn areas are WASHED OUT with solvent to open the mesh of the stencil.

Tympan The plastic sheet placed between the SCRAPER BAR and the paper laid on top of the PRINTING ELEMENT in a direct LITHOGRAPHY PRESS. The press is designed so that the scraper bar applies pressure directly through the tympan to the paper and printing element on the press BED below. The tympan is greased to ensure a smooth passage for the scraper bar.

Vacuum Contact Frame A mechanical device used for exposing prepared film, masking film, or images drawn on plastic sheets to sensitized plates or screens. The machine is constructed of two horizontal metal frames hinged together on one side; the fixed bottom one carries a flexible rubber sheet (called a BLANKET) and the movable top one, a sheet of flawless glass. The rubber blanket is connected to a vacuum pump by means of a rubber tube. When in use, the plate is laid, coated side up, on the blanket, and the prepared film is laid on the plate. The glass top is closed and locked to the base frame. The vacuum pump is activated, and the air is sucked from the compartment between the two frames. This creates a vacuum, and the flexible rubber blanket collapses against the glass, forcing the film and plate into close contact. A mercury vapor lamp emitting shortwave radiation exposes the sensitized film, plate, or screen.

Vacuum Forming A process for forming wet PULP into single or multiple flat or shaped papers using a specially designed vacuum table. Flat sheets are either formed by couching or by pouring pulp directly onto a thin polyester fabric laid on the vacuum table. Shaped pieces are made by laying newly made, partially pressed sheets over or by pouring pulp into a relief MOULD placed on the table. The table has a perforated top with a sealed chamber below connected to a vacuum pump and tank. Work on the table is covered with a flexible plastic sheet, and a compressor beneath the table draws air and water from the plastic-covered enclosure, creating a vacuum and compressing the pulp.

Vacuum Screen Press A screen-printing press consisting of a vacuum table for holding the paper during printing and a frame device hinged to the table for keeping the screen in position. The table is an airtight box with a grid of evenly spaced holes on the top surface. It is equipped with a vacuum pump, which is activated during printing to draw the paper flat against the bed, ensuring even contact by the SQUEEGEE.

Vandercook Press A motor-driven flatbed cylinder machine in which the printing surface is flat and the impression surface cylindrical. Paper is pressed against the inked relief PRINTING ELEMENT by the impression cylinder. The machine has a motorized inking system, an automatic-fed FRISKET, and a manually operated gripper device for delivery of paper to the printing element. However, printing elements are often hand-inked for stronger effects.

Variant Proofs PROOFS that have been identically printed and then altered by some method to make them different from one another, or proofs that have been varied in edition printing to make them unique.

Vat The large container that holds the SLURRY for papermaking.

Verso The back of a sheet of paper.

Vinyl Paints A group of chemically inert, lightfast, opaque, mat-finish paints that are water soluble when wet and insoluble when dry. The base is an emulsion of high-grade polymers, microscopic particles separated from one another by water. When the water evaporates during drying, these particles are fused with the pigments that were mixed with them. Since vinyl paints are an emulsion, it is possible to introduce a wide variety of materials, such as sand, glitter, or pulp, into the colors. The workshop began using vinyl paints to color paper pulp in 1975.

Viscosity Printing An INTAGLIO method based on the principle that inks of different viscosities applied on a plate with a multi-level surface do not mix when printed in one pass through the press. In this method the design is bitten into the plate in two or three levels. With three-level plates the lowest level is wiped with stiff intaglio ink, and the middle and top levels are inked with rollers carrying inks of different viscosities (a hard roller is used for the thicker ink, a soft roller for the thinner ink). Two-level plates are generally inked with rollers only.

Wash Drawing In LITHOGRAPHY, a drawing made with diluted tusche (and sometimes with diluted ink). One of the most subtle of graphic techniques, giving the artist the freedom to draw spontaneously a wide range of continuous tones directly on the stone, aluminum plate, or TRANSFER PAPER. Preparation and printing of a wash drawing demand the highest skill of the printer. Even in the hands of the most experienced and gifted printer, there will always be slight losses and changes in the tone gradations. Stone produces the greatest range of tones. TRANSFER PAPER produces a harder and coarser effect than stone or aluminum plate. In the last ten years the workshop has perfected SCREENLESS LITHOGRAPHY so that wash drawings can be accurately and dependably produced. This technique has virtually replaced directly drawn stones and metal plate lithography. *See also* **Continuous-Tone Film; Litho Tusche.**

Washed Out A screen-printing term describing one of the steps in making a photographic screen stencil. After EXPOSURE in a VACUUM CONTACT FRAME, the unexposed light-sensitive coating on a screen or film is *washed out* with a fine spray of water. The exposed hardened coating remains to form the stencil image.

Washing Out A shop term for the removal of an image coating from a lithography plate or stone by use of LITHOTINE or other solvents.

Waterleaf The newly made wet sheet of any finished paper with no SIZING. Paper with a low degree of sizing is termed *slack sized*.

Watermark A design formed in fine wire or low-relief metal castings and sewn on the upper side of the papermaking MOULD. Since the design is in relief, less PULP lies on it than on the rest of the mould. The resulting thick and thin areas make the watermark slightly more translucent than the rest of the sheet. Watermarks are sometimes simulated by embossing or by printing with transparentizing oil or resin.

Western Papermaking The invention of paper by Ts'ai Lun in China around A.D. 105 slowly spread westward to the Arab world, arriving in Spain in the twelfth century. The hand papermaking process that developed in Europe subsequently has gone through little change, and this process is similar to the one used today at the workshop. The basic raw materials, cotton and linen rags or cotton LINTERS, used

singly or in combination, are reduced to FIBERS in a BEATER. The fibers mixed with water are poured into a VAT, and a MOULD (wove or laid type) with DECKLE is dipped into the vat solution (SLURRY) in one continuous scooping action, made level several inches below the surface, pulled up smoothly out of the vat, and given a slight side-to-side shaking. The mould is held still for a few moments until the excess water drains through its surface, forming an even sheet of intertwined fibers. The deckle is removed, the mould is turned upside down, and the wet sheet is pressed onto a damp FELT using a rocking action (COUCHING). If more than one sheet is to be made, this procedure is repeated until a pile, or POST, has been made. The post is placed on a hydraulic press BED, and pressure is applied to squeeze out the excess water. After pressing, the compressed papers are separated sheet by sheet from the felts. The paper is then placed on screen trays or blotters for drying. Colored paper may be made by adding coloring matter to the vat or by applying dyes and COLORED PULPS to the surface of newly made sheets before or after pressing.

Wipe-on Aluminum Plate A photolithography plate made by hand-wiping the surface of a commercially grained, anodized plate with either a negative- or positive-type DIAZO coating prior to use. Artwork is contacted directly to the plate, exposed, and developed.

Wire Side The side of a sheet of paper that is in contact with the wire (cover) of the MOULD, as distinguished from the felt, or top, side.

Wood Fiber Fiber derived from trees or woody plants and prepared by mechanical or chemical treatment.

Woodcut A method of RELIEF PRINTING in which wood is the PRINTING ELEMENT. A wide variety of cutting tools, power tools, or laser cutting machines are used to carve woodblocks. Woodcuts are the first known prints. The earliest woodcut prints and illustrations in existence were produced in China from Buddhist scriptures in A.D. 868. By the thirteenth century the process had reached Europe but was used only for textile printing. The earliest known woodcuts printed on paper in the West date from the end of the fourteenth century.

Work Proof A PROOF that the artist has drawn, painted, or collaged on. This study is often used during proofing to indicate changes and becomes a reference for future printmaking.

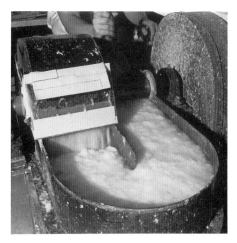

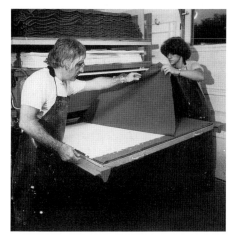

(top to bottom)
Cotton pulp is macerated in a Hollander beater; after beating, pulp is added to the vat with water; the mould is removed from the vat.

(top to bottom)
Paper is couched onto a damp felt; newly made sheets are pressed between felts in a hydraulic platen press; the felts are separated from the pressed paper.

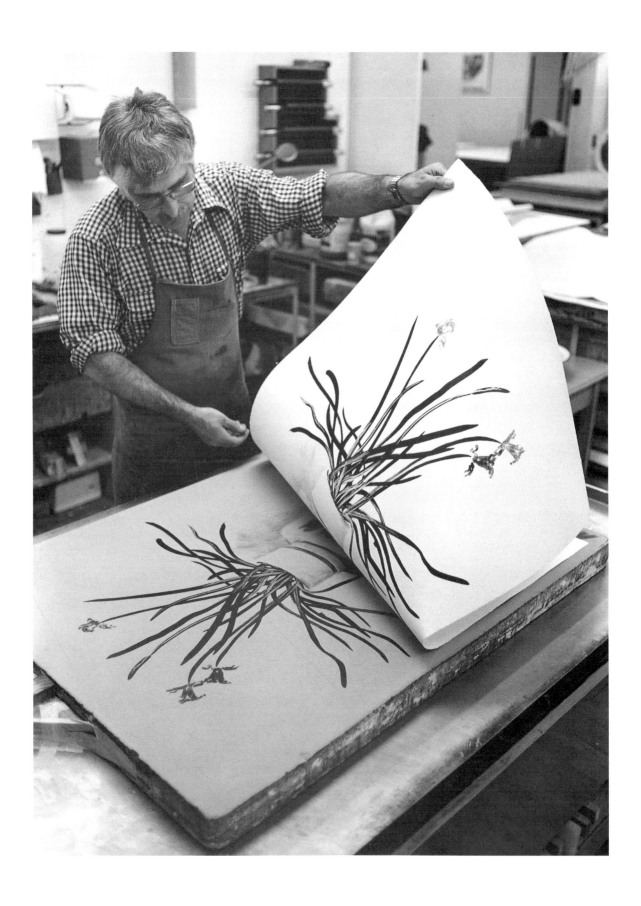

Kenneth Tyler pulling an impression of
David Hockney's *Potted Daffodils*, 1980.

Acknowledgments

The publication of a catalogue of this scope could not have been accomplished without the cooperation of many individuals. In addition to the staff of Tyler Graphics Ltd., I would particularly like to thank Karen Jacobson, whose editorial skills helped transform a complexity of technical information into a lucid, straightforward presentation, and Pat Gilmour, who wrote the informative introduction to this volume. I am also indebted to Walker Art Center's graphic designer, Lorraine Ferguson, who helped streamline the format of this ambitious project. I would like to extend special thanks to Nancy Roth, Betsy Wright, Karen Lovaas, and Sheri Stearns, former and present Walker Art Center staff members, who provided key research and administrative assistance. Mildred Friedman, the museum's design curator, and David Galligan, administrative director, also helped guide the book to its completion. I am also pleased to acknowledge the contributions of the staff of Abbeville Press in New York; the help of Dana Cole, Sharon Gallagher, and Nancy Grubb has been particularly appreciated. Finally, I am fortunate to have the support of Martin Friedman, director of Walker Art Center, whose wise counsel guided the publication from the outset.

Elizabeth Armstrong

I am extremely grateful to Pat Gilmour for her scholarly advice on the form of the catalogue raisonné, for her relentless criticism, which served only to improve our document, and, finally, for her encouragement. I extend my warmest thanks to Barbara Delano, Marabeth Cohen, and Kim Tyler for their undaunted collaboration, without which this catalogue would not have been completed. To my dear friend Leonard Schlosser, whose expertise on papermaking was invaluable, and to all the artists and printers mentioned in this catalogue, who have made my life's work possible, I offer my gratitude.

Kenneth E. Tyler

Printers

Roger Campbell
Born 1944, Birkenhead, England
Canterbury College of Art, City and
Guilds, 1963

Bob Cross
Born 1956, Goshen, Indiana
Atlanta College of Art, B.F.A., 1981

Ron Davey
Born 1958, Kenosha, Wisconsin
University of Wisconsin, Parkside,
B.A., 1981
Ohio University, M.F.A., 1984

Lee Funderburg
Born 1953, Yellow Springs, Ohio
Ohio University, B.F.A., 1978

Rodney Konopaki
Born 1949, Moose Jaw,
Saskatchewan, Canada
University of Saskatchewan, B.F.A.,
1972

Mark Mahaffey
Born 1959, Oklahoma City
Kansas City Art Institute, B.F.A.,
1983

Steve Reeves
Born 1953, Glens Falls, New York
State University of New York,
Purchase, B.F.A., 1979

Tom Strianese
Born 1957, Mount Kisco, New York
St. Lawrence University, B.A., 1979

Kenneth Tyler
Born 1931, East Chicago, Indiana
Chicago Art Institute, B.F.A., 1957
Herron School of Art, M.A.E., 1963

Roger Campbell

Rodney Konopaki

Bob Cross

Mark Mahaffey

Ron Davey

Steve Reeves

Lee Funderburg

Tom Strianese

Staff

Marabeth Cohen

Barbara Delano

Kim Tyler

Marabeth Cohen
Born 1962, Newton, Massachusetts
State University of New York,
Purchase, 1985–87

Barbara Delano
Born 1945, Boise, Idaho
Colorado College, B.A., 1966
University of New Mexico, M.F.A.,
1982

Kim Tyler
Born 1956, Chicago
Sarah Lawrence College, B.A., 1979

John Wagner
Born 1950, Mount Kisco, New York
Pace University, B.B.A., 1972

Past Printers and Staff
(1974–1984)

Robert Bigelow
Don Carli
Betty Fiske
Lindsay Green
Kim Halliday
Charles Hanley
John Hutcheson
Katherine Komaroff
Duane Mitch
Paul Sanders
Kay Tyler
Igor Zakowortny

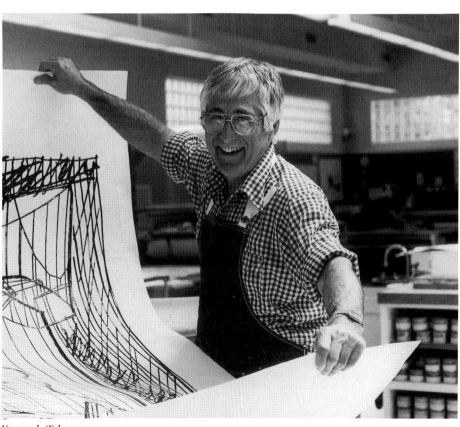

John Wagner

Kenneth Tyler

Reproduction
Credits

All photographs are by Steven Sloman, except those noted below.

Richard Bellamy
p. 125

Joan Broderick
p. 400 (bottom right)

Roger Campbell
line drawings, pp. 248, 402, 407, 413, 424

Marabeth Cohen
pp. 428 (except top right), 429 (except top left and bottom right)

Barbara Crutchfield
pp. 112 (right), 113

Anthony D'Ancona
p. 425 (center left)

Roxanne Everett
p. 281

Betty Fiske
pp. 45, 65, 149, 191, 409

Lindsay Green
pp. 8, 16, 21, 67, 107, 111, 153, 161, 185, 189, 235, 269, 277, 291, 311, 331, 367, 405–6, 407, 408, 410, 415 (top left), 418 (left), 426, back jacket (top and bottom)

John T. Hill
p. 37

Christopher Little
p. 233

Hans Namuth
p. 223

Courtesy Nancy Hoffman Gallery
p. 365

Renate Ponsold
p. 117

Neil Selkirk
p. 229

Jack Shea
p. 203 (right)

Kenneth Tyler
pp. 129, 141, 183, 207, 283, 317, 319, 321, 418 (right), 423, 425 (top left)

Kim Tyler
p. 429 (top left)

John Wagner
p. 416

Courtesy Walker Art Center
front jacket

In Erratum:
Ronald Davis: image 166:RD5 printed upside down.
Frank Stella: images 575:FS34 and 579:FS38 printed in reversed positions.